ARTIST'S GUIDE TO HUMAN ANATOMY

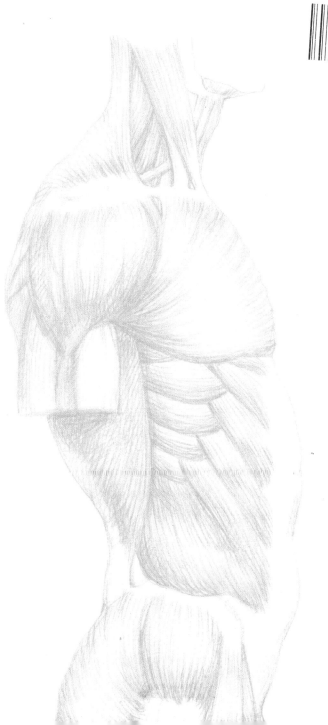

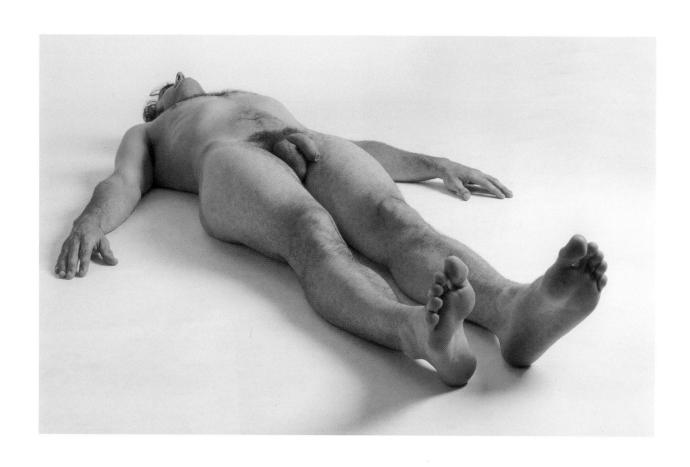

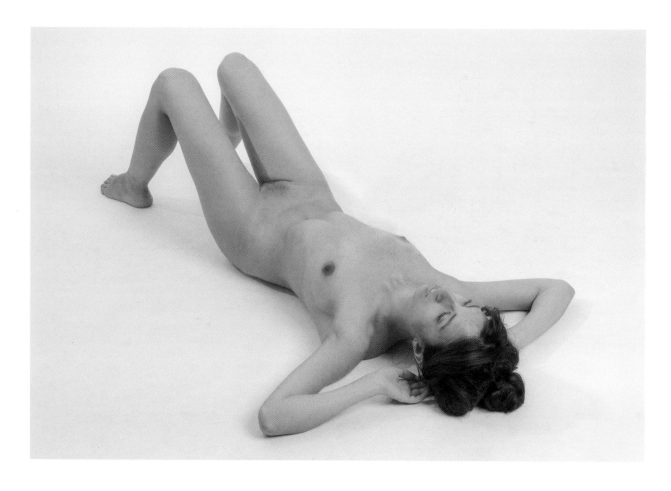

GIOVANNI CIVARDI

ARTIST'S GUIDE TO HUMAN ANATOMY

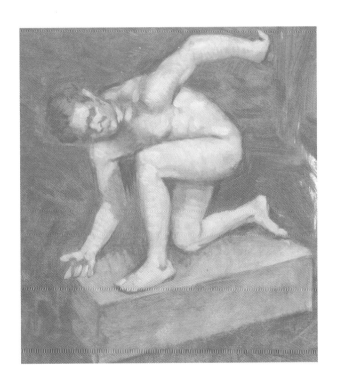

SEARCH PRESS

First published in Great Britain in 2020
Search Press Limited
Wellwood, North Farm Road,
Tunbridge Wells, Kent TN2 3DR

© *Il Castello S.r.l., via Milano 73/75, 20010 Cornaredo (Milano)*
Italy; 1994, 2018, 2020
info@ilcastelloeditore.it | www.ilcastelloeditore.it

ISBN: 978-1-78221-737-4

The Publishers and author can accept no responsibility for any consequences arising from the information, advice or instructions given in this publication.

Publishers' note:
The photographs and drawings were created with the help of professional models. The diagrams are by Giovanni Civardi; some are taken or adapted from previous books by the same author. The source credits are stated for old images or those by other authors. Reproduction of texts and images – in any format (including photocopies or electronic scans) – that substitute the purchase of the book itself, and for any type of use, is strictly prohibited. Any breach will lead to legal action.

Dedication:
In memory of my mother, Anselma Marchi, and my father, Lino Civardi.

Whoever knows nature cannot but have faith.

'Nobody can predict whether homo sapiens is destined to perish or survive, but we have a duty to fight so that he can survive.'

– Konrad Lorenz

Acknowledgements:
The responsibility for omissions or shortcomings, errors or imprecisions and perhaps for a few merits lies entirely with the author. However, a complex commission also requires collaboration and inspiration from various sources and from many other people. Of these, I would like to publicly thank: the management and editing team at Il Castello publishing company; the models: Monica Calabrese and Marco Mazzaro, and their photographer, Giorgio Uccellini; Professor Gérald Quatrehomme (Laboratoire de Médecine Légale et Anthropologie mèdico - légale, Faculté de Médecine, Nice); Professor Cristina Cattaneo (Forensic Medicine Department, University of Milan); the illustrator Alarico Gattia and the painter Umberto Faini, for their helpful friendship; Vanessa, as the body takes its meaning from the soul; but above all, praise be to God.

Giovanni Guglielmo Civardi *was born in Milan on 22 July 1947. With a degree in Economics, he later attended the Faculty of Medicine and the School of Nudes at the Accademia di Brera, dedicating himself to portraits and sculpture. He drew illustrations for newspapers, magazines and book covers for over a decade. He organized personal sculpture exhibitions and furthered his studies of anatomy during frequent stays in France and Denmark. He has held anatomy and figure-drawing courses for many years, condensing his teaching experience into many books. Most of them have been translated into several languages (English, French, Spanish, Russian, German, Japanese, etc.) and republished many times. He currently lives and works in Milan, Casteggio and Nice, frequently taking part in medico-legal and artistic conferences. Since 2014, some of his live drawing notebooks and original drawings for many of his books have been kept at the historical archive in the Accademia di Brera's library and in the Civiche Raccolte at Castello Sforzesco in Milan.*

CONTENTS

Preface to the fourth edition *7*

Preface to the first edition *9*

General information about the study of anatomy *11*

Definition of anatomy *11*

Anatomy and art: historical notes *11*

The morphological method *14*

Concepts of normality and variation *15*

Anatomical topography and terminology *17*

Evolution, human diversity, constitution, sexual dimorphism *22*

Notes on the macroscopic structure *30*

Notes on the microscopic structure *32*

General information about the shape of the human body *33*

General information about the proportions of the human body ... *34*

The historical development of proportional canons *37*

Anatomy of the locomotor system: general information *42*

The skeletal component: osteology *42*

The articular component: arthrology *51*

The muscular component: myology *54*

Bone and muscle reference points on the nude body *62*

The Integumentary system *66*

Superficial veins *68*

Subcutaneous adipose tissue *68*

SYSTEMATIC SURFACE ANATOMY OF THE
 LOCOMOTOR SYSTEM *71*

Introduction *72*

The head *75*

Notes on external morphology *75*

Osteology *77*

Arthrology *88*

Myology *89*

Head muscles of interest for artistic representation *91*

The eye *100*

The nose *102*

The lips *103*

The ear *104*

The function of facial muscles in expressions *106*

The trunk *109*

Notes on external morphology *109*

The spine *112*

Osteology *112*

Arthrology *114*

Myology *117*

The neck *118*

Osteology *118*

Arthrology *118*

The chest *119*

Osteology *119*

Arthrology *120*

The abdomen *123*

Osteology *123*

Arthrology *123*

Myology *124*

Trunk muscles of interest for artistic representation *132*

The neck *159*

The shoulder *161*

The armpit *162*

The breast *163*

The navel *165*

The external genital organs *165*

The buttocks *166*

The upper limbs *168*

Notes on external morphology *168*

Osteology *169*

Arthrology *172*

Myology *174*

Muscles of the upper limb of interest for artistic representation ... *181*

The arm *196*

The elbow *197*

The forearm *198*

The wrist *199*

The hand *200*

The lower limbs *203*

Notes on external morphology *203*

Osteology *205*

Arthrology *208*

Myology *209*

Muscles of the lower limb of interest for artistic representation ... *218*

The thigh *232*

The knee *233*

The leg *234*

The ankle *235*

The foot *236*

APPENDIX

Anatomy and drawing: from structure to shape *240*

Notes on static and dynamic dimensions
 of the human body *242*

Bibliography *250*

Anatomical index *252*

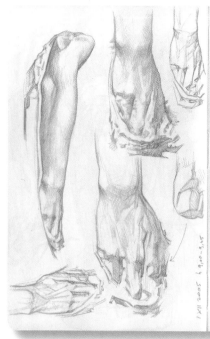
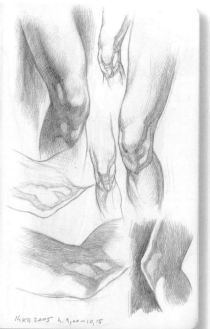

14 XII 2005 h. 9,00 — 10,15

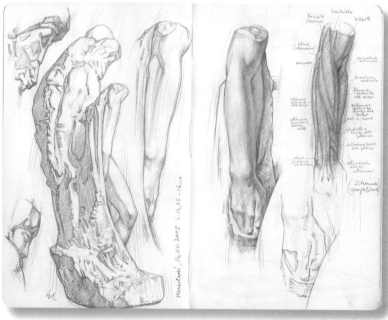

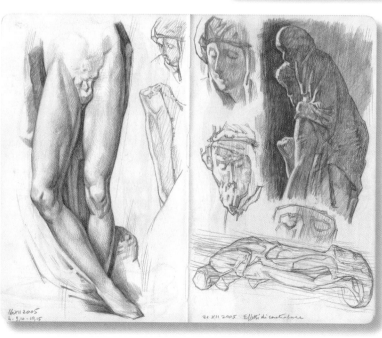

14 XII 2005
h. 9,10 — 19,15

21 XII 2005 Effetti di controluce

PREFACE

TO THE FOURTH EDITION

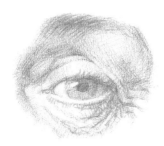

After almost twenty-five years of life and success for this book of mine dedicated to human anatomy for the artist, I thought an overall update of both the text and images was appropriate. Books age too... The methodological principles that inspired the layout of the book and organized how I addressed the subject were already covered in the preface to the first edition and have not changed, even with the evolution of aesthetic sensibilities and of the intellectual and technological tools that guide the development of any kind of knowledge and culture.

In this edition, I have almost totally removed the image gallery section, made up solely of photographs, and there are several reasons for this. Photographs of the human body have historically had several extremely important functions, and they still do: as anthropological and judicial documents for identification; as aids for artists which substitute or supplement living models; as a tool for experiencing aesthetics or for recording movement and fleeting expressions; and more besides. However, while having mutual influences, there are also substantial differences (of both concept and expression) between photography of the human body (now supplemented by computerized programs) and drawings of the human body (interpreted anatomically or aesthetically. For example, a drawing tends to be a selective process, excluding, including or emphasizing various physcial features in an effort to identify the model's individual traits. Photographs are more suitable for identifying the subject, indiscriminately recording all physical details and related information. I have, therefore, favoured the use of drawings and diagrams, while continuing to think of photographs as indispensable tools for investigating the human body. However, I have also applied a few procedural tricks: for example, always carrying out a rapid sketch of the figure before taking a photograph of it; keeping an eye on shadows and their intensity (preferring natural, diffused light to artificial light); and using a weak zoom lens in order to avoid changing the perspective and proportions too much (these can easily be evaluated and checked, once the photograph has been taken, by enlarging it and tracing only the outline of the figure).

In addition to correcting a few typographical errors and revising several sections, coordinating them with more suitable images, I also decided it was better to include some mention of the historical development of proportional canons, and I added a few notes on facial expressions and, in an appendix, some consideration of the static and dynamic dimensions of the human body.

Here, therefore, I think it appropriate to add a few notes on the topic we are dealing with, without wishing to make dogmatic statements, but leaving open all routes of interpretation and exploration after simply suggesting and stating them from my own point of view.

- Anatomy divides the body into parts, but only for the requirements of technical investigation and for the practical purposes of knowledge and description. The human body is an organic, structural unit. For the figurative artist, the description of the body is also related to the interpretation of shapes: it uses a rational process of analysis from which the emotive, expressive or interpretive process is born (or accompanies it).

- For the artist, anatomy is not an exhaustive study of figures placed in various poses (of which, as we can imagine, there are an unlimited number). It is used solely to provide the artist with the methodological and observational tools that allow him to reconstruct the human body in any position he wishes to portray it, using his own knowledge and aptitude, portraying it live or using his imagination or memory.

- Paradoxically, the study of artistic anatomy is particularly necessary for those who do not work with traditional systems of representation (drawing, painting, sculpture etc.), but who use the most innovative computerized methods such as 3D modelling, animation, simulation and virtual reality.

- Artistic anatomy, unlike medical anatomy, is not only structural, aimed at learning the constitutional and functional elements of the body. It also introduces an aesthetic factor, evaluating the external appearance, both in normal circumstances and in a variety of shapes and proportions, capturing the character of the form and the relations between its various parts. It helps to direct the gaze to elements of importance or permanence, sometimes distracting us from the transitory and changeable; it helps to discriminate between the unsaid and the explicit...

- The human body has reached a certain stage in its evolution: anatomy has the task of describing it as it is, leaving other sciences to explain the path of evolution and to forecast the destiny of somatic forms and their integration or connection with technological prostheses.

- The study of anatomy, if not limited to itself, offers the artist a tool (both fact-finding and informative, educational and operational) and this is how it should be viewed. Creative and imaginative expression can be more effectively dveeloped if it is based on objective knowledge and planned systematically: sound without order does not become music, it is just noise; marks without order do not become expression, they are just tracks... Perhaps. But, in the end, there is no transgression if there are no limits...

- The anatomical study of the human figure and morphology comes from not just looking at paintings, drawings or sculptures, but from also studying the living model; analytical tables of bones and muscles are just maps, itinerary tracks in anatomical analysis – a kind of anatomy on paper. The three standard projections (front/rear/side), which we can supplement with transverse sections, are the only ones required and they are sufficient to reconstruct the three-dimensional aspect of the body, both in classical learning routes and in the current application of computer and 3D digital aids. In fact, alongside traditional photography, there are other techniques for producing images of the body: Computerized Axial Tomography, Magnetic Resonance, ultrasound, xerography, digital scanning etc.. Digital cadavers have increasingly been used for some years now, and they may (with some exceptions, especially in forensic medicine) be a substitute for real cadavers: they comprise several transverse sections, from head to the feet, electronically reconstructed to produce a path on the computer screen that travels through all the dimensions of the virtual body. We should also consider the different characters of freehand drawings and computer program-assisted drawings used in computer graphics: a large part of the current output of commercial drawing (illustration, comics, cinematography

etc.) is drawn directly using computers, with a decreasing use of traditional graphic tools.

- Scientific anatomic drawing, with a taxonomic and descriptive purpose, concentrates on the typical traits of the portrayed subject, which they reproduce using suitable graphic conventions. Artistic anatomic drawing, with expressive and representational purposes, mostly focuses on evoking the individual traits of what is being observed.

- In modern art, but even more so in contemporary art, artists react to the need to study anatomy with varying degrees of enthusiasm, from exasperated acceptance to outright refusal. In most cases, although with significant exceptions, contemporary art no longer feels the need to be mimetic, representing the outside world. Instead it chooses to provoke ideas using any suitable media, whether conceptual or technological. In essence, the physical work itself does not matter, but the artist's representation does. Even the studio (intended as the work environment, the operational site) is replaced by smaller or non-existent spaces: the 'studio' is the artist himself, aided by new technological tools provided by digital art, the internet etc.. Frequently, the artist does not portray himself as the author, but as the proponent of creative, participatory events: often the work is carried out by others on the artist's instructions, almost always abolishing or blurring the distinction between traditional arts such as painting, sculpture, music and dance. All in all, in a period of dissolution of the form, there is no longer a standard comparison and so there is no longer a shared criterion for judging art.

- In spite of the main trends great attention is shown in contemporary art to the human body and its organic, anatomical structure, probed in its most varied aspects of expression, representation and transformation... Origin and destiny. Nowadays, the body is reappraised by artists in every expressive line and by scientists in the most advanced biological or technological subjects. However, at the same time it also makes us think that almost everything has become possible or acceptable, or will be in the near future: transplanting organs strengthened by electronic prostheses; constructing autonomous anthropomorphs governed by artificial intelligence; programming genetic mutation in the laboratory, or remodelling the body at will by changing, adding or replacing shapes and organs. This huge field of research, both fascinating and disturbing, opens up to the artist who studies 'classic' anatomy!

Giovanni Civardi
Milan, February 2018

Note to the second edition
This second edition is an almost unchanged reprint of the first; I have limited myself to correcting typographical errors and adding some minor omissions. I would like to thank the publisher for their helpfulness. Years later, books must either be left as they appeared in their first edition or rewritten: additions and variations to the original project usually corrupt the good qualities and emphasize the flaws. On the other hand, the reception of this book of mine and the success it achieved (abroad, as well as at home, both artistically and in a medical environment) show me the validity of the chosen methodological format. However, I hope that I can soon commence a similar work, larger in size and containing broader topics, where I can include further research, analyses and reflections on the content and meaning of anatomy as a tool of knowledge and training for the artist.

Giovanni Civardi
Nice, September 2000

Note to the third edition
This third edition is also an almost unchanged version of the text from the previous one. However, I have corrected some explanatory passages, substituted some photographic images and added to and updated bibliographical references.

Giovanni Civardi
Milan, April 2011

PREFACE

Anyone who works with the human figure is inevitably involved in the study of anatomy, and on setting out, artists ask themselves to what point they must commit to these studies. Effectively, anatomy is the knowledge of a body's structure, and it is the task of anatomists to describe the components and organization of the body. It is clear that for those dedicated to figurative art, anatomical notions enrich the visual capacity: they help the eye to observe and impose a healthy discipline. However, we might assume that there is nothing else useful about the study of anatomy, and that to operate as artists, we need only the essential knowledge and a basic technique, and that the rest is a mostly visual experience. On this point it is necessary to make a few observations as, if we wish to draw something that is a credible representation of a real object (in our case, the human body), we must know something about its structure – the general principles of organization and construction at the very least, as ignorance in this area may easily lead to excessive or badly understood details, to the detriment of the mature, essential understanding of the form. The task for artists is also to work out the limits of knowledge, as they must know what is important and useful to portray from what they see, and what can be left aside as irrelevant for expressive purposes. However, learning 'too much anatomy' can also lead to working from memory, basing the image on what we know, to the detriment of observation: generalizing instead of individualizing.

Also, artists are interested in a different understanding of anatomy to what is required of doctors, as they do not think in terms of detail, but in terms of mass, planes, volumes, lines, chromatic and tonal values, movement.

The relationship between medical anatomy (which, in a simplified, incomplete way, is traditionally associated with the cadaver) and artistic anatomy is extremely complex and it is not possible to discuss it here: suffice to say that there is a difference between scientific accuracy (in which phenomena are analysed objectively, without the influence of the observer's emotions, and the results can be controlled and compared) and artistic accuracy (in which what is observed should be also be communicated while preserving the memory, the trace of the feelings felt by the author). Rudolf Arnheim gives an interesting illustration: an artist can paint a picture in which a fierce tiger is accurately portrayed and therefore easily recognizable, but if there is no fierceness in the colours and strokes, the tiger will look as though it is embalmed, and there can be no fierceness in colours and strokes if the qualities of the subject's character are not precisely acknowledged and expressed.

Likewise, in the human body, expressive analogies can be made between the characteristics of tissues and the strokes that represent them; rigid parts (bone, contracted muscle, tendons) are expressed using hard, straight, clear strokes; soft parts (relaxed muscle, adipose tissue) using blurred, soft, delicate strokes and so on.

In recent times, there was also the problem of the usefulness for the artist of studying the dissection of the cadaver: this unresolved argument seems to have been set aside in art schools (and partly in medical schools too) and replaced by the use of other techniques (photographs, three-dimensional models, electronic drawings, etc.), for theoretical reasons but most of all because of the obvious practical difficulties. I believe that it is not useful or necessary for the artist to carry out full dissections or even to attend autopsies, because of the significant

morphological changes in a cadaver compared with the living body (hardened tissue, flattening, muscle and fat retraction, etc.). The artist must think of the living, mobile subject and therefore the best way to address anatomy is to observe the living subject's visible form, and then understand and interpret the structures that create the external shapes through anatomical theory. Dissection may possibly be useful for artists who have already understood the human figure well, as it then serves to add to and consolidate that knowledge: but just observing the underlying truth in this way is not enough in itself to reach high levels of competence.

As it is the school's task to provide intellectual and operational tools of expression and guide pupils in using them in the most suitable way in keeping with each individual's aptitudes, I am sure that practical experience of dissection (in addition to knowing how to draw, of course) is, on the other hand, indispensable for anyone who wants to teach artistic anatomy seriously, and in a stimulating manner – not just from a book, but in accordance with the demands of modern culture. This is an aspect of the relationship between art and science: there has always been ambiguity in anatomy in these two apparently opposing disciplines, and they co-exist happily only in a very few cases. Paul Richer is a good example of this: he was a well-known expert whose work hugely influenced subsequent studies of human body morphology, and he was a doctor, sculptor and teacher. It was said that he was considered a great artist by doctors, and a great doctor by artists.

The living body, in our modern understanding, can be seen as the result of superimposing three layers: skin (sensoriality), muscles (movement), the skeleton (stability) and this means that anatomy, when applied to art, should bear in mind the implications and interrelations between soma and psyche. It should even evolve into the broader concept of morphology, which is extremely interesting and full of intellectual and aesthetic stimulations from both a biological and representative point of view. Morphologists, in fact, do not only attempt to understand the structure and the function of organisms (anatomy), but also the reasons that have led to the taking on of certain forms and the reasons for structural variability in individuals of the same species, using all available techniques: dissection, microscopic analysis, radiography, anatomic comparison, cinematography, computer processing and simulation and more. To be of use, artistic anatomy (morphology) must be an intellectual tool that each artist can use according to their own expressive needs, but that can also be consciously set aside if knowledge becomes an obstacle to working creatively. The acceptance or setting aside depends on the artist's chosen path. Some reasons favouring the study of anatomy could be as follows: the human form can be represented well without studying bones and muscles, but correct knowledge of them allows better representation, also perhaps in a freer way. A summary can only be fully reached after analysis proceeding from a perception of the whole. Free will (or licence) can only be acceptable if the underlying knowledge is there, but it gives the appearance of a mistake or ignorance if used inappropriately. An artist's sensitivity and intelligence, however, should not reduce the study of figures and anatomy to the point of being a boring academic exercise that can perhaps help to solve a few formal problems and provide useful references, but that is not sufficient in itself to provide stimulus for interest and cultural dilation. If it is seen as such,

artistic anatomy can only make a good 'craftsman' but not necessarily a better artist.

When an author writes the preface to their book, they may have various aims in mind (trying to make a fault appear as a quality, justifying missed opportunities, declaring intentions), but usually they summarize and formalize the reasons that brought them to write. Even more simply, it would seem appropriate to sum up in a schematic way, some criteria that I have attempted to follow when planning this book.

- As things are not always what they seem, I have tried to guide the reader towards a path of individual discovery: first observing the human body (people that surround us offer varied examples) and then looking for anatomical reasons that justify the usual or typical form and that of the specific subject being observed. The figurative artist is basically visual, but I have insisted on the verbal description of the morphology of many parts of the body (for example: the eye, the hand, etc.) because if this is repeated and integrated by the reader, it fosters accurate analysis and emphasizes the need to try and recognize the true characteristics being revealed. It would be helpful for everyone to check the morphological characteristics being examined on themselves, as far as possible.

- The bone structure, while fundamental, has been addressed in an extremely summary manner as, currently, a skeleton (or at least an educational one reproduced in synthetic material) can easily be found in any school, to be used to learn to study the forms and draw or model endless aspects and perspectives of each bone and the full articulated skeleton. The nomenclature is secondary in importance to understanding the three-dimensional form of bones and their reciprocal spatial orientation. Reproducing the diagrams of anatomy atlases is a boring, pointless exercise when it is possible to refer directly to the full skeleton. The drawings of bones have therefore been carried out summarily, tracing only the most important projections (as a kind of topographical map that guides our exploration of the area).

- On the other hand, the muscular structure has been handled more widely as, unlike the bones, muscles can only be studied indirectly, via images. However, in this case too, I believe that it is pointless to reproduce extensively detailed artists' anatomy diagrams, as the form of the muscle in the cadaver is rather different to what is in the living body. Therefore, reproducing an image that we already know from the outset does not correspond to the truth, can be misleading as well as pointless, allowing pseudo-realistic impressions to take root in the mind. I have therefore chosen to provide very simple diagrams that help to memorize the topographical situation and attachment points for each muscle on the skeleton, dedicating a thorough description to the influence they have on the surface anatomy. The traditional order of succession of muscles has changed, in some cases, for reasons related to the book's layout.

- The anatomical parts described and the relative diagrams of both bones and muscles refer to an abstract male adult subject and, almost invariably, reproduce the right-hand part of the body, according to tradition, as the other antimere is a symmetrical mirror of it.

Lastly, I think it is interesting to add a few notes about the models who posed for the photographs (almost all black and white) that accompany the text of the book. The word 'model', in common usage, indicates an example to imitate, to conform to, a kind of ideal, perfect prototype to refer to. This is exactly what I tried to avoid: the subjects used were not chosen according to a criterion of formal perfection, but only of normality, and I did this deliberately, as I believe that artists must compare themselves with their surrounding reality, from an anatomical study point of view. The search for ideal beauty, almost always an abstract standard, is the task of other subjects and the concept itself is rather questionable, being subjectively, culturally and socially relative. When translated into body reality, as often happens, it is found to be insignificant. There is, however, greater interest to be found in what we call 'character', the expressive form. Male and female models who pose in art schools are usually 'typical' subjects, like the many that we meet every day in social life. Anatomical study is aimed at clarifying the reasons why internal body structures determine a certain external shape or modify it through movement, the force of gravity or disease. I would say that a scholar of external morphology must train themselves to recognize the individual characteristics that belong to each subject, to accept variability compared with the 'normal' description. It will therefore be easy to find some slight imperfections or deformities in the images provided for this purpose, while the body still conforms to perfectly normal standards.

The preparation of this book required thorough research, carried out especially for the purpose of verification, and encouraged by a real personal interest in the subject. Each author has huge debts towards those who have preceded him or her in handling the same subject, forming a kind of stratification of knowledge to which each of them makes their own contribution (or hopes to). I would like to thank some of the many people, who have been particularly helpful to me:

- Professor Martin E. Matthiessen, director of the Institute of Medical Anatomy at the University of Copenhagen, for having placed the dissection room at his institute at my disposal, allowing me to carry out careful investigations on several cadavers. My thanks also go to Doctor Claus Larsen, a doctor and scientific illustrator, who made this occasion possible.

- Professor Enrico Lui, a painter and set designer, the creator and director of the Osservatorio Figurale in Milan, for having given me the opportunity to study several male and female models who attend his courses, and to work in his studio, for extended periods of time in such favourable conditions.

- I am grateful for the collaboration of the photographer Guido Cataldo, who patiently and expertly photographed so many of the images, and also for Doctor Antonio Diomaiuta's willingness to allow me to reproduce some images taken from the *Atlante di Anatomia* by Rohen-Yocochi published by the E.M.S.I. publishing house in Rome, which he represented.

- Lastly, my thanks also go to the models who kindly posed for this book – you know who you are.

Giovanni Civardi
Milan, 1994

GENERAL INFORMATION ABOUT THE STUDY OF ANATOMY

DEFINITION OF ANATOMY

In its broadest sense, anatomy is the study of the shape and structure of a human's, animal's and plant's entire organism and its individual organs, through dissection and other research methods. It is therefore a biological science, the basic task of which is to study the body's structure and the reciprocal relations of organs. Anatomy then encompasses other branches: veterinary anatomy, aimed at the study of animals; anatomy of man (or human)[1]; plant anatomy and comparative anatomy, which compares animal structures with the same embryological origin (homologous organs) or with the same function (analogous organs) and is, therefore, an auxiliary science of human anatomy. This can be very useful for the artist, although generally speaking the comparison is limited to the form of only one animal 'type' – vertebrates – while the comparative study of other types is included in zoological anatomy.

Human anatomy is the specific subject of our study, which, from ancient times, has been carried out on cadavers: using dissection techniques, cutting skin, separating organs and exploring the macroscopic structures using the senses, especially sight and touch.

The term 'anatomy' (from the Greek *ana* ('through') and *tomé* ('section')) thus comes from this main method of studying. Other observation tools were added to it at a later point, such as the optical microscope, which allowed the development of microscopic anatomy, and the electronic microscope (ultrastructural anatomy), radiology, computerized axial tomography, ultrasound. These have provided for more sophisticated, fuller investigations, not just on cadavers but also on living organisms. The macroscopic-dissecting study of anatomy is therefore supplemented by cytological, histological and embryological studies at microscopic level, which investigate cells and tissues and their development up to the formation of organs. In recent years, computerized investigation and simulation or diagnostic imaging tools have been associated with other three-dimensional detection and reconstruction media. Classic dissection and forensic medical autopsies are also adopting the auxiliary use of special electronic scanning programs which reduce or avoid direct intervention on the cadaver.

In medical disciplines, human anatomy can be separated into various areas according to how the study is planned:

- Normal descriptive and systematic human anatomy describes the position, relations, form and structure of organs and, based on these data, classifies them into systems. It is divided into osteology, myology, arthrology, angiology, neurology, and splanchnology. (The meaning of 'normal' will be discussed later in the book).
- Topographic (from the Greek *topos* meaning 'place') or regional anatomy comes from descriptive anatomy, but its studies of the body are according to its division into areas bordered by visible reference points that are recognizable to touch. It is also known as surgical anatomy as it is useful for operation purposes, since the investigation is conducted in sucessive layers, moving from the external layer, from the skin, to the internal parts, going deeper and deeper. It is aimed at describing the various organs that are encountered in each area, highlighting their mutual relations and their projection on to the body surface.

- Functional anatomy, which aims in particular at correlating the structure of various organs with the functions they carry out, individually or together in a system, aims at a dynamic vision of anatomical study. Modern anatomy considers both the descriptive direction and functional direction.

- Pathological anatomy aims to study alterations that occur in organs as a result of illness, in form, volume, structure, function and relations, making a continuous comparison with data from normal descriptive anatomy. Classical investigation is carried out post-mortem, via autopsy and the microscopic examination of tissues.

- Artistic (plastic, surface, or morphological) anatomy investigates the external forms of the human body, bearing in mind knowledge coming from descriptive and topographical anatomy, and adding to it through constant reference to living humans, both in static and moving states. It assimilates knowledge acquired from physical anthropology (which studies the comparative morphological characteristics of various human racial groups and various body types) and kinesiology (which studies the mechanisms of body movement), and from the history of art, social customs and contemporary aesthetics.

ANATOMY AND ART: HISTORICAL NOTES

It is difficult to discover the origins of anatomy and the knowledge of the body by prehistoric man. We can only make assumptions using as our reference 'graffiti' or markings and rock paintings, anthropomorphic stone and clay statues, and human skeletal remains that, among other things, prove that rudimentary surgical operations such as amputations or skull drilling took place. However, the first depictions of men and women date back to the Palaeolithic age (between 40,000 and 10,000 years BC) and our idea of what happened in earlier eras is mostly mere conjecture: it would seem likely that prehistoric man knew the anatomy of large animals that he killed to feed himself or to defend himself with better than he knew his own. Of his own anatomy he may have had some knowledge coming from the observation of external forms, from treating large wounds and from burial practices. However, fragments of engravings, papyruses, items of art and the tools found during archaeological digs show us the already advanced, and in some cases accurate and exact, anatomical knowledge that the populations had at the start of this historical period. For this reason, the names or the graphic descriptions of several internal organs such as the heart, lungs, liver, spleen, intestines, uterus and blood vessels, have been passed on to us. We gather that ancient Babylonian, Jewish, Egyptian, Indian, Etruscan and Roman doctors and priests were able to observe these organs directly during the celebration of sacrificial or propitiatory rituals

1 It is quite clear that the reference to 'man' or 'human' has no gender value but is solely of traditional value and refers to an individual belonging to the human species. It is quite interesting to note that in the West the majority of anatomical representations, with a few rare exceptions, refer to the male body and the European human type. There are reasons for this: the western origin of 'scientific' anatomic study and the fact that the first dissected bodies were of criminals and convicts and that anatomical understanding and application was mostly used in war surgery, in which the injured subjects were also mostly men.

in which animals or humans were sacrificed, or by treating large war or hunting wounds.

In some populations, but especially the Egyptians, the widespread practice of embalming bodies brought with it considerable anatomical knowledge about the arrangement of the internal organs, and some evidence suggests surgeons also had some limited anatomical understanding gained from treating wounds, albeit without attempting systematic research.

In the West, the first roots of anatomy, intended as the rational study of the human and animal body, therefore with scientific intention, can be traced back to the 6th century BC in Greece and its Italic colonies, where large schools of philosophy were formed, attended by many scholars of medicine and natural sciences: Alcmaeon, Parmenides, Hippocrates, Aristotle, Empedocles of Agrigento, Diogenes of Apollonia. They studied anatomy and physiology primarily on animal bodies, and it is doubtful that they carried out thorough human dissections, but this did not stop them from making careful experimental and theoretical observations, extending them to human bodies, using several intuitions that proved to be correct.

In the Hellenistic world, anatomy made great strides at the school of Alexandria in Egypt, of which Herophilus (340–300 BC) and Erasistratus (320–250 BC) were the best-known representatives. They practised human dissection, which was authorized and encouraged by the public authorities, providing a sizeable descriptive basis for human anatomy, which up to that point had been rather speculative and comparative.

Alexandria's cultural heritage then moved to Rome in later centuries, where it dried up, however, due to the gradual abandonment of the practice of human body dissection. A few names can be remembered from this rather lengthy period, including Celsus (active in the 1st century AD) and above all Galen (131–201 AD) who had a huge influence on medicine in the western world throughout the Middle Ages. In fact, after his death, a long period of general cultural decline began that slowed down scientific evolution in many civilized populations: the Byzantines, Arabs and Christians did not practise cadaver dissection for religious reasons, as the body had to remain whole and unviolated. For more than a millennium, Galen's writings, together with those of the Arab Avicenna who lived around 1000 AD, were considered to be indisputable on the subjects of anatomy and medicine and as such, were commented on and passed on to scholars in schools of medicine.

Only in the early decades of the 14th century did we finally see a widespread interest in anatomical studies, as shown in the works of Mondino de Liuzzi (circa 1275–1326), Guy de Chauliac (circa 1300–1368) and other scholars at the Universities of Bologna, Padua and Montpellier. Dissection of cadavers was restored in these universities, in spite of persistent bans from the church and general reluctance to systematically violate the mystery of the dead body. In that period, anatomical descriptions also appeared, accompanied by extremely concise, and at times imaginative, illustrations, but which began to highlight the importance of visual documentation together with supporting literary descriptions. The true rebirth of human anatomy study took place in the 15th century, when the direct observation of bodily structures in cadavers (a practice taken up widely in many medical centres of study and by some artists) corrected and replaced dogmatic reference to classic texts, marking the start of scientific investigation and experimental research.

It was the work of Andreas van Wesel (1514–1564) and the anatomic investigations carried out by artists in the 15th and 16th centuries within the philosophical climate of Humanism and Renaissance, that created the foundations of modern human anatomy, not only for doctors but also for painters and sculptors. We can say, then, that the roots of artistic anatomy are to be found in the 16th century.

Ancient western art, particularly Greek and Roman sculpture, has the almost exclusive theme of the human body and, in subsequent eras, we see the emphasis on or, conversely, abandonment of interest in correct, accurate or idealized anatomical representation, depending on the prevailing cultural and aesthetic milieu. The careful study of the superficial muscles in athletes certainly advanced strictly anatomical knowledge in those times, yet it led artists and philosophers to formulate aesthetically ideal proportional rules for portraying the human body that established the canons which followed. However, the studies remained faithful and accurate with regard to body structure.

The publication of essays or collections of loose illustrations became increasingly frequent after Leonardo da Vinci's (1452–1519) studies, which were condensed into several notebooks and unfortunately remained almost unknown to his contemporaries: these include the studies of Lorenzo Ghiberti (1378–1455), Donatello (1382–1466), Luca Signorelli (circa 1441–1523), Leon Battista Alberti (1404–1472), Albrecht Dürer (1471–1528) and the collaboration of several artists with doctors, for works where they carried out engravings of great aesthetic value and important illustrative interest. These images were usually dedicated to depicting the human body's skeleton and musculature and, therefore were often inextremely useful for artists as they reduced the need for dissection: it must be remembered that, while tolerated, dissection was viewed with a certain degree of suspicion by several social institutions of the era.

The engravings illustrating the essay by Vesalius, *De Humani Corporis Fabrica Libri Septem* (1543), and his *Tabulae Anatomicae* (1538) were

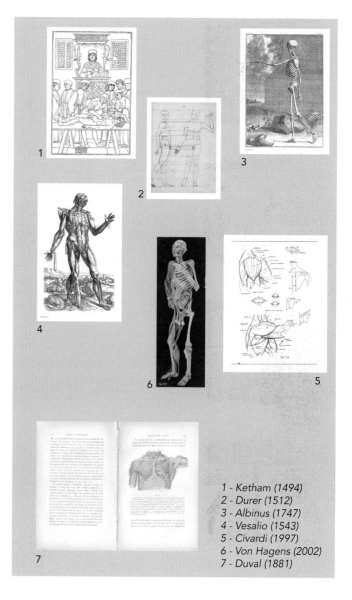

1 - Ketham (1494)
2 - Durer (1512)
3 - Albinus (1747)
4 - Vesalio (1543)
5 - Civardi (1997)
6 - Von Hagens (2002)
7 - Duval (1881)

probably mostly carried out by Giovanni Stefano da Calcar, one of Titian's pupils, and these works quickly became the standard reference material for anatomical studies among artists, and remained so for some time. This was the case at least until the 17th century when, at times inspired by Baroque aesthetic tastes, some essays specifically focused on anatomy for painters appeared, written, for example, by Paolo Berrettini da Cortona (1596-1669; *Tabulae Anatomicae*, 1741), Bernardino Genga (1655-1734; *Anatomia per Uso et Intelligenza del Disegno*, 1691, together with Charles Errard) and Carlo Cesio (1626-1686; *Anatomia dei Pittori*, 1697). The illustrations by Bernard Siegfried Weiss Albinus (1697-1770) are scientifically accurate and of an almost insurmountable beauty, and *Tabulae Sceleti et Musculorum Corporis Humani*, 1747, engraved by Jan Vandelaar and published between 1747 and 1753, began to constitute a kind of 'paper anatomy' and were used as an example for many essays on the same subject that appeared towards the end of the 18th century and beginning of the 19th century. These were written by many experts in anatomy applied to the arts: Jacques Gamelin (circa 1738-1803; *Nouveau Recueil d'Ostéologie et de Myologie*, 1779), Giambattista Sabattini (*Tavole Anatomiche per li Pittori e Gli Scultori*, 1814), Ercole Lelli (1702-1766; *Anatomia Esterna del Corpo Umano*, circa 1750), Jean Galbert Salvage (1772-1813; *Anatomie du Gladiateur Combattant*, circa 1796), Giuseppe del Medico (*Anatomia per uso dei Pittori e Scultori*, 1811), Pierre-Nicolas Gerdy (circa 1797-1856; *Anatomie des Formes Extérieures du Corps Humain*, 1829). At the same time as the first anatomic illustrations, some myological sculptures portraying the skinned human body also appeared, which clearly showcased surface muscles. The first were

carried out towards the end of the 16th century by Ludovico Cardi, known as Cigoli (1559-1613) and by Marco Ferrari d'Agrate (circa 1490-1571). In the 18th century, the ones sculpted by Ercole Lelli, Edme Bouchardon (1698-1762) and Jean-Antoine Houdon (1741-1828) became very well known, and on the basis of these, generations of painters and sculptors practised in the Academies. Until the start of the 20th century, in almost all art academies, anatomy lessons were given not just observing the living model, but also cutting up (or watching the cutting up of) cadavers and drawing osteo-myological images, often in close collaboration with faculties of medicine. It is still possible to find the plaster casts of anatomical parts, perhaps kept alongside skeletons (or the residues of them), now gathering dust in these venerable institutions.

Recently, a substitute for myological statues was created by Gunther von Hagens using a process of plastic infusion (plastination, 1977). Authentic cadavers (donated) are preserved, dissected and 'exploded', and placed in spectacular, inelegant positions of pejorative taste, far from the purposes of classical myological sculptures.

Ceroplastics is the extremely faithful reproduction of complex anatomic parts using modelling wax and moulding it on to real models, and this has been an aid for medical students, but is also of great use for artists. The tradition started and was developed mostly in Italy by Gaetano Giulio Zumbo (1656-1701), Ercole Lelli (1702-1766), Clemente Susini (1754-1814), Giovanni Manzolini (1700-1755), Anna Morandi (1716-1774) and in France by André-Pierre Pinson (1746-1828).

During the 19th century, especially in the second half, several essays about artistic human anatomy were published in which the authors tended to adapt the wealth of medical anatomy knowledge now available to them to the representational needs in art. These works emphasize an interest in body proportions, movement, external morphology and the myological study of facial expressions above all. This was in harmony with the cultural trends inspired by positivism, for which reason large amounts of data and systematic experimental observation on descriptive anatomy and physiology were collected, not just on the human body, but also on animal bodies. Experts also used photographic and later cinematographic and radiological techniques. Pioneers of photographic investigations took a series of photographs captured in rapid sequence, with the intention to analyse the body in motion, and this had a deep influence on artistic development. These pioneers included Eadweard Muybridge (1830-1904), Etienne-Jules Marey (1830-1904) and Albert Londe (1858-1917). Alongside these scientific and artistic studies of movement, we must also place physical anthropology studies, aimed at furthering knowledge of the somatic and skeletal structure of people belonging to various human populations with their different social conditions, creating a kind of extended catalogue of measurements and scientific descriptions which were mostly only of statistical and classificatory value. The contributions of Cari Gustav Carus (1789-1869), Carl Heinrich Stratz (1858-1924), Alphonse Bertillon (1853-1914) and Rudolf Martin (1864-1925) are still beneficial for an artist's anatomical studies, however. The development of printing techniques such as lithography and then photogravure allowed atlases and extremely accurate anatomic tables to be drawn up in the 19th century, which were used for medical training but were also of interest (at least for the topic of the locomotor apparatus) for figurative artists, some of whom were dedicated to scientific illustration, while others used them for precise information and references. For example, the atlases by Jean-Baptiste Bourgery and Nicolas Jacob (1832/1854), Johannes Sobotta (1904) or Eduard Pernkopf (1937) are still valuable.

Many works written in the last decades of the 19th and early 20th centuries concentrated on the transition of the focal point from a purely osteo-muscular one to that of external forms (morphology). These are full of information which is still useful today, especially those of

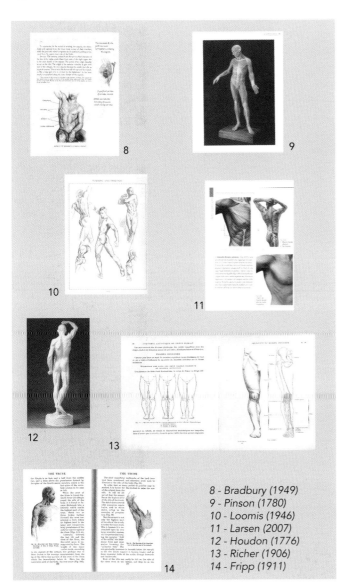

8 - Bradbury (1949)
9 - Pinson (1780)
10 - Loomis (1946)
11 - Larsen (2007)
12 - Houdon (1776)
13 - Richer (1906)
14 - Fripp (1911)

Mathias-Marie Duval (1844–1907), Paul Richer (1849–1933), Antoine-Julien Fau (1811–1880), John Marshall (1818–1891), William Rimmer (1816–1877), Arthur Thomson (1858–1935), Alberto Gamba (1831–1883), Giulio Valenti (1860–1933) and Wilhem Tank (1888–1967). These are only a few scholars best-known for the research they carried out and the contributions they made. In the specific area of the muscles that form expression (associated with physiognomy in ancient traditions), fundamental observations were made by Johann Lavater (1741–1801), Guillaume Duchenne de Boulogne (1806–1875), Charles Darwin (1809–1882), Paolo Mantegazza (1831–1910) and more recently by Leone Augusto Rosa (1959) and Paul Ekman (1978).

The end of the 19th and start of the 20th centuries saw the culmination of the anatomical research described here in detail, not just in the type aimed at artists, but even more in the field of medical anatomy, so the need soon arose to favour the functional aspect rather than the descriptive one, reducing systematic data to more easily usable limits. On the other hand, profound artistic changes increasingly diverted aesthetic research away from the objective representation of reality, and there was a general weakening of interest in anatomy intended as a fundamental cultural asset for artists and as a tool of representation. For example, some of the many authors who dedicated time to the modern direction of anatomical investigation for the artist enjoyed particular success as teachers, including Jeno Barcsay (1900–1988), Gottfried Bammes (1920–2007), Charles Earl Bradbury (1888–1967), George Brant Bridgman (1864–1943), Gheorghe Ghitescu (1915–1978), Paul Bellugue (1882–1955), Angelo Morelli and John Raynes.

Currently, works on artistic anatomy show the effect of this uncertain direction, alternating between the realistic, academic study of the human body and its spontaneous, immediate, emotive representation, and the interpretation of the body in a psychologically liberating and therapeutic sense. Written mainly by artists rather than by doctors, they are decidedly guides to observing the human figure and include works by Andrew Loomis (1892–1959), Robert Fawcett (1903–1967), Burne Hogarth (1911–1996), combining classic, strictly technical anatomical notions with the modern principles of visual perception, the psychology of form and gestural expression.

THE MORPHOLOGICAL METHOD

For some decades, anatomy has increasingly tended to distance itself from the pure description of the structure and external appearance of organs and has embraced morphology, or rather the science of forms. Morphology (from the Greek *morphé* meaning 'form') still makes use of analytical descriptive methods but considers description to be a means rather than an end of anatomy. The morphological method has its roots in the basic fact-finding process that, since Galileo, has given rise to modern scientific thought, especially in the natural sciences: from the description (the fruit of observation) a classification (name or taxonomy) is created, leading to the formulation of 'laws' (systemization or nomothetics) and lastly to critical interpretation.

The purpose of morphology is to interpret forms. Having perceived them via the senses and his or her tools, the scholar tries to gain knowledge of them by identifying their meaning and functional value.

14

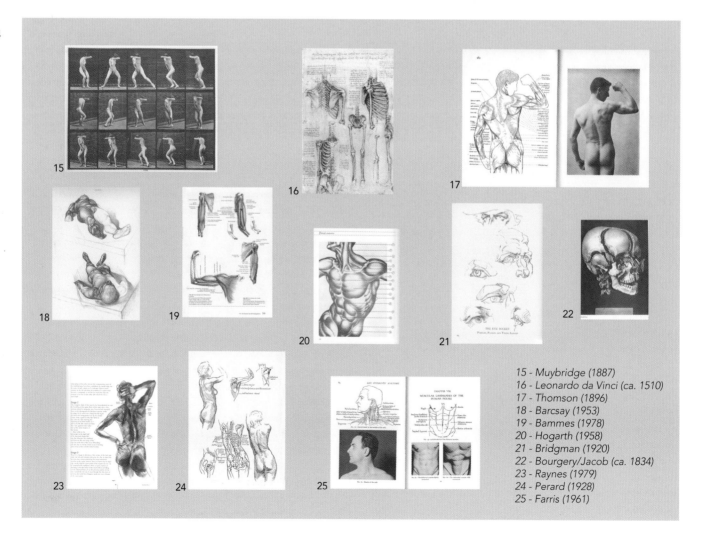

15 - Muybridge (1887)
16 - Leonardo da Vinci (ca. 1510)
17 - Thomson (1896)
18 - Barcsay (1953)
19 - Bammes (1978)
20 - Hogarth (1958)
21 - Bridgman (1920)
22 - Bourgery/Jacob (ca. 1834)
23 - Raynes (1979)
24 - Perard (1928)
25 - Farris (1961)

The analytical and descriptive stage, therefore, is only the first step in recognizing the inner workings of human forms, and it must be followed by a search for the determining causes and a demonstration of their evolutionary and functional meaning. This investigation is no longer limited to inspecting cadavers but is supplemented, *in vivo*, by the verification and examination of functions and forms using physiological, biochemical, histological, genetic and radiological techniques. These help the scholar to account for the studied organ's evolution in time by carrying out an interpretive evaluation of it, highlighting the differences between the cadaver and the living form.

There are not only practical but also importantly philosophical and socio-theoretical reasons at the root of the morphological method – reasons that can be traced to the Platonic view of the relationship between form and material, or 'essence' as a determination of being. In the broadest sense, the form is perceived as a whole, but in a narrow sense it is increasingly only a 'form'. The real form, as it 'really is', is therefore seen as a unit of form and material, but what is decisive is always the form.

In this sense, morphology can be viewed as the science that tends to capture the essence of living forms. Thus we see the evolution of anatomy from a reductionist viewpoint, breaking down and classifying (a process which has finished the collection of data after centuries of investigation so that it is subject to only minor further developments) to a holistic approach of a synthetic, interpretative, functional nature. Following this evolution, anatomy has begun a path of renewal, broadening its investigation to embryology, physiology and biochemistry, using more up-to-date, sophisticated methods of study, including *in vivo* experiments with which to interpret the data gathered from dissecting cadavers more correctly.

In this way, several different possibilities for addressing anatomy can be considered, such as individualized anatomy, relating to various ages, genders, ancestral groups and physical constitutions. Interesting comparisons that are significant in practice can emerge from these investigations. These studies are of significant interest to the figurative artist, who may find several sources of inspiration in them, if they are addressed with intelligence, as well as enriching his cultural sensibilties and his art.

CONCEPTS OF NORMALITY AND VARIATION

The basic direction for anatomical studies is the one followed by normal human anatomy, which connect, as we have already mentioned, to the other more specialized branches of anatomy. The intuitive meaning that can be given to the term 'normal' is that of a healthy man, suggesting a counter-position with pathological anatomy dedicated to the study of the organism in diseased states.

However, the concept of normality in biological and medical sciences is more complex, and the very word 'normal' in scientific language, as in common language, takes on various meanings, that can rarely overlap, such as: typical, average, healthy, regular, suitable for the purpose, perpendicular, compliant with a model and so on. In fact, the definition of 'normal' comes from statistics and mathematical methods processed by it to discover data and correlations between data. The data, gathered by observing the elements forming a statistical group, are composed into a succession of terms to form a series or a distribution of frequencies (seriation), depending on whether the character of the phenomenon being studied is quantitative (that is, measurable and numerable) or qualitative (that is, definable by attributes). The series thus formed is then processed using various methods. In relation to the research to be carried out and the degree of accuracy that one intends to reach,

the simplest is the mathematical mean, represented by the quotient, which is obtained by dividing the sum of the terms by their number. The mean value thus obtained does not, however, have great significance for defining normality.

This definition emerges from another statistical procedure regarding the distribution of frequencies: the use of Cartesian diagrams. These are based on the system of orthogonal axes, that is, two straight lines (the horizontal, x-axis called the abscissa and the vertical y-axis known as the ordinate) intersecting in a point known as the origin, on which the data collected through observation are arranged. Using these diagrams shows the behaviour of one phenomenon according to another.

Each piece of statistical data can be represented by a point on the Cartesian diagram, obtained by the crossover of the relative coordinates and, therefore, a statistical succession can be represented by a number of points on the Cartesian diagram. By joining all the points representing gathered data in a line – a line which may be straight, curved or broken – the behaviour of the phenomenon is described in relation to the two quantities observed. If there is a large amount of collected data arranged on the axes of the first quadrant, with frequencies on the ordinate and intensity on the abscissa, a frequency curve is formed (also known as a binomial curve or Gaussian curve), seen on page 16. This tends to form a bell shape as the frequency of an intensity grows slowly at first, then rapidly, up to a point of culmination (known as the mean) from which it then decreases symmetrically. This is the typical Gaussian distribution: however, it is necessary to note that, in anthropomorphic and biometric findings, such an ideal curve is rarely found, also because values are found (for example, for height, weight, body diameters etc.) above or below which it is not biologically possible to go. In the simplest case, that of the ideal curve, the line that joins the mean point with the abscissa data (known as the mode) is indicated as the median and falls exactly halfway between the data observed, dividing the series into two equal parts. Therefore, the modal (or normal value) of a series is the measurement of the term that shows the highest frequency and is a particular mean value of the frequency distribution, showing the intensity of the phenomenon that most often occurs. It should be said, however, that only in the event of frequency distributions with a typically Gaussian trend (symmetrical), does the arithmetic mean coincide with the normal value and the median.

The area between the frequency curve and the abscissa, therefore, corresponds to the total number of observed cases.

In many ways, the normal value is more significant than other average values as it is a number or intensity that has actually occurred – unlike, for example, the arithmetic mean or other averages, which are abstract values and may not coincide with any of the empirical data that they represent. Also, the normal value is also the most frequent in the set of collected data and can therefore hold more effective representation in all the statistical problems for which it is necessary to highlight the measurement of the phenomena that has the highest probability of occurring.

The phenomena under investigation are susceptible to taking on different qualitative and quantitative modalities, and they are subject to variability, which can be given an expressive measurement, in one or few numbers, of the characteristics of the set of statistical data or distribution. This result can be obtained by obtaining a mean value that globally represents the series, but this average value expresses only one quantitative dimension of the set and does not show the actual quantities of the values from which the series is taken and does not describe the distribution of said values.

One significant measurement of variability is the standard deviation ('s') with which the variability range of the curve is studied, the dispersion of values with respect to the mean. Graphically speaking, the

standard deviation is the distance between the median and the point where the bell curve changes its gradient from convex to concave. Note that 34 per cent of cases are always found between the mean and this point, and therefore there are 68 per cent of examined cases between the two symmetrical points of inflection on the curve.

By doubling the difference from the mean ('2s'), two other symmetrical points are found on the curve that correspond to 95 per cent of the observed cases: beyond these limits, the curve draws closer to the abscissa without ever touching it, and the corresponding observed cases are reduced to a very low number. From a statistical point of view, biological normality corresponds to 95 per cent of the observed cases and is, therefore, determined by the mean ± 2s: beyond these limits, data are considered to be abnormal. Thus we have mentioned the statistical meaning of normality as formed by the successive stratification of collected data: as the custom of cadaver dissection became more frequent and widespread, the information collected also became larger in quantity and comparable. On the other hand, alterations in form and function were also found frequently in organs, as well as slight deviations from normality which were connected with disease, and in this way, substantial additions to pathological anatomy were also added.

However, to conclude, it is wise to state the boundaries between normal and abnormal in anatomical application. These concepts are used to describe a certain condition or a deviation from it, linked to a given hereditary structure; therefore it is necessary to outline the characteristics of those from specific ancestry, species or types. This means that, in terms of 'normality' (when it refers to humans), the typical characteristics of species and ancestry are noted. For example, the normal number of fingers in humans is five and nothing else. Somatic characteristics common to most human beings are described as typical, along with physiological parameters; features and qualities observed within a collection of individuals or specific ancestral groups are highlighted only where appropriate and necessary. Please note that the high frequency of certain conditions (such as, for example, dental decay or eyesight defects) do not signify normality, even if found in the majority of those belonging to the human race, as they do not correspond to the prototypical, biologically functioning human being.

The concept of variation is also connected to that of normality, which indicates the distance of an observed characteristic from the norm. In consideration of the various types of organic constitution, there are also individual anatomical diversities in organs (for example: shape, weight, size, topography); this means that the same organ does not always have the same characteristics in all people. Normal deviations which function perfectly are found with a certain frequency (paradoxically it has been said that in anatomy, the exception is the rule).

The variations (or variety) regarding the locomotor apparatus also concern the presence, absence and number of organs. Alongside most of the constant organs (always present, or absent only in rare and decidedly abnormal cases), there are others, known as inconstant, that may quite frequently be missing or present, and may be more or less developed or be divided or merge. As they are of interest to the artist when they modify the superficial anatomy by analytically looking at the bones, and above all the muscles of the human body, some of these variations will be indicated.

Deviations from normal arrangements that are extremely significant and that also cause an altered function of the organ are instead defined as abnormalities or anomalies.

The Gaussian distribution, or Gaussian curve, is the characteristic line of statistical distribution of random events. Its typical bell shape indicates that the most probable events occupy the central part of the diagram, while the progressively less probable ones are found in increasingly peripheral positions.

ANATOMICAL TOPOGRAPHY AND TERMINOLOGY

• The anatomical position and planes of reference

The human body is seen in an erect, vertical position, with the upper limbs positioned straight down along the trunk, palms of the hands facing forward (as this is how the bones of the forearm become parallel), fingers extended, feet with heels together and the toes slightly separated. This is the anatomic position that is always referred to when describing the position, relations and spatial orientation of the body's organs. Further information about the specific terminology for position and movement will be provided later, as they are general characteristics of the human body (see page 30); for now, it is sufficient to observe and imagine the body in a parallelepiped, in the anatomic position, of which the faces (or planes) of reference are recognized in pairs, which touch the most protruding parts of the body's surface. They are identified as follows: the frontal plane and dorsal plane, positioned at the front and rear, vertical and extended from one side to the other; the right lateral and left lateral plane, positioned vertically at the sides and extended sagittally, from front to back (the middle plane is known as the median sagittal plane of symmetry and divides the body into two halves, or antimeres, which are symmetrical in mirroring each other); the upper and lower planes, horizontal and positioned so they touch the soles of the feet and the top of the head.

• Body areas and their topographic limits: landmark points and lines

In man, as in all vertebrates, the body is divided into parts: some are axial and one-sided (the head, neck and trunk); others are appendicular and two-sided (the upper (or thoracic) limbs and the lower (or pelvic, abdominal) limbs). Body parts are further divided into territories, in the trunk, and in areas in the limbs: thus, the skull and the face in the head; the chest and abdomen in the trunk; the shoulder, arm, forearm and hand in the upper limb; the hip, thigh, leg and foot in the lower limb. Each of these territories or areas is divided into regions, that is, into surface areas that are bordered by conventional lines, known as landmark lines, that are traced by joining some points (landmarks) that are especially visible and recognizable on male and female bodies alike.

Determining the body regions, as well as facilitating anatomical descriptions, is also extremely practical in medicine as it allows a precise indication, for example, of the site affected by a disease or lesion. From a surgical point of view, depending on topographical anatomy, this provides for exact intervention in surface areas within well-defined limits that are sometimes established artificially but that correspond to organs with given spatial and functional relations, at various layers of depth.

From an artistic point of view, dividing the body does of course not require such detailed precision, although, especially for the figurative sculptor, it is as useful as it is for medical science for recognizing and fully understanding external morphology. Many regional definitions are well known, even though often in a rather vague and improper manner, and this simplifies anatomical language. It must, however, be pointed out that in some cases, the description of a region in artistic anatomy may rather differ from the one followed in topographical anatomy. For example, the shoulder and the armpit, for artistic purposes, are considered to be a part of the trunk and are studied together with the chest, while, more correctly, due to the muscle insertions and articular dynamics, they should be considered as part of the upper limb. The artist needs only to carefully observe illustrations to recognise the boundaries of each region and, at least for the trunk, to distinguish the vertical lines of reference, both frontal and dorsal. These notions will be useful when addressing the varying appearance of the body's external forms and the anatomical superficial structures that determine them.

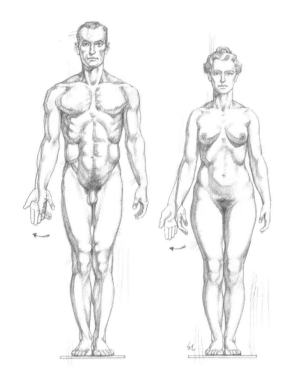

Frontal and rear projection of the body in a natural erect position: the turning of the palms of the hands forwards characterizes the anatomical position.

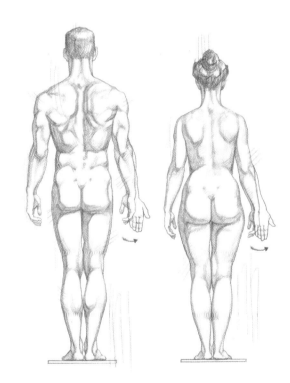

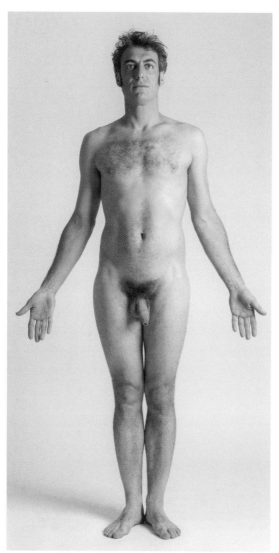
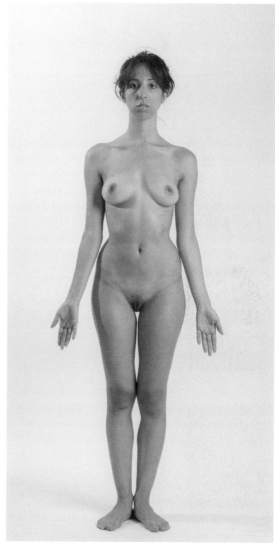

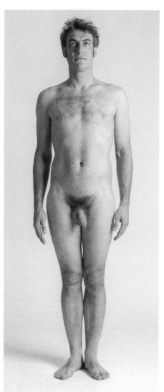
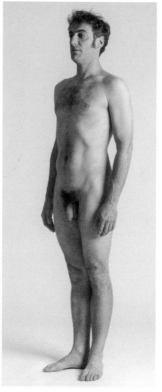
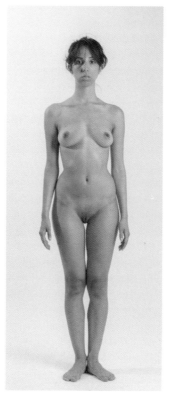
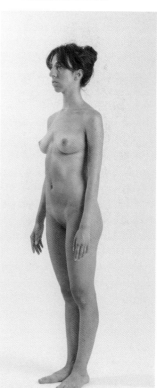

Some oblique projections of the natural position.

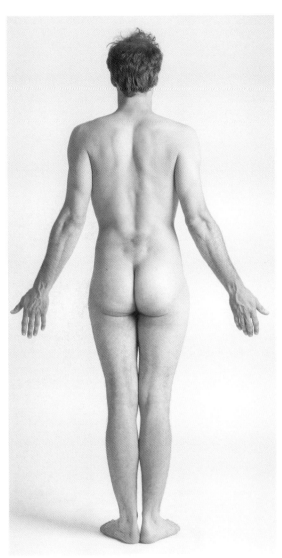
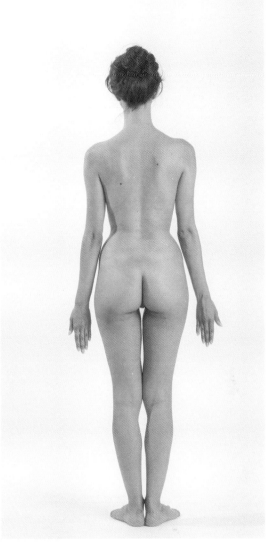

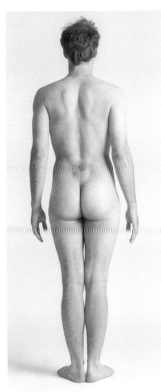
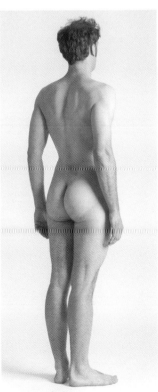
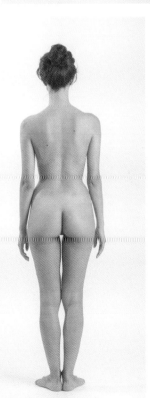
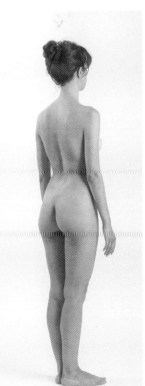

Some oblique projections of the natural position.

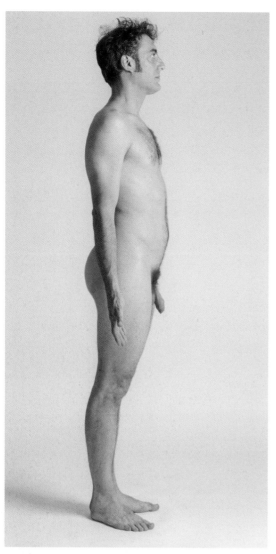
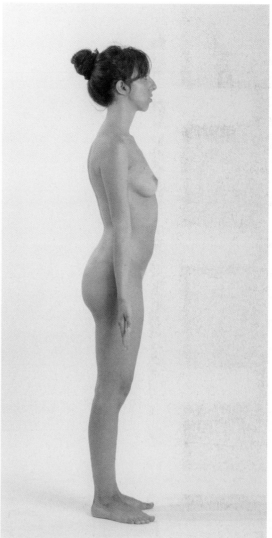

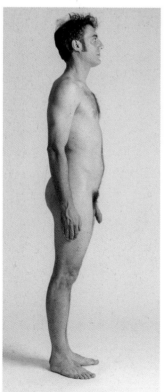
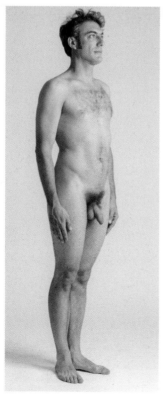
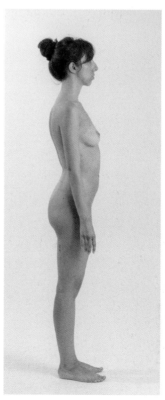
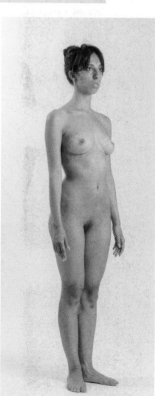

Some oblique projections of the natural position.

Boundaries of the main body areas

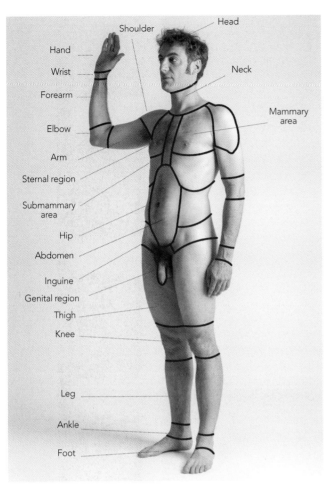

Shoulder
Head
Hand
Wrist
Neck
Forearm
Mammary area
Elbow
Arm
Sternal region
Submammary area
Hip
Abdomen
Inguine
Genital region
Thigh
Knee
Leg
Ankle
Foot

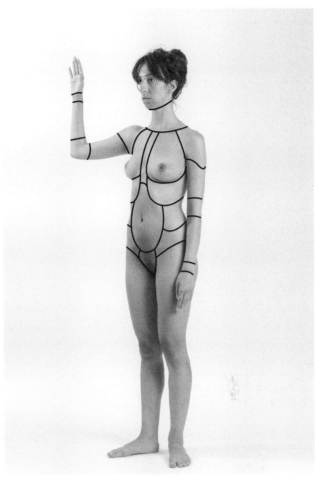

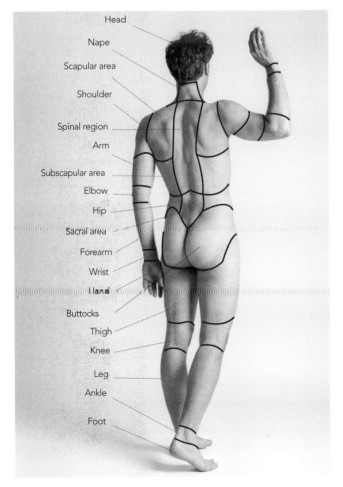

Head
Nape
Scapular area
Shoulder
Spinal region
Arm
Subscapular area
Elbow
Hip
Sacral area
Forearm
Wrist
Hand
Buttocks
Thigh
Knee
Leg
Ankle
Foot

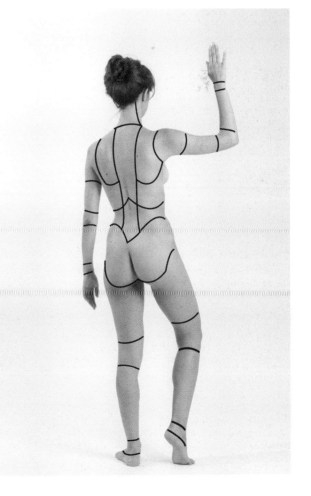

EVOLUTION, HUMAN DIVERSITY, CONSTITUTION, SEXUAL DIMORPHISM

• Evolution

Evolution is the gradual passing of an animal or vegetable species from one form to another more complex one. The theories of evolution maintain that living organisms evolved from common ancestors, who in turn evolved from primordial cells. From a zoological point of view, current man belongs to a single species, *Homo sapiens*, which belongs to the order of Primates, which is about 70 million years old.

Primates belong to the Mammal class[2], and several characteristics indicate them as the most evolved of the classes, for example: the differentiation between front limbs, suitable for climbing, and lower limbs, suitable for moving and balancing; mobility of the limbs in all directions; flattened nails; teeth suited to omnivorous diets; tree life habits; greater development of the braincase compared with the facial block.

The characteristics that allow man to be zoologically separated from other primates are: erect, vertical stance and biped gait; the conformation and function of hands and feet; brain development and the breadth of the braincase, mental qualities and language. If these are the most obvious characteristics, others can be recognized by comparative anatomy as specific adaptations to two different lines of evolution according to which, from an anatomical point of view, all primates except man, who is the sole biped, are basically quadrupeds adapted to tree life. In fact, from the time of separation of the two evolutionary lines of the superfamily *Hominoidea* within the Primate order (which is believed to have taken place between five- and six-million years ago) into *Hylobatidae* ('lesser apes') and *Hominoidea* ('great apes', from which man descends), the important and complex characteristics that led to man being considerably different from the original form and to achieve his cultural development occurred slowly in the latter, with various offshoots at a later period.

Among these characteristics, the erect position and consequent bipedal gait affected the development of the brain, language and other superior functions. Acquiring the erect position brought about profound changes that involved the position of the visceral organs, but above all, the skeleton, muscles, joints and nervous system for motor and postural coordination. Recent interpretations indicate climate and environmental conditions as the factors that triggered the selective pressures leading to such anatomical and walking adaptations: the formation of large territories with grass, trees and forests, following multiple sizeable climate changes, created conditions for considerable natural selection among the various species in competition, allowing only the most suitable to survive. The possibility of standing up and moving around easily using only two limbs was an evolutionary advantage which, over millions of years, led to the survival of individuals who habitually stood erect (orthograde posture).

The orthograde posture allowed many benefits and favourable characteristics. The primates in the other evolutionary line have a horizontal vertebral axis, parallel to the ground, and therefore offload their body weight on to the posterior – or pelvic – limbs, but sustain it also with the anterior – or thoracic – limbs, meaning that all the limbs are used for both posture and for locomotion. However, it is important to note that sometimes Old World anthropoids temporarily assume a semi-erect position, in which case the weight of the body is supported by the pelvic limbs, while the thoracic limbs act as secondary support.

The difference in posture made man the 'anthropomorphic monkeys': in man, who evolved to an erect position, the body weight is offloaded vertically along the vertebral column, the sacral bones and the pelvic limbs. Consequently the pelvis plays a fundamental role for both static and dynamic functions; the centre of the body's gravity is located in the pelvis; the pelvic limbs are the only ones involved in locomotion and therefore the thoracic limbs are free, allowing the hands to carry out other functions. The human hand has evolved to the point of becoming prehensile, due to its ability to oppose the thumb with the other fingers, while the foot has not developed this characteristic, but has perfected its bone structure, which is both strong and flexible, to support weight better while adapting to various surfaces.

It is interesting to observe the skeletal similarities and differences between Old World anthropoids and man because, in artistic anatomy, this helps to make sense of the special attention paid to bone conformation and its effects on the surface. The skull has several characteristics: that of the Old World anthropoids is more developed in the facial block, while in man it is the braincase (neurocranium) that is larger than the face (splanchnocranium) and this is due to respective difference in brain development. The general form of the skull is also markedly different: in Old World anthropoids, the cranial vault is low and flattened at the position of the eye sockets, with the arches notably protruding, while in man the frontal elevation above the eye socket arches is characteristically much less prominent. This conformation creates a different profile of the sections according to a frontal plane: the Old World anthropoid's skull is more or less ogival (bullet shaped), decreasing rapidly from a maximum lateral width at the top of the head to a weakly curved peak at the jaw; in man, on the other hand, the section is decidedly more oval, a 'horseshoe': narrower in the lower part, then widening to a maximum width at temporal height, and then finally finishing with a regular curve in the skullcap.

The form of the occipital bone clearly indicates the different habits of posture in Old World anthropoids and in man. The former have a flattened, occipital scale, attached at the corner to the parietal bones, and have the foramen magnum oriented on a plane that is angled forwards, from high to low, to then join the cervical section of the vertebral column: prevalently walking on four limbs forces them to keep the face directed forwards;, therefore the skull must join and move with the column positioned horizontally. In man, on the other hand, the rounded, convex, occipital scale and the foramen magnum are tilted backwards, from high to low, so as to easily maintain the orthogonal insertion on the vertebral column, which is typical of the erect stance.

Further cranial differences are found in the temporal region, in the zygomatic region (the facial block in anthropomorphs is flat and facing forwards; it is also without the canine fossa, the suborbital canal that is typical of man), in the maxilla bone (which is solid and receding in the anthropomorphs, without the chin protuberance, which is specifically human) and in the teeth.

The skeleton of the trunk in humans has characteristics linked to the vertical position of the biped, like the vertebral column that bends slightly at the cervical, dorsal and lumbar areas, with alternating convexity forwards and backwards. Old World anthropoids have a less pronounced dorsal and lumbar curvature, but they do not have, or have only slightly, a cervical curve (and this is related to the way in which this part of the vertebral column joins and moves with the skull).

In Old World anthropoids the pelvis is typical of a quadruped, so narrow and stretched, while in man it is short, wide and with a bigger opening directed upwards to contain the visceral organs.

22

2 Classification of man on the zoological scale – Kingdom: Animal; Type (subphylum): Vertebrate; Class: Mammal; Order: Primates; Family: Ominides (Omininaes); Genus: Homo; Species: Homo sapiens; Subspecies: Homo sapiens (sapiens).

The thoracic limbs in Old World anthropoids are extremely long and correspond to the adaptation to life in the forest, where movements are mainly by brachiation from branch to branch. The upper limbs in humans, on the other hand, have adapted to being especially useful for prehension and, therefore, are much shorter, reaching halfway down the thighs, while the corresponding limbs in the other primates, when held in an erect position, reach below the knee. The hand is also significantly different as the human hand has a long opposable thumb, allowing greater prehension and dexterity than other primates.

The pelvic limbs in Old World anthropoids are rather short and solid. They extend with difficulty, often taking on a condition of part flexion. Man's lower limbs are long and can extend to the point of placing femur and tibia on the same axis; to address the problems of balance that this presents, man has therefore adapted to bipedal ambulation. This aptitude has also been improved by the structural characteristics of the foot. In Old World anthropoids the foot is long and does not place the entire plantar surface on the ground; it also has a large toe which, to some extent, is able to oppose the other toes without it becoming prehensile. However, in man, the foot has adapted to being placed solely on the ground (not just on the side, as observed in Old World anthropoids) which allows it to almost 'adhere' to the surface completely. Furthermore, the bone structure has evolved towards effective mechanical solutions of resistance and elasticity.

The study of the evolution of extant forms that, through the various stages and the passing of millions of years, have led to the appearance of the human species, allows us to understand the ancient derivations of the conformation, position, structure and function of human features and organs. It is believed that the first forms of life date back to about three billion years ago, but the oldest fossil vertebrates are fish (which can be dated to about six-hundred million years ago) – which must be differentiated from amphibians, then reptiles, and then mammals (about two-hundred million years ago), from which primates derive (about seventy million years ago). The human species began to differentiate itself approximately three million years ago, evolving to the stage of 'anatomically modern humans' or 'archaic humans', which is similar to the anatomy of man today. Fossils of modern man (*Homo sapiens*) that have been found date back to about forty thousand years ago. It is interesting to consider the origin and evolutionary history of some organs or body parts. The mouth is the start of the digestive tract, developed millions of years ago in the first living aquatic forms. The entire structure of the human body is constructed around this tube: the part that searches for food in time became the front part of the body, while the opposite end is where the excretory functions are arranged.

The head is the most important part of the body and developed around the anterior extremity of the digestive canal to carry out the search for and selection of food in the best possible way.

The human nose, due to its particular position, can fully exploit the sense of smell to recognize and examine food, even if the primary means of locating food has been taken on by the faculty of sight.

Originally, the eyes of human ancestors were located at the sides of the head, like fish and reptiles seen today. This means that two separate images could be seen, but without being able to perceive depth of field. But when these human ancestors evolved and came out of the water, first as amphibians and then as animals that climbed trees, their eyes adapted to their new needs – they moved to the front, allowing the two visual fields to coincide, and in this way, man acquired the faculty to observe the world three dimensionally. Ears are also the evolutionary results of the hearing system that in water allowed primitive fish to perceive changes in pressure in its aquatic environment.

The current human skeleton is a functional transformation of the skeleton of the most ancient living forms. The latter had an exoskeleton, meaning that they were protected externally by a skeletal shell (some examples still exist today, like the lobster), but this limited mobility and growth in such a way as to direct it towards the evolution of an internal skeleton (endoskeleton) to support and protect organs distributed around the digestive tube and the contents of the rib cage and pelvis. The shoulder joint is a well-developed part of our skeleton; it is mobile, strong and evolved from the dorsal fin of primordial fish when they emerged and tried to move on land as amphibians. A similar development can be seen in the upper limbs which were, once upon a time, the anterior locomotor limbs of primates, first developed from fins and then from amphibian limbs. The vertebral column, intended as the basic structure of the skeleton, is a characteristic of the evolutionary process that led to man as it allowed animals to stand up on their rear legs to grasp food on trees and explore the territory. The pelvis is the connection point between the vertebral column and the pelvic limbs and evolved, as we have said, by connecting and widening, to contain the internal organs in the vertical position and allow the passage of children, with increasing cephalic volume in females.

In hands, the evolution of fingers has made the full physical and cultural development of man possible, because, among other things, prehensile hands and walking on two limbs have been able to replace just the mouth as the main organ for searching for food. Hands have become an extremely versatile tool, unique in the animal world.

It has been mentioned above that, based on current knowledge, modern man may have begun to spread around the world a long time after his appearance, about thirty-thousand years ago. He may have started from the areas of origin in Africa and western Asia, where, much further back in history, man had differentiated and evolved to the point of being able to adapt to diverse climates and environmental situations, from the cold of the north to the equatorial heat. Evolution occurs due to the accumulation of small functional and structural changes (mutations) on which natural selection and adaptation to the environment act through variations in the genetic heritage, that can be passed on to subsequent generations. From the point of view of the species, *Homo sapiens* is very recent, and so it is unthinkable that the genetic structure has been permanently stabilized; to the contrary, current knowledge in this field make us believe that environmental modifying factors and natural genetic selection will continue to act to change some genes and, therefore the human species – in other words, man is still evolving.

There have not been any substantial changes in physical appearance since the time of prehistoric man; however, some developments can be noted: a reduction of the number of teeth due to the increasingly rare appearance of the third molar (or wisdom tooth); a reduction in the antero-posterior diameter of the skull (brachycephalisation), especially in populations with paler pigmentation; an average increase in stature and so on. However, these observations are based on statistical findings that are still too limited and show an evolutionary trend of adaptation not just to the environment but also to minor locomotor needs (loss of muscle power and volumetric reduction of limbs, for example) and a parallel, compensatory brain and skull development.

A hypothesis could therefore be drawn (with indeed a large margin of uncertainty) that the evolutionary trend, in the far-off future, will not concern simple, natural anatomical modifications, but rather developments connected with cerebral and motor functions and social interaction, with minor physical adaptations or the use of electronic prostheses that strengthen, integrate or replace purely biological qualities, possibly as a result of technological changes in our environment.

Human diversity

The definition of 'species' is a set of individuals who are biologically similar, in that they can share genes and breed with each other and have fertile descendants. The term 'race' means a group of animals or plants that due to a given number of similar hereditary biological characteristics (of similarity or difference) can be distinguished from others belonging to the same species. Currently, rather than race (a term that is used only for expressive brevity), we prefer to speak, in scientific and morally more appropriate terms, of human types, groups or populations. The concept of race, therefore, is still rather questionable but, if one understands it in the appropriate forensic anthropological sense, purified of any improper meaning, it can help the artist in his or her research for anthropological and morphoscopic data that are useful for painting or sculptural works. It should also be noted that race differs from the concept of ethnicity, which is a mainly cultural concept. Although there are some external morphological differences (which are marginal, and perhaps only worth noting for the purposes of artistic representation) humans living on the earth today belong to the same single species: *Homo sapiens.*

The hereditary characteristics that can be passed on are physiological (regarding the function of organs), psychological (regarding cognitive and emotional reactions), pathological (regarding susceptibility to diseases), but above all anatomical, regarding the structure of organs and physical conformation. The latter are the most evident and immediate characters that distinguish the various ecotypes seen within humans. As we have just stated, it is therefore necessary to bear in mind the fact that the concept of race is rather blurred and does not coincide with cultural, language, religious or national characteristics: here it is mentioned solely to suggest a careful and constant observation of the complex and multiform human reality to the artist, grasping the diversity to be found within human species. There are several physical, somatic (or phenotype) characteristics that can be transmitted according to the rules of genetic heredity, and some are very interesting for the figurative artist studying living human anatomy: the colour of skin, hair and iris; the type of hair; height; the shape of the head, nose, lips and eyes; the positioning of adipose fat deposits; the distribution of body hair and so on. These will be mentioned when discussing the external morphology of the human body.

Racial groups (which, we must remember, are not the same as the nationalities, state organizations and cultures of the various populations) tend to be separated into three large lines (Caucasoids, Negroids and Mongoloids), each with characteristic physical traits that tend to be consistent from generation to generation. These three main groups then split into several more groups with more blurred, intermediate characteristics that are sometimes difficult to classify, bearing in mind the frequency of intermixing of populations. In addition to the division above, skin pigmentation is often used to distinguish human racial groups – this naming based on the colour of skin has altered, depending on the scholars, to Leucoderms, Xanthoderms, Melanoderms or to Caucasoids, Mongoloids, Negroids). Many other more analytical and complex classifications have been suggested, some concentrated on the areas of origin and life, the 'anthropological regions' (Boreal region, Equatorial region, etc.; African, Asian, Amerindians, European, etc.). This is to bear in mind the complexity of the characteristics to be considered (not just morphological-somatic, but also physiological, psychological, genetic, environmental, geographic etc.) and the increasingly more widespread effects of intermixing of populations.

Constitution

Constitution means all the somatic and functional characteristics of a person, and it is the result of the genetic heritage (genotype) and of the modifying action carried out by environmental factors. It is a common observation that, in every population and independently of the purely racial characteristics, every individual has a different conformation and the differences are mostly somatic. Typically, the human body is one of two sexes, and this in itself creates differences in constitution (external genital organs, breasts, body hair distribution etc.). Within each sex, height and body size can vary greatly. Based on these parameters, added to by physiological and psychological considerations, an attempt at classifying human constitutional types has been made, but as there is disagreement among the many experts over criteria, it is difficult to outline key morphological characteristics of human groups; thus, one is limited to considering only the exterior appearance. It may be useful for this purpose to define the systematic unit that includes all the individuals made according to the same organization plan as 'type' in animal and plant classifications. Various authors have proposed many classifications of morphological types and we will mention a few here that can be useful for the artist, at least for an initial fact-finding approximation.

The simplest conception (Schreider et al.) is the bipolarity of somatic structures, which, while remaining within the limits of normal variability, are distributed between two opposite extremes: on one side the individuals in which longitudinal measurements prevail are called vertical structure types, characterized by long lower limbs compared with the trunk, and by a narrow long face; on the other side the individuals in which horizontal dimensions are dominant, known as horizontal structure types, which have a wide, long trunk compared with the lower limbs and a developed abdomen, with a wide face, especially around the jaw. Between these two extremes, at equal distance, the harmonic type can be found, with intermediate characteristics. It must be noted that a person's height is not decisive in the classification of these types, which is based instead on the ratios between relative vertical and horizontal measurements.

A second useful classification is the one proposed by Giacinto Viola (1870-1943), who distinguishes three constitutional categories by considering the proportions between the trunk (associated with vegetative life) and limbs (associated with relational life) where the volumetric values are highlighted rather than the linear values. Normotypes are distinguished in this way, defined by a harmonic development of trunk and limbs; longitypes, with a very long trunk; brachitypes, with short limbs. The average values are represented by normotypes, and they differ by excess from longitypes and by defect from brachytypes. In addition to somatic aspects, a third classification, by Ernst Kretschmer (1888-1964), considers psychic aspects and distinguishes the asthenic type, with a thin, long body structure, sometimes extremely longilineal (leptosomic type), with a slim chest, narrow shoulders, a long, thin face and a predisposition for gastric illnesses; the athletic type, with developed, strong muscles, a robust skeleton and characterized by a good mental and somatic balance; the pyknic type, who is broad sometimes obese, with a narrow rib cage, a prominent abdomen, a wide, pentagonal shaped face and a predisposition to hypertension and mood swings (cyclothymia).

Lastly, a fourth classification by William Herbert Sheldon (1898-1977), distinguishes three constitutional components placed in relation with three embryonic layers (endoderm, mesoderm and ectoderm) from which tissues and organs are developed. In consideration of the

preponderance of one of these layers, three morphological types can be recognized: endomorphs, who are plump with a round profile and have a predominant trunk compared with the limbs, a wider pelvic region than the shoulders, weak muscles, thin bones, small hands and feet; mesomorphs, with robust skeletons, powerful, well-developed muscles which give the body a sharp profile, with long, strong extremities and a wider chest and shoulders compared with the abdomen and pelvis; ectomorphs, who are thin and slender, with very long limbs compared with the trunk, flat chest and abdomen and a small splanchnocranium compared with the neurocranium.

Just from the few short mentions made thus far, it can be seen how interesting the matter of the origin and physical conformation of man can be for artists, although it is extremely vast and specialized, still largely unexplored and does not strictly come into the domain of classical artistic anatomy. Scientific knowledge, together with the careful and detailed observation of the natural model, surely helps the figurative artist to understand and portray human beings as inspired during the difficult study of real-life anatomy.

• Sexual dimorphism

It has already been stated that in the human population, regardless of the specifically racial characteristics, an individual does not have the same conformation as another, but differs in the way his or her body develops – that is, in constitution, with various interpretations of the common somatic characteristics. The constitutional types described above reflect both the bodily (anatomical) and the functional (physiological and psychological) characteristics of a person. These characteristics depend on the interaction between genetic heritage, an ever-changing environment and behavioural factors. Sexual dimorphism refers to all the differentiating biological characteristics that determine a person's belonging to the male or the female sex, and this is the most immediately recognizable constitutional difference in any human population: the one between male and female. This diversity, at a fundamental level, is genetic and chromosomic in nature (the male, as we know, has one X and one Y sex chromosome, while the female has two Xs) and occurs in the 'primary' sexual characteristics (internal and external), especially in the reproductive functions. All the other differing characteristics, the ones that interest the artist more, are known as 'secondary'. Although upon adulthood these (usually) mean rather different appearances between males and females, these secondary characteristics are, for the most part, common to both sexes. The most important morphological differences between the male body and the female body mainly concern the locomotor apparatus (the skeleton in particular) and the integumentary system. Most of the biological differences between man and woman (at least in normal development) can be traced back to two basic facts. The first is the different reproductive functions (for example, in females the pelvis is wider and lower, and the mammary glands are much more developed); the second is the different rates of reaching sexual maturity (in the

Constitutional types

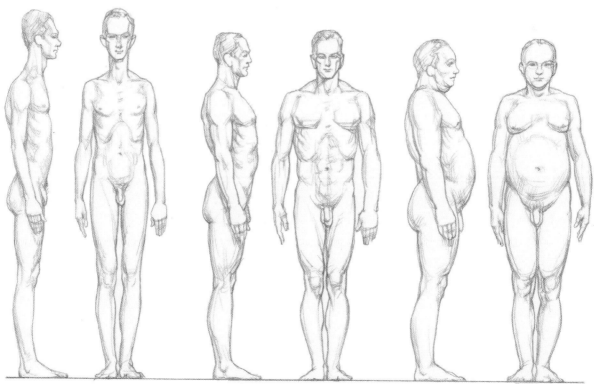

Longitype/leptosome/ectomorph. *Normotype/athletic/mesomorph.* *Brevilineal/pyknic/endomorph.*

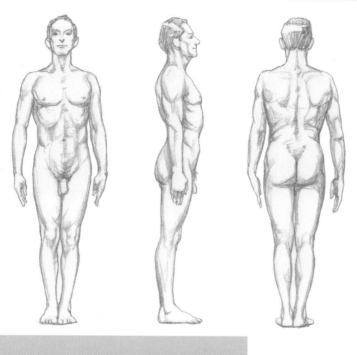

Ectopmorph

Mesomorph

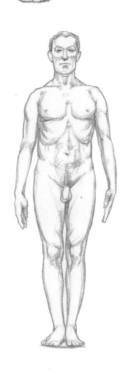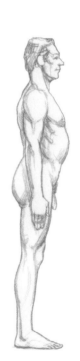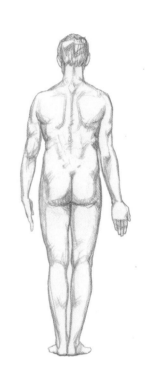

Endomorph

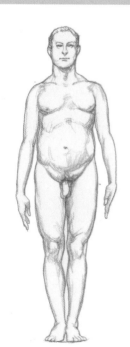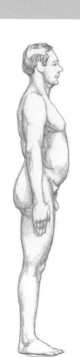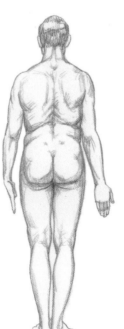

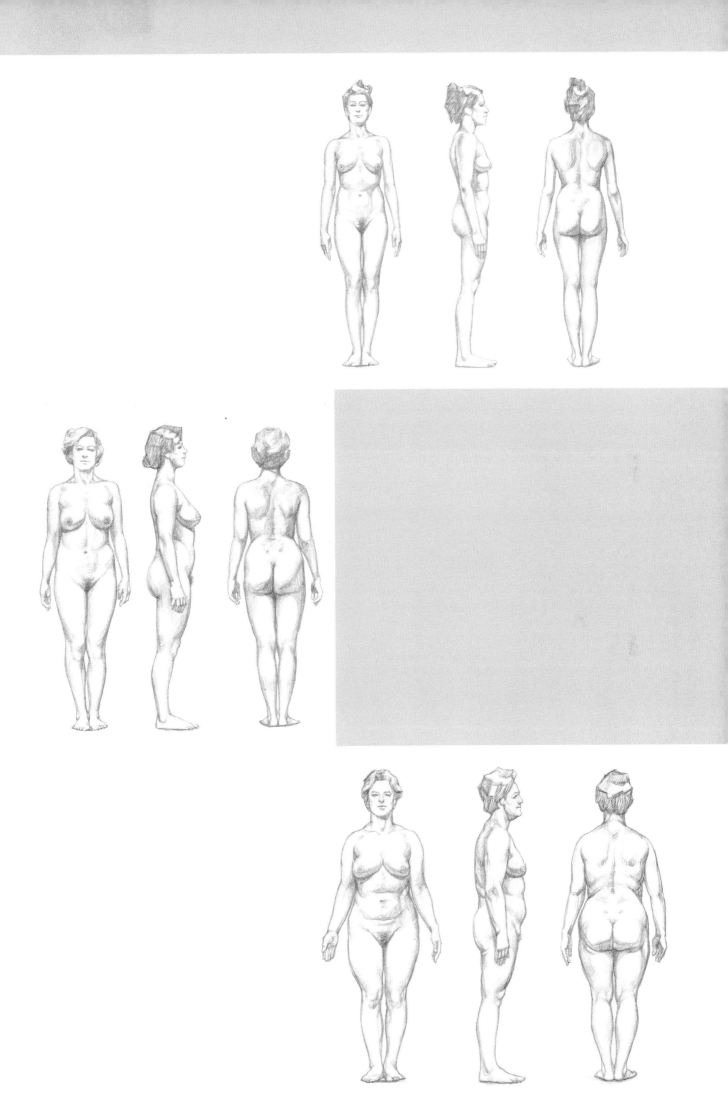

female this is faster, and this influences the smaller size and greater weakness of some parts of the locomotor apparatus). As an outline for preliminary study or for any more in-depth study, it may be useful to list and compare some of the most important body differences and provide some information that the artist can think about in order to understand and portray the human body better. The artist must, however, carefully and directly observe male and female models, comparing them to find the typical morphological differences in the large variety of individual somatic characteristics.[3]

The male skull is larger than that of the female. The forehead is more tilted, the upper bones of the eye sockets are more marked, with a sharper angle on the lower profile of the jaw, and the thyroid cartilage protrudes more (the Adam's apple). Generally speaking, males tend to have a longer head, the cranium vault is more convex and the face is higher, while females tend to have a more rounded head, their faces are smaller and narrower at the chin, the lips are larger and the vermilion border is more exposed.

Hair distribution in males is rather diffuse and abundant: on the face (beard, moustache), head (hair), chest, on the dorsal surface of forearms and hands, and on the lower limbs. Pubic hair extends from the external genital organs towards the navel, while in women it is delimited horizontally. There is also less hair on the female body, with almost none on the face.

In males there is more of a scapular development than a pelvic one, while in females this is the reverse – that is, the pelvis is wider than the shoulders. Measurements are taken between the two anterior iliac spines and the acromia. On this matter, we must point out that in the male sacral region there are four shallow dimples (fossae lumbales laterales) that correspond to the respective iliac spines, while in women there are only two, that correspond to the posterior inferior iliac spines. In women, the tilting of the axes in the upper limb (between arm and forearm) and in the lower limb (between thigh and leg) is more accentuated than that in males.

Adipose tissue is also located differently in males and females (see page 68). In the male body, the overall volume of the trunk decreases progressively from the shoulders to the hips, while the opposite happens for the female body. It can be noted that, when drawing it, the male figure is best characterized by using straight, angular lines, while the female figure corresponds to more gently rounded lines. The simplest outline of the overall male figure can be symbolized by an upside-down triangle and that of the female by an ellipse. The smaller average height of a woman compared with a man can also be noted, while the proportional standard is common and corresponds to about eight modules ('heads') (see page 34)

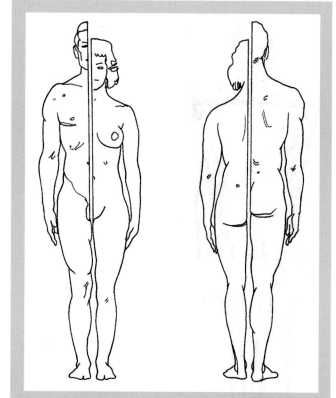

Comparative diagrams between the male and female body, in the anatomical position.

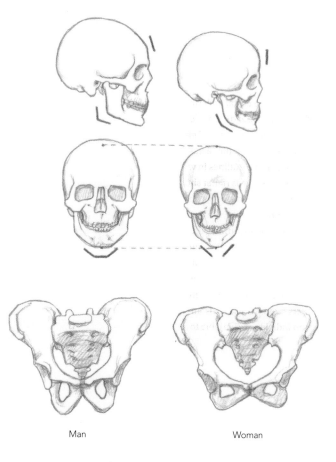

Man Woman

Comparison between a typically male and female pelvis and skull.

3 It is known that, especially in recent decades, important improvements have been made in endocrinological treatments and reconstructive and plastic surgery techniques. These are able to provide ablation, augmentation or insertion of prostheses, and they aim to provide a greater alignment of identity between the body and mind of the individual.

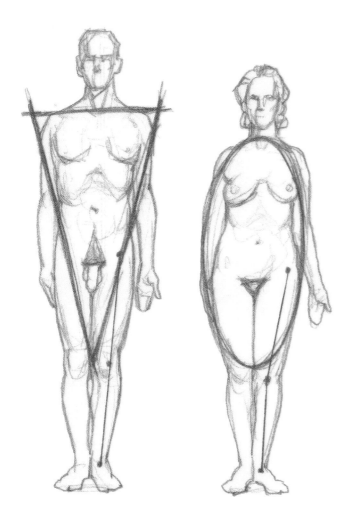

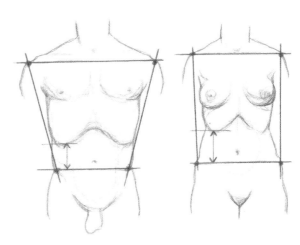

The diagrams highlight the structural differences in diameter, axis and conformation (both of bones and muscles) between the male trunk and the female trunk.

In males, the costal arch (the margin between chest and abdomen) is often evident and quite wide, while it is narrower in women. The male abdomen has a vertical groove which is the central depression (linea alba) between the rectus abdominis muscles, while the region has more delicate outlines in women, due to adipose tissue. Also, as the female rib cage is rather short, the abdominal region appears to be proportionally longer compared with the male version. The navel is located on the linea alba: in men it is almost equidistant from the pubic bone and the lower part of the sternum, while in women it is located higher up and has a more vertical appearance.

When drawing the trunk, it is necessary to pay a lot of attention to correctly placing the skeletal structure (vertebral column, pelvis, scapular girdle) as this is where the characteristic forms of the two genders mainly originate from: the other elements, muscles and skin, are too individually variable to be considered as guides to proportion.

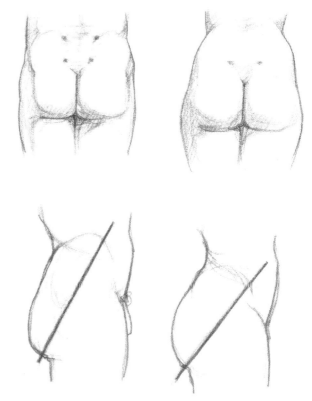

The number of sacrolumbar indentations (four in males, two in females) and the tilt of the pelvis are rather different between the two sexes.

NOTES ON THE MACROSCOPIC STRUCTURE

The complex structure of the human organism can be broken down by apparatus or systems, that is, by the organization of certain organs that are related by the same function.

Therefore we can recognize the digestive, respiratory, cardio-circulatory, endocrine and nervous systems and many more too: each of them carries out a specific function and takes part in the fundamental functional unity of the organism as a living being. Knowing them would certainly be useful and advisable for a fully cultural in-depth study, but as we have said, the aspect of the human body that most interests the study of applied anatomy for the figurative arts is the locomotor apparatus, which we can investigate by analyzing three systems – skeletal, articular and muscular. These systems are closely connected by the fact that they support and protect other internal organs, and enable movement; therefore, the locomotor apparatus will be the only one taken into consideration in these preliminary notes. However, we must not forget that external bodily forms, if mainly determined by the conformation and behaviour of the bones and muscles (and also by the integumentary system, which is very important for individual morphological characteristics *in vivo*), clearly undergo considerable influence from all the other systems, and indeed influence those systems in turn.

For description purposes only, the human body is traditionally divided into various parts: head, neck, trunk (in turn divided into chest and abdomen), limbs (even and symmetrical structures divided into upper and lower limbs). For convenience and simplification of study and description, each of the various body parts is usually divided further into certain superficial regions (see page 21). The one referring to the locomotor apparatus has also been the subject of anatomical investigation that many great artists in the 15th and 16th centuries attended to and studied, with these artists sometimes working with scientists and thus laying the foundations of modern anatomy.

Since the appearance of Vesalius's work (1543), the successive order of description, especially regarding the skeletal and muscular systems, has now been consolidated, as it has proven to be the only one rationally possible (being based on topographical and functional criteria) and the most advantageous for learning significant terminology and a consistent, organic vision of the human body. Thus, the locomotor apparatus is observed and described according to the three basic projections (front, back and side). These are the only ones required and sufficient for a correct appreciation of the volumes of forms, and they are studied by starting from the axial part of the body, the trunk, continuing with the neck and head and lastly the appendicular part, comprising the upper and lower limbs. In the latter, the osteo-, arthro- and myological structures are examined, starting with the proximal sections closest to the trunk (and sites of large joints, the shoulders and the hips), and then moving on to the distal sections: the hands and feet. However, some volumes follow a slightly different order of study, a more regional one: head, neck, trunk, upper limb, abdomen, lower limb. This method seems preferable in artistic anatomy when describing the external morphology (or surface anatomy) of the human body.

It may be useful to recall some position and movement terms used in anatomical descriptions.

• Terms of position

The anatomical description refers to the normal human body in adulthood, in the erect position characteristic of the human species, with the upper limbs positioned vertically next to the trunk, the surfaces of the palm of the hands turned forwards, the heels together and toes slightly apart. This conventional position is known as anatomical (basically it is the position that a cadaver most easily assumes when supine, that is, lying on its back on an anatomical table). The anatomical position is different from the natural erect position where the arms hang along the trunk and the palms of the hands are turned towards the body. All anatomical structures are described, in form and reciprocal relations, always referring to the subject in the anatomical position. Imagine the body enclosed in a parallelepiped and, to describe the situation of the various parts, we refer to the imaginary planes of the parallelepiped:

- **anterior** (or ventral, frontal, palmar) plane
- **posterior** (or dorsal) plane
- **right** plane (right-hand side of the examined body)
- **left** plane (left-hand side of the examined body)
- **superior** (or cephalic, cranial, rostral) plane.
- **inferior** (or caudal, podalic) plane.

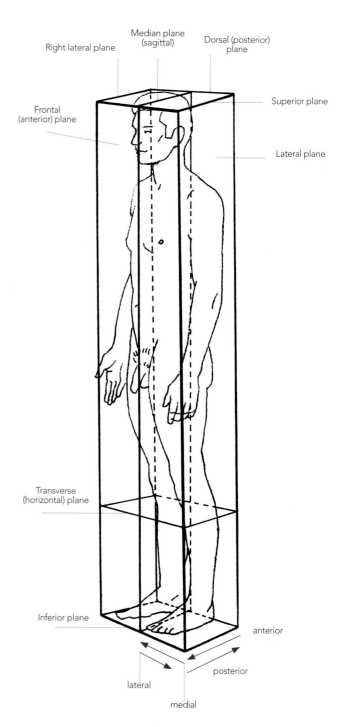

Reference planes and spatial directions in a parallelepiped.

We consider another plane of the parallelepiped, the median plane of symmetry, traced in a sagittal direction (antero-posterior) and from the superior to the inferior face. This plane divides the body into two (almost) symmetrical halves: the left and right antimeres. The following terms also refer to it:

- **medial:** towards, close to the median plane of symmetry

- **lateral:** close to the lateral plane (right or left), external. Referring to internal cavity organs, the terms external (superficial) and internal (cavity); referring to membranes: parietal and visceral.

Especially with regard to limbs, the following references are used:

- **proximal and distal:** to indicate a part of the body or organ that is closer to (proximal) or further from (distal) its origin and the centre of the body (trunk)

- **radial (lateral, external)** and **ulnar (medial, internal)**, in the upper limb

- **fibular (lateral)** and **tibial (medial)**, in the lower limb

- **sagittal:** any plane parallel to the median plane of symmetry

- **transversal:** any horizontal plane

- **volar:** the part towards which some organs (forearm, finger and leg) bend

- **dorsal:** the opposite part to the volar.

• Terms of movement

In body behaviour, whether static or dynamic, the centre of gravity (that is, the imaginary point that represents the centre of weight, or in which the body weight is concentrated) varies in position depending on movement or temporary posture: in the anatomic position, it is located in the pelvis, in front of the sacrum.

The line of gravity passes vertically through the centre of gravity, and therefore, can also vary. In a position of equilibrium, the line of gravity must fall within the area of support.

The possibility of movement is allowed by the existence of joints. The following terms are commonly used:

- **flexion:** this is movement carried out along the sagittal plane, with the direction towards an anterior plane

- **extension:** this is the opposite movement, with the direction towards a posterior plane.

With reference to limbs, flexion indicates a movement that takes a limb in a forward direction and determines bending; extension, on

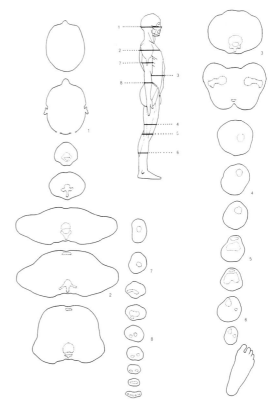

Transverse diagrams carried out at different levels of the male body.

the other hand, indicates the movement that stretches out the limb, lengthening it and tending to direct it backwards. When referring to the foot, extension is called plantar flexion, as opposed to dorsal flexion). (When referring to lateral movements of the trunk, the term lateral flexion is used.) Other movements include:

- **abduction:** this indicates a movement on the frontal plane that moves away from the median plane of symmetry

- **adduction:** indicates a movement on the frontal plane that moves towards the median plane

- **rotation:** this indicates a movement of one part of the body around its own axis

- **circumduction:** indicates a complex, circular movement that is carried out on different planes, generally involving the combination of some or all the other movements stated here so far.

Directions of movement

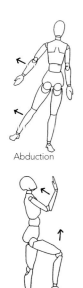

Abduction

Adduction

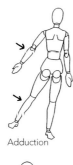

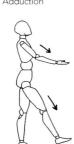

Flexion

Extension

Flexion Extension

Lateral flexion

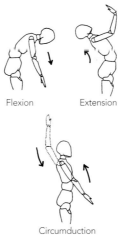

Circumduction

Rotation

NOTES ON THE MICROSCOPIC STRUCTURE

Anatomy is a morphological subject: it studies the form and structure of organisms, both animal and vegetable, and considers the various parts or organs in them, made of tissues and joined together in systems and apparatuses. The anatomical technique uses two investigation methods: dissection (incision of the cadaver at various points and opening of its large cavities) and preparation (separation and isolation of organs). These two methods of investigation refer to the structures that can be studied with the naked eye or with the help of a magnifying glass, and traditionally belong to macroscopic anatomy (see page 30). There are also examination techniques that mostly use microscopes (optical or electronic) that can highlight extremely small structures. This is the field of microscopic anatomy, to which histology (the study of tissues) and cytology (the study of cells) are connected. Naturally, this type of investigation is of no immediate interest to the artist, other than factual (except, perhaps, the chromatic and structural suggestions of certain microscopic images); nevertheless, a brief overview of this topic may be useful to better understand the elements that make up an organism: the human body in this case.

A cell is defined as the smallest structural and functional part of an organism, which is able to live and therefore has the properties of living elements: reactivity, metabolism, self-regulation and the ability to grow and reproduce.

The cell comprises a nucleus and a cytoplasm with its organelles and is contained by a cell membrane. It is also able to reproduce itself and carry out various functions (such as contraction, secretion, absorption) and this determines a functional differentiation that leads to the constitution of tissues that can then be defined as a group of cells with the same structure and functions.

The study of tissues is the specific subject of histology, which classifies them according to morphological characteristics, functional activities and embryological provenance. On this matter, we must remember that a fertilized egg cell splits progressively and the cells obtained by this segmentation arrange themselves into three overlapping layers in a short period of time, creating three primitive sheets from which, by differentiation, the final tissues are developed which then go on to make up the body's organs. The final tissues are classified into epithelial, connective, muscle and nervous tissues.

- **Epithelial tissues**
 - epithelial lining tissues (they cover the outer surface of the body and that of internal cavities communicating with the external part).
 - epithelial glandular tissues (comprising specialized cells for secretion).
 - epithelial sensory tissues (specialized to receive stimuli and connected to the specific sensory organs).
 - differentiated epithelial tissues (lens of the eye, tooth enamel, hair, nails, etc.).
- **Connective tissue** A wide variety of tissues that support and feed organs, in addition to connecting other tissues: mucous tissue, cartilage tissue, bone tissue, endothelia, blood and lymph, adipose tissue.
- **Muscle tissue** Has contractile capacity, that is, it can actively modify its own form under the influence of certain nervous stimuli: smooth (or visceral) muscle tissue, striated (or skeletal), muscle tissue.

- **Nervous tissue** This spreads into all the other tissues with the function of gathering the stimuli caused by the external environment and of determining the organism's suitable responses.

To conclude, it is perhaps useful to provide an outline of the various levels of organisation of the organisms in man, since these are the general characteristics of bones and muscles:.

- **Cell** (the smallest part of an organism, capable of living alone)
- **Tissues** (groups of cells similar in shape and structure and destined to carry out the same function)
- **Organs** (more or less isolated parts of an organism, that carry out a defined function and comprise various tissues)
- **Systems** (groups of all the parts of an organism formed with the same tissue, regardless of the function that it is given in the given group)
- **Apparatuses** (groups of organs, formed by different tissues, which carry out the same function or a set of coordinated functions)
- **Body** (the entire organism as a whole).

There are excellent books that address the matter in a complete and thorough manner, if the artist wishes to study microscopic structure to a greater degree.

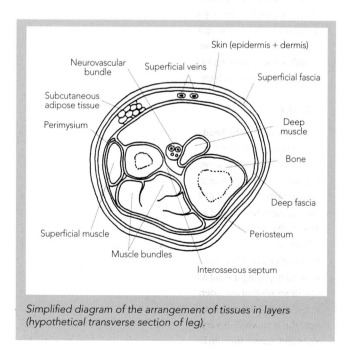

Simplified diagram of the arrangement of tissues in layers (hypothetical transverse section of leg).

GENERAL INFORMATION ABOUT THE SHAPE OF THE HUMAN BODY

The external morphology of the human body will be addressed in the sections that discuss the anatomy of the living body, but it would be advisable to mention some general information here (much of which is common knowledge) where a systematic analysis of the locomotor apparatus can be provided.

As has already been mentioned, for the purposes of anatomical description and the study of external morphology, man is considered in the position that is most natural and characteristic to him, that is, the erect position, with upper limbs extended along the trunk and turned forwards, and lower limbs together. In this position, the observer sees the body from the anterior (or ventral) face, the posterior (or dorsal) face and the two lateral faces of the profile. Examination of the whole body must be done at a suitable distance to provide an overall view, before moving on to the individual regions, in order to capture the general characteristics of the structure. This includes the ratios between the parts, the sexual differences, the muscular and skeletal conformation, the position of the adipose pads and hair distribution.

Frontal observation shows the normal (although not perfect) symmetry of the body compared with the median sagittal plane, the transverse alignments at the shoulders and the pelvis, the ratio between the chest and the abdomen and the axis of the lower limbs. Lateral observation shows the body axis, which normally follows a perpendicular line that can be projected just in front of the external auditory meatus and the lateral malleolus, passing through the centre of the shoulder joints, the elbow, the hip and the knee. However, the anterior profile of the trunk, the curve of the neck and back, the muscle and adipose consistency of the abdomen, buttocks and thighs can also be seen.

The general form of the human body is determined by the skeleton, which is the fundamental weight-bearing structure, the muscles attached to it and the panniculus adiposus (or adipose pads). The main part of the body, the trunk (or axial part) has a rounded upper portion (head), a narrower, almost cylindrical intermediate portion (neck) and a wider lower portion, which is like a flattened cylinder in an antero-posterior direction (commonly known as the trunk). There are two appendages attached to the upper part of the trunk, the upper limbs, which hang freely in the anatomical position to the sides; in the lower part, another two appendages are attached – the lower limbs, which hang downwards from the base of trunk until it stands on the floor.

• Head and neck

There are two parts to the head: an upper ovoidal part, with a larger axis in an antero-posterior direction, flattened to the sides and the front (the forehead): it is the cerebral portion or braincase; the other lower, anterior part is the face or facial block. There are large sexual differences to the head overall, but in particular in the face: think of the presence of facial hair (beard and moustache) only in the male adult and the smaller, more delicate structure of the female skull compared with the male. There are also several small, individual differences of general conformation and individual details (eyes, ears, nose, lips) that we are used to paying special attention to, since we use them to identify people. There are also considerable changes that gradually occur in the same individual due to age, nutrition and habits during life: for example the face, which is very short in younger children due to late development, then returns to being short in old age due to the thinning of the mandible or the loss of teeth; and also, rounded in young, well-nourished individuals, it becomes wrinkled and creased in older people due to the reduction of subcutaneous fat and skin elasticity.

The neck generally has an almost cylindrical shape, or more frequently a truncated cone shape which is flattened in the antero-posterior direction, and with the wider base on the chest; therefore it appears to be thinner or thicker depending on whether the shoulders are lowered or raised, in relation to muscle development in that region. The rear part of the neck is called the nape.

• Trunk

The flat posterior part of the trunk is known as the back. This flattened shape, which allows the body to assume the supine position easily, is characteristic of the human species. However, it is not absolute: especially at the abdomen level, in the lumbar region, the back is transversally convex and vertically concave. Considered from the front, the trunk can be divided into the thorax (chest), abdomen and pelvis. However, the external limit between thorax and abdomen does not correspond to the internal limit. This is because the chest has a skeleton formed from twelve pairs of arched bones, the ribs, which connect to each other at the front via the sternum. Its inferior external boundary corresponds to the lower edge of the thoracic skeleton (the rib cage) while the inner limit is the dome of the diaphragm muscle.

The shape of the abdomen, without the ribs (skeletal support is provided only by the lumbar section of the spinal column), is determined by several factors: the breadth of an upper skeletal ring formed by the last ribs in the rib cage; a lower ring of bone, the pelvic ring, to which the lower limbs are attached; the volume of the organs contained in the cavity; and the tone of the muscles extended between the two skeletal rings, which more or less oppose the pressure of the internal organs against the abdominal walls. In males, the abdomen is cylindrical; in females it is rather wider at the bottom (corresponding to the greater width of the pelvis), and in children it is wider at the top.

In subjects carrying fat, the abdomen is prominent since it is distended at the front, and it sags to a greater or lesser extent. The pelvis is largely masked by the root of the lower limbs. Many individual sex and age differences found in the trunk depend on the different rate of development of the muscles, the conformation of the skeleton and the amount of subcutaneous adipose connective tissue; therefore bone and muscle may appear to be hidden to a greater or lesser extent, even difficult to find in some cases. Considerable sexual differences can be found in the chest, which in women features much more accentuated mammaries; the width of the pelvis and the distribution of hair, which only covers the pubic mound in women, while in some males, although sparser, it spreads further up the midline to the chest, where it expands laterally on to pectoral areas.

• Limbs

The upper (thoracic) limbs and the lower (pelvic) limbs, although adapted to different functions (prehensility for upper limbs, walking and support for lower limbs) are clearly constructed in a similar way and divided into corresponding segments which, proceeding from the trunk to the free extremity, are respectively: the shoulder and the hip, the arm and the thigh, the forearm and the lower leg, the hand and the foot, fingers and toes. An important difference, however, lies in the fact that the shoulder is placed on either side of the upper extremity of the chest and is extremely mobile, while the hip and pelvis form a solid group fixed to the lower part of the vertebral column. The range of movement for the arm in relation to the shoulder, therefore, is greater than that of the thigh in relation to the hip.

Between the arm and forearm there is the elbow, which in the lower limb corresponds to the knee, positioned in a reverse direction of flexion however. Between the forearm and hand there is the wrist, which corresponds to the 'neck' of the foot (ankle); however, while the

longitudinal axis of the hand continues directly to that of the forearm, the foot joins the leg at a right angle, so that the sole of the foot, corresponding to the palm of the hand, can position itself on the ground.

Shoulders have rounded protuberances turned outwards and are raised or drooping depending on whether the upper part of the chest is wide or not. If the arm is distanced from the trunk, the inferior face of the arm, which was previously reduced to a groove, becomes a pit (axilla), limited forwards and backwards by the anterior and posterior axillary folds, and in adults, lined with hair. The arm is quite cylindrical in women and children, while in males there are clear muscular traces and the arm is rather flat transversally. The elbow, on the other hand, is widened transversally and corresponding to that of the arm, the forearm axis continues, forming a very obtuse angle that is open laterally.

The forearm has the shape of a truncated cone, flat in an antero-posterior direction and thinner towards the hand. The wrist widens considerably transversally when closer to the hand, which is flat and has an anterior face (palm) and posterior face (back). The palm is hollowed (the hand hollow) due to the presence of two muscle elevations, joined at the top towards the wrist and separated at the bottom where there is a third transversal elevation. The lateral elevation is the thenar eminence, the medial one is the hypothenar eminence and the transversal one is the palmar digital eminence. The five fingers are mobile with respect to the hand in almost all directions. They comprise segments, the phalanges, joined with each other in order to be able to flex or extend from each other. The fingers are numbered from outside inwards and are respectively: thumb, index, middle, ring and little finger. The thumb has only two phalanges (while the other fingers have three) and, detaching from the edge of the hand pointing laterally, can make a movement in the opposite direction which allows the prehensile nature of the hand. The nail, a hard, horny plate, is grafted onto the lower half of the back of the last phalanx of each finger.

The lower limbs are overall longer and sturdier than the upper limbs. Hips merge into the pelvis, thighs have a truncated cone shape with a lower apex and the knee is an irregular cylinder shape. The leg, which forms an open obtuse angle outwards with the thigh, is cylindrical, larger at the top where it widens transversally and has the wide, vertical elevation of the calf in the posterior position. The neck of the foot (ankle), which is rather slim, is the shape of a wedge with a posterior base and has the elevation of the malleolus on each side. The sole of the foot corresponds to the palm of the hand and has a posterior elevation (heel) and an anterior transversal elevation (palmar digital eminence). The sole rests on the ground with these elevations and with the side corresponding to the little toe, is raised in the middle and medially (side of hallux) to a varying degree depending on whether the foot is arched or flat. The dorsal part of the foot is, instead, convex.

The foot also has five digits which, while shaped like those of the hand, are considerably shorter and less mobile, all of them detaching from the extreme edge of the foot and rather flexed with an inferior concavity, except for the large digit. They are numbered from medial to lateral, but only the first and last have specific names, respectively the big toe or hallux and the little toe. The hallux is very large compared with the other toes and cannot perform the opposing movement.

GENERAL INFORMATION ABOUT THE PROPORTIONS OF THE HUMAN BODY

The proportions of the human body can be considered in ratio to the length of the head: other methods of gauging proportion have been suggested but this is the principal one used today. The study of ideal body proportions was developed in figurative art, before it was in medicine, through the formulation of sets of rules (canons), founded not only on direct observation of the body but more so on ideal aesthetic concepts of beauty, which vary, of course, historically, culturally and geographically. The proportional evaluation that an artist can use generally requires the comparison of lengths and widths, choosing a part of the body (for example the head) as a measurement unit (module) and relating it to bone or muscle reference points noted on the nude body.

The height (or 'length') of the head corresponds to the distance between two parallel horizontal planes, one tangential to the top of the

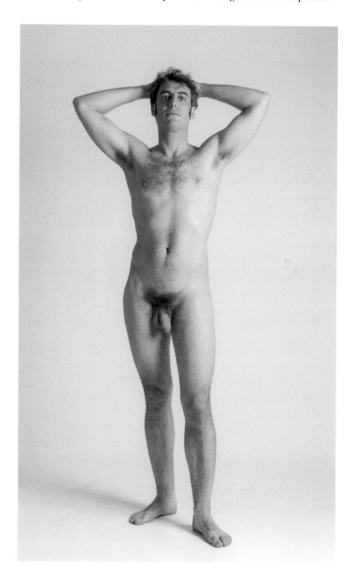

braincase (craniometric point: vertex) and the other to the base of the chin (craniometric point: gnathion).

The natural canon, obtained by analysing several series of anthropometric data, indicates that the total height of the body is seven-and-a-half heads, although aesthetic considerations can sometimes recommend extending it to eight or even nine. Consequently, the trunk and the neck measure the length of three heads, the maximum distance between the most protruding point of the two shoulders is two heads, the maximum width at the buttocks is one-and-a-half heads, the upper limbs are three heads long and the lower limbs are three-and-a-half heads long. The mid-height of the body is about at the level of the pubic symphysis. The proportional ratios in the female body are slightly different from those of the male, in compliance with bone, muscle and adipose characteristics that can be found in the two sexes (see page 25).

Body proportions also change with a person's age in relation to corresponding changes to the skeleton which, during growth, does not grow uniformly; instead the ratios between the lengths of the various parts vary over time. In the uterus, the foetus develops most of all in the head, which is very large: this is due to the growth of the brain; when born, a baby's head is therefore more developed than the rest of the body, representing about a quarter of the total length. The brain completes its volumetric growth early, so on comparing the measurements of the head and those of the body during growth, we notice a reduction in the measurements of the head in relation to the increase in those of the rest of the body.

Height, which at birth is about 50cm (1ft 8in), grows at different rates in subsequent years until it stabilizes at about the age of twenty for women and twenty-two for men, respectively with average measurements of 168cm (5ft 6in) and 174cm (5ft 8½in)[4]; however, it must be considered that, within normal ranges, there are considerable variations linked to climate, nutrition, different social conditions and race. At full maturity, after about forty years, both sexes begin an inverse process caused by the reduction in thickness of the intervertebral discs and articular cartilage in the lower limbs, which causes the height to decrease by some centimetres.

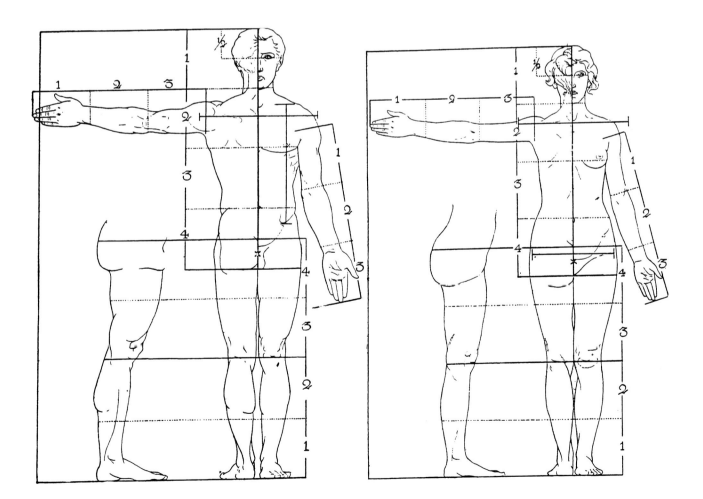

Average proportions in a man and a woman, taken from Dr. Paul Richer's Artistic Anatomy (1971).

4 Based on data gathered on the Italian population in 2018.

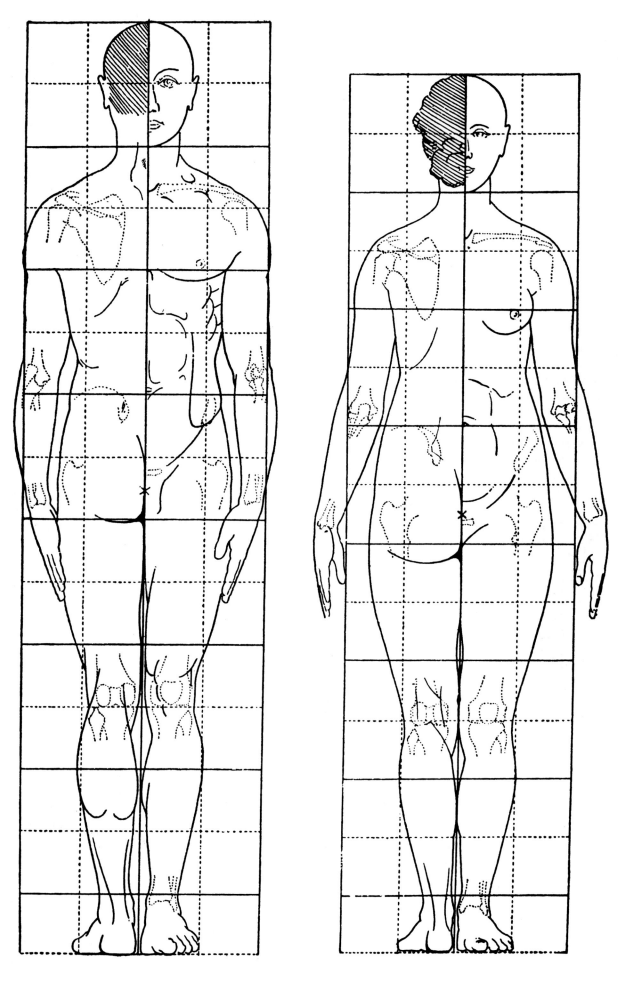

Proportions of male and female figures in heads and half-heads by Arthur Thomson.

THE HISTORICAL DEVELOPMENT OF PROPORTIONAL CANONS

Proportion is the ratio of the parts of an object either compared with each other or in relation to the whole. It is a mathematical concept that has also taken on considerable importance in the visual arts (painting, sculpture, architecture, etc.) in which it means a harmonious and correct distribution of the parts of the whole to which they belong. In fact, there has always been the spontaneous tendency not only to search for balance and beauty, but also to seek to make the language of art forms intelligible, establishing technical standards, conventions of geometric analogy and above all, ratios. These can be expressed by starting from the whole (a unit known as a 'module') and dividing it into parts or by multiplying one part until the whole is reached and they find a correspondence of meaning, for example, in the 'metrics' of poetry and music. It must be noted that, while proportions exist in the objective reality of the form, in the field of arts the subjective sense must be grasped, that is, the way in which artists have recognized and accepted, modified or ignored standards in their artistic creation. A historical examination of 'proportional theories' shows how this research has been varied and changed over time depending on different civilizations, cultural environments and also individual artists, who have frequently made a creative and aesthetic 'ideal tool' out of them. The human figures, taken from ancient times as a comparison and as such projected onto the outside world, served as a measure and their parts indicated the units of length: head, hand, digit, cubit, thumb, foot and so on. The set of rules and measurements via which it is possible to deduce the measurements of one part from those of the whole or those of the whole from one of its parts was said by the Greeks to be a 'canon' (from *kanon* meaning 'cane' or 'measurement') and this gave rise to literary,

artistic and musical canons. Like all the standards proposed or imposed in artistic practice, they were (and can still be, for those who wish to apply them today) simultaneously a restriction (leading to repetitive and conventional formulas) but also a stimulus for imaginative freedom, as they indicate new ways for them to be surpassed or adapted to in an intelligent and expressive manner. Investigations in this sector of studies are still somewhat lacking, due to the difficulty (at least for Eastern and Western worlds) of tracing aesthetic canons that were not formally expressed in figurative arts in the past, and due to the modern cultural climate which, with some reason, considers them to be archaic and a little distant from its own interests. In portraying the human body, the proportional ratios are fully valid when one observes the body in an erect posture and from a 'normal' visual angle, but they undergo considerable alterations (or even cannot be applied) when the figure is in perspective, in movement or observed from unusual points of view. If we think of large paintings and sculptures, or either one placed at a great height, the upper parts of the body (those furthest in perspective) must be made larger to appear convincing and correct by those looking at them from below: one example is that of Michelangelo's sculpture, *David*. As this was conceived to be placed on a high pedestal, the head is rather large if the sculpture is observed at eye level halfway up the body.

For the contemporary artist, then, it may be useful to go over the main theories of human body proportions, however briefly. Proportions of the human body are normally observed in the adult and in normal conformation, sometimes comparing the average male subject with the average female, or in various stages of growth.

● **The canons of ancient art**

The Egyptian canon There were several proportional canons that can be reconstructed by examining the long history of Egyptian art, but all are based on a grid system, a practical system that can be applied to representations where the figures appear in static and stereotyped positions. Up to the 26th dynasty (Saite, 663–525 BC) a grid of eighteen squares was used, probably referring to the length of the middle finger as the measurement equivalent to the width of the palm of the hand. For example, the standing figure shows these correspondences: two squares from the top of the forehead (that is, the root of the hair) to the base of the neck; ten squares from the neck to the knees; six squares from the knees to the soles of the feet. One square was reserved for the

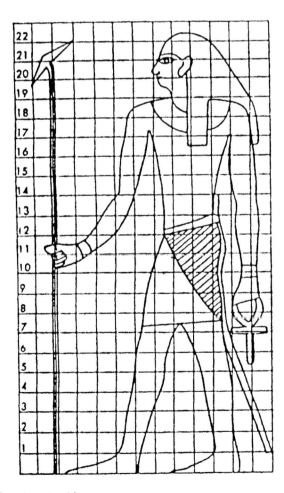

Egyptian art: grid canon.

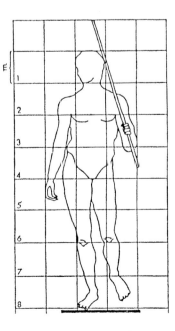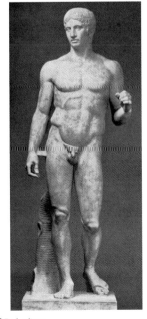

Diagram that reconstructs the canon of Polyclitus.

height of the hair. A sitting figure, on the other hand, measured fourteen squares in height, plus one square for the hair. As the head minus the hair includes about three measurements (squares), the height of the erect figure, if in ratio with the most common canon used in the Western world, corresponds to about six to seven times the head. After the 26th dynasty, it was increasingly frequent to find a canon of height for the erect figure (excluding hair) that corresponded to twenty-one-and-a-quarter squares. In it, some parts of the body were set in a permanent fixed position. For example, the ankle is placed on the first horizontal line; the knee on the sixth; the shoulder on the sixteenth and so on. The length of the foot corresponds to three squares or a little more, the space between the legs in one step is ten-and-a-half squares. It is probable that similar rigid systems, applied for the practical reason of proportion when creating works, were also applied in sculpture and in wall painting among the other populations of Mesopotamia, and perhaps in early Greek art.

The Greek canon The Greeks did not consider proportions to be a practical tool for representation, but rather an aesthetic idea of harmony of the parts making up the human body – real life was the subject of careful observation and accurate measurement. By examining the works of art from that era, in the various styles, and a few surviving literary references, one can deduce that the canons were established and matured a little at a time, from the most archaic ones (pure symmetry of the parts and use of the head as a module repeated seven-and-a-half times to establish the figure's height) to the one applied by Polyclitus, a sculptor from the classic period. This sculptor from the 5th century BC renewed the aesthetic concepts of the human figure (mainly male) by representing athletes, whose bodies corresponded to the canon that he proposed (in a now lost essay) and applied in his works. The statue *Doryphoros*, of which there are still a few Roman copies, immediately became the standard *par excellence*, and had a long-lasting, consistent influence on artists, some of whom (Parrhasius, Euphranor, Apelles) may have written theoretical essays on the subject. A note left to us by Galen tells us that the standard applied by Polyclitus' followers considered the middle finger to be the smallest measurement and stated that the midway height of the body was located at the root of the lower limbs; that the head corresponded to about one-eighth of the body, the face to one-tenth and the foot to one-sixth. Polyclitus' proportions were modified by Lysippus (a sculptor from the 4th century BC) and by other artists who wanted to portray movement and study the physical and psychological nature of the human form characteristic of Hellenistic art (4th–1st centuries BC).

The most common canon in that period is known through the *De architectura*, a piece written by Vitruvius (a Roman architect from the 1st century BC) who, also widely citing other authors, states that two defining principles of architectural beauty are *eurythmia* (meaning 'proportion' or 'harmony') and symmetry, based on ratios between the parts of the well-formed human body. For example, both the face (from the chin to the root of hair), and the extended hand correspond to one-tenth of the height of the body; the head (from the chin to the top of the skull) corresponds to one-eighth; the length of the foot corresponds to one-sixth. Also, the face can be divided into three parts of equal height: the first from the base of the chin to the base of the nose, the second from the base of the nose to its root, the third from the root of the nose to the hairline. The 'centre' of the human body is the navel, so an erect man with limbs extended and spread apart can be set inside a circle tangential to the tips of the fingers and the toes, or (considering the fact that height equals the maximum span of the upper limbs) can be bordered inside a square. These statements, exemplified by the figures passed down by Cesariano (an architect from the 16th century), were partly corrected by Leonardo.

• The canons of Christian art

In the passage from the ancient world to the Middle Ages, the proportional canons changed in various ways that are difficult to define as there are few written records. One mainly notices an impoverishment of anatomical knowledge accompanied by indifference to uniformly applied set rules. The figure is not studied in nature, but follows a simple proportional module: it seems that artists from the Middle Ages preferred a schematic concept, with a strong, ideal, religious hallmark when applying the proportional ratios of figures, unlike the Egyptian concept, which was practical and constructive and the Greek concept, which was anthropometric and aesthetic.

The Byzantine canon In Byzantine art the image is conceived superficially, without referring to nature, and the ratios of the human face, seen from the front, are reduced to the application of a module set in series of concentric circles in which the height of the forehead is equal to that of the nose and of the chin. The method has been passed on to us from the *Hermeneia* or *The Painter's Manual*, written by the monk Dionysius from Fourna circa 1730 as a practical guide for creating figures in mosaics or frescoes. It belatedly codified the most widespread canon applied in previous centuries.

For example, the height of a man's body, from the forehead to the heels, corresponds to nine times the head, and the head (considered as a measurement) is divided into three equal parts (the forehead, the nose, the beard) to which a fourth part is offered corresponding to the hair; from the chin (or beard, which partly covers the neck) to the midpoint of the body, there are three measurements; the two eyes are the same as each other and the space between them is equal to one eye; the knee is equivalent to the height of the nose, and so on. In the centuries in which Byzantine art developed (and still today in the execution of icons), other canons coexisted or overlapped: the height of the erect figure can correspond to seven-and-a half times the measurement of the head to eight or nine, and the lengthening is mostly evident in Russian art starting from the 14th century. A similar proportional division can be found used in works by Cennino Cennini (end of 14th century) in the *Libro dell'arte*, where the modular canon described is perhaps referring to Giotto's art. For example, the height of the human body is divided into eight-and two-third faces: the height of the trunk corresponds to three faces and the geometric centre of the body is maintained at the level of the pubis.

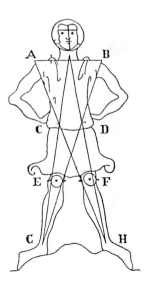

Construction method of the frontal figure by Villard de Honnecourt, from 13th century.

The Romanesque and Gothic canon Villard de Honnecourt, a French architect from the 13th century, left us an essay that contained practical methods for portraying natural images. He inserted the human figure into geometric shapes (triangles, circles, squares, cones) and maintained some characteristics of Byzantine canons, such as the head set in a circle and contained seven-and-a-half times in the height of the body. Applying this geometric shape sometimes led to representing figures in lively, decorative gestures. For example, by observing the many sculptures in Gothic cathedrals from this point of view, we note that body height is interpreted in various ways, also in relation to architectural requirements, and can correspond to seven-and-a-half times the head, eight, eight-and-a-half, and sometimes even nine. Parallel to the modular canons, we also find the creation of fractionary canons which tend to express the numerical, mathematical ratios that existed between the various parts of the body. These numerical ratios were already considered, for example, in the canons of Polyclitus and Vitruvius. They make use of the fraction of the total body height rather than the multiplication of a unit (module). Although they are less rigid than the modular ones, they are rather complex and difficult to apply.

- ## Renaissance canons

Towards the end of the 15th century, the use of theoretic, geometric and purely modular canons declined, leaving room for those based on a more attentive and precise observation of nature and real anatomical structure. The Renaissance returned to the problem of the classic canon in search of new solutions, and artists tried to assimilate the scientific culture of the era, drawing up and perfecting theories of proportion according to this culture through the comparison between the measurements taken on old statues and the ones taken on living models (usually male, but with some interest in females too). The fact that there was a multitude of human types was soon admitted, and consequently there was a need for differentiation in the realm of the ideal canon. Leon Battista Alberti drew up a new canon of proportions in his *De statua* (circa 1435), which adoped a method founded on empirical observation and on the monitoring of anthropometric data using ingenious instruments. His system was linked to that of Vitruvius and uses the 'foot' as a measurement of length of the body. The measurements shown in the tables form a complex metric canon (known as *exampeda*, as the height of the body corresponds to six

feet) and express the length of the limbs in multiples of some basic units. The foot is divided into 10 inches and the inch is divided into 10 minutes. In his *Trattato delle proporzioni* (circa 1498), which was preceded by Ghiberti, Leonardo da Vinci verified Vitruvius' statement about the engraving of man in the circle (see diagram below, left) and in the square, and corrected it in the well-known drawing (see diagram below, right), establishing the exact position that the body must assume to create it: the tips of the fingers on the extended hands placed at the top of the head, the lower limbs apart to the point of describing an equilateral triangle. Also, in reference to the Greek canon and preferring above all that of Lysippus, he considered the height of the head as one eighth of the height of the body, and remembered to compare the proportions in his research with movement, age, foreshortening and perspectival effects. Albrecht Dürer, the heir of the Nordic and Gothic art traditions, greatly expanded the observations and measurements of both the male and female human body in different ages, sometimes even analyzing deformations and imperfections, in the work *Symmetry of the body* (circa 1528). He applied the Alberti method in his findings (which he discovered during his stay in Italy, perhaps from Jacopo de' Barbari) but instead of attempting to summarize his research into a single ideal canon, he multiplied them into different specific canons, depending on the various body types. Other artists and theoreticians took an interest in body proportions, especially in Italy (Michelangelo, Il Danti, Il Gaurlco, Piero della Francesca and so on) but in the late Renaissance, there was also the conviction that it was not possible to achieve an absolute and indisputable canon of beauty, considering the relativity of the human type to the various climates, times and environments. It appeared to be possible to create a perfect human form without this being subject to a rigid proportional canon, perhaps even violating it if necessary for the benefit of expressive appearance. Within his *Le Vite de' più eccellenti pittori, scultori, e architettori* (1568), Giorgio Vasari sums up the proportional criteria of the human body accepted by most artists from the Renaissance period.

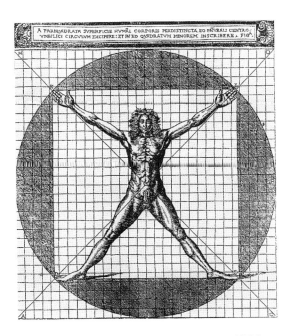

Vitruvian canon according to Cesare Cesariano (1521).

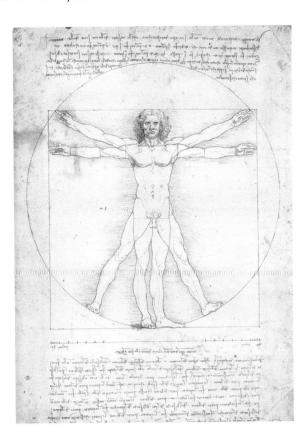

Vitruvian man according to Leonardo da Vinci.

• Eastern canons

The search for proportions and the drawing up of ideal canons of the human figure mostly developed in western cultures and quite a number of theoretical formulae have survived, as we have shown, from this complex branch. This was not the case for non-European arts, for which there are very few documents, and many of them are thousands of years old, and it is necessary to refer to tradition as well as to works. The human canon was the subject of study among the Chinese and Japanese. In an essay from the end of the 18th century, for example, there are some indications of proportions that recall the ones recognized in the West: total height of the body is equal to eight heads; height of the navel, five heads; height of the pubis, four heads; and so on. Indian art was intended to portray an idealized human body, according to aesthetic and symbolic canons that conjure up calculated, intense emotions, rather than a realistic anatomic accuracy. In this tradition, we find canons that are reminiscent of Greek art. The proportional system is named *talamana* and is based, as a unit of measurement, on 'tala' (equivalent to the width of the palm of the hand) divided into twelve smaller units, or fingers. The parts of the body are constructed according to these units. For example: the face is twelve fingers. The neck is four, the trunk (from the neck to the pubis) is divided into three portions of twelve fingers each, the thigh and the leg are each twenty-four fingers. The knee and foot are four fingers each.

• Modern canons

Proportional canons of the human body lost a lot of their practical importance for artists when collections of precise anatomical tables became widespread and in common use towards the end of the 16th century. Many painters and sculptors (some of whom actively took part in illustrating dissection) found it easier to consult these images to have the necessary references and comparisons. Proportions of the the human body formed by artists, however, still lurk beneath scientific objectivity and the illustrations of these artists (Vesalius first, then Pietro da Cortona, Bidloo, Albinus, etc.) can be found in the first modern books on anatomy. The 'modules' are still traditional ones: the head is multiplied about eight times to make the height of the body.

After the Renaissance, and up to the end of the 18th century, artistic beauty was mainly identified with Ancient Greek and Roman statues. The proportions, studied on statues that were mostly faithful to real life, became stereotyped and secondary to the imitation of the ideal classic form and the general configuration of stance. In the Neoclassic era in particular, canons were devised that were based on the ancient world and on statuary measurements collected by archaeology and art experts such as G. Audran, H. Testelin, J. de Wit, J. Winckelmann, C. Watelet, J. Cousin, G. de Lairesse, Bosio, etc., rather than by actual working artists. From the end of the 18th century, research into body proportions was abandoned by artists and art theoreticians, and was of

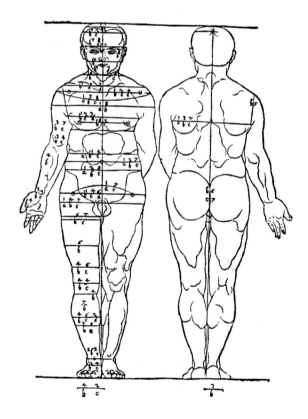

Study of proportions in the male body by Albrecht Dürer (1528).

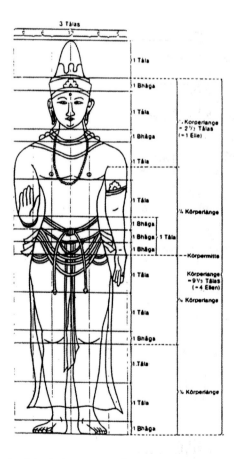

An example of the Indian canons of proportion (6th century).

interest only to anthropologists and scientists. The latter, also studying the comparison between man and woman, the stages of growth and ageing, the morphological differences of belonging to various ethnic groups, drew up a kind of generic scientific canon, far removed from aesthetic inspirations and consistent with a statistical average based on the countless measurements taken on living bodies. In this canon, the head (not the face) was used once again, which was found to be seven-and-a-half times the height of a man of average stature, eight times in that of a tall man; four times in the lower limbs, from the ground to the groin; four times in the trunk, from the top of the head to the gluteal fold. In this way, the upper and lower parts of the body overlap by the measurement of half a head. The scientific canon, due to its adherence to reality and to the positivist cultural climate of the second half of the 19th century, soon became the most popular proportional canon among art schools and was named the *canon d'atelier*, or studio canon. It is still useful today for the objective correctness of constructing a figure, though with a few adaptations such as greater height, as there is a real tendency to increased stature in recent generations. The anthropometric research on which this standard is based prevailed over aesthetic and artistic aims and was encouraged and supported for the purpose of ergonomic and industrial applications. Among the many authors who studied this subject, we must mention at least: Salvage, Stratz, Richer, Schadow and Topinard. One of the most modern

and original canons was created by Schmidt (1849) and improved by Fritsch (1895). He considers man in an erect position, seen frontally, and his module is the distance between the base of the nose and the upper edge of the pubic symphysis. The quarter part of this distance is the submodule. An outline of a figure was traced using these units, corresponding to the proportions between the parts of a well-shaped body and, using this procedure (knowing the measurement of the module), it is possible to reconstruct the entire figure from single parts. The path of 20th-century art drastically diverted most artists from the objective portrayal of the human body with, of course, some important exceptions, especially in the ever-growing artistic sector of publishing and advertising illustration. In more recent years, sophisticated computer programmes have also allowed the figure to be drawn, automatically applying proportionality criteria when constructing shapes and movements. However, with the influence of Cubism, some further research was carried out on the optimal proportional ratios of a symbolic, aesthetic-mathematical nature, rather than for the purpose of mimesis. For example, Le Corbusier's Modulor (1949), Bauhaus studies, and those of Gino Severini or Matila Ghyka.

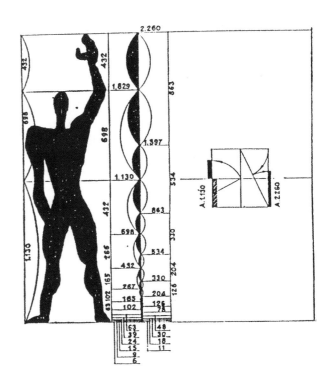

Above: *Modular study of proportions by Le Corbusier (1949).*

Left: *Proportional canon by Gustav Fritsch (1895). The construction method is as follows.*
For the axial part:
 Nn = module
 Nv = ¼ of module = submodule
 dd' = Nv width of the head = 1 submodule
 ss' = distance between the shoulder joints = 2 submodules
 mm' = distance between nipples
 aa' = distance between the hip joints = 1 submodule
 O = navel.
For the upper extremities:
 sg = length of the arm = sm'
 gp = length of the forearm = mo
 px = length of the hand = oa.
For the lower extremities:
 ah = length of the thigh = ma'
 hk = length of the leg = ma
 ks = height of the foot = ¼ of submodule.

ANATOMY OF THE LOCOMOTOR SYSTEM: GENERAL INFORMATION

THE SKELETAL COMPONENT: OSTEOLOGY

• General information about bone structure

The skeletal system comprises all the bones – the hard, tough elements that work to support, and in many cases protect, the internal organs. These bones, attached *in vivo* by ligaments, joints and muscles, contribute as passive organs of movement stimulated by muscle contraction and transmitted by tendons as an adaptation to the environment. Other functions of the bone, merely mentioned here, are of mineral deposit, which is necessary above all for maintaining calcium levels in the body, and hemopoietic, as bones contain the bone marrow which produces elements of blood (red blood cells and leukocytes) and which in adults is mainly located in specific bones (long bones, sternum, iliac crests).

The skeleton of an adult man comprises bones and cartilage: cartilage tissue is a supporting connective tissue that is different from bone, as it is softer and yielding and is not mineralized. Cartilage is limited to particular areas: the ends of ribs, the bridge of the nose, the ear drum and so on. One particular type of cartilage (articular cartilage) covers bone parts that touch each other in mobile joints.

All the bones comprising the skeleton are in some way connected with another (with the exception of the hyoid bone) and are dependent on the vertebral column. This is placed on the median line and is the most important support structure of the entire organism, as it supports the head, contributes to forming the rib cage (onto which the upper limbs converge), and discharges the weight of the trunk onto the lower limbs via the pelvis.

Based on these data it is possible to recognize a distinction between the axial skeleton, including the cranium, the vertebral column and the rib cage (the 'post-cranial' section), and the appendicular skeleton, comprising the upper and lower limbs. The two sections are connected by the shoulder girdle and the pelvis. The bones can also be divided into two categories: the median unpaired bones, of which there is only one with bilateral symmetry, and the paired bones – one on the right side of the body and one on the left – and are a mirror image of each other. It has been noted that there is a proportional relationship between the length of the single bones and the height of the individual to whom they belong, therefore measurement methods have been devised with which it is possible to gather reliable information about sex, stature, somatic conformation, age, race and ethnicity. Studying the form and extension of the areas of tendon insertion on bones also allows us to determine the rate of development and muscle power. Some basic data regarding bones which are of interest to the artist are briefly referred to in the following summaries.

• External appearance

Models of bones for scientific and medical studies are sometimes made of real human bone. They are immersed in water or other solvents, a procedure which eliminates any trace of organic elements that covered or were attached to the bone *in vivo* (periosteum, marrow, vessels, nerves, etc.), lending a whitish colour to the bone which is characteristic of calcification. *In vivo*, bones tend to be ivory-coloured in adults and yellowish in older people. After steeping, all components of the skeleton are completely disarticulated, that is, separated into individual bones, apart from the ones firmly joined to each other by especially fixed joints such as sutures.

We must remember that bones thus treated maintain the morphological characteristics perfectly, but lose most of the mechanical properties, particularly those of resistance and elasticity, and that they are normally recomposed into the articulated skeleton, in which the individual elements are joined using metal wires and other means of containment to simulate the natural ratios of direction and location. When studying or drawing from the articulated skeleton, however, it is

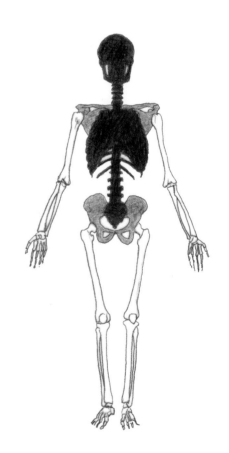

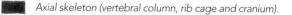

Axial skeleton (vertebral column, rib cage and cranium).

Articular skeleton (limbs).

Connecting structures (shoulder girdle, pelvis).

always necessary to bear in mind the limitations, stiffening or excessive mobility of some bone segments compared with others, for example the fixed nature of the scapular and the clavicle (blocked with metal wires at the ribs and the sternum), the approximate articular housing of the head of the humerus, the relative reduction in mobility of the head of the femur in the acetabulum, the rigidity of the vertebral column, the position of the patella and so on. To avoid drawing imprecise or even incorrect information from these bone models, it is necessary to compare the living model with radiographic images and with the articulated skeleton, thus suitably integrating the traditional anatomical tables and live drawing of the skeleton. This counts above all in the extremely frequent event where there may be an artificial articulated skeleton available, even if sufficiently faithful, instead of a natural skeleton.

• Functional characteristics

With their shape and position, bones determine the general form of the human body and, as already mentioned, they support other organs and protect them. However, above all, they are also essential for movement, made possible by the additional drawing action of muscle contraction.

That being said, movement is still somewhat restricted by the breadth of joints. This topic will be addressed later on, due to the relative implications it can have on drawing the dynamic human body.

It is useful to remember that bones act as levers. A lever is any rigid body which turns around a point known as the fulcrum. The three elements that operate rotation are the acting force (power), the fulcrum and the resistant force (resistance): based on the position of these elements, levers can be separated into first order levers (the fulcrum is placed between the power and the resistance), second order levers (resistance is between the power and the fulcrum) and third order levers (the power is between the fulcrum and the resistance).

When a bone acts as a lever (or acts as a support, like for example in the erect position), it is necessary to consider the mechanical axis, which corresponds to the straight line that joins the centres of the joints at the ends of the bone in question. Alternatively, if it is a bone positioned in a terminal segment, it corresponds to the straight line that joins the centre of the extremities (for example, the third phalanx or terminal phalanx) with the proximal joint. As these analyses mainly concern long bones, note that the mechanical axis may not correspond to the natural axis, the diaphysis; this is very clear, for example, in the femur.

• Number

The number of bones in the human skeleton depends on the classification system used and certain embryological identification criteria followed by several experts and also on individual variation, such as the presence of extra bones (due to the non-fusion of some primitive ossification nuclei, which results in the bone being split into two parts), supernumerary bones (found in unusual areas of the body, and are residual features that, in most, have disappeared over our evolutionary years), sesamoid bones (small bones that may form after birth, embedded inside tendons or ligaments, close to areas with mechanical actions).

On average, there are just over 200 bones that can be identified (between 203 and 206; the difference is attributed to the variable number of coccyx bones) and the number may be reduced due to the process of synostosis – that is, fusion of bone elements.

It has been calculated that there are approximately 177 bones used in voluntary movement. The total weight of an adult man's skeleton has been estimated to be about 9kg (1½st/20lbs), which is about 16 per cent of an average individual's body weight.

• Form

While displaying great morphological variation, as we have already mentioned, bones can be grouped into two large categories: median unpaired bones, that are arranged on the symmetrical plane; and paired bones, of which there are two, left and right, which are symmetrical to each other. In each of these two broad categories, in addition to the external appearance, and considering constructive characteristics such as quantitative ratios between compact structure and spongy structure, there are:

- **Long bones** In these bones, the main parameter is that of length and they are typically formed so that the central part (diaphysis) is long and the two ends (epiphyses) are wider.
- **Short bones** In these bones, the three size parameters are approximately equivalent.
- **Flat bones** The parameters of length and width are clearly prevalent compared with that of thickness.
- **Irregular or mixed bones** These have a complex shape and come from the fusion of short bones or flat bones.
- The **cranium** comprises pneumatic bones which enclose spaces containing air.

Some examples can be provided: long bones are the ones with free ends (humerus, ulna, radius, metacarpals, phalanges, femur, tibia, fibula, etc.); short bones are the vertebrae, patella, the carpal and tarsal bones, etc.; flat bones are the cranium, the sternum, the scapula and ribs; irregular bones are the sacrum, the coccyx, the temporal bone, the occipital bone and so on.

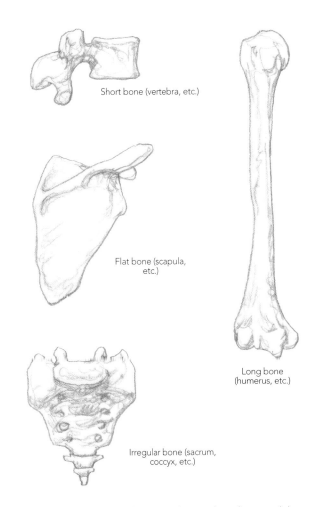

Short bone (vertebra, etc.)

Flat bone (scapula, etc.)

Long bone (humerus, etc.)

Irregular bone (sacrum, coccyx, etc.)

Some types of bones (classified according to their shape and the ratio between compact and spongy components).

• Terminology

In anatomy, we use names that are now conventionally unified and codified, often derived from ancient definitions that focused on geometrical or functional analogies; for example, cuboid, cuneiform, vomer and parietal. In addition, specific terms are used to define individual parts of bones and indicate their morphological characteristics, the meaning of which should be learnt, although in many cases they are intuitive:

- **Diaphysis and epiphyses:** the central long part and the wider ends respectively on long bones
- **Apophyses:** the short, squat outgrowths that emerge from the bone surface with a rather wide base
- **Processes:** large, well-defined protuberances with a narrow base
- **Tuberosities:** rounded protuberances with a wide base
- **Tubercles:** small, rounded protuberances
- **Spurs:** long, flat protuberances
- **Crests:** long protuberances in a line
- **Fossae:** round hollows
- **Recesses:** long hollows
- **Sulci:** shallow, thin hollows
- **Foramina and fissures:** openings of various sizes that pass through the bone
- **Canals:** very long openings
- **Laminae and squamae:** thin areas of flat bone of various dimensions
- **Facets:** small flat areas, usually in joints
- **Condyles:** articular surface with a hemispherical protuberance
- **Trochleae:** hollow articular surface
- **Epicondyles and epitrochleae:** small protuberances in a position above condyles and trochleae
- **Head:** the proximal wide end of some long bones.

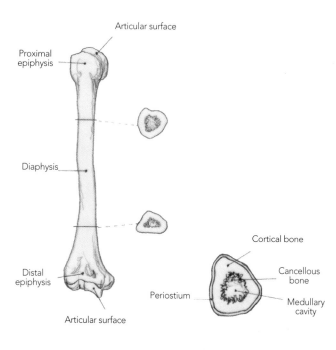

Parts of a long bone (humerus) and its transversal section.

• Microscopic structure

Regardless of its form, each bone has an external part, known as the cortical bone, of compact tissue that is arranged in lamellar layers, and an interior part (cancellous bone) where the bone tissue thins out, forming thin, woven trabeculae, arranged so that, according to given lines of mechanical force, they contribute to giving lightness and elasticity to the entire bone, but also making it considerably resistant to external stress. Bone marrow is found in the trabeculae. Bone is a supporting connective tissue made up of cells (osteocytes) immersed in a large quantity of a thick, amorphous intercellular substance rich in minerals. It undergoes continuous remodelling, that is, of growth and breakdown, carried out by bone cells; in this way, the tissue that has already grown is replaced and renewed using a particle demolition process and a subsequent new deposit.

Periosteum, a thin connective membrane, is laid over all external bone surfaces apart from joints, where there is articular cartilage and also apart from the tendon entry points. The periosteum nourishes the bone that it covers via extensive vascular infiltrations; it reinforces tendon insertions, repairs, as it is osteoblast-rich and forms bones as it is able to regenerate damaged or fractured bone tissue.

The smallest structures (known as second and third order, namely: osteocytes, bone gaps, the Haversian canal system and the osteon system etc.) are part of the specific field of study of histology and have a low value in terms of artistic representation, therefore it is pointless mentioning them here: for a cultural knowledge and suitable explanation of the matter, there are several excellent books to be read.

It is also advisable to consider the changes in character and consistency in the bone as adults age (osteoporosis, after which bone renewal slows down and the bones become fragile and decalcified) and the considerable physiological and morphological influences on bone coming from habitual stances, exercise and movement, which, in addition to causing muscle development and power to change, can also strengthen and extend certain tendon insertions on bones (the effect of functional modelling).

After this brief introduction, we can conclude by defining osteology as that branch of anatomy that studies the morphological characteristics and the behaviour of bones in the human body. As we have already said, the form of bones is usually described and studied by observing their appearance after they have been steeped, which is necessary to detach all the surrounding soft parts. The fact that bone elements are largely wrapped in muscle or other organs may lead those only interested in anatomy for artistic purposes to underestimate the importance of the bone structure. To the contrary, knowledge of the characteristics of each main bone, but also their overall layout and interdependent spatial relations is essential for giving sense to the static body and the body in motion, and also for deforming, accentuating or summarizing them in artistic expression, rendering the natural and biological nature of the human figure plausible and not arbitrary. As we will explain later, the articular pairing characteristics are very important for artists, as their knowledge, coming from a careful observation *in vivo* of the breadth of movement possible in the various body parts and the understanding of articular mechanisms, allows muscles and their insertion of tendons to be placed more precisely, lending a natural and expressive factor to drawing dynamic postures. To give a worthwhile aspect to the study of anatomy (which would otherwise be dry and pointless), the artist must understand the structural meaning of the whole: for osteology they must be able to precisely determine the position of each bone in the living human body and recognize the bone parts which are most easily visible under the skin or more easily located using palpation.

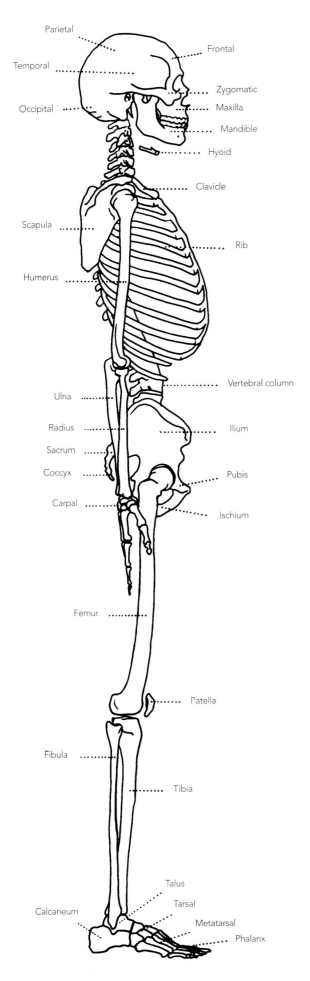

Parietal

Temporal

Occipital

Frontal

Zygomatic

Maxilla

Mandible

Hyoid

Clavicle

Scapula

Rib

Humerus

Vertebral column

Ulna

Radius

Ilium

Sacrum

Coccyx

Pubis

Carpal

Ischium

Femur

Patella

Fibula

Tibia

Talus

Tarsal

Calcaneum

Metatarsal

Phalanx

Schematic drawing of the male skeleton: lateral projection.

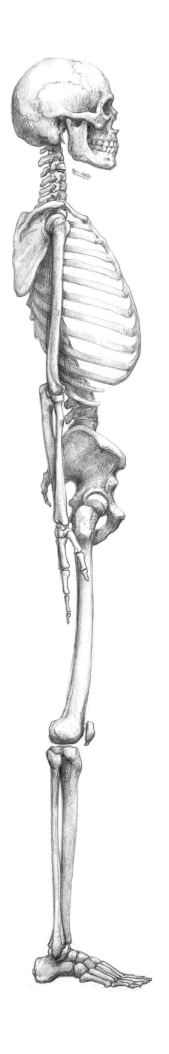

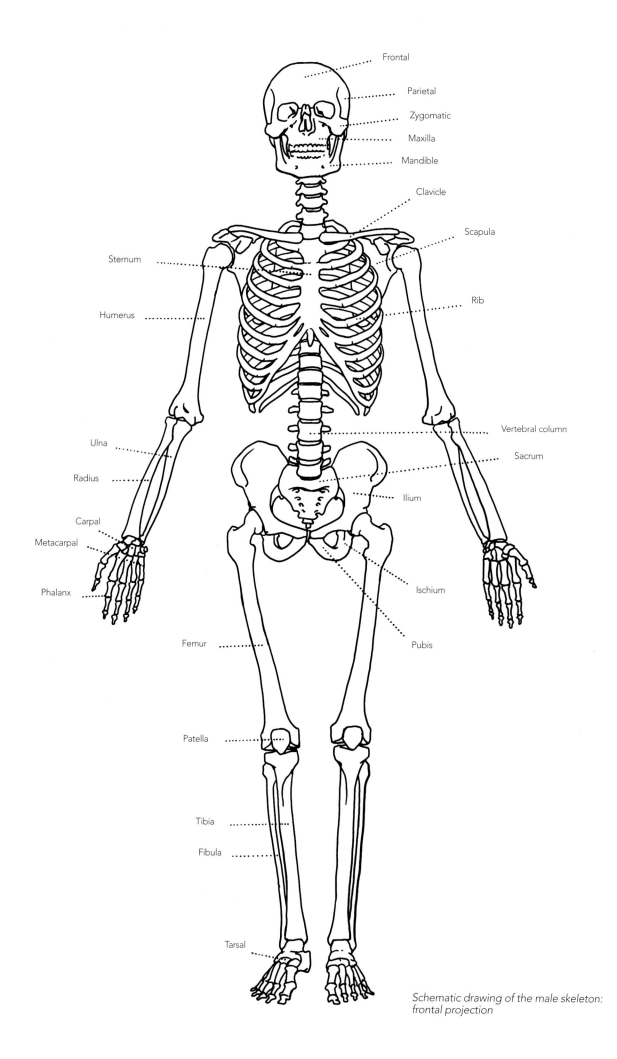

Frontal

Parietal

Zygomatic

Maxilla

Mandible

Clavicle

Scapula

Sternum

Rib

Humerus

Vertebral column

Sacrum

Ulna

Radius

Ilium

Carpal

Metacarpal

Ischium

Phalanx

Pubis

Femur

Patella

Tibia

Fibula

Tarsal

*Schematic drawing of the male skeleton:
frontal projection*

46

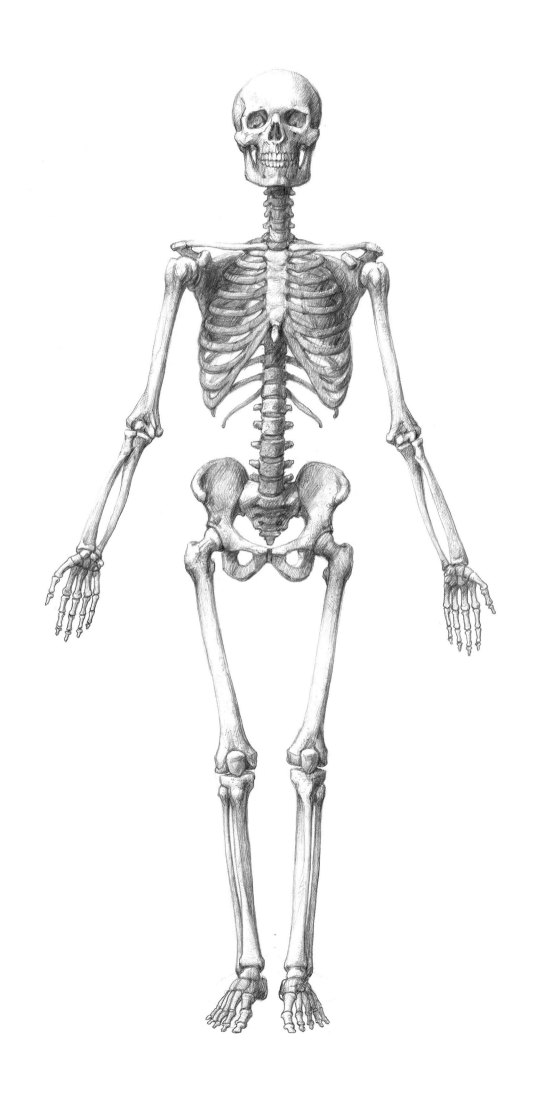

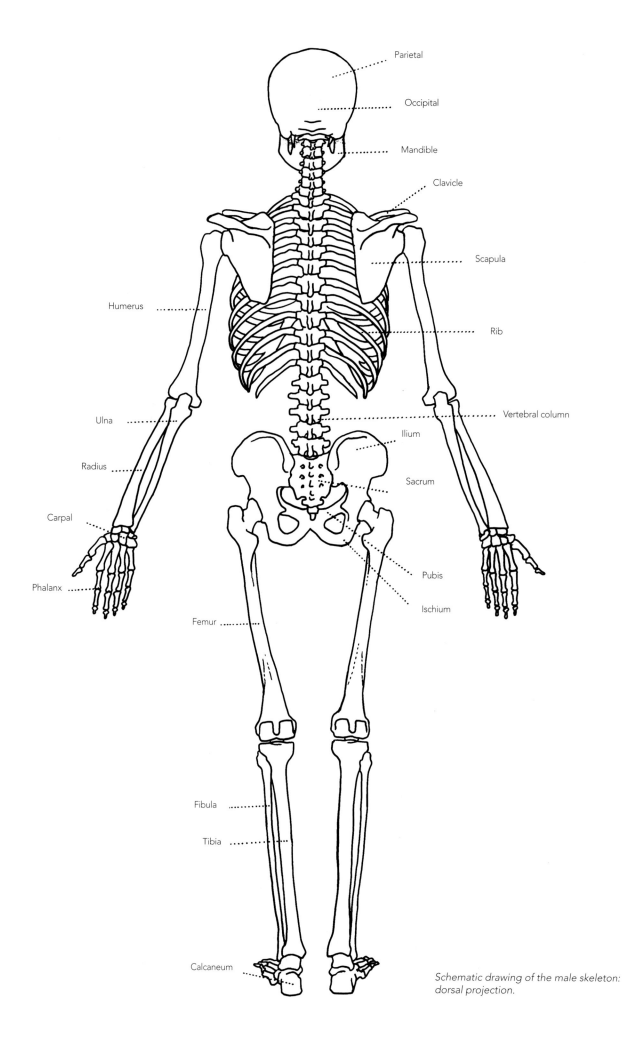

Parietal

Occipital

Mandible

Clavicle

Scapula

Humerus

Rib

Ulna

Vertebral column

Radius

Ilium

Sacrum

Carpal

Phalanx

Pubis

Ischium

Femur

Fibula

Tibia

Calcaneum

Schematic drawing of the male skeleton:
dorsal projection.

48

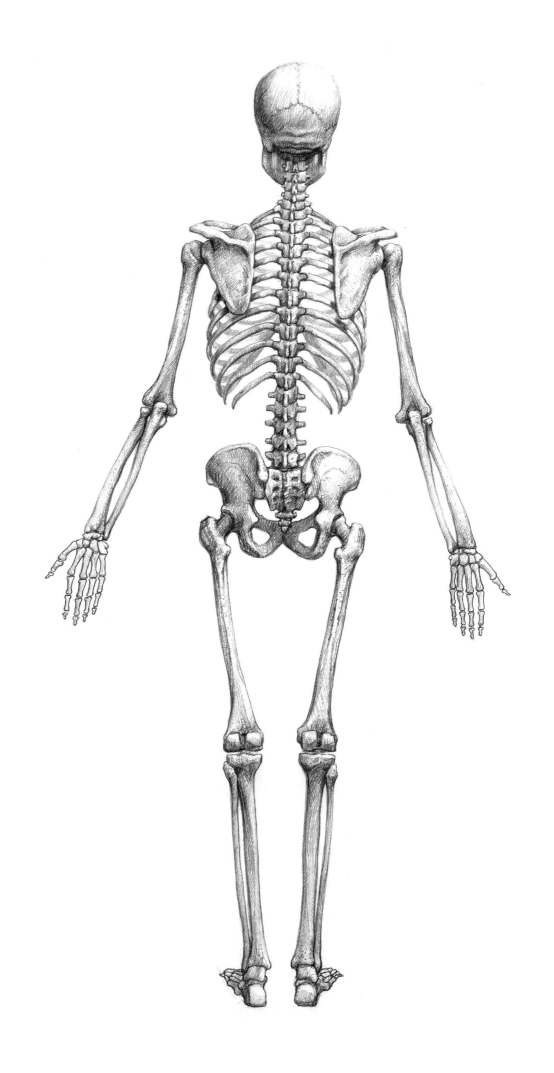

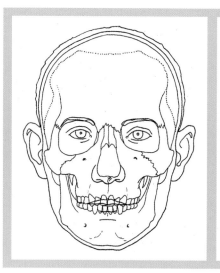

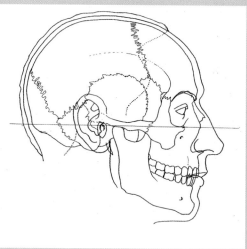

Diagram of the relations between the bone structure of the head and the soft tissue (muscles, adipose tissue, skin, etc.) which lies on top of it.

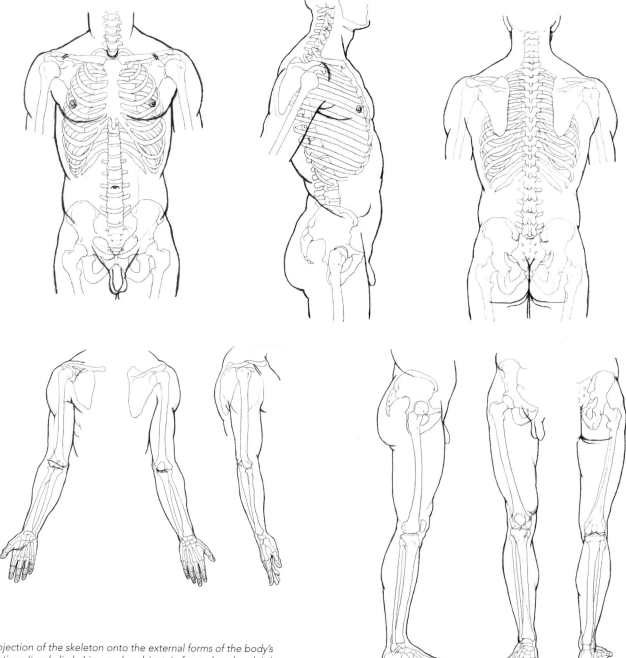

Projection of the skeleton onto the external forms of the body's sections (trunk, limbs) in a male subject, in front, dorsal and right-hand lateral projections.

THE ARTICULAR COMPONENT: ARTHROLOGY

• General information on articular structure

Joints are anatomical devices that establish intersections between different bones via the relative articular extremities, thus allowing movements between the individual bones and at the same time making sure of the union of all elements making up the skeleton. Alongside the high level of heterogeneity in bone shapes, and therefore of the relative bone heads, there is also a complex variety of intersections. Therefore, the joints are classified in a complex manner, taking into account the shape of the articular surface, the movements they allow, and the type of tissue placed between them. One common system of classification places joints into two broad categories, characterized by the presence or absence of an articular cavity between the bone ends, and is the system used on this page and those that follow. These are synarthrosis (fixed joints with little or no movement, or joints by continuity) and diarthrosis (freely moveable joints, or joints by contiguity).

• Synarthrosis

These joints have a simple structure: they do not have an articular cavity and comprise two articular surfaces with a connective tissue between them (cartilaginous or fibrous) which separates them but at the same time keeps them together. There are very limited possibilities of movement, therefore, but instead there is a considerable level of guaranteed solidity. With no articular cavity, the articular capsule, synovial membrane and synovial fluid are all missing. Particular types of synarthrosis are:

- **Synchondrosis (or cartilaginous synarthrosis)** The middle tissue is cartilaginous, allowing limited movements of flexion and torsion (for example: joints between vertebrae)

- **Sutures (or fibrous synarthrosis** The usually thin bone margins are joined by fibrous tissue that continues into the periosteum: these are fixed joints with no movement (for example: sutures between cranial bones)

- **Syndesmosis (or ligamentous synarthrosis)** Bones right next to each other or slightly spaced are joined by ligaments (as ropes, ribbons, laminae) that allow limited movements (for example: the coracoacromial joint).

• Diarthrosis

These are strong joints that allow wide, complex movements. The main characteristic is having an articular cavity between the heads of the bones, allowing the two articular surfaces (smooth and covered in cartilage) to slide over one another. Sliding is aided by the presence of synovia in the articular cavity, a fluid secreted by the synovial membrane attached to the internal face of the capsule, thereby reducing friction between the articular heads.

The bone segments are kept in contact by a fibrous joining sleeve, the articular capsule, strengthened by articular ligaments, which are fibrous ribbons of varying thickness. These structures help to prevent detachment of the articular extremities and guide movement, limiting or stopping the possible joint dynamics.

Articular ligaments are made of strong, flexible, fibrous tissue that is highly resistant to traction, but is also slightly elastic; they are shaped like thin ribbons, fascia or small laminae, and are whitish in colour, similar to bones. They fit strongly onto the articular bones at the edge of the capsules, but in some cases also reach parts of the bone that are a long way from the joint, expanding into large membranes. In some complex joints (hip, knee), we find intra-articular ligaments located inside the capsule, with a greater mechanical strength.

Types of joints
and their diagrammatic representations

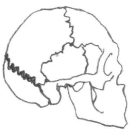

Suture (skull

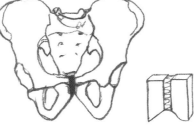

Symphysis (pubis)

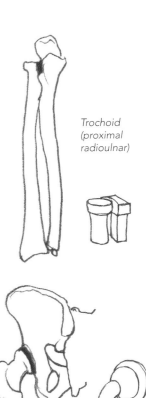

Trochoid (proximal radioulnar)

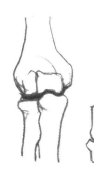
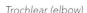

Trochlear (elbow)

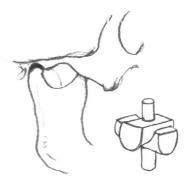

Condyloid (temporomandibular)

Enarthrosis (hip)

Diarthrosis includes various types in its classification, based on the shape of the articular heads, on which the degree and characteristics of movement depend:

- **Arthrodial**, where the articular surfaces are flat or slightly curved, touching one another via the respective cartilage covering and held by a capsule sleeve inserted into the surrounding cartilage. They allow only sliding and rotational movements as the flat surfaces in contact with each other cannot tilt to allow angular movements. One example is given by the joints between the carpal bones

- **Condyloid**, where the touching articular heads have ovoid or ellipsoid surfaces: one that is concave (condyloid cavity), the other being convex (condyle). They allow angular movements on two planes, but do not permit rotation. Examples include: temporomandibular, radiocarpal and humeroradial joints

- **Enarthrosis**, where one of the two heads is hemispherical in shape and convex, and the other is concave, in order to create a spheroid joint. This type of joint is triaxial, that is, it allows all rotation and angular movements (flexion, extension, abduction, adduction, circumduction, etc.) as their breadth is only restricted by the capsule and the ligaments: examples: hip (coxofemoral), arm (scapulohumeral) joint

- **Saddle joints**, where one end is concave and the other convex (thus saddle shaped). As both bones have a concave/convex surface, they can articulate by reciprocal reception. This joint is a variation of the condyloid and allows the same movements on two axes, with greater mobility. Examples: the carpometacarpal joint of the thumb, ankle joint (tibiotarsal) and calcaneocuboid joint

- **Ginglymi**, where the articular heads are approximately the shape of cylindrical segments, one of which is concave, with grooves, the other is convex. There are two types:
 - *Lateral ginglymi (or trochoids)*, which have an osseous pivot surrounded by a ring, limiting movement to rotation around the axis (joint between epistropheus and atlas); or they have adjacent articular bone heads, one next to the other (radioulnar joint)
 - *Angular ginglymi (or trochleae)*, where a hinge movement can be carried out, as one articular head has a longitudinal channel and the other fits into the cavity, allowing movements only on one plane around a single axis (humeroulnar joint)

- Lastly, there are the **articular complexes**, where two heads of the bone live within a single joint and are joined by the same capsule: important examples of this are the elbow joint and the knee joint.

The movements allowed by the joints are either simple (if it involves a single joint) or complex (when more than one joint is involved). The simple movements are movements on an axis, that is, those movements where either two bones moving from reciprocal relationships do not modify the angle that they have in the body's anatomical position, or angular movements where there is a variation in the existing angle between the two bone heads involved.

There are only two movements on an axis: limited sliding, when the articular heads slide over each other, moving the axes but leaving the angle between them unchanged; and rotation, when the two articular heads slide over each other, turning around a common axis of both bones. With regard to angular movements, there are much more – flexion, extension, abduction, adduction, circumduction, etc. – the definitions of which have already been mentioned as they are terms of movement. We must also remember torsion as one of the complex movements and a variation of the ones included in circumduction, which is not the result of movement entirely on the axis (as circumduction would be), but is the sum of small sliding movements of various joints: for example, torsion of the vertebral column.

It is said that the main function of joints is to allow bones to be moved, working as levers, under the traction of muscles. However, we must consider that some factors, such as the conformation of the articular surfaces, the limiting effect of ligaments, the action of antagonist muscles or stabilizers and also the tendon insertions of muscles (which can, with constant training, be lengthened, thus improving the range of articular movement), although they increase the dynamic capacity, they also highlight the second function of joints: to guarantee the stability of bone segments, ensuring the joining of skeletal components without obstructing mobility.

Knowledge of the structure and articular dynamics (at least the main mechanisms) is important for a figurative artist's anatomical training. As indicated already, understanding the effects on the nude model's surface model, of the different types of bone joints and the limitations of their movement, is essential for a consistent and efficient dynamic performance of the body. To fully understand the articular structure and the inherent relations between structure and function, it is necessary however to consult books, anatomical tables, radiographic images and computer aids, along with a careful examination of the mounted skeleton, most of all taking care to recompose the relations of the bones involved as precisely as possible, at least for limb joints, the interactions of the bones involved, simulating the joint capsule with elastic materials and with other inextensibles, the ligaments. The live drawing of these artificial preparations is educational, especially if recorded in sequence, and also if the intermediate stages of an articular movement (typically those of limb or the trunk) between the two extreme positions are superimposed (see diagrams opposite).

Lastly, on a live model (or on oneself) and comparing with the assembled skeleton, it would be advisable to examine the real range of movement permitted by the main joints, evaluating the movements that some surrounding bones or the ones involved in the joint are subjected to (for example: clavicle, scapula) and observing the adaptation of the entire body (but especially the vertebral column and the pelvis) when a certain movement is carried out.

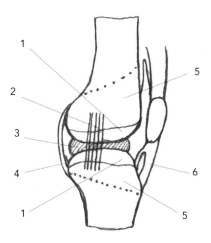

Diagram of elements that make up a typical mobile joint (diarthrosis): knee joint.
1 - Articular cartilage
2 - Ligaments
3 - Intra-articular disk
4 - Capsule
5 - Articular head
6 - Bursa mucosa.

Diagrams showing the range
of articular movements

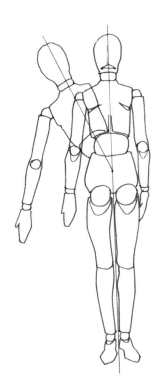

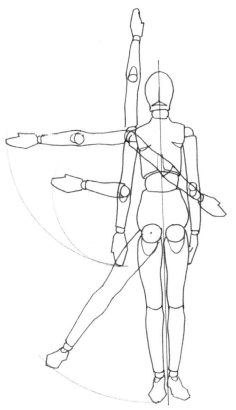

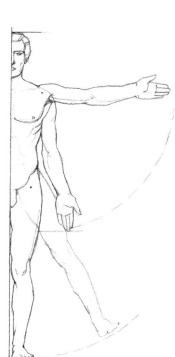

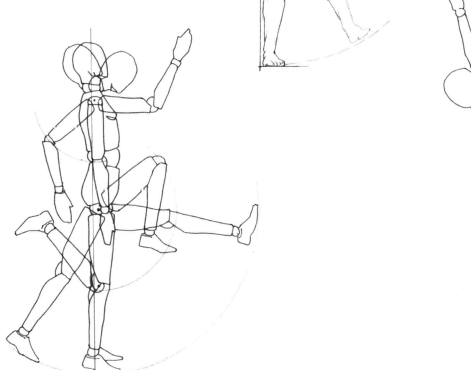

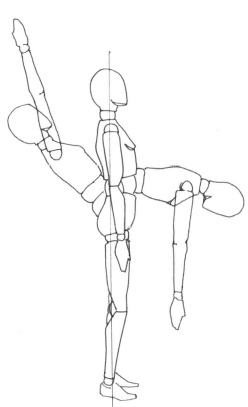

THE MUSCULAR COMPONENT: MYOLOGY

• General information about muscle structure

Muscles are organs that have the ability to contract in response to nervous stimuli. The muscles involved in the locomotor apparatus are the ones that maintain the body's posture and control movement. These are known as skeletal muscles and belong to the category of voluntary muscles as they are subjected to control by will, through the central nervous system.

Depending on the functional and structural characteristics, muscles can be classified into three groups. Voluntary muscles (the only ones that we will look at in this book) are the organs of the human body's active movement, and are subject to will. They are attached to bones by tendons, and when they contract (shorten) they generate movement – albeit within the limits allowed by the respective joint. They comprise bundles of striated muscle fibres and have three important properties: extensibility, elasticity and contractility. They have a high contraction speed and force but can carry out this function effectively for rather short periods of time.

Involuntary muscles (also known as white muscles) are found mainly in the walls of the viscera and the blood vessels. Their contraction and relaxation does not depend on any voluntary act, but rather on the autonomic nervous system. They are formed by smooth muscle tissue and contract slowly and over prolonged periods of time. The myocardium is the muscular tissue of the heart, with particular characteristics: it is striated like skeletal muscles but contracts regularly and without interruption, regardless of will.

There are several skeletal muscles: it is believed there are approximately 327 paired muscles – meaning there are two of each in the body, one on each side. There are more than 700 muscles overall, including visceral and a few unpaired muscles. This numerical imprecision depends on the criteria followed by those who study them, but above all on individual variability, whereby some muscles are sometimes absent, others excessive in number, or merged with other surrounding muscles. In a person of average conformation, muscles weigh a little less than one half of the body weight.

In muscle there is:

- A fleshy part, known as the contractile part or belly. In cadavers it is a dark red, almost brown colour, with a first rigid (rigor mortis), then flaccid consistency; in living people it is brighter red (due to the presence of myoglobin, a protein that carries iron and oxygen) and becomes very stiff when in a contracted state. However, even when the muscle is distended and relaxed, there is still a partial contraction of the muscles (muscle tone) and residual muscle tension.

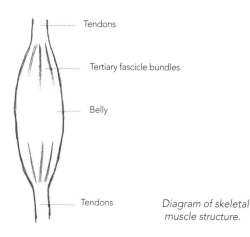

Diagram of skeletal muscle structure.

Tendons

Tertiary fascicle bundles

Belly

Tendons

- The surface of the muscle belly is smooth, but underneath the connective fascia (epimysium) that covers it, there is a slight longitudinal fascicle bundle, which may also be visible in large muscles (gluteus, deltoid, pectoral, etc.). This is due to the microscopic structure of the contractile part, which is made up of large fascicle bundles (the tertiary fasciae), each of which is wrapped in a connective sheath (perimysium) and is separated from the others by septa or connective laminae of various sizes. Each tertiary bundle, in turn, comprises smaller bundles (secondary bundles) and these are made from even smaller bundles (primary bundles) of very long muscle fibres.

- The muscle fibres are the contracting units of the muscle. They are made up of lots of cells (in fact, they contain many nuclei) and are made up of myofibrils, long chains of proteins (filaments) that have characteristic transverse striations – that is, the alternation of light and dark stripes caused by the change in protein structure when a muscle contracts or relaxes. The contraction of these structures, of the protein filaments, after nervous stimulation is the basis of the entire muscle's shortening.

 As described, muscle fibres also have different colours. The red fibres contain large amounts of myoglobin, and many of these are used in long-lasting, slow contractions (for example in static muscles, destined to keep particular parts of the skeleton in certain positions for a long time). The white muscle fibres are used mainly in the rapid contraction, energetic, short-lasting muscles, for example flexor muscles.

- At each end of the muscle belly, the tissues extend to form a tendon. Tendons are made of fibrous tissue, are very strong and shiny and whitish in colour. The internal connective membrane of the contractile part gradually transition into the tendon fascicle bundles – that is, the secondary and tertiary bundles of the muscle belly merge towards the end of the tendon. As the tendon is practically inextensible (although a small number of elastic fibres serves to reduce any sprain trauma in a violent contraction), the traction caused by the contractile muscle mass is easily and fully transmitted to the point of insertion onto the bone.

 Generally speaking, tendons have the form of a rope, but when they start from wide or flat muscles, they also become flat or laminar, in which case they are known as aponeuroses. Usually, the passage between the contractile part and the tendon part takes place on a different level, but in the case of wide or flat muscles the intramuscular connective membranes merge in a rather narrow area. For this reason, there is usually a conoid or laminar thinning of the muscle belly.

Alongside the main muscle structures, the contractile belly and the tendons, there are other auxiliary or complementary parts. The covering fasciae are connective membranes that generally cover the superficial muscles of some body regions (cervical fascia, brachial fascia, etc., with the exclusion of cutaneous muscles which attach directly to the deepest layer of skin) or wrap and separate functionally similar deep muscle groups, containing them during contraction. It must be noted that the superficial fasciae – loose or fatty connecting tissues – are found at subcutaneous layers, to which the skin is also held, causing the formation of characteristic folds. The sheaths and fibrous fasciae (retinacula, etc.) are containing devices: they hold tendons, especially those of the long muscles, which adhere to bone planes in the points where they pass over joints, sometimes acting as mechanical reflection points. They can be found in the wrist, elbow, ankle and so on. The muscle tendon attachment points on bones are normally separated into two types: firstly the point of origin (or fixed point), which has low mobility and a shorter tendon length and is generally located in a more

proximal position, towards the axial skeleton. Then there is the point of insertion (or mobile point), characterized by greater mobility, a longer tendon and attachment to a mobile bone in the skeleton. We must bear in mind the fact that muscles exercise their traction force on both points of attachment, attempting to move one towards the other. For skeletal muscles, the indication of origin and of attachment is determined according to the dominant muscle action, but in many cases, depending on dynamic circumstances, the points can also be reversed. The few cutaneous muscles, on the other hand, always have attachment on the deep layers of the skin.

The skeletal muscles have complex names coming from many different origins: for example, they may derive from their shape (trapezius, deltoid, soleus, etc.), from the action they carry out (elevator, abductor, supinator, flexor, extensor), from the region they occupy (pectoral, dorsal, brachial), direction (oblique, rectus, transverse), the number of heads (biceps, triceps), or the number of components (semitendinosus, semimembranosus), from the attachment bones (sternocleidomastoid) and so on. Committees meet that are appointed to standardize, update and rationalize anatomic terminology, codifying names and functions in protocols (previously Nomina Anatomica, now Terminologia Anatomica) that are welcomed by the scientific community.

Muscles also vary in shape depending on the function that each of them can carry out, but they can be separated into some groups:

- **Long muscles** are cylindroid or fusiform, tapering towards the ends; sometimes they are very long or ribbon-shaped (like the sartorius). Their fibres are arranged parallel to their length. There are various types, distinguished by the presence of various muscle bellies converging into a single tendon (of insertion, usually): biceps, triceps, quadriceps or digastric, and each has two muscle bellies connected by an intermediate tendon. Long muscles are mainly located around bones in the limbs.

- **Wide muscles** are rather flat, sometimes laminar, and are only a few millimetres thick. The fibres are also parallel to each other, in the direction of the tendons (known as aponeurosis of attachment) that are large and wide in shape. Wide muscles are located especially in the trunk, where they form the abdominal walls and cover the rib cage.

- **Short muscles** are short and usually arranged around joints – which require energetic movements with a small extension – and around the vertebral column, where they form a complex system of muscle.

- The **penniform muscles** have a long, central tendon in the muscle belly, into which the muscle fibres are inserted at an oblique angle (for example the rectus femoris). Variants include unipennate and bipennate muscles. They are mainly 'power' muscles (short fibres), as they cannot contract much but do so with great energy.

- **Orbicular or sphincter muscles** have a circular structure, sometimes with tendon parts in the middle of them, and are rare in skeletal muscles, since they are mostly limited to the head and digestive apparatus.

Lastly, we must mention that the muscles are arranged in layers. There is a covering layer of muscle on the surface (superficial muscle) and then further layers that are progressively deeper beneath the surface (deep muscle). It is clear that there are close relations between the two systems, superficial and deep, and the interplay is important for the purpose of artistic representation.

The possibilities of movement within different body parts are linked to mechanical functions, which can the traced back to that of levers in the three basic types, although with particular differences due to the arrangement of the muscles and the relative lines of force. It is rarely one sole muscle or group of muscles that carries out the movements; more often there are complex actions in particular situations, indicated by the following terms:

- **Agonist muscles:** muscles that can cause the same movement, but have different side effects because of the different points of origin and insertion. They are also known as motor muscles.

- **Antagonist muscles:** these are the ones that partly or fully carry out opposing actions to those of the agonists (a typical example is that of the flexor and extensor muscles).

- **Support or stabilizing muscles:** these are muscles which, when contracted, act against the force of gravity or against the action of a motor muscle to support or immobilize a part of the body.

- **Neutralizing muscles:** muscles that combat the undesired secondary actions of an agonist muscle.

- **Synergist muscles:** muscles that participate in concert (to a varying degree) in determining a certain movement or position of a part of the skeleton. Synergism is a very frequent situation, as each movement, from the simplest and most limited to the more complex, requires the contribution of several muscles, with a delicate balance between antagonist forces or opposing synergic groups. It is useful to mention that the muscle, intended as a contractile element, is only an executor, a motor machine, whose

Some types and conformations of skeletal muscles:
1 - Orbicular (orbicularis oculi)
2 - Wide and flat (latissimus dorsi)
3 - Long (sartorius)
4 - Fusiform (tensor fasciae latae)
5 - Biceps (biceps brachii)
6 - Unipennate (extensor carpi ulnaris)
7 - Bipennate (extensor digitorum)
8 - Polygastric (rectus abdominis)
9 - Digastric (digastric)
10 - Polycaudal (flexor digitorum superficialis).

functional significance is provided solely by the nervous centres, which are responsible for the exact regulation of contraction and relaxation impulses. It can also be noted that muscle contraction does not necessarily mean the shortening of the muscle in action. Kinesiology studies have distinguished between concentric (or shortening) contraction, where the muscle actually decreases in length; eccentric (or lengthening) contraction, which occurs when the contracted muscle is gradually relaxed, and static contraction, when the muscle is all or partly contracted, without this causing any modification in length.

If verified on a nude model for the effects of the muscles on the surface, this information is particularly useful for the artist, who is therefore able to recognize and then effectively represent the different dynamic situations of the human body.

Muscles and their actions are the objects of study for the medical purposes of rehabilitation, using various methods to verify hypotheses. This kind of study is also useful for figurative artists, within the limits of what they may be interested in. The methods used are: cadaver dissection, through which the insertions, path and topographical relationships of each muscle and the conformation of joints are observed (in purely static conditions, of course); visual and manual inspection of a living person's muscles when carrying out certain actions, using photographic, cinematographic and electronic techniques; construction of models that simulate bones, along with the positioned joints and muscles between them that intervene in certain actions – an articulated skeleton is often used, with muscle functions reproduced using elastic materials; electromyography, a technique used to record the electrical currents produced by a muscle or a group of muscles in action. All these methods must be mutually integrated and require careful interpretation in order to prevent reaching erroneous conclusions. Of course, it is recommended that the artist consults additional books on the topic, which contain a wealth of information and in-depth, specialized studies. These are not at all boring but, on the contrary, quite stimulating and inspiring for anyone approaching human anatomy with a creative and investigative spirit.

Skeletal muscles are grouped together, usually following a topographical criterion which, however, as the muscle group have frequently similar paths and direction, also coincides with a functional criterion. In a few cases, as for the paravertebral dorsal muscles, an embryological origin criterion is also used.

Diagram of the topographical position of muscles in a limb (arm) in a transverse section:
1 - Subcutaneous tissue
2 - Bone (humerus)
3 - Vessels and nerves
4 - Muscle bellies

To conclude the general notes that we have made so far, we can state that myology, the branch of normal human anatomy that studies the muscles and their related structures, is essential for the artist who intends to understand and accurately portray the human body in its endless static and dynamic aspects (albeit with the broadest freedom of expression). Muscles form below the teguments (adipose layers, skin and relative appendages) – the fleshy part of the body which is most visible. Mere superficial observation of the nude body is not enough for serious artistic study, as the interpretation of each movement requires topographical and functional knowledge of the muscles involved and an examination of their behaviour and synergistic or antagonist interrelations. This is an examination that, if carried out intelligently, does not at all restrict creative artistic endeavours; rather, it frees and empowers them.

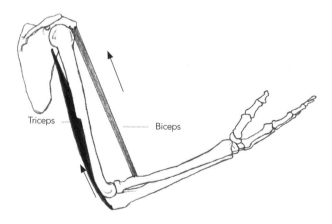

Diagram of muscle flexion/extension action:
In flexion, the biceps is the agonist and the triceps is the antagonist; in extension, vice versa.

P = power (muscle); F = fulcrum (joint);
R = resistance (weight or passive weight of the limb).

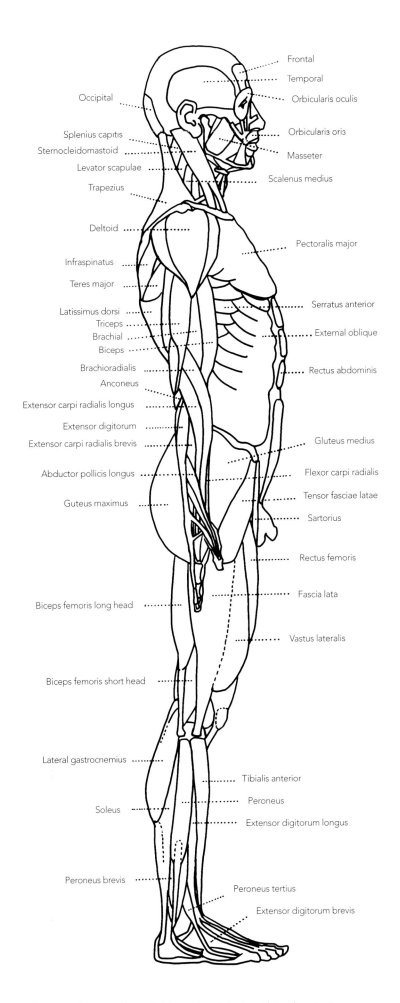

Occipital

Splenius capitis
Sternocleidomastoid
Levator scapulae
Trapezius

Deltoid

Infraspinatus
Teres major

Latissimus dorsi
Triceps
Brachial
Biceps

Brachioradialis
Anconeus

Extensor carpi radialis longus

Extensor digitorum
Extensor carpi radialis brevis

Abductor pollicis longus

Guteus maximus

Biceps femoris long head

Biceps femoris short head

Lateral gastrocnemius

Soleus

Peroneus brevis

Frontal
Temporal
Orbicularis oculis

Orbicularis oris

Masseter

Scalenus medius

Pectoralis major

Serratus anterior

External oblique

Rectus abdominis

Gluteus medius

Flexor carpi radialis

Tensor fasciae latae

Sartorius

Rectus femoris

Fascia lata

Vastus lateralis

Tibialis anterior

Peroneus

Extensor digitorum longus

Peroneus tertius

Extensor digitorum brevis

Schematic drawing of superficial muscles: right-hand lateral projection.

Superficial muscles: right-hand lateral projection.

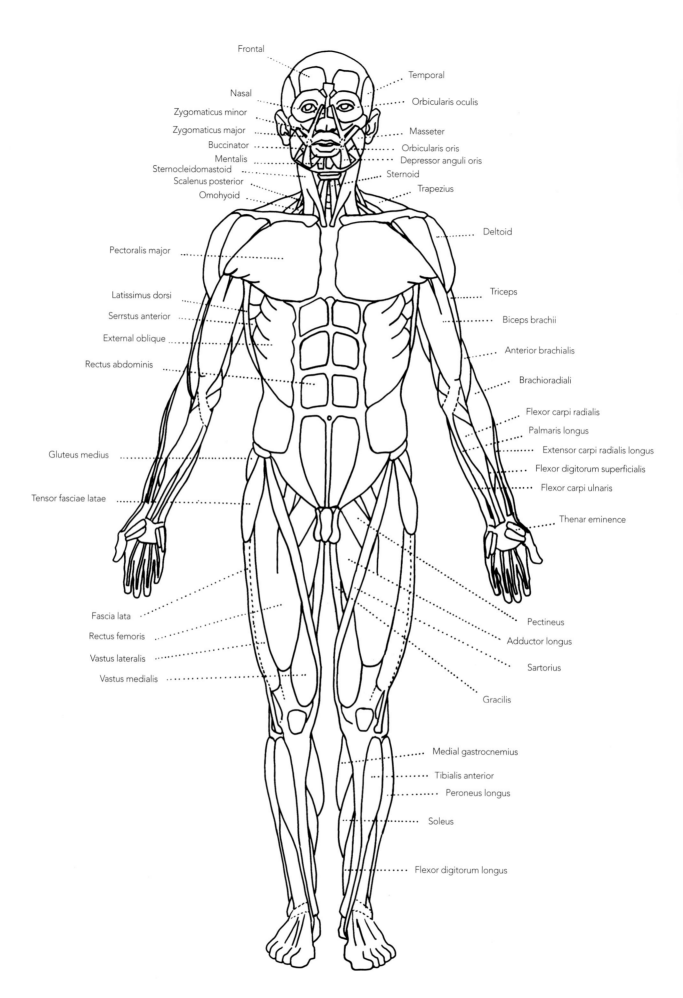

Frontal

Temporal

Nasal

Orbicularis oculis

Zygomaticus minor

Zygomaticus major

Masseter

Buccinator

Orbicularis oris

Mentalis

Depressor anguli oris

Sternocleidomastoid

Sternoid

Scalenus posterior

Trapezius

Omohyoid

Deltoid

Pectoralis major

Triceps

Latissimus dorsi

Biceps brachii

Serrstus anterior

Anterior brachialis

External oblique

Brachioradiali

Rectus abdominis

Flexor carpi radialis

Palmaris longus

Extensor carpi radialis longus

Gluteus medius

Flexor digitorum superficialis

Flexor carpi ulnaris

Tensor fasciae latae

Thenar eminence

Fascia lata

Pectineus

Rectus femoris

Adductor longus

Vastus lateralis

Sartorius

Vastus medialis

Gracilis

Medial gastrocnemius

Tibialis anterior

Peroneus longus

Soleus

Flexor digitorum longus

Schematic drawing of superficial muscles: frontal projection.

59

Superficial muscles: frontal projection.

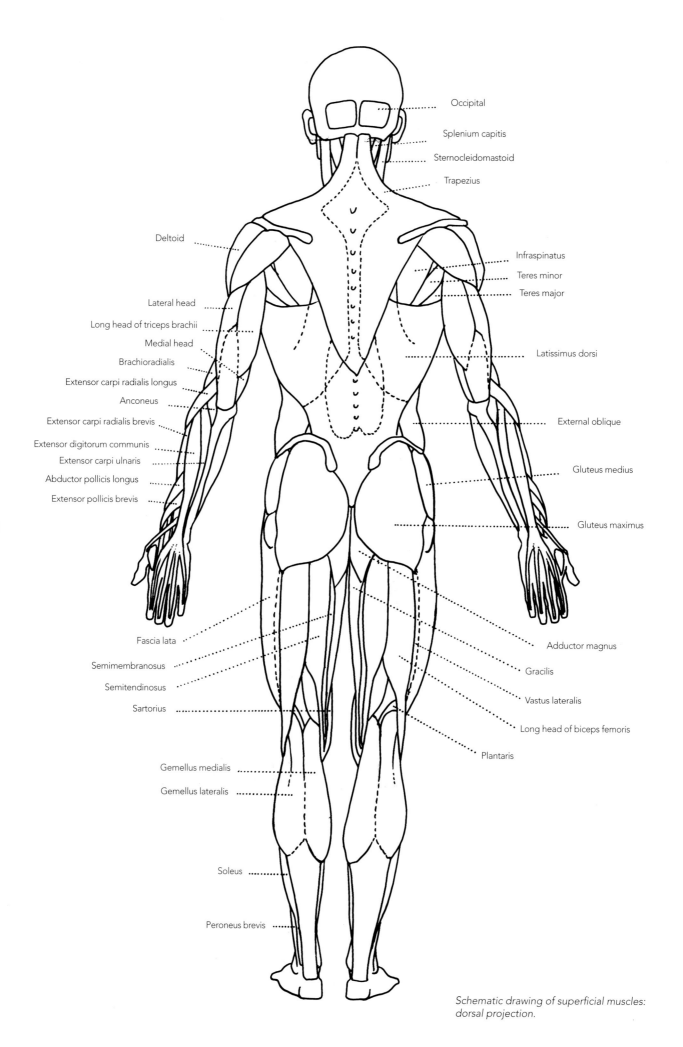

Occipital

Splenium capitis

Sternocleidomastoid

Trapezius

Deltoid

Infraspinatus

Teres minor

Teres major

Lateral head

Long head of triceps brachii

Medial head

Brachioradialis

Extensor carpi radialis longus

Anconeus

Extensor carpi radialis brevis

Extensor digitorum communis

Extensor carpi ulnaris

Abductor pollicis longus

Extensor pollicis brevis

Latissimus dorsi

External oblique

Gluteus medius

Gluteus maximus

Fascia lata

Semimembranosus

Semitendinosus

Sartorius

Adductor magnus

Gracilis

Vastus lateralis

Long head of biceps femoris

Plantaris

Gemellus medialis

Gemellus lateralis

Soleus

Peroneus brevis

60

Schematic drawing of superficial muscles: dorsal projection.

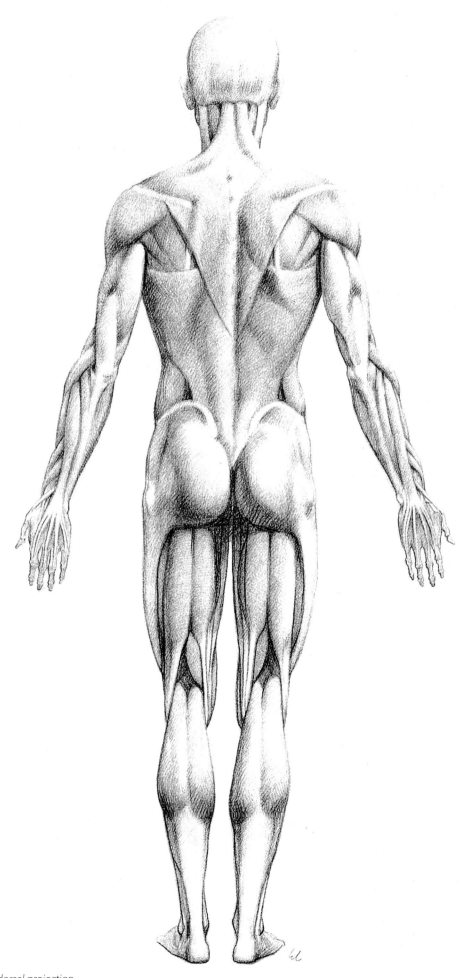

Superficial muscles: dorsal projection.

BONE AND MUSCLE REFERENCE POINTS ON THE NUDE BODY

It is easy to find bone and muscle reference points on the surface in several body regions. They are also known as landmarks, and they are particularly useful for artists when they are painting, drawing or sculpting a human figure from a live model. These points, especially the bone landmarks, are also used to calculate or verify body proportions, both for the entire body and for individual parts, as they are constant and independent of the position the model assumes or his or her physical constitution.

These bony landmarks are subcutaneous and almost always cause pronounced protuberances over which the skin is tight and thin. They are therefore easy to spot by sight, or even better, by palpation, even in fatty individuals of both sexes (see page 65).

The muscle landmarks are much more variable than bone landmarks and are frequently difficult to recognize in individuals with low muscle development or with large amounts of body fat. However, examining live muscles (rectus abdominis, deltoid, trapezius, quadriceps, etc.) can help to define the volumes and proportions of several regions.

The skin landmarks (such as the nipple, the earlobe, the nasal tip, etc.) vary greatly given their relative movability and wide-range of variation in individuals.

62

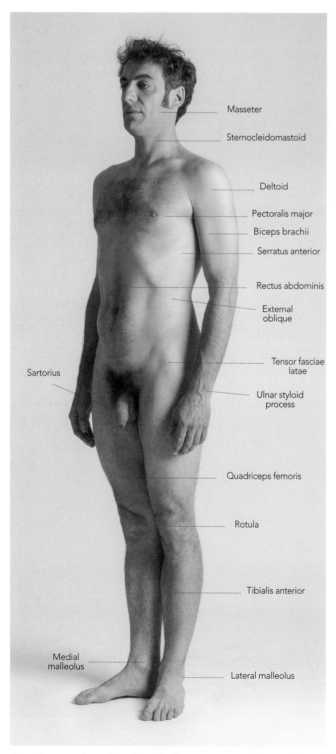
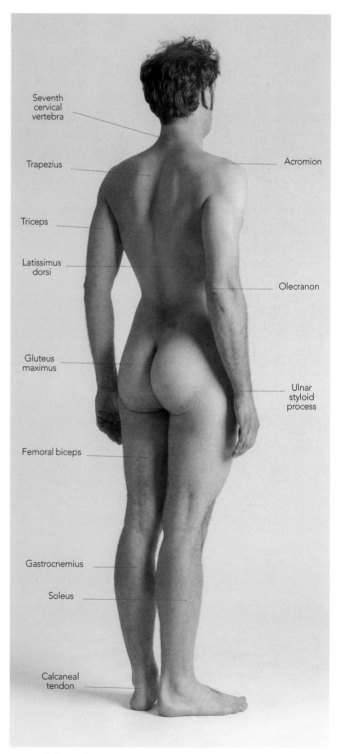

Some bone and muscle points of reference, perceptible or visible on the surface of the body.

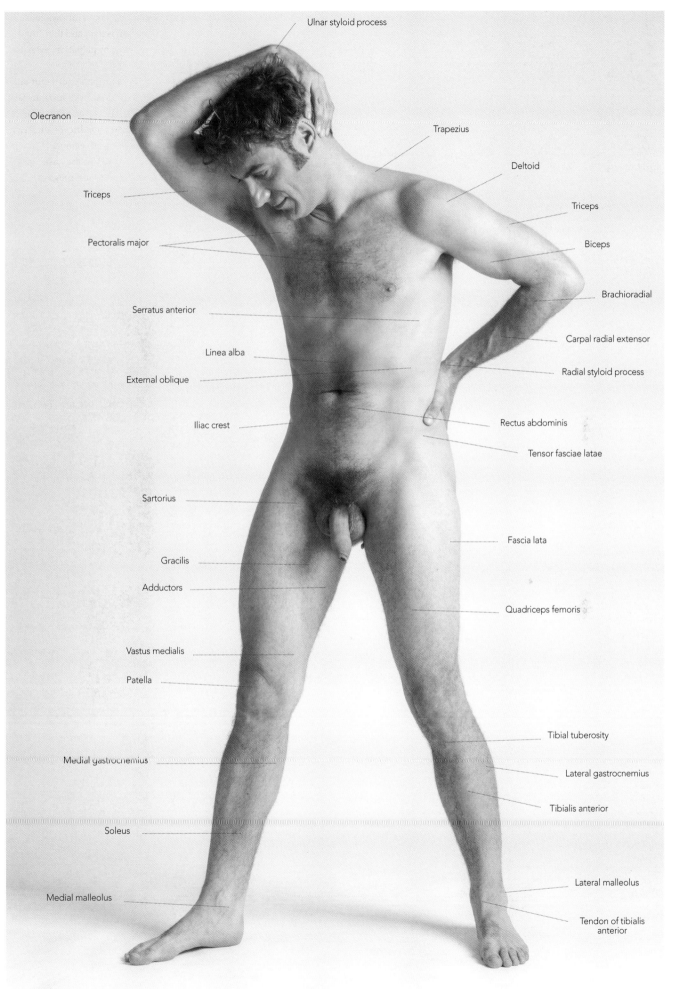

Ulnar styloid process

Olecranon

Trapezius

Deltoid

Triceps

Triceps

Pectoralis major

Biceps

Brachioradial

Serratus anterior

Carpal radial extensor

Linea alba

Radial styloid process

External oblique

Iliac crest

Rectus abdominis

Tensor fasciae latae

Sartorius

Fascia lata

Gracilis

Adductors

Quadriceps femoris

Vastus medialis

Patella

Tibial tuberosity

Medial gastrocnemius

Lateral gastrocnemius

Tibialis anterior

Soleus

Lateral malleolus

Medial malleolus

Tendon of tibialis anterior

63

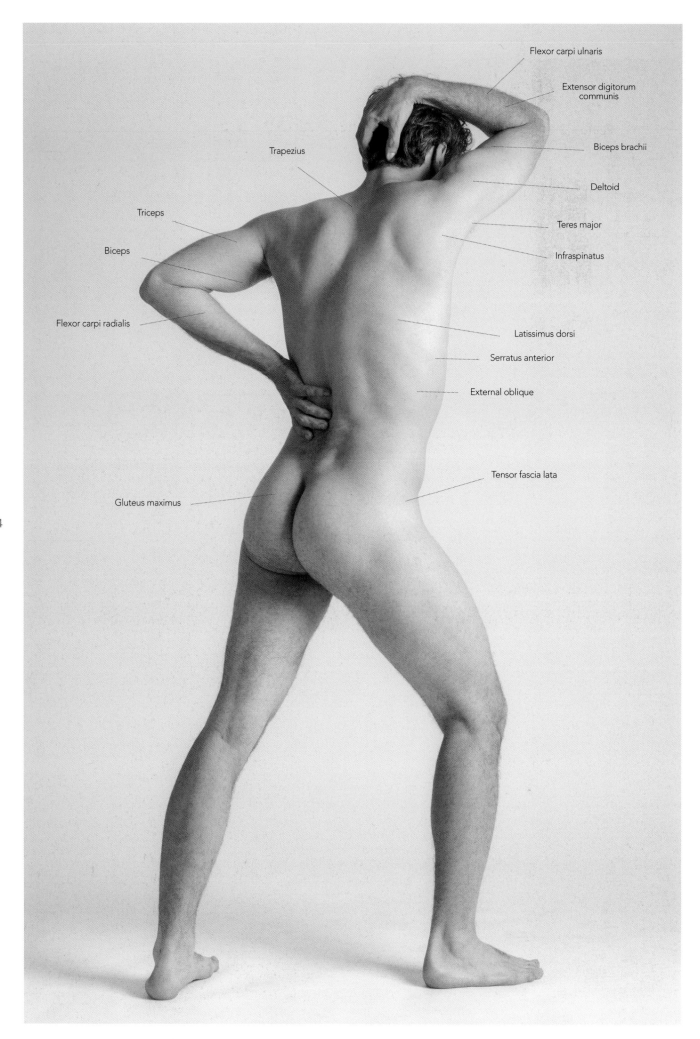

Flexor carpi ulnaris

Extensor digitorum communis

Biceps brachii

Deltoid

Teres major

Infraspinatus

Trapezius

Triceps

Biceps

Latissimus dorsi

Serratus anterior

External oblique

Flexor carpi radialis

Tensor fascia lata

Gluteus maximus

64

Main subcutaneous bone landmarks

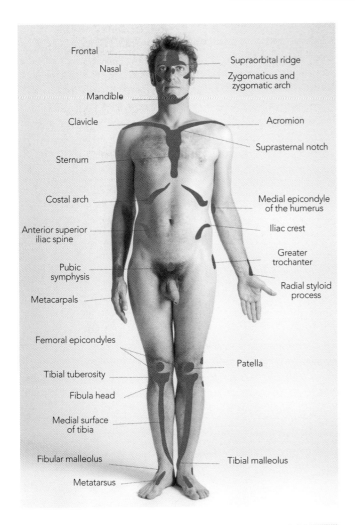

Frontal
Nasal
Mandible
Clavicle
Sternum
Costal arch
Anterior superior iliac spine
Pubic symphysis
Metacarpals
Femoral epicondyles
Tibial tuberosity
Fibula head
Medial surface of tibia
Fibular malleolus
Metatarsus

Supraorbital ridge
Zygomaticus and zygomatic arch
Acromion
Suprasternal notch
Medial epicondyle of the humerus
Iliac crest
Greater trochanter
Radial styloid process
Patella
Tibial malleolus

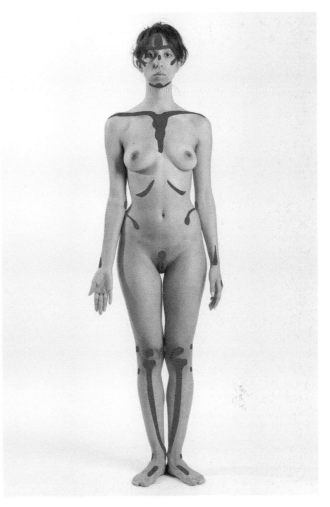

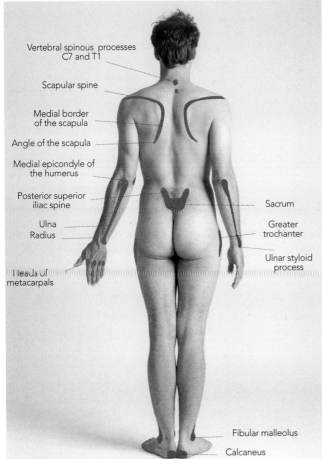

Vertebral spinous processes C7 and T1
Scapular spine
Medial border of the scapula
Angle of the scapula
Medial epicondyle of the humerus
Posterior superior iliac spine
Ulna
Radius
Heads of metacarpals

Sacrum
Greater trochanter
Ulnar styloid process
Fibular malleolus
Calcaneus

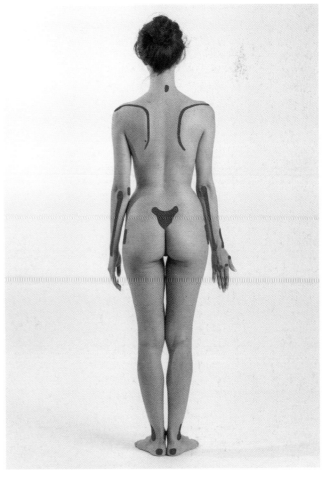

THE INTEGUMENTARY SYSTEM

The integumentary system comprises the skin and its related structures – that is, tissues that cover the human body and protect it from the external environment. The study of this topic is therefore very interesting and useful for the figurative artist, who should begin with the careful observation of the live model's body surface and then move on to examining the bone and muscle structures that support it and determine its external morphology.

The skin is an especially complex membrane that covers the entire body surface and, with regard to natural orifices, continues in the mucosa of the respiratory, digestive and genitourinary systems. There are three basic skin layers: the epidermis, the dermis and the subcutaneous layers. The epidermis is the outer-facing, surface layer, and is an epithelial covering that is divided into five strata, the first and last of which have particular characteristics:

- The **stratum basale** is located deeply, in contact with the dermis to which it is strongly anchored (but from which it is separate) by the undulations and digitations of the basal cells. These have the ability to divide and produce new cells and are therefore essential for maintaining the balance between the cutaneous cells that are naturally eliminated and the cells destined to replace them. Moreover, it is in this stratum that the skin's pigment, melanin, is produced, which gives the skin its characteristic colour, dependent on ancestry and sun exposure, and protects the individual against some of the effects of solar radiation.

- The **stratum spinosum**, the **stratum granulosum** and the **stratum lucidum** are, in order, layers of successive and progressive evolution towards cornification (typical of the outermost epidermis layer) and are characterized by an increasing flattening of the cells and by the gradual loss of cell organelles, especially of the nucleus.

- The **stratum corneum** is the most superficial of the strata comprising the epidermis. It is composed of cells that have undergone a deep transformation as they have lost the nucleus, are no longer able to reproduce themselves and become a simple flat, impermeable covering (aided by keratin, a protein that forms hair and nails too), and so provides an effective barrier to penetration and loss of the body's fluids. These cells are continuously eliminated by exfoliation and are substituted by others that gradually replace them, keeping the protective layer integral and functional.

The dermis is the layer underneath the epidermis and has a compact, off-white appearance. It is a connective tissue of varying thickness, rich in fibres and the origin of blood vessels, nerve endings and glands. Collagen fibres confer the compactness and mechanical resistance to traction.

The subcutaneous (or hypodermis) layer includes connective tissue and adipocytes. It is the deepest layer of the skin containing adipose tissue (forming subcutaneous panniculus adiposus) and therefore has the function of thermally insulating the underlying tissues and protecting them from mechanical stress, in addition to allowing the skin to glide over the fascial planes, causing reversible deformation such as, for example, folds. The panniculus adiposus varies in thickness, as in certain body regions it can be absent while in others it can be abundant (as we shall see later, when covering the living person's superficial

morphology). We should remind the artist to bear this fact in mind when searching for correspondences on the nude body with the skin of the anatomical tables or sculptures, or when trying to identify the superficial myological structure on the model. It is perhaps a banal observation, but the artist who has not studied cadavers or taken part in practices on an anatomical table (or who simply has not considered this topic well) almost always commits basic errors and inconsistencies, not giving adequate consideration to the fact that, in anatomical myology images, the panniculus adiposus and the skin are not represented, as they have been removed, and this makes the volume of the individual areas of the body appear much smaller. However, the figurative artist must understand anatomical structure, but also be free to interpret and recreate aesthetically what he sees; so, with reference to the panniculus adiposus, it can be especially instructive to visualize the transverse sections through the body, not of a cadaver (where there are obvious deformations and sunken areas) but instead using images obtained live via computerized axial tomography or other radiology techniques.

We know that the skin carries out complex, diverse mechanical and chemical functions for the whole body. It represents a barrier against the penetration of micro-organisms, regulates exchanges of liquids and heat with the environment, receives sensory stimuli, chemically transforms solar radiation and reveals emotional states. It is necessary to add some information that may also be useful for the artist. The area of skin in an adult human being of average build is almost 2.5m (2¾yd) square, and weighs (including the subcutaneous layer) approximately 16kg (2st 5lbs/35lbs). Skin is thicker on extension surfaces compared with flexion surfaces, and is thicker in males compared with females, who, on the other hand, have a more developed panniculus adiposus. The thickness of skin can, however, vary from 0.5mm (⅕₀in) to almost 5mm (³⁄₁₆in), as it varies according to an individual's body regions: the skin of the eyelids, the face, the breasts, the anterior surface of the forearm, etc. is thin; the skin on the palm of the hand, the back of the trunk, etc. is medium in thickness; and the soles of the feet have the thickest skin. The skin thickens in areas subjected to heavy friction or continuous mechanical stress. The subcutaneous layer also varies in thickness, according to the amount of adipose tissue deposited in it: therefore, it is significant in the buttock area, abdominal region and mammary region. In other areas, given the greater adhesion of the skin to deeper planes, there is little or no adipose deposit in the subcutaneous layers, therefore thickness is limited. Although a common notion, it is interesting to observe that the adipose deposit takes place in different areas in the male and female bodies and this is in relation to hormonal factors too: thus, in males, the accumulation of fat is concentrated in the abdominal region, in females there is a greater tendency to deposit fat in the thighs, buttocks and breasts. The skin is a membrane that is resistant to mechanical action, with a certain level of elasticity; therefore the deformations caused by traction or pressure gradually regress and the skin returns to its primitive form. As the level of elasticity decreases with age, the skin's ability to revert back to its basic form is extremely slow in elderly people.

The skin is firmly joined to the deep connective planes, especially the superficial fascia and the deep fascia which cover the subcutaneous muscles and organs; however, it can partly slide over them and is easily moved and lifted in folds. The extent of these movements varies according to the regions of the body and is extremely limited in some areas, such as the front of the tibia, the posterior surface of the sacrum, the acromion, the iliac crest, the skullcap, the palms of the hand and the soles of the feet. Some considerations about the tone and surface appearance of the skin will be of particular interest to the artist.

Skin is slightly shiny as a very thin layer of oily material is normally spread over it. At the points where this is abundant (for example, the forehead and the bridge of the nose), light can even be almost totally reflected, causing some lucent points. The cutaneous surface is pitted with tiny irregularities, to form quadrangular or triangular areolae, especially in the areas of the body containing hairs (areolae skin), while on hairless areas of skin like the palm of the hand, there are only slight parallel and longitudinal grooves (skin with epidermal ridges). Folds in the skin are slim depressions, grooves of varying depth and length, almost impossible to reverse, which form in specific body areas due to the repeated mechanical action of muscles and joints. Some are due to the type of movement, but many are found consistently in the same sites in all individuals. In general they are arranged transversally to the direction of muscles fibres and articular movements: on the volar surface of the limbs, fold lines appear (for example on the joints of the fingers, the palm of the hand, the popliteal fossa, the elbow, the wrist) while on the opposite surface, there is a corresponding number of more or less marked folds due to the excess amount of skin, which stretches during flexion.

Ageing of the skin, lastly, causes wrinkles due to the loss of cutaneous elasticity, the reduction of the adipose layer, the action of some muscles and the reduction of muscle volume. Facial wrinkles are typical (forehead wrinkles and expression lines), as are wrinkles on the back of the hand, the elbow and knee joints.

Skin tone depends on several connecting factors. First of all, the amount of pigment (melanin) that the skin contains. Darker skins contains more melanin than lighter skins, but even among Europeans, for instance, there are wide variations in skin tone – between Nordic and Mediterranean populations, for example – due to exposure to solar radiation, climate effects, hereditary factors and constitution. As a general characteristic, however, it must be noted that the same person constantly has cutaneous areas that are more pigmented and therefore darker than others: for example, the nipple and areola, external genital organs, the face, the back of hands. Conversely, the skin on the palms of the hands and the soles of the feet is almost without pigment, and this is the case in all races and individuals. The amount of pigment attributes various hues of colour to skin, from ivory in certain very pale complexions, to pink, golden, deep brown and almost black. If the stratum corneum is highly developed (thicker), light is reflected more and the skin takes on a yellowish colour.

A second factor is the combination of absorption and reflection of light by the skin, which as well as offering a finely irregular surface, is also a turbid medium of refraction that has a considerable influence on the reddish colour of venous and arterial blood vessels: the former, as they are frequently subcutaneous, look like blue cords.

The third, more specific, factor, is the colour of the blood contained in the very dense network of capillaries and the thickness of the skin: in normal conditions of vascularization and in medium-high thickness of skin, the colour is mainly due to pigmentation as the capillaries are not easily seen in these conditions, but where the skin is thin (for example around the border of the lips and on cheekbones, fingertips and the bridge of the nose), the colour of capillaries becomes more emphasised and the skin takes on a rosy appearance, accentuated or reduced depending on the emotional state of the person and the temperature of the external environment.

The study of the skin must be completed by studying its related structures – the organelles within skin cells which control the growth of hairs, sebaceous and sweat glands, and nails. Only a few general notes will be made here, but a small examination of hair and facial hair, nails and also the mammaries – and addressing the body regions in which these organs are located – are of interest for artists from an external morphology standpoint.

Hairs are thin filaments of corneous material, of varying diameter and length. They are flexible, resistant and regenerable; other parts of the hair include the hair follicle, the arrector pili muscle and sebaceous glands. The hair follicle is located in the dermis or hypodermis, and is tilted compared with the skin surface. It is the complex structure that allows hair to originate and grow. The arrector pili muscle is a small bundle of smooth muscle fibres located alongside the follicle in the obtuse angle that this forms with the stratum corneum of the epidermis. Its role is to contract, erecting the hair as a reflex action caused by certain external sensory situations or temperature, allowing the hairs to trap air above the skin as heat insulation. This well-known phenomenon is known as 'goose bumps' or 'goose pimples'. The sebaceous glands excrete an oily material, sebum, to protect the hair and surrounding skin.

In a few areas, the sebaceous glands emerge on the skin surface independently of the vicinity of a hair follicle. Most of the body surface has some hairs, apart from a few areas: the soles of the feet, the palms of the hands, the dorsal surface of the distal phalanx and the internal surface of female genitals. Sometimes hairs are present only in the form of a fine down. The coarsest type of hair, which appears during puberty, is concentrated in certain areas of the body, the size and location of which depend on individual factors in relation to hormonal activity. In females, hair development is concentrated mainly on the scalp, the external genital area and the underarm region. In males, in addition to the above-stated areas, hair also grows more coarsely on the dorsal surface of the forearms and hands, on the chest and sometimes on the back, on the lower limbs and on the perineum. The presence of dense hairs on the face, forming a beard and moustache, is also clearly characteristic of men.

Hair colour is determined by factors of light absorption and reflection, which is related to the amount of pigment: for example, if this is very high, and absorbs a large proportion of light rays, the hair appears to be dark. Dry, clean hair appear to be lighter, due to the effect of microscopic surface irregularities, compared with slightly greasy hair. The appearance of grey or white hair depends on the reduction or absence of pigment, and the presence of microscopic air bubbles among the elements making up the hair shaft. There are many sweat glands spread over all the skin. Although there are different types of sweat gland, they all excrete sweat – a liquid that easily evaporates and is essential for maintaining a constant internal body temperature, even when environmental conditions vary (albeit within certain limits). It is useful for the artist to consider the presence of this thin layer of liquid on the skin, which is also produced under emotional stimuli and during muscular work, as it makes the skin shiny and reflective. Lastly, it must be remembered that a complex network of superficial capillaries and veins originate in the dermis and subcutaneous layer, and there are also several nervous receptors (peripheral sensory organs) working to perceive sensations such as those of pressure, touch, heat and pain.

SUPERFICIAL VEINS

Veins are conduits that collect blood from the peripheral capillary system which then feeds into the artery system, sending the blood to the heart. While the arteries and some veins are located deeply, a dense network of veins of varying size runs under the skin and are subject to many individual and physiological factors, such as emotion or physical effort. Their presence affects the local external forms of the body, sometimes causing cord-like elevations or a blue colour that shows their path under the skin and that is easily visible in individuals with light, thin skin.

• The subcutaneous veins of the head

These are found in the subcutaneous area of the regions where the skin is thin, like the forehead, the temple, the eyelids or the base of the mandible.

• The subcutaneous veins of the neck

They are mostly visible on the anterolateral surface. The external jugular vein begins to appear posteriorly to the corner of the mandible and runs vertically, crossing the sternocleidomastoid muscle, inserting into the supraclavicular fossa. The median vein, which is less visible, runs medially from the suprahyoid region to the suprasternal notch.

• The subcutaneous veins of the chest and abdomen

The superficial venous reticulum of the trunk is not visible on the back but only on the chest and abdomen, and is rarely particularly evident. The thoracoepigastric vein appears on the lateral wall of the chest, just under the costal arch, and travels vertically to the axillary cavity, crossing the ribs. The superficial epigastric vein originates from the veins surrounding the navel and travels vertically towards the groin (to the femoral vein), running over the rectus abdominis muscle sheath. In many thin individuals, or in athletes, it is also easy to see the thin reticula underneath the skin of the abdominal region, the pectoral region, and, especially in women, in the breast and around the nipple, where they are especially visible during lactation.

• The subcutaneous veins of the upper limb

In the upper limb the network of superficial veins is mostly visible on the anterior surface of the arm and forearm and on the back of the hand. These veins, which are subject to wide individual variations of position, can be very prominent when the limb is hanging along the side of the body, while they almost totally disappear when the limb is raised, as the blood flows away by force of gravity. The veins on the back of the hand (dorsal digital and metacarpal) are connected to each other and flow into the two largest veins of the limb. In fact, the cephalic vein originates from the back of the hand at the root of the thumb, laterally to the wrist and, with its lateral border travelling along the anterior surface of the long limb, and then inserts into the sulcus between the deltoid and the pectoral muscles. The basilic vein originates from the back of the hand, continues in an anterior direction and runs along the ulnar border of the forearm, collecting the confluence of several other veins in the anterior surface of the forearm. The next section on the arm runs medially alongside a part of the biceps and then pushes towards the deep system. The cephalic vein and the basilic vein are joined at the elbow crease by the median vein, in an oblique direction.

• The subcutaneous veins of the lower limb

The network of superficial veins is visible in the lower limb in particular on the back of the foot, on the medial and posterior surfaces of the leg, on the knee and on the anteromedial surface of the thigh. The venous reticulum of the back of the foot begins with small dorsal digital veins that flow into a venous arch at the head of the metatarsus, and continues in a medial marginal vein and a lateral marginal vein. Travelling behind the malleoli, they are the origins respectively of the great and small saphenous veins. The great saphenous vein travels along all the medial surface of the limb as far as the groin, collecting several tributaries. The small saphenous vein runs largely along the posterior surface of the leg, from the lateral malleolus to the popliteal fossa, but it is only easily visible in the lower half of the leg, where it also collects several other venous branches. The upper section, on the other hand, travels in the sulcus between the two gastrocnemius muscles and is covered by the related fascia.

SUBCUTANEOUS ADIPOSE TISSUE

Fat (or adipose tissue) is distributed over the whole body in a layer of varying thickness, located in the subcutaneous layer, which lies between the deep layer of the skin (the dermis) and the superficial fibrous fascia that covers the entire muscle mass. Its presence influences the external morphology to different extents and this depends mostly on individual characteristics of age, state of nutrition and health, but also sex and ethnic origin.

The diagrams on page 70 show the main areas, located differently in men and women, where adipose tissue is normally present and evident in the surface shape of the body.

Path of the main subcutaneous surface veins

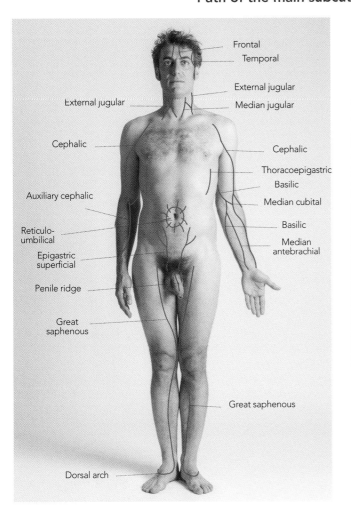

Frontal
Temporal

External jugular
Median jugular

External jugular

Cephalic

Cephalic
Thoracoepigastric
Basilic
Median cubital

Auxiliary cephalic

Basilic

Reticulo-
umbilical
Median
antebrachial

Epigastric
superficial

Penile ridge

Great
saphenous

Great saphenous

Dorsal arch

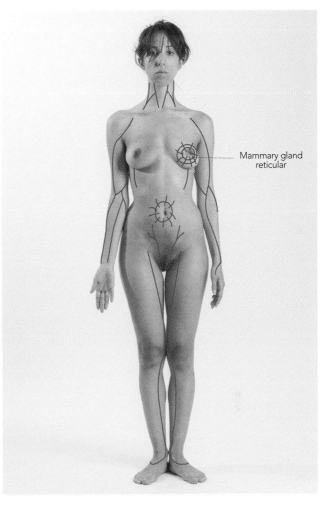

Mammary gland
reticular

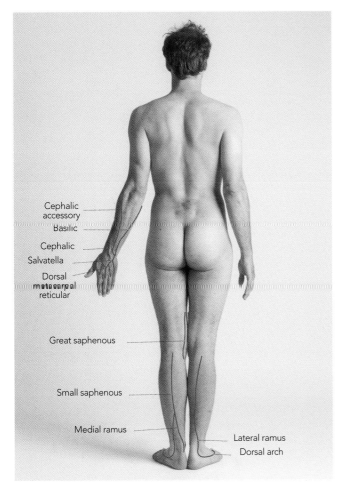

Cephalic
accessory
Basilic
Cephalic
Salvatella
Dorsal
metacarpal
reticular

Great saphenous

Small saphenous

Medial ramus
Lateral ramus
Dorsal arch

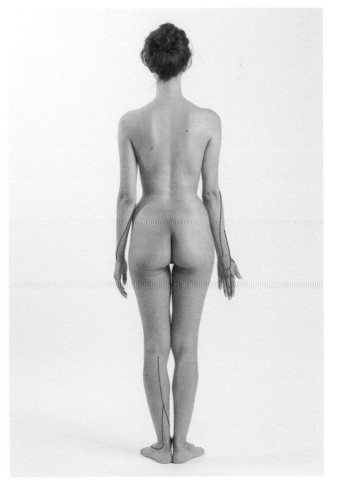

Main sites of subcutaneous adipose tissue

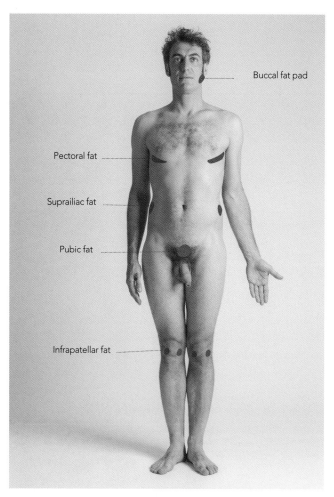

Buccal fat pad

Pectoral fat

Suprailiac fat

Pubic fat

Infrapatellar fat

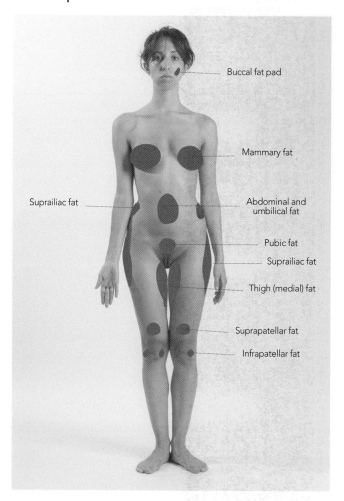

Buccal fat pad

Mammary fat

Suprailiac fat

Abdominal and umbilical fat

Pubic fat

Suprailiac fat

Thigh (medial) fat

Suprapatellar fat

Infrapatellar fat

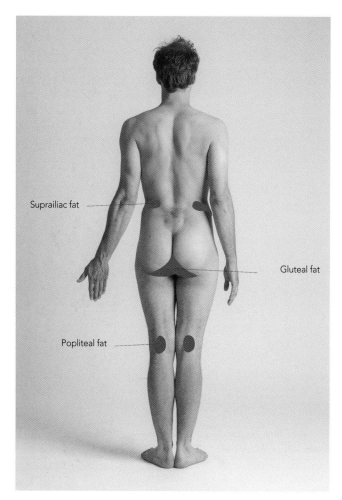

Suprailiac fat

Gluteal fat

Popliteal fat

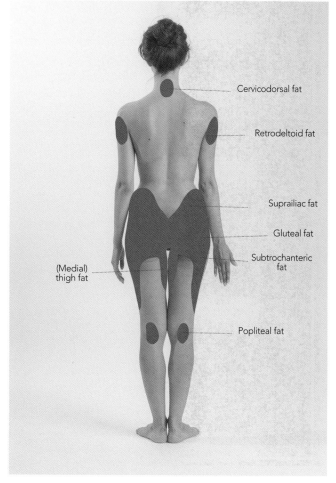

Cervicodorsal fat

Retrodeltoid fat

Suprailiac fat

Gluteal fat

Subtrochanteric fat

(Medial) thigh fat

Popliteal fat

SYSTEMATIC SURFACE ANATOMY OF THE LOCOMOTOR SYSTEM

INTRODUCTION

At the microscopic level of the human body (see page 32), cells can be seen as the most elementary living unit, and tissues are a group of cells with the same structure and functions. Monocellular organisms, protozoa, occupy the lowest levels of the zoological scale, and individually carry out their activities for survival and reproduction in an environment that is favourable to their existence. Multicellular organisms, metazoa, comprise variable numbers of cells that come together in specialized groups for different tasks that are useful for a better, longer-lasting life in the environment.

Therefore, each cell of an organism, in addition to the fundamental activities for its own survival (metabolism, growth, reproduction, etc.), also carries out specialized functions (such as secretion or absorption or contraction, etc.) for the benefit of the entire organism. A process of cell differentiation and aggregation is therefore implemented in specific sites, and this leads to grouping together into cell complexes which differ in function, tissues and paths and which are connected by circulating fluids (blood, lymph).

As it is unlikely for a tissue to be able to carry out its function without the collaboration of others, tissues with different specializations tend to join together, forming organs, which are discrete collections of different tissues designed to carry out the same function (for example the eye, lung, kidney, etc.). In more complex organisms, the organs also group together to carry out a function and thus make up different apparatus (for example, digestive apparatus, respiratory apparatus, locomotor apparatus). In the event that one of four types of tissue (see page 32) dominates in constituting the organs grouped together in a single apparatus, the entire organization is called a system (for example: muscle system, nervous system etc.). In considering the functions carried out, it is possible to separate the apparatus and systems into two groups:

- **Relational functions:** systems which maintain relations with the external environment.
- **Vegetative functions:** systems which control the organism's internal life, to preserve life and to reproduce itself.

The integumentary and endocrine apparatus are located in an intermediate position between these two function groups as they take part in both to different degrees.

Therefore, the following outline is applicable to the human body structure and sums up the overall organization:

- **Relational systems:**
 - nervous (central, peripheral, sensory organs);
 - locomotor: skeletal, muscular, articular.
- **Integumentary system**
- **Endocrinal apparatus** (endocrine, exocrine)
- **Vegetative systems:**
 - nutrition (digestive, respiratory, circulatory, uropoietic);
 - reproduction (male genital, female genital).

The traditional realm of competence of artistic anatomy is limited to the locomotor apparatus and the integumentary system and therefore no other apparatus is discussed here, as their full understanding requires in-depth biological and medical studies. However, this does not mean that the artist need know nothing about them, especially if one considers that the various systems are not independent of one another but have a mutual influence, which contributes to maintaining the integrity of the organism. The artist should research anatomy with the aim of acquiring valid experience and knowledge for recognizing, understanding and interpreting the forms of the human body in the broadest sense. Artists should look at morphology as an explanation of the appearance, and should investigate not just anatomical appearance, as traditionally intended, but also pay attention to the dynamic, physiological and typological aspects of the human body, and perhaps also the pathological ones, as far as they influence external forms and behaviour. The artist, therefore, can only gain cultural enrichment and creative stimulation from the full reading of a good modern book on human anatomy (the current educational trend is aimed at integrating the strictly descriptive and functional notions with ones relating to structural variability, physiology, pathology and so-called superficial anatomy).

Here, though, it may be useful to sum up the sequence of layers that make up the integumentary system in a simple summary, and also list the structures noted on page 66 from the outer surface inwards:

- **Skin:**
 - epidermis (epithelium, basal membrane)
 - dermis (connective tissue, elastic fibres, capillaries, etc.).
- **Subcutaneous layers:**
 - areolar layer (pannicular adiposus): connective tissue, adipose material
 - superficial fascia of the subcutaneous: thin connective fascia, absent on the face: facial expression muscles
 - lamellar layer: connective tissue and adipose material with different structure to that of the areolar layer, veins
 - superfical (deep layer): a series of thin connective tissue which covers and holds the muscular layer.

The locomotor apparatus, which comprises bones, joints and skeletal muscles (see page 42), specifically carries out the functions of movement, but also those of protection, in the axial part, as it borders the large body cavities and the organs contained within.

The study of the skeletal, muscle and joint systems also offers the possibility of investigating biological and environmental mechanisms that determine the growth and development of the organism in various stages of life. This evolution (studied in auxology) entails important morphological changes (both during the stages of growth, and in the ones connected with ageing) which are of considerable interest for the purpose of artistic representation and which, for this reason, deserve a few short details, limited to the locomotor apparatus and the period following birth.

• Growth

The physical growth of a person brings about modifications to stature (the height of the body in an erect position), weight and volume, and normally follows the successive stages that characterize different periods.

- **Neonatal period** (from birth to the first fifteen days of life).
 At birth, a new-born infant is about 50cm (19¾in) long, slightly more in males than females, and weighs about 3.5kg (7lb 11oz). Body proportions are rather different from those of an adult: the head is very large and measures about one quarter of the entire height of the body, the height of the trunk is greater than that of the limbs, the abdomen is larger than the chest, the upper limbs are longer than the lower limbs. The skeleton is still partly cartilaginous.

- **Nipiologic period** (from sixteen days to one year).
 At the end of this period, the body reaches about 10kg (22lb) in weight and about 76cm (30in) in height: both measurements are slightly larger in males than females. The body is round and the size of the head and the trunk stay large, while the limbs are short, rounded and do not reveal any muscle. The chest is cylindrical but tends to widen and continues into the abdomen without any clear passage being defined. At the start of this period, the vertebral column has a single curvature with anterior concavity and only towards the age of one year does the cervical and lumbar curvature begin, following the first attempts to straighten the head and lift the feet.

- **Turgor primus** (from two to three years old).
 This period is characterized by a slow increase in height and a rapid increase in weight, with progressive subcutaneous accumulation of adipose tissue, especially in the buttocks and thighs, but all over the body generally, with a rounding of forms and formation of soft folds between the segments of the limbs.

- **Proceritas prima** (from four to seven years old).
 This stage is characterized by a considerable reduction in fat in favour of an increase in height and the lengthening of the trunk. At the end of the period, the human body's morphology takes on longilineal proportions and aspects, due to a great increase in height. Increase in weight is greater in females than males.

- **Turgor secundus** (from eight to eleven years old).
 This period sees an important increase in weight and an accentuated muscle development. Due to hormonal influence, the morphological separation between the two sexes begins: the timing of the subsequent growth stages are therefore different for males and females, normally occurring earlier for the latter.

- **Proceritas secunda** (from twelve to thirteen years).
 This stage is characterized by an increase in height, predominantly with a development of the limbs (especially the lower ones) compared with the trunk. Bones tend to grow rapidly, while the muscle mass develops more slowly. In the female, the pelvis increases in size, the breasts develop and fat is accumulated in the buttocks, abdomen and thighs.

- **Puberty** (from approximately fourteen to eighteen years old).
 During this period there are a number of biological and psychological changes that differ in the two sexes. In females there is a large increase in both height and weight, the pelvis widens and muscles develop. It can also be noted that the length of the thigh and arm are respectively greater than that of the leg and forearm. In males, the testicles grow and the penis lengthens and the Adam's apple appears, as does facial hair. There is an increase in muscle mass, especially in the upper part of the trunk. Bone lengthening is greatest in the leg and in the forearm compared with that of the thigh and the arm. In both sexes, hair appears in the pubic region, with specific distribution patterns.

- **Post-puberty period** (up to about the age of twenty).
 In this period, a person's height development is completed, reaching almost final skeletal sizes and the normal ratios of proportion between trunk and lower limbs (see page 35). The morphological characteristics in both males and females are consolidated: the difference in height between the two sexes is due to the different length of the lower limbs, which are generally longer in males than females.

73

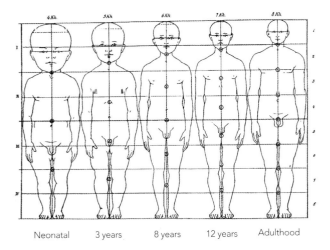

Diagram of somatic growth by Carl Stratz, 1904.

Neonatal 3 years 8 years 12 years Adulthood

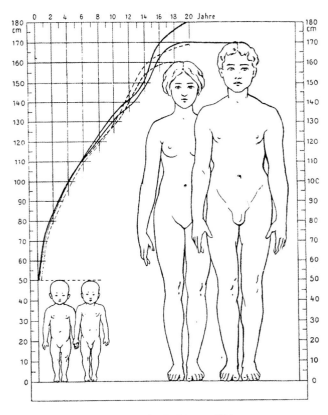

Growth in a man and a woman by Carl Stratz, 1904.

- **Maturity** (up to about forty years old)
 In this period, the body shape matures, with an increase in weight (partly due to deposits of adipose tissue), and the measurements of the trunk, especially the antero-posterior diameter of the chest, increase. Height is stable.

The observation of human growth stages has allowed some general considerations (auxological laws) to be formed that help us to understand the process. For example: a) growth in height is extremely rapid in the months preceding the onset of puberty, while the increase in weight tends to be more considerable in subsequent months; b) growth takes place mainly in bones prior to puberty and mainly in muscle after puberty; c) the lengthening and enlarging stages of bones alternate and do not take place at the same time in the various body areas; d) the growth stages of the trunk alternate with those of growth in the limbs.

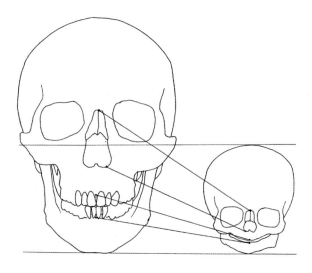

Developments of the proportions in the facial block, from birth to adulthood.

- **Ageing**

The physical ageing process begins to show itself in the pre-senile age (between fifty and seventy years old) and continues gradually until the end of life, connected with the natural decline of the organism. External manifestations are easy to observe and commonly known. Here we will list some typical characteristics that are of interest for the purpose of effective artistic representation:

- Stature decreases after forty years of age. Up to the age of eighty, there can be a total loss of almost 6cm (2¼in). This process applies to both sexes and mainly concerns the trunk, as it is due to the thinning of the intervertebral disks. Consequently the curves of the vertebral column are accentuated, including lateral ones, and the shoulders tend to stoop forwards.

- Bones become thinner and more fragile due to the loss of calcium and other minerals. The mandible is reduced in size, and if occurring together with the loss of teeth, brings about the alteration of proportional ratios in the face.

- Joints become less mobile after the tissues that form them begin to degenerate.

- Muscle mass is lost due to the reduction in the percentage of water contained in the entire organism, while fat deposits are accentuated and localized. Hair thins out and turns grey throughout the whole body, however some bristly, irregular hairs may appear in the nostrils and ears.

- Skin loses its elasticity and wrinkles, with several irreversible grooves and folds in the skin. Pigmentation may appear irregular and uneven, with melanin marks especially on the face and the backs of the hands. Subcutaneous veins increase and become more noticeable, especially in the lower limbs and on the back of the hands.

74

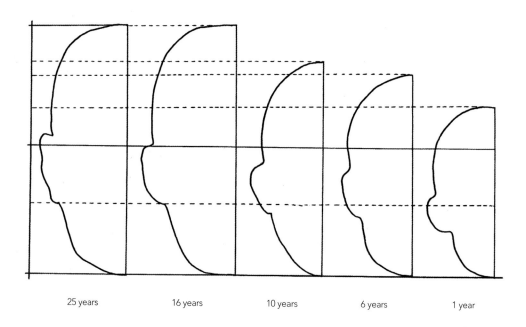

25 years 16 years 10 years 6 years 1 year

Comparison of the development of head proportions and dimensions.

THE HEAD

NOTES ON EXTERNAL MORPHOLOGY

The head is the upper part of the human body, located above the vertebral column. It has an overall rounded shape and comprises two parts: the cranium (in the narrowest sense) – the highest portion, ovoid in shape, lengthened in an antero-posterior direction – and the face – the anterior portion underneath the cranium, also ovoid, but lengthened in a vertical direction. The external morphological section differs from the osteological one (see page 77) because the forehead is also considered in the face and the border is traced by the anterior and lateral hair attachment lines, as far as the auricles. The skull is mostly covered by strong skin, the scalp, with hair implanted into it, while the skin is bare, smooth and thin on the frontal region. The face is bordered at the top by the roots of hair, at the bottom by the chin and at the sides by the outer ears. On the face, where bones are covered by several subcutaneous muscles and contain some of the main sensory organs, we therefore note: the forehead; the eyebrows, partly corresponding to the supraorbital arches; the eyes, contained in two orbital cavities; the nose, a pyramid-shaped, long protuberance on the face's median axis; lips that are the upper and lower borders of the oral cavity opening; and the outer ears, placed symmetrically at the sides of the head, which are cartilaginous and concave in shape.

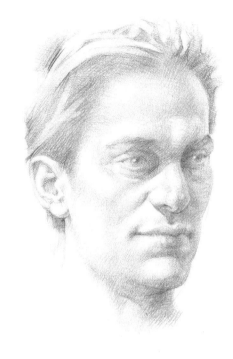

External morphological profile of a male head.

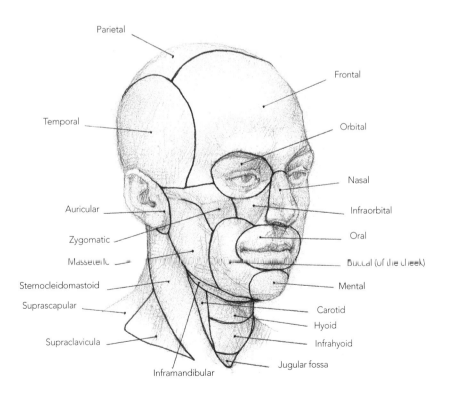

Parietal

Frontal

Temporal

Orbital

Nasal

Auricular

Infraorbital

Zygomatic

Oral

Masseteric

Buccal (of the cheek)

Sternocleidomastoid

Mental

Suprascapular

Carotid

Hyoid

Supraclavicula

Infrahyoid

Jugular fossa

Inframandibular

Boundaries of the main regions of the head.

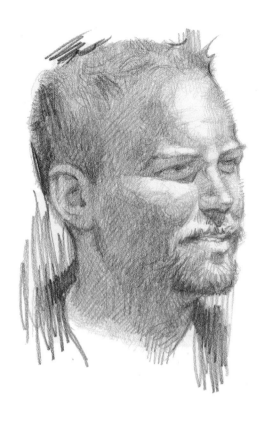

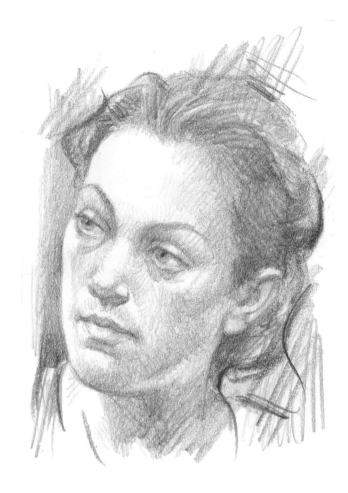

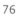

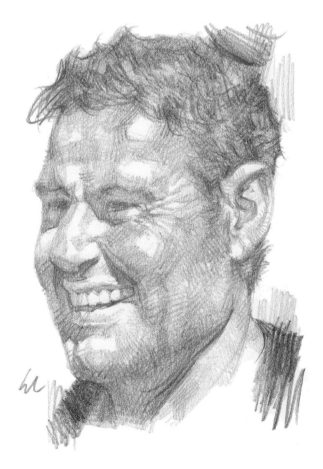

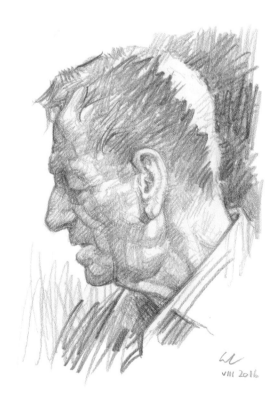

VIII 2016

OSTEOLOGY

• General characteristics

The skull (intended in the broadest sense) is the skeletal structure that supports the head, the upper part of the trunk, joined to the vertebral column (of which it is the extremely dilated continuation and of which the fundamental construction modes are visible) via the first vertebra, the atlas, with which it moves jointly when the head moves. The cranium comprises several bones. Most are firmly joined to each other, and form the border of the two parts into which we can divide the skull: the neurocranium and the splanchnocranium.

The braincase (or neurocranium, or cranium as we call it) is formed by flat bones arranged to house an ovoid-shaped space that is used to enclose and protect the brain. The extrinsic muscles of the head are also inserted onto the cranium, that is, the ones that, originating from the trunk and from the neck, move the entire head in its various directions.

The facial block (splanchnocranium, or face) is placed anteriorly to the braincase and is formed by complex-shaped bones that border several cavities designed to house the sensory organs of sight, hearing, taste, smell and also the initial sections of the respiratory and digestive systems. The intrinsic muscles of the skull are applied on the facial block, separated into the muscles of expression, mainly with cutaneous insertions, and into masticatory muscles, with insertion on the mandible, the only mobile bone in the skeleton of the head. The distinction between the two groups, neurocranium and splanchnocranium, is due to the different function and the different embryological origin of the bones and the organs that they are designed to house and protect.

On examining the skull externally, the border is a line that passes on the superior border of the orbital sockets and extends as far as the external auditory meatus. Before studying each bone, it is useful to proceed by generally examining the full skull externally, observing the illustrations to learn the correlations of shape and function, the morphological characteristics and the name and reciprocal ratios of the bones.

The processes of bone development in the skull are particularly complex and protracted over time. This is because volumetric growth takes place at different speeds, in correlation with the development of the content and function of each of the two parts of the cranium in childhood. This means that in the early months of life, the cranium grows more rapidly than the facial block, while later and up to about eighteen years of age, the order is reversed, with the facial block growing faster than the cranium. It can be seen that in new-born infants and up to just over one year of age, the intersections of the cranium contain fontanelles – areas of dense fibrous connective tissue. The residues of these between the bones eventually form sutures – joints that can allow a slight ulterior growth of the braincase. When growth is complete, connective tissue is replaced by osseous tissue in adulthood (a process called synostosis), reaching complete fusion of the bones in the cranium vault in senescence.

The cranial bones, the shape and size of which differ greatly between the two sexes and in various populations and ages, contribute decisively to the external appearance of the head, characterizing its physiognomic features, even though it sits beneath layers of skin and muscle. For the artist, the bone structure of the head is of great interest, especially in light of the fact that it weighs almost 5kg (11lb) in adults and has a considerable influence on the entire body in both static and

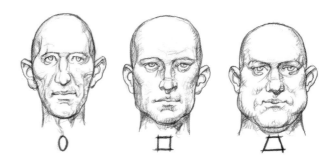

Some conformations (oval, square, trapezoid) of the head and of the face: these are determined by the bone structure and the varying thickness of the soft tissue that covers it.

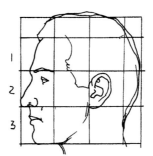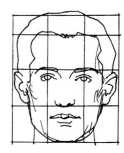

Simplified grid diagram, useful for evaluating proportions of an adult male head.

77

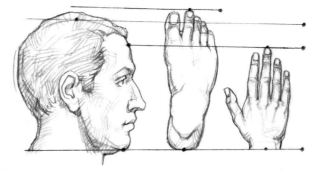

Comparison between the height of the head and the length of the hand and foot in the same adult.

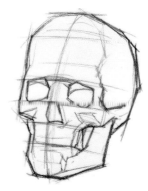

Geometrized structure of the skull.

1 The structure of the skull is very complicated, and some areas of bone, important from a functional and medical perspective for the organs they contain, will be described only summarily here. This is because they have no influence on the superficial anatomy of the head and are therefore of no relevance for artistic representation. For this reason, we will only briefly touch upon the bones that have direct relevance for external morphology.

dynamic states. The skull can be observed from various points of view; the ones codified for anatomical descriptions are said to be 'normas': norma lateralis, if the skull is seen from the side, norma frontalis if seen from the front, basalis, verticalis (or zenithalis), or occipitalis respectively if the cranium is seen from below, above or the rear. To carry out comparable external findings and position the individual bones spatially, the convention is to inspect the skull in an erect position, so that the inferior margins of the eye sockets and the superior margins of the external auditory meatus are on the same horizontal plane, known as the Frankfurt plane (see the illustration below and the bottom skull opposite).

On the other hand, the shape of the internal face of the cranium is only visible after removing the brain, separating the vault from the base of the neurocranium using a saw or scalpel, making a cut that corresponds to the transversal plane which passes just above the orbital arches and the occipital protuberance.

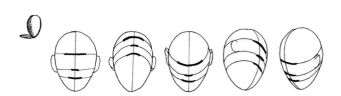

Perspectival effects of the volume of the head: the lines corresponding to the levels of the eyebrows, nose and lips indicate the relative perspective ratios in the various positions and projections of the head.

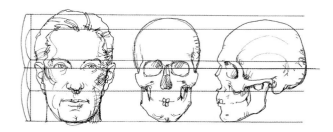

A horizontal line placed at the level of the eyeballs divides the height of the head into two roughly equal halves.

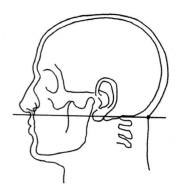

Diagram of the ratios between the bone surface and the thicknesses that cover it. The horizontal line is parallel to the Frankfurt Plane which, by convention, is tangential to the lowest point of the eye socket and the external auditory meatus.

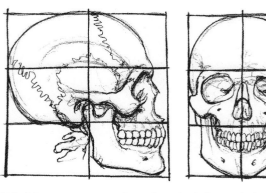

Grid of the average proportions of a male skull as a whole, in right-hand lateral and frontal projections.

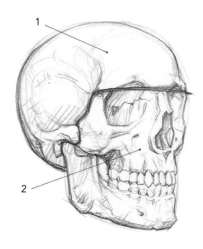

Border line between the neurocranium (braincase) (1) and splanchnocranium (facial block) (2).

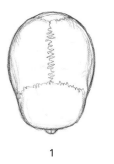
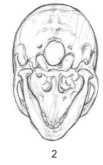

Appearance of upper surface (norma verticalis) (1) and lower surface (norma basalis) (2) of the cranium. The diameter of maximum width of the cranium is located close to the posterior pole and joins the most protruding parts (eminences) of the parietal bones.

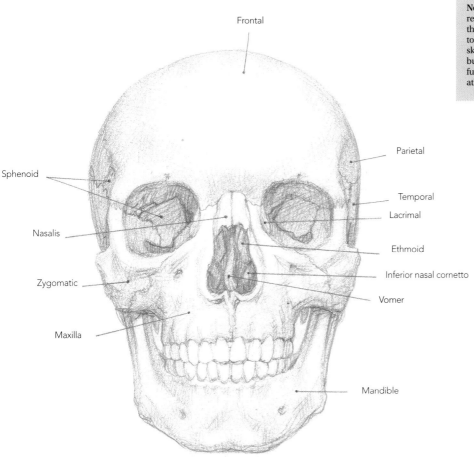

Frontal

Sphenoid

Nasalis

Zygomatic

Maxilla

Parietal

Temporal

Lacrimal

Ethmoid

Inferior nasal cornetto

Vomer

Mandible

79

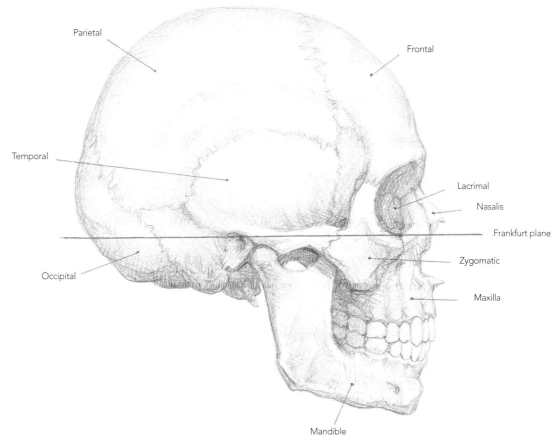

Parietal

Frontal

Temporal

Lacrimal

Nasalis

Frankfurt plane

Zygomatic

Occipital

Maxilla

Mandible

External shape of the cranium and overall arrangement of the individual bones of the head, seen in norma frontalis and in right-hand norma lateralis.

The bones of the braincase

The braincase (or skull) is made up of the union of seven bones (some classifications, however, also include the ethmoid bone, which is placed in the facial block by others), three of which are unpaired (occipital, sphenoid, frontal) and two of which are paired (temporal and parietal).

- **Occipital (os occipitalis):** This is located posteriorly and inferiorly and comprises a basilar part, or body, that is a small cubic formation from which the two lateral masses start (condyles) that surround the occipital foramen; it is a large squama, wide and concave, with characteristic sulci and crests (superior and inferior nuchal lines).

- **Sphenoid (os sphenoidale):** This butterfly-shaped bone is positioned deep down at the base of the braincase, towards the front of the skull, although the edges of the wings can be seen on the external cranium surface. It is unpaired and median in size, comprising a body and two pairs of wings – one small and one large – and two pairs of vertical processes (pterygoid processes). The body has a superior depression, the sella turcica, upon which the pituitary gland sits.

- **Frontal (os frontal):** This is the bone that forms the anterior portion of the cranium vault; the largest part is the squama frontalis, which is externally convex, with two slight symmetrical protuberances, the frontal eminences, below, separated by a small flat area (glabella). There are two curved elevations, the supraciliary arches, beyond which the orbital faces of the bones spread, and between them there is the nasal face, located on the contour of the ethmoidal notch. Laterally, the squama frontalis fades into two symmetrical areas known as temporal faces.

- **Temporal (os temporal):** This is the most complex bone of the cranium, both in shape and in embryologic formation. It is paired and located in a lateroinferior position to the skull, surrounded by the frontal, parietal, occipital and sphenoid bones. The external configuration of the exocranial face is formed laterally by a smooth semi-circular lamina (squama) from which the zygomatic process originates at the bottom. Below this, there is the external auditory meatus and the conoid elevation of the mastoid process. The external face of the temporal bone continues below with very irregular elevations and some depressions (mandibular fossa, mastoid notch, etc.), and the styloid process emerges from one of them, through the stylomastoid foramen.

- **Parietal (os parietale):** This is a large square bone which occupies a large portion of the lateral wall of the braincase. The external surface is convex and smooth, but has grooves close to the temporal suture with two shallow arched elevations: the temporosuperior line and the temporoinferior line, the area where the temporal muscle originates.

Frontal bone

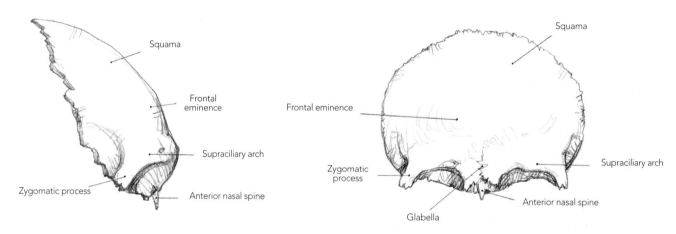

Parietal bone (right)

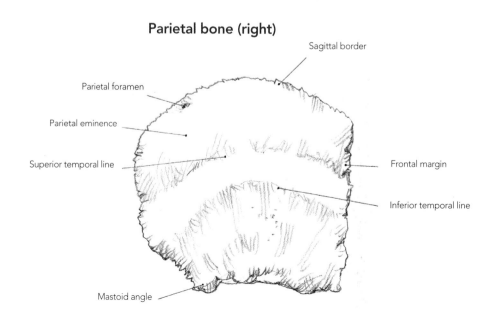

Occipital bone (external surface)

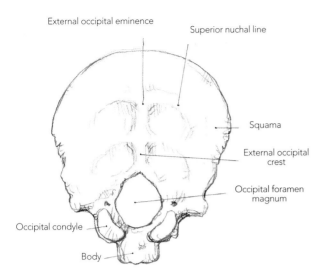

External occipital eminence

Superior nuchal line

Squama

External occipital crest

Occipital foramen magnum

Occipital condyle

Body

Temporal bone (right)

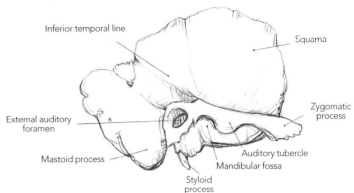

Inferior temporal line

Squama

External auditory foramen

Zygomatic process

Mastoid process

Auditory tubercle

Mandibular fossa

Styloid process

- ## The bones of the facial block

The facial block largely comprises paired, symmetrical bones and some unpaired bones, grouped into two regions, nasal and maxillary, to which the mandible can be added.

Delicate bones that are almost totally uninvolved (apart from the two nasal bones) in the external modelling of the face belong to the nasal region. They are: the ethmoid, lacrimal, vomer, nasal concha and nasal bone, which defines, together with the contralateral, the shapes of the upper section of the external nose and, in part, its profile. The nose cartilage must be added to these bones, which can be separated into: septum cartilage, which divides the nasal fossae; lateral, paired cartilage, which forms the lateral walls of the nasal wing and in the upper part joins together on the bridge with the septum cartilage; and the paired alar cartilage in the lower part of the nose, around the two nostrils and joined at the tip of the nose.

The following bones belong to the maxillary region:

- **Palatine (os palatinum)**. This bone is located very deep in the facial block and helps form the nasal fossae, with its laminar portion sitting horizontally.

- **Maxilla**. This is a large, paired bone bordering several other bones in the cranium, and the two joined bones form the support for teeth in the upper dental arch. The body of the curved anterior surface extends laterally. There is a depression in the orbital area, the canine fossa, where the orbital foramen appears. The orbital surface is positioned superiorly and obliquely; and the posterior surface is joined internally with the palatine. Lastly, the medial surface faces the nasal cavity.

Some processes emerge from the body: the frontal process, positioned anteriorly at the side of the nasal fossa; the palatine process, an internal lamina which joins with the contralateral lamina on the medial plane of symmetry contributes to forming the palate vault and, anteriorly, the nasal spine extends as an appendix, placed at the base of the pyriform aperture; the semi-circular alveolar process, which supports the teeth inserted into the dental alveoli; and the zygomatic process, an accentuated lateral elevation which slots into the zygomatic bone.

Maxillary bone (right)

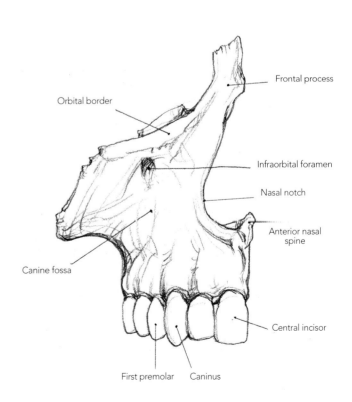

Orbital border

Frontal process

Infraorbital foramen

Nasal notch

Anterior nasal spine

Canine fossa

Central incisor

First premolar

Caninus

- **Zygomatic bone (os zygomatlcum).** This is an important bone for the external morphology as it has both individual and ancestral distinguishing characteristics. The main part is a pyramid shape and some processes start here: the temporal process, directed posteriorly towards the temporal bone, contributes to forming the zygomatic arch; the zygomatic process which connects the zygomatic bone to the maxilla – the frontal process – heads upwards and is placed laterally around the orbital cavity.

- **Mandible (mandibula).** This is also known as the lower jaw bone and it is a large unpaired bone, formed from the fusion of two symmetrical parts: the meeting point is the mandibular symphysis and the relative protuberance (chin). The structure comprises a body which forms the main laminar part (curved, almost like a parabola or horseshoe), the internal surface of which has some sulci and elevations, while the external surface is much more even - and two laminar expansions, the mandibular rami. These end by dividing into two coronoid processes, the anterior one thick and rounded, and the condyloid, the posterior one, which is cylinder-shaped and ends with an articular condyle with the temporal bone. The alveoli for the teeth in the lower arch are carved out of the upper border of the mandible.

- Below the mandible, in the neck, we find the thin, unpaired, median, arched **hyoid bone**, which contributes to forming the floor of the oral cavity and is the point of origin of some muscles (infra- and supra-hyoid) that work the mandible.

Mandible

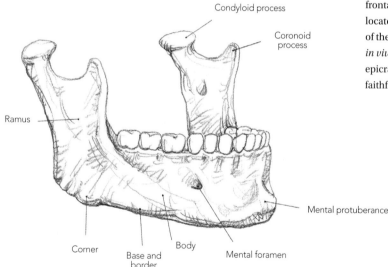

Condyloid process

Coronoid process

Ramus

Mental protuberance

Corner

Base and border

Body

Mental foramen

External morphology of the head's skeleton

Considered as a whole, the skeleton of the head is an ovoid (directed in an antero-posterior direction), with a perimeter that can vary according to the individual, and with the widened end at the rear; in the front we find the set of facial bones which are overall smaller than the braincase, and of an approximate pyramid shape with the apex at the bottom and forwards. The average height of the full skull, including the mandible, is 18–22cm (7–8½in) in an adult, measured as the vertical distance between the top of the vault (bregma) and the lower extremity of the mandible (tip of the chin).

The bone surface is generally rather smooth, but appears rough in several areas to favour the insertion of muscles, especially the masticatory muscles; in other areas it has irregularities such as depressions, protuberances, foramina and canals corresponding to the vessels and nerve that run through it.

The position of the various bone elements in the facial block form the boundaries of cavities and spaces of various sizes, often of an extremely complex shape, that are made to house the sensory organs and the delicate formations of the upper digestive tract and airways.

On an initial observation, we also note the arrangement of the sutures and the temporomandibular joint. As we have mentioned, an external examination of the skull is carried out by observing the norms from certain precise points of view, required for a more uniform description and easier comparison.

- The **upper surface (norma verticalis)** shows the vault which extends from the supraorbital arches to the external occipital protuberance and comprises a wide part of the frontal bone and the parietal bones and a portion of the occipital bone.
 These bones are joined by fixed joints, sutures, with an extremely jagged path: the sagittal suture is positioned on the median line and joins the two parietal bones, the coronal suture joins the frontal bone to the parietal bones and the lambdoid suture is located between the occipital bone and the posterior borders of the parietal bones. The top of the vault is also mostly visible *in vivo*, especially in bald people, as it is covered only by the epicranial aponeurosis and the skin, the thickness of which faithfully follows the convex shape of the skull.

Dental arches in normal occlusion

Frontal projection

Left lateral projection

Zygomatic bone (right)

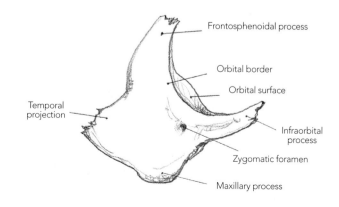

Frontosphenoidal process

Orbital border

Orbital surface

Temporal projection

Infraorbital process

Zygomatic foramen

Maxillary process

- The **inferior surface (norma basalis)** comes from the external surface of the cranium base and extends from the incisor teeth in the maxillary bone to the superior nuchal lines of the occipital bone: it can be examined better if the mandible is removed, the characteristics of which are usually considered separately. The inferior surface is very irregular, complex surface, being mostly formed by the bones of the facial block, especially in the anterior portion. The occipital bone dominates the posterior portion. It borders the large occipital foramen and the temporal mastoid processes. The inferior surface of the skull is totally hidden in a living human by the muscle formations in the neck and the floor of the oral cavity.

- The **posterior surface (norma occipitalis)** has an irregular square profile, where the straight base joins the two mastoid processes and the other rounded sides are formed by the two parietal bones. The largest surface is that of the occipital bone, where the external occipital protuberance can be seen, also *in vivo*. The superior and inferior nuchal lines can also be detected; some neck muscles are inserted here.

- The **lateral surface (norma lateralis)** extends from the boundary of the vault to the corner of the mandible and shows a very complex, irregular region due to the presence of the mastoid process, the external auditory opening, fossae and processes in both the braincase and the facial block. The temporal fossa and the intramuscular fossa can be found among these shapes, due to the characteristics of the various bone surfaces.

 The *temporal fossa* is wide and open (while *in vivo* it is occupied by the temporal muscle and other fasciae formations) and is bordered at the top by the arched border of the temporal squama and at the bottom by the superior border of the zygomatic arch. The width of this fossa can be quite pronounced in some populations, especially in those of Asian ancestry.

 The *intramuscular fossa* is covered by the mandibular ramus and is an irregular space that links to the temporal fossa via the opening between the zygomatic arch and the lateral wall of the skull, at the sphenoid bone.

- The **zygomatic arch** is formed by the temporal process of the zygomatic bone and the zygomatic process of the temporal bone that join to form a bone bridge detached from the rest of the skull and which is easily visible between the cheek and the temple. The external auditory meatus opens into the temporal fossa at the end between the zygomatic process and mastoid process.

- The **anterior surface (norma frontalis)** extends from the supraorbital arches of the frontal bone to the base of the mandible. It therefore includes the face, in the common use of the word, but excludes the forehead, whose shape is determined by the frontal bone squama. On the median plane, the supraorbital arches have a small elevation which is more accentuated in the male skull than in the female one, which fades into a limited flat area known as the glabella.

 The orbital cavities open below the supraorbital arches. The cavity walls are formed from several bones. Each cavity is an approximate pyramid shape with the base in an anterior direction and the apex directed in depth, medially, reaching the aperture of the optic canal. The anterior aperture of the eye socket is rather square in shape, with slightly curved borders. The following can be distinguished: the superior supraorbital border, formed by the frontal bone; the medial border meeting with the root of the nose, slightly elevated; the inferior border, oblique, directed laterally and rather sharp, formed by the maxillary bone and the zygomatic bone; the lateral border, which is clearly elevated, formed by the zygomatic bone and completed by the zygomatic process of the frontal bone. The eye socket, designed to contain the eyeball and its related structures, has a depth of about 4cm (1½in), width of about 4cm (1½in) and a height of about 3.5cm (1⅜in). Also, the medial border is forward compared to the lateral border, therefore the plane adjoining the orbital aperture is rather oblique in a lateral direction.

 Below the glabella and between the orbital cavities, we find the nasal bones, which, together with the maxilla bones, surround the anterior, pyriform nasal aperture, which is wider at the bottom. Arranged on two arches, upper and lower, in an adult, there are thirty-two teeth, set into the alveoli, the cavities in the maxilla and the mandible. The crowns of the teeth are different shapes, and are therefore grouped into incisors, canines, premolars and molars. The teeth are divided into an equal number in both arches, with sixteen teeth on the maxillary bones and sixteen on the mandible bone, arranged symmetrically on the two antimeres starting from the median line: in order, two incisors, one canine, two premolars and three molars. When the mouth is closed and the molars are touching, the upper dental arch does not fully match the lower arch, as the upper incisors are in front of and partly cover the lower ones.

• Influence of bones on external morphology

The skeleton of the head largely determines the superficial shape and facial features. Hair hides a large part of the skull but, especially with a shaved head, the vault appears, just covered by the extremely adherent membranous fasciae and by the scalp. The mastoid process can clearly be noted behind the outer ear. The forehead also reproduces the bone structure exactly, only lightly covered by the frontal muscle. The orbital socket, which houses the eyeballs with the muscles and attached formations, is clearly evident, especially in the upper and lateral borders. It is useful to notice that the supraciliary arch and the eyebrow overlap perfectly only in the middle section as, towards the root of the nose, the eyebrow originates a little lower than the arch, while laterally it runs above it, as the arch moves directly diagonally downwards.

The nasal bones and cartilage form the ridge of the nose and the nostrils. *In vivo* they are always subcutaneous and the zygomatic bone and the zygomatic arch are easy to see, the latter especially in the

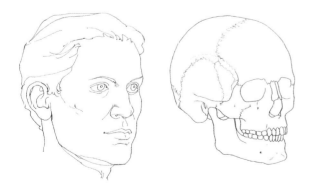

The influence of bone structure on the external morphology of the head.

inferior border as the superior one is blurred by the effect of the insertion of the temporal muscle fascia. Lastly, the outer auditory hole indicates precisely the position of the auricle and is a fixed reference point for some important measurements and proportional evaluations. The mandible always clearly shows its arched shape and the prominence and angle of the chin.

• Anthropological observations

The skeleton of the head in relation to age

From birth to old age, the skeleton of the head changes considerably in both its external shape and in the proportions between the various components. At birth, the skull is spherical in shape and it is larger than the facial block, where the bones of the nasal and maxillary regions are still under-developed. These characteristics remain throughout childhood, accentuating the protuberances of the frontal and parietal eminences due to the greater development of the brain and therefore of the neurocranium.

From puberty to adulthood, the facial block consolidates and develops particularly in the mandible and in the nasal and maxillary areas, while the cranium reaches its ovoid shape: the entire cephalic skeleton reaches its full and final shape. In old age, the main changes are due to bone atrophy: the mandible wears thin, the vault becomes less thick, natural teeth sink into the alveoli or fall out and cranial sutures are almost completely obliterated.

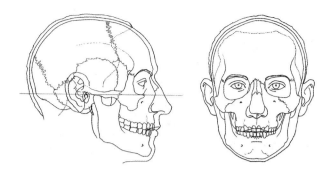

Transparent diagrams of the ratios between the bone structure and soft tissue, superimposed in right-hand lateral projection and in frontal projection.

Comparison between the profile and volume of the head of a child (about two years of age) and an adult.

84

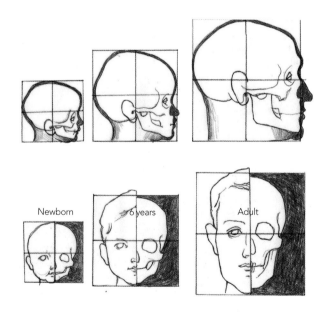

Newborn 6 years Adult

Proportion and thickness ratios between bone structure and external forms (created by soft tissues). In newborn babies, the maximum length (fronto-occipital) of the head is approximately 11cm (4¼in), the maximum width (biparietal diameter) is approximately 9cm (3½in).

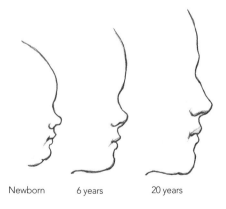

Newborn 6 years 20 years

Facial profile at different ages.

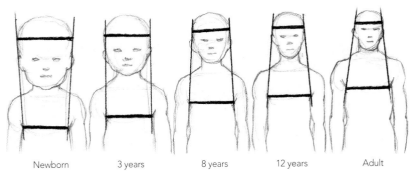

Diameter of the head in relation to the diameter of the thorax, during and on completion of growth.

| Newborn | 3 years | 8 years | 12 years | Adult |

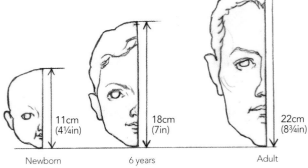

Newborn 11cm (4¼in) 6 years 18cm (7in) Adult 22cm (8¾in)

Average height of the head at different ages.

The forms of the skull and craniometric observations

Anatomy and anthropology have identified a set of reference and measurement points on the skull (craniometric points) that allow a comparison between the various normal shapes and the evaluation of deviations from the norm in the pathological field. The main measurements concern the two skeletal sections of the head; for the cranium, we evaluate: the antero-posterior diameter (the distance between the glabella and the occipital tubercle) which on average is 17cm (6¾in) for males and 16cm (6¼in) for women; the transversal diameter (the greatest distance between the two parietal bone protuberances) that corresponds to 13cm (5⅛in) for both men and women; the vertical diameter, (the distance between the top of the vault and the occipital foramen) corresponding to 13cm (5⅛in) in males and 12cm (4¾in) in females.

For the facial block, the vertical diameter (the distance between the nasofrontal joint and the chin), evaluated at 11–12cm (4¼–4¾in), and the transversal diameter (the maximum distance between the two zygomatic arches) evaluated at 11–14cm (4¼–5½in) for both sexes.

Some indices can be calculated from these measurements, including the cephalic index, that is, for the cranium, the ratio between the transversal diameter multiplied by 100 and the antero-posterior diameter. Up to 75, the index defines dolichocephalic skulls (long skulls), between 75 and 80 the index defines mesocephalic skulls or normocephalic skulls (skulls of medium length), and the index above 80 defines brachycephalic skulls (short skulls).

A useful measurement evaluates the facial angle (Camper's angle), which defines the degree to which the facial block juts out, comparing two planes, one passing through the external auditory holes and the nasal spine, the other tangential to the glabella and the upper incisors. A low index corresponds to the acute angle and defines a marked facial projection, known as prognathism.

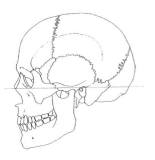

Left-hand lateral profile of the total skull, oriented to the conventional plane chosen for anthropological observations (craniometric), the Frankfurt plane.

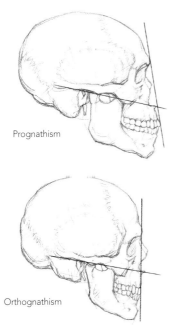

Prognathism

Orthognathism

Breadth of the facial angle (Camper angle).

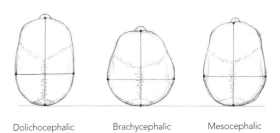

Dolichocephalic Brachycephalic Mesocephalic

Appearance of some normal skull shapes, evaluated in the norma verticalis.

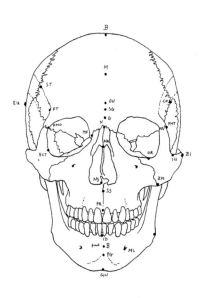

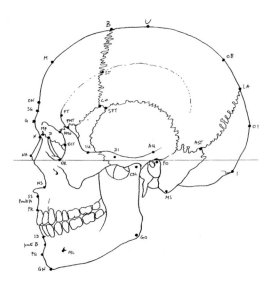

Craniometric points. Physical anthropology has drawn up extremely analytical techniques for evaluating and comparing the skeletal structure, especially that of the skull, and has identified several reference points from which to deduce measurements and indexes. The cephalometric points mostly correspond to the craniometric points, evaluated not on the 'dry' skull but on the outer surface of the head, defined by the thickness of soft tissues.

• Sex and ancestry in the skeleton of the head

The differential characteristics between the skeleton of the fully developed adult male and female head are not always so clear as to allow a certain distinction without appropriate comparisons and measurements. However, the typical distinctive characteristics of the female skull compared with the male skull are the following: a smaller cranium, less convex in the vault, with thinner walls, a more vertical forehead, more accentuated frontal eminences, more honed mastoid processes and narrower zygomatic arches. The female block is smaller and proportionally wider than the male.

In terms of ancestry, it is necessary to consider the fact that modern humans today have a variety of extremely complex, mixed physical characteristics, therefore it is advisable to provide only a few summarial indications about the cranial morphology of some historical groups. Skulls of African ancestry often have dolichocephalic skulls, with wide pyriform apertures and marked prognathism. Those of Asian origin tend to have wide, round, brachycephalic skulls, with wide, flat faces, elevated cheeks and wide noses. North Europeans have mesocephalic skulls, long facial blocks and straight noses; central Europeans have brachycephalic skulls and wide faces; Mediterraneans have long skulls, narrow, oval facial blocks and straight, narrow noses.

86

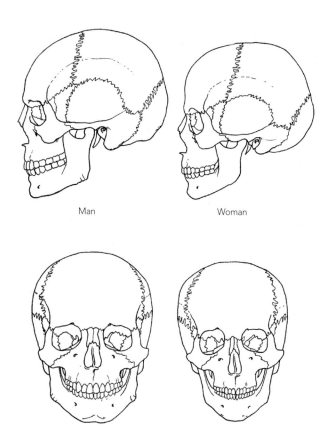

Comparison between an adult male skull and an adult female skull, in lateral and frontal position: some of the typical differences in size and proportion are evident.

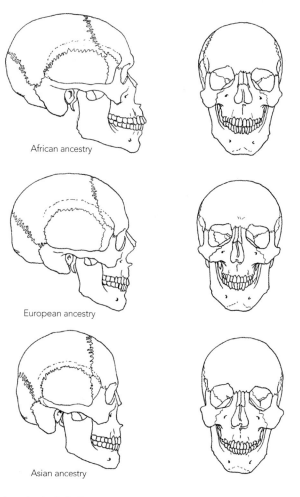

Adult male skulls belonging to three fundamental human groups, determined by forensic anthrolopology.

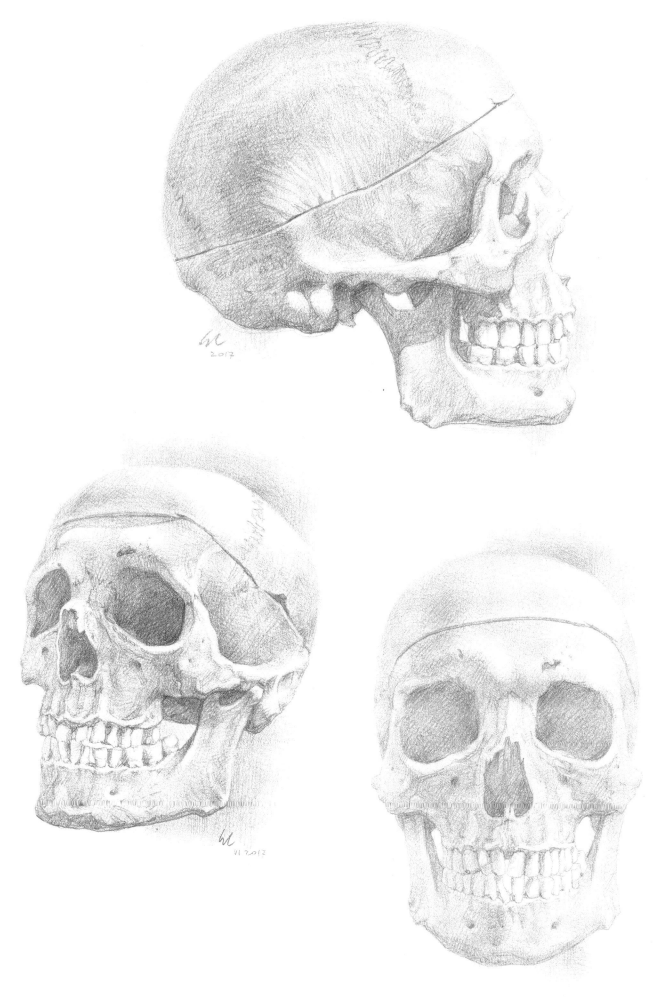

ARTHROLOGY

The bones of the braincase and facial block are mostly joined by sutures, which means the possibility of movement is almost zero; movement is also difficult because the jagged borders fit together with minimal amounts of connective tissue. The only mobile joint is that of the mandible. There are therefore several sutures on the cranium: the coronal suture, which joins the posterior border of the frontal bone to the two parietal bones; the sagittal suture, which is situated on the median plane of symmetry and joins the two parietal bones; the lambdoid suture, which joins the posterior border of the two parietal walls with the superior borders of the occipital bone; the temporoparietal suture which joins the external surfaces of the lower border of the parietal walls with the temporal squama. Other visible sutures are: the temporo-sphenoidal suture, the sphenofrontal suture, the occipitomastoid suture and the temporozygomatic suture. There are several sutures between the bones of the facial block and these are difficult to see in some cases. The joint of the mandible

with the temporal bone (temporomandibular joint) works via its two condyles situated in the articular part of the temporal fossae. It is a condyloid mobile joint (a rounded bone that is received by a concave cavity), and as the articular surfaces do not fully correspond, there is a fibrocartilaginous disc between them to aid a seamless attachment.

The articular heads are kept together by a loose, thin fibrous capsule, the borders of which surround the articular heads. The joint is strengthened by several ligaments: temporomandibular, sphenomandibular and stylomandibular.

The articular movements are rather wide and allow the oral cavity to open by lowering the mandible. The mandible can be raised and lowered, but also moved slightly forwards and backwards, and to a lesser extent, sideways, which is functionally essential for chewing. Lastly, it must be remembered that the base of the skull joins with the atlas, the first vertebra. The atlas is an articulation of the trunk and vertebral column in particular.

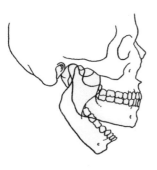

Diagram of the movement of the temporomandibular joint, in occlusion and at the maximum degree of opening of the mouth. The mandibular condyle is, in this case, displaced slightly forwards.

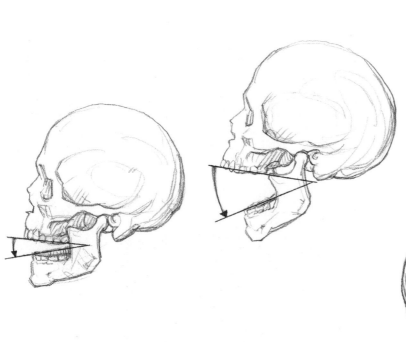

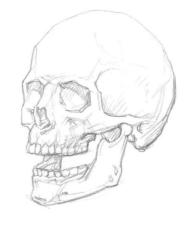

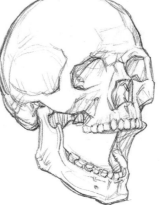

Diagrams of the articular mechanism of the mandible, in various degrees of opening and in various projections.

MYOLOGY

Several muscle groups are arranged on the skull, which differ in origin and function. They are separated into: the muscle group attached to the eye, the muscle group pertaining to the upper digestive tract and, above all, the skeletal muscles – the only ones belonging to the locomotor apparatus. These are divided into two groups: the masticatory or mandibular muscles (masseter, temporal, pterygoid), which determine the movements of the mandible by acting on the temporomandibular joint; and the mimic muscles (expression or cutaneous muscles of expression), which pertain to facial expression, mainly arranged on the facial block and only partly on the braincase. Almost all of these have cutaneous insertions and act on the skin of the eyelids, nose, lips, cheeks and outer ear. Some muscles of the neck, back and spine are also inserted on the skeleton of the head (these muscles will be treated separately and are described in more detail later). The analytical study of the head's myological structure is rather complex, due to both the large number of muscles and the difficulty of preparation and identification that the anatomist sometimes encounters, especially for muscles inserted into the skin, which make it difficult (and sometimes discordant) to classify them. For the analytical description of the head muscles, please refer to the section below. Moreover, in the various human populations, several differentiating characteristics in the facial muscles have been noted – either in shape, thickness, number or arrangement. For example, in many human populations of African and Asian ancestry, some mimic muscles are absent or reduced, or are grouped into thick bundles and are not differentiated as much as the ones in European populations. While facial expressions tend to be basically similar in all populations, the muscle component can partly explain variations of intensity in the subtler expressions.

• Auxiliary organs of the masticatory muscles

These are:

- **Temporal fascia:** a laminar membrane that, originating from the upper temporal line of the skull and inserting into the zygomatic arch, covers the temporal muscle and closes the temporal fossa

- **Parotideomasseteric fascia:** this covers the parotid gland and the masseter

- **Buccal fat pad:** a mass of adipose tissue located partly in the temporal fossa and partly extended along the anterior border of the masseter.

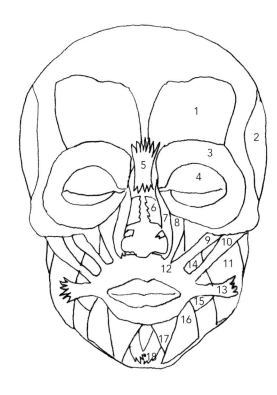

Position of the head muscles seen in frontal projection.
1 - Epicranial (frontal part)
2 - Temporalis
3 - Orbicularis oculi (eyeball part)
4 - Orbicularis oculi (eyelid part)
5 - Pyramidalis
6 - Nasalis
7 - Levator labii superioris (corner part)
8 - Levator labii superioris (infraorbital part)
9 - Zygomaticus minor
10 - Zygomaticus major
11 - Masseter
12 - Orbicularis oris
13 - Risorius
14 - Caninus
15 - Buccinator
16 - Depressor anguli oris
17 - Depressor labii superioris
18 - Mentalis

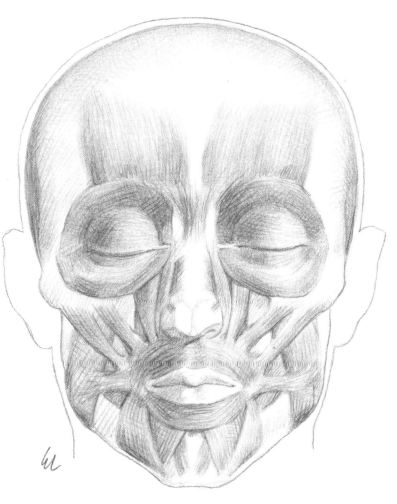

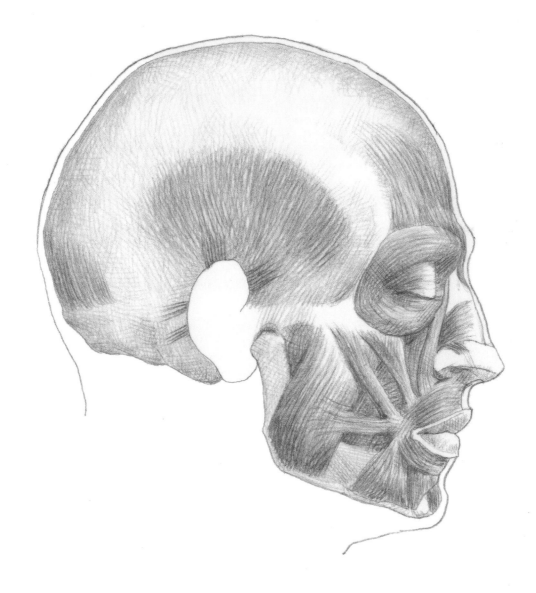

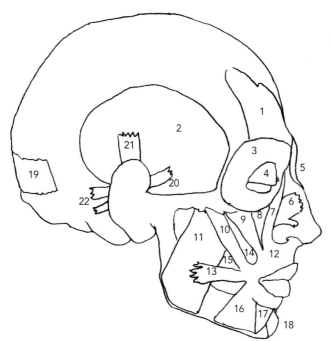

Arrangement of the muscles of the head seen in right-hand lateral projection:
1 - *Epicranial (frontal part)*
2 - *Temporalis*
3 - *Orbicularis oculi (eyeball part)*
4 - *Orbicularis oculi (eyelid part)*
5 - *Pyramidalis*
6 - *Nasalis*
7 - *Levator labii superioris (corner part)*
8 - *Levator labii superioris (infraorbital part)*
9 - *Zygomaticus minor*
10 - *Zygomaticus major*
11 - *Masseter*
12 - *Orbicularis oris*
13 - *Risorius*
14 - *Caninus*
15 - *Buccinator*
16 - *Depressor anguli oris*
17 - *Depressor labii superioris*
18 - *Mentalis*
19 - *Epicranial (occipital part)*
20 - *Anterior auricular*
21 - *Superior auricular*
22 - *Posterior auricular*

HEAD MUSCLES OF INTEREST FOR ARTISTIC REPRESENTATION

EPICRANIUS MUSCLE (Occipitofrontalis)

Form, structure, relations. The epicranial muscle is positioned on the vault of the skull and comprises two square muscular bellies that are long and thin (one anterior: the frontal muscle, one posterior: the occipital muscle), joined by a thick, large fibrous lamina, the galea capitis or epicranial aponeurosis. The temporoparietal muscle is added to these components. This is a thin triangular muscle lamina that covers the temporal muscle. It originates laterally from the galea capitis and goes as far as the auricular cartilage, frequently merging with the superior auricular muscle. Both the frontal muscle and the occipital muscle are paired, bilateral, but sometimes the bellies of the two frontal antimeres in the area just above the glabella are joined by small bands that join the lower parts of the medial borders.

Origin. Frontal muscle: anterior, frontal border of the epicranial aponeurosis.
Occipital muscle: lateral section of the superior nuchal line (occipital bone) and mastoid process (temporal bone).

Insertion. Frontal muscle: deep face of the skin corresponding to the entire eyebrow and the nose root.
Occipital muscle: posterior border of the epicranial aponeurosis.

Action. Frontal muscle: upward traction of the forehead skin and the root of the nose; lifting of the eyebrows.
Occipital muscle: traction and posterior movement of the epicranial aponeurosis. The joint action of the two muscles fixes the galea capitis or, if contracted one at a time, moves the scalp slightly forward and backward.

Surface anatomy. Contraction of the frontal muscle (usually at the same time in the two antimeres, but also individually in only one of them) causes the formation of some transversal wrinkles on the forehead. If the two other medial portions of each frontal muscle are contracted at the same time (in synergy with the corrugator supercilii muscle), the central part of the forehead is lifted in folds and only the heads of the eyebrows lift, while if the more lateral portions of the two frontal muscles are also contracted, the wrinkles extend to the temples and the whole eyebrow arch is raised. This causes various facial expressions: surprise, terror, interest, attention, suffering, amazement and a questioning or upwards look. The occipital muscle is normally covered by hair and even in bald individuals, contracting it only causes slight transversal wrinkles.

AURICULAR MUSCLES (Auriculares)

Form, structure, relations. The auricular muscles are slim bands that run from the temporal bone in the section that corresponds to the medial surface of the auricle. There are three muscles: anterior, superior and posterior, with the fibres running in different directions.
The superior auricular muscle is formed by a small bundle that runs vertically from origin to insertion, while the anterior portion and the posterior auricular muscle, which are just as thin, run almost horizontally, one anteriorly and the other posteriorly, ending in the ear. The superior auricular muscle is sometimes a portion of the temporoparietal muscle (see epicranial muscle). The auricular muscles, which are more developed in many animals, are morphologically irrelevant in humans and almost insignificant from a functional point of view.

Origin. Anterosuperior auricular: galea capitis; temporal and parotid fasciae. Posterior auricular: base of the temporal bone mastoid process (at the insertion tendon of the sternocleidomastoid muscle).

Insertion. Anterosuperior auricular: skin of the auricle cartilaginous region in the outer ear, in the helix.
Posterior auricular: skin of the cartilaginous region in the outer ear, in the concha.

Action. Weak traction on the auricle, with slight movement forwards, upwards, backwards.

Surface anatomy. Irrelevant.

INCISIVUS LABII INFERIORIS MUSCLE

Form, structure, relations. The incisivus labii inferioris muscle is very small and thin, and thought to be influenced by the obicularis oris muscle. It borders medially with the mentalis muscle (deep chin muscle) and runs along the inferior border of the orbicularis oris muscle.
Origin. Mandible, at the alveolar ridge of the canine tooth.
Insertion. Skin at the corner of the vermillion border, merging with other muscles: caninus, orbicularis oris, depressor angularis oris.
Action. (See orbicularis oris muscle, opposite).
Surface anatomy. (See orbicularis oris muscle, opposite).

DEPRESSOR ANGULI ORIS MUSCLE (Triangularis menti/depressor anguli oris)

Form, structure, relations. The triangular-shaped depressor anguli oris muscle has a wide base originating in the mandible and narrows as it rises to the corner of the mouth, thus giving it its triangular shape. It is separated into two parts: a more superficial part (also known as the risorius muscle that, generally, is considered to be a separate muscle) that adheres to the parotideomasseteric fascia; and a deeper muscle (also known as the transversus menti muscle) where the fasciae extend to the tubercle and symphysis of the chin.
The medial border partly covers the depressor labii inferioris muscle; the initial section continues with the platysma and the insertion section with the orbicularis oris muscle (and possibly with the risorius muscle.
Origin. Oblique line of the base of the mandible.
Insertion. Skin of the corner of the mouth.
Action. Depression and lateral traction of the corner of the mouth; curving downwards of the labial commissure. Contributes to lending expressions of sadness to the face.
Surface anatomy. The muscle appears as a slight subcutaneous elevation stretched diagonally between the corner of the mouth and the base of the mandible. Expressions: disdain, scorn, disgust, perplexity, etc., or even a forced smile (in antagonism with the zygomaticus major muscle).

DEPRESSOR LABII INFERIORIS MUSCLE (Depressor labii inferioris/quadratus labii inferioris/quadratus menti)

Form, structure, relations. The depressor labii inferioris muscle is square in shape and its fibres head diagonally from origin to insertion, where they merge with those of the contralateral muscle and the orbicularis oris muscle. It may have extended connections with nearby muscles and is partly covered by the triangularis menti muscle, continuing into the platysma at the base of the mandible.
Origin. Oblique line of the mandible base, in the section between the mental foramen and the mandibular symphysis of the chin.
Insertion. Skin below the lower lip.
Action. Traction downwards of lower lip, which is moved slightly laterally and projected forwards to show the internal mucosa lining.
Surface anatomy. The visible effect is the downward curve of the medial portion of the lower lip, when talking and in expressions of irony and disgust. The mentolabial sulcus, below the lip, is also clearly visible during these actions.

LEVATOR LABII SUPERIORIS MUSCLE (Levator labii superioris alaeque nasi)

Form, structure, relations. The levator labii superioris muscle is square and can be separated, at the origin, into three portions, two of which are frequently distinguished and classified as autonomous muscles: the zygomaticus minor muscle and the levator labii superioris muscle.

The three portions join at the insertion point, also extending on to the orbicularis oris. In a few cases, the muscle may be totally absent, or the nasal bundle may be missing (angular part).

Origin. Angular portion (nasal): lateral surface of the upper maxilla frontal process.

Infraorbital (or suborbital) portion: lower orbital border of the upper maxilla, above the infraorbital foramen.

Zygomatic portion (or zygomaticus minor muscle): inferomedial margin of the zygomatic bone (medially or above the origin of the zygomaticus major muscle).

Insertion. Greater alar cartilage and skin of nasal ala; skin of the lateral section of the upper lip.

Action. Lateral portion (zygomatic) draws the upper lip upwards and sideways until the incisors are revealed; the medial bundle dilates the nostril.

The simultaneous contraction of the three portions forming the muscle lift the upper lip and move the nasolabial sulcus upwards.

Surface anatomy. The muscle acts in expressions of sadness, disdain, disgust, disapproval, and so on. It can be contracted alone or at the same time as the contralateral muscle, causing a slight inside-out movement of the upper lip as well as raising it, an upward movement and the deepening of the nasolabial sulcus, the formation of transversal grooves in the skin on the sides and ridge of nose (in synergical connection with the depressor supercilii and the procerus muscle), and dilation and upper traction of the nostrils.

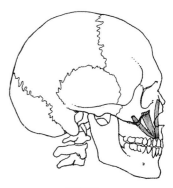

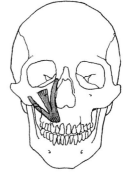

INCISIVUS LABII SUPERIORIS MUSCLE

Form, structure, relations. The levator labii superioris muscle comprises thin bands directed laterally along the upper lip. It is considered to be a peripheral portion of the orbicularis oris muscle and, at the corner of the lips it merges with the buccinator, triangularis and caninus muscle bundles.

Origin. Alveolar process of the maxilla, at the lateral incisor.

Insertion. Skin of the upper lip, up to the labial angle.

Action. (See orbicularis oris muscle).

Surface anatomy. (See orbicularis oris muscle).

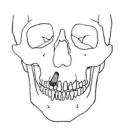

ORBICULARIS ORIS MUSCLE (Orbicularis oris)

Form, structure, relations. The orbicularis oris muscle is made up of a number of muscular fibres arranged in a ring formation around the lip area and extends upwards to the base of the nose and downwards to the chin, at the mentolabial sulcus. The muscle may receive additional muscular fibres from the mandibular symphysis. Due to its complex structure, we can identify: a deep, internal portion, closer to the lips and mostly formed by fibres coming from the buccinator, arranged parallel to the lips; a subcutaneous peripheral portion, closer to the surface, which is formed by fibres coming from the caninus, triangularis, elevator labii superioris, zygomatic and depressor labii inferioris muscles. The more marginal fibres can be recognized as partly separate muscles: the depressor labii inferioris muscle and the levator labii superioris muscle. Fibres from several muscles, converging at the corner of the lips, form two nodular condensations (modioli) which are easily visible and palpable. They move on contraction of the muscles inserted in that position and create the ring shape.

Origin. Several muscular bundles coming from muscles inserted into the lips (buccinator, triangularis, caninus).

Insertion. Deep layers of the lips' skin and mucosa.

Action. Closing, puckering, protrusion of the lips.

Surface anatomy. Weak muscle contraction closes and brings the lips near to the teeth, making the skin of the areas above and below the lips jut out slightly; the strong contraction, on the other hand, brings the corners of the mouth closer medially and projects the lips, causing a number of vertical sulci around the lip area. The muscle acts when a person drinks, kisses, sucks, speaks and also collaborates in a large number of expressions: aggressiveness, doubt, determination and so on.

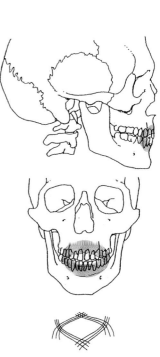

NASALIS MUSCLE (Nasalis compressor naris – transversal part, dilatator naris – alar part)

Form, structure, relations. The nasalis muscle is a muscular lamina that originates from the maxilla, fans out and heads upwards towards the side of the nose. There are two parts to the muscle: firstly the transversal part (also known as the compressor naris), the fibres of which branch off on the side of the nose and are inserted onto the tendinous aponeurosis of the ridge of the nose until it joins with the contralateral muscle. Secondly the alar part (also known as the dilator naris) which is not visible; it is short and quite wide at the point of origin.

The transverse part is deep compared with the levator labii superioris and the nasal ala and may continue into the procerus muscle; the alar part is partly covered by the most peripheral fibres of the orbicularis oris muscle.

Origin. Transverse part: maxilla, to the side of the base of the nasal aperture (piriform aperture). Alar part, below and lateral to the base of the nasal aperture at the lateral incisor fossa.

Insertion. Transverse part: aponeurosis of the nasal ridge.

Alar part: skin of the outer area of the nostril and nasal cartilage.

Action. Transverse part: narrowing of nostril, especially of the nasal cavity in the passage between nasal vestibule and nasal fossa.

Alar part: dilation of the nostril with lateral movement of the nasal ala.

Surface anatomy. Contraction of the transverse part (which usually occurs together with that of the contralateral muscle) flattens the skin on the nasal ridge and also on the sides; contraction of the alar part flares the nostrils and moves their lateral border slightly upwards, making the opening wider and the median septum more visible. Overall, the nasalis muscle takes part in the action of breathing in, when sniffing, and in some expressions of emotion (desire, greed, surprise, etc.).

DEPRESSOR SEPTI NASI MUSCLE (Depressor septi)

Form, structure, relations. The depressor septi muscle is a small lamina made of fibres that originate from the maxilla and head diagonally upwards up to the nasal septum. It is often considered to be a part of the alar portion of the nasalis muscle as the two muscles work together in dilating the nostrils during deep intakes of breath.

Origin. Maxilla, in the section above the medial incisor.

Insertion. Skin and posterior part of the nasal septum cartilage.

Action. Downward traction of the mobile part of the nasal septum and also slightly of the nasal ala.

Surface anatomy. Contraction of the depressor septi muscle lowers the septum, making the nose seem longer vertically and the tip thinner. The nostril openings seem wider due to the downward and slightly lateral traction of their posterior border.

ZYGOMATICUS MAJOR MUSCLE (Zygomaticus maior)

Form, structure, relations. The zygomaticus major muscle is shaped like a rather long, thin ribbon. It originates with a short tendon and is directed obliquely forward and downwards to the corner of the lips. In some cases, it may originate from the masseter fascia or from the buccinator fascia, rather than from the zygomatic bone; it may be covered, together with adjacent muscles, by a thin layer of muscle (malaris muscle) coming from the orbicularis oculis muscle (see opposite).

At the start it runs above the masseter muscle, then crosses the depressor anguli oris muscle and branches onto the caninus, orbicularis oris and triangularis muscles.

Origin. Temporal process of the zygomatic bone, at the zygomatic-temporal suture.

Insertion. Skin at the corner of the mouth.

Action. Upper and lateral traction of the corner of the mouth, stretching the labial commissure and causing a slight deviation of the lips. It works with the zygomaticus minor muscle, a branch of the levator labii superioris muscle.

Surface anatomy. The effects of the contraction of the zygomaticus major muscles can be seen in the happy expressions of laughing and smiling in synergy with other expression muscles (risorius, zygomaticus minor, orbicularis oculis, etc.): the nasolabial sulcus becomes deeper and forms the relative skin fold; the lip area skin stretches; slight wrinkles are formed at the corners of the mouth and at the base of the lower eyelid; a slight depression is sometimes formed in the cheek, due to the movement of subcutaneous adipose tissue.

CANINUS MUSCLE (Levator anguli oris/orbicularis oris, pars marginalis)

Form, structure, relations. The caninus muscle is rather small and its fibres travel downwards and sideways to the point where they attach to the skin of the lips, weaving with the fibres of the zygomaticus major, triangularis and orbicularis oris muscles. It is situated at depth compared with other facial muscles and the size is sometimes inversely linked to those of the zygomaticus major muscle.
Origin. Canine fossa of the maxilla, below the infraorbital foramen.
Insertion. Skin at the corner of the mouth and labial commissure.
Action. Upwards traction of upper lip, lifting the commissure and revealing the canine tooth.
Surface anatomy. It contributes to forming the nasolabial sulcus. Contraction produces a slight sideways and upwards movement of the corner of the mouth (amenable smile) stretching the lips and the skin on the chin.

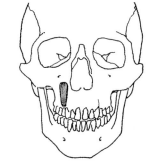

RISORIUS MUSCLE (Risorius)

Form, structure, relations. The risorius muscle is formed by a bundle of superficial fibres which are wider at the origin and narrower at the insertion point, with an almost horizontal direction from the cheek to the lips. It is frequently considered to be a portion of the triangularis muscle. It varies greatly in shape and size; it can originate from the zygomatic arch or extend to the platysma and it can even be totally absent.
Origin. Parotideomasseteric fascia.
Insertion. Skin of the corner of the mouth and the labial commissure.
Action. Lateral and posterior traction of the labial commissure.
Surface anatomy. Its acts in expressions of smiling, irony, sarcasm (together with the zygomaticus major muscle), but also in speech movements. In expressive movements, the lips are pulled sideways and grow thinner, the lower portion of the nasolabial sulcus is drawn posteriorly and appears to be more evident.

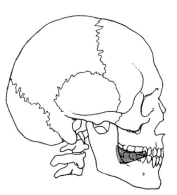

ORBICULARIS OCULI MUSCLE (Orbicularis oculi/orbicularis palpebrarum)

Form, structure, relations. The orbicularis oculi muscle is ring-shaped, wide and flat. It surrounds the eye socket and covers the eyeball, forming the muscular lamina of the eyelids. It comprises three rather large parts and is arranged to form the peripheral portion of the muscular ring; the thin eyelid part is more proximal to the palpebral fissure; the lacrimal part (also known as Horner's muscle) is located medially, close to the lacrimal bone. Some bundles in the orbital part may be inserted superiorly in the skin and subcutaneous of the supraciliary area which forms the depressor supercilii muscle. Other bundles which extend from the temporal fascia to the nasolabial sulcus skin cover the zygomaticus major, zygomaticus minor and levator labii superioris muscles with a thin layer, forming the malaris muscle. The orbicularis oculis muscle contracts both voluntarily and as a reflex during facial expressions, in reaction to external mechanical, light or sound stimulae, in winking and in the rhythmic and rapid palpebral contraction to humidify the ocular surface. In some cases, the orbital muscles on the two sides can join on the median line.
Origin. Orbital portion: nasal part of the frontal bone; frontal process of the maxilla, medial palpebral ligament.
Palpebral portion: medial palpebral ligament.
Lacrimal portion: lacrimal fascia; the upper part of the ridge and lateral surface of the lacrimal bone.
Insertion. The muscular fibres are arranged in a ring around the circumference of the eye socket joining up and inserting into the skin and subcutaneous layer of the eyebrow, on the palpebral ligament and on the tarsi (fibrous connective tissue laminae) of the eyelids.

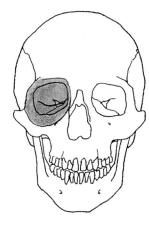

Action. Convergence and closing of eyelids: the orbital portion closes them tightly, drawing the skin of the forehead, temple and cheeks towards the nose and causing heavy creasing around the eyelids; the palpebral portion closes the eyelids gently, as happens during sleep or when winking: in these cases the depressor bundles lower the upper eyelid (in antagonism with levator palpebrae superioris muscle) and the levator bundles slightly raise the lower eyelid. The lacrimal portion aids the secretion, distribution and the drainage of lacrimal fluid (tears).

Surface anatomy. Contraction of the muscle forms folds and grooves of various degrees in relation to the intensity of the expression that the muscle is taking part in (smile, laughter, attention, pain, concentration, hostility, etc.). Contraction of the muscle is usually bilateral, but can also be on one side only as, for example, in the action of winking. The levator palpebrae superioris muscle (stretching from the inferior surface of the small wing of the sphenoid to the skin and tarsus of the upper eyelid), acting together with the frontal muscle and in antagonism with some orbicular fibres, makes the edges of the lids separate widely, typical of the wide-eyed expression (terror, stupor, etc.).

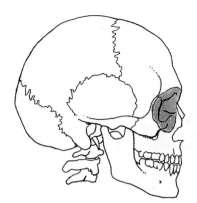

BUCCINATOR MUSCLE (Buccinator)

Form, structure, relations. The buccinator is a laminar muscle inserted into the cheek, between the mouth cavity mucosa and the skin. It is quite large and quadrangular in shape. The muscular fibres form three bundles directed at converging anteriorly: the upper one travels downwards, the lower one travels upwards and the central one is arranged almost horizontally. The most peripheral upper and lower fibres, on the other hand, do not converge at the corner of the mouth, but extend along the skin of the lips. The muscle may have connections with the surrounding muscles or with the pharynx muscles, forming the buccopharyngeal muscle group. The muscle origin is hidden by the mandibular ramus, from which it is separated by a fat pad; it is in contact with the internal pterygoid muscle, the zygomaticus major, the risorius, the caninus and the triangularis muscle.

Origin. External surface of the alveolar processes of the maxilla and the mandible, corresponding with the molar teeth; pterygomandibular ligament (or raphe).

Insertion. Skin and mucosa at the corner of the labial commissure.

Action. Contraction, mostly bilateral, of the buccinator muscles draws the corners of the labial commissure posteriorly (but not laterally) and also compresses the cheeks against the teeth when they are distended by the presence of food or air in the buccal cavity, as when chewing and blowing.

Surface anatomy. Contraction of the muscle causes the corner of the mouth to retract, with a slight stretching of the lips and a slight upwards curve of the lateral portions of the commissure. From the corners of the mouth, below the labial sulcus, there may be small folds directed laterally and downwards. It also contributes to different facial expressions: pleasure, disapproval, laughter, crying, etc.

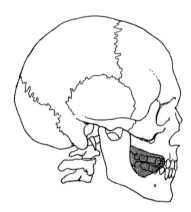

PROCERUS MUSCLE (Procerus)

Form, structure, relations. The procerus muscle is a thin, flat, triangular-shaped muscle, the fibres of which are directed almost vertically from the root of the nose to the forehead (glabella). The muscle is paired, but frequently the two muscles are joined on the median line in a single formation, influence by the frontalis muscle. Laterally, it partly covers the corrugator supercilii muscle and inferiorly it continues with the transverse part of the nasalis muscle.

Origin. Fascia that covers the lower portion of the nasal bone and upper part of the lateral cartilage of the nose.

Insertion. Skin between the two arches of the eyebrows and skin of the central inferior portion of the forehead.

Action. Downwards traction of the skin in the glabella area and upwards traction of the skin of the nose root.

Surface anatomy. Contraction of the muscle produces a transverse sulcus in the skin at the nose root and, when acting together with the corrugator supercilii and depressor supercilii muscles, contributes to expressions of attention, threat, anger, pain, etc.

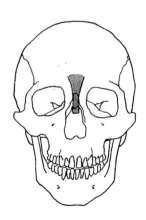

CORRUGATOR SUPERCILII MUSCLE (Corrugator supercilii)

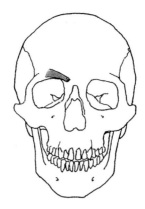

Form, structure, relations. The corrugator supercilii muscle is flat, thin, long and pyramidal in shape. Its fibres are directed diagonally upwards, from the point of origin to the point of insertion, running almost parallel to the eyebrow. They are mostly deeper than the frontal muscle and the orbicularis oculis muscles, except in the most medial section, where they are inserted in the skin. In some cases, the muscle may merge with the orbital muscle and can be considered dependent on it.

Origin. Frontal bone (medial extremity of the supraorbital ridge and glabella).

Insertion. Skin of the supraorbital section corresponding to the eyebrow.

Action. Medial and slightly downwards movement of the medial section (head) of the eyebrow.

Surface anatomy. Contracting the muscle, usually bilaterally, causes some vertical creases to appear in the skin between the two eyebrows, in the area corresponding to the glabella (the typical effect of knitting your eyebrows): this action is designed as a reflex of protection for the eyes from excessive light stimuli, but also appears in many expressions (attention, concentration, suffering, interest, concern, apprehension, pain, etc.).

MENTALIS MUSCLE (Mentalis)

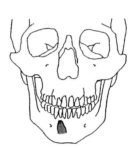

Form, structure, relations. The mentalis muscle (or chin muscle) is a small, almost conoid, slightly flat muscle that is directly vertically below the mandible to the chin. The muscular fibres also branch off to the skin of the lower lip, intertwining with those of the orbicularis oris and buccinator muscles. The muscle almost always contracts together with the corresponding contralateral one, as they have many joining fibres. In the event that the two muscles are clearly separated, the skin adheres to the bone surface, causing a characteristic depressions (*peau d'orange* or golf ball dimpling).

Origin. Mandible, at the medial incisor fossa.

Insertion. Skin of the chin.

Action. Lifting and profusion of the lower lip with wrinkling of the skin of the chin.

Surface anatomy. Contraction of the muscle raises the lower lip, produces a consequent downward curve of the rima oris and the formation of several small grooves or depressions on the skin of the chin and an accentuation of the mentolabial sulcus. It acts during drinking and in expressions of doubt, contempt, disgust, etc.

PTERYGOIDEUS MEDIALIS MUSCLE (Pterygoideus medialis)

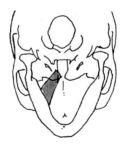

Form, structure, relations. The pterygoideus medialis muscle is flat, quadrangular in shape, directed diagonally downwards and laterally with bundles that insert on the ramus and the corner of the mandible via a short, strong lamina. The muscle may have close connections with the nearby muscles; the lateral surface adheres to the medial surface of the ramus of the mandible, from which it is separated, only in the upper section, from the pterygoideus lateralis muscle. The medial surface is connected with the pharynx and nearby intrinsic muscles.

Origin. Pterygoid fossa (medial surface of the lateral lamina of the pterygoid process of the sphenoid); pyramidal process of the palatinus muscle; maxillary tuberosity.

Insertion. Medial surface of the mandibular ramus, at the corner and along the inferior border.

Action. Elevation of the mandible, with chewing function; protrusion and lateral movements of the mandible.

Surface anatomy. The muscle is deep, not visible or palpable.

LATERAL PTERYGOID MUSCLE (Pterygoideus lateralis)

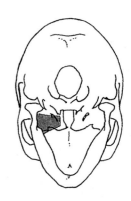

Form, structure, relations. The lateral pterygoid muscle is short, often conoidal in shape, and separated into two bundles which travel posteriorly downwards and converge into a single insertion tendon. It may be connected to nearby muscles. The muscle is positioned medially to the mandibular ramus and the zygomatic arch: coming into contact with the temporal tendon and the masseter, the medial surface rests on the upper part of the pterygoideus medialis.

Origin. Base of the skull, with two separate bundles: the upper bundle, the upper part and lateral surface of the greater wing of the sphenoid; and the lower bundle, the lateral surface of the lateral lamina of the pterygoid process.

Insertion. Mandibular condyle, at the pterygoid depression; capsule and articular disc of the temporomandibular joint.

Action. The upper bundle carries out an anterior traction on the condyle with the opening of the mouth and protusion of the mandible (together with the pterygoideus medialis and in antagonism with the posterior bundles of the temporalis muscle); the lower bundle contributes to the movements of closing the mouth, chewing, swallowing and grinding teeth.

Surface anatomy. The muscle is deep, not visible or palpable.

MASSETER MUSCLE (Masseter)

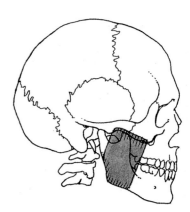

Form, structure, relations. The masseter muscle is an almost quadrangular lamina about 4cm (1½in) wide. It is extremely robust and rather thick (approximately 1cm (⅜in) stretched diagonally between the zygomatic arch and the corner of the mandible. It comprises a superficial layer and a deep layer which together are able – due to the vigorous, repeated masticatory traction – to influence the individual development of the facial block's skeletal structure and the size of the mandibular corner.

The two bundles making up the muscle may be completely separate. The deep surface adheres to the entire surface of the mandibular ramus and covers the area of insertion of the temporalis muscle in the section between the mandible and the zygomatic arch. The superficial face is subcutaneous and is covered by the parotideomasseteric fascia, which extends to the point where it inserts into the inferior border of the zygomatic arch and covers the parotid gland, located along the posterior border of the muscle.

It is also connected with the platysma, the zygomaticus major and along the anterior border with the adipose mass (known as Bichat's fat pad) in the infratemporal fossa.

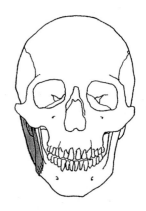

Origin. Zygomatic arch. In particular: the superficial layer of the muscle with a strong tendinous aponeurosis originates from the zygomatic process of the maxilla and from the anterior two-thirds of the inferior border of the zygomatic arch. The deep layer originates from the posterior portion of the medial surface and the lower edge of the zygomatic arch.

Insertion. Lateral surface of the mandibular ramus. In particular: the superficial layer inserts into the corner and lower half of the lateral surface of the mandibular ramus; the deep layer inserts into the upper section of the lateral surface of the mandibular ramus and the coronoid process.

Action. Elevation of the mandible, for chewing, and consequent closing of the mouth.

The oblique direction of the superficial layer's muscular fibres may cause limited forward movements (profusion) of the mandible, while the vertical direction of the deep layer allows a slight backward and lateral movement (retrusion).

Surface anatomy. The muscle is subcutaneous, therefore easily palpable and visible below the teguments during contraction.

The anterior border is clearly visible, especially in slim people, where the fat pads are smaller, while the posterior border is covered by the parotid gland.

The zygomatic arch is always visible as it is slightly raised compared with the muscle. The muscle mass becomes evident in chewing or when tightly closing the jaw in some expressions of anger, aggression, emotional tension, etc.

TEMPORAL MUSCLE (Temporalis)

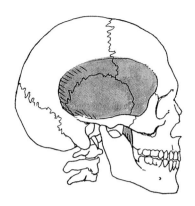

Form, structure, relations. The temporal muscle is flat and fan-shaped: the large upper edge is semi-circular and thin, while the apex is narrow, rather thick – 2cm (¾in) approximately – and occupies the temporal fossa, below the zygomatic arch, ending with a short, robust insertion tendon. The muscle comprises muscle bundles that travel in different directions, which contract separately and can each slightly influence the overall action: the anterior ones run almost vertically downwards, the median ones head obliquely downwards and forwards and the posterior ones are positioned almost horizontally. The deep surface of the muscle adheres to the external wall of the cranium and at the bottom is connected with the temporal fossa, the pterygoideus lateralis and medialis muscles. The anterior border is next to the zygomatic bone and is separated from it by an adipose pad that can be pushed forward when the mouth is wide open, due to the forward movement of the mandibular condyle, appearing as a slight elevation under the zygomatic arch. The superficial surface of the temporal muscle is subcutaneous and covered by the temporal fascia, a dense fibrous lamina to which the auricular muscles, the temporoparietal muscles and a part of the orbicularis oris adhere, and on which the surface temple vessels run.

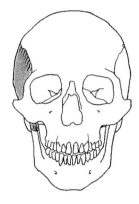

Origin. Temporal plane (including the area comprising the temporal squama, the greater sphenoid wing, and the parietal as far as the inferior temporal line), the temporal fossa, the deep surface of the temporal fascia.

Insertion. Apex and medial surface of the mandibular coronoid process.

Action. Elevation of the mandible, for chewing, causing the dental arches to draw together and the mouth to close. Slightly lateral movements of the mandible.

Surface anatomy. The temporal muscle is subcutaneous and therefore easily palpable along its entire extension. However, as it is covered by the large temporal fascia, when contracted it is visible only in the anterior section, on the temple, when chewing or clenching the jaw bones. The remaining part of the muscle is usually hidden by hair.

THE EYE

The organs that make up the visual apparatus are located symmetrically in the orbital cavity and form the orbital region for the outer parts. This area is bordered by the margins of the eye socket and is occupied by the eyebrow, a part of the eyeball and the eyelids.

- The eye (eyeball) is a sphere that is slightly flattened antero-posteriorly and has an average diameter of approximately 2.5cm (1in). The part of the eyeball that can be seen externally, bordered by the eyelids, is the front part and has a small transparent spherical cap (cornea), which juts out compared to the remaining opaque, off-white part (sclera) as it has a smaller curvature radius than the entire eyeball. This elevation is easily noted when observing the eye from the side and is also visible through the thickness of the closed upper eyelid.

- The eye's sclera is off-white in colour and covered by the conjunctival membrane. It is shiny due to the lacrimal fluid, and occupies two triangular areas with curved edges. The lacrimal caruncle and lateral corner are placed at the sides of the iris, with the medial one slightly larger, and are subject to larger or smaller exposures in relation to the eye's movements. There is a semi-lunar fold on the caruncle, a raised line that is formed by the meeting of two conjunctival sheets.

- The iris, a disc-shaped membrane with a diameter of just over 1cm (⅜in), is immediately behind the cornea, and easily visible through it. The iris varies in colour and at its centre there is a circular aperture, the pupil, that appears to be black as the lens looks on to the eyeball cavity. The pupil has the ability to dilate and shrink in response to light intensity, emotional states and the distance from the object observed.

 The colour of the iris varies from blue, to grey, brown, and various intermediate hues and is often connected to the colour of the hair; for example, individuals with dark hair normally have dark eyes. Moreover, the colour is not uniform and compact, but comprises varying intensities of pigment that produce different patterns for each person. There is frequently a greater density of colour close to the external circumference, from which there are stripes of colour arranged radially and converging towards the pupil.

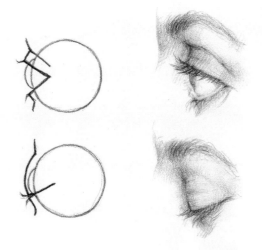

Relationship between eyelids (open and closed) and the eyeball.

- The eye socket is rather large compared with the size of the eyeball; the eye is therefore protected by abundant adipose material which envelops it almost entirely, apart from the anterior part, and fills the spaces not occupied by the vascular, nervous and muscular devices. The eyeball is delicately moved by some intrinsic muscles in the eye socket that can cause fine, precise movements: the superior, inferior, lateral and medial rectus muscles that move the eye in the directions indicated by their names. Two other muscles, superior and inferior oblique, create intermediate movements, diagonally upwards or downwards. It must be noted that under normal conditions, the two eyeballs move together, in coordinated, simultaneous movements to point the gaze in the same direction: when looking into the distance, the axes of the eyeballs are parallel, while in close-up sight, they are slightly convergent.

- The eyelids are two mobile cutaneous folds, one longer, upper one and one lower one. They each end with a free external border that contains rigid hairs, the eyelashes. The free margins of the upper eyelid and the lower eyelid can join and completely close the eye, but while seeing, the two eyelids are separated and form the border of the opening of the palpebral fissure, which shows the anterior part of the eye.

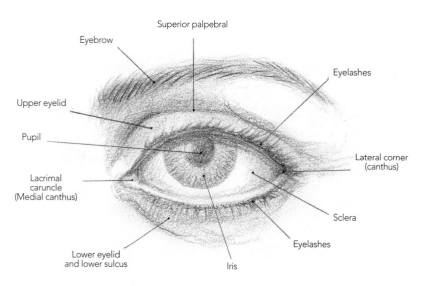

External appearance of the left eye viewed frontally and its main morphological components.

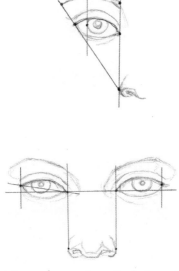

Location and proportion ratios between the eye, the eyebrow and the nose.

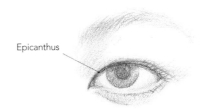

Epicanthus

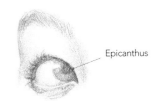

Epicanthus

Illustrations of the epicanthic fold, a layer of skin on the upper eyelid that covers the eye's medial canthus (inner corner).

The palpebral fissure ends in an acute angle on the two sides (commissures) in different ways: the medial commissure (or angle, or canthus) is wide, and shows a pink, slightly protruding conformation, the caruncle, where the lacrimal duct emerges, and is considered to be an important landmark as it does not move. The lateral commissure, on the other hand, borders a narrower area, with no particular characteristics and may move slightly as the eye moves.

The palpebral fissure is oval and elliptical, varying according to the individual and their ancestry (monolid and doublelid, for example), but it also depends on the movements of the eyeball, according to the direction in which the gaze is aimed. In normal conditions, with the gaze directed forwards, the eyelids are resting on the spherical shape of the eye and follow the curved surface. There are some particularities: the larger axis of the aperture is transversal, almost horizontal, but slightly oblique as the lateral canthus is located a little higher than the medial one. The border of the upper eyelid is downwardly concave in the medial half and straighter in the lateral half. The lower eyelid is more evenly upwardly concave, although it may present the opposite trend to the upper eyelid, that is, being more concave in the lateral half, and straighter in the medial half. The upper eyelid covers a small portion of the iris, while the lower eyelid just touches its border.

The eyelids are about 3mm (⅛in) thick and their wall is made of a fibrous lamina, the tarsus. Its internal surface faces the eyeball and is covered by the conjunctiva, while the external surface comprises the muscular layer (especially the orbicularis oculis) and skin. The upper eyelid is much larger than the lower one and this is easily noted when the eye is closed. When the eye is open, the eyelid retracts to varying degrees thanks to the levator palpebrae superioris muscle and the tarsal muscles, and forms a deep fold (superior orbitopalpebral sulcus) between the eyelid skin and the skin coming from the eyebrow.

The lower eyelid is smaller and less mobile. It is frequently thickened by adipose deposits and is separated from the cheek by the inferior orbitopalpebral sulcus.

The skin that covers the eyelids is extremely thin, to the point that it allows the capillary network to show through, and is subject to small wrinkles, especially close to the lateral canthi.

- The eyelashes are aimed outwards and are positioned only on the free border of each eyelid: the ones on the upper eyelid are curved upwards and are rather long and dense; the ones on the lower lids are curved downwards and are short and sparse.

- The eyebrows are two even, symmetrical transverse cutaneous elevations that are extremely mobile as there are several facial expression muscles inserted in the same location. Their shape corresponds with the orbital arches of the forehead. They separate the forehead from the upper eyelids and are covered by hairs that trace a slightly downwards concave arch on each side. The eyebrow hairs, which are generally of a similar colour to the head hair, or slightly darker, are arranged in a particular fashion: in the medial portion of the eyebrow (head) they are denser, arranged with a slight lateral tilt and located slightly lower than the supraorbital bone section; in the intermediate portion (body) they are more tilted laterally, almost horizontally; in the lateral portion (tail) they are located slightly above the edge of the bone. They are blurred and sparse and are arranged in fish-scale fashion, ending in a point.

Eyebrow shapes change according to gender (female eyebrows are more regularly and finely arched), age (in older people, the hairs become coarse, jut out, and make the eyebrows bush-like) and also ancestry: for example, in Nordic populations or East Asian populations, eyebrows are fine, while they are thicker in Mediterranean populations, sometimes even with medial extension on to the glabella area.

Projection of the iris between the open eyelids.

Head Body Tail

Diagram showing the direction of the left eyebrow hairs.

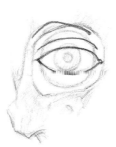

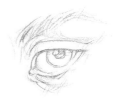

Position of the eyeball, eyelids and eyebrow in relation to the margins of the eye socket.

THE NOSE

The outer nose is a pyramidal-shaped protuberance at the centre of the face, arranged along the median line in an area between the forehead at the top, the orbital cavity and the cheeks to the sides, and the upper lip at the bottom. Some parts of the nose surface are considered morphologically, with the main characteristics being commonly known: the bridge, the ridge, the wings, the tip, supported by an osteocartilaginous skeleton. In fact, the bridge, the upper portion of the ridge and the lateral surfaces correspond to the bones that border the pyriformis aperture of the facial block, that is, the nasal bones and the frontal and palatine processes of the maxillary bones, while the remaining parts of the nose are mobile as they have cartilaginous support.

The skin of the nose lies on a thin adipose layer and contains, particularly on the tip and wings, several sebaceous glands that make the surface shiny; also, along the rim of the inferior apertures, the nostrils, they line the vestibule, giving rise to a certain number of coarse hairs, the vibrissae. The bridge or apex of the nose is a thin area placed between the supraorbital arches, below the median surface of the forehead, from which it is sometimes separated by a transverse crease (nasofrontal sulcus). In males, the jutting out of the eyebrow arches normally causes a depression between the forehead and the bridge of the nose, while in women, in whom the bone structure is normally smaller, as seen when observing the characteristics of the skull (see page 86), this depression is usually absent or only slightly marked. The bridge begins and continues along the ridge of the nose, which is the rounded anterior border on the median plane, formed by the meeting of the two lateral surfaces.

The ridge varies in shape and size depending on ethnic and individual characteristics, as it can be thinner and longer or shorter and wider. Considering its profile, some basic types of nose have been identified: straight (rectilinear), aquiline (convex), turned-up (concave), snub (flattened). A slight elevation on the ridge, sometimes marked, shows the passage point between the bone skeleton and the cartilaginous skeleton. The lateral faces are narrow and flat towards the bridge, but then become convex and wider, extending downwards, where the nasal alae (or wings) are formed, which can dilate or narrow to a varying degree, due to the cutaneous muscles. The border is a curved crease (alar sulcus) that begins around the tip of the nose and moves backwards and downwards, surrounding the nostrils. It extends towards the cheek and the upper lip, forming the nasolabial sulcus, which varies in depth and length according to an individual's skin characteristics, age and habitual expressions.

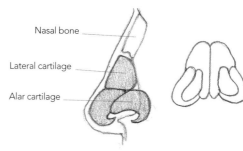

Arrangement of nasal bones and cartilages.

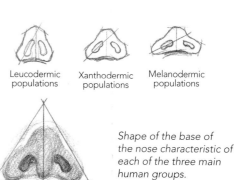

Leucodermic populations Xanthodermic populations Melanodermic populations

Shape of the base of the nose characteristic of each of the three main human groups.

The tip of the nose (lobule), located at the vertex of the pyramid formed by the meeting of the lateral faces, the base and the ridge, is a rounded fleshy elevation, but, especially in men, may have distinctive, clear planes, shaped by the underlying cartilage. In many cases, the tip appears to be separated into two symmetrical halves by a slight vertical median crease.

The base of the nose has a triangular shape and two of its sides, corresponding to the wings, converge towards the tip, bordering the nostrils, that is, the two apertures of the upper airways. They are separated on the median line by the inferior portion of the nasal cartilaginous septum and the nasal spines of the maxilla. They are oval in shape, wide and with rather thick walls in the posterior section, narrower at the front, and arranged on the greater axis in an antero-posterior direction and slightly laterally deviated. The shape of the nose, and especially of the nostrils, allows a rough anthropological distinction into some of the common types: leptorrhine, narrow, thin noses; platyrrhine, wide, flattened noses; and mesorrhine noses with intermediate morphological characteristics.

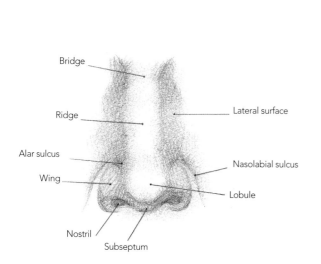

Bridge — Ridge — Alar sulcus — Wing — Nostril — Subseptum — Lateral surface — Nasolabial sulcus — Lobule

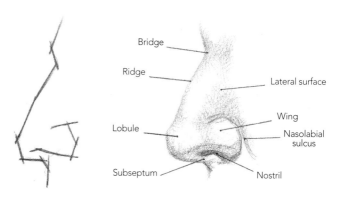

Bridge — Ridge — Lobule — Subseptum — Lateral surface — Wing — Nasolabial sulcus — Nostril

THE LIPS

The lips form the contour of the mouth and cover the anterior portion of the dental arches. They are two folds, one upper and one lower, which come into contact with the free margins, forming the border of the transversal opening (labial rim or buccal rim), and converge laterally, joining to the corners of the mouth (labial commissures) where thicker muscular fibres form a small oval elevation (modiolus).

The upper lip continues into the cheeks and the lower lip passes into the chin. Together they form the anterior wall of the vestibule of the mouth, bordered at the top and sides by the base of the nose and the nasolabial sulcus, and below by the mentolabial sulcus. The walls of the lips comprise three strata: an external one, cutaneous; an intermediate one, muscle and adipose; and an internal one, mucosa. The outer cutaneous covering and the inner mucosa lining continue into one another via a transition zone (vermilion border) which, due to the thinness of the specific skin, appears pink in colour and corresponds to the surface of the lips as commonly understood and visible. The intermediate stratum contains the cutaneous muscles that influence the buccal region (orbicularis, buccinator, risorius, zygomaticus, levator, triangularis, mentalis), which, when contracted, cause several features to alter. The external surface of the mouth is covered by thin skin. Mainly in males, the upper lip is covered by thick, coarse hair (moustache) and on the median line has a slight oval depression (philtrum) which originates from the infranasal sulcus and heads vertically as far as the lip. The lower one also has a small median depression bordered laterally by two column elevations (pillars) and inferiorly by the clear transversal mentolabial sulcus. This area in males is densely covered by hairs (the soul patch) according to a characteristic arrangement of the beard and may have a small convex elevation at the centre.

The overall shape of the lips varies from individual to individual, ranging from thick, protruding lips to thin, flat lips. It is a known fact that the width of the rim can also also be subject to individual variations, leading to small, wide, or medium mouths.

The shape of each lip has some specific morphological characteristics. The upper lip is rather thin and has an elevation (tubercle) on the median plane, corresponding to the joint of the philtrum borders. At the sides there are two slight depressions followed by two slightly convex sections up to the commissures. The lower lip is thicker: it has a slight vertical depression on the median plane where the tubercle is located and two symmetrical oval elevations at its sides. The border between the skin and the vermilion border is slightly raised and always easily visible. It appears as a clear, smooth, sinuous line on the edge of the upper lip, curving evenly on the lower lip, where a

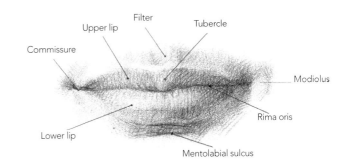

External appearance of the lips in frontal projection.

thickening can sometimes be noted in correspondence to the medial depression and the sections close to the commissure The lips undergo several sizeable variations in shape and volume in relation to the expressive and functional movements, after which, they are more or less contracted, everted, stretched or curved. The rima oris may be half-closed or open to a varying degree, allowing the partial exposure of teeth. There is also a dense area of vertical ripples on the surface, or their disappearance, depending on whether the lips are pursed and jutting out or widened and drawn. The nasolabial sulcus, which adapts to all these modifications, laterally borders the slight ovoid elevation of the modiolus, located at each commissure, formed by the overlapping and crossing of various muscle bundles (see orbicularis oris muscle, page 93).

The external surface of the mouth extends laterally towards the cheeks, the shape of which is provided by the maxillary bones and the subcutaneous buccal fat pads, and it continues into the chin. This constitutes an elevation that, characteristic of the human race, is positioned on the median plane and outlines the face at the bottom, rendering characteristic individual appearances in relation to the form of the mandible and the local deposit of subcutaneous adipose tissue. On average, in a man, it is rather wide, jutting, clearly defined and covered with hair (beard), while in women it is rounder, smaller and smoother-skinned. The chin is separated from the lower lip by the mentolabial sulcus and often has a depression or dimple in the centre due to the direct adherence of the skin to the surface of the bone.

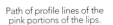

Path of profile lines of the pink portions of the lips.

The surface and volume of the lips can be broken down into 'planes' which include the protrusion of the tubercle, on the upper lip, and the depression of the median sulcus on the lower lip.

THE EAR

The outer ear comprises the auricle and the external auditory meatus (or canal), which reaches the eardrum. The auricle is a cutaneous fold with a cartilaginous skeleton located symmetrically on the lateral faces of the skull at the point where the borders of the face, the skull and the neck meet. The external auditory meatus corresponds to the temporal foramen of the same name and represents an important landmark. The shape of the ear is rather complex, similar to that of an oval-shaped shell, or with schematic simplification, to a very flat ovoid with the widest portion at the top. The larger axis is almost vertical, slightly sloping backwards, oblique to the side and bottom, and on average measures about 6cm (2⅜in). The smaller axis is horizontal, directed laterally to form an acute angle with the cranium wall, open at the back, and measures about 3cm (1¼in). If the head is seen in lateral projection, the auricle is not perfectly perpendicular to the visual axis, but slightly oblique towards the frontal plane. It can normally be located at the mastoid process, posteriorly to the mandibular ramus, and its height is included between two horizontal parallel lines that pass through the eyebrow and the base of the nose; the slope of greater axis is similar to that of the nose and mandibular ramus. The medial surface of the auricle is turned towards the skull, it is convex and undulated by protuberances and depressions which correspond to those of the outer surface, and is attached to the cranial wall only by its anterior convex part, while the wide oval border is free and away from the wall.

The outer surface of the auricle has several folds that give rise to the characteristic convolutions. The central part, which is towards the anterior edge of the ear, is occupied by a large depression, the concha, at the bottom of which the auditory meatus commences. The peripheral part, the free border of the ear, is the helix, a curved fold that originates from the bottom of the concha, just above the auditory canal (thus dividing it into an oval upper section and a deeper, larger lower section). It then outlines all the external border of the auricle, growing thinner in the lower portion of the ear, the lobe. On the anterior edge of the curve on the upper section of the helix, there is frequently a slight, pointed protuberance, the auricle tubercle (or Darwin's tubercle).

104

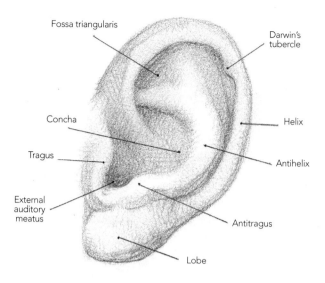

External appearance of the left auricle in lateral projection.

The lobe is a small fleshy mass, oval and flat in shape, with no cartilage, which mostly has free borders as only the upper portion of its anterior border adheres to the skull, at the base of the mandible. Concentrically to the helix, edging the posterior border of the concha, there is the antihelix, a marked semi-circular cartilage protuberance, concave anteriorly, that starts high up with two converging elevations (the bottom being a clearer one, the upper one being less pronounced) which border the scaphoid fossa of the antihelix, which is curved and ends with a rounded protuberance, the antitragus. The area between the helix and the antihelix (helix sulcus) is flat and slightly depressed.

The concha is bordered anteriorly by the tragus, a triangular, rounded, jutting flap where some hairs may grow on its inner wall. It corresponds to the temporomandibular joint and then continues towards the antitragus with a raised border, bordering the intertragic notch. Also, as mentioned, the concha is the posteromedial wall of the auricle, highly convex (in relation to corresponding concavity of the external surface) and joined to the cranial wall at about a 20–30-degree anterior inclination of the external surface of the auricle.

The ear has an elastic cartilaginous skeletal structure, which is absent only in the lobe and in a short part of the lower border of the helix. The auricle therefore is rather flexible and also slightly mobile due to the auricular muscles (see page 91) and few intrinsic fibres. The skin is very thin, with high vascularization: this pinks skin colour, a shade which may intensify under emotional and heat influxes.

The auricle can vary greatly in shape, depending on individual characteristics, which are partly hereditary: for example, the ears of many populations with black skin are smaller and thinner, and sometimes have almost no lobe. It can also be noted that the female ear is thinner, small and with more marked folds than the male ear. As we grow old, the ear tends to grow longer according to the larger diameter due to the loss of elasticity and consequent stretching of support tissues, forming some vertical folds in front of the tragus.

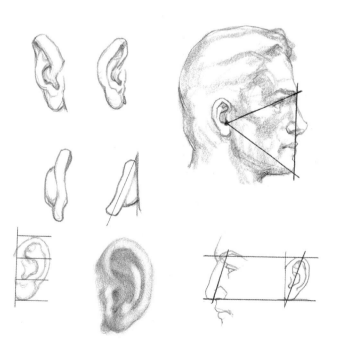

Direction, position and size of the outer ear.

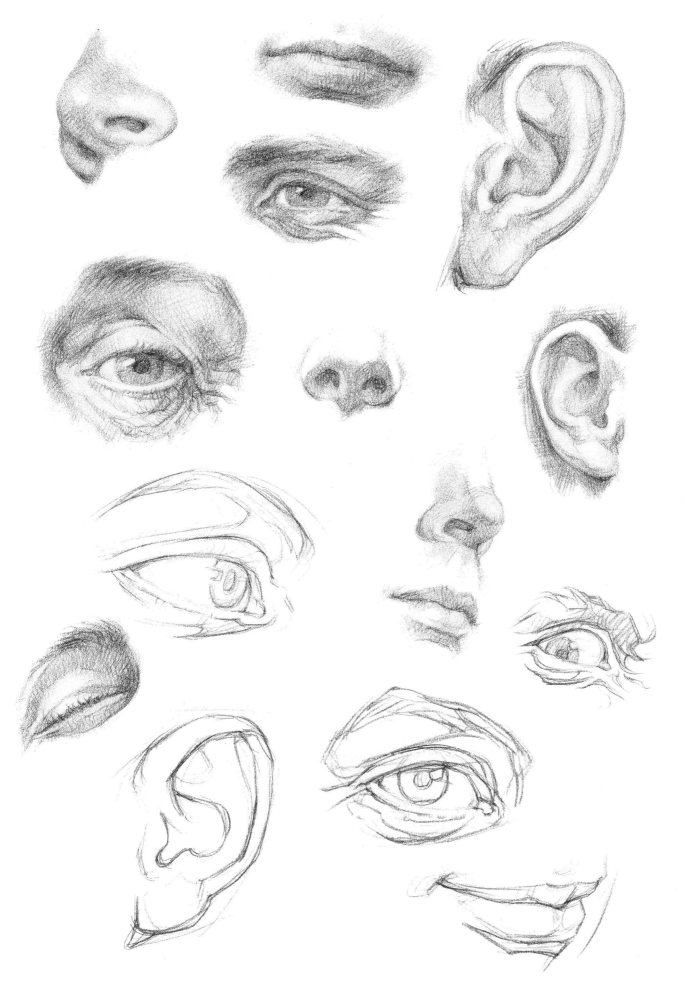

THE FUNCTION OF FACIAL MUSCLES IN EXPRESSIONS

Various muscle groups which differ in origin and function are arranged on the skull. Some of them pertain to specific organs of the head, for example: the muscles that move the eyeballs or the ones connected to the upper digestive system, but most are muscles resting on the skeletal structure, belonging to the locomotor system and these are the only ones of interest to the artist. In consideration of their functions, these muscles can be divided into two groups: 1) the masticatory muscles that determine the movements of the mandible and act on the temporomandibular joint; 2) the mimic muscles, that are used in facial expressions, arranged mainly on the facial block and only partly on the cranium. The muscles in this second group are named cutaneous or mimic muscles as almost all of them are inserted into the skin and act, according to the lines of traction, on the forehead, eyelids, nose, lips, cheeks, and minimally, on the outer ear.

The analytical study of mimic muscles is rather complex due to the high number of muscles and the difficulty in identifying individual muscular bundles, which are very thin, branching, and partly act synergistically. Knowing the essential characteristics and the topography of the main head muscles is useful for understanding some of the mechanisms that bring about the expressions that our faces can show. With the face, we can communicate with others and perceive their reactions. We can instil fear, show pleasure, pain, interest or indifference, not only spontaneous and genuinely, but also to a certain extent as a simulation or adherence to cultural convention. Facial 'language' is almost totally absent in other animals or very basic, and only mammals have created a repertoire of facial behaviours – and even so, only to a certain extent. For example, felines reveal their teeth and lower their ears when acting in defence or offence and to shown submission; chimpanzees can contract their lips and turn them outwards, or raise their eyebrows. In man, these possibilities are much wider and relevant, to the point of being the subject of some of the older anthropological studies. We should mention those of Duchenne, Darwin, Marey and Mantegazza, to name a few, who used electromyography to carry out the first 'scientific' studies in the second half of the 19th century. In recent years, sophisticated, complex computer programs have been applied, mostly for identification, security and simulation in computer graphics images or in the construction of humanoid robots, featuring anthropomorphous interaction. Although the basic expressions (crying, threatening, smiling, surprise, etc.) are instinctive, most are genetically programmed and present from birth, developed, refined and integrated through socialization and culture. The art of mimicry, that is, imitating expressions and representing a dramatic action only by gestures, is of interest to those studying in physiognomy. In this field, the inclinations and qualities of a person are presumed by looking at the morphological characteristics of the individual's head. The parts of the face with the greatest potential for expression are the eyes and lips: these two areas are rather important because, even taken alone, they determine the overall attitude of the face.

The mimicry mechanism is the same for men and women, and at various ages, but with different nuances. It is necessary, therefore, to look at a few characteristics of the eye area and the mouth area. The upper portion of the face is dominated by the eyebrows, eyes and eyelids, rather mobile elements, as we know, arranged in correspondence to the eye sockets. Eyebrows, which are highly visible, approximately follow the upper orbital arch. They are moved in their entirety or in single portions (medial or lateral) by muscles, so they contribute to several different expressions. In fact, although they act to shelter the eyes from falling sweat or rain sliding down the forehead, and to protect them from too much light or aggressive events, it would seem that they actually evolved above all to show states of mind. Consequently, eyebrows can take on myriad positions, affecting the surrounding areas too (wrinkles on the forehead, grooves around the eyelids, etc.).

Lowered eyebrows brought closer together produce vertical wrinkles at the bridge of the nose, while the horizontal wrinkles along the forehead flatten out and appear in two different types of situations: aggression towards others or focused attention (in this case, there may also be a rotation of the eyebrows, raising of the lower eyelids and contraction of the zygomaticus muscles).

Raised eyebrows wrinkle the forehead and move slightly in a vast range of different expressions (surprise, amazement, expectation, anxiety, etc.), with significant widening of the eyes and extension of the visual field. Raised eyebrows close together cause some wrinkles or folds on the forehead and between the brows, and express complex emotions of anxiety and pain.

Raising a single eyebrow while the other is lowered causes various effects across the skin, and often expresses an uncertain state of mind (perplexity, questioning, etc.).

The visible part of the eyeball is surrounded by the eyelids, mobile laminae, which when contracted cause them to partly or fully close or dilate with visible skin creases, especially at the base of the lower eyelid and at the lateral corner towards the temple. The lower portion of the face is dominated by lips which close the mouth. Emotional states cause a varied, rich series of movements of the lips based on the combination of movements that they can carry out: opening and closing, moving forwards and backwards, rising and lowering, tightly closing or drawing back. The orbicularis oris muscle is rather delicate as its deep fibres press the lips against the teeth, while the superficial ones push them out and, together, close them tightly or wrinkle them up. However, this muscle does not act alone as other muscles in the mouth region work in antagonism (in order to open the mouth) to create the most subtle facial expressions. In brief, they can be divided into groups: muscles that raise the lips, in expressions of worry, contempt, laughter, pleasure, etc.; muscles that lower the lips, in expressions of irony, disgust, pain, unhappiness, etc.; muscles that push out or draw back the lips, in expressions of challenge, perplexity, pain, etc..

The opening of the mouth to varying degrees is caused by lowering the mandible and this is achieved by the muscles that act on it, mainly by a thin, wide muscle (the platysma) located at the sides of the neck. As it contracts, the platysma causes the skin to lift in long, thin elevations that are almost parallel and easily visible, especially in expressions of anger, physical effort and fear.

Artists from the past paid great attention to the study of human expressions and their faithful representation. Just think of the paintings and sculptures of historical, celebratory or religious subjects until almost the start of the 20th century. In the art of subsequent decades and in modern contemporary art, interest in realistic representation of the figure has progressively waned, but is still alive in portrait painting and illustration. Particular investigative sophistication is now applied by experts in behavioural psychology, human ethology or information technology, with the main purpose of individual identification, communicative interaction or analysis of emotions that are of collective relevance. In order to draw expressions accurately, it may be useful to summarize a few basic yet valuable observations.

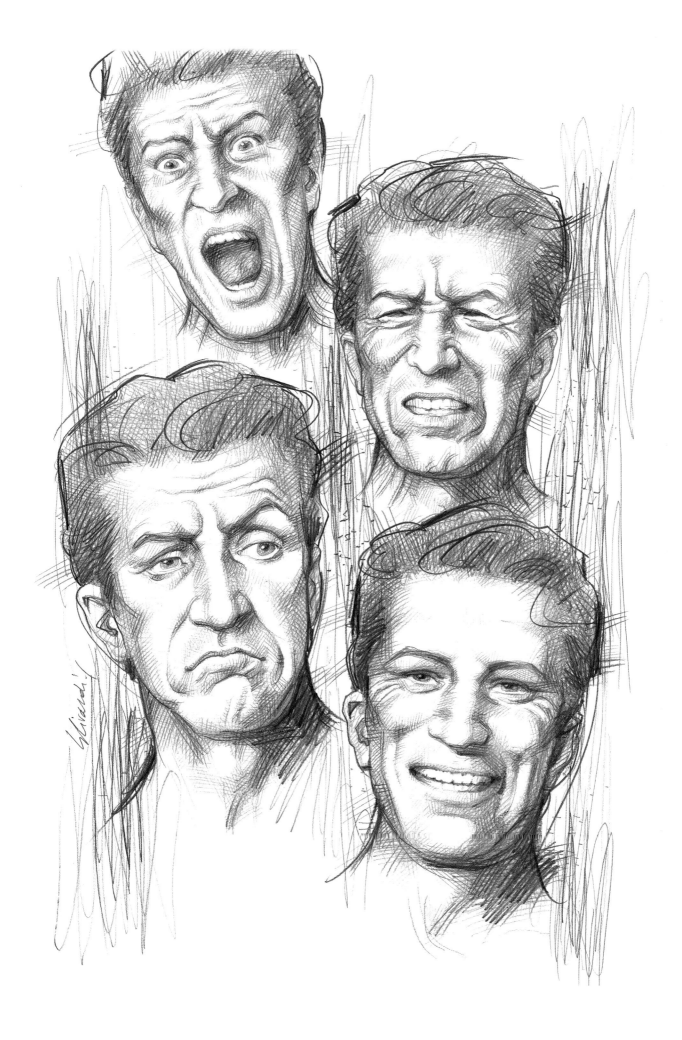

Drawing a certain expression becomes more effective if the fundamental characteristics are captured (without creating a caricature, however), omitting tiny, minor details, for example, an excessive amount of small wrinkles.

Facial expression is very important, but equally one should not neglect the whole stance of the body, which helps to express the state of mind through a kind of non-verbal body language. For example, particular attention should be paid to the hands and gestures, and the relationship between head and shoulders.

The facial muscles almost never act individually, but instead usually work in synergy and sometimes in antagonism, causing complex and subtle changes to the skin's surface. Expressions are often transitory and fleeting, but the habitual repetition of certain expressions writes a character 'history' on the face. To capture expressions well, anatomical knowledge must be combined with the careful observation of reality, possibly augmented with the use of photographs, videos or sequential computerized reconstructions. Many illustrators have effectively studied their own facial expressions reflected in one or two mirrors, in order to observe them from different points of view and not just face-on.

Facial expressions can be divided into three main groups, each with a dominant tendency, as described briefly here.

- **Neutral expressions:** The face does not show muscle contractions or alterations in the skin, each component is in normal anatomical relations and has only slight nuances that allow us to recognize (or deduce) expressions of relaxation, decision or moderate attention.

- **Positive expressions:** The face tends towards dilation, as if it were subject to pushing outwards from a centrifugal force. For example, the widening of the mouth, dilation of eyelids, distancing between eyebrows, all generally show expression of optimism: laughing, smiling, wonder or happiness. We may say that the individual has nothing to fear from the outside world and opens up to it.

- **Negative expressions:** The face tends to concentrate inwards, under the drive of centripetal forces. For example, the lowering of eyebrows, eyes closing, nose wrinkling and the lips curving downwards show pessimistic expressions: crying, pain, disgust, sadness, scepticism, hostility, anger. In these cases, the individual fears attacks from the outside world, or directs hostility towards it, and therefore tends to close itself as a shield to protect and defend itself. At the same time, intense expressions, especially aggressive ones (anger, strong pain or terror, etc.) bring with them the dilating of the nostrils and opening of the mouth to form a more threatening or visible mask and to increase the flow of air required by physiological situations of offence or defence.

Muscular mechanism in some expressions

- **Seriousness, Meditation, Reflection:** Eyebrows close together and lowered, they form vertical wrinkles (two or three) in the middle of the forehead, eyelids are partly closed or closed, but not contracted. Muscles acting: corrugator supercilii, orbicularis oculis.

- **Attention, Wonder:** Eyebrows are arched, transversal wrinkles form on the forehead, eyelids are widened, mouth slightly open. Muscles acting: frontal and occipital, levator palpebrae superioris, muscles lowering the mandible (platysma, digastric, etc.).

- **Pain, Spasm:** Eyebrows raised and brought close together, with the medial parts (heads) pulled up a little. Transversal and vertical wrinkles form in the middle of the forehead, gaze is directed upwards, lips are separated or contracted. Muscles acting: corrugator supercilii, frontal (medial portion), levator palpebrae superioris, levator labii superioris, depressor anguli oris, risorius. Sometimes: temporal, masseter, platysma.

- **Prayer, Begging, Ecstasy:** Eyebrows are totally raised, gaze is aimed upwards, mouth partly open, a few transversal wrinkles on the forehead. Muscles acting: frontal, levator palpebrae superioris, zygomaticus minor.

- **Smiling:** The mouth is closed or just closed, the lips are slightly drawn and curved upwards, the nasolabial sulcus is accentuated by the formation of small depressions in the cheeks, the lower eyelid is slightly raised and forms small folds at the base, near the temple. Muscles acting: orbicularis oculis (lower portion, palpebral), zygomaticus minor, nasalis.

- **Laughter:** The eyes are partly closed, the mouth partly open with an upwards concave arch, the eyebrows are slightly raised, the nasolabial sulcus is marked, nostrils dilated, with long folds under the eyelids and at the temples. Muscles acting: orbicularis oculi, nasalis, levator labii superioris, risorius, zygomaticus major.

- **Crying:** The eyes are partly closed and the eyelids are contracted, the forehead is wrinkled, nostrils dilated, small creases at the sides and on the ridge of the nose, the mouth is a little open and takes on an almost square shape, the chin is creased and long folds appear on the neck (platysma). Muscles acting: corrugator supercilii, orbicularis oculi, levator labii superioris, depressor anguli oris, mentalis.

- **Disgust, Disdain:** Eyebrows are close together and raised, vertical wrinkles on forehead, lower lip is pushed up and out a little, the labial commissure is lowered, the chin is creased, the nasolabial sulcus is pulled upwards at the upper end and downwards at the lower end. Muscles acting: orbicularis oculi, orbicularis oris, levator labii superioris, depressor anguli oris, corrugator supercilii, mentalis.

- **Doubt, Perplexity:** The lower lip is pushed upwards and forwards, the chin is creased, the labial commissures are curved downwards forming oblique folds under the lower lip, the forehead is slightly creased and the eyebrows are arched. Muscles acting: frontal, orbicularis oculi and orbicularis oris, mentalis, levator labii superioris, depressor anguli oris.

- **Anger, Fury, Rage:** Eyebrows are lowered and brought together, forming vertical grooves in the middle of the forehead and transversal ones at the bridge of the nose, the eyes are wide open, lower eyelids are slightly raised with wrinkles that radiate laterally from the base. The mouth can be tightly shut or open and so the nasolabial sulcus becomes longer and deeper, cheeks become bigger towards the zygomatic bones. Muscles acting: corrugator supercilii, orbicularis oculi, nasalis, caninus, levator labii superioris, masseter, platysma.

THE TRUNK

NOTES ON EXTERNAL MORPHOLOGY

The trunk is the axial part of the human body, excluding the head, which we have already discussed. The free extremities of the upper and lower limbs, which are the appendicular parts of the body, are inserted on to it. The trunk, which overall has a cylindrical shape slightly flattened antero-posteriorly, is divided into an upper section, the chest (or thorax), and a lower section, the abdomen, each with a slightly angled axis on the sagittal plane, that follow the curvature of the vertebral column. For a more complete description of the external shapes, we can add the neck (a cylindrical segment that connects with the head), shoulders and buttocks. The thoracic section, corresponding to the rib cage, is a truncated cone, flattened antero-posteriorly and with a wide base towards the abdomen. On its anterior surface there are pectoral elevations, separated by a slight sternal depression and bordered at the

top by the protruding clavicle bones. On the posterior surface, the back, there is a dorsal region, corresponding to the vertebral column and bordered at the sides by the scapula bones and ribs. The breadth of the upper section of the chest is increased by the shoulders. The abdominal section is ovoid in shape and supported only by the lumbar section of the vertebral column and is enclosed inferiorly by the pelvic bones, while the other walls are formed by large muscles. On the anterior surface runs a medial line of depression, where two-thirds of the way down there is the umbilical scar (umbilicus, or belly button); in the lower extremity, there are the external genital organs. The posterior and lateral surfaces continue into the regions of the sacrum, hip and buttocks, then transition into the surface of the thigh, apart from the posterior medial section, where the buttock is clearly outlined by a cutaneous fold.

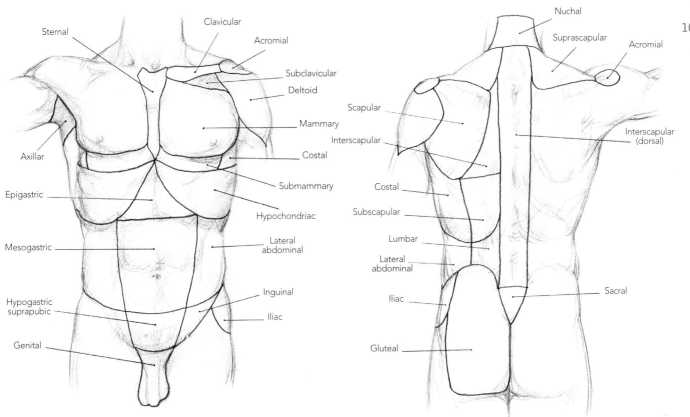

Boundaries of the main areas of the trunk.

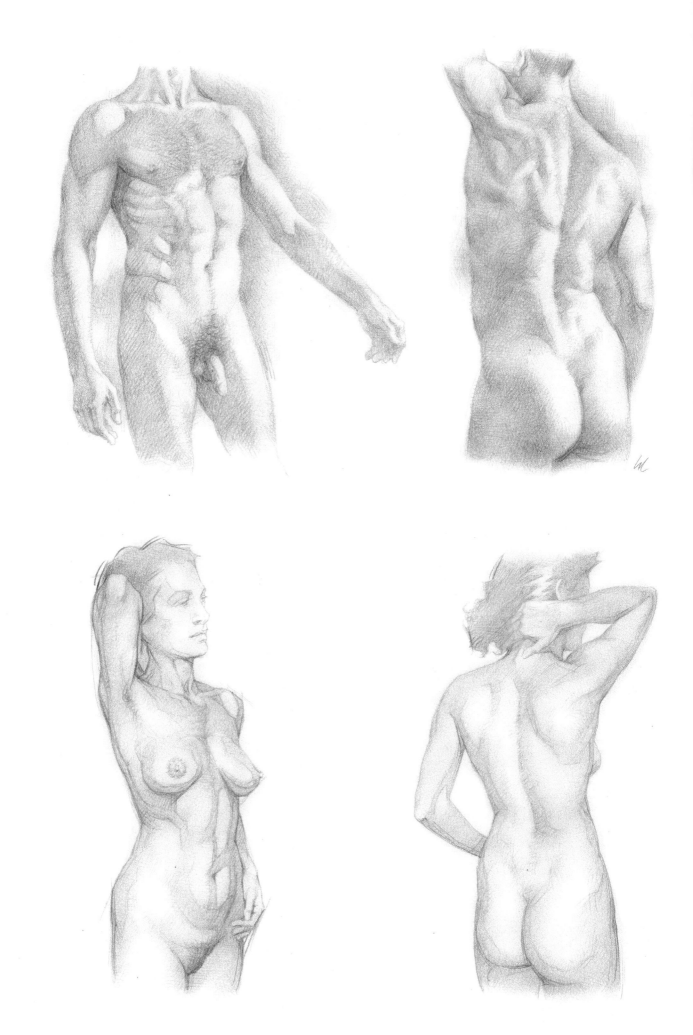

• General characteristics

The trunk, if we add the head, is the axial part of the human body, to which the appendicular segments are attached – that is, the upper limbs (via the bones that form the shoulder girdle) and the lower limbs (via the pelvic girdle). For a better and more holistic description, according to topographical functional criteria, the skeleton of the trunk – with its relative joints and muscle connections – is divided into the following sections.

The vertebral column, which is the main structure of the entire skeleton, to which all the others are connected, runs along and supports the entire trunk and, together with the articular devices and muscles surrounding it, forms the spine. The first section of the trunk, corresponding to the cervical section of the spine, is the neck. The second section of the trunk, corresponding to the thoracic spine and the rib cage, is the chest. The third section, corresponding to the lumbar spine, is the abdomen.

This last section includes the pelvis, which, while being the skeletal part by which the lower limbs are attached, is considered as belonging to the trunk as it is the insertion point of several muscles and abdominal ventral and dorsal fasciae. A similar consideration can be made for the shoulder girdle (scapula and clavicle) in relation to the upper limbs from a functional point of view; however, topographically, it can be ascribed to the trunk.

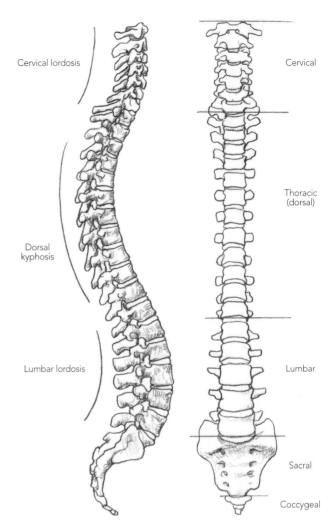

Schematic drawing of the vertebral column seen in right-hand lateral projection and in frontal projection. The physiological curves and the vertebral sections are shown.

111

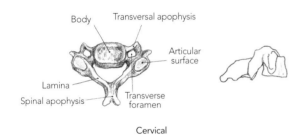

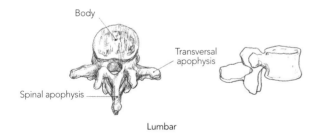

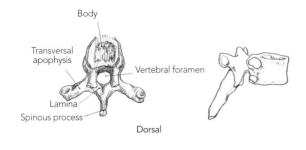

Diagrams of typical vertebrae.

Diagrams of the overall bone structure of the male trunk.

THE SPINE

OSTEOLOGY

• The vertebral column

The vertebral column (columna vertebralis) is an apparatus comprising the vertebrae – short bones placed in a craniocaudal column and joined together by joints and ligaments. There are about thirty-three or thirty-four vertebrae: the variation is due to the bones at the caudal extremity which can vary in number. Based on morphological characteristics, it can be divided into sections: cervical (seven), thoracic (twelve), lumbar (five), sacral (five) and coccygeal (four or five). There are therefore twenty-four free vertebrae, with the last two groups being practically immobile and the vertebral elements almost fused with each other.

The parts making up a vertebra are: the vertebral body, the vertebral arch, the transverse processes (in cervical and thoracic vertebrae), costal processes (in lumbar vertebrae), the spinous process and the articular processes. Almost all vertebrae have all or some of these general structural elements; therefore the presence or absence of certain anatomical details and variations in size allow us to identify vertebrae as belonging to different groups. The vertebral column as a whole has a cylindrical appearance, but we can see that the overall volume of the vertebrae grows progressively from the cervical area to the last lumbar vertebra, then decreases; that the largest volumes and vertebral arch are in the thoracic section; that the vertebral body assumes characteristic aspects in the various sections: flat in the cervical area, cylindrical in the thoracic area, and cylindrical but widened in the lumbar vertebrae.

The vertebral column is wrapped in strong muscles which together form the spine, and is a fundamental load-bearing structure and, above all, a dynamic structure the characteristics of which depend on the shape of each vertebral section.

Cervical vertebrae (C) are the first seven bones of the vertebral column. The general morphological characteristics are as follows: flat vertebral body, wider transversally, with a hollow superior plane and the inferior plane jutting out so that the subsequent vertebrae can slot in; transverse processes that are a laminar shape from the root of the vertebral arch and contain a hole in the centre (intertransverse foramen); slightly jutting spinous process, with a bifid (cleft) termination; and large intervertebral foramen, bordered by the triangular vertebral arch. From these common characteristics, three types of vertebrae can be distinguished according to anatomical details: the first cervical vertebra (atlas) does not have a vertebral body, the lateral masses (articular facets) jut out, the anterior arch is short and hooks on to the next vertebra, that is, with the epistropheus (axis); the posterior arch (vertebral arch) is extremely marked, with no processes. The second vertebra (epistropheus or axis) has a large process (odontoid process or epistropheus tooth) on the superior surface of the body that connects with the anterior arch of the atlas. The seventh cervical vertebra (prominent vertebra) has a high, only slightly hollow vertebral body, with a small intertransverse foramen, and the spinous process juts out with a large tubercle.

There are twelve thoracic or dorsal (T or D) vertebrae of medium size; the body volume increases gradually, proceeding from the first to the last. The most important distinctive characteristic is the presence of the devices that attach to the ribs. Other common characteristics are: the vertebral body, which increases in volume, thickness and height from

T1 to T7. On the lateral faces, at the origin of the arch, there are articular facets for the heads of the ribs (which therefore insert between two vertebrae) but in eleven and twelve there is only one articular facet per side – the vertebral arch, which starts with a peduncle on the superior plane of the body and borders a large notch inferiorly. The arch forms a circular hole. The transverse process is well developed and has joint facets with the head of ribs up to number ten. The articular processes are laminar and develop vertically. Lastly, the spinous process juts out obliquely downwards. Note that the typical characteristics stated refer to the thoracic vertebrae from T3 to T10: the first and last have morphological characteristics that merge, respectively, towards those of the cervical vertebrae and the lumbar vertebrae.

There are five lumbar vertebrae (L) and these are the largest vertebrae in the column. A common distinctive characteristic is the presence of large lateral protuberances, costal processes, which originate from the arch. The vertebral bodies are large with an elliptical section. The superior and inferior planes are sloping and slightly convergent. The articular processes are raised; the spinous process is rather short and squat. Each lumbar vertebra has particular characteristics and variations of these common elements, making them easily recognizable: the two planes of L5's vertebral body have a significant posterior converging slope as the vertebra's particular characteristic: it is thus said to be promontory, also in consideration of the site it occupies in the general arrangement of the vertebral column. There are five sacral vertebrae that are fused together by synostosis to form the sacrum bone: the union takes place at the vertebral body and lateral apophysis mass areas, while the foramina (sacral foramina) between the laminae remain separated. The sacrum bone is considered to be almost pyramidal in shape: in fact, the upper surface (base of the sacrum) is articulated with L5. There is a highly concave and sloping anterior surface towards the bottom; a convex posterior surface with a ridge along the median line as a residue of the spinous processes fused together; and two lateral faces, which are thin and wrinkled and are mostly joined with the iliac bones. The coccygeal vertebrae are

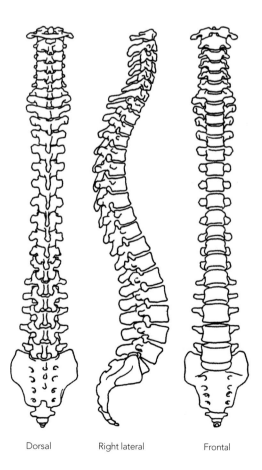

Dorsal Right lateral Frontal

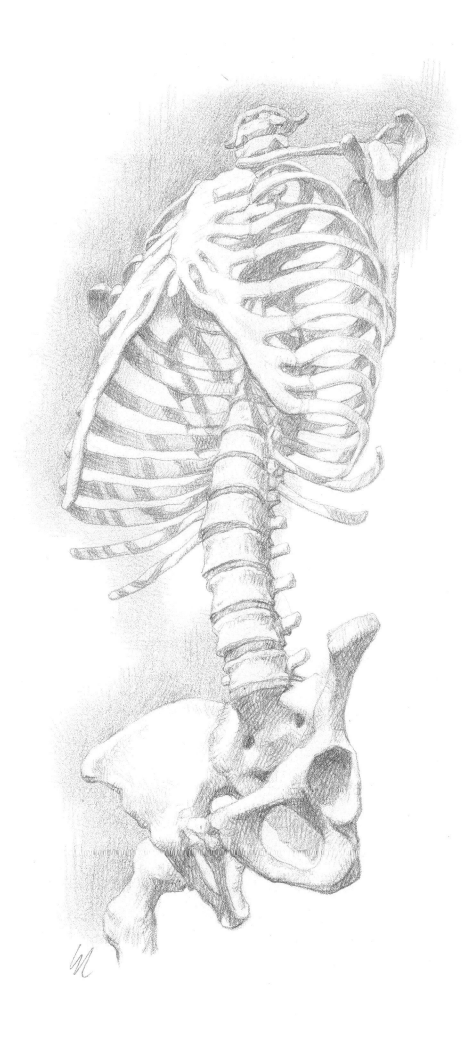

rudimentary and incomplete. There are three to five of them, fused together to form the coccygeal bone (or coccyx).

The structural characteristic of the vertebral column must, for the purpose of anatomy for artists, be considered in its overall shape and function, making a more analytical description of each vertebra superfluous at this point.

• External morphological characteristics of the vertebral column

The vertebral column as a whole (considering it composed of the discs between the vertebrae and the ligaments that join them, in addition to the vertebrae themselves) appears to be straight on the sagittal plane, but seen from the side, it displays curves which, when associated with the articulated column's elasticity, are an important factor for the whole structure's resistance and flexibility. In craniocaudal order, the curves are: cervical lordosis, with anterior convexity; dorsal kyphosis, with posterior convexity; and lumbar lordosis, with anterior convexity, which is more marked in women than men. The general form of the vertebral column is determined by the vertical overlap of the vertebrae (the vertebral bodies decrease in size from the lumbar to the cervical ones) and is cone-shaped with the base on the sacrum bone. The sacrum and coccyx form a small pyramid with the apex at the bottom. The anterior surface of the column shows the anterior surface of the vertebral bodies and the intervertebral discs, with some differences in shape between the three sections. The lateral surface has the spinous and transverse apophysis protrusions, with different characteristics in the three areas. The posterior surface has a number of spinous processes that are double-ended in the cervical section, and with a rounded head jutting out in the other two sections.

The total length of the column varies depending on age, sex and individual constitutional characteristics. In males, it also varies slightly in ratio with stature. Some anthropometric findings: the average total length in an adult male with a statue of 170cm (5ft 7in) is 73-75cm (28¾-29½in); in women: 60-65cm (23½-25½in). The average length of the individual sections: cervical 13-14cm (5-5½in); thoracic 27-29cm (10½-11½in); lumbar 17-18cm (6¾-7in); sacrococcygeal 12-15cm (4¾-6in).

In the anatomical position, the body's line of gravity runs along the vertical line of the vertebral column, in front of the body of the T2 vertebra, in the centre of the T12 vertebra, in front of the body of L5 vertebra, and then descends to the ground, within the area where the feet are placed. The natural (physiological) curvatures of the vertebral column only appear in lateral projection, there is no lateral curvature in the front or dorsal projections. Only in pathological conditions, even slight ones (which are rather frequent), is it possible to deduce scoliosis by observing the figure live. Scoliosis is an anomalous lateral curvature of the column, to varying degrees and extents.

ARTHROLOGY

Vertebrae are connected by joints reinforced by several strong ligaments that lend considerable robustness to the entire vertebral column as well as mobility and elasticity. Joints can be separated into two functional groups: the joints between the vertebral bodies are synarthroses (symphysis); the joints between the articular processes are diarthroses (arthrodia). There are also the joints between the vertebrae and the skull, which have particular characteristics of note.

- **The joints between the vertebral bodies.** There is a fibrocartilaginous, lens-shaped disc, which is thinner on the perimeter and rounded in the centre, between the bodies of two consecutive vertebrae. In the central part, the disc's thickness increases in a craniocaudal direction: 3mm (⅛in) at the neck,

5mm (¼in) in the dorsal section, 9mm (⅜in) in the lumbar section and progressively decreases with age, due to dehydration and alteration of the fibres, in particular the fibres in the gel-like central nucleus. The intervertebral discs have a cushioning function for weight loads and pressures of movement from the parts overlying the column and form a series of functional units, known as intervertebral symphyses, with the longitudinal ligaments.

- **The joints between the articular processes.** These are arthrodic diarthroses, except in the lumbar region, where the rounded articular surfaces make them closer to condyles. They are small joints where the bone heads in contact with each other are wrapped in a capsule strengthened by thin ligaments: they therefore have little possibility of movement, especially in rotation, but the sum of these several small spacers provides the entire column with considerable flexibility in all directions.

The vertebral column's ligament system is formed by a group of longitudinal ligaments which extends to the entire column and a group of ligaments which joins the arches of adjacent vertebrae. The longitudinal ligaments are arranged on the anterior surfaces of the vertebral bodies: the anterior ligament, which starts off thin at the base of the occipital and extends as a band over all the vertebrae to the pelvic surface of the sacrum; and on the posterior surfaces: the posterior ligament, which starts from the endocranial face of the base of the occipital bone and continues in short bundles between adjacent vertebrae, covered by long bundles, down to the sacrum. Particular ligaments, known as the anterior, lateral and posterior sacrococcygeal ligaments, join the sacrum and the coccyx.

The ligaments between the vertebral arches are short, fibrous bundles which extend from one vertebra to the next, closing the spaces between the bone processes. We can identify: the interlaminar ligaments, known as yellow ligaments (because they contain a large amount of elastic material which lends them this colour), which join the lower margin of a vertebral arch with the upper border of the adjacent vertebral arch; the intertransversal ligaments, which are positioned vertically to join one transverse process to the next; and interspinous ligaments, which join the adjacent processes and are strengthened by a (supraspinous) ligament which extends along the entire column. This ligament is especially developed around the cervical vertebrae level, where it is known as the nuchal ligament; it takes on the form of a triangular lamina between the base of the occipital bone, the external occipital protuberance and the spinous processes. It is extremely important for helping to maintain the position of equilibrium for the head on the occipital condyles and on the cervical column.

- **The craniovertebral joints.** These run between the occipital bone and the first two vertebrae which, for bone and ligament construction reasons, are considered to be a part of a single functional complex.

The atlanto-occipital joint is paired as it is formed between the two occipital condyles and the superior articular cavities of the atlas' two lateral masses, surrounded by the capsule and strengthened by anterior and posterior ligaments. Movements are mostly flexion and extension, but are rather limited and occur in synergy with those of the other adjacent joints.

The atlanto-axial joints are paired and form between the inferior articular surfaces of the atlas (C1) and the upper articular surfaces of the axis (C2). They are reinforced by thin anterior and posterior ligaments which can be modified and allow slight forward and backward sliding movements.

The atlanto-odontoid joint forms a contact between the articular surface of the axis tooth and the anterior arch of the atlas; it is a hinge diarthrosis joint and is strengthened by several ligaments: the transverse ligament, cruciate ligaments, alar ligament and tectorial membrane, which together form a strong connection between the odontoid process, the atlas and the occipital bone. The head can rotate laterally thanks to this joint, acting as a pivot on the axial tooth and the maximum breadth of movement is due to the sum of single torsion movements of the subsequent cervical vertebrae.

• Structural aspects of the vertebral column

The vertebral column is the fundamental structural element of the skeleton (just think that, biologically, it is considered to be one of the most distinctive characteristics of vertebrates), as it is a robust, flexible and supportive point of connection for myriad bones in other areas of the body.

Flexibility is largely due to the ease of curving forward. The body forms a continuous arch, with a more limited extension concentrated on the cervical and lumbar regions. The mechanical limits are due to the overlapping of the vertebral processes and, above all, the presence

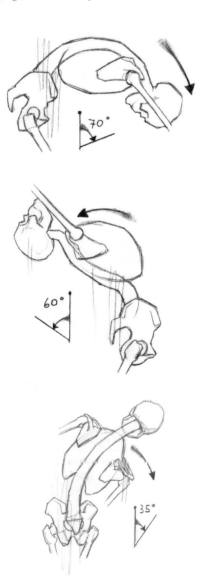

Normal limits of flexion, extension and lateral flexion movements in the trunk of a typical person.

of ligaments between the bodies: the loosening of the ligaments (either due to age or physical exercise) allows a greater breadth of flexion and extension than normal.

Lateral flexion movements are rather limited. The vertebral column is essential for the body's static position as, in the erect position, it receives the weight of the head and the upper limbs, supports the thoracic organs, discharges the overall weight onto the ground through the lower limbs, and evenly distributes the weight on the pelvis. The curvature of the spine mechanically assists the bearing of weight, bringing the axis of equilibrium closer to the line of gravity.

However, the characteristics of the vertebral column are mostly highlighted in the body's dynamic movements. The column's movements, as already mentioned, are flexion, extension, lateral inclination, torsion and lateral rotation. The considerable range of these movements (within the limits described, owing to the shape of the vertebrae and the presence of ligaments), is due to the combination of partial movements of each vertebra and the various sections of the column. The cervical section is the most mobile, being able to carry out all the movements; the lumbar section is quite mobile, while the thoracic section has limited mobility.

The overall movement of the trunk also depends on the movement of the pelvis, as well as the column's dynamic possibilities, and also the adaptation of the pelvis to the various positions of the lower limbs.

• Functional characteristics and movements of the vertebral column

In this section, I will summarize the preceding observations. For the purposes of artistic representation of the human body, it is essential to know some of the construction characteristics of the spine (as already mentioned) and its relations with the head and the pelvis, as in this way it will be possible to correctly interpret not just the movement of the trunk, but also the positions of equilibrium for the whole body. Therefore, it may be useful to return to the topic and add a few functional-morphological observations regarding the vertebral column as a whole rather than just its individual components.

The skeletal structure that runs along the trunk in the median posterior part, from the head to the pelvis, is called the vertebral column, and forms the spine together with a strong system of joints and specific muscles. This is particularly important in static and dynamic positions of the body if we think that it has to not only support and stabilize the upper limbs and head (with any applied forces), but also ensure that they can move freely. These characteristics are associated with a particular anatomical structure, formed by several separate elements of bone which, from a functional aspect, are closely linked in order to ensure solidity (static function) and mobility (dynamic function) at the same time. The vertebral column is formed from a number of overlapping bones, the vertebrae, of which there are normally thirty-two or thirty-three, divided into five segments: seven cervical vertebrae (corresponding to the neck), twelve thoracic vertebrae which connect to the same number of pairs of ribs, five lumbar vertebrae, five sacral vertebrae and three or four coccygeal vertebrae, which are small and rudimentary. While the first three segments are mobile, the last two sections are formed by bones that are fused together, therefore without possibility of movement, and are an integral part of the pelvis, connecting the two iliac bones. Almost all the vertebrae (with a few exceptions, such as, for example: the atlas, the first cervical vertebra connecting with the occipital) have some of their own morphological characteristics which allow them to be easily allocated to the segment they belong to, but which also have common construction parts. A typical vertebra of the mobile portions is formed by different parts fused together to form a single bone:

- the cylindrical body, with slightly concave superior and inferior surfaces (to house the intervertebral disc), which become progressively stronger and larger from the cervical vertebrae to the lumbar vertebrae
- the rounded arch, located posteriorly, borders the vertebral foramen
- the superior and inferior articular processes (on each side), connecting with the corresponding processes of the adjacent vertebrae
- transverse processes, which are positioned postero-laterally
- the median, unpaired spinous process, which is directed dorsally, slightly lower down.

The structural complexity of vertebrae is also justified by the main functions that the whole vertebral column carries out: supporting the trunk, allowing mobility and protecting the spinal cord (the nerve bundle that originates in the canal formed by the overlapping of vertebral foramina).

Observing the vertebral column laterally, as well as the tendency for vertebrae to increase in volume from the cervical to the lumbar ones (for the obvious reason of having to support progressively greater weight), it can be noted that there are also at least three physiological curves, which give an S shape to the spine: cervical lordosis, dorsal kyphosis, and lumbar lordosis. As we know, these curves become more marked in elderly people or in pathological conditions and cause the entire back to curve.

The column seen from an antero-posterior position (frontal and dorsal) appears to be straight, except in the rather frequent cases in which there is a lateral curvature (scoliosis, which is not necessarily pathological if only slight), especially in the thoracic section, thus causing postural adaptations. These characteristics of external morphology are sometimes perceivable on models and it is therefore necessary to keep them in mind to capture the meaning of a deviation from normality and possibly correct them in artistic representation. The vertebrae that form the column are connected by joints which differ according to the shape of the parts that come into contact.

- The joints between the vertebral bodies are synarthroses (symphyses, or immobile), where the surfaces of the adjacent vertebral bodies of the vertebrae are joined by the intervertebral discs. These are formed by fibrous tissue which vary in density, being denser at the peripheral section and more gelatinous in the centre. This has a weight-bearing or shock-absorbing function, as well as increasing the range of movement for each single vertebra. It is common knowledge that, with age, the discs degenerate and thin, causing a reduction in movement of the trunk in the elderly person and also a decrease in height, sometimes of a few centimetres (an inch or two).
- The joints between the articular processes are diarthroses (arthrodia) covered by articular capsules. They allow movements in varying degrees and directions, depending on the sections. These are mostly flexion and extension movements.
- Some other types of joint can be found in certain sites along the column, for example: the atlanto-occipital joint (between C1 and the occipital bone), the costotransverse joints (between the thoracic vertebrae and the ribs) and the lumbosacral joint (between L5 and the sacrum).

The joints of the vertebral column are strengthened by several ligaments, which ensure robustness and flexibility for the entire structure. The ligaments common to the entire column (others are arranged between adjacent vertebrae or small groups of vertebrae) are: the anterior longitudinal ligament, along the anterior surface of the bodies, from the atlas to the sacrum; the posterior longitudinal ligament, along the posterior surface of the vertebral bodies; and the supraspinous ligament, which passes over the spinous processes, especially from C7 to the sacrum (in the cervical section, it takes the name nuchal ligament, and is quite strong, to keep the head in a balanced position without excessive muscle strain).

There are several muscles which act on the vertebral column and are arranged in rather complex, overlapping layers, separated into muscles of the vertebral column (or paravertebral muscles, which start next to the vertebrae and act directly on them) and muscles of the dorsal and abdominal wall. These work with the previous muscles and the axioappendicular muscles of the upper and lower limbs, to create static positions and various movements for the trunk (flexion, extension, rotation, lateral inclination).

Detailed knowledge of each part of the motor muscle structure in the vertebral column is not essential for the artist, of course, as many of them are located at depth and are therefore not directly visible. It is, however, of academic interest and useful for the representation of nudes to consider the main muscle groups at least, divided according to the functions and actions that they carry out overall and in synergy.

The extending action of the vertebral column is due to:
- the sacrospinal muscles, which run posteriorly to the column from the sacrum to the nape of the neck, forming a muscle system with several layers of short bundles that are stretched between the arches and the spinous processes of adjacent vertebrae
- the long dorsal muscles, which run diagonally from the sacrum and the lumbar vertebrae to the ribs; the splenius muscles, which go from the cervical column to the occipital bone and extend the head
- the trapezius which, together with other muscles stretched from the scapula to the occipital bone, extends the head and the neck.

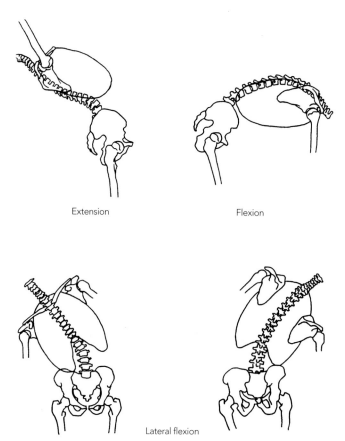

Extension Flexion

Lateral flexion

Variation in vertebral column curvature.

The flexing action is mostly carried out by the abdominal muscles, which bring the thorax closer to the pelvis (especially the rectus abdominis muscles), as they are inserted onto the ribs and the pelvis, and also allow rotation with lateral flexion (especially the internal and external oblique muscles). The iliopsoas muscles, located in the pelvic cavity and stretched between the lumbar vertebrae and the femurs, also act here, along with the supra- and infrahyoid muscles, the platysma, and the sternocleidomastoid muscles, all aiding flexion and rotation of the head and the neck.

Rotation is carried out by the same muscles that flex the column when they are contracted on one side only. Here, we can also add the scalenus muscles and the short nuchal muscles at the level of the head and neck (the most mobile section of the vertebral column).

However, full rotation movement of the whole column requires the combined action of a number of muscles on both sides, and also the rotating paravertebral muscles.

Lumbar lateral flexion is achieved by the quadratus lumborum muscles (which reach the twelfth ribs, the costiform processes of the lumbar vertebrae and the iliac crest), the psoas muscle and the internal and external oblique muscles. In the cervical section, it is carried out by the splenius muscles (between the first four cervical vertebrae and the upper corner of the scapula), the scalenus muscles (between the cervical vertebrae and the first two ribs) and partly by the sternocleidomastoid muscle (stretched between the sternum, the clavicle and the temporal mastoid process). Lateral flexion is also assisted along the vertebral column by the paravertebral set of transverse and intertransverse muscles. The main functions of the vertebral column have already been mentioned: supporting the trunk, protecting the marrow and ensuring mobility.

The function of stability, or statics, is fully carried out by the overlapping element structures (vertebrae) which allow elasticity, essential for cushioning recoil and for maintaining the erect position through physiological curvatures. In fact, the various segments of the column receive and suitably discharge the weight of the overlying body parts in order to concentrate them on the axis of gravity which, in the erect anatomic position, from the occipital bone and on the median plane, crosses the body of the L4 vertebra. It passes through the centre of the pelvis and reaches the area where the feet are placed.

The function of mobility is also allowed by the same characteristics of construction, therefore the slight movements between the individual vertebrae (while limited by the shape of the processes and by the articular ligaments) add up along the entire column and allow wide flexibility: just consider the high degree of flexion and extension that can be achieved by contortionists, which is the result of long training associated started at a young age and an unusal laxity in the ligaments.

The movements that the vertebral column can normally carry out, therefore, are as follows:

- **Flexion**. This is the forward and downward bending along the sagittal plane. This is achieved by compressing the anterior portion of the intervertebral discs, especially in the cervical and lumbar sections but less so in the upper thoracic section, due to the conformation of the rib cage.

- **Extension**. Backward movement along the sagittal plane; this is in the cervical section, and in particular in the lumbar region (lumbosacral joint), but is mechanically limited by the protrusions of the spinous processes.

 (Note: In both flexion and extension, the physiological curves are reduced or eliminated, reaching an accentuated continuous curve in maximum flexion, while in extension, the thoracic section and part of the lumbar section tend to straighten out.)

- **Rotation (or torsion)**. This is movement to the right or left side on a horizontal plane. It is achieved mainly in the cervical section, and in the thoracic section (to the limits of the rib cage), while it is less possible in the lumbar section due to the strong articular and ligamentous connections.

- **Lateral flexion.** This is bending to the side on a frontal plane; it is mostly possible in the cervical and lumbar sections, but is limited by the ribs and in the muscle-ligamentous system, therefore flexion movements are almost always associated with moderate torsion.

- **Circumduction**. This is the successive combination of various movements and is rather limited, except in the cervical section.

The vertebral column, which occupies the whole posterior median part of the trunk, is largely covered by the back muscles and relatively robust fasciae. Therefore the external morphology of the region, considering the body in an anatomical position, presents some unobtrusive characteristics which are rather important for an effective drawing or modelling of the human trunk. The spinous processes are the only elements in the vertebrae where the apices are subcutaneous. They run along a vertical groove which is deeper in the lumbar section, bordered by the protuberances of the superficial and deep dorsal muscles, which are extremely robust and almost column-like in the lumbar section. The processes are almost entirely invisible along the whole groove, except at C7 (known as the vertebra prominens) and the top thoracic vertebrae, where they are well outlined on the surface.

In the same position, however, it is easy to locate some of the other vertebrae (especially useful for the sculptor), if we consider some reference points. For example: the transversal line that joins the lower corners of the scapular bones crosses the spinous process of the vertebra T7, and the line which joins the peaks of the iliac crests crosses the spine at vertebra L4.

The spinous processes become even less evident in extension, as they move deeper into the groove, but emerge as clear subcutaneous ovoid-shaped elevations, arranged in a row at even distances from each other, during anterior flexion, as the muscles flatten out on to the rib cage, making the groove disappear.

Movements of the vertebral column also determine other external morphological variations in the whole trunk (such as abdominal folds, the emergence of ribs and costal arch, bending of the pelvis, and scapular and clavicular movements etc.) which can easily be seen *in vivo*, especially in an athletic male type, and above all if the movement is carried out slowly and repeatedly, rather than attaining and fixing these movements in any phase.

MYOLOGY

The muscles of the vertebral column are made up of several small paravertebral muscles that are grouped together in homofunctional groups: iliocostalis, longissimus, spinal, multifidus, intertransversal, interspinous, etc., and these are briefly described in the next section, together with other muscles from various sections of the trunk. Generally, the muscles and ligaments used to extend and flex the column are strong and powerful and better organized than the ones used for lateral flexion and rotation. Some mention of the overall characteristics of the spine's muscles has already been made in the summary observations contained in the previous chapter.

THE NECK

OSTEOLOGY

The skeletal component corresponding to the neck comprises the cervical section of the vertebral column, that is, the first seven vertebrae, which have already been examined. In the neck, there are also two important structures for the region's external morphology, a bone (hyoid bone) and cartilage (thyroid cartilage).

The hyoid bone (os hyoideum), named thus due to the similarity with the shape of the corresponding Greek letter, is located superficially in the top part of the neck, just below the base of the mandible; it is semi-circular in shape and has a median body that extends behind and upwards into two thin horns on each side – the lesser and greater horns. The hyoid bone supports the thyroid cartilage, to which a membrane is joined, and is the attachment for several neck and oral cavity muscles.

The thyroid cartilage belongs to the larynx, the first segment of the lower airways, and is a cartilaginous structure which is visible in a living person and is mobile when swallowing. The cartilage is formed by two flattened laminae which are more or less quadrangular in shape, directed anteromedially and joined on the median side, forming a sharp edge. The curved upper border is located about 2cm (¾in) below the hyoid bone, to which it is joined by a membrane. The entire cartilage, about 3cm (1¼in) high, can be found between the levels of C4 and C5 vertebrae. The female larynx, and therefore the thyroid cartilage, is usually smaller than that of the male. Below the thyroid cartilage and other small adjacent formations, the trachea begins, with its overlapping ring-like characteristics which are sometimes visible when the head and neck are greatly extended.

ARTHROLOGY

(Corresponds to that of the cervical section of the vertebral column, see page 114.)

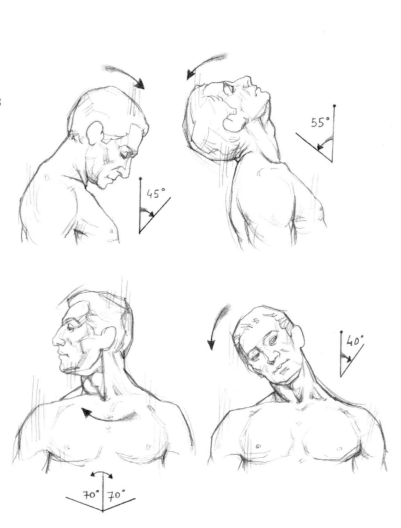

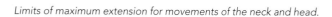

Limits of maximum extension for movements of the neck and head.

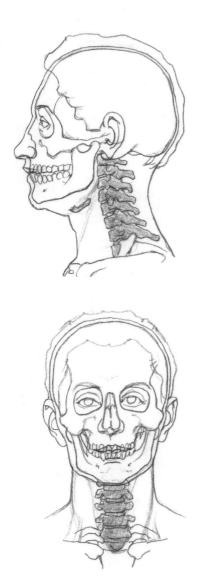

Projection of the cervical vertebral section and the hyoid bone on the external shapes of the neck.

THE CHEST

OSTEOLOGY

The skeleton of the chest comprises the twelve vertebrae of the thoracic section of the vertebral column and twelve pairs of bones, the ribs, which are articulated dorsally with the vertebrae and ventrally with an unpaired median bone, the sternum, by means of cartilage. These bones form the rib cage. Due to topographical location, the shoulder girdle is also included in the description of the thoracic skeleton, comprising the clavicle and the scapula which, from a functional point of view, are related to the upper limbs.

- The ribs (costae) are flat, curved bones, with a vertebral extremity, a body and a sternal extremity. The twelve pairs of ribs can be divided into two groups: the first seven which are the true ribs (or sternal ribs), articulated by a single cartilage directly on to the sternum; and the remaining five pairs of false ribs, the first three of which are known as asternal, as they join to the sternum only indirectly through a cartilage arch which is fused with the cartilage of the seventh true rib; and the last two pairs are known as floating ribs, as they are not jointed to the sternum and their extremities are free.

 In the ribs we can see: a vertebral extremity, the head of which articulates with the vertebrae; and the subsequent section known as the neck which, after forming a costal angle and a slight torsion, becomes the flat, semi-circular body; and a sternal extremity, which is articulated directly on to the sternum via a segment of cartilage. Each rib varies in torsion and extent of curvature, which increases from the first to the tenth, while the floating ribs are short and hardly curved.

- There are ten costal cartilages, which are flat and join the anterior end of the ribs with the lateral border of the sternum. Although they are not bone, they are always left in situ in the preparations of articulated skeletons, for reasons of support and mechanical connection of the ribs. The cartilages vary in length: the first is very short – approximately 2cm (¾in); the subsequent ones are longer: the second and third 3cm (1¼in), the seventh 12cm (4¾in). The last three asternal ribs are joined to a single cartilage section which forms the curved lower border of the rib cage (costal arch).

- The sternum is a median, unpaired and flat bone, positioned anteriorly in the rib cage and to which the ribs join. It is about 20cm (8in) long and comprises three parts: firstly the manubrium, that is the upper flat, quadrangular portion, with two small lateral surfaces that join with the clavicles and have a marked notch on the upper margin; and the body, a flattened, elongated and slightly convex oval with small transversal ridges. This joins with the manubrium, forming a slight angle (sternal angle) which is a useful landmark for the second rib; the lateral margins contain the articular facets for the costal cartilages; the xiphoid (or ensiform) process, a small bony appendix, is about 1cm (⅜in) long and varies in shape, but is slightly cone-shaped. The sternum slopes forward from top to bottom; the slope in women is slightly less marked than in men, making it more vertical, and it can change due to illness or age.

Right-hand scapula

Posterior surface (dorsal)

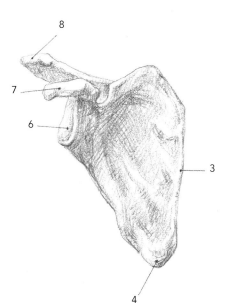

Anterior surface (costal)

Lateral projection

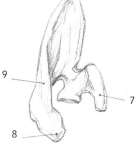

Superior projection

1 - Medial angle
2 - Supraspinatus fossa
3 - Medial border (vertebral)
4 - Inferior angle
5 - Infraspinatus fossa
6 - Glenoid cavity
7 - Coracoid process
8 - Acromion
9 - Scapular spine

- The clavicle (clavicula) is a long, flat, slightly undulating bone. It has a cylinder-shaped body and two extremities: a flat lateral (acromial) one, with the articular facet joining with the acromion of the scapula; and a medial (sternal) one joining with the sternum. The larger axis of the clavicle is almost horizontal.

- The scapula is a flat, triangular bone with its base at the top and its apex facing caudally. There are some distinctive parts: a triangular laminar part with two surfaces, anterior (or costal, as it faces the ribs) and posterior, (superficial, with the spine protuberance); the scapular spine, a large protruding process from the dorsal face, which is flat, concave and elevated, articulated at its acromial end with the clavicle; the coracoid process, which is a curved, cylinder-shaped process originating from the superior border of the scapula, laterally and opposite the acromion. The glenoid cavity is located on the lateral border, joining with the head of the humerus (see upper limb). The scapula is a paired bone of medium height, located on the posterior wall of the rib cage, extending from the third to the seventh ribs, with the vertebral border parallel with the column (in the anatomical position). The scapula, jointly with the clavicle, undergoes movement in relation to movement of the upper limb.

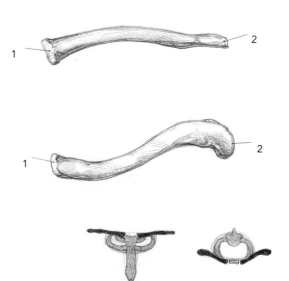

Left clavicle in frontal and superior projection and its position in the shoulder girdle.
1 - Sternal extremity
2 - Acromial head

• The rib cage: general morphology

Overall, the rib cage is a truncated cone or a flat ovoid in the antero-posterior sense, widely open at the extremities, even more so at the lower end, and with its axis headed obliquely downwards and forwards when the individual is erect. The height of the rib cage – on average 30cm (12in) – even with individual variations, is always greater than the antero-posterior diameter, which is about 20cm (8in) at the xiphoid process and the transverse diameter which is about 28cm (11in) at the eighth rib.

The upper aperture is circular or heart-shaped, not very wide and bordered by the upper border of the sternum, the T1 vertebra and the internal border of the first ribs. The rib cage tilts forwards so that the sternal manubrium notch can be projected on to the body of the T2 vertebra. The bottom aperture (costal arch), on the other hand, is wide, with rounded edges, and is laterally rather low down, while it tends to rise up to the sternum on the median plane, marking out a triangular space with a vertex on the xiphoid process and a width that varies according to individual characteristics.

The anterior surface of the rib cage shows the sternum, the costal cartilages and the ribs, which gradually pass through the lateral surfaces; it is the smallest surface, rather flat and diagonal top to bottom. The lateral surfaces show the maximum height of the cage and its characteristic ovoidal shape. They also show all the ribs, with the downward sloping direction, parallel and with regular intercostal spaces that are slightly wider in the anterior section than the dorsal one. The posterior surface contains the thoracic section of the vertebral column, from which the ribs originate, in a downward diagonal direction.

The general shape of the rib cage varies in relation to respiratory movement and according to constitutional type: these aspects are easily detectable also *in vivo*, as the bones are largely subcutaneous or easily palpable. Based on the relations of the diameters and the form of the inferior aperture, there are narrow, long rib cages in longilineal types; low and wide rib cages in brevilineal types; and rib cages of several intermediate shapes depending on the individual characteristics such as development of muscle mass or the presence of pathological conditions. Lastly, we must mention that the rib cage is attached to the shoulder girdle: the clavicles anteriorly and the scapulae dorsally. The rib cage varies in size and proportions that are not solely individual, but also

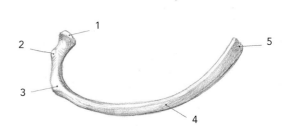

Diagram of a sternal rib.
1 - Articular head
2 - Tubercle
3 - Costal angle
4 - Body
5 - Sternal extremity

connected to age, ancestry and gender. For example, it tends to become wider and more rounded in advanced age; in the female adult the rib cage is often is shorter and with a more diagonal sternal section than in the male (barrel-chested, pigeon-chested, etc.).

ARTHROLOGY

The skeletal elements of the rib cage, ribs and sternum are articulated with each other and the vertebral column (of which we have already discussed the joints). The basic joints are the costovertebral and sternocostal ones; others (sternal joints, costochondral joints, interchondral joints) are not wholly relevant in terms of movement.

The joints in the shoulder girdle (acromioclavicular, sternoclavicular and, especially, the scapulohumeral ones which will be discussed together with the limb) provide movement to the upper limb in relation to the axial skeleton.

- The costovertebral joints are diarthroses through which the vertebral ends of the ribs are joined to the respective vertebrae. They are dual joints, as one is between the head of the rib and

Rib cage

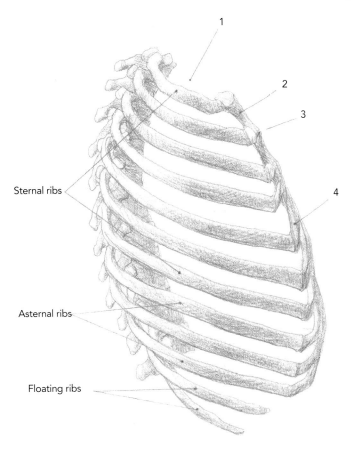

1

2

3

4

Sternal ribs

Asternal ribs

Floating ribs

Right lateral projection

1 - *Superior aperture*
2 - *Sternal manubrium*
3 - *Sternal angle*
4 - *Costal cartilage*
5 - *Jugular notch*
6 - *Sternum body*
7 - *Xiphoid process*
8 - *Costal arch*
9 - *Costal arch*

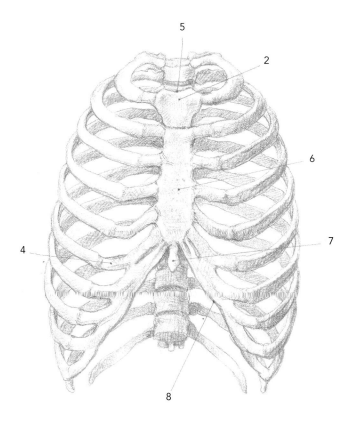

5

2

6

4

7

8

Frontal projection

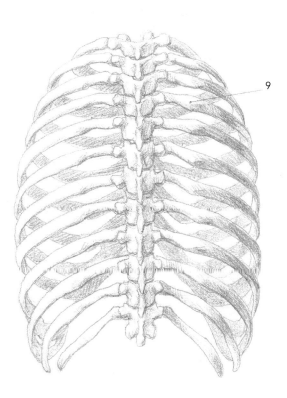

9

Dorsal projection

the articular facets of the vertebral bodies of two adjacent vertebrae, and the other is between the costal tubercle and the transverse process of the vertebra. This latter joint, known as the costotransverse joint, is missing in the last two ribs given the absence of the transverse process on the corresponding vertebrae (T11 and T12). The costovertebral joints are strengthened by strong ligaments arranged in three groups: radial ligaments (at the joint of the rib head with the vertebral body), costotransverse ligaments (between the rib tubercle and the transverse process), and the interosseous ligaments (between the transverse process and the underlying neck). Other ligaments extend onto adjacent vertebrae and respective intervertebral discs.

- The sternocostal joints are condyloid diarthroses, through which the articular sternal extremities of the costal cartilages slot into the respective articular facets on the sternum's lateral borders, wrapped in fibrous capsules that are reinforced by ligaments.

- Acromioclavicular joint. This is a diarthrosis that joins the articular facets of the lateral end of the clavicle with the scapular acromion. The joint is wrapped in the capsule and reinforced by strong ligaments: the acromioclavicular ligament, stretched superiorly to the capsule, from the acromion to the clavicle; the coracoclavicular ligament, with other ligamentous groups, joins the coracoid process to the clavicle. Movement is limited.

- The sternoclavicular joint involves the sternal section of the first rib, as well as the sternal articular head of the clavicle and the sternum's articular surface. It is a complex saddle diarthrosis joint, with an articular disc, wrapped in the capsule and reinforced by ligaments. Movements are limited and are of an angular nature, lowering and backward and forward movement. A slight circumduction is possible by putting together all these movements.

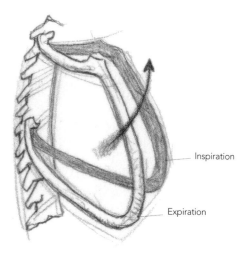

Diaphragmatic excursion (movement) limits of the rib cage during inspiration and expiration.

Inspiration

Expiration

• The movements of the rib cage and its functional characteristics

The articular parts on the rib cage indicate that the possible movements of the ribs are determined by the way the ribs are joined with the vertebrae.

Movement permitted by the dual costovertebral joints is rather limited, but the sum of individual movements allows the rib cage to dilate considerably, especially in the lower section, where diaphragmatic excursion is greater and the ribs are longer. The sternum acts as an anterior costal connection point and follows the movement of the ribs, moving upwards and outwards with them. The rib cage acts to protect the cavity organs, but its movements are essential for the mechanical movements of breathing, during which there are rhythmic increases and decreases in volume, corresponding to inspiration and expiration. During inspiration, the ribs rise and twist slightly so that the rib cage dilates in an antero-posterior direction and in a transversal direction, especially in the lower section, while the thoracic vertebral column remains immobile or undergoes a slight extension accompanied by some body movements (raising of shoulders, flattening of abdomen) which tend to aid the operation. During expiration, the opposite mechanical phenomena take place; the ribs, therefore, are lowered and the volume of the cage decreases.

For the physiological relations between thorax and abdomen, it is useful to note that the internal volumetric changes are regulated by the muscle between the two body sections, the diaphragm, and that there are two types of breathing: thoracic breathing, depending on the articular mechanisms and muscles of the rib cage, and abdominal breathing, which is regulated by the diaphragm. The two breathing modes co-exist and are integrated, but to a different degree in the two genders: in males, abdominal breathing is predominant, while in women it is thoracic breathing.

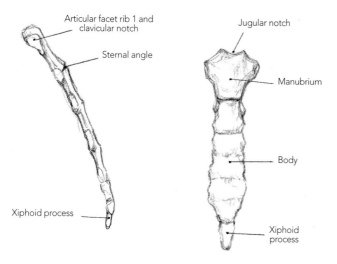

Articular facet rib 1 and clavicular notch

Sternal angle

Xiphoid process

Jugular notch

Manubrium

Body

Xiphoid process

Sternum in frontal and lateral projection (isolated from the ribs).

THE ABDOMEN

OSTEOLOGY

The main skeletal formation of the abdomen is the pelvis or pelvic girdle. Functionally, it belongs to the lower limbs, for which it is the articular and muscular point of attachment, but is also the terminal section of the bone for the trunk that it is a part of, and it integrates with the lumbar and the sacrococcygeal sections of the vertebral column as a container for the visceral organs. The pelvis also plays a fundamental role in a person's erect stance and in walking, as it receives the weight of the upper half of the body, especially via the vertebral column, and discharges it to the ground through the two lower limbs. It can be seen that the column in the abdominal section is the only skeletal support of the upper segment of the body, and that the tasks of containing the visceral cavity organs are carried out solely by the abdomen's tendinous fasciae and muscle laminae. The pelvis is a bony apparatus comprising the joining of two complex bones, the bones of the hips, articulated anteriorly between each other by a symphysis, and posteriorly with the lateral surfaces of the sacrum, via two diarthroses. The resulting structure is stable, given very limited articular movement and the presence of several ligaments.

The hip bone (ox coxae) is a large, flat, paired bone varying in thickness, but generally is thin where there are two extended parts, superior and inferior, and a narrower central part: overall there are several curves and twists. The hip bone is formed of three parts joined through synostosis: the ilium, ischium and pubis, which are fused at the acetabulum, an almost hemispherical fossa bordered by a raised edge, interrupted by a notch and serving as the housing for the femoral head.

The ilium (os ilium) is the largest part and comprises a laminar part, the wing, and a constricted part, the body, which contributes to forming the acetabulum. The iliac wing has two surfaces: an external one (gluteal surface) on which there are the inferior, anterior and posterior gluteal lines, and an internal one (iliac fossa). The iliac crest is the superior border of the wing and starts anteriorly with the anterosuperior iliac spine, ending with the posterosuperior iliac spine. The ischium (os ischii) is the posteroinferior part of the hip bone. It comprises a body that borders with the ilium in the acetabulum and a ramus that joins with the inferior hook of the pubic bone, defining a circular/triangular space (obturator foramen) and forming an angular expansion, the ischial tuberosity. Dorsally, there are two clear notches of different sizes: a superior one, the greater sciatic notch, and a smaller one, the lesser notch.

The pubic bone (os pubis) has a rather thick body which, fused with the ischium and ilium, contributes to the formation of the acetabulum cavity, and a superior, descending ramus, which is joined to the ascending branch of the ischium. The two pubic rami are the anterior and medial borders of the obturator foramen which, in the medial section where they meet, form the joint with the contralateral pubic bone (pubic symphysis).

- **Morphological characteristics of the pelvis**

The pelvis, which inferiorly encloses the trunk and surrounds a large cavity, is a truncated cone with the larger base turned upwards. On external examination, we can recognize: a posterior surface, formed by the sacrum and posterior surfaces of the ilium wing, mostly covered by ligaments; a lateral surface, which shows the external surface of the iliac wing, the acetabular cavity, the ischium and partly the obturator foramen; and a small anterior face, formed by the ischiopubic branches, the pubic symphysis and the obturator foramen, which surround the large anterosuperior aperture of the pelvis. Examination of the cavity, on the other hand, suggests a division into two sections of differing size: the greater pelvis is a vast hemispherical space, open at the top, bordered by the medial surfaces of the iliac wings; the smaller pelvis is a smaller space, almost cylindrical, positioned inferiorly to the greater pelvis, with the walls made from the posterior surfaces of the pubic bone, the ascending ischiatic rami, the coccyx and the anterior surface of the sacrum.

The pelvis is a very characteristic bone structure for the purpose of anthropological and racial investigations, as well as for the practice of obstetrics: therefore many systematic measurements have been carried out to determine the overall inclination (in relation to the horizontal line, when the subject is erect), the diameters of each cavity and the dimensional ratios. Many parameters can be measured *in vivo* too, for example the bitrochanteric diameter. Also, the pelvis is the skeletal part with the most important sexual differences: compared to the male, in the female, the iliac fossae are wider and sloping outwards (for reasons connected to childbirth), the obturator foramina are triangular (rather than oval), and they are more tilted and overall lower and wider.

ARTHOLOGY

The basic articulation of the pelvis is the one with the femur, that is, the hip joint (or coxofemoral joint) which, for functional reasons, is described when discussing the lower limb.

The joints within the pelvis, on the other hand, are almost immobile or with limited movement. There are two of them: the sacroiliac joint and the pubic symphysis.

The sacroiliac joint joins the lateral surface of the sacrum with the articular surface of the ilium: it is therefore paired, symmetrical, almost immobile (being able to carry out only small, sliding movements) and

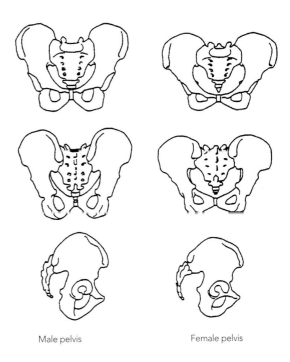

Male pelvis Female pelvis

Comparison between male pelvis and female pelvis.

the capsule reinforced by strong ligaments (anterior and posterior sacroiliac) which is stretched over it.

The pubic symphysis is unpaired, median and joins the two pubic bones via a fibrocartilaginous section, which varies in size and thickness depending on sex and age. Superiorly and anteriorly, there are some stretched fibrous ligaments which only allow the articular heads to widen slightly.

During pregnancy or under hormonal influence, the joint becomes more yielding in women, to facilitate childbirth.

There is a complex apparatus of ligaments on the pelvis which make it more stable and also contribute to bordering its cavity walls. The iliolumbar ligament is a strong group of ligaments which originate in the costal processes of the L5 and L6 vertebrae and branch off onto the sacroiliac joint. The sacrosciatic ligaments are positioned in the inferior part of the pelvis and are separated into two groups originating from the anterior surfaces of the sacrum and coccyx, one of which is directed towards the ischial spine (sacrospinous ligament) and the other towards the ischial tuberosity (sacrotuberous ligament).

MYOLOGY

The trunk is the axial part of the human body and the appendicular parts are joined to it: the upper and lower limbs. More specifically, the trunk, intended in the broadest sense, is divided into head, neck and trunk, and the latter is separated into thorax (chest), abdomen and pelvis (see page 109).

For a more useful artistic description of the external forms of the trunk in this sense (sometimes called the torso), it would be worthwhile to add the axioappendicular muscles to these, that is, those that are attached between the axial part and the appendicular part, correspond to the shoulder girdle and the pelvic girdle. However, if we categorize them according to system and function, they belong to the upper and lower limbs. In this section, therefore, a description is provided in the following text of the muscles located along the vertebral column, the neck, back, shoulder, chest, abdomen and hips, areas for which only the osteo-articular component has already been described:

- The spine muscles comprise paired, symmetrical muscle systems that are aligned in position along the vertebral column from the skull to the coccyx. They can be separated into two groups: spinal muscles (or vertebral grooves) and the ventral muscles of the spine. All these muscles are paravertebral, that is, located around the vertebral column.

- The muscles in the neck are a complex group. They can be separated into groups: the lateral (or paravertebral) muscles, comprising the scalenus muscles and covered by the platysma; the sternocleidomastoid muscle; and the muscles of the hyoid bone region (suprahyoid and infrahyoid). Some muscles (suboccipital, splenius, rectus muscles) are assigned to the spinal muscles, while the trapezius muscle determines the external morphology of the nape of the neck.

- The chest muscles comprise the intrinsic muscles, that is, the muscular organs that are inserted into the bones of the rib cage and the vertebral column, and whose main action is respiratory mechanics. These muscles are grouped into two systems: muscles in the intercostal spaces (intercostal, levatores costarum, transversus thoracis) and spinocostal muscles (serratus posterior inferior and superior). The diaphragm muscle can be added to these. However, the external morphology of the chest and the back is determined by the last axioappendicular muscles, divided into two groups: thoracoappendicular muscles (pectoralis major and minor, subclavius, serratus anterior) and spinoappendicular muscles (trapezius, latissimus dorsi, rhomboid, levator scapulae). The shoulder muscles (deltoid, subscapular, supraspinatus and infraspinatus, teres minor and teres major) can be added to these.

- The abdominal muscles comprise large muscles (quadratus lumborum, rectus abdominis, external and internal oblique muscles, transverse) and also the perineum muscles.

- The pelvic and hip muscles comprise the spinoappendicular muscle group (psoas minor, iliopsoas: from the Greek psoa = kidney, loins) and the buttock muscles (gluteus minimus, medius and maximus, internal obturator, gemellus, quadratus femoris femur and tensor fasciae latae.

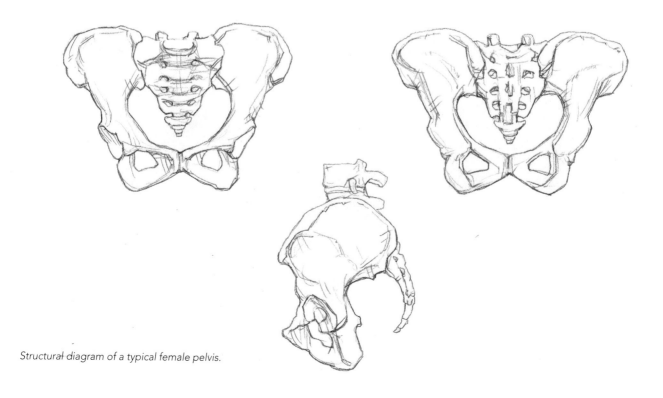

Structural diagram of a typical female pelvis.

- **Auxiliary organs for the trunk muscles**
 - **Spine:** These are the nuchal fascia and lumbodorsal fascia, the connective laminae that cover the deep muscles and separate them from the ones in the more superficial layers: trapezius, rhomboid and latissimus dorsi.

 - **Neck:** These are membranous fasciae placed at various depths. The superficial cervical fascia is the fascia plane for ventral coverage of the neck, below the integumentary plane and continuing the spinoappendicular muscle fascia of the spine. The medium cervical fascia is located deeper and is stretched between the two left and right omohyoid muscles. The deep cervical fascia is thin but strong, and adheres to the paravertebral formations.

 - **Chest and back:** These are membranous fasciae that cover the muscles in the various regions and together form a large, consistent, superficial lamina cover. These are the pectoral fascia, the deltoid fascia, the superficial fasciae of the trapezius and the latissimus dorsi, and the axillar fascia.

 - **Abdomen:** These are fasciae, both superficial and deep, which cover the abdomen muscles and that are important for containing the visceral organs. These are: external oblique muscle fascia, transverse fascia, linea alba (onto which the umbilical formation adheres), the rectus muscle sheaths, the inguinal ligament and the perineum fascia structures.

 - **Hip:** These are fasciae which cover the muscles in the buttock. The superficial gluteal fascia, which adheres to the iliac crest and extends over the gluteus maximus and over the fascia that covers the thigh, is notable. Inferiorly to the gluteus maximus, it adheres to the coccyx, forming a fold that contributes to determining the external conformation of the gluteal fold.

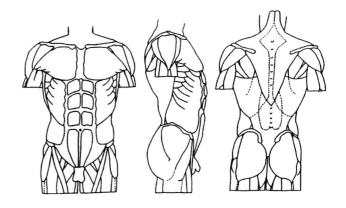

Diagram of the superficial muscles of the trunk.

Male pelvis

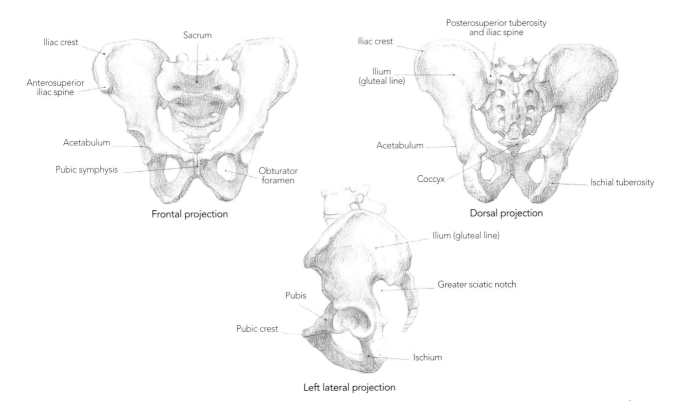

Iliac crest
Sacrum
Anterosuperior iliac spine
Acetabulum
Pubic symphysis
Obturator foramen

Frontal projection

Posterosuperior tuberosity and iliac spine
Iliac crest
Ilium (gluteal line)
Acetabulum
Coccyx
Ischial tuberosity

Dorsal projection

Ilium (gluteal line)
Greater sciatic notch
Pubis
Pubic crest
Ischium

Left lateral projection

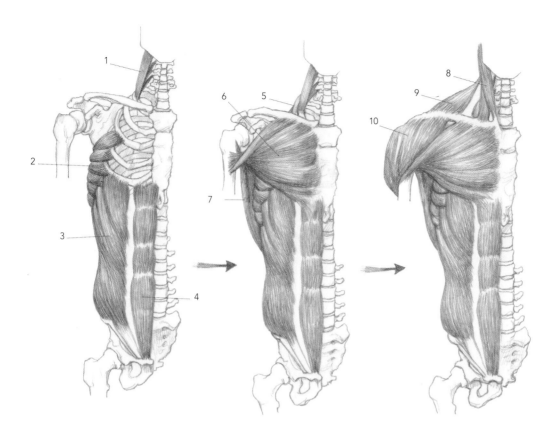

Topographical diagram of some muscles in the trunk (frontal projection) from deep layers to superficial layer.
1 - Scalenus medius
2 - Serratus anterior
3 - Abdominal external oblique
4 - Rectus abdominis
5 - Levator scapulae
6 - Serratus anterior
7 - Latissimus dorsi
8 - Sternocleidomastoid
9 - Trapezius
10 - Deltoid

Diagram of surface muscles of the trunk (frontal projection):
* - Thickness of skin and subcutaneous layer
1 - Digastric
2 - Sternohyoid
3 - Sternothyroid
4 - Sternocleidomastoid
5 - Omohyoid
6 - Trapezius
7 - Deltopectoral triangle
8 - Deltoid
9 - Pectoralis major
10 - Latissimus dorsi
11 - Triceps
12 - Biceps
13 - Serratus anterior
14 - Abdominal external oblique
15 - Rectus abdominis
16 - Pyramidal
17 - Sartorius
18 - Pectineus
19 - Adductor longus
20 - Gracilis
21 - Iliopsoas
22 - Tensor fasciae latae
23 - Gluteus medius
24 - Sheath of rectus abdominis
25 - Platysma

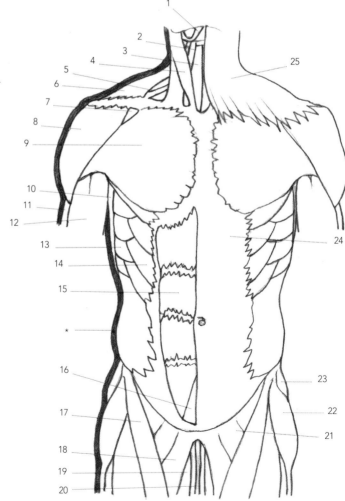

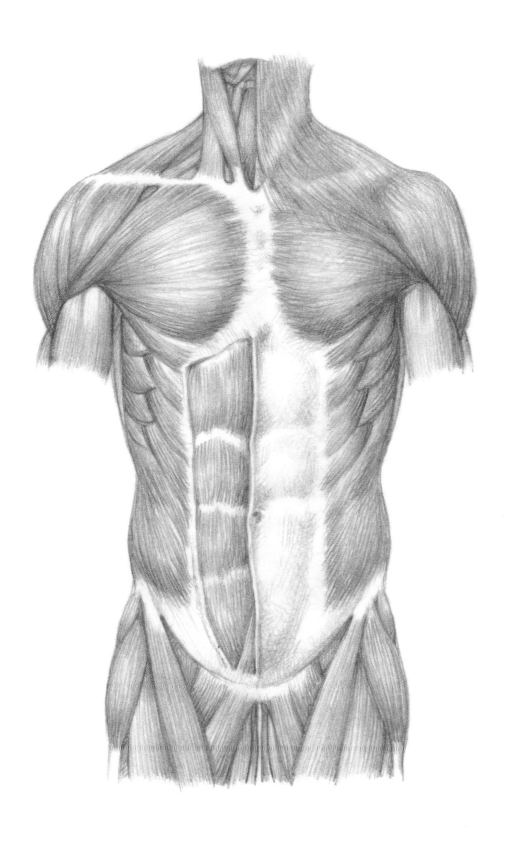

Surface muscles of the trunk: frontal projection.

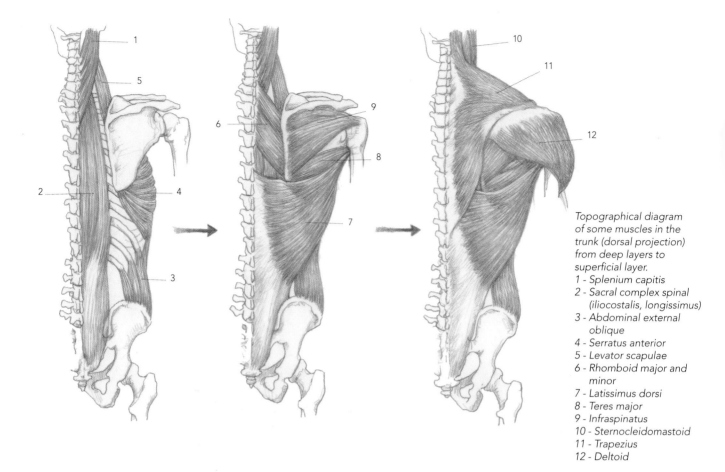

Topographical diagram of some muscles in the trunk (dorsal projection) from deep layers to superficial layer.
1 - Splenium capitis
2 - Sacral complex spinal (iliocostalis, longissimus)
3 - Abdominal external oblique
4 - Serratus anterior
5 - Levator scapulae
6 - Rhomboid major and minor
7 - Latissimus dorsi
8 - Teres major
9 - Infraspinatus
10 - Sternocleidomastoid
11 - Trapezius
12 - Deltoid

Diagram of surface muscles of the trunk (dorsal projection):
* - Thickness of skin and subcutaneous layer
1 - Splenium
2 - Trapezius
3 - Infraspinatus
4 - Teres minor
5 - Teres major
6 - Rhomboid
7 - Triceps
8 - Latissimus dorsi
9 - Abdominal external oblique
10 - Lumbar triangle
11 - Gluteus maximus
12 - Tensor fasciae latae
13 - Biceps femoris
14 - Semitendinosus
15 - Gracilis
16 - Gluteus medius
17 - Deltoid
18 - Seventh cervical vertebra
19 - Sternocleidomastoid

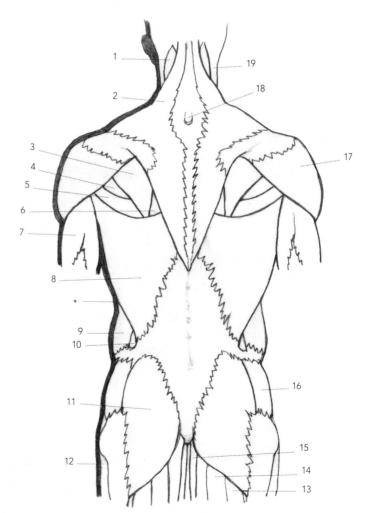

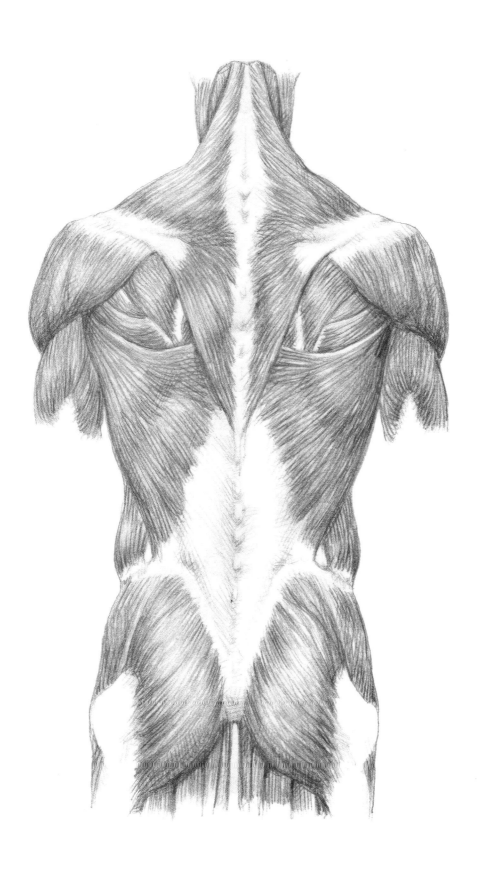

Superficial muscles of the trunk: dorsal projection.

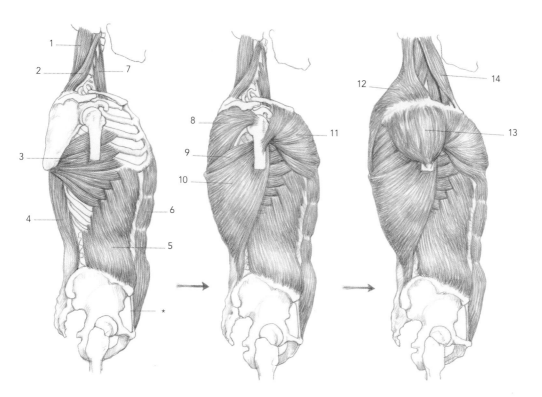

Topographical diagram of some muscles in the trunk (lateral projection) from deep layers to superficial layer

* - Inguinal ligament
1 - Splenius capitis
2 - Levator scapulae
3 - Serratus anterior
4 - Sacrospinal
5 - Abdominal external oblique
6 - Rectus abdominis
7 - Scalenus medius
8 - Infraspinatus
9 - Teres major
10 - Latissimus dorsi
11 - Pectoralis major
12 - Trapezius
13 - Deltoid
14 - Sternocleidomastoid

Diagram of surface muscles of the trunk (lateral projection):

* - Thickness of skin and subcutaneous layer
1 - Sternocleidomastoid
2 - Splenium
3 - Scalenus
4 - Trapezius
5 - Deltoid
6 - Teres major
7 - Triceps
8 - Brachial
9 - Biceps
10 - Latissimus dorsi
11 - Gluteus medius
12 - Gluteus maximus
13 - Biceps femoris
14 - Quadriceps: rectus femoris
15 - Tensor fasciae latae
16 - Sartorius
17 - Abdominal external oblique
18 - Serratus anterior
19 - Pectoralis major
20–22 - Omohyoid
21 - Sternohyoid
23 - Thyroid
24 - Rectus abdominis (sheath)

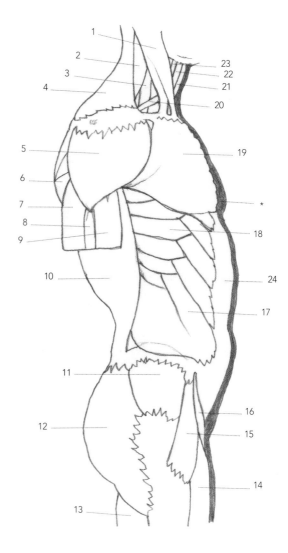

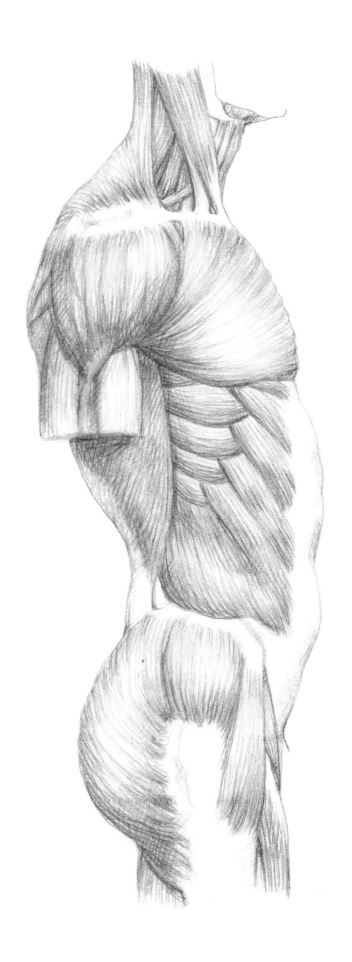

Superficial muscles of the trunk: right lateral view.

PLATYSMA MUSCLE (Platysma)

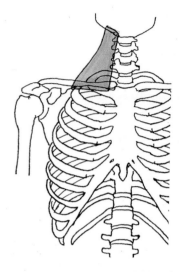

Form, structure, relations. The platysma muscle is a flat, thin and wide lamina which covers the anterolateral surface of the neck, extending from the clavicular region to the mandible and the corner of the mouth. It is considered to be a muscle of expression, a rudimentary equivalent to the panniculus carnosus of some mammals, and is subject to considerable individual variations: it can be missing, very small, limited to only one side or extend onto the facial block, or the back or the armpit. The platysma is subcutaneous, therefore its external surface touches the skin, while the deep surface, which adheres to the superficial fascia, covers the clavicle, the external jugular vein, the pectoralis major, deltoid, sternocleidomastoideus, omohyoideus, anterior belly of the digastric, mylohyoid and masseter muscles.

Origin. Fascia which covers the pectoralis major and deltoid muscles.

Insertion. Inferior border of the mandible; skin of the lower part of the face and the corner of the mouth; contralateral platysma muscle (along the medial border).

Action. Downward traction of the mandible, the corner of the mouth and lower lip; upward traction of the chest skin.

Surface anatomy. Contraction of the muscle allows the formation of several thin grooves and folds directed obliquely from the clavicle to the mandible, especially in connection with muscular effort or in intense emotional expressions: fear, pain, terror, disgust etc.. In relation to this effect, the neck appears to widen and the suprasternal notch seems deeper. In elderly individuals, the medial border of the platysma may form a vertical, rope-like fold, which also remains when the muscle is relaxed, and is placed medially to the omohyoid muscle.

STERNOCLEIDOMASTOID MUSCLE (Sternocleidomasteoideus)

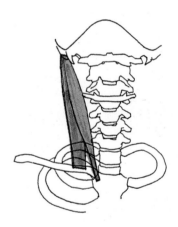

Form, structure, relations. The sternocleidomastoid muscle is a large, ribbon-like, flat formation, directly obliquely upwards and backwards from the origin towards the sternum, with the insertion on the temporal bone, crossing the lateral surface of the neck. It has two heads of separate origin: the sternal (or medial) head and the clavicular (or lateral) head, which overlap during their path (the clavicular head is behind the sternal one) and join close to the insertion point, forming a thick, rounded muscle belly. The sternal bundle originates as a cone shape and flattens immediately, reaching a width of about 2cm (¾in), while the clavicle bundle is thin and laminar, with an extended origin section.

The muscle is related to the platysma, which covers its lower half; with the skin and with the parotid gland in the upper half. The infrahyoid muscles (sternohyoid, sternothyroid, omohyoid) are located deeply; posteriorly, the muscle is in relation to the splenius, levator scapulae and the scalene muscles; at insertion, the sternocleidomastoid muscle is superficial compared with the splenius muscle, the longissimus capitis muscle and the posterior belly of the digastric muscle. The muscle can differ somewhat: it can be missing; the two heads can be completely separate, with the formation of two separate muscles (sternomastoid and cleidomastoid), and there can be anomalous insertions, connections with nearby muscles, etc..

Origin. Sternal head: superior border and upper part of the anterior surface of the sternum manubrium. Clavicular head: superior surface of the medial third of the clavicle.

Insertion. Lateral surface of the mastoid process of the temporal bone; lateral half of the superior nuchal line.

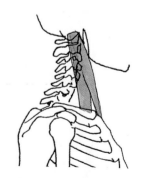

Action. Extension and flexion of the head, if contraction is bilateral; flexion and lateral rotation of the head, if the contraction is unilateral. Also, the muscle works in synergy with other neck muscles to move the head and keep it in an erect position.

Surface anatomy. The muscle is superficial, contained within the splitting of the superficial cervical fascia, covered by the platysma and the skin, and is therefore visible and palpable for the whole of its extension. It appears as an elevation at the side of the neck, directed obliquely to the area behind the auricle. The lateral region of the neck is thus divided into two triangular areas: the anterior one (supra- and infrahyoid region) is bordered by the neck's median line, from the base of the mandible, from the anterior border of the sternocleidomastoid muscle; the posterior one (supraclaveal region) is bordered by the posterior border of the sternocleidomastoid, from the middle third of the clavicle and from the anterior border of the trapezius muscle. Also clearly visible are the origin tendon of the sternal head, which appears as a rope-like bundle at the side of the jugular notch, the triangular depression between the sternal head and the clavicular head and the superficial jugular vein (see page 68).

SCALENE MUSCLES (Scalene)

The scalene muscles are the lateral group of vertebral muscles and they are the cranial continuation of the intercostal muscles. They extend obliquely downwards and laterally, from the cervical vertebral column to the first ribs, and have an inspiratory function. There are three different muscles: scalenus anterior, scalenus medius and scalenus posterior.

SCALENUS ANTERIOR MUSCLE (Scalenus anterior)

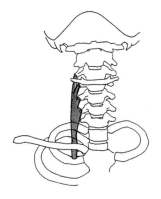

Form, structure, relations. The scalenus anterior muscle is thin and long; its various origin heads merge into a single belly directed downwards and slightly laterally, as far as the first rib. It is the most anterior of the three scalene muscles and is located deeply in the neck. Due to its particular position, it has relations with several other muscles: anteriorly, in addition to the clavicle, the omohyoid and sternocleidomastoideus muscles; posteriorly, the scalenus medius; inferiorly, the longus colli; superiorly, the longus capitis. The muscle may be missing or have anomalous or more than normal numbers of insertions.

Origin. Anterior tubercles of the transverse processes of the third, fourth, fifth and sixth cervical vertebrae.

Insertion. First rib (scalene tubercle and superior border, anteriorly at the groove for the subclavian artery).

Action. Anterior and lateral flexion (with slight rotation) of the cervical section of the vertebral column if contraction is unilateral; raising of the first rib if contraction is bilateral.

Surface anatomy. The muscle is located deeply.

SCALENUS MEDIUS MUSCLE (Scalenus medius)

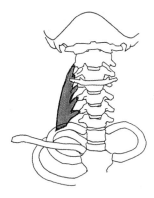

Form, structure, relations. The scalenus medius muscle is the largest of the three scalene muscles. It is long, with origins that head from the cervical vertebrae downwards and laterally, merging into a single belly, and insert onto the first rib. Its anterolateral surface is in relation to the clavicle, the omohyoid muscle and the sternocleidomastoideus muscle: the anterior border is adjacent to the scalenus anterior muscle; the posterolateral surface is connected to the scalenus posterior and levator scapulae muscles. Sometimes the muscle may be missing.

Origin. Axis (transverse process); anterior part of the posterior tubercles of the transverse processes of the last five cervical vertebrae (from C3 to C7).

Insertion. First rib (superior surface, between the costal tubercle and the subclavian artery sulcus).

Action. Lateral flexion of the cervical section of the vertebral column and raising of the first rib when breathing in.

Surface anatomy. The muscle is located deeply.

SCALENUS POSTERIOR MUSCLE (Scalenus posterior)

Form, structure, rations. The scalenus posterior muscle has a similar shape and structure to that of the other scalene muscles: it is small and thin, directed downwards and laterally until it inserts onto the second rib, where the origin heads merge into a single belly . As it is located deeply, it is mostly covered by the scalenus medius and its posterior surface is in relation to the other muscles of the spine (longissimus cervicis and longissimus capitis muscles, etc.). The muscle can sometimes be fused with the scalenus medius.

Origin. Posterior tubercles of the transverse processes of the fourth, fifth and sixth cervical vertebrae.

Action. Lateral flexion of the cervical section of the vertebral column, especially if the fixed point is on the rib; slight raising of the second rib.

Surface anatomy. The muscle is located deeply.

INFRAHYOID MUSCLES

The infrahyoid muscles are a muscle group located in the anterior region of the neck, between the hyoid bone and the bones of the shoulder girdle. There are four muscles: sternohyoideus, sternothyroideus, thyroideus and omohyoideus. Their overall action, which lowers the hyoid bone, is antagonistic to that of the suprahyoid group.

SUPRAHYOID MUSCLES

The suprahyoid muscles form a muscle group located between the mandible and the hyoid bone, mostly forming the oral cavity floor. There are four muscles: digastric, stylohyoid, mylohyoideus and geniohyoid.

MYLOHYOID MUSCLE (Mylohyoideus)

Form, stucture, relations. The mylohyoid muscle is a flat triangular lamina, stretched between the internal surface of the mandible and the body of the hyoid bone forming the muscle floor of the oral cavity, together with the muscle on the other side. The two muscles are joined by a median fibrous raphe (suprahyoid linea alba) stretched between the mandibular symphysis and the hyoid bone. Two fibre bundles of different lengths start from here, directed slightly lower, posteriorly and medially. The muscle can have several individual variations: it may be missing, fused with the contralateral part without the raphe between them (and in this case it is considered to be a single unpaired median muscle), connected to the surrounding muscles, or divided into several bundles. The superficial (or inferior) face of the mylohyoid muscle is covered by the anterior belly of the digastricus muscle on the lateral part; while the medial part is covered by the superficial cervical fascia and by the platysma. The internal (or superior) surface is related to the geniohyoid muscle, with the muscles of the body of the tongue, and with the sublingual vessels and glands.
Origin. Mandible: internal surface of the body, along the mylohyoid line.
Insertion. Body of the hyoid bone; median fibrous raphe.
Action. Elevation of the mouth floor, in the early stages of swallowing; lowering of the mandible; elevation of the hyoid bone.
Surface anatomy. The medial portion of the mylohyoid muscle is superficial, covered by the superficial cervical fascia and the skin, and it can be seen when the head is greatly extended. It appears as a rope-like elevation placed medially to the anterior belly of the digastricus muscle: between the two mylohyoid muscles, there is a slight posterior depression at the median raphe. The oral cavity floor, which the suprahyoid muscles are a part of, is upwardly concave, therefore when the head is in its anatomical position and placed in profile, it appears like a lamina that starts from the hyoid bone and works slightly upwards until it reaches the base of the mandible.

STERNOHYOID MUSCLE (Sternohyoideus)

Form, structure, relations. The sternohyoid muscle is the most superficial of the infrahyoid group. It is flat, narrow and ribbon-shaped and leads superiorly and medially from the sternum to the hyoid bone. The muscles on the two sides are separate in the original section, and come together on the median line in the insertion section, forming a triangular space where the thyroid cartilage, the thyroid gland and the sternothyroid muscles appear. This muscle is frequently missing, or fused to nearby muscles. There may be a tendinous insertion in the lower section, or a head originating in the clavicle (therefore the muscle is sometimes called sternocleidohyoid). The sternohyoid muscle covers the sternothyroid muscle, and is covered by the middle cervical fascia, the sternocleidomastoid muscle (in the lower section) and then by the superficial cervical fascia; the lateral border adjoins the superior belly of the omohyoid muscle.
Origin. Clavicle: posterior surface of the sternal extremity; posterior sternoclavicular ligament; posterosuperior surface of the sternum manubrium.
Insertion. Hyoid bone: lower border of the body.
Action. Lowering of the hyoid bone, taking part in swallowing, speaking and breathing.

Surface anatomy. Although subcutaneous, the muscle is difficult to identify: In some circumstances, in contraction, it appears as a rope-like vertical elevation, medially to the sternocleidomastoid muscle. It is separate from the medial border of the platysma because this is more superficial, located more laterally and with a more oblique direction.

DIGASTRIC MUSCLE (Digastricus)

Form, structure, relations. The digastric muscle comprises two long and thin muscle bellies, the anterior belly and the posterior belly, joined by a large intermediate tendon joining it to the hyoid bone that it is fixed on by a strong fibrous fascia. The muscle is underneath the body of the mandible and forms a downwardly concave arch, the ends of which are inserted on to the temporal bone and the mandible. The digastric muscle is the most superficial muscle in the suprahyoid group and can vary greatly: it may be missing, it may have only a single belly, or have connections with surrounding muscles, etc.. The anterior belly is covered by the superficial cervical fascia, the platysma, and covers the mylohyoid muscle; in the section next to the insertion, the posterior belly is located deeply, resting on the stylohyoid muscles, to the side of the rectus lateralis muscle, and is covered by the longus capitis, splenius and sternocleidomastoid muscles; while after being covered by the parotid gland and the submandibular gland, the remaining section is superficial at the hyoid bone.
Origin. Mastoid process of the temporal bone.
Insertion. Base of the mandible, in the digastric notch on the median line.
Action. Lowering of the mandible and raising of the hyoid bone: the two muscle bellies always act together and are a part of the swallowing mechanism.
Surface anatomy. The anterior belly is subcutaneous and easily visible when the head is extended. The base plane of the mandible is exposed in this position, and the muscle appears as a slight elevation, even when not contracted, aimed posteriorly and slightly laterally next to the mylohyoideus muscle, which is almost on the median line.

STYLOHYOID MUSCLE (Stylohyoideus)

Form, structure, relations. The stylohyoid muscle is small, thin, long, and headed obliquely downward and forwards from the styloid process to the hyoid bone. It is crossed at the insertion point by the intermediate tendon of the digastric muscle and is covered laterally, at least at the start, by the posterior belly of the digastric muscle. The stylohyoid muscle may have several individual variations: it can be missing, there may be two, it may insert onto the corner of the mandible, or it may be connected with surrounding muscles (digastric, omohyoid, styloglossus, hyoglossus, genioglossus).
Origin. Temporal bone: lateral superficial base of the upper section of the styloid process.
Insertion. Hyoid bone: lateral surface of the body, at the origin of the greater horn.
Action. Elevation and retraction of the hyoid bone. The stylohyoid muscles from both sides act at the same time and in synergy with other supra- and infrahyoid muscles. They fix the hyoid bone, and are a part of swallowing and speaking.
Surface anatomy. The muscle is located deeply.

GENIOHYOID MUSCLE (Geniohyoideus)

Form, structure, relations. The geniohyoid muscle is thin, flat, slightly cone-shaped, stretched from the mandible to the hyoid bone and positioned along the median line, deeply at the mylohyoid muscle, to which it runs almost parallel. The geniohyoid muscles on the two sides may merge along the medial border and form a single muscle with similar functions to the mylohyoid muscle.
Origin. Mandible: inferior mental spine (or genial spine) located on the posterior surface of the mandibular symphysis.
Insertion. Hyoid bone: anterior surface of the body's central section.
Action. Raising and forward movement of the hyoid bone; lowering of the mandible (when the hyoid bone is fixed).
Surface anatomy. The muscle is located deeply.

STERNOTHYROID MUSCLE (Sternothyroideus)

Form, structure, relations. The sternothyroid muscle is flat, wider than the sternohyoid muscle and located deeper. It travels vertically from the sternum to the thyroid cartilage, it covers the trachea and the anterolateral surface of the thyroid gland and is covered mostly by the sternohyoid muscle, except in the sternum section, which remains subcutaneous. The muscle is in contact with the contralateral muscle in the origin section, but subsequently, the medial borders separate slightly, causing an interval that is occupied by the underlying organs. There are many commonly occuring, natural variations in the muscle: it can be missing, it may be connected with the contralateral muscle along the median line and with the surrounding muscles, or it may have tendinous origins.

Origin. Sternum: posterior surface of the manubrium, below the origin of the sternohyoid muscle; border of the first costal cartilage.

Insertion. Oblique line of the thyroid cartilage lamina.

Action. Lowering of the larynx (when this is moved upwards, as happens when swallowing or speaking).

Surface anatomy. The muscle is not visible externally, not even in the subcutaneous section at the jugular notch.

THYROHYOID MUSCLE (Thyrohyoideus)

Form, structure, relations. The thyrohyoid muscle is small, flat, and quadrangular, and can be considered as the upward continuation of the sternothyroid, as it extends vertically from the thyroid cartilage to the hyoid bone. The muscle is covered by the sternothyroid and by the superior belly of the omohyoid muscle on the lateral border.

Origin. Oblique line of the thyroid cartilage lamina.

Insertion. Hyoid bone: inferior border of the greater horn and the body.

Action. Lowering of the hyoid bone; raising of the larynx.

Surface anatomy. The muscle is located deeply.

136

OMOHYOID MUSCLE (Omohyoideus)

Form, structure, relations. The omohyoid muscle is thin, ribbon-shaped and digastric, as it has two bellies, one upper and one lower, joined by an intermediate tendon; overall, it is stretched diagonally from origin to insertion, forming an upwards concave curve. The inferior belly is flat, narrow, directed obliquely forwards and upwards. It runs behind the clavicle, crosses the lower part of the neck (supraclaveal fossa) deeply at the trapezius muscle, and travels behind the sternocleidomastoid muscle, terminating in the intermediate tendon. The superior belly continues the muscle, starting from the tendon and heading upwards, almost vertically, to the hyoid bone. It travels parallel to the lateral border of the sternohyoid muscle, mostly covered by the sternocleidomastoid and also, for a short section, only by the middle cervical fascia, the platysma and skin.

The intermediate tendon is contained by a bundle (depending on the middle cervical fascia) that fixes it to the clavicle and the first rib, causing the angled shape of the muscle. Some variations in the muscle have been described: missing, origin of the inferior belly directly from the clavicle, merging of the superior belly with the sternohyoid muscle, etc..

Origin. Scapula (or omoplata): superior border, at the supracoracoideus scapula notch; superior transverse ligament of the scapula.

Insertion. Hyoid bone: lower border of the body.

Action. Lowering of the hyoid bone in speaking, swallowing and breathing; tension of the middle cervical fascia, favouring the blood flow of cervical blood vessels.

Surface anatomy. With certain kinds of breathing, when rotating the head or when the neck muscles are tensed, the inferior belly can appear as a rope-like elevation crossing the supraclavicular fossa diagonally, including between the posterior elevation of the trapezius muscle, the emergence of the clavicle and the sternocleidomastoid muscle. This elevation is frequently hidden or softened by the platysma muscle.

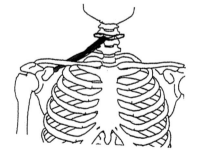

LONGUS COLLI MUSCLE (Longus colli)

Form, structure, relations. The longus colli muscle is located on the ventral surface of the vertebral column, between the third thoracic vertebra and the atlas. It is triangular in shape due to the presence of three thin muscle fibre groups: the vertical part (also called the rectus neck muscle) forms the very long base of the triangle, parallel to the vertebral column; the lower oblique part, which is rather short and directed upwards, and the upper oblique part, which is long and directed downwards, form the two converging sides to the spinous processes of the fourth and fifth cervical vertebrae.

The muscle varies greatly in the number and extension of the thin bundles that form it and may be connected to the nearby prevertebral muscles of the neck (longus colli, rectus capitis anterior and lateralis, etc.) and with the anterior and posterior scalene muscles. The posterior surface of the longus colli muscle is related to the bone surface of the vertebral column, covering the intertransversal muscles; the anterior surface is covered by the rectus capitis anterior minor and the prevertebral fascia of the neck (deep cervical fascia).

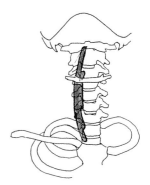

Origin. Lower oblique part: anterior surface of the first, second and third thoracic vertebrae. Upper oblique part: anterior tubercle of the transverse process of the third, fourth and fifth cervical vertebrae.

Vertical part: anterior surface of the body of the fifth, sixth and seventh cervical vertebrae and first, second and third thoracic vertebrae.

Insertion. Lower oblique part: anterior tubercle of the transverse processes of the fifth and sixth cervical vertebrae.

Upper oblique part: anterior lateral surface of the tubercle on the anterior arch of the atlas.

Vertical part: anterior surface of the body of the second, third and fourth cervical vertebrae.

Action. Anterior flexion of the neck with forward and downward movement of the head, if the muscles on both sides contract at the same time. If the muscle (especially with its oblique fibres) contracts alone, on one side only, the neck flexes and bends laterally, with a slight rotation: the upper oblique part rotates the cervical column on its side, the lower oblique part rotates it in the opposite direction. It is the antagonist of the longissimus cervicis muscle.

Surface anatomy. The muscle is deep and is not visible or palpable.

LONGUS CAPITIS MUSCLE (Longus capitis)

Form, structure, relations. The longus capitis muscle is wedge shaped, and is formed by four muscular bundles with the fibres running from the cervical vertebral processes, from which they originate very close together, running upwards and widening when they insert on to the occipital bone. Sometimes it is called the rectus capitis anterior major muscle.

The muscle runs medially to the longus colli muscle, partly covering it, together with the rectus capitis anterior muscle; its superficial face is covered by the prevertebral fascia. The number of origin heads can vary as some bundles can extend to the atlas, the axis or the contralateral muscle.

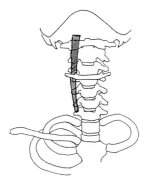

Origin. Anterior tubercles of the transverse processes from third to sixth cervical vertebrae.

Insertion. Inferior external surface of the basal part of the occipital bone, laterally to the pharyngeal tubercle.

Action. Flexion of the head and neck, if the muscles are contracted on both sides. Unilateral contraction, on the other hand, takes part in a slight lateral inclination and rotation of the head.

Surface anatomy. The muscle is not visible or palpable, as it is located deeply.

RECTUS CAPITIS ANTERIOR MUSCLE (Rectus capitis anterior)

Form, structure, relations. The rectus capitis anterior muscle is short, flat and laminar. Its fibres head upwards and almost vertically from the atlas to the occipital bone; they are located deeply, in contact with the bone surface and the atlanto-occipital joint, and are covered by the upper portion of the longus capitis muscle.

The muscle may be missing or have extra heads; in a few cases these can be identified as the intermediate rectus capitis minor muscle and internal rectus minor capitis muscle.

Origin. Anterior surface of the lateral mass of the atlas; base of the transverse process of the atlas.

Insertion. Inferior surface of the basal part of the occipitalis, anteriorly to the condyle.

Action. Flexion of the head, when contracted bilaterally, and synergically with the rectus capitis lateralis muscle; if contracted unilaterally, there is a slight lateral flexion and a slight rotation of the head.

Surface anatomy. It is a deep muscle, and therefore not visible or palpable.

RECTUS CAPITIS LATERALIS MUSCLE (Rectus capitis lateralis)

Form, structure, relations. The rectus capitis lateralis muscle is small, short, flat and directed slightly diagonally upwards, from the atlas to the occipital bone. The muscle may be missing or assimilated, even for function, by the posterior intertransversarii muscles.

Origin. Upper part of the transverse process of the atlas.

Insertion. Inferior surface of the jugular tubercle of the occipital bone.

Action. Slight flexion and lateral inclination of the head, if contracted unilaterally; however, usually the two muscles act together and in synergy with the rectus capitis anterior muscles.

Surface anatomy. It is a deep muscle, and therefore not visible or palpable.

SPLENIUS CERVICIS MUSCLE (Splenius cervicis)

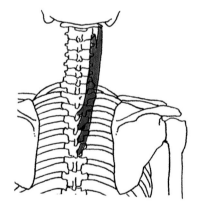

Form, structure, relations. The splenius cervicis muscle is flat and thin; its fibres run upwards, stretched from the thoracic vertebrae to the cervical vertebrae. It covers the cervical part of the sacrospinal muscle and, while rather superficial, is covered by the trapezius muscle, and partly by the serratus superior, the rhomboid, and the levator scapulae. The splenius cervicis muscle can be fused with the splenius capitis muscle or have excess bundles or it can be completely missing.

Origin. Spinous processes of the third, fourth, fifth and sixth thoracic vertebrae.

Insertion. Posterior tubercles of the transverse processes of the first, second and third cervical vertebrae.

Action. Extension of the neck (if the muscles of the two antimeres act at the same time); slight lateral rotation of the neck (if contraction is unilateral). It functions in synergy with the splenius capitis muscle, therefore both are considered to be part of a single extensory muscle group, which helps to maintain the head balanced on the cervical column.

Surface anatomy. The muscle is deep, and therefore not visible or palpable.

SPLENIUS CAPITIS MUSCLE (Splenius capitis)

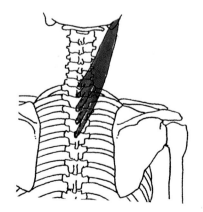

Form, structure, relations. The splenius capitis muscle is flat and rather wide, both in the origin section on the vertebral column, and in the insertion section on the skull. It is positioned obliquely. It covers the splenius cervicis muscle and the levator scapulae muscle; it is covered by the trapezius muscle and, partly, by the sternocleidomastoideus muscle. In some cases, it may be fused with the splenius cervicis muscle (see above).

Origin. Spinous processes of the seventh cervical vertebra and the first four thoracic vertebrae (from T2 to T4).

Insertion. Mastoid process of the temporal bone; occipital bone, below the lateral section of the superior nuchal line.

Action. Extension of the neck and head, if contraction is bilateral; lateral inclination of the head if the contraction is unilateral. It functions in synergy with the splenius cervicis muscle.

Surface anatomy. The muscle is located deeply, covered by the trapezius muscle and, at insertion, by the sternocleidomastoideus muscle. It is superficial for a small stretch only, in a small area of the neck between the trapezius muscle, posteriorly, and the levator scapulae and sternocleidomastoideus muscles, anteriorly.

SACROCOCCYGEAL MUSCLES

The sacrococcygeal muscles are a set of thin muscular bundles that run on the ventral surface of the sacrum and coccyx. They are rudimental and functionally insignificant.

SACROSPINALIS MUSCLE (Sacrospinalis, Erector spinae)

This muscle group is arranged parallel to the side of the vertebral column. It comprises three muscle strips (iliocostalis muscles (lateral), longissimus (intermediate) and spinal (medial)), which have common origins along the entire vertebral column. Each strip, in turn, comprises shorter sections: loins, thorax and neck. The sacrospinal muscle group is an extensor of the vertebral column; it occupies the vertebral grooves and is therefore located deeply. In the lumbar and thoracic region, it is in fact covered by the lumbodorsal aponeurotic fascia; in the lower section, by the serratus posterior inferior muscle; in the upper section, by the rhomboid and splenius muscles and by the serratus posterosuperior muscle. The muscle mass is, however, visible in the lumbar section, appearing as an elevation that runs parallel to the vertebral column, bordered laterally by a boundary that crosses the ribs, heads upwards and increases medially.

ILIOCOSTALIS MUSCLE (Iliocostalis)

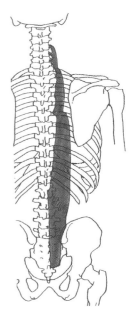

This is the lateral component of the sacrospinalis muscle and has three sections:
ILIOCOSTALIS LUMBORUM (Iliocostalis lumborum)
Origin. Dorsal surface of the sacrum; external border of the rear section of the iliac crest; spinal aponeurotic fascia (lumbodorsal).
Insertion. Lower borders of the costal angles from the twelfth to the fifth rib.
ILIOCOSTALIS THORACIS (Iliocostalis thoracis)
Origin. Upper borders of the costal angles from the twelfth to the sixth rib (medially to the insertion tendons of the iliocostalis lumborum muscles).
Insertion. Upper borders of the costal angles from the sixth to the first rib; superior surface of the transverse process of the seventh cervical vertebra.
ILIOCOSTALIS CERVICIS MUSCLE (Iliocostalis cervicis)
Origin. Costal angle of the third, fourth, fifth and sixth ribs (medially to the insertion tendons of the iliocostalis muscle of the thorax).
Insertion. Posterior tubercle of the transverse processes of the fourth, fifth and sixth cervical vertebrae.
Overall action of the iliocostalis muscle: extension of the vertebral column, if contraction is bilateral: the lumbar and thoracic section extend the trunk, the cervical section extends the neck. Unilateral contraction of the muscle causes a slight lateral flexion of the trunk in various sections.
Surface anatomy. The muscle is deep, and is not directly visible: It participates in forming the emergence of the sacrospinalis muscle only in the lumbar section.

LONGISSIMUS MUSCLE (Longissimus)

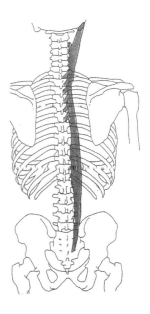

This is the intermediate part of the sacrospinalis and comprises three sections:
LONGISSIMUS THORACIS (Longissimus thoracis)
Origin. Posterior surface of the transverse processes (costal) of the lumbar vertebrae; middle layer of the lumbodorsal (or thoracolumbar) fascia.
Insertion. Apices of the transverse processes of all thoracic vertebrae; tubercles and costal angles of the last nine or ten ribs.
LONGISSIMUS CERVICIS (Longissimus cervicis)
Origin. Transverse processes from the first to the fifth thoracic vertebrae: the bundles are arranged medially to those of the longissimus thoracis.
Insertion. Posterior tubercle of the transverse processes from the second to the sixth cervical vertebrae.
LONGISSIMUS CAPITIS (Longissimus capitis)
Origin. Articular processes of the second to seventh cervical vertebrae. The muscle is located between the longissimus cervicis and the semispinalis capitis.
Insertion. Posterior surface of the temporal mastoid process, below the splenius capitis and the sternocleidomastoideus muscle.
Overall action of the longissimus muscle: extension and bending of the vertebral column, chest and neck, extension of the head (in particular the longissimus capitis) if contraction is bilateral; slight lateral flexion of the trunk and rotation of the head, if contraction is unilateral.
Surface anatomy. The muscle is located deeply (see iliocostalis).

SPINALIS (or SPINOSUS) MUSCLE (Spinalis)

This is the medial component of the sacrospinalis and has three sections:

SPINALIS THORACIS (Spinalis thoracis)
Origin. Spinous processes of the first and second lumbar vertebrae and the eleventh and twelfth thoracic vertebrae.
Insertion. Spinous processes of the first four (in some cases eight) thoracic vertebrae.

SPINALIS CERVICIS (Spinalis cervicis)
Origin. Lower part of the nuchal ligament; spinous processes of the seventh cervical vertebra and the first and second thoracic vertebrae.
Insertion. Spinous processes of the first three cervical vertebrae.

SPINALIS CAPITIS (Spinalis capitis)
Origin. Apices of the transverse processes of the seventh cervical vertebra and the first seven thoracic vertebrae; articular processes of the fifth, sixth and seventh cervical vertebrae.
Insertion. Occipital bone, between the superior nuchal line and inferior nuchal line, at the semispinalis capitis tendon.

Action of the spinalis muscle: extension of chest, neck and head. Contraction is mainly bilateral.

Surface anatomy. The muscle is located deeply, covered by the trapezius muscle.

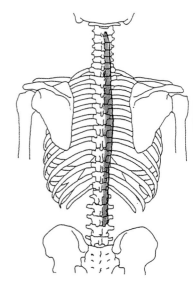

TRANSVERSUS SPINALIS MUSCLE (Transversus)

The transversus spinalis, (or spinous muscle) is an erector of the trunk and extends from the sacrum to the occipital bone. It comprises a system of muscle bundles running diagonally and medially from the transverse processes to the spinous processes of adjacent vertebrae, arranged along the entire vertebral column. The muscle is located deeply, adhering to the bone surface and covered by the sacrospinal muscle: there is a superficial layer (formed by the semispinalis muscle, of which there are three segments: thorax, neck and head), and intermediate layer (formed by the multifidus muscle) and a deep layer (formed by the rotatores, transversus and interspinales muscles).

140

SEMISPINALIS MUSCLE (Semispinalis)

This is the superficial layer of the transversus spinalis muscle. The thin bundles that form it travel vertically and extend the length of three or four vertebrae, joining the spinous processes and the transverse ones. It comprises three segments:

SEMISPINALIS THORACIS (Semispinalis thoracis)
Origin. Transverse processes of sixth to tenth thoracic vertebrae.
Insertion. Spinous processes of the first four thoracic vertebrae and the sixth and seventh cervical vertebrae.

SEMISPINALIS CERVICIS (Semispinalis cervicis)
Origin. Transverse processes of the first six thoracic vertebrae.
Insertion. Spinous processes of the first five cervical vertebrae.

SEMISPINALIS CAPITIS (Semispinalis capitis) – also called the digastric nuchal muscle as it has an intermediate and transverse tendon attachment.
Origin. Apex of the transverse processes of the first six thoracic vertebrae and the first cervical vertebrae (the muscle is located in the rear part of the neck, covered by the splenius muscle and positioned medially to the longissimus cervicis and longissimus capitis muscles).
Insertion. Occipital bone, in the medial section of the area between the superior and inferior nuchal lines.

Overall action of the semispinalis muscle: extension of the chest, neck and head if the contraction is bilateral; slight rotation of the chest, neck and head if the contraction is unilateral.

Surface anatomy. The muscle is not visible as it is located deeply.

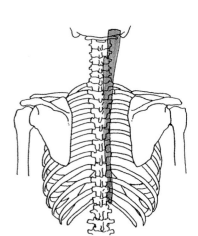

MULTIFIDUS MUSCLE (Multifidus)

Form, structure, relations. This is the intermediate layer of the transversus spinalis muscle. It has short, diagonal fibres that join the transverse processes and the spinous processes of the nearby vertebrae, running along the space of two or three vertebrae, and arranged from the sacrum to the second cervical vertebra (atlas excluded). In the neck, it is covered by the semispinalis muscle and in the dorsolumbar section, by the longissimus muscle.

Origin. Posterior surface of the sacrum; aponeurotic fascia of sacrospinalis muscle origin; posterior superior iliac spine; transverse processes from the fifth lumbar vertebra to the fourth cervical vertebra.

Insertion. Spinous processes, from one to four vertebrae over the vertebra of origin.

Action. Extension of the trunk with slight lateral flexion and rotation, if muscle contraction is unilateral. Maintaining balance and the erect position.

Surface anatomy. The muscle is not visible as it is located deeply.

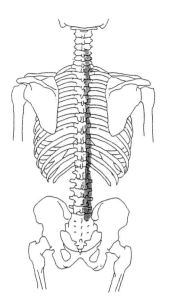

ROTATORES MUSCLES (Rotatores)

Form, structure, relations. This is the deepest layer of the transversus spinalis muscle, in contact with the bone surface of the vertebral grooves, formed by thin bundles arranged obliquely between adjacent vertebrae. It includes the rotatores muscles of the thorax (the most developed), the neck and the lumbar regions.

Origin. Superior and posterior surface of the transverse processes of the cervical, thoracic and lumbar vertebrae.

Insertion. Inferior and lateral surface of the vertebral laminae above the origin, along the entire vertebral column.

Action. Weak rotation of the trunk and maintaining the erect position.

Surface anatomy. The muscles are deep, and are therefore not visible.

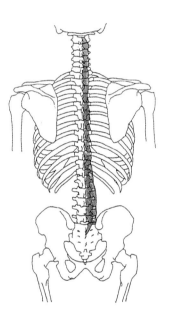

INTERTRANSVERSARII MUSCLES (Intertransversarii)

Form, structure, relations. The intertransversarii muscles are small, thin laminated bundles, the fibres of which run almost parallel to the spinal column. They are separated into three sections: lumbar, thoracic and neck areas.

Origin and insertion. Transverse processes of adjacent vertebrae along the entire column.

Action. Weak lateral flexion of the trunk and control of erect stance.

Surface anatomy. The muscles are deep, and are not visible or palpable.

INTERSPINALES MUSCLES (Interspinales)

Form, structure, relations. These are small muscle bundles placed deeply in the vertebral grooves, which join the spinous processes of adjacent vertebrae. They are arranged symmetrically at the sides of the interspinous ligament. They develop in the cervical and lumbar sections, while they are almost non-existent in the thoracic section.

Origin and insertion. Spinous apophysis of adjacent vertebrae.

Action. Extension of the trunk.

Surface anatomy. The muscles are deep, and therefore not visible.

SUBOCCIPITAL MUSCLES

The suboccipital muscles (or short nuchal muscles) are a set of four paired symmetrical muscles, positioned deeply touching the bone surface in the neck. These muscles are: rectus capitis posterior major and minor muscles, which help to extend the head by acting on the atlanto-occipital joints; and the obliquus capitis inferior and superior muscles, which rotate the head and the atlas on the axis. Overall, the suboccipital muscles are head extensor and rotator muscles, connecting the first cervical vertebrae with each other and with the occipital bone squama. They are covered by the semispinalis capitis muscles and, closer to the surface, by the trapezius muscle.

RECTUS CAPITIS POSTERIOR MINOR MUSCLE (Rectus capitis posterior minor)

Form, structure, relations. The rectus capitis posterior minor muscle is flat, positioned along the median line next to the contralateral one. It is triangular in shape: narrow at its origin and widening towards insertion. Each muscle has a medial and a lateral bundle, where the lateral border is in contact with the rectus capitis posterior major muscle.
Origin. Tubercle of the posterior atlas arch.
Insertion. Occipital bone: medial section of the inferior nuchal line and the underlying area that extends as far as the occipital foramen.
Action. Extension of the head, if the contraction is bilateral; slight lateral flexion of the head, if contraction is unilateral.
Surface anatomy. The muscle is not visible as it is located deeply.

RECTUS CAPITIS POSTERIOR MAJOR MUSCLE (Rectus capitis posterior maior)

Form, structure, relations. The rectus capitis posterior major muscle is flat, laminar, lateral to the rectus minor muscle and triangular in shape, as its origin is narrow and widens towards its insertion. Its fibres are directed upwards and laterally.
Origin. Spinous process of the axis (C2), at the tubercle.
Insertion. Occipital bone: lateral section of the inferior nuchal line and the underlying bone area.
Action. Extension of the head if the contraction is bilateral; slight rotation of the head if the contraction is unilateral.
Surface anatomy. The muscle is deep, and is therefore not visible.

OBLIQUUS CAPITIS INFERIOR MUSCLE (Obliquus capitis inferior)

Form, structure, relations. The obliquus inferior muscle is a tapered bundle, larger than the obliquus superior muscle, travelling upwards and sharply diagonally outwards from the point of origin to the point of insertion, running laterally to the rectus capitis posterior major muscle.
Origin. Lateral surface of the spinous process and adjacent portion of the upper section of the axis arch lamina.
Insertion. Posteroinferior surface of the atlas transverse process.
Action. Rotation of the head; extension of the head if contraction is bilateral.
Surface anatomy. The muscle is deep and is therefore not visible.

OBLIQUUS CAPITIS SUPERIOR MUSCLE (Obliquus capitis superior)

Form, structure, relations. The obliquus superior muscle is rather long, narrow in the origin part and wider at insertion, heading upwards and slightly medially until it covers the insertion of the rectus capitis posterior major muscle.
Origin. Upper surface of the transverse process of the atlas.
Insertion. Occipital bone, in the area between the upper and lower nuchal lines.
Action. Extension, inclination, lateral rotation of the head. By acting bilaterally, it collaborates with other suboccipital muscles in maintaining the erect position of the head.
Surface anatomy. The muscle is deep, and is therefore not visible.

DIAPHRAGM MUSCLE (Diaphragm)

This is a dome-shaped muscular, tendinous lamina which originates from the side of the rib cage and travels to a central membranous portion (phrenic centre). The diaphragm separates the thoracic cavity from the abdominal cavity and has mainly respiratory and internal-abdominal pressure regulation functions.

SERRATUS POSTERIOR SUPERIOR MUSCLE (Serratus posterior superior)

Form, structure, relations. The serratus posterior superior muscle is more or less quadrangular in shape, thin and features some digitations that, originating from a wide tendon in the first few thoracic vertebrae, head laterally downwards until they insert into the second, third, fourth and fifth rib. The muscle is located externally to the rib cage, in the posterior superior area; it covers the splenius cervicis muscle, part of the splenius capitis muscle and the other vertebral groove muscles; it is covered by the rhomboid, trapezius and levator scapulae muscles.
Origin. Lower section of the nuchal ligament; spinous processes of the seventh cervical vertebra and the first three thoracic vertebrae.
Insertion. External surface of the second, third, fourth and fifth ribs, laterally to the costal rib.
Action. Raising of the ribs, for inspiratory functions. The muscles on the two sides work in synergy.
Surface anatomy. The muscle is located deeply.

SERRATUS POSTERIOR INFERIOR MUSCLE (Serratus posterior inferior)

Form, structure, relations. The serratus posterior inferior muscle is a quadrangular lamina that originates with a wide tendon in the vertebral column and heads obliquely upwards and laterally, inserting onto the last four ribs with some digitations. The muscle is located on the external wall of the rib cage in its posterior inferior area, it covers the external intercostal muscles and the vertebral groove muscles and is covered by the latissimus dorsi muscle.
Origin. Spinous processes and supraspinous ligaments of the last two thoracic vertebrae and the first two or three lumbar vertebrae.
Insertion. External surface of the last four ribs, laterally to the costal angle.
Action. Lowering of the ribs, collaborating with the exhalation function. Muscles on both sides work in synergy.
Surface anatomy. The muscle is located deeply.

PECTORALIS MINOR MUSCLE (Pectoralis minor)

Form, structure, relations. The pectoralis minor muscle is flat, triangular and completely covered by the pectoralis major muscle. Its bundles originate with three digitations from the rib surface and travel laterally upwards, converging into a flat insertion tendon on the scapula. The muscle varies widely: it can be missing, have anomalous origin or insertion digitations, connect with nearby muscles, or have the presence of an additional bundle known as the pectoralis minimis muscle. It adheres to the upper ribs and covers some digitations of the serratus anterior muscle. An aponeurotic fascia (suspensory ligament of the axilla) detaches from the lateral inferior border of the muscle which, after wrapping round it, extends to the floor of the axillary cavity, inserting on to the subcutaneous surfaces and keeping the skin of the axilla suspended in a dome shape.
Origin. Superior border and external surface of the third, fourth and fifth ribs.
Insertion. Medial border and upper surface of the coracoid process of the scapula.
Action. Downward traction, anterior inclination and slight rotation of the scapula, with lowering of the shoulder joint. The muscle almost always acts in synergy with the serratus anterior, rhomboid, and levator scapulae muscles and can lift the ribs, intervening in forced inspiration.
Surface anatomy. The muscle is located deeply.

THORACIC MUSCLES

Intrinsic thoracic muscles are inserted onto the bones of the thorax, that is, the vertebrae and the rib cage, with a mainly respiratory mechanical action, designed to move the ribs effectively and are aided in this action by other spinoappendicular, thoracoappendicular and neck muscles. The muscles of the thorax that act on breathing actions have no influence on the body's external appearance (except for variations in volume of the chest during inspiration and expiration) and they are, therefore, mentioned merely here for the purposes of descriptive completeness.

INTERCOSTAL MUSCLES (Intercostales)

Form, structure, relations. There are external and internal intercostal muscles. Each group has eleven muscular laminae located between adjacent ribs to close the intercostal spaces from the inside and outside. The fibres in the two groups have different oblique directions, almost opposing.
Origin. Inferior border of a rib; on the external or internal border, depending on the muscle group.
Insertion. Superior border of the rib after the one on which they originate (external or internal border).
Action. Elevation of the ribs by the external intercostal muscles; depression of the ribs by the internal intercostal muscles. The overall function is that of inspiration and expiration.
Surface anatomy. They are deep muscles, completely covered by other muscles in the chest and abdomen.

SUBCOSTAL MUSCLES (Subcostales)

Form, structure, relations. The subcostal muscles are slim bundles placed on the internal surface of the rib cage, at the corner of every rib, but frequently limited to the lower ones. They are considered to be dependent on the internal intercostal muscles for their position and function.
Origin. Internal surface of the rib, in the corner.
Insertion. Internal surface of the second or third rib after the rib of origin.
Action. Lowering of the ribs.
Surface anatomy. These are deep muscles.

LEVATOR COSTARUM MUSCLES (Levatores costarurn)

Form, structure, relations. There are twelve levatores costarum muscles on each side, rather strong and triangular in shape, arranged between the vertebral column and the external surface of the ribs, at the costal angles, with a diagonal downwards and lateral direction.
Origin. Apices of the transverse processes of the seventh cervical vertebra and the first eleven thoracic vertebrae.
Insertion. Superior border and external surface of the corner of the rib underneath the vertebra from which each muscle originates.
Action. Raising the ribs.
Surface anatomy. These are deep muscles.

TRANSVERSUS THORACIS MUSCLE (Transversus thoracis)

Form, structure, relations. The transversus thoracis muscle (or sternal triangular or sternocostal muscle) is formed by some digitations, which can vary in number, travelling obliquely upwards and laterally from the origin on the internal surface of the sternum to the costal cartilages. It is therefore attached to the internal surface of the anterior thorax wall.
Origin. Inferior portion of the sternum body, on the internal surface and xiphoid process.
Insertion. Costal cartilages of the overlying ribs, up to the second.
Action. Lowering of the costal cartilages.
Surface anatomy. This is a deeply located muscle.

PECTORALIS MAJOR MUSCLE (Pectoralis major)

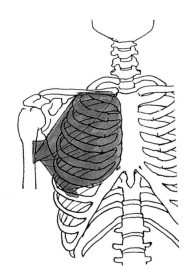

Form, structure, relations. The pectoralis major appears as a large quadrangular muscle when the arm is in the anatomical position, while it takes on a clearly triangular shape when the arm is raised to maximum extension. The muscle is wide and laminar, although in some points of the inferior-lateral border it can be up to almost 3cm (1¼in) thick, covers the entire upper part of the rib cage, extended from the wide origin section on the clavicle, to the sternum and ribs and to the narrow insertion border on the humerus. The pectoralis major comprises three parts which are determined according to the area of origin and with the fibres in different directions; the clavicular part, running laterally and downwards; the sternocostal part, running laterally; the abdominal part, running laterally and upwards. The bundles are quite large and can sometimes also be seen on the surface, lending a convexed appearance to the region. The three parts merge into the narrow insertion portion and overlap in the last part, becoming thicker and forming the anterior pillar of the axilla and the inferolateral border of the muscle. The pectoralis major, which may be totally or partially missing, or have anomalous insertions and connections with the nearby muscles, covers the ribs and the pectoralis minor muscle; its upper border is related to the deltoid muscle and also slightly covered by it. The muscle is therefore almost completely subcutaneous along its entire extension, covered by the pectoral fascia, which the mammary gland adheres to, by the platysma muscle and then by skin.

Origin. Clavicular part: medial section of the anterior border of the clavicle.
Sternocostal part: medial part of the sternum's anterior surface; costal cartilage from second to sixth rib.
Abdominal part: aponeurosis of the external oblique muscle and the rectus abdominis muscles.

Insertion. Front lip of the bicipital sulcus of the humerus, below the greater tuberosity (by a strong, flat tendon, 5–6cm (2–2⅜in) wide, comprising two laminae next to each other that come from the overlapping of the muscle bundles in the end section.

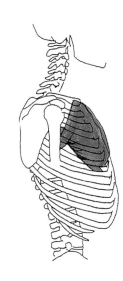

Action. Adduction (lowering the raised arm) and medial rotation of the arm; and lifting and bringing the trunk closer to the humerus, if the fixed point is on the arm (as, for example, in climbing: in this case the pectoralis muscles on both sides are aided by the latissimus dorsi, trapezius and serratus posterior superior muscles). Also raising and anterior traction of the humerus if only the clavicular bundle contracts; and lowering of the humerus and shoulder girdle if only lower bundles are contracted.

Surface anatomy. The pectoralis major muscle is subcutaneous along almost its entire extension, except for the part of the tendon for insertion and a small area covered by the deltoid. It occupies the anterosuperior quadrant of the thorax and causes a slightly convex surface that is bordered at the bottom by the muscle border, thickened by an adipose pad of various sizes, located in the lateral section. The border, which is clearly raised in the anatomical position, flattens out and disappears almost entirely if the arm is raised, while it becomes more marked if the arms are highly adducted towards the median plane. In this case, the muscle contracts, increases the volume by jutting out considerably and shows a fan-shaped number of bundles under the skin. The medial border at the sternum is also raised from the bone surface in athletes.

The mammary gland, to which the nipple corresponds on the surface, adheres to the subcutaneous surface of the pectoralis major muscle, separated from the pectoral fascia and adipose tissue, and is located at the lateral section of the inferior muscle border.

SUBSCAPULAR MUSCLE (Subscapularis)

Form, structure, relations. The subscapularis muscle is wide, flat and triangular, adheres to most of the costal surface of the scapula and laterally converges before inserting onto the upper extremity of the humerus. The anterior surface of the muscle is in relation to the serratus anterior with which, in the section next to the insertion, it helps to form the posterior wall of the axillary cavity. The tendon is crossed anteriorly by the coracobrachialis and biceps muscles (long head).

Origin. Medial area of the subscapular fossa.

Insertion. Small tuberosity of the humerus and anterior part of the scapulohumeral joint capsule. Between the tendon and the bone, there is a sliding mucous sac.

Action. Medial rotation and slight adduction of the humerus.

Surface anatomy. The subscapular muscle is deep and is not visible on the surface.

RHOMBOID MUSCLE (Rhomboideus)

Form, structure, relations. The rhomboid muscle is flat, thin at the top and a little thicker at the bottom. Its shape is as its name implies – a rhombus. Its fibres run downwards and laterally from the point of origin on the vertebral column to the insertion point on the scapula's medial border. The muscle is almost always divided into two separate, adjacent, parallel parts – the upper portion (or rhomboid minor muscle) and the lower portion (or rhomboid major muscle) – but it may have more heads of origin, or connections with nearby muscles and with the contralateral muscle. The rhomboid muscle, which covers the serratus posterior superior muscle, the splenius cervicis muscle and the levatores costarum muscles, is almost fully covered by the trapezius muscle, from which it is separated by a fascia, and also by the latissimus dorsi muscle, but only for a small part at the lower corner of the scapula.

Origin. Rhomboid major: spinous processes from the second to the fifth thoracic vertebrae and relative spinous ligaments. Rhomboid minor: spinous processes of the seventh cervical vertebra and the first thoracic vertebra; lower portion of the nuchal ligament.

Insertion. Rhomboid minor: upper section of the scapula's medial border. Rhomboid major: lower section of the scapula's medial border.

Action. Adduction of the scapula towards the vertebral column. The muscle takes part in stabilizing the scapula on the rib cage and in the extension movement of the arm.

Surface anatomy. The rhomboid muscle is almost fully covered by the trapezius, with which it works to bring about the muscle elevation located between the vertebral column and the medial border of the scapula. If the scapula is abducted (for example, when the flexed arm is placed behind the back), a small portion of the muscle may be visible under the skin in a limited area between the inferior border of the trapezius and the upper border of the latissimus dorsi: its fibres, running upwards and medially, have a perpendicular route to that of the trapezius.

SUPRASPINATUS MUSCLE (Supraspinatus)

Form, structure, relations. The supraspinatus muscle is long, triangular, flat at its point of origin, but narrower and thicker (almost 2cm/¾in) at its insertion point. The muscle is located horizontally in the fossa above the scapular spina, from which it is separated by a lamina of connective tissue, apart from in its area of origin. It is completely covered by the trapezius muscle.

Origin. Medial surface of the supraspinatus fossa of the scapula.

Insertion. Upper surface of the greater tubercle of the humerus. The tendon adheres to the scapulohumeral joint capsule.

Action. Weak abduction of the arm, with lateral rotation of the humerus; stabilization of the humerus head in the articular cavity.

Surface anatomy. The muscle is located deeper than the trapezius muscle, but when contracted (as in abduction of the limb), it can contribute to forming a visible elevation above the scapular spine, and parallel to it.

INFRASPINATUS MUSCLE (Infraspinatus)

Form, structure, relations. The infraspinatus (or subspinatus) muscle is often flat and triangular in shape. It takes up the entire subspinatus fossa of the scapula, from where it originates and from where it heads laterally and upwards until its insertion into the humerus. When considering the arrangement of the fibres, the infraspinatus muscle can be divided into three portions: the upper and lower and the middle, the latter of which is the largest and is penniform. At the bottom, the muscle touches the teres major and the latissimus dorsi; its deep surface adheres to the scapula; the superficial surface is mostly covered by other muscles: the trapezius in the upper medial corner and the deltoid laterally and at the top. The remaining area is subcutaneous, covered only by the muscle's aponeurotic fascia (infraspinatus fascia) and the skin.

Origin. Subspinatus fossa of the scapula; infraspinatus fascia; fibrous septum separating from the teres major muscle.

Insertion. Middle surface of the greater tubercle of the humerus.

Action. Lateral rotation of the humerus with slight abduction of the arm (in synergy with the supraspinatus and teres minor muscles, for the rotation action).

Surface anatomy. The subcutaneous portion of the muscle appears as a triangular elevation at the centre of the scapular region and is bordered: medially by the border of the trapezius, superolaterally by the deltoid and inferiorly by the teres major and minor muscles. The jutting out muscle area is accentuated if the arm is taken to its maximum lateral rotation, while the subcutaneous surface appears to be further extended and flattened if the arm is raised.

TERES MINOR MUSCLE (Teres minor)

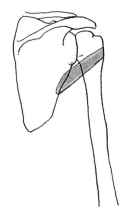

Form, structure, relations. The teres minor muscle is flat, narrow and elongated, travelling laterally and upwards from its origin to insertion on the humerus. It is contained in the same fascia that covers the infraspinatus muscle and is often fused with it. The teres minor is partly covered by the deltoid and by the infraspinatus; therefore, only a small part of it is subcutaneous. The insertion section crosses and passes behind the triceps long head tendon; the lower border touches the teres major muscle.
Origin. Upper section of the lateral border of the scapula and adjacent dorsal surface; fibrous septa of the infraspinatus fascia (it separates it from the infraspinatus muscle at the top and from the teres major at the bottom).
Insertion. Inferior face of the greater tubercle of the humerus; inferoposterior surface of the scapulohumeral joint capsule.
Action. Lateral rotation and adduction of the humerus (in part synergy with the infraspinatus and supraspinatus muscles, for the rotation element).
Surface anatomy. The teres minor muscle is only subcutaneous for a very small portion and is difficult to see on the surface, but if the limb is abducted horizontally and rotated laterally, it may look like a slight elongated elevation between the infraspinatus muscle and the teres major, close to the posterior border of the deltoid.

LATISSIMUS DORSI MUSCLE (Latissimus dorsi)

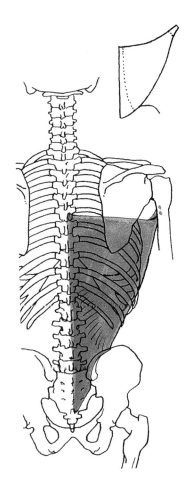

Form, structure, relations. The latissimus dorsi is a laminar muscle (the average thickness is about 5mm, but thickens closer to insertion). It is very wide, triangular in shape, and extended from the vertebral column to the humerus. The muscle originates from a large aponeurotic lamina, corresponding to the lumbar region, on which the muscle bundles trace a curved line, convex at the bottom and running laterally and downwards. There are three groups of muscle bundles in the muscle, all running upwards and laterally, but with different inclinations: the upper bundles are almost horizontal, the middle ones are upwardly diagonal and the lower ones are sharply oblique in an upward – almost vertical – direction. The insertion section is narrow, flat, borders the teres major muscle, with which it forms the posterior pillar of the axilla. The latissimus dorsi muscle, which may frequently have morphological variations in both the extension of the origin bundles, and in insertion, is subcutaneous, covered by the dorsal fascia and by skin; only a small superior medial portion is covered by the trapezius muscle. The deep surface is connected to the ribs, the vertebral muscles, the serratus posterior inferior muscle and the posterior part of the external oblique muscle; the upper border covers the lower angle of the scapula; the lower lateral border crosses and partly covers the serratus anterior muscle.
Origin. Spinous processes from the seventh to the twelfth thoracic vertebrae; spinous processes of the lumbar vertebrae, dorsal surface of the sacrum and posterior section of the iliac crest: the muscle fibres originate from these points, via a wide aponeurotic lamina that adheres to the superficial sheet of the lumbodorsal fascia. Some bundles originate from the last three or four ribs.
Insertion. Ridge of the greater tubercle of the humerus: when rotating a little on itself, the tendon covers that of the teres major muscle and between them there is a subtendinous bursa that can reduce the mechanical effects of friction.
Action. Adduction of the arm (lowering when raised) with slight medial rotation of the humerus; posterior traction of the arm and shoulder (in synergy with some trapezius muscle bundles and in antagonism with the pectoralis major muscle); raising of the trunk, if the upper limbs are fixed (as in climbing) and the two muscles act bilaterally. The muscle also takes part in forced exhalation and in the act of coughing.

Surface anatomy. The latissimus dorsi muscle is subcutaneous along almost its entire extension and as it is very thin, the shapes appearing on the surface are determined by the muscles it covers (sacrospinalis, serratus anterior) and by the bone structure of the lower part of the thorax. Especially during contraction and when the arm is abducted, the lateral border of the muscle appears quite clearly, like an elevated border that crosses the serratus anterior muscle diagonally. The lower section of the border at the iliac crest is hidden by the adipose tissue on the hip. The upper border of the latissimus dorsi runs under the trapezius for a short medial section and then covers and horizontally crosses the bottom corner of the scapula.

DELTOID MUSCLE (Deltoideus)

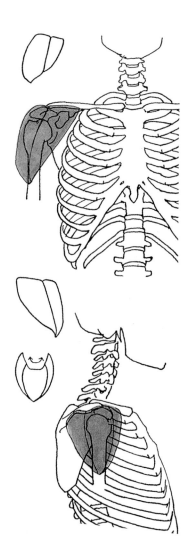

Form, structure, relations. The deltoid muscle is flat at the edges, but is also rather thick, around 2cm (¾in), in the middle portion. It is voluminous, strong and triangular in shape, with the origin base positioned on the shoulder girdle bones and the vertex aimed downwards, inserting onto the humerus. The triangular shape, similar to that of the Greek letter delta, is where the muscle gets its name from. According to the segments of origin, there are three parts making up the deltoid muscle: the clavicular (or anterior) part originates from the clavicle and its fibres travel downwards, laterally and posteriorly; the scapular (or posterior) part originates from the spine and travels downwards, laterally and anteriorly; the acromial (or intermediate) part travels downwards with a convex path onto the head of the humerus. The acromial part is the thickest and largest; it is multipennate in formation, as four intramuscular tendon septa, which originate from the tendon onto the acromion, travel downwards and merge with three other septa, which are travelling upwards and come from the tendon on the humerus. This structure has functional advantages, as it allows powerful contraction and also causes a visible secondary bundling of the muscle. The deltoid muscle frequently has morphological differences that are also of artistic interest: it may have separate, independent heads of origin, or may be partly merged with nearby muscles or inserted onto the humerus at the proximal or distal part. The muscle covers the scapulohumeral joint, the biceps muscle tendons, the pectoralis minor, pectoralis major, coracobrachialis, subscapular, infraspinatus, teres minor and triceps, and its superficial face is only covered by the muscle fascia, the subcutaneous surface and skin. A small area may be covered medially by the platysma muscle. The anterior border of the deltoideus borders with the pectoralis major, from which it is separated by the subclavicular fossa, in which the cephalic vein runs.

Origin. Clavicular part: anterior border of the lateral section of the clavicle.

Acromial part: lateral border of the acromion.

Scapular part: inferior border of the scapular spine.

Insertion. Deltoid tuberosity of the humerus. A mucosa bursa is situated between the tendon and the bone surface.

Action. Abduction of the arm (if the contraction involves the entire muscle, or the acromial part); forward traction and flexion with slight medial rotation of the humerus (contraction of the clavicular part); backward traction and extension with slight lateral rotation of the humerus (contraction of the scapular part).

Surface anatomy. The deltoideus muscle is entirely subcutaneous and determines the rounded profile of the shoulder. In the anatomical position, with the limb positioned alongside the trunk, the muscle maintains a physiological tension (tone) that makes the separation between the tree parts and the bundle structure of each of them easily visible; and these structures are accentuated when contracted. A slight cutaneous depression indicates the separation groove between the anterior border of the deltoideus muscle and the pectoralis major muscle. The upper surface of the acromion is totally subcutaneous and is a precise, identifiable reference point in all arm movements: when the arm is extended upwards, the origin border of the acromial part creates a skin fold and there is also the formation of an anterior–posterior groove.

TERES MAJOR MUSCLE (Teres maior)

Form, structure, relations. The teres major is a thick, flat muscle, cylindrical in shape and larger than the teres minor, which is positioned deeper and almost parallel to it. The muscle bundles run laterally and upwards from the origin on the scapula to the insertion point on the humerus. The muscle, which may be missing or fused with the latissimus dorsi, is mostly superficial; the lower border touches the latissimus dorsi; in the medial area, the upper border is adjacent to the infraspinatus and teres minor muscles. The insertion tendon, which is flat and about 5cm (2in), is behind the latissimus dorsi tendon (from which it is separated by a mucosa bursa) and is crossed at the back by the triceps long head tendon.

Origin. Lower corner of the scapula, in a narrow area of the posterior surface.

Insertion. Medial lip of the bicipital groove (intertubercle) of the humerus.

Action. Adduction and downward traction of the arm, with medial rotation and slight extension (in synergy with the latissimus dorsi muscle and in antagonism, by effect of the rotation, with the teres minor, which rotates the humerus laterally).

Surface anatomy. The teres major muscle is almost entirely subcutaneous and together with the latissimus dorsi, forms the posterior border of the axilla, particularly elevated if the limb is abducted or raised. If the arm is in the anatomical position, the muscle shows as a consistent elevation, almost transverse, placed laterally to the lower corner of the scapula.

TRAPEZIUS MUSCLE (Trapezius)

Form, structure, relations. The trapezius muscle owes its name to its shape – a trapezium. The longer base is located along the vertebral column and the oblique sides converge towards the shorter base located on the shoulder girdle bones. The trapezius is a large muscle lamina extended between the occipital bone, the vertebral column and the scapula. Its bundles travel laterally, but in different orientations, and based on this, the muscle is divided into three portions: the thin upper (or descending) part, directed obliquely downwards; the rather thick middle (or transverse) part, directed almost horizontally; and the thin lower (or ascending) part, directed obliquely upwards. The vertebral tendon of origin, which is rather narrow at the top, widens considerably in the middle (at the point of the sixth cervical vertebra and the first thoracic vertebrae), therefore with the muscles on both sides it forms an egg-shaped, or elongated rhombus tendinous area where the vertebral spinous processes jut out. The trapezius muscle can also have some limited variations: separate origin head or origin limited to the first ten thoracic vertebrae. It covers the deep muscles of the neck, the splenius, rhomboid and supraspinatus muscles superiorly and a small part of the latissimus dorsi muscle inferiorly. The muscle is subcutaneous and is therefore only covered by the dorsal aponeurotic fascia and the skin; its superior border comes close to the insertion point of the sternocleidomastoideus muscle and is a part of the supraclavicular space border.

Origin. Upper part: occipital (medial section of the superior nuchal line and external protuberance); nuchal ligament.

Middle part: spinous processes and supraspinatus ligaments from the first to the fifth thoracic vertebrae.

Lower part: spinous processes and supraspinatus ligaments from the sixth to the twelfth thoracic vertebrae.

Insertion. Upper part: clavicle (posterior border of the lateral section).

Middle part: scapula (medial border of the acromion and superior border of the spine).

Lower part: scapula (medial section of the upper border of the spine and triangular area of the spine).

Action. Stabilization of the scapula, taking part in abduction and flexion of the arm; elevation of the scapula (contraction of the upper part); adduction of the scapula (middle and inferior part); depression of the scapula (lower part). If contraction is bilateral, the head is extended and the scapulae approach on the medial plane.

Surface anatomy. The trapezius muscle is fully subcutaneous; its upper section determines the posterolateral curved line of the neck (cucullaris line); the thick, middle section covers the rhomboid muscle and with it forms a sizeable elevation between the vertebral column and the scapular spine; the lower section is thin, therefore its lateral borders cannot easily be distinguished underneath the skin, while its end section may appear as a sharp elevation parallel to the last thoracic vertebrae. The long origin tendon borders form a slight median groove on the posterior surface of the neck (nape) between the muscles on each side and then a larger, rhomboid-shaped depression (aponeurotic lozenge) in the centre of which the spinous process of the seventh cervical vertebra emerges.

LEVATOR SCAPULAE MUSCLE (Levator scapulae)

Form, structure, relations. The levator scapulae muscle (scapular angle) is strong, long and flat, travelling almost vertically downwards from the origin on the vertebrae to its insertion on the scapula. The muscle, which may be missing, have anomalous insertions or be connected with nearby muscles, covers the long neck muscles, the splenius muscles, the serratus posterior superior, the scalenus posterior, and is partly covered by the sternocleidomastoideus muscle laterally, and by the trapezius muscle at the rear.

Origin. Transverse processes of the first four cervical vertebrae (with four separate bundles).

Insertion. Medial border of the scapula, in the section between the superior angle and the origin of the spine.

Action. Elevation and adduction of the scapula, with medial downwards rotation of the lateral angle.

Surface anatomy. The levator scapulae muscle is only subcutaneous in the section that runs in the upper part of the supraclavicular fossa. If the head is heavily rotated with resistance or the arm is bearing a weight, the muscle appears to be a short diagonal elevation between the border of the trapezius muscle (posteriorly and inferiorly located) and the sternocleidomastoideus muscle (positioned anteriorly and superiorly).

SERRATUS ANTERIOR MUSCLE (Serratus anterior)

Form, structure, relations. The serratus anterior muscle is wide, flat, adheres to the lateral thoracic wall, from which it originates with nine or ten digitations that travel backwards and medially, until they insert into the scapula. The muscle can be divided into three parts, by origin and insertion: upper, middle and lower. The upper part has the bundles from the first two digitations, coming from the first and second rib, with an almost horizontal direction; the middle part comprises bundles originating from the second, third and fourth rib, with a diagonal direction, converging towards the insertion point; the lower part is the largest, formed by strong bundles from the remaining digitations. The muscle, which may have more or fewer digitations, or may have one of its parts missing, covers the ribs and intercostal spaces with its deep surface and is covered by the latissimus dorsi, the pectoralis major and slightly by the subclavian, pectoralis minor and subscapular muscles. Only the last four digitations are subcutaneous and cross over with the digitations from the external oblique muscle.

Origin. Upper part: first and second rib.

Middle part: Second, third, fourth and fifth ribs.

Lower part: Sixth, seventh, eighth, ninth (and sometimes tenth) ribs.

Insertion. Upper part: upper angle of the scapula.

Middle part: medial border of the scapula.

Lower part: lower angle of the scapula.

Action. Abduction of the scapula. Due to the different directions of its fibrous bundles, the serratus anterior muscle carries out different actions. Overall contraction of the muscle slightly raises the ribs (inspiratory function) and draws the scapula forwards, contributing to the anteromedial rotation of the arm, in antagonism to the rhomboid muscle's action; contraction of the upper and lower bundles adheres the scapula to the thorax, together with the rhomboid muscles; contraction of the lower bundle rotates the lower angle of the scapula laterally and forwards, thus allowing the arm to be elevated horizontally, in synergy with the trapezius and deltoideus muscles.

Surface anatomy. The serratus anterior muscle is only subcutaneous in the section containing the last four digitations, as the posterior portion is covered by the latissimus dorsi muscle and the upper portion is covered by the pectoralis major. The largest, most clearly visible digitation is the top of the four, at the submammary fold that extends lateroposteriorly, while the other three decrease progressively in size. The digitation elevations intersect obliquely, on the lateral face of the ribs, with those of the abdominal external oblique muscle which, in comparison, are less evident and small, allowing the ribs to be seen.

SUBCLAVIUS MUSCLE (Subclavius)

Form, structure, relations. The subclavius muscle is small, thin and elongated. It is triangular in shape. Its fibres are directly, sharply, obliquely upwards and laterally from the first rib to the clavicle. The muscle may be missing or substituted by a ligament, originate from the second rib, or have additional bundles. It is almost entirely covered by the clavicle, covered by an aponeurotic fascia that separates it from the pectoralis major muscle and that extends upwards towards the cervical fascia and downwards towards the membrane formation that covers the pectoralis minor.

Origin. Inferior surface of the first rib (in the costal cartilage section, laterally and posteriorly to the sternaoclaviular joint).

Insertion. Inferior surface of the clavicle, in the subclavian groove.

Action. Lowering of the clavicle and shoulder; stabilization of the sternoclavicular joint.

Surface anatomy. The muscle is located deeply.

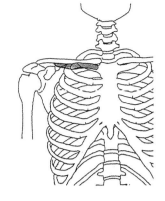

RECTUS ABDOMINIS MUSCLE (Rectus abdominis)

Form, structure, relations. The rectus abdominis muscle is located in the anterior abdominal wall, immediately to the side of the median line. The muscles of both sides run adjacent to each other, wrapped in a complex fibrous sheath and separated from a thickened section called the abdominal linea alba. The muscle bundle is ribbon-like, about 40cm (15¾in) long, about 7cm (2¾in) wide in the upper section and about 1cm (³/₈in) thick in the lower section. It travels vertically upwards from the point of origin, which is rather thick and narrow, on to the pubis, to the insertion point, which is wider, flat and divided into some digitations that reach the seventh, sixth and fifth costal cartilage. The muscle is interrupted by some tendon insertions, usually three of them: one at the navel level, one under the costal arch at about the height of the tip of the xiphoid process and a third one midway between the navel and the xiphoid process. The tendon insertions are often incomplete, and do not fully involve the entire width of the muscle; they are slightly oblique and are rarely located at the same levels in the muscles on both sides. Sometimes there may be a fourth tendon attachment, located in the section between the pubis and the navel.

The rectus abdominis muscles are wrapped in a strong fibrous sheath and are superficial: the anterior surface is covered by the sheath and skin. The deep posterior surface, covered by the transverse fascia, is directed at the abdominal cavity. The medial border is adjacent to that of the contralateral muscle, to which it is joined by the linea alba. The lateral border is in contact with the aponeurosis of the abdomen's wide muscles (internal oblique, external oblique, transverse abdominal), and then goes on to cover the entire muscle, fusing with the rectus muscle sheath.

Origin. Pubis: superior border, between the tubercle and the symphysis.

Insertion. Fifth, sixth and seventh cartilage, with branches also on the anterior face of the fifth and sixth rib and on the xiphoid process.

Action. Flexion of the trunk, acting in antagonism with the sacrospinal group muscles. If contraction is on both sides and the fixed point is on the pelvis, the rib cage flexes on the pelvis, with marked dorsal kyphosis and a reduced lumbar lordosis; if the fixed point is on the rib cage, the pelvis rises and flexes on the thorax. Contraction of the rectus muscle on one side only can bring about a slight twisting and lateral inclination of the trunk. The normal tone of the rectus muscles contains the inner organs. The synergical contraction with other abdominal muscles (in particular the transverse abdominal muscle) increases internal abdominal pressure, creating the 'abdominal press' – important for carrying out some physiological functions: breathing, coughing, sneezing, defecating and giving birth. Contrary to what one may think, the abdominal muscles generally have little to do with walking and maintaining the erect position.

Surface anatomy. The rectus abdominis is subcutaneous and is particularly visible along its entire extension of the region, especially in individuals who do a great deal of physical or athletic exercise. The linea alba and the transverse tendon insertions appear as grooves between which the muscle segments emerge. During strong contractions, the muscle fibres shorten, therefore the transverse grooves seem to be closer together, the rectus muscle bundle juts out noticeably, especially when flexing the trunk and some horizontal folds appear, just above the navel. Conversely, when fully extended, the transverse grooves recede and the anterior abdominal wall appears to be smooth and flat.

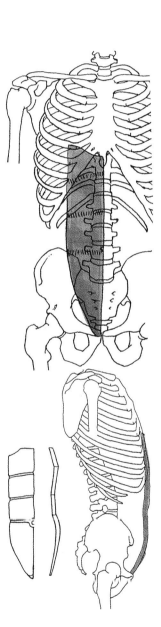

PYRAMIDALIS MUSCLE (Pyramidalis)

Form, structure, relations. The pyramidalis muscle is small and triangular, wrapped in the fibrous sheath of the rectus abdominis muscles, which double up at this point to contain it. Its fibres travel medially upwards, decreasing in width as they rise, until they insert onto the pointed end of the linea alba, at a point more or less equidistant between the pubis symphysis and the navel. The pyramidalis muscle, which can vary in size and can also be missing, is superficial and covers the origin section of the rectus abdominis.
Origin. Pubis, anterior area between symphysis and tubercle, in front of the abdominis rectus muscle tendon.
Insertion. Abdominal linea alba.
Action. Tension of the linea alba.
Surface anatomy. The muscle is not directly visible, as it is covered by a fibrous sheath.

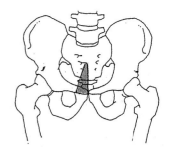

QUADRATUS LUMBORUM MUSCLE (Quadratus lumborum)

Form, structure, relations. The quadratus lumborum muscle is an almost rectangular quadrilateral, with the insertion and origin sides being short, the medial and lateral sides being rather long, placed vertically, parallel to the lumbar vertebrae. The muscle is flat but rather thick, as it can be up to 2cm (¾in) at its thickest point, and comprises two muscle laminae alongside each other: the main part is located closer to the surface and posteriorly; the abdominal part is positioned in front of the main part and faces the abdominal cavity and the visceral organs. The muscle is located deeply, covered by the lumbodorsal fascia, the iliocostalis muscles and the latissimus dorsi muscle; the medial border runs parallel and close to the lumbar column, partly covered by the iliopsoas muscle; the lateral border crosses the lumbodorsal fascia.
Origin. Middle section of the iliac crest's internal lip; iliolumbar ligament.
Insertion. Main part: middle section of the inferior border of the twelfth rib.
Abdominal part: apices of the transverse processes (costal) of the first four lumbar vertebrae.
Action. Elevation of the pelvis and lateral flexion of the trunk, if contraction is unilateral. If muscles on both sides act at the same time, the rib cage is stabilized on the pelvis with a stiffening of the lumbar section of the spine, which is necessary to maintain an erect position.
Surface anatomy. The muscle is located deeply and, therefore, not visible; however, it can be felt in the origin section, laterally to the spinal muscles.

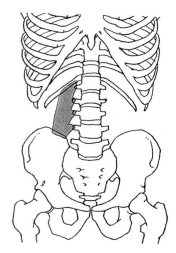

OBLIQUUS INTERNUS ABDOMINIS MUSCLE (Obliquus internus abdominis)

Form, structure, relations. The internal oblique muscle (or obliquus minor) is located deeply compared with the obliquus externus, compared to which it is thinner and less developed. Its fibres travel diagonally in an upwards and anterior direction, widening as a fan shape in the wide insertion border on the rectus muscle sheath and have an opposite direction to that of the obliquus externus muscle. The muscle, which may have some individual variations (be partly missing; have origin bundles partly missing; have excess origin or insertion bundles; have a branch, known as the cremaster muscle, that runs towards the testicle), completely covers the transverse abdominal muscle and is covered by the external oblique muscle, while only a short posterior section is covered by the large dorsal muscle.
Origin. Lateral border of the inguinal ligament; anterior iliac crest; lumbodorsal fascia (common aponeurotic fascia with the latissimus dorsi muscle).
Insertion. Lower borders of the last three or four ribs; aponeurosis that contributes to forming the rectus muscle sheath and the inguinal ligament, connecting to the linea alba and the pubis.
Action. Rotation of the thorax to the side where the muscle is acting and lateral flexion of the trunk, if contraction is unilateral (in this case, the action is synergical with that of the external oblique muscle on the same side); flexion of the thorax onto the pelvis, if contraction is bilateral.
Surface anatomy. The muscle is located deeply: in some conditions and in some individuals, a short posterior section, next to the latissimus dorsi, may appear on the surface.

TRANSVERSE ABDOMINAL MUSCLE (Transversus abdominis)

Form, structure, relations. The transverse abdominal muscle is the thinnest at around 5mm (¼in) of the three wide abdominal muscles. It is located deeper than the others and its fibres travel horizontally forwards, connected to the vertical column and linea alba with wide aponeuroses. The muscle is fully covered by the internal and external oblique muscles and faces the abdominal cavity, with its deep surface covered by the transverse fascia and the peritoneum.

Origin. Internal surface of the last six ribs; lumbo-dorsal aponeurosis; internal border of the anterior section of the iliac crest; lateral border of the inguinal ligament.

Insertion. Aponeurosis of the rectus muscles, of which it forms the posterior lamina (the insertion border of the fleshy part of the tendon forms a wide, curved line known as the linea semilunaris).

Action. Shrinking of the abdominal cavity. Contraction is usually bilateral and takes part, together with other abdominal wall muscles, in containing and compressing the visceral organs, creating the 'abdominal press' which is important for serveral physiological actions. It also aids expiration, as it causes a weak depression of the rib cage.

Surface anatomy. The muscle is deep and is therefore not visible.

OBLIQUUS EXTERNUS ABDOMINIS MUSCLE (Obliquus externus abdominis)

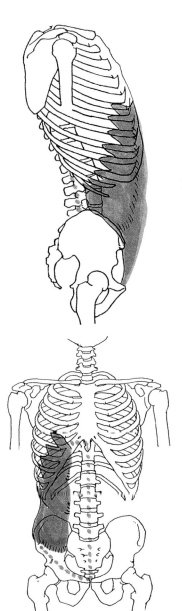

153

Form, structure, relations. The external oblique (or obliquus major) muscle is a wide lamina, about 5 or 6mm (¼in) thick, that constitutes the superficial muscle layer of the anterolateral wall of the abdomen. The muscle is stretched between the rib cage – where it originates with eight digitations from the last eight ribs – to the pelvis, to which it connects via a long, tendinous lamina. The muscle fibres travel inferiorly and anteriorly, but with different paths depending on the points of origin: the fibres coming from the last three ribs head almost vertically to the iliac crest, which they insert on; the other fibres travel diagonally, diverting medially and downwards to terminate on the aponeurotic lamina along an almost vertical line, which crosses the joining point between the sixth rib and its cartilage, then continues downwards onto the inguinal ligament. This is a strong elongated tendon which connects the anterior superior iliac spine with the pubis, bridging the iliopsoas muscle and other inguinal vascular–nervous formations. Its path borders a very important, complex area from a surgical point of view.

The superficial face of the external oblique muscle is covered by its own aponeurotic fascia, that continues posteriorly with that of the latissimus dorsi muscle; it is covered by the skin and in the inferior posterior section, partly by the latissimus dorsi muscle and in the upper section by the pectoralis major muscle. The deep surface covers the internal oblique muscle and, with the aponeurotic part, the rectus abdominis muscle and the pyramidalis muscle. The posterior border is free and in contact with the latissimus dorsi muscle, with which it forms the border of a triangular space; the costal digitations have different relations: the top five interlock with the serratus anterior muscle digitations along the insertion lines on the ribs; the bottom three intersect with the thoracic digitations of the latissimus dorsi muscle. The external oblique muscle may have connections with nearby muscles (internal oblique, serratus anterior, latissimus dorsi, intercostal) or have extra digitations from the tenth or eleventh rib.

Origin. External surface and inferior border of the 5th to 12th ribs (upper digitations originate from the cartilage of each rib, the last one originates at the apex of the last rib, the middle ones originate on the ribs, close to the respective cartilages).

Insertion. Ilium and pubis. The posterior muscle bundles insert directly onto the front half of the external lip of the iliac crest. The remaining part of the muscle ends on the tendinous lamina, that inserts on to the iliac crest border, on the pubis (via the inguinal ligament), on the abdominal linea alba.

Action. Flexion of the trunk at the thoracic and lumbar column level, if contraction is bilateral, in synergy with the rectus abdominis muscles; lateral flexion of the trunk, if contraction is unilateral, and slight rotation of the trunk, in synergy with the column rotator muscles, towards the opposite side from the acting muscle.

Surface anatomy. The external oblique muscle is almost entirely subcutaneous and forms the lateral wall of the abdomen. The upper digitation originates below the first visible bottom digitation of the serratus anterior muscle, which juts out more and travels in a more horizontal direction. The digitations are not, however, particularly clear, even when the muscle is in action, as they are covered by the strong tendinous fascia. The lower border of the muscle juts out (even when not contracted) externally towards the iliac crest, partly covered by an adipose

layer. The inguinal ligament, stretched between the anterior superior iliac spine and the pubic tubercle, is dependent on the insertion lamina, forming the lower border, and forms a curved line, downwardly convex and slightly raised, which indicates the separation between the abdomen and the thigh.

PERINEUM MUSCLES

The perineum is the region bordered by the lower aperture of the pelvis. The muscles located in this space, together with some complex containing fasciae, are located at a different depth and form the pelvic diaphragm and urogenital groups, which differ in males and females due to the conformation of the respective genital organs. Overall, the muscles are designed to carry out urination and defecation functions, but are also an effective containing and support wall for the visceral organs. The perineum muscles are not important from an external morphological point of view and are only listed here for complete information purposes.

ISCHIOCOCCYGEUS MUSCLE (Ischiococcygeus)

Form, structure. The ischiococcygeus muscle is paired, symmetrical, triangular, flat and forms the posterior superior part of the pelvic diaphragm.
Origin. Internal surface of the ischial tuberosity.
Insertion. Lateral border of the sacrum and the coccyx.
Action. Tension and stiffening of the pelvic cavity walls.
Surface anatomy. The muscle is located deeply.

LEVATOR ANI (Levator ani)

Form, structure. The levator anis muscle is rather complex as it is formed by two portions, lateral and medial (also known as the iliococcygeal muscle and the pubococcygeal muscle), the fibres of which have different paths and that, as inserted together, form a large part of the muscle floor of the pelvic cavity.
Origin. Iliococcygeal: ischial spine; pelvic fascia.
Pubococcygeal. Posterior surface of the pubic bone, internal obturator muscle fascia.
Action. Narrowing of rectum and vagina; support for abdominal visceral organs in the erect position.
Surface anatomy. The muscle is located deeply.

TRANSVERSUS PERINEI MUSCLE (Transversus perinei superficialis)

Form, structure. The superficial transverse muscle of the perineum is small (more developed in males than in females), cylinder-shaped and directed medially.
Origin. Medial border of the inferior ramus of the ischium.
Insertion. Median raphe of the perineum, joining with the contralateral muscle.
Action. Strengthening of the pelvic floor.
Surface anatomy. The muscle is located deeply.

TRANSVERSUS PERINEI PROFUNDUS MUSCLE (Transversus perinei profundus)

Form, structure. The transversus perinei profundus muscle is rather long and flat, forming a large part of the urogenital diaphragm.
Origin. Anterior surface of the ischial ramus and the inferior ramus of the pubis.
Insertion. Tendinous centre of the perineum, joining with the contralateral muscle and bordering the urethra and the vagina.
Action. Strengthening of the pelvic floor.
Surface anatomy. The muscle is located deeply.

BULBOSPONGIOSUS MUSCLE (Bulbospongiosus)

Form, structure, relations. The bulbospongiosus muscle is considered with the contralateral muscle, functionally forming an unpaired median semi-cylindrical muscle that borders the urethral bulb in men and borders the vagina in women (inferior vaginal constrictor muscle).
Origin. Median perineum raphe at the central tendinous point.
Insertion. Corpus cavernosum of the clitoris (in females); dorsal surface of the penis (in males).
Action. Arrowing of the vagina (in females); urination and erection of the penis (in males).
Surface anatomy. The muscle is located deeply.

ISCHIOCAVERNOSUS MUSCLE (Ischiocavernosus)

Form, structure. The ischiocavernosus muscle is thin and elongated, it runs forwards from the ischiatic tuberosity until it joins with the contralateral muscle, at the root of the corpus cavernosum (in males) and of the clitoris (in females).
Origin. Ischial tuberosity.
Insertion. Root of penis and clitoris.
Action. Erection of penis or clitoris.
Surface anatomy. The muscle is located quite close to the surface, covered by the superficial perineal fascia and skin, but has no influence on the external morphology of the region.

SPHINCTER URETHRAE MUSCLE (Spincter urethrae)

Form, structure. The sphincter urethrae muscle is an unpaired, ring-shaped structure that surrounds the urethra in both males and females, but with a different extension, as in women it also surrounds the vagina.
Origin. Transverse perineal ligament.
Insertion. Urethra perimeter (and vaginal perimeter, in women).
Action. Narrowing of the urethra (the muscle relaxes during urination).
Surface anatomy. The muscle is located deeply.

ANAL SPHINCTER MUSCLE (Sphincter ani externus)

Form, structure. The sphincter anis externus is an unpaired, median, thick muscle, separated into a superficial lamina and a deep lamina, and forms a ring around the lower part of the rectal intestine and the anal canal.
Origin, insertion. Perineal tendinous raphe, anteriorly; anococcygeal raphe, posteriorly.
Action. Narrowing of the anal canal: the muscle tone is normally sufficient to keep the terminal section of the rectum closed.
Surface anatomy. The muscle surrounds the anal orifice.

PSOAS MINOR MUSCLE (Psoas minor)

Form, structure, relations. The psoas minor muscle is thin, long, flat and can often be missing. The belly lies in front of the psoas major, travelling laterally downwards from the origin on the vertebral column to its insertion point on the pectineal line of the pubis, via a thin, flat tendon.
Origin. Lateral surface of the body of the 12th thoracic vertebra, the first lumbar and the intervertebral disc.
Insertion. Pectineal line of the pubis; iliopectineal eminence; iliacus muscle fascia.
Action. Tension of the iliacus muscle fascia; synergical collaboration with the psoas major muscle.
Surface anatomy. The psoas minor muscle is located deeply and has no influence on external morphology.

ILIOPSOAS MUSCLE (Iliopsoas – psoas major and iliacus)

Form, structure, relations. The iliopsoas is functionally considered to be a single muscle formed by two parts, the psoas major and the iliacus, originally separate but which merge into a single insertion tendon on the femur. The psoas major is a large, long, tapered muscle that occupies the lumbar region. It travels downwards and slightly laterally from the lumbar vertebrae, where it originates with five digitations, to the lesser trochanter. The muscle's anterior surface is near the abdominal cavity organs and in the section next to the insertion point, and is partly covered by the sartorius and the rectus femoris muscles; the deep surface rests on costal processes of the lumbar vertebrae and on the quadratus lumborum muscle. The iliacus muscle is flat and triangular, located in the iliac fossa – where its origin is enlarged by the ilium and then heads downwards and narrows towards its insertion point on the femur. The upper part of the muscle's posterior surface adheres to the medial surface of the ilium, and the lower part covers the hip (coxofemoral) joint; the anterior surface, covered by the iliac fascia and retroperitoneal fat, is in contact with the abdominal cavity organs, but then has the same muscle relations as the corresponding section of the psoas major, with which it merges, close to the insertion point.

Origin. Psoas major muscle: anterior surface and inferior border of costal processes of the lumbar vertebrae; lateral surface of the lumbar vertebrae and relative intervertebral discs. Iliacus muscle: upper half of the medial surface of the ilium; medial lip of the iliac crest; upper part of the lateral portion of the sacrum; anterior sacroiliac ligament.

Insertion. Lesser trochanter of the femur, with the interposition of a subtendinous mucosa bursa.

Action. Flexion, with slight adduction and lateral rotation, of the thigh on the pelvis (if contraction of the psoas major and the iliacus is simultaneous); flexion and lateral inclination of the trunk (especially the iliacus). The iliopsoas muscle participates in the act of walking, and if acting together with the contralateral muscle, allows the trunk to bend forward.

Surface anatomy. The iliopsoas muscle is located deeply in the iliac fossa, and is not visible externally. Only the short section close to the insertion point that runs into the thigh root is subcutaneous. It appears medially to the initial portion of the sartorius muscle, below the inguinal ligament and laterally to the pectineal muscle.

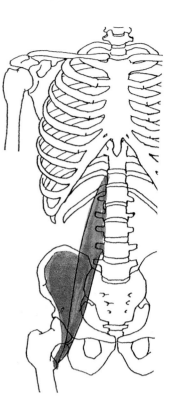

OBTURATORIUS INTERNUS MUSCLE (Obturatorius internus)

Form, structure, relations. The internal obturator muscle is long and flat. Its fibres run almost horizontally: they originate in the pelvic cavity, in the area around the obturator foramen, and are directed laterally and backwards as far as the small sciatic notch. In the next section, the fibres change direction, bend at a right angle and converge anteriorly and laterally until their insertion onto the femur. In the pelvic cavity, the muscle covers the internal surface of the obturator membrane and is covered by a thick aponeurotic fascia on which other perineal muscles insert; in the extrapelvic section, it adheres to the coxofemoral joint, is covered by the gluteus maximus, and the corresponding gemellus muscles run alongside, above and below it.

Origin. Border of the obturator foramen (superior and inferior rami of the pubis, inferior ramus of the ischium): pelvic surface of the obturator membrane.

Insertion. Trochanteric fossa of the femur.

Action. Lateral rotation of the thigh; slight abduction of the thigh, if this is flexed on the pelvis.

Surface anatomy. The internal obturator muscle is located deeply and therefore does not affect external morphology.

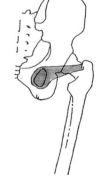

OBTURATORIUS EXTERNUS MUSCLE (Obturatorius externus)

Form, structure, relations. The external obturator is a flat, triangular muscle, located on the anterior surface of the base of the pelvis. Its muscle fibres originate from the wide surface of the external margin of the obturator foramen, and head laterally, a little backwards and upwards, converging with the thin insertion tendon on the femur. The muscle covers the obturator membrane and the coxofemoral joint and is covered by the thigh adductor muscles and the quadratus femoris muscle.

Origin. Superior and inferior rami of the pubis; inferior ramus of the ischium.

Insertion. Trochanteric fossa of the femur.

Action. Lateral rotation of the thigh.

Surface anatomy. The external obturator muscle is located deeply and therefore has no influence on external morphology.

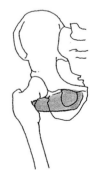

QUADRATUS FEMORIS MUSCLE (Quadratus femoris)

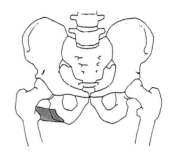

Form, structure, relations. The quadratus femoris muscle is flat, square and rather thick at approximately 2cm (¾in). It travels laterally and slightly upwards from its origin on the ischium to its insertion on the femur. The muscle is related at the top with the gemellus inferior, at the bottom with the adductor muscles, and deeply with the external obturator muscle. It is covered by the gluteus maximus.
Origin. Lateral border of the ischial tuberosity.
Insertion. Intertrochanteric crest of the femur.
Action. Lateral rotation of the femur, with slight adduction.
Surface anatomy. The quadratus femoris muscle is located deeply and therefore has no influence on external morphology.

GEMELLUS SUPERIOR AND INFERIOR MUSCLES (Gemellus superior, inferior)

Form, structure, relations. The gemellus superior and the gemellus inferior are two small muscles at the sides of the internal obturator muscle, with which they have a similar function and relations. Both the muscles run laterally downwards, from their point of origin on the pelvis to their insertion point on the femur.
Origin. Gemellus superior: lateral surface of the ischial spine.
Gemellus inferior: superior surface of the ischial tuberosity.
Insertion. Medial surface of the greater trochanter of the femur.
Action. Lateral rotation of the thigh, in synergy with the obturatorius internus.
Surface anatomy. The gemellus muscles are located deeply and therefore do not have any influence on external morphology.

PIRIFORMIS MUSCLE (Piriformis)

Form, structure, relations. The piriformis muscle is thin, flattened at the start but then becomes cylinder-shaped. Its fibres travel almost horizontally, from their origin on the pelvic surface of the sacrum bone to insertion on the femur, crossing the large sciatic foramen. The muscle, which may be missing or divided into two separate bundles, adheres to the wall of the pelvis in the intrapelvic section, covered by the visceral organs; in the extrapelvic section, it is in contact with the gluteus minimus (below), with the gemellus muscles and the internal obturator muscle (above) and covers the coxofemoral joint.
Origin. Anterior surface of the sacrum, between the second and fourth foramen.
Insertion. Superior border of the greater trochanter.
Action. Lateral rotation of the thigh, especially when extended; slight abduction and extension of the thigh, when flexed.
Surface anatomy. The piriformis muscle is located deeply, and therefore has no influence on the external morphology.

GLUTEUS MINIMUS MUSCLE (Gluteus minimus)

Form, structure, relations. The gluteus minimus muscle has a similar shape and situation to the gluteus medius, by which it is completely covered as it is smaller in size. It is small, thick, triangular, located on the lateral surface of the ilium, from which it originates with a wide border. Its fibres travel downwards and converge into a short, small insertion tendon on the femur. The muscle, which may fuse with nearby muscles or be separated into several distinct bundles, adheres to the lateral face of the wing of the ilium, covers the coxofemoral joint and is covered by the gluteus medius. A small independent bundle positioned along the anterior border of the gluteus minimus is known as the gluteus anterior muscle.
Origin. Lateral face of the wing of the ilium, in the area between the anterior gluteal line and the inferior gluteal line.
Insertion. Apex of the great trochanter.
Action. Abduction and medial rotation of the femur compared with the pelvis, together with the gluteus medius muscle.
Surface anatomy. The gluteus minimus muscle is located deeply, and therefore has no direct influence on external morphology.

GLUTEUS MEDIUS MUSCLE (Gluteus medius)

Form, structure, relations. The gluteus medius muscle is wide, thick, triangular and located on the lateral external surface of the ilium. The muscle bundles originate in a large, superior curved border and travel vertically downwards, converging at a wide, flat insertion tendon on the femur. At the point of origin, two groups of bundles, one anterior and one posterior, can sometimes be identified, partly overlapping the previous bundle. The muscle, which may be connected to nearby muscles, is mostly subcutaneous, covered by the gluteal fascia, adipose tissue and then skin; it totally covers the gluteus minimus; its posterior border is covered by the gluteus maximus and the anterior border is touching the tensor fasciae latae.

Origin. Lateral surface of the wing of the ilium, in the area between the iliac crest's external border (up to the anterosuperior iliac spine), the posterior gluteal line and the anterior gluteal line.

Insertion. Lateral surface of the great trochanter.

Action. Abduction of the thigh: contraction of the rear portion allows the thigh to extend and laterally rotate, contraction of the front portion causes a slight medial rotation. The muscle helps to keep the pelvis horizontal while walking, in the stages when the body rests on a single limb.

Surface anatomy. The gluteus medius muscle is mostly subcutaneous. During contraction, it appears as an elevation below the iliac crest, in an area placed above the greater trochanter and between the gluteus maximus (posteriorly) and the tensor fasciae latae (anteriorly).

GLUTEUS MAXIMUS MUSCLE (Gluteus maximus)

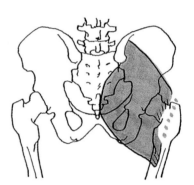

Form, structure, relations. The gluteus maximus is a large, thick muscle (as it can be up to 4cm/1½in deep), with a quadrilateral shape, located on the posterolateral face of the pelvis. It is the largest and most superficial muscle in the region and its particular development is connected to the human characteristic of the erect position of the trunk. The muscle fibres head laterally downwards, from their origin on the pelvis to insertion on the femur. They are grouped into large bundles separated by fibrous septa and adipose material, and therefore the muscle takes on a bundled appearance, sometimes visible under the skin. In consideration of the extended points of origin and insertion, the muscle is divided into three portions (upper, middle and lower), each with specific functional effects, due to their different lines of traction. The gluteus maximus muscle is covered by the gluteal fascia and also by subcutaneous tissue and by skin; the upper border is covered by various amounts of adipose tissue and the lower border is medially in contact with a large adipose mass that lends the rounded shape to the buttock. The muscle partly covers the gluteus medius, at the top, and adheres to the ilium, sacrum and coccyx, covering the deep muscles of the gluteal region (gemellus, piriformis, internal obturator, quadratus femoris). Some muscle bundles, identified as the ischiofemoral muscle, run along the lower border of the gluteus maximus and are a dependent of the latter.

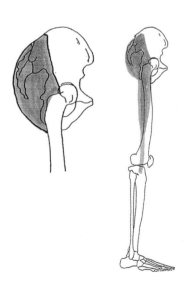

Origin. Upper portion: posterior area of the iliac crest, between the posterior gluteal line and the iliac crest. Middle portion: lumbodorsal fascia. Lower portion: dorsal surface of the lower part of the sacrum and lateral border of the coccyx.

Insertion. Upper portion: iliotibial section of the fasciae latae (femoral fascia). Middle portion: gluteal tuberosity of the greater trochanter of the femur (there is a mucosa bursa between the tendon and bone).

Lower portion: expansion of the femoral fascia at the point of the gluteal fold.

Action. Extension and lateral rotation of the thigh on the pelvis with slight abduction (upper portion) and slight adduction (lower portion). The muscle actively takes part in some of the stages involved in walking and helps to maintain an erect position.

Surface anatomy. The gluteus maximus muscle is totally subcutaneous and, together with some adipose tissue areas, determines the shape of the buttock. The muscle is bordered at the bottom by a transverse cutaneous fold (gluteal fold) that separates it from the posterior surface of the thigh. The fold is horizontal, more evident medially and less evident towards the side: in this latter section, the fold corresponds to the inferior border of the muscle, while it is formed by a large adipose deposit in the medial portion. During the normal erect position, the gluteus maximus muscle is relaxed, soft, slightly flattened, with rounded edges. During contraction, whether voluntary with a static body, or caused by a slight anterior flexion of the trunk or by a posterior extension of the thigh, the muscle flattens laterally, taking on a more rounded, narrower and elongated shape, while there is also a marked depression posteriorly to the greater trochanter, at the point of the insertion of the fasciae latae.

THE NECK

The neck is the section of the body which joins the head to the thorax, forming the first section of the trunk. It is supported by the cervical section of the vertebral column, around which several muscles are layered. It is also connected to two adjacent formations: the hyoid bone and the thyroid cartilage. The vertebral joints provide wide flexion, rotation and extension movements.

The overall shape of the neck is a truncated cone, with a slightly forward-sloping longitudinal axis, following the vertebral curvature; it is almost cylindrical close to the head, and transversely wider at the base. The neck height is determined by that of the cervical section of the vertebral column, but can vary widely in individuals, depending on the different rate of muscle development and exercise, gender, age and the amount of adipose tissue. In fact, it can be noted that the male neck is usually shorter and more solid than the female neck, which is longer and more cylindrical in consideration of the smaller size of the mandible, the lesser muscle development, the smaller size of the rib cage and the consequent lower position of the sternum and the shoulder girdle.

The posterior region of the neck (nape) is flattened: this corresponds to the cervical portion of the trapezius muscle, which rests on deep muscles and hides the spinous processes of the cervical vertebrae, allowing only those of the sixth and, most importantly, the seventh cervical vertebrae to emerge. The posterior surface begins below the occipital bone, forming a small depression below the external occipital protuberance, usually covered by hair, and then extends to the oval depression of the aponeurosis stretched between the two trapezius antimeres. The elevation of the seventh cervical vertebra emerges at the centre of this area, particularly during anterior flexion of the neck; in some individuals, however, and above all in women, this elevation may be hidden by a sizeable local deposit of adipose tissue that fills the oval hollow and makes the neck profile into a continuous curve. The trapezius muscle continues to the sides of the neck and then widens at the base, continuing towards the shoulders with a rather thin, concave border (cucullaris line).

The anterior region of the neck (throat) is bordered laterally by the anterior regions of the sternocleidomastoid muscles and at the top, by the submandibular surface, which is sloping. The hyoid bone, which is difficult to see at the surface, except when the head is extended backwards, further divides the median area into a suprahyoid portion and an infrahyoid portion, corresponding deep down to the muscles of the same name.

The throat's external morphology is widely influenced by the presence of thyroid cartilage (the Adam's apple): this is a laryngeal prominence which is vertically mobile during swallowing and speaking, formed by the anterior joining of two quadrangular laminae, whose total upper border is curved and slightly hollowed into the median edge. It is more pronounced in males; less so, almost imperceptible, in women.

Below the cartilage, the neck's surface sometimes has a slight swelling due to the presence of the thyroid, a gland which can vary in size and is normally more evident in women, in whom, it in fact makes the base of the neck more rounded. The paired, symmetrical elevations

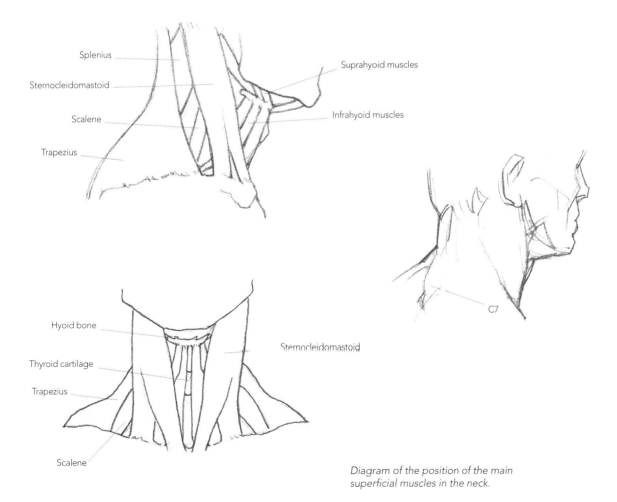

Diagram of the position of the main superficial muscles in the neck.

of the two sternocleidomastoid muscles form the two lateral pillars of the neck: each of them from the mastoid process, where it is separated from the mandibular ramus by a slight hollow, converge medially towards the upper border of the sternal manubrium, where the two thin, close, well-elevated tendons contribute to the jugular notch border. In certain conditions, transverse protuberances of some of the trachea's cartilage rings are visible under the skin in the area between the notch and the thyroid cartilage.

The lateral surface of the neck is mostly occupied by the sternocleidomastoid muscle, which crosses it diagonally in an antero-posterior direction, connecting the mastoid process to the sternum. As there are two points of origin, sternal and clavicular, a small cutaneous hollow forms between them (a triangular notch) that can easily be seen, especially when the head is rotated.

The muscle's posterior border contributes to outlining a larger triangular area (supraclavicular notch), together with the clavicle and the trapezius border. This notch contains the scalene, splenius and levator scapulae muscles. The sternocleidomastoid muscles form different elevations separately, depending on the movements that they transmit to the head. They are crossed vertically by the external jugular veins and are covered by the platysma, the cutaneous muscle that covers a large area of each side of the neck.

The skin of the neck is thin, although a little thicker in the posterior region: the throat has a couple of transverse grooves, which are light, semi-circular wrinkles (upwardly concave). These are more visible and characteristic in females.

There are sometimes adipose deposits in the submandibular area and at the base of the neck, while old age, associated with the state of nutrition, favours the formation of senile rope-like folds, typically in the median area of the mandibular base, heading upwards towards the hyoid bone and caused by the protuberance of the digastricus muscle bellies.

160

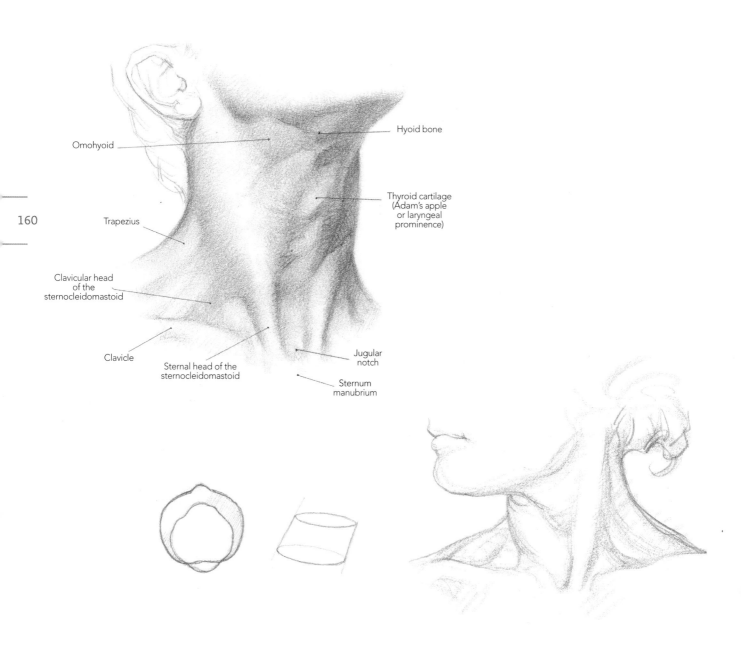

Omohyoid

Hyoid bone

Thyroid cartilage
(Adam's apple
or laryngeal
prominence)

Trapezius

Clavicular head
of the
sternocleidomastoid

Clavicle

Sternal head of the
sternocleidomastoid

Jugular
notch

Sternum
manubrium

THE SHOULDER

The shoulder is the part of the body which joins the trunk to the upper limb, of which it is a robust (but also extremely mobile) attachment, corresponding to the scapulohumeral joint. Morphologically, it includes the deltoid region, the axillar region (see page 162) and the scapular region, muscles that are attached to the skeleton of the arm and the shoulder girdle.

The external shape of the shoulder is rounded, as the deltoid elevation dominates it. This muscle rests on almost the entire anterolateral and posterior border of the shoulder girdle and extends to cover the proximal section of the humerus. It occupies the entire deltoid region, which is bordered at the front by the deep deltopectoral groove of separation between the two muscles of the same names, and at the rear it transitions almost seamlessly into the scapular region. Consequently, the overall shape of the shoulder is elevated and rounded on the superior anterolateral border, but flattened on the posterior border and in the lower section where it inserts on to the humerus.

The size of the deltoid depends on the degree of physical exercise habitually taken by the individual, and the bundling of muscle can usually be distinguished under the skin (see deltoid muscle on page 148), although a layer of adipose tissue softens the elevations and the external shape overall. This latter phenomenon applies partcularly to females, in whom the fatty deposits, localized on the posterior surface of the shoulder, extend onto the superior portion of the arm, covering a part of the triceps , determining the characteristic rounded shape of the female arm.

The elevation of the inferior border of the pectoral muscle appears on the anterior surface of the shoulder, which forms the bridge towards the axilla, and the protuberance in the lateral section of the clavicle, below which there is a hollow (subclavicular fossa) which can be more or less evident, depending on the position of the limb and individual characteristics of the skeleton. For example, it disappears when the shoulders are strongly pulled back.

The constant protuberance of the acromion can be seen on the upper surface of the shoulder, which is the part of the scapula that joins with the lateral extremity of the clavicle. It is surrounded by the deltoid, which contracts as the arm is abducted, increases in volume and brings the bone prominence forward, which appears to be sunk into a hollow of varying depth.

The posterior surface of the shoulder passes into the scapular region without clear borders, characterized by the jutting out of the scapular spine arranged transversely with a slightly downward slope towards the median plane. Its presence divides the region into an upper part, covered by the trapezius, in which the supraspinatus muscles are housed, and a larger, lower part occupied by the infraspinatus, teres muscles etc., partly covered by the deltoid and the latissimus dorsi.

The external morphology of the scapular region can vary greatly depending on the muscles that control the movements of the arm and shoulder; it is also important to note the movements of the clavicles and the scapulae during one-sided or two-sided movements of the shoulders and arms. During these, the vertebral border and the lower corner of the scapula are brought closer to the median plane or distanced from it and rotated laterally to varying degrees, sliding on the curved wall of the rib cage (see page 122).

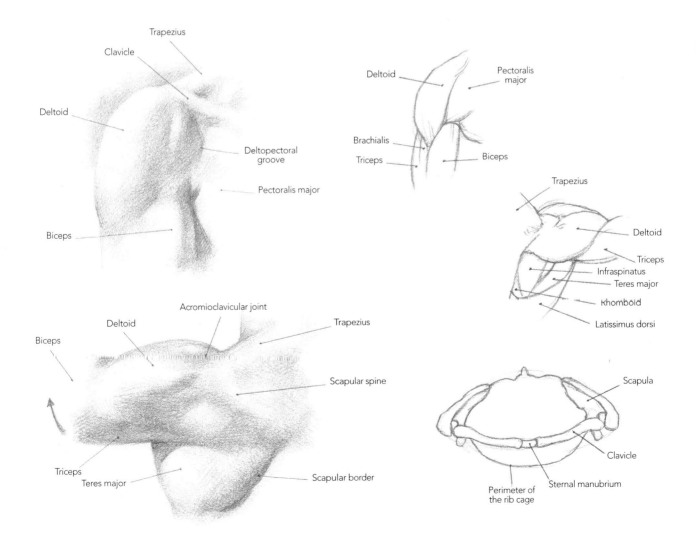

THE ARMPIT

The region of the axilla is a hollow located between the upper part of the lateral thoracic wall and the upper medial part of the arm.

If the arm is adducted, close to the trunk, the axillary cavity is reduced to a deep, antero-posterior fissure. If the arm is abducted, that is, distanced from the trunk to a horizontal position, the axilla appears at its maximum depth. It therefore appears to be dome-shaped or a truncated pyramid shape, with the apex (bottom of the axilla) corresponding to the medial face of the coracoid process, and it heads towards the base of the neck.

The axillary cavity opens forwards and laterally, bordered by two muscle bridges (pillars) covered by the axillary portion of the superficial fascia: the anterior one, almost a lamina, forms the anterior wall and is formed by the pectoralis major and minor muscles; the posterior one, which is thicker and larger, forms the posterior wall and is formed by the latissimus dorsi and the teres major.

The medial wall of the axillary cavity is represented by the superior portion of the lateral thoracic wall, that is, by the first four to five ribs covered by the serratus anterior. The lateral wall is reduced to a border outlined by the humerus and the proximal sections of the coracobrachialis and the short head of the biceps.

The axilla skin, especially that at the bottom of the cavity, has many sweat glands, lymph nodes and adipose tissue and has a developed piliferous system. The axilla's morphology changes radically if the arm is brought vertically upwards by abduction and rotation: in this position, the cavity flattens and the protuberance of the humerus head is revealed.

162

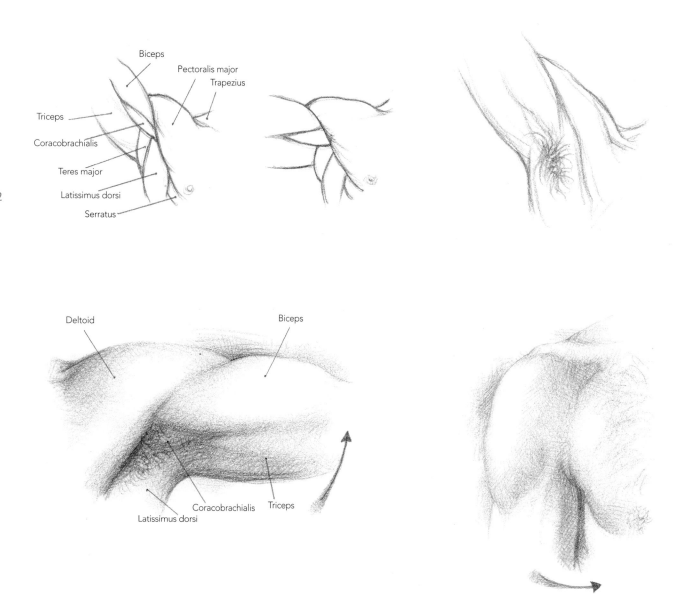

THE BREAST

The breasts are organs of the integumentary apparatus, which are located evenly in the pectoral region. They are characteristic of mammals and contain the cutaneous glands that, in females, are particularly developed for the secretion of milk used to provide nourishment for offspring in the early months of life. The mammary is a jutting body with a protuberance at its apex, the nipple, surrounded by a small cutaneous area, the areola, with particular characteristics. It comprises about twenty gland lobules arranged in a cluster, whose excretory ducts converge towards the nipple where they are close together and emerge externally. The gland lobules vary in size depending on the functional phase and are wrapped in adipose tissue, the amount of which contributes to determining the shape and size of the breast and at the same time allow the entire mammary body to move compared with the deep surface. The adipose tissue rests on the superficial fascia that covers the anterior surface of the pectoral muscle, without being closely adhered to it. The breasts are located at the front of the thorax, occupying an area which, on average, extends from the lateral border of the sternum to the anterior pillar of the axilla (sometimes continuing, with a 'tail', towards the thoracic lateral wall) and from the third to the seventh rib. Therefore, the base of the mammaries mostly lie on the pectoralis major and partly on the serratus anterior, on the upper margins of the large oblique and the rectus abdominis muscles.

The two breasts are separated along the median line of the sternal region by a hollow of varying size and depth in relation to their size, and the individual morphological characteristics of the rib cage on which they rest.

Each breast has blended borders with the thorax walls, but in adult women, there is almost always a clearer limit (submammary fold) between the lower border of the breast and the skin of the underlying thoracic wall. On this matter, it must be added that the size of the breast does not relate to the functional capacity of the gland, but most of all depends on the adipose accumulation, and this is not in relation to the total amount of fat distributed on the body: for example, some slim women have larger breasts; conversely sometimes rather overweight women have relatively small breasts.

It is also common to find that the shape of the female breast varies greatly, depending on individual's age and physiological conditions, but also ancestry: for example, some women have elongated breasts with a narrow base, while others have small breasts with a wide base. Also, it can be stated that the two breasts are almost never symmetrical in shape and size in a woman.

In the body's anatomical position, the breast has a cone or hemispherical shape, slightly wider transversely, with the lower half more convex (due to force of gravity) than the upper half, which fades into being almost flat. The areola is located at the apex of the breast. This is a circular cutaneous area, which varies in diameter from 2–7cm (¾–2¾in), with varying degrees of pigmentation (from pink to brown), with some small folds and papillary protuberances dotted around. Sometimes the areola is inverted; in a few cases it is slightly raised and convex, surrounded by a few sparse hairs; its chromatic border with the surrounding skin is not clear, but slightly blurred.

163

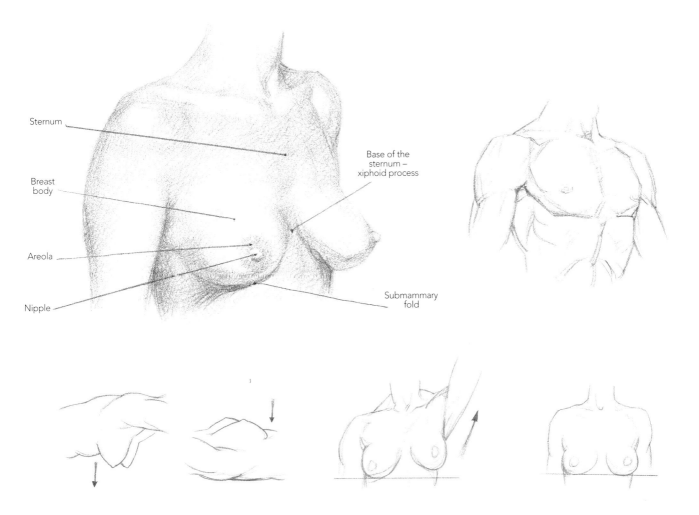

Sternum

Breast body

Areola

Nipple

Base of the sternum – xiphoid process

Submammary fold

The nipple is located almost at the centre of the areola. It is a cone- or cylinder-shaped protuberance, about 1cm (⅜in) wide and high, with a rougher and more pigmented surface than the areola.

The shape and size of the nipple varies greatly, it may be missing (athelia), be only slightly elevated, have hollows or protrude considerably. The skin that covers the areola and nipple may undergo changes due to the contraction of the smooth muscle bundles that it contains: for example emotional states, changes in temperature or rubbing can cause the nipple to wrinkle, harden, swell and sometimes even become paler.

With extreme approximation and considering an average-sized breast, the nipple can be projected on to the fourth rib or fourth intercostal space, and faces forwards, slightly upwards and slightly laterally. The body of the breast has the same orientation, resting on the convex rib cage: consequently, by observing the female thorax obliquely, the nearest breast appears frontally, while the one furthest away is positioned almost in profile. In adults and in relation to the amount of adipose tissue, the female breast is soft and doughy, and is especially subject to contingent changes in shape produced by compression or stretching. In fact, the external morphology of the breast also changes according to the movements of the shoulder and arm, as well as by force of gravity in relation to different body positions:

for example, by lifting the arm, the breast becomes more hemispherical, the submammary fold softens and the areola appears to be more elliptical vertically; in anterior flexion of the trunk it becomes pendulous and its lower surface moves away from the thoracic wall. The artist can study the variable morphology of this body part only through direct and careful observation.

The skin covering the breast is extremely elastic and therefore adapts to changes in the shape and size of the organ, but is also extremely thin, leaving the subcutaneous vein network visible.

The male breast is usually reduced to a rudimentary state, hardly elevated and comprising almost solely the nipple, the position of which on the thorax is less mobile compared to that of the female nipple: it is projectable on to the fifth rib or fourth intercostal space. The male nipple is very small, placed in the centre of a small, circular or elliptic areola, horizontal or slightly diagonal towards the axilla. It is located on the lower border of the pectoralis major, moved laterally, corresponding to a small, thin adipose deposit (see pectoralis major muscle, page 145). The male nipple, like the female one but to a lesser extent, undergoes movements by effect of the limb moving and modifications due to heat, emotional or mechanical influences. In the anatomical position, the nipple is usually located on the oblique line that joins the acromion with the navel.

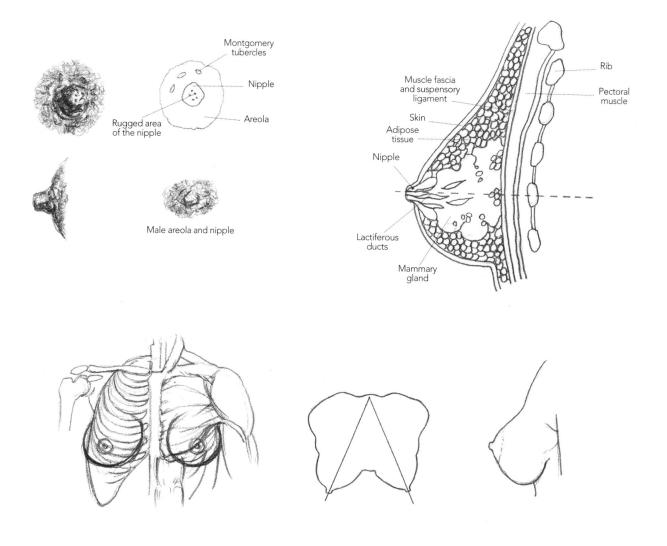

THE NAVEL

The navel is a cutaneous depression due to the scar that forms after birth following the severing of the umbilical cord which connects the foetus and the placenta in the uterus. It is located on the median plane of the abdominal wall, in the linea alba groove, corresponding to the point in which it crosses over with the inferior tendinous origin of the rectus abdominis muscles. It is equidistant from the pubis and the xiphoid process; in males this is a little closer to the pubis, while in women it is located a little higher up.

In the erect anatomical position, the position of the navel can be projected on to the disc between the third and fourth lumbar vertebrae.

The external shape of the navel varies greatly depending on individual characteristics, body shape and the amount of surrounding adipose tissue: it normally appears like a round hollow about 1cm (⅜in) wide and 1cm (⅜in) deep, but can also be horizontally elliptical or, especially in slim individuals and in women, in a vertical direction. The navel is bordered at the top by a clear cutaneous fold, the umbilical collar, which fades to the sides bordering the umbilical groove: on the bottom, the skin is a small eminence with an irregular surface.

THE EXTERNAL GENITAL ORGANS

In both sexes, some parts of the genital apparatus are located on the surface in the perineal anterior portion, at the lower extremity of the abdomen and, as they are visible to a certain extent on the outside, they are of interest for artistic representation.

Man The male external genital organs are the testicles and penis. The testicles, two sexual glands which produce spermatozoa, are located as a pair in an almost symmetrical position close to the median plane, and are a slightly flattened ovoid in shape, in a transverse direction. They are contained in the scrotum, a pyriform sack of skin where the left testicle is usually located lower than the right one. The scrotum is covered in highly pigmented skin, and differs greatly on an individual level in size and shape, depending on age and some physiological conditions, and it may contract in size (through the action of muscles contained within the wall) under emotional or environmental influences. The skin of the scrotal sac has transverse wrinkles originating from the median raphe, a vertical rope-like elevation, but fade towards the root of the sack, and there are sparse hairs that grow denser towards the pubic area.

The penis is the male erectile organ, which serves for reproduction and contains the urethra, which conducts urine to the outside. It is located on the median plane, laid symmetrically when in a state of rest, on the anterior surface of the scrotum, which normally protrudes, with the base below its extremity.

The shape, consistency, direction, volume and size of the penis vary considerably depending on whether it is flaccid or erect. This latter phase depends on the filling of blood in the internal organs of the penis – the corpora cavernosa, accompanied by a rich vascular system, which causes the length and width of the organ to grow by about one third. The penis, the skin of which is hairless and rather pigmented, is full of superficial veins and has an almost cylindrical shape except in the terminal part, the glans, which is enlarged and conical and covered almost entirely by the foreskin. This is a cutaneous fold with a circular aperture border, known as the preputial ring, which partly leaves the tip of the glans uncovered and therefore visible, revealing, slightly off centre, the urinary meatus opening. The foreskin is very elastic and slides over the glans, allowing it to be uncovered, sometimes only partially. In

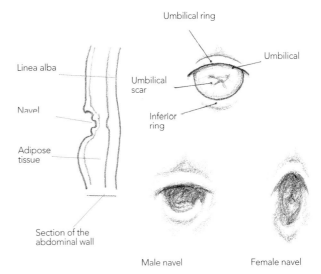

Projection of the navel on to the skeleton.

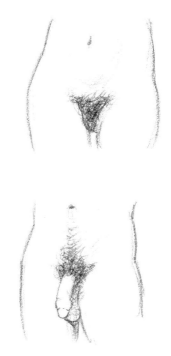

Appearance of external female and male genital regions.

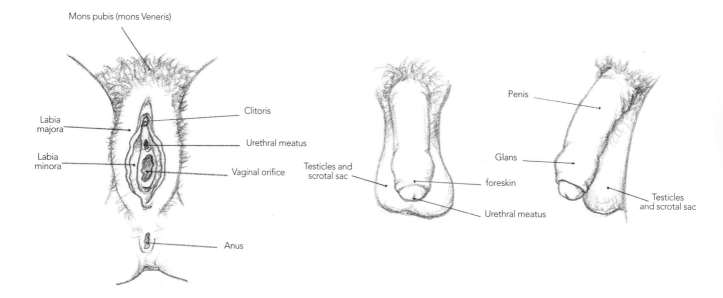

some populations, it is a widespread practice for religious and hygienic reasons to carry out circumcision, which consists of the surgical ablation of the entire foreskin, after which the glans – the skin of which is pinkish in colour – is permanently exposed.

Woman The female external genital organs are located in the anterior area of the perineum and comprise the vulva, an unpaired median elevation, ovoid in shape, inside which two canals open up, the urethra and the vagina. The vulva begins anteriorly with a rounded elevation, the mound of Venus, formed by a thick adipose layer on the upper border of the pubic symphysis, and continues with two large symmetrical skin folds, the labia majora, that are normally side by side on the median plane. They grow thinner as they descend and converge into the commissure located at the centre of the perineum, about 1cm (⅜in) from the anal opening, laterally bordered by a clear groove separating them from the internal surface of each thigh.

The cutaneous area of the mound of Venus and the lateral area of the labia majora are densely covered in darker hairs. On this matter, the different arrangement of said hairs in both sexes can be mentioned: in women, the hairs end almost clearly with a transverse line just above the pubic symphysis and do not extend on to the medial surface of the thigh, while in men, the hairs may continue, although more sparsely, along the median line, rising up to the navel and also extending onto the thighs.

Medially and below the labia majora, there are two folds varying in size (labia minora), which are thin, hairless, and sometimes bright pink in colour. They are partly positioned one over the other, to protect the vaginal vestibule and the urinary meatus, and their free borders, rather irregular in shape, may protrude from the labia majora. At the front, the labia minora join together in a complex manner, joining a small erectile organ (clitoris) that is a very reduced version of the male penis. The medial face of the labia minora gradually merge into the vaginal vestibule, narrowed by the presence of the hymen, an incomplete thin membrane that varies in shape.

THE BUTTOCKS

The three gluteus muscles form the buttocks which, together with the hip, form the gluteal region. This is arranged laterally and posteriorly to the pelvis, extending on the surface from the iliac crest, the border line with the lumbar region and the side, to the transverse gluteal fold which forms the bottom border of the buttock. The hip and the buttock are not clearly separate from each other: the term 'hip' refers to the upper part of the area's lateral region. The term 'buttock' refers to the posterior rounded elevation.

The external surface of the buttock is extremely convex (more so in the lower part than in the upper part) due to the presence of the gluteus maximus (see page 158) and an adipose deposit which varies in size and is more abundant in women. On this matter, it can be noted that the gluteal fold comprises a fibrous septum of the superficial fascia, which is firmly attached to the sciatic tuberosity, forming a pocket-shaped cutaneous fold where the fat is deposited. The medial section of the gluteal fold is therefore very clear, while it fades gradually towards the lateral portion where, in some cases, and especially in males, it can divide into two shallow parallel grooves. The gluteal fold is clearly more or less accentuated depending on the movements of the thigh in comparison to the trunk: for example, it is more marked during extension and tends to disappear during extreme flexion.

The two buttocks are separated, in the lower portions, by a deep vertical groove on the median plane of symmetry: it begins at the level of the coccyx and extends to the perineum.

The sacral region is rather flat and separates the two buttocks posteriorly, in the upper portion, following two lines that join the origin of the groove with the two lateral lumbar notches that correspond to the posterior superior iliac spines, transversely further apart in females due to the greater width of the pelvis.

The curvature and protuberance of the buttocks is particular to the human species, connected to the erect stance and walking with two limbs. Also, the panniculus adiposus has ethnic and gendered characteristics of location and quantity: it is more abundant and evenly distributed in females, lending a more rounded shape to the area, which also extends to the side of the thigh. In males, on the other hand, the buttock is more globular, smaller in size, with less adipose tissue and often with a lateral hollow close to the greater trochanter (extremely marked in athletic individuals), corresponding to the insertion aponeurosis of the gluteus maximus. This hollow disappears when the thigh is flexed.

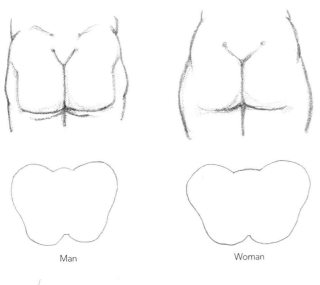

Man Woman

Conformation of the buttocks in
male and female subjects.

The morphology of the buttock is influenced by
both the volume of the gluteus maximus (a) and
the adipose tissue (b).

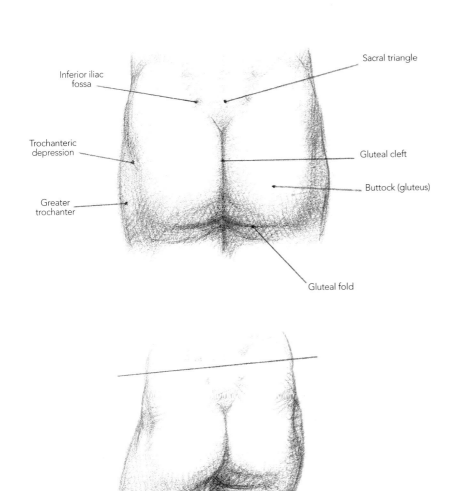

Sacral triangle

Inferior iliac
fossa

Trochanteric
depression

Greater
trochanter

Gluteal cleft

Buttock (gluteus)

Gluteal fold

THE UPPER LIMB

NOTES ON EXTERNAL MORPHOLOGY

The upper limbs are paired and symmetrical, positioned at the sides of the trunk. They are capable of a wide range of movement and each of them comprises a free part (separated into: arm, forearm and hand) articulated with the shoulder girdle and joined to the thorax at the shoulder, which has been morphologically described in the section on the trunk (see page 161). Some large muscles, the pectoralis muscle at the front, the scapular muscles at the rear and the deltoid muscle at the top, travel towards the top segment of the limb, the arm, and determine the rounded shape of the shoulder anteriorly and laterally, although it is rather flat posteriorly.

The arm is a slightly compressed cylinder in shape. It is attached transversally to the trunk via the shoulder and, together with the lateral wall of the thorax, outlines the axilla cavity. Its muscles are arranged around a single axis, the humerus, divided into two cavities, anterior and posterior.

The forearm, which joins the arm at the elbow joint, has a flattened truncated cone shape antero-posteriorly, with a wider proximal part. Its muscles are arranged around two bones, the ulna and the radius, divided into two cavities, anterior and posterior.

The hand is flat and slightly concave on the palmar surface, and has a complex shape due to the presence of several bones: the carpal and metacarpal bones correspond to the wrist and the palm and the phalanges correspond to the fingers. The hand is joined to the forearm by the wrist joint and continues the longitudinal axis of the limb.

Borders of the main regions of the upper limb

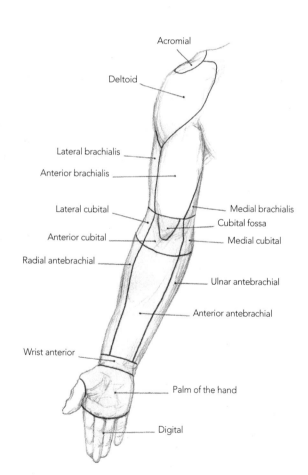

Frontal projection.

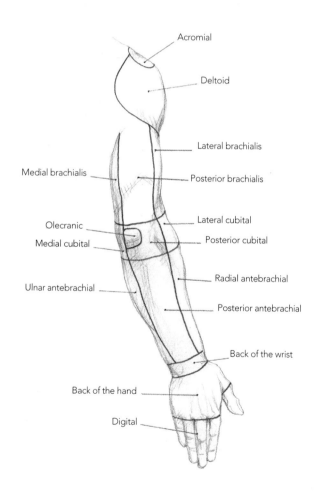

Dorsal projection.

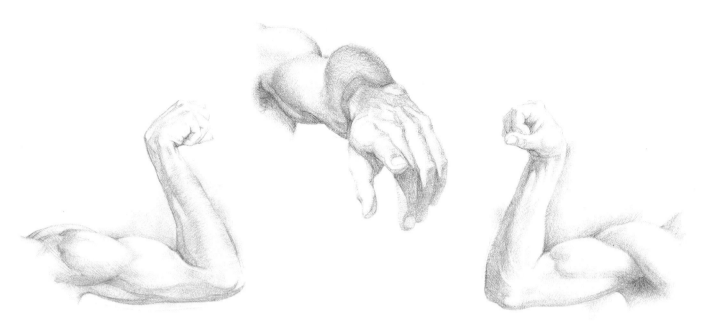

OSTEOLOGY

The bone apparatus of the upper limb (or thoracic limb) comprises two elements, the clavicle and the scapula (as already discussed), which connect together to form the shoulder girdle, a joint that operates freely from the axial skeleton as part of the appendicular skeleton. The skeleton of the thoracic limb includes: the humerus, the bone corresponding to the arm; the ulna and the radius, corresponding to the forearm; and the carpus, metacarpus and phalanges, corresponding to the wrist and the hand. The bone segments, in the anatomical position, are craniocaudally consecutive, slightly set at an angle with each other. Also, the two bones of the forearm are positioned parallel to each other, that is, in the supine position, to describe them similarly to corresponding ones in the lower limb. The humerus is a typical long, tubular bone, separated into: a body, or diaphysis, which is cylindrical with slightly flattened surfaces and widens towards the epiphysis. It has shallow hollows, crests and grooves where muscle tendons attach; and an upper extremity from which a hemispherical cap emerges, facing medially, which is covered in cartilage. This is the head of the humerus joining with the scapula in the glenoid cavity and where there are also tubercles.

These are the greater and lesser tubercle and lastly a transversally wide, flat, lower extremity, with a transverse, roughly semicylindrical formation, with the lateral section known as the condyle (joining with the radius) and the medial section known as the trochlea (joining with the ulna), and to the sides there are also two tubercles: the external one is above the condyle and is short, while the medial one (epitrochlea) is extremely accentuated. As the inferior epiphysis is flat, there are two faces, anterior and posterior, each with particular depressions: radial fossa, coronoid fossa (anteriorly) and olecranon fossa (posteriorly).

The radius is a long bone which, in the anatomical position, is positioned laterally in the forearm and where two very different extremities contrast: a body with flat surfaces and a triangular section of which the superior, proximal end joins with the humerus. It is thin and cylindrical and is known as the radial head; the inferior (distal) one joins with the hand bones and is wide and flat; laterally it includes the styloid process, medially the articular surface for the ulna.

The ulna (or cubital) is a long bone positioned medially in the forearm with a general shape that contrasts that of the radius: the body has a triangular section and is rather robust in the upper section, then grows thinner and more rounded in the lower section. The upper extremity is very large and forms the main part of the joint with the humerus. It comprises two processes, which result in a wide semi-

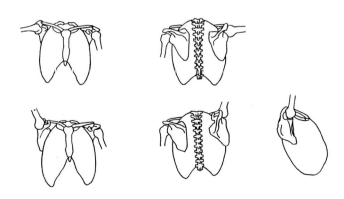

Movement of the scapula and the clavicle in the movements of abduction and elevation of the arm.

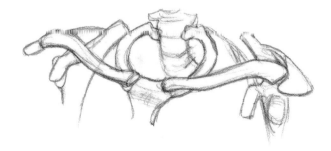

Shape of the and arrangement of the bones included in it (sternum, clavicle and scapula.

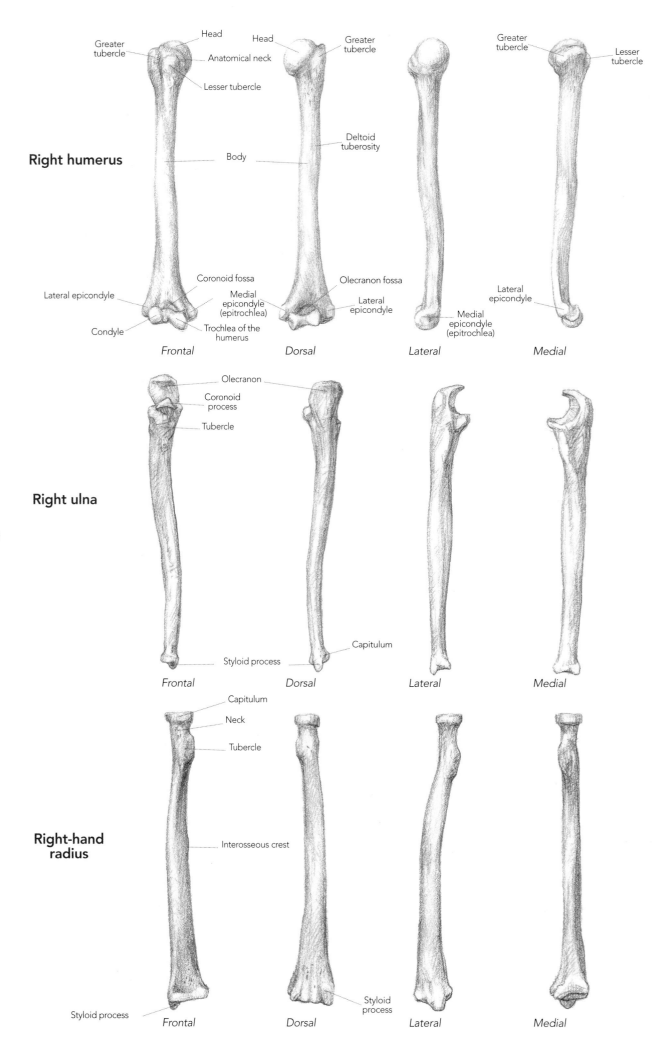

Right humerus

Greater tubercle
Head
Anatomical neck
Lesser tubercle
Body

Lateral epicondyle
Coronoid fossa
Medial epicondyle (epitrochlea)
Condyle
Trochlea of the humerus

Frontal

Head
Greater tubercle
Deltoid tuberosity
Olecranon fossa
Lateral epicondyle

Dorsal

Lateral

Greater tubercle
Lesser tubercle
Lateral epicondyle
Medial epicondyle (epitrochlea)

Medial

Right ulna

Olecranon
Coronoid process
Tubercle

Styloid process

Frontal

Capitulum
Styloid process

Dorsal

Lateral

Medial

Right-hand radius

Capitulum
Neck
Tubercle

Interosseous crest

Styloid process

Frontal

Styloid process

Dorsal

Lateral

Medial

a b

The two bones of the right-hand forearm positioned in their anatomical position in the supine position: in frontal (a) and lateral (b) projection.

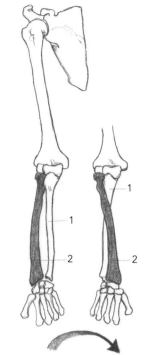

Overlapping mechanism of the radius and ulna in pronation movement (right limb in frontal projection).

circular notch: the olecranon, which is curved and located posteriorly, and the coronoid process, which is short, pyramid-shaped and positioned anteriorly. The lower extremity is very thin and cylindrical in shape, with a short, evident process positioned medially and posteriorly (styloid process of the ulna).

The carpus is formed by eight short bones, each with its own morphological characteristics, but which together form a flat, anteriorly concave semilunar formation.

The bones are arranged in two lines side by side, each comprising four elements, but lined up in an irregular, complex manner. In the proximal row, which joins with the bones of the forearm, there are the scaphoid, the lunate, the triquetrum and the pisiform; in the other row, joining with the metacarpal bones, we find the trapezium, the trapezoid, the capitate and the hamate.

The metacarpus comprises five long bones of different lengths, each with particular characteristics, but which can be traced back to a common structure: a rather curved, anteriorly concave cylindrical structure, a volar; a well-developed, hemispherical head, joining with the phalanges; a narrower base, with an irregularly cubic surface, joining with the carpal bones. The bone segments are arranged closer together in the basal section and then diverge at the heads, especially the first metacarpal, which corresponds to the thumb.

The phalanges are the small bones of the fingers, arranged as three per finger, except for the thumb, which has only two phalanges as the middle one is missing. We can distinguish the proximal phalanges (or first phalanges) which are the largest, with the joint bases with the metacarpals, the short bodies and the joint heads with the subsequent phalanges; the middle phalanges (or second phalanges) with characteristics similar to the first, but smaller in size; and the distal phalanges (or third phalanges) which are very short, with a widened spoon-like termination on which the fingernails sit. Two hemispherical sesamoid bones, medial and lateral, are frequently found at the head of the thumb's metacarpus, next to the joint with the phalanx.

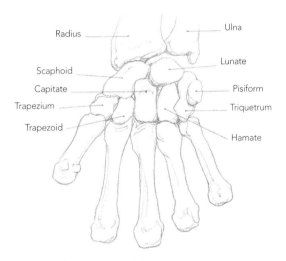

Radius — Ulna
Scaphoid — Lunate
Capitate — Pisiform
Trapezium — Triquetrum
Trapezoid — Hamate

Drawing of the position of the carpal bones (right hand, palm surface).

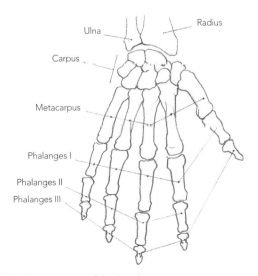

Ulna — Radius
Carpus
Metacarpus
Phalanges I
Phalanges II
Phalanges III

The bone groups of the hand.

Bones of the right hand

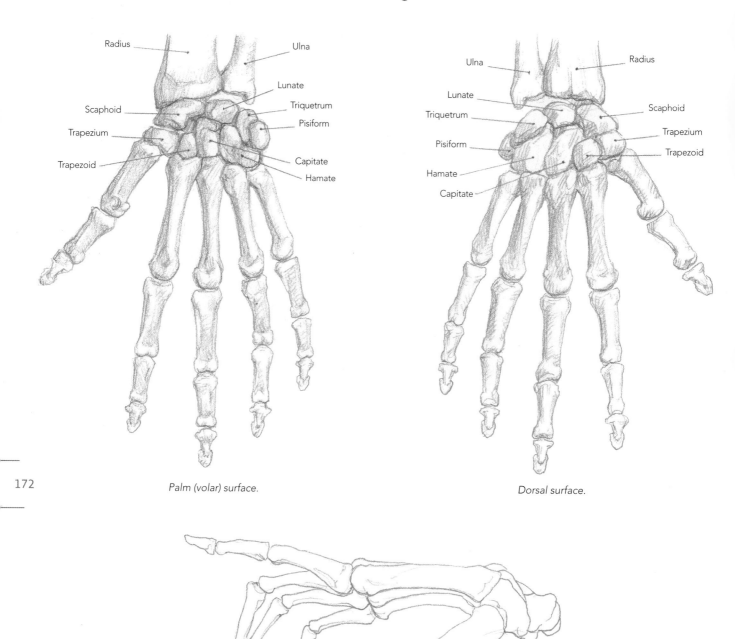

Palm (volar) surface.

Dorsal surface.

ARTHROLOGY

There are several joints in the free part of the upper limb, due to the progressive increase in number of bone segments from the humerus to the hand. According to functional and morphological criteria, three groups of joints can be distinguished: the joints of the shoulder girdle (acromioclavicular and sternoclavicular), joining the upper limb and the axial skeleton, which have already been described in their topographical relations with the thorax; the joints of the free part (scapulohumeral joint, elbow joint, distal and proximal radioulnar joints, radiocarpal joint); and the joints of the hand. The scapulohumeral joint (or shoulder joint) creates the union between the head of the humerus and the glenoid cavity of the scapula. While the humeral head is hemispherical, the glenoid cavity is rather oval, slightly hollow, and *in vivo* is enlarged by a fibrocartilaginous disc that surrounds it. A considerable difference of extension and of shape of the contact surfaces can therefore be seen, and this is a factor that favours the wide range of the movement in the limb.

The two articular surfaces are covered by cartilage and are joined by a capsule reinforced by ligaments coming from the coracoid apophysis (coracohumeral ligament, which extends towards the greater tubercle of the humerus) and from the glenoid lip (glenohumeral ligaments, superior, middle and inferior). In addition to the ligaments, the joint is strengthened by the tendons of some

muscles (subscapular, supra- and infraspinatus, and teres minor). All these devices are containing but not binding; therefore the joint, which is an enarthrosis, allows a wide range of movement: abduction, adduction, flexion and extension, rotation and circumduction.

Firstly there is the elbow joint. The humerus, the bone of the arm, is joined with the two bones of the forearm, the ulna and the radius, via this compound joint with three articular heads contained in a single capsule. Based on the characteristics of the articular heads, three types of joint can be recognized in the section: trochlear, between the humerus and ulna; trochoid, between the radius and ulna, proximally; condyloid, between the humerus and ulna, which is the functionally dominant joint for movements of the forearm on the arm. Because of the type of joint, movements can be angular on one plane and therefore only of flexion and extension.

The articular capsule of the elbow is strengthened by various ligaments: the collateral (or medial) ulnar ligament, which originates from the humeral epitrochlea and extends in wide bundles on to the olecranon and the medial surface of the ulnar on the capsule border; the collateral (or lateral) radial ligament, which originates from the humeral epicondyle and splits into two cords, anterior and posterior; and the annular ligament of the radius, located inside the capsule, which surrounds the radius capitulum and inserts onto the ulna to strengthen the joint during pronation and supination of the forearm.

The distal radioulnar joint is a lateral ginglymus formed by the head of the ulna and the ulnar notch of the radius. The articular heads, between which a fibrocartilaginous disc is placed, are wrapped loosely by the capsule; therefore the movements allowed by this joint, together with that of the proximal radioulnar joint, are pronation and supination of the forearm (and consequently of the hand). These movements take place by moving only the radius, which rotates around the ulna. In the anatomical position, the palm of the hand faces forwards and therefore the bones of the forearm are positioned parallel, the ulna medially and the radius laterally: this position is known as supine. The pronation movement rotates the radius on the ulna, arranging to cross it, and consequently, the palm of the hand is directed posteriorly.

We can also note that these movements are aided by the presence of the interosseous membrane stretched between the ulna and radius, and also by a slight rotation of the humerus. The radiocarpal joint is condyloid and joins the forearm to the hand. It is formed by the proximal carpal bones and the inferior surface of the radius, wrapped by a capsule and attached by a disc. The strengthening ligaments are positioned ventrally, dorsally and laterally: the palmar and dorsal ligaments and the ulnar and radial collateral ligaments. The radiocarpal joint allows complex movements: flexion, extension, adduction, abduction and circumduction, which is determined by combining them.

The widest movements are those of extension and flexion, therefore the hand can be brought dorsally and ventrally until its axis is almost at a right angle with that of the forearm.

The hand joints are particularly complex as the individual segments of the bone, which have have several contact surfaces, are connected by a network of ligaments that stabilize them or bring about joint movements (proximal interosseous, intermetacarpal-interosseous, and transverse metacarpal head ligaments). The joints of the hand can be separated into groups. The carpal joints form between the bones of the proximal row of the carpus, wrapped in a capsule and are joined by several ligaments (palmar, dorsal, interosseous).

They are arthrodiae sliding joints, allowing small sliding movements, making the relationship of the wrist with the forearm more stable and elastic.

The carpometacarpal joints are positioned between the bones of the distal row of carpal bones and the bases of the metacarpal bones.

The joint between the trapezium and the first metacarpal is a saddle joint and the most important, as it corresponds to the thumb; it thus allows the wide-ranging flexion, extension, abduction, adduction and opposition movements that are characteristic of humans. The carpometacarpal joints of the remaining four fingers are arthrodiae and allow small sliding movements.

The intermetacarpal joints form between the bases of the metacarpals wrapped by capsules and strengthened by dorsal, palmar, interosseous ligaments and a very strong transverse ligament, designed to keep the metacarpals close together. Movements are limited and overall cause the palm of the hand to be more concave.

The metacarpophalangeal joints join the heads of the metacarpals at the base of the first phalanges of the five fingers. These are enarthroses and the articular heads are kept together by fibrous capsules and collateral ligaments: movements allowed by these joints are flexion (up to a right angle); very limited extension; lateral movement, that is, moving away toward the ulnar side or radial side and possible only in the extended hand; circumduction, basically limited to the index finger. The interphalangeal joints join the phalanges to each other and occur between the head of one phalanx and the base of the next one: there are, therefore, one for the thumb (which does not have a second phalanx) and two for each of the remaining four fingers. The articular surfaces are kept together by the capsule and collateral ligaments: as they are trochlear, the movements allowed by these joints are only flexion – almost to a right angle – and a slight extension, limited to the last phalanx.

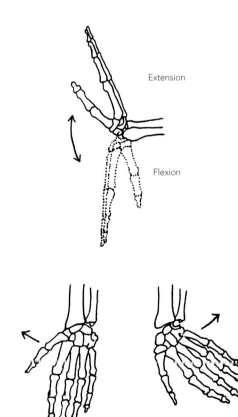

Extension

Flexion

Lateral flexion (abduction) Medial flexion (adduction)

Limits on range of wrist movements.

Functional characteristics of the upper limb

The upper limb carries out particular complex functions for the human being, in whom the evolutionary achievement of the erect position and the consequent anatomical adaptations have brought about the specialization of the limb in activities not linked to that of supporting the body.

The freedom of movement of the shoulder girdle joints and the free part allow the limb to flex and also to place itself in various directions, but the basic functions are carried out by the hand, with its prehensile ability, opposition of the thumb, pronation and supination. In fact, the hand is skeletally structured and articulated in order to permit the complex muscles, especially those of the thumb and the muscles of the forearm, to act with powerful but also delicate movements. Lastly, it is useful to remember that the upper limb, via the shoulder girdle, has important functional relations with the trunk, based on which the possibilities of extending the limb's movements are broadened. This also affects the static or dynamic balance of the entire body, such as, for example, the alternating and rhythmical oscillation of the limbs in walking and running.

MYOLOGY

There are many upper limb muscles and their number increases in the proximal–distal direction, in relation to the similar increase in bones and the specific functions of the hand. The connecting muscles between the axial body section and the upper appendicular section act on the shoulder girdle and on the proximal section of the humerus: these are axioappendicular muscles (including spinoappendicular and thoracoappendicular muscles) and shoulder muscles.

These have already been described in the section on the trunk (see page 124). This section includes the muscles of the limb, that is, the muscles of the arm, forearm and hand. The arm muscles are long and they are arranged parallel to the humerus, which they almost completely cover. We can distinguish the forearm flexor muscles, placed in the anterior cavity (biceps, coracobrachialis, brachialis, anconeus), and the extensor muscle, the triceps, positioned in the posterior cavity.

There are several muscles in the forearm. These have bellies which extend into thin tendons and therefore the section of the forearm close to the elbow has a greater diameter compared with close to the wrist. There are two groups which mainly act on the hand: the flexor muscles, positioned in the anterior cavity, and the extensor muscles, positioned in the posterior cavity. The hand muscles are on the palmar surface, while on the dorsal surface, there are only the tendons from the forearm muscles with an extensor function. The muscles are short and flat, joined into three groups: the muscles of the thenar eminence (abductor brevis, flexor brevis, opponens and adductor pollicis), located laterally; the muscles of the hypothenar eminence (abductor, flexor brevis, opponens digiti minimi), located medially; and the interossei and lumbricales groups of muscles, located between the metacarpal bones.

Auxilliary organs to the upper limb muscles

These are some formations (membranous fasciae, tendinous sheaths, fibrous devices and tendon-containing fasciae, mucosa bursae) which cover the muscles and aid their functions.

All the muscles in the limb are covered by a subcutaneous, superficial, membranous fascia which runs deeply inside the limb, bordering the muscle cavities, and which divides topographically into the shoulder fascia (which covers the shoulder muscles), originates from the fascia that covers the pectoralis major and extends to cover the deltoid, trapezius and latissimus dorsi muscles. Some septa (tissue walls) push deeply and others are a part of the border of the axillar cavity. There are two arm fasciae: there is a cylindrical, membranous, laminar formation which covers the muscles of the arm and another similar one that covers the muscles of the forearm. The fasciae separates into cavities and adheres to subcutaneous points on the bone. The hand fascia covers the bones and muscles of the hand both dorsally and on the palm. It is considerably thicker in this latter area and is known as the palmar aponeurosis.

The fibrous-containing structures that are the laminar, membranous and superficial formations work to keep the long tendons in place and adhere to the deep surfaces and long tendons, especially in the forearm and the hand. They also act as a mechanical reflection and anchoring point for tendons during flexion and extension movements.

We can see: the carpal containing device, which is a thickening of the forearm fascia and, splitting into a dorsal ligament and a palmar ligament, surrounds the wrist and covers the tendons, especially the flexors, which are ventrally reinforced by the transverse ligament of the carpus. Then there are the tendinous containing devices of the fingers, which are only on the volar face of the fingers and form some fibrous channels extended from the metacarpus to the third phalanx. Flexor tendons run in them (dorsally, on the other hand, the tendons insert directly on to the bone). The tendon or mucosa sheaths are channels located in the containing devices which aid the sliding of the tendons, reducing friction. They are located ventrally and dorsally, and in particular, in the carpus and fingers. The mucosa bursae are cushioning devices which contain synovia in mechanical friction points between muscles, tendons or fascial organs. They are not constant in volume, location and individual characteristics, varying according to habits such as work or sports activities causing particular stress.

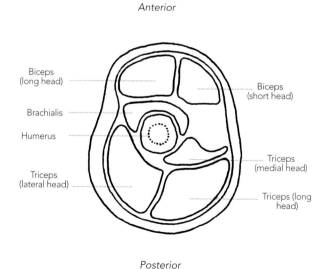

Anterior

Biceps (long head)
Biceps (short head)
Brachialis
Humerus
Triceps (medial head)
Triceps (lateral head)
Triceps (long head)

Posterior

Transverse section of the left arm in the middle third.

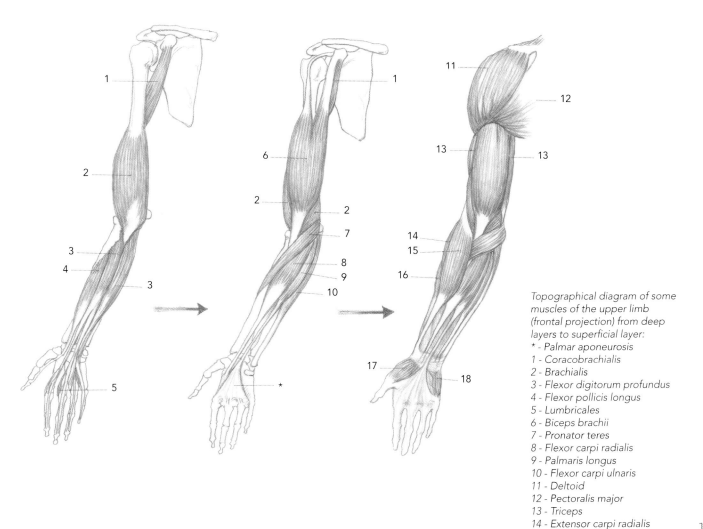

Topographical diagram of some
muscles of the upper limb
(frontal projection) from deep
layers to superficial layer:
* - Palmar aponeurosis
1 - Coracobrachialis
2 - Brachialis
3 - Flexor digitorum profundus
4 - Flexor pollicis longus
5 - Lumbricales
6 - Biceps brachii
7 - Pronator teres
8 - Flexor carpi radialis
9 - Palmaris longus
10 - Flexor carpi ulnaris
11 - Deltoid
12 - Pectoralis major
13 - Triceps
14 - Extensor carpi radialis
 longus
15 - Brachioradialis
16 - Extensor carpi radialis
 brevis
17 - Thenar eminence
18 - Hypothenar eminence

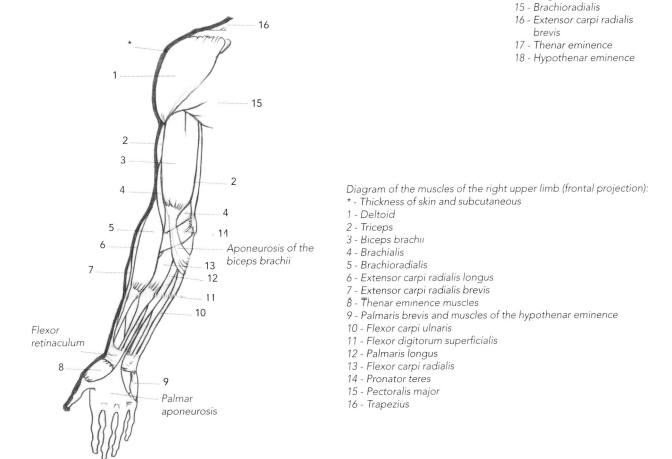

Diagram of the muscles of the right upper limb (frontal projection):
* - Thickness of skin and subcutaneous
1 - Deltoid
2 - Triceps
3 - Biceps brachii
4 - Brachialis
5 - Brachioradialis
6 - Extensor carpi radialis longus
7 - Extensor carpi radialis brevis
8 - Thenar eminence muscles
9 - Palmaris brevis and muscles of the hypothenar eminence
10 - Flexor carpi ulnaris
11 - Flexor digitorum superficialis
12 - Palmaris longus
13 - Flexor carpi radialis
14 - Pronator teres
15 - Pectoralis major
16 - Trapezius

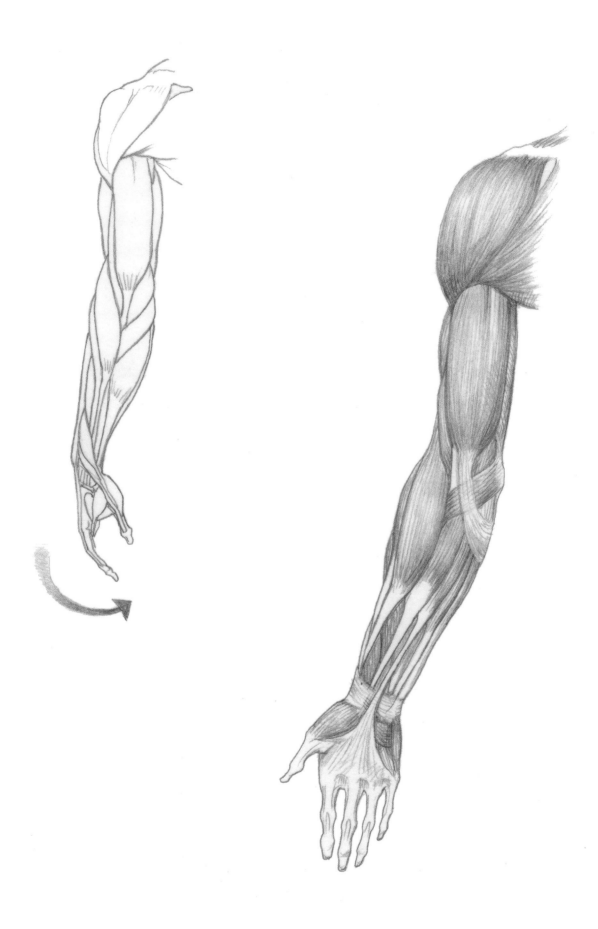

Superficial muscles on the right upper limb: frontal projection (see also diagrams on page 175).

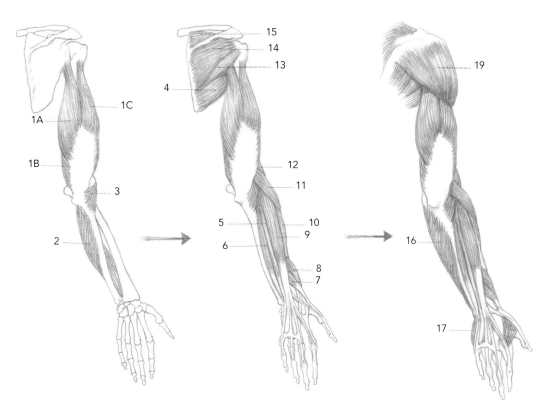

Topographical diagrams of some upper limb muscles (front projection), from deep layers to the superficial layer:
1 - Triceps:
 - long head (A)
 - Medial head (B)
 - Lateral head (C)
2 - Flexor digitorum profundus
3 - Anconeus

4 - Teres major
5 - Extensor digiti minimi
6 - Extensor carpi ulnaris
7 - Extensor pollicis brevis
8 - Abductor pollicis longus
9 - Extensor digitorum
10 - Extensor carpi radialis brevis
11 - Extensor carpi radialis longus
12 - Brachioradialis

13 - Teres minor
14 - Infraspinatus
15 - Supraspinatus
16 - Flexor carpi ulnaris (covers the flexor digitorum profundus)
17 - Hypothenar eminence
18 - First dorsal interosseus
19 - Deltoid

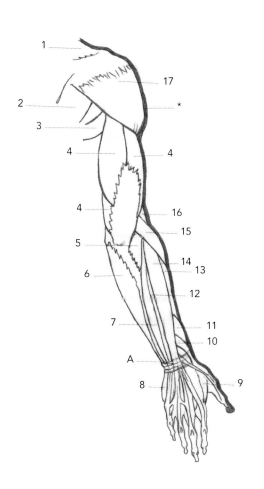

Diagram of the muscles of the right upper limb (dorsal projection):
* - Thickness of skin and subcutaneous layer
A - Carpal ligament (extensor retinaculum)
1 - Trapezius
2 - Infraspinatus
3 - Teres major
4 - Triceps
5 - Anconeus
6 - Flexor carpi ulnaris
7 - Extensor carpi ulnaris
0 - Hypothenar eminence muscles
9 - First dorsal interosseus
10 - Extensor pollicis brevis
11 - Abductor pollicis longus
12 - Extensor digiti minimi
13 - Extensor carpi radialis brevis
14 - Extensor digitorum communis
15 - Extensor carpi radialis longus
16 - Brachioradialis
17 - Deltoid

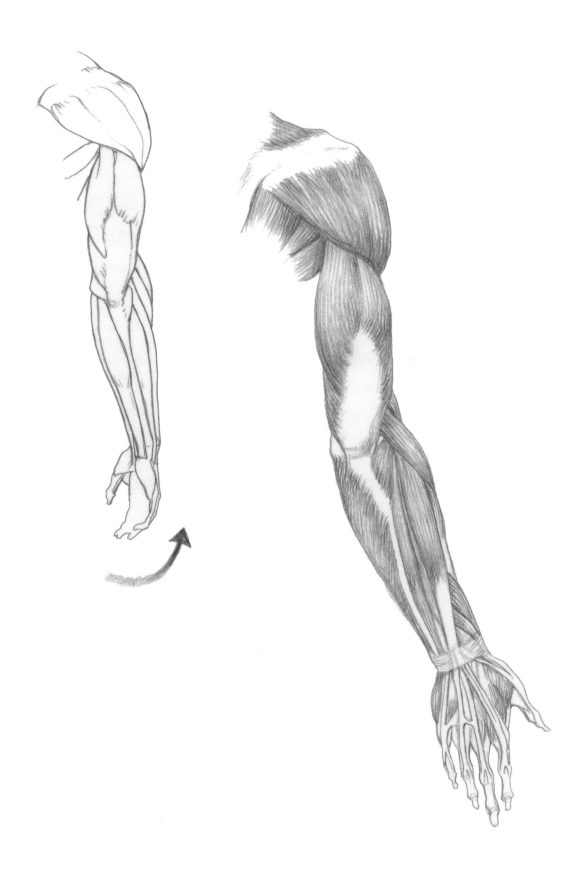

Superficial muscles of the right upper limb: dorsal projection (see also diagrams on page 177).

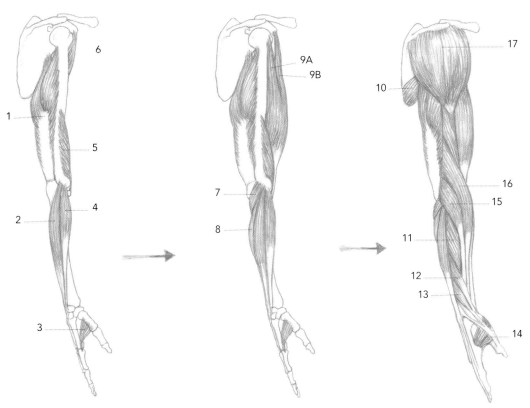

Topographical diagram of some muscles
of the upper limb (lateral projection) from
deep layers to superficial layer:
1 - Triceps
2 - Extensor digitorum communis
3 - First dorsal interosseus
4 - Extensor carpi radialis brevis
5 - Brachialis

6 - Coracobrachialis
7 - Anconeus
8 - Extensor carpi ulnaris
9 - Biceps brachii:
 - Long head (A)
 - Short head (B)
10 - Teres major
11 - Extensor carpi radialis brevis

12 - Abductor pollicis longus
13 - Extensor pollicis brevis
14 - Adductor pollicis
15 - Extensor carpi radialis longus
16 - Brachioradialis
17 - Deltoid

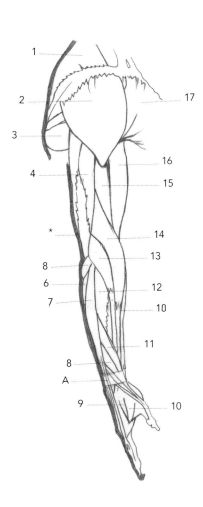

Diagram of the muscles of the right upper limb (lateral projection):
* - Thickness of skin and subcutaneous layer
A - Carpal ligament / transverse carpal ligament
1 - Trapezius
2 - Deltoid
3 - Teres major
4 - Triceps
5 - Anconeus
6 - Extensor digiti minimi
7 - Extensor digitorum communis
8 - Extensor pollicis brevis
9 - First dorsal interosseus
10 - Abductor pollicis
11 - Adductor pollicis
12 - Extensor carpi radialis brevis
13 - Extensor carpi radialis longus
14 - Brachioradialis
15 - Brachialis
16 - Biceps
17 - Pectoralis major
18 - Flexor carpi radialis

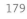

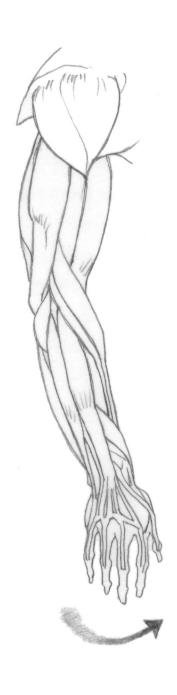

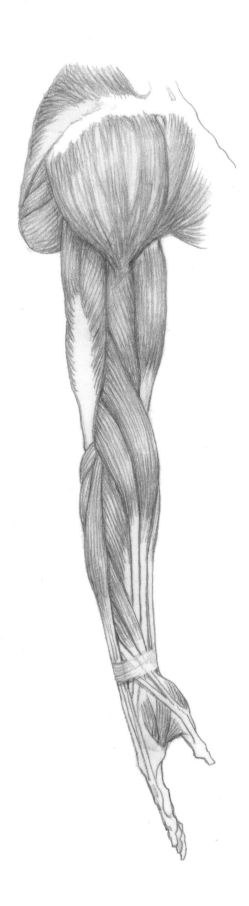

Superficial muscles of the right upper limb: lateral projection (see also diagrams on page 179).

MUSCLES OF THE UPPER LIMB
OF INTEREST FOR ARTISTIC REPRESENTATION

BICEPS BRACHII MUSCLE (Biceps brachii)

Form, structure, relations. The biceps brachii muscle is large and tapered (at the widest point it can reach 5cm (2in) and the maximum thickness can be 3cm (1¼in), positioned in the anterior cavity of the arm. It owes its name to the fact that it has two points of origin on the scapula: the long head, located laterally, originates with a long, thin tendon from the supraglenoid tubercle; the short head, located medially, originates with a short, strong flattened tendon from the coracoid process. The two muscle bellies run parallel and only merge in the distal section, inserting onto the radius with a very robust, wide single tendon. An aponeurotic lamina (lacertus fibrosus of the biceps) widens from the medial border of the tendon, at the cutaneous elbow fold, which runs obliquely downwards and medially, expanding onto the fascia that covers the groups of forearm flexor muscles. The muscle (which may have anomalous insertions, with the two heads connected or fully separated, or one of the two missing) is almost entirely subcutaneous, covered only by the superficial fascia of the arm (fascia brachialis) and the skin. The deep surface of the muscle covers the brachialis; the medial border has relations with the coracobrachialis; the lateral border has relations with the deltoid and the brachioradialis; the superficial face, only at the point of origin, is covered by the pectoralis major and the deltoid. The insertion tendon is placed between the medial group and lateral group of the forearm's flexor muscles.

Origin. Long head: supraglenoid tubercle and glenoid lip of the scapula. The tendon also runs inside the fibrous capsule of the scapulohumeral joint. Short head: apex of the coracoid process of the scapula.

Insertion. Posterior surface of the bicipital tuberosity of the radius; antebrachialis aponeurotic fascia (via the lacertus fibrosus).

Action. Flexion of the forearm on the arm, with light lateral rotation (supination) of the forearm. (It is useful to note that the biceps muscle has no insertions on the humerus.)

Surface anatomy. The biceps brachii muscle is subcutaneous along almost its entire length. In a relaxed state, it appears as a semicylindrical surface located in the front part of the arm. The elevation of the muscle belly is clearer at the insertion head, while the section at the points of origin is covered by the deltoid muscle. When contracted, the muscle shortens and increases in thickness, often in the lower half, which thus appears more conspicuous than the upper half. Also in this state, both the insertion tendon and the lacertus fibrosus are clearly seen: the tendon appears clearly if the forearm is in supination and flexed at right angles to the arm, while the lacertus fibrosus is seen more clearly if, when flexed, the forearm is slightly rotated medially.

The origin tendon of the short head runs behind the anterior pillar of the axilla and anteriorly to the coracobrachialis tendon. The separation line of the two origin heads is frequently visible underneath the skin and, in a few cases, the path of the cephalic vein and a small secondary bundling of the muscle belly can also appear.

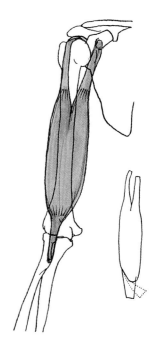

BRACHIORADIALIS MUSCLE (Brachioradialis)

Form, structure, relations. The brachioradialis (or supinator longus) muscle is long, slightly flattened and voluminous. It is located superficially on the medial side of the forearm, stretched between the humerus and the radius. It is almost triangular in shape as the fibres originate from a wide surface and then halfway down the forearm, converge into a long, thin, flat insertion tendon. The muscle, which may have anomalous insertions or connections with nearby muscles, has the extensor carpi longus radialis longus alongside it medially and posteriorly; medially and anteriorly, it has relations with the pronator teres (which it partly covers) and the flexor carpi radialis. The distal section of the insertion tendon is crossed by the abductor pollicis longus and the extensor pollicis brevis tendons.

Origin. Lateral border (supraglenoid tubercle) of the humerus; anterior surface of the lateral intermuscular septum.

Insertion. Superior surface of the radial styloid process.

Action. Flexion of the forearm on the arm (particularly effective if the forearm is in the intermediate position between pronation and supination).

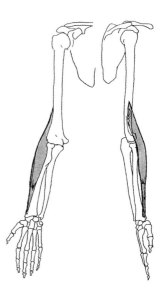

Surface anatomy. The brachioradialis muscle is subcutaneous along almost its entire extension. When relaxed, its fleshy mass cannot be distinguished from that of the adjacent extensor carpi radialis longus, but when sharply contracted, it appears as a clear elevation (radial rope) on the upper two-thirds of the radial side of the flexed forearm. It therefore forms the lateral border of the cubital fossa, where the bicipital tendon elevation is located medially to the brachioradialis muscle.

TRICEPS BRACHII MUSCLE (Triceps brachii)

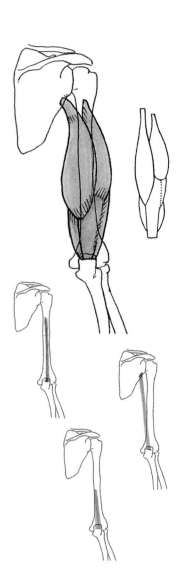

Form, structure, relations. The triceps brachii muscle is large and about 4cm (1½in) thick and occupies the posterior cavity of the arm entirely, extending from the scapula and the humerus to the ulna. It comprises three muscle bellies that remain separate and have only the wide insertion tendon in common: the medial head, located deeply; the lateral head and the long head, located superficially. The medial head is triangular in shape and thin, with its fibres running obliquely, from top to bottom and laterally. It is mostly covered by the long head, the lateral head and the common tendon, from which it overflows slightly at the sides in the lower portion of the arm. The long head overlaps the lateral head for a short section: both are superficial and run parallel, occupying the upper part of the arm. The long head's origin tendon continues into an aponeurotic lamina which medially covers the muscle belly and determines a flattening of the arm's medial surface, which is more visible in extension. The triceps muscle is mostly subcutaneous, covered by the brachial aponeurotic fascia and the skin. In the initial section, the long head runs in front of the teres minor and behind the teres major, and is covered by the deltoid; the lateral head has a relation with the brachialis, anteriorly, and with the anconeus, inferiorly; the medial head adheres to the posterior surface of the humerus and is covered by the common tendon.
Origin. Long head: subglenoid tuberosity of the scapula and fibrous capsule of the scapulohumeral joint.
Lateral head: posterior and lateral surface of the humerus (the area between the radial nerve, the deltoid tuberosity and the insertion of the teres minor); lateral intermuscular septum.
Medial head: posterior and medial surface of the humerus (the narrow area between the radial nerve groove, insertion point of the teres minor and the humeral trochlea); medial and lateral intermuscular septa.
Insertion. Ulna (posterior and superior surface of the olecranon); antebrachial fascia. Insertion is via a long, robust, flat tendon, into which three muscular bellies converge and which comprises two overlapping aponeurotic laminae which originate about halfway down the muscle, one deeply and the other superficially. A sliding bursa mucosa, a subtendinous bursa, is located between the bone surface and the tendon, and superficially, the subcutaneous bursa of the olecranon.
Action. Extension of the forearm on the arm. It can be noted that the long head of the triceps acts on two joints, arm and elbow, also aiding a weak adduction and a dorsal movement of the arm; the medial and lateral heads, on the other hand, act only on the elbow joint, determining extension.
Surface anatomy. The triceps muscle is almost entirely subcutaneous along its extension and takes up the posterior section of the arm. The long head is the clearest, most prominent portion, with the superior section covered by the deltoid muscle; the lateral head is positioned laterally to the long head and is partly covered by it; the medial head is covered by the common tendon and only the borders close to the epicondyles of the humerus are visible. The common tendon forms a large, flat, slightly convex area, almost rectangular in shape and heading obliquely downwards and medially compared with the longitudinal axis of the arm. The muscle fibres of the lateral head, and some from the medial head, insert on the upper and lateral sides; the long head fibres insert on the medial side and the fibres from the medial head insert on the lower section. If the muscle is contracted, its bellies (above all the long head and the lateral head) are prominent in the upper half of the arm, in contrast with the flattened area, which corresponds to the common tendon which occupies the lower half. If the muscle is relaxed or if the forearm is flexed onto the arm, the triceps elevations are much less evident and the entire posterior region of the arm takes on a normal rounded or flattened appearance.

SUPINATOR MUSCLE (Supinator)

Form, structure, relations. The supinator muscle (or supinator brevis) is flat, short and almost triangular in shape. It is placed inferior and posterior to the elbow joint. It is directed obliquely and laterally from the ulna to the radius, which it borders in its proximal third. The supinator muscle (which can be separated into two overlapping, superficial, deep laminae, or have anomalous insertions) adheres to the radius and the articular elbow capsule. Posteriorly, it is covered by the common extensor digitorum and extensor carpi ulnaris muscles; anteriorly it is in relation with the biceps tendon.
Origin. Lateral epicondyle of the humerus; elbow joint ligaments; lateral border of the ulna (on the supinator crest, a rough area positioned inferiorly to the semilunaris notch).
Insertion. Anterior and lateral surface of the upper third of the radius, at the tuberosity.
Action. Supination of the forearm (lateral rotation of the radius on the ulna).
Surface anatomy. The muscle is deep and is therefore not visible underneath the skin.

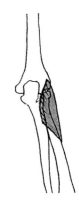

CORACOBRACHIALIS MUSCLE (Coracobrachialis)

Form, structure, relations. The coracobrachialis is a small, elongated muscle, almost cylindrical or conical in shape, which travels obliquely downwards and outwards from its origin on the scapula to its insertion on the humerus. The muscle, which can vary in length, is mostly covered by the short head of the biceps, while its tendon of origin is crossed anteriorly and superiorly by the pectoralis major muscle and the deltoid, and posteriorly by the latissimus dorsi, teres major and subscapularis.
Origin. Apex of the coracoid process of the scapula (the tendon is positioned medially to the biceps short head tendon).
Insertion. Anteromedial surface of the middle third of the diaphysis of the humerus.
Action. Adduction of the arm, with slight anterior flexion and medial movement, stabilization of the humerus in the scapulohumeral joint. (It can be noted that the topographical situation and adduction action of the muscle are similar to those of the adductor muscles of the thigh).
Surface anatomy. The coracobrachialis muscle is only subcutaneous for a short section of the origin tendon: it appears as a rope-like elevation placed behind the anterior border of the axilla and underneath the short head of the biceps, which runs adjacent to it. The superficial section is mostly visible if the arm is abducted and the forearm is flexed at a right angle.

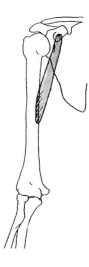

BRACHIALIS MUSCLE (Brachialis)

Form, structure, relations. The brachialis (or brachialis anterior) is a strong, flat, long and rather wide muscle, located on the anterior surface of the elbow joint, stretched between the humerus and the ulna. The muscle, which can be split into several separate bundles, adheres to the ventral surface of the humerus and is mostly covered by the biceps. The medial border has relations with the pronator teres; the lateral border has relations with the brachioradialis and extensor carpi radialis longus, from which it is separated by a neurovascular bundle. Some of the medial and lateral borders are superficial.
Origin. Lower half of the anterior surface of the humerus, medial and lateral intermuscular septa.
Insertion. Ulnar tuberosity; rough surface of the anterior surface of the coronoid process.
Action. Flexion of the forearm, in synergy with the biceps muscle and acting more efficiently when the forearm is already partly flexed.
Surface anatomy. The brachialis muscle is wide, therefore its medial and lateral borders overflow from the biceps at the elbow joint and are subcutaneous at the sides of the arm. The superficial surface section is short and causes a flattened area at the biceps tendon, while the lateral section is extended to the point where it inserts onto the deltoid and is a prominence between the biceps and the lateral head of the triceps.

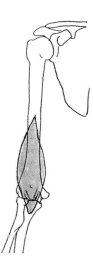

PRONATOR TERES MUSCLE (Pronator teres)

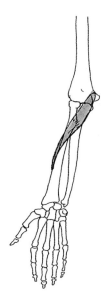

Form, structure, relations. The pronator teres muscle is short, fleshy and cylinder-shaped in the point of origin, at the humerus, and is flattened towards the insertion tendon on the radius. The muscle is the most lateral of the group which originates from the medial epicondyle (or epitrochlea) of the humerus and heads laterally downwards, crossing the anterior cavity of the forearm obliquely. The pronator teres originates with two separate heads, one from the humerus and one from the ulna, which fuse almost immediately into a single belly. The upper portion of the muscle is superficial, while the inferior part, mainly tendinous, is covered by the muscles in the lateral region of the forearm. The deep surface covers the brachialis and the flexor digitorum superficialis tendons. The lateral border of the muscle borders the cubital fossa medially, which is a triangular hollow in front of the elbow joint and in which the biceps tendon, the brachialis and the supinator brevis are located deeply, below the lacertus fibrosus.

Origin. Humeral head: medial epicondyle (epitrochlea) of the humerus; medial intermuscular septum. Ulnar head and medial surface of the ulnar coronoid process.

Insertion. Lateral surface of the middle section of the radius.

Action. Pronation of the forearm (i.e. rotation, towards the limb's axis, of the radius on the ulna, in synergy with the pronator quadratus muscle and in antagonism with the supinator muscle); weak flexion of the forearm.

Surface anatomy. The proximal part of the pronator teres muscle is subcutaneous but is not easily distinguishable from the nearby muscles. If the forearm is in pronation under resistance and is slightly flexed, the contracted muscle can appear as a short rope-like prominence on the anteromedial surface of the forearm, underneath the cubital fold, in an area between the brachioradialis (positioned laterally and from which it is separated by a groove) and the medial epicondyle of the humerus.

PRONATOR QUADRATUS MUSCLE (Pronator quadratus)

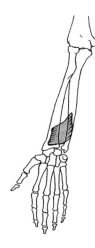

Form, structure, relations. The pronator quadratus muscle is flat, almost laminar, and quadrangular, located in the distal section of the anterior cavity of the forearm, at the wrist joint. The muscle bundles are arranged to form two overlapping laminate layers which connect the ulna to the radius transversally or slightly obliquely. The muscle may vary in length and volume or be divided into several separate bundles. It is located deeply and adheres to the forearm bone and the interosseous membrane. It is covered by the flexor muscle tendons (flexor carpi ulnaris, flexor digitorum superficialis and profundus, palmaris longus and brevis and flexor pollicis) and then by the antebrachial fascia and skin. The upper border of the pronator quadratus is quite thin, while the lower border is thicker and thus contributes to determining the volume of the distal, anterior segment of the forearm.

Origin. Distal section of the anterior surface of the ulna.

Insertion. Distal section of the anterior surface of the radius, above the ulnar notch.

Action. Pronation of the forearm.

Surface anatomy. The pronator quadratus muscle is deep and is not visible or palpable.

ANCONEUS MUSCLE (Anconeus)

Form, structure, relations. The anconeus muscle is small, flat and triangular, as its fibres originate from a narrow area and fan out as they travel medially downwards towards the insertion point. The muscle, which may also be fused with the lateral head of the triceps, is superficial, covered by the antebrachial fascia and the skin; its deep surface adheres to the posterior surface of the elbow joint. The upper border has relations with the lateral head of the triceps and the latero-inferior border has relations with the extensor carpi ulnaris.

Origin. Posterior surface of the lateral epicondyle of the humerus, with a short tendon and as a continuation of the lateral head of the triceps.

Insertion. Posterolateral surface of the ulna (on and below the olecranon).

Action. Extension of the forearm (in synergy with the triceps muscle); participation in pronation and supination movements of the forearm.

Surface anatomy. The anconeus muscle is superficial and when contracted (with the forearm highly extended), it appears as a small elongated elevation placed laterally to the olecranon, between the triceps tendon and the group of muscles originating from the lateral epicondyle of the humerus (extensors).

FLEXOR CARPI RADIALIS (Flexor carpi radialis)

Form, structure, relations. The flexor carpi radialis (or palmaris major) muscle has a large belly and is tapered and slightly flattened in the section where it travels along the long insertion tendon. It travels inferiorly and laterally, from the medial epicondyle of the humerus to the second metacarpal bone, obliquely crossing the ventral surface of the forearm. The muscle may also be missing, have anomalous insertions or be partly fused with nearby muscles. It is almost entirely superficial, covered by the antebrachial fascia and skin. It covers the flexor digitorum superficialis, and the pronator teres muscle runs laterally to it, while the palmaris longus muscle runs medially.

Origin. Medial epicondyle of the humerus; antebrachial fascia.

Insertion. Anterior surface of the base of the metacarpal bone (the distal part of the tendon, covered by a synovial sheath, originates medially at the scaphoid bone and is covered by the palmar carpal ligament).

Action. Flexion of the hand on the forearm (in synergy with the flexor carpi ulnaris); weak abduction and pronation of the hand.

Surface anatomy. The flexor carpi radialis muscle is subcutaneous; however, its belly is not easily distinguishable from those of the other flexor superficialis muscles which originate from the medial epicondyle (flexor carpi ulnaris, palmaris longus, and pronator teres) as these are also all covered by a strong aponeurotic insertion fascia, to which the antebrachial fascia adheres. However, the insertion tendon is easily visible under the skin, on the ventral surface of the forearm, close to the wrist. Especially if the hand is slightly flexed and moved radially, it looks like a rope-like prominence located radially to the forearm's median line and laterally to the palmaris longus muscle tendon, which is thinner and even more prominent. If the forearm is in its anatomical position, the tendon's axis heads towards the index finger, while it heads obliquely and closer to the radial border if the forearm is pronated. The contractile part of the muscle extends some fibres to the sides of the insertion tendon for a short section, which then appears depressed compared with them and, during contraction, can cause a shallow cutaneous, triangular depression on the surface.

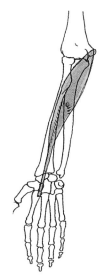

FLEXOR CARPI ULNARIS MUSCLE (Flexor carpi ulnaris)

Form, structure, relations. The flexor carpi ulnaris muscle is long and flat, positioned on the medial border of the forearm, running vertically from the humerus to the carpus. It is the largest and most medial of the superficial flexor muscles of the forearm: the two origin heads, the humeral head and the ulnar head, merge into a single belly which, around the distal third of the forearm, extends into a thin, flat tendon. The muscle (which may be missing the ulnar head, have anomalous insertions or be connected to nearby muscles) is subcutaneous along its entire extension, covered by the antebrachial fascia. The deep surface has relations with the flexor digitorum superficialis and profundus and the pronator quadratus muscles.

Origin. Humeral head: medial epicondyle of the humerus.
Ulnar head: medial border of the ulna (olecranon); upper section of the rear border of the ulna, via the aponeurotic lamina.

Insertion. Pisiform bone, with extensions to the hamate bone and the base of the fifth metacarpal (close to the insertion point, the tendon is connected with the antebrachial fascia by an aponeurotic section).

Action. Flexion of the hand on the forearm (in synergy with the flexor carpi radialis and the palmaris longus); adduction (medial deviation) of the hand.

Surface anatomy. The flexor carpi ulnaris muscle is subcutaneous, but difficult to distinguish from the nearby muscles due to the aponeurotic fascia which covers them (see flexor carpi radialis muscle above). At times, the contracted muscle belly may create a slight groove parallel to the ulna, bordered by this and by the ulnar border of the muscle where the basilic vein flows. On the other hand, the tendon is easily visible. It is more medial than the flexors and borders the anterior medial border of the wrist. If the limb is in an anatomical position, the tendon is slightly elevated and runs next to the ulna, without adhering to it, as between them is a light adipose layer which contributes to shaping the region's external morphology. If the hand is flexed, the tendon is prominent medially to the palmaris longus tendon, from which it is separated by a cutaneous groove which corresponds to the deeper path of the flexor digitorum superficialis tendons.

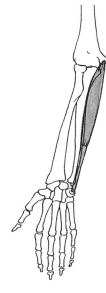

FLEXOR DIGITORUM SUPERFICIALIS MUSCLE (Flexor digitorum superficialis; flexor digitorum sublimis)

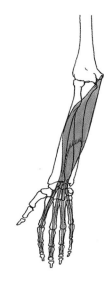

Form, structure, relations. The flexor digitorum superficialis is a wide, flat muscle located deep in the anterior section of the forearm, which runs entirely along its axis. There are two origin heads, the humeroulnar head and the radial head, which have two corresponding bellies arranged on a deep plane and on a superficial plane, each divided into two heads. These continue in four long cylindrical tendons which insert on to the fingers, excluding the thumb. The two tendons coming from the superficial layer overlap those from the deep layer and at the wrist and hand, head to the two central fingers, the middle finger (or third digit) and the ring finger (or fourth); the two tendons of the deep layer, on the other hand, change direction and head to the other fingers, the index (or second) and the little finger (or fifth). The muscle can vary greatly (missing the medial head, separation into four separate muscles, missing tendon for the fifth finger, etc.) and have extended relations. In the forearm, it covers the flexor digitorum profundus and is covered by the palmaris longus, the flexor carpi radialis, the pronator teres, and the brachioradialis. In the wrist, the four tendons cover the corresponding tendons from the flexor digitorum profundus and the flexor pollicis longus tendon; and they are wrapped in a synovial sheath and covered by the transverse carpal ligament. The tendons are covered by the palmar aponeurosis in the hand. In the fingers, each tendon covers the corresponding one from the flexor profundus, except in the section close to insertion, at the second (or middle) phalanx, where it splits in two and runs alongside it.

Origin. Humeroulnar head: medial epicondyle of the humerus; medial surface of the coronoid process of the ulna (superiorly to the ulnar head of the pronator teres); ulnar collateral ligament. Radial head: anterior border of the radius (in the third section).

Insertion. Borders at the sides of the second phalanges in the second to fifth fingers.

Action. Flexion of the second (middle) phalanx on the first (proximal) of the last four fingers of the hand; weak flexion and ulnar inclination of the hand.

Surface anatomy. The flexor digitorum superficialis muscle is located deeply and contributes to forming the fleshy mass of the upper half of the forearm. In its anterior part and on the medial border, only a thin portion of the belly is subcutaneous, along the medial border of the forearm, between the palmaris longus (positioned antero-laterally) and the flexor carpi ulnaris (positioned medially). Based on these relations, the bundle of four tendons (which still run closely together as far as the wrist) is visible between the palmaris longus and flexor carpi ulnaris tendons in the distal section of the forearm, especially if the hand is made into a fist and slightly flexed. If the fingers are flexed while the hand is open, the diverging prominences of the four tendons can be seen in the palm, covered by the palmar aponeurosis and the skin.

PALMARIS LONGUS MUSCLE (Palmaris longus)

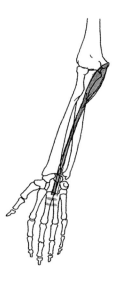

Form, structure, relations. The palmaris longus (or palmaris minor, palmaris gracilis) muscle is very slender, thin, fusiform and short as it does not reach the midpoint of the forearm before changing into a long, thin tendon. It is superficial and arranged slightly obliquely on the anterior surface of the forearm, compared with the limb's axis, heading laterally downwards from its origin on the humerus to its insertion on the palmar aponeurosis. Frequently the muscle may be missing, divided into two separate portions or almost entirely tendinous. The flexor carpi radialis runs alongside it laterally, the flexor carpi ulnaris and the flexor digitorum superficialis medially, over which it partly runs.

Origin. Medial epicondyle of the humerus; antebrachial fascia; fibrous septa separating from nearby muscles.

Insertion. Palmar aponeurotic fascia. Passing over the transverse carpal ligament and under the palmar carpal ligament, the tendon fans out and extends, with deep lateral bundles onto the insertion tendons of the thenar eminence muscles.

Action. Tension of the palmar aponeurosis; weak flexion of the hand onto the forearm.

Surface anatomy. The palmaris longus is subcutaneous, but its belly cannot be easily distinguished from those of the other flexor muscles (see flexor carpi radialis muscle, opposite). The tendon appears like a very prominent rope, thinner than that of the flexor carpi radialis, which runs laterally parallel to it. Next to the transverse cutaneous fold of the wrist, it widens a little due to its shape and insertion method.

EXTENSOR CARPI ULNARIS MUSCLE (Extensor carpi ulnaris)

Form, structure, relations. The extensor carpi ulnaris (or cubitalis posterior) muscle is long, thin and flat, and diagonally crosses the dorsal surface of the forearm from its origin on the humerus to its insertion on the metacarpus. The muscle belly, at the distal third of the forearm, extends to the sides of the flattened tendon which, prior to insertion, passes medially to the lower extremity of the ulna and underneath the dorsal carpal ligament. The muscle, which may have anomalous insertions or connections with nearby muscles, is superficial, covered by the antebrachial fascia and the skin. It adheres to the posterior border of the ulna and covers the abductor pollicis longus and the extensor digitorum indicis. The extensor digitorum minimi runs alongside it laterally and anteriorly. It has relations with the anconeus superiorly and medially.

Origin. Lateral epicondyle of the humerus; posterior border of the ulna.

Insertion. Dorsal surface and medial tubercle of the base of the fifth metacarpal (little finger).

Action. Extension of the hand on the forearm (in synergy with the extensor carpi radialis); adduction of the hand (in synergy with the flexor carpi ulnaris and in antagonism with the abductor pollicis longus).

Surface anatomy. The extensor carpi ulnaris muscle is subcutaneous and its belly runs alongside the posterior border of the ulna, which stays a little sunken between the prominences of the extensor carpi ulnaris and the flexor digitorum profundus, located posteriorly and medially. When contracted, the muscle appears to be a longitudinal elevation on the dorsal face of the forearm, between the ulna and the extensor digitorum communis. The tendon can easily be seen on the back of the wrist, medially to the ulnar styloid process, especially if the hand is in extension and adducted.

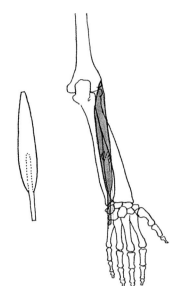

EXTENSOR CARPI RADIALIS BREVIS MUSCLE (Extensor carpi radialis brevis)

Form, structure, relations. The extensor carpi radialis brevis (or second external radial) muscle is a similar shape to that of the radialis longus, but is shorter and thicker, and is located deeper and dorsally to it. The long, thin, flat tendon starts halfway down the forearm and runs medially to the radialis longus tendon. The abductor pollicis longus, the extensor pollicis brevis and the dorsal carpal ligament overlap in its distal section. The muscle's deep surface is in relation with the lateral surface of the radius, while the superficial surface is covered by the extensor radialis longus, in its proximal section.

Origin. Lateral epicondyle of the humerus, collateral and annular radial ligaments of the elbow joint.

Insertion. Dorsal surface of the base of the third metacarpal.

Action. Extension and abduction of the hand compared with the forearm.

Surface anatomy. The extensor carpi radialis brevis muscle is only subcutaneous on the forearm's lateral border, in a short part of its belly, the part not covered by the extensor radialis longus. During contraction accompanied by pronation of the forearm, it appears as a rope-like elevation between the extensor radialis longus (anteriorly) and the extensor digitorum communis (medially), parallel to the longitudinal axis of the limb. The distal section of the insertion tendon runs medially to that of the extensor radialis longus, but is not easily visible.

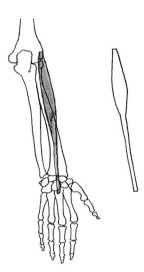

EXTENSOR CARPI RADIALIS LONGUS MUSCLE (Extensor carpi radialis longus)

Form, structure, relations. The extensor carpi radialis longus (or first external radial) muscle comprises a short, tapered belly that is slightly flattened in the middle third of the forearm in the part that continues into a long, flat tendon. The muscle occupies the latero–posterior border of the forearm, running superficially and having relations with the brachioradialis (superiorly and anteriorly) and the supinator (at depth). The upper portion partly covers the radialis brevis of the carpus, a muscle similar in path and shape, but located deeper and posteriorly. The distal section of the tendon, at the point of the radius' styloid process, is crossed over and covered by the abductor pollicis longus, the extensor pollicis brevis tendons and the dorsal carpal ligament.

Origin. Lateral supracondyloid area of the humerus; lateral intermuscular septum.

Insertion. Dorsal surface of the base of the second metacarpal.

Action. Extension and abduction of the hand compared with the forearm, at the wrist, acting in synergy with the extensor carpi ulnaris and the extensor carpi radialis brevis (for extension) and with the flexor carpi radialis (for abduction); weak flexion of the forearm, aiding closure of the fist, and weak pronation (due to the oblique (lateral to posterior) direction of the muscle traction line).

Surface anatomy. The extensor carpi radialis longus muscle is subcutaneous along almost its entire length. Together with the supinator and the extensor brevis radialis, which are next to it, it occupies the lateral border of the forearm from the humeral condyle to the wrist. The three muscles cannot be distinguished separately when relaxed, but if the forearm is flexed under resistance, the long radial muscle appears clearly. The tendon is located on the lateral border of the dorsal surface of the wrist, where it can be seen when the hand is extended. The extensor carpi radialis longus tendon runs medially to it, on the median line and much less clearly.

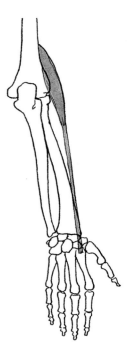

EXTENSOR DIGITORUM COMMUNIS MUSCLE (Extensor digitorum communis)

Form, structure, relations. The extensor digitorum muscle is the most lateral of the extensor group located in the superficial layer of the posterior cavity of the forearm. The belly is fusiform, elongated and slightly flattened and divides into muscle bundles about halfway down the forearm, which then continue into four flat tendons travelling to the back of the last four fingers. Wrapped in a common synovial sheath, the tendons run together up to the posterior carpal annular ligament. They then pass under it and then spread out to the fingers, but more obliquely compared with those of the metacarpal bones. They are joined at this level by thin transverse tendinous expansions, which are useful for containing them and making extension movements. The muscle is covered by the antebrachial fascia and the skin; it covers the supinator, the abductor pollicis longus, the extensor carpi ulnaris, the extensor digitorum indicis, the radiocarpal joint, the metacarpals and the phalanges. It has the extensor digiti minimi running alongside it along the medial border.

Origin. Lateral epicondyle of the humerus; ulnar and radial ligaments; antebrachial fascia.

Insertion. Dorsal surfaces of the second phalanges (with fibrous expansions at the bases of the distal phalanges) in the index, middle, ring and little fingers.

Action. Extension of the last four fingers, at the metacarpophalangeal joints, with slight abduction of the index and little fingers. The extension of each finger, especially the ring finger, is limited by transverse fibrous connections. The muscle action brings the first phalanges in line with the metacarpals and also allows them to flex dorsally, but only by a few degrees. Also, the index and little fingers are extremely mobile as two specific muscles act on them, the extensor digitorum indicis and the extensor digiti minimi, with the tendons running parallel and alongside those of the extensor communis tendons.

Surface anatomy. The extensor digitorum communis muscle is subcutaneous. Its muscle belly is visible on the forearm's dorsal surface, in the upper section, in the elongated area between the extensor carpi radialis longus and the extensor carpi radialis brevis (positioned laterally), and the extensor carpi ulnaris (positioned medially). While the back of the wrist is flat, as the robust dorsal carpal ligament covers the tendons, these become very evident on the back of the hand and the proximal phalanges when the fingers are stretched, appearing as rope-like prominences diverging from the wrist to the phalanges. Their diagonal direction is greater than that of the metacarpal bones, especially at the second and fifth. The index and little finger tendons run alongside those of the respective specific muscles (extensor digitorum indicis and extensor digiti minimi).

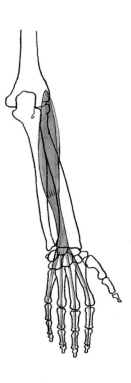

188

EXTENSOR POLLICIS LONGUS (Extensor pollicis longus)

Form, structure, relations. The extensor pollicis longus muscle is rather large, long and slightly flat, located deep in the posterior cavity of the forearm. The muscle belly originates from the middle section of the ulna and heads diagonally downwards onto the posterior surface of the radius, continuing into a thin tendon up to insertion. The muscle adheres to the ulna and the interosseous membrane; alongside it, medially, there is the extensor digitorum indicis; laterally, the extensor pollicis brevis; superiorly, the abductor pollicis longus. It is covered by the extensor digiti minimi and the extensor carpi ulnaris. The tendon runs into a groove on the posterior surface of the lower end of the radius, which acts as a reflection centre; it is covered by the dorsal carpal ligament; obliquely crosses the extensor radialis longus and brevis tendons and heads to the first finger, passing medially to the extensor pollicis brevis tendon.

Origin. Middle third of the posterolateral surface of the ulna; interosseous membrane.

Insertion. Dorsal surface of the base of the thumb's distal phalanx.

Action. Extension of the thumb's distal phalanx with slight adduction and lateral rotation. It also extends the proximal phalanx and the first metacarpal, in synergy with the extensor brevis and the abductor longus.

Surface anatomy. The extensor pollicis longus muscle is located deeply. Only the tendon is subcutaneous and when the muscle is contracted, it appears as a prominent rope-like elevation directed from the wrist to the back of the thumb. The tendon forms the medial border of a hollow (known as the anatomical snuffbox) that separates it from the extensor pollicis brevis tendon and is the more prominent of the two. It then runs on the back of the first metacarpal, over the metacarpophalangeal joint and on the back of the proximal phalanx, which is not precisely on the median line, but still runs somewhat medially. When the thumb is flexed onto the palm of the hand, the tendon is not visible as it flattens against the surfaces of the bone.

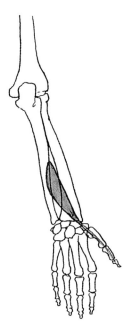

EXTENSOR DIGITI MINIMI MUSCLE (Extensor digiti minimi)

Form, structure, relations. The extensor digiti minimi has a very thin, slender muscle belly positioned medially to the extensor digitorum communis muscle and is therefore superficial on the dorsal surface of the forearm. The belly transforms into a thin, flat tendon which splits at the wrist and heads towards the fifth finger, where it runs next to the extensor communis tendon up to the insertion point. The muscle, which may fuse with the extensor communis, has the extensor carpi ulnaris running medially to it, and covers the extensor pollicis longus and brevis muscles. The tendon, wrapped in a synovial sheath, is covered by the dorsal carpal ligament at the wrist and travels in a posterior channel of the ulna head, together with that of the extensor carpi ulnaris, splitting into two terminal bundles.

Origin. Lateral epicondyle of the humerus.

Insertion. Dorsal surface of the last two phalanges of the fifth finger.

Action. Extension and slight abduction of the little finger (in synergy with the extensor communis, therefore the little finger enjoys the highest possibility of independent movement compared with the other long fingers).

Surface anatomy. The muscle belly of the extensor digiti minimi is subcutaneous, but is rarely visible: sometimes it may appear at the point of a thin strip between the extensor digitorum communis laterally and the extensor carpi ulnaris medially. On the other hand, the tendon is very evident at the ulnar border of the back of the hand and on the back of the first phalanx of the fifth finger. In fact the tendon which usually appears in this area is that of the extensor digiti minimi as the extensor communis tendon heading to the little finger is less prominent.

FLEXOR POLLICIS BREVIS MUSCLE (Flexor pollicis brevis)

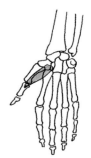

Form, structure, relations. The flexor pollicis brevis muscle is small, elongated and thin. The muscle belly is directed obliquely downwards and laterally, from the carpus to the thumb, and separates into two origin heads: superficial and deep. The muscle, which can fuse with the opponens pollicis, has the abductor brevis running medially alongside it and partly covering it, and it covers the opponens pollicis and the adductor pollicis.

Origin. Superficial part: inferior face of the trapezium tubercle; transverse carpal ligament. Deep part: trapezium; capitate; carpal palmar ligaments.

Insertion. Anterior surface of the base of the thumb's first phalanx. The tendon incorporates the lateral sesamoid bone of the metacarpophalangeal joint in the thumb.

Action. Flexion of the proximal phalanx of the thumb, with slight flexion and medial rotation of the first metacarpal.

Surface anatomy. The flexor pollicis brevis muscle contributes to forming the thenar eminence and is partly covered by the adductor brevis, which leaves only the medial border free. This, however, has no specific influence on the external morphology as it is masked by the palmar aponeurosis and by a subcutaneous adipose layer.

EXTENSOR POLLICIS BREVIS MUSCLE (Extensor pollicis brevis)

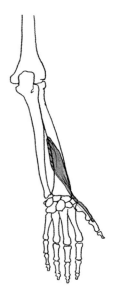

Form, structure, relations. The extensor pollicis brevis muscle is small and flat, located on the dorsal surface of the lower third of the forearm. The muscle belly heads downwards and laterally, with a brief section becoming superficial. It continues into the tendon which, after being covered by the dorsal carpal ligament, travels to the thumb, where it is joined medially by the extensor pollicis longus tendon. The muscle, which can also be missing or fused with the abductor pollicis longus, adheres to the radius and the interosseous membrane; alongside it laterally is the abductor pollicis longus and medially, the extensor longus, and at origin, both muscles, while the remaining part is covered by the extensor digitorum communis.

Origin. Distal third of the posterior surface of the radius; interosseous membrane.

Insertion. Dorsal surface of the base of the thumb's proximal phalanx. (The tendon runs on the lateral border of the radius and crosses the extensor radialis brevis and longus carpal tendons and the insertion section of the brachioradialis).

Action. Extension of the distal phalanx of the thumb and the first metacarpal; slight abduction, in synergy with the abductor pollicis longus and brevis muscles.

Surface anatomy. The extensor pollicis brevis is only subcutaneous in the section that corresponds to the lateral border of the radius at the wrist where, together with the abductor pollicis longus, it helps to create the slightly convex surface. The muscle appears under the skin in a slim area between the abductor pollicis longus, the extensor carpi radialis (laterally) and the extensor digitorum communis (medially). The tendon, which is covered by the dorsal carpal ligament at the wrist, becomes superficial and its prominence, which is less visible than that of the extensor pollicis longus, forms the lateral border of the anatomical snuffbox.

FLEXOR POLLICIS LONGUS MUSCLE (Flexor pollicis longus)

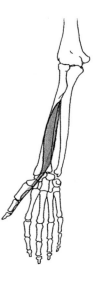

Form, structure, relations. The flexor pollicis longus muscle has a thin, rounded belly which extends into a flat tendon in a semipennate structure. It is located laterally to the flexor profundus digitorum, deep in the anterior cavity of the forearm. The tendon passes under the transverse carpal ligament and then runs between the opponens pollicis muscle (closer to the surface) and the oblique head of the adductor pollicis muscle (medial), and heads to the insertion area. The muscle, which can fuse with others nearby or have separate origin heads, is covered by the flexor superficialis digitorum and the palmaris longus; it adheres to the radius and the interosseus membrane; it crosses the pronator quadratus.

Origin. Anterior surface of the middle third of the radius and the interosseous membrane; a small bundle may originate from the lateral border of the ulnar coronoid process, or from the medial epicondyle of the humerus.

Insertion. Anterior surface of the base of the distal phalanx of the first digit (thumb).

Action. Flexion of the distal phalanx of the thumb onto the proximal phalanx and of the latter onto the first metacarpal, with slight adduction.

Surface anatomy. The flexor pollicis longus muscle is located deeply. A subcutaneous pulsation can be noted in the lower ventral half of the forearm, close to the lateral border, when the thumb is repeatedly flexed: in this case, the tendon prominence can also be felt on the palm face of the thumb's first phalanx.

EXTENSOR INDICIS MUSCLE (Extensor indicis)

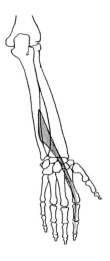

Form, structure, relations. The extensor indicis is thin, elongated and located deeply, on the ulna's posterior face, in the distal half of the forearm. The muscle, which may also be missing, or connected to nearby muscles or have anomalous insertions, is covered by the extensor communis, the extensor digiti minimi, and the extensor carpi ulnaris. The belly changes into a thin tendon which, passing under the dorsal carpal ligament, runs medially to the corresponding flexor digitorum communis and shares the insertion point.
Origin. Distal third of the ulna's posterior surface; interosseous membrane.
Insertion. Base of the distal phalanx and dorsal aponeurosis of the index finger.
Action. Extension and slight adduction of the index finger (in synergy with the extensor digitorum communis: the dual tendon insertion makes the index finger more mobile than the other long fingers).
Surface anatomy. The extensor indicis is located deeply. Only the tendon is visible as the finger is extended: it is positioned medially to the extensor communis, and runs parallel with it, determining the characteristic double rope-like elevation on the back of the hand, at the point of the second metacarpal and the first phalanx of the index finger.

FLEXOR PROFUNDUS DIGITORUM MUSCLE (Flexor digitorum profundus)

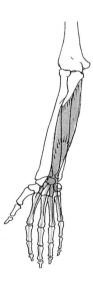

Form, structure, relations. The flexor profundus digitorum is large, flat and positioned anteriorly and medially in the forearm. The muscle belly, which is the only one at the origin point, then divides into four bundles that run alongside each other on the same plane, and then, about halfway down the arm, extend into the same number of long, thin tendons travelling to the last four fingers from the index finger to the little finger. The muscle may have separated origin heads and be connected with nearby muscles, and covers the ulna, interosseous lamina and pronator quadratus; it is covered by the flexor digitorum superficialis and medially by the flexor carpi ulnaris; laterally it has relations with the flexor pollicis longus. The four insertion tendons follow the same path as those of the flexor superficialis, which covers them.
Origin. The anterior and medial faces of the ulna (in the proximal two-thirds); interosseous membrane.
Insertion. Distal phalanges on the anterior faces of the bases of the fingers, from second to fifth.
Action. Flexion of the distal phalanges on the middle ones, with slight flexion of the fingers, also individually, on the metacarpophalangeal joints (together with the flexor digitorum superficialis).
Surface anatomy. The flexor profundus digitorum muscle cannot be seen below the skin but contributes to forming the fleshy anteromedial mass in the forearm. In some conditions, for example, if the forearm is pronated and the fingers are repeatedly flexed, the elevation of the muscle belly border may appear, next to a thin cutaneous strip between the posterior border of the ulna and the belly of the flexor carpi ulnaris muscle.

ABDUCTOR POLLICIS LONGUS MUSCLE (Abductor pollicis longus)

Form, structure, relations. The abductor pollicis longus is a tapered, slightly flat muscle located in the posterior cavity of the distal half of the forearm, travelling laterally downwards from the ulna to the thumb. The muscle belly becomes superficial in the section close to the wrist and continues into the strong, flat tendon which runs onto the lateral surface of the distal end of the radius. Covered by the dorsal carpal ligament, it then heads to the insertion points, sometimes splitting into two bundles, moving laterally to the extensor pollicis brevis tendon. The muscle, which may be fused with the extensor brevis or divided into two bundles, adheres to the ulna, the radius and the interosseous membrane; it is inferiorly and medially adjacent to the extensor pollicis brevis; in the section of origin, it is covered by the supinator and the extensor digitorum communis. Before reaching the wrist, the tendon crosses the extensor carpi radialis longus and brevis tendons, which are located deeper.

Origin. Middle sections of the posterior surface of the radius and the posterolateral surface of the ulna; interosseous membrane.

Insertion. Lateral border of the base of the first metacarpal, with expansions towards the trapezium.

Action. Abduction and extension of the first metacarpal (in synergy with the abductor pollicis brevis and the extensor pollicis).

Surface anatomy. The abductor pollicis longus muscle, although partly subcutaneous, is not easy to see on the surface. It helps to form the slight convexity of the lateral border of the forearm, close to the wrist, together with the extensor pollicis brevis. When the thumb is abducted under resistance, the strong tendon can be felt at the base of the first metacarpal, laterally to the extensor pollicis brevis tendon.

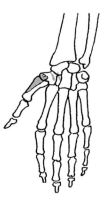

OPPONENS POLLICIS MUSCLE (Opponens pollicis)

Form, structure, relations. The opponens pollicis muscle is flat, triangular and located deep in the thenar eminence, travelling obliquely downwards and laterally from the carpus to the first metacarpal bone.

The muscle, which may be missing or divided into two separate bundles, covers the first section of the flexor pollicis brevis (positioned medially) and is covered by the abductor pollicis brevis, except on the lateral margin, along the metacarpus border.

Origin. Tubercle of the trapezium; transverse carpal ligament.

Insertion. Lateral and superficial border of the palmar surface of the first metacarpal.

Action. Opposition of the thumb, with flexion and medial rotation. Through this combination of movements, the tip of the thumb can be brought into contact with the tip of any other fingers.

Surface anatomy. The opponens pollicis muscle is located deeply in the thenar eminence and contributes to determining its shape. Not even the subcutaneous border is visible on the surface.

ABDUCTOR POLLICIS BREVIS MUSCLE (Abductor pollicis brevis)

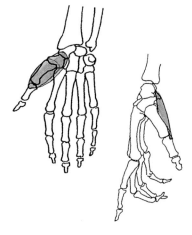

Form, structure, relations. The abductor pollicis brevis muscle is flat, laminar and triangular, travelling obliquely downwards and outwards from the carpus to the first phalanx of the thumb. It is the most superficial of the muscles of the thenar eminence (a group of muscles situated laterally on the palm of the hand, which act on the thumb). It is therefore only covered by the palmar fascia and the skin, while it partly covers the opponens pollicis, located laterally, and the flexor pollicis brevis, located medially.

Origin. Transverse carpal ligament; scaphoid; trapezium; abductor pollicis longus tendon.

Insertion. Lateral edge of the base of the thumb's proximal phalanx with tendinous expansions onto the lateral sesamoid bone and the back of the phalanx.

Action. Abduction and slight medial rotation of the thumb (orthogonally distancing the first metacarpal bone forwards and upwards from the palm of the hand).

Surface anatomy. The abductor pollicis brevis muscle is subcutaneous medially to the first metacarpal and, together with the other muscles in the group, it lends the rounded shape to the thenar eminence. During heavy contraction, the muscle belly may appear to have a slight hollow travelling along it longitudinally, caused by some tendinous expansions of the superficial fascia. When the thumb is at its maximum abduction, several thin transverse creases appear on the skin.

ADDUCTOR POLLICIS MUSCLE (Adductor pollicis)

Form, structure, relations. The adductor pollicis is the largest muscle of the thenar eminence. It is extremely wide at the origin, flat and triangular, running almost horizontally from the metacarpal bones and the carpus to the first phalanx of the thumb. It is divided into two parts, the oblique head and the transverse head, separated by a clear space. They flow into a single tendinous expansion, which also includes the medial sesamoid bone. The muscle covers the second and third metacarpal bones; it has relations, in depth, with the first dorsal interosseous muscle; and it is crossed superficially by the first lumbrical muscle and by the flexor digitorum communis tendon on the index finger.

Origin. Oblique head: capitate bone; base of the second and third metacarpals; palmar carpal ligaments.

Transverse head: palmar surface of the third metacarpal.

Insertion. Medial surface of the base of the thumb's first phalanx.

Action. Adduction of the first metacarpus, bringing the thumb towards the palm of the hand, with a slight flexion of the first phalanx. In synergy with the opposing muscle, it aids the opposition movement, especially against the fifth finger.

Surface anatomy. The adductor pollicis muscle is located deeply, covered by the superficial muscles of the thenar eminence and by the superficial fascia and the palmar aponeurosis. The lower border of the transverse head is a part of the skin fold that joins the palm of the hand to the base of the thumb.

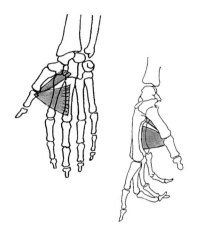

ABDUCTOR DIGITI MINIMI MUSCLE (Abductor digiti minimi)

Form, structure, relations. The abductor digiti minimi muscle is tapered, located on the medial border of the fifth metacarpal bone, forming the largest component of the hypothenar eminence muscle group. The belly is directed vertically from the carpus to the first phalanx of the fifth finger, where it inserts via a large, flat tendon. The muscle is superficial, covered by the aponeurotic fascia, the palmaris brevis and the skin; it has relations laterally with the flexor digiti minimi brevis, which it covers in the section close to insertion, together with the opponens digiti minimi.

Origin. Pisiform bone; pisohamate ligament; flexor carpi ulnaris tendon.

Insertion. Medial surface of the base of the first phalanx of the fifth finger, with dorsal expansions onto the extensor digiti minimi tendon.

Action. Abduction of the little finger, moving it medially and away from the ring finger.

Surface anatomy. The abductor digiti minimi muscle is subcutaneous and contracting it causes an elongated elevation on the medial border of the hand.

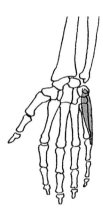

PALMARIS BREVIS MUSCLE (Palmaris brevis)

Form, structure, relations. The palmaris brevis (or superficial) is a thin, quadrangular expression muscle, between the subcutaneous adipose layer and the superficial fascia. It transversally covers the muscles located towards the medial border of the palm of the hand, at the point of the fifth metacarpal bone (together known as the hypothenar eminence).

Origin. Transverse ligament of the carpus; medial border of the palmar aponeurosis.

Insertion. Skin and subcutaneous tissue of the medial border of the palm of the hand.

Action. Creasing of the skin of hypothenar eminence, which becomes more prominent, thus aiding the grip.

Surface anatomy. Muscle contraction is only detected by the creasing of the skin.

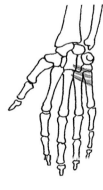

FLEXOR DIGITI MINIMI BREVIS MUSCLE (Flexor digiti minimi brevis)

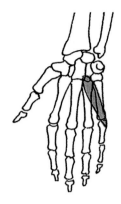

Form, structure, relations. The flexor digiti minimi brevis is a flat, thin, elongated muscle, located at the medial border of the hand, where it takes part in forming the hypothenar eminence. It runs downwards and medially from the carpus to the first phalanx of the little finger, between the abductor, which travels more superficially and laterally, and the opponens digiti minimi which it covers.

Origin. Hamate bone process; palmar part of the transverse carpal ligament.

Insertion. Medial surface of the base of the first phalanx of the fifth finger.

Action. Flexion of the first phalanx of the little finger, with slight medial rotation, to aid opposition movement.

Surface anatomy. The flexor digiti minimi brevis muscle is partly subcutaneous, but the thickness of the aponeurotic fascia and the subcutaneous adipose layer does not permit its contraction to be noticed on the surface. It contributes to lending the rounded shape to the hypothenar eminence.

OPPONENS DIGITI MINIMI MUSCLE (Opponens digiti minimi)

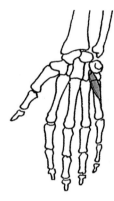

Form, structure, relations. The opponens digiti minimi muscle is the deepest in the hypothenar eminence group. It is triangular, flat and short, and is directed downwards and medially from the carpus, where it originates narrowly, to the fifth metacarpal, where it widens at the insertion section. The muscle is covered by the flexor digiti minimi brevis and by the abductor digiti minimi.

Origin. Hamate bone process; palmar part of the transverse carpal ligament.

Insertion. Medial border of the fifth metacarpal bone.

Action. Slight flexion and lateral rotation of the fifth metacarpal, aiding opposition of the little finger to the thumb.

Surface anatomy. The opponens digiti minimi muscle is located deeply and therefore has no influence on the external morphology.

LUMBRICALES MUSCLES (Lumbricales)

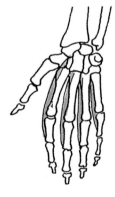

Form, structure, relations. The lumbricales are four very thin, elongated muscles positioned on the palmar surface of the metacarpus. They run parallel to the lateral border of the flexor profundus digitorum tendons, from which they originate.

Origin. Flexor profundus digitorum tendons.

Insertion. Lateral surface of the base of the first phalanges of the index, middle, ring and little fingers; tendinous expansions on to the back of the fingers and the extensor communis tendons.

Action. Flexion of the proximal phalanx and extension of the middle and distal phalanges of the last four fingers.

Surface anatomy. The lumbricales muscles contribute to determining the morphology of the hollow of the hand, but as they are covered by the superficial palmar aponeurosis, when they contract they are not visible on the surface.

INTEROSSEI PALMARES MUSCLES (Interossei palmares)

Form, structure, relations. The interossei palmares (or volar) muscles are four small fusiform muscles which each originate from a single metacarpal bone (the dorsal ones originate with two heads from two adjacent metacarpal bones), occupy the intermetacarpal spaces and insert onto the bases of the first phalanges. The first palmar interosseus muscle is located in the space between the first and second metacarpals and is sometimes considered an additional bundle of the adductor pollicis brevis, while the other interossei palmares are better identified. Their deep surface is in relation with the dorsal interossei, and the superficial surface is covered by the deep palmar fascia, then by the lumbricales and the flexor muscle tendons, and lastly by the palmar aponeurosis.

Origin. Lateral border of the palmar face of the first, second, fourth and fifth metacarpal bones (the second muscle, on the other hand, originates from the medial border).

Insertion. Dorsal tendinous expansion and base of the first phalanx of the first, second, fourth and fifth fingers (on the lateral border), except the second muscle, which inserts onto the medial border).

Action. Adduction of the index, ring and little fingers, bringing the fingers close to the median bone of the hand (adduction of the thumb is mostly achieved by the adductor and flexor brevis); weak flexion of the first phalanges and extension of the middle and distal ones.

Surface anatomy. The interossei palmares muscles are located deeply and are also covered by the palmar aponeurosis.

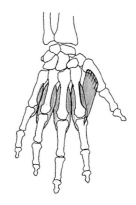

INTEROSSEI DORSALES MUSCLES (Interossei dorsales)

Form, structure, relations. The interossei dorsales are four bipennate muscles (unlike the palmar ones) which originate with two heads from adjacent borders on metacarpal bones. In each muscle, the fibres of each head converge towards a single, central insertion tendon on the first phalanges of the long fingers. The largest and most developed muscle is the first dorsal interosseous muscle (known as the abductor indicis) which starts from the medial border of the first metacarpal and from the lateral border of the second metacarpal and inserts onto the lateral margin of the index finger's first phalanx. It is triangular and superficial. The interossei dorsales muscles are covered by the fingers' extensor tendons and then by the dorsal aponeurotic fascia; in depth, they have relations with the interossei palmares.

Origin. Medial and lateral borders of two adjacent metacarpal bones, from the first to the fifth.

Insertion. Bases of the first phalanges and dorsal tendinous expansions of the three central long fingers, with particular ways for each muscle.

Action. Abduction of the index, middle and ring fingers, distancing them from the axis of the hand (in particular: the first dorsal interosseous abducts the index fingers by moving it laterally compared with the middle finger, but does not adduct the thumb's metacarpal); flexion of the proximal phalanges and extension of the middle and distal ones, in synergy with the lumbricales and the interossei palmares.

Surface anatomy. The interossei dorsales muscles are hardly visible on the back of the hand as they are covered by the aponeurotic fascia and the extensor tendons. Only the first interosseous can be seen underneath the skin, occupying the space between the thumb's metacarpus and the index finger's metacarpus on the back of the hand. When contracted, the belly appears to be an accentuated, ovoid-shaped elevation that stops a short distance from the index finger's metacarpophalangeal joint.

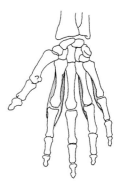

THE ARM

The arm is the part of the upper limb between the shoulder and the elbow. It is cylindrical in shape and rather flat on the sides due to the arrangement of the muscle masses around the humerus. Consequently, the antero-posterior diameter is greater than the transverse diameter. However, in people with low muscle development or in a large proportion of women, the arm is cylindrical and of uniform diameter.

The anterior region is almost entirely occupied by the biceps muscle. Its cylindrical or slightly tapered volume in a resting state becomes more globular and highly prominent in its middle part when contracted, necessary for flexing the forearm. The anterior surface is met at the top by the deltoid border which crosses it obliquely: there is a slight longitudinal, median hollow below it that corresponds to the separation point between the long head and the short head of the biceps.

The posterior region of the arm is occupied by the triceps muscle, with a more irregular shape than the anterior region. The triceps is larger than the biceps, also in a resting state: the three bellies that comprise it (see page 182) are located in the upper, medial and lateral half of the arm, easily distinguishable during contraction. The lower half of the arm, on the other hand, is flattened due to the morphological characteristics of the insertion tendon on the ulna. On the sides of the arm, the two prominences of the anterior and posterior muscle groups are separated by two shallow vertical grooves, one medial, the other lateral, which correspond to the paths of the superficial fascia septa which descend towards the humerus, dividing the two cavities.

In particular, the medial groove is shallow and neurovascular bundles run along it. The lateral groove is shorter but more evident: it starts from the deltoid depression, a hollow formed by the joining of the two grooves bordering the lower borders of the deltoid, and then separates into two slightly divergent rami. The anterior one separates the brachialis from the biceps and the posterior one separates the brachialis from the triceps, outlining a thin, elongated triangular area, the elevation of which corresponds to the lateral border of the brachialis and the proximal portions of the brachioradialis and the extensor carpi radialis longus.

The external morphology of the arm is influenced to varying degrees by the presence of adipose tissue deposits, particularly in women, where they are found in the posterosuperior portion, adjacent to the shoulder.

Two superficial veins run under the skin of the arm at the sides of the biceps: the basilic vein is positioned medially, the cephalic vein laterally and the latter continues almost invisibly in the groove between the deltoid and the pectoralis major. Other rami with varying paths can be seen on the anterior surface, especially in athletic individuals during intense physical effort.

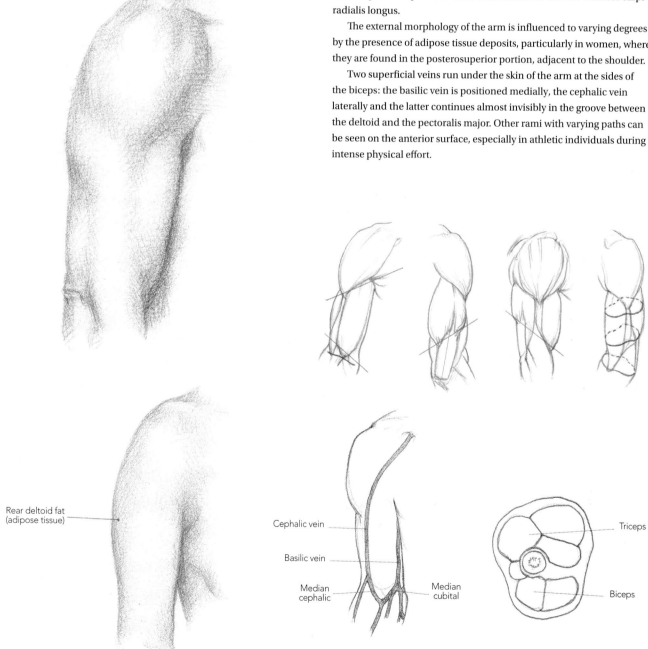

Rear deltoid fat (adipose tissue)

Cephalic vein

Basilic vein

Median cephalic

Median cubital

Triceps

Biceps

THE ELBOW

In the skeleton of the upper limb, the elbow corresponds to the joint of the same name which is created between the humerus, the ulna and the radius. It is shaped like a flattened cylinder in the antero-posterior direction.

In the limb's anatomical position, the external morphology of the anterior region (or elbow fold) is determined by three muscle protuberances: the median protuberance is from the inferior portion of the biceps, from its tendon and from the attached lacertus fibrosus, from the inferior portion of the brachialis. The rounded lateral protuberance comes mostly from the muscles of the lateroposterior cavity (extensors) of the forearm, which originate from the epicondyle and the lateral border of the humerus (mainly the brachioradialis and extensor carpi radialis longus). The medial protuberance comprises the muscles in the anterior cavity (flexors) of the forearm, which originate from the humeral epitrochlea (mainly the pronator teres, gracilis, flexor carpi ulnaris and radialis muscles).

Below the median muscle prominence, there is a triangular depression, with the apex at the bottom (cubital fossa): deep down there are arteries and large nerve bundles and therefore there are structural analogies with the popliteal fossa located on the posterior surface of the knee.

The other two muscle prominences determine the asymmetric profile of the elbow, as the lateral group is positioned higher up and covers the lateral epicondyle of the humerus and thus forms a wide, marked curve; while the medial group, which originates below the medial epicondyle (epitrochlea) is placed lower down and forms a short, slightly convex curve. The epitrochlea is subcutaneous above the muscle elevation.

The anterior surface of the elbow has some slightly oblique transverse skin folds, which are slightly upwardly concave. They are located at the point of the biceps tendon and are emphasized when the forearm is flexed almost at a right angle on to the arm. It also has the two largest superficial veins running through it: laterally the basilic vein and medially the cephalic vein, connected by two small rami, the median cephalic and the median basilic, with a formation reminiscent of the letter M, although it is subject to individual variation (see page 68).

The posterior region is occupied by the subcutaneous bony prominence of the olecranon of the ulna, which becomes especially evident when the forearm is at maximum flexion. In the limb's anatomical position, the elevation is located almost at the centre of the region, slightly medially, and has some large skin creases over it, arranged close together and transversally. They make the surface of the region rather creased, more so in elderly individuals, but this smooths out and disappears when the forearm is flexed. The olecranon has a small hollow medially to it, which separates it from the epitrochlear, and laterally has a larger, deeper hollow, bordered by the anconeus and the lower border of the extensor carpi radialis longus. This hollow is said to be condyloid as it corresponds to the humeral condyle which joins with the head of the radius.

The shape of the elbow's lateral border is determined by the brachioradialis and extensor carpi radialis longus muscle prominences, while the shape of the medial border is influenced by the bony prominence of the humeral epitrochlea, below which there is a group of flexors.

The external morphology of the elbow, particularly in the posterior region, can vary according to flexion movements, after which the olecranon is more evident, as are the medial and lateral epicondyles. On the anterior surface, on the other hand, there is the robust, rope-like tendon of the biceps at the centre, and slightly medially there is the thin, diagonal protuberance of the lacertus fibrosus (see biceps brachii muscle, page 181).

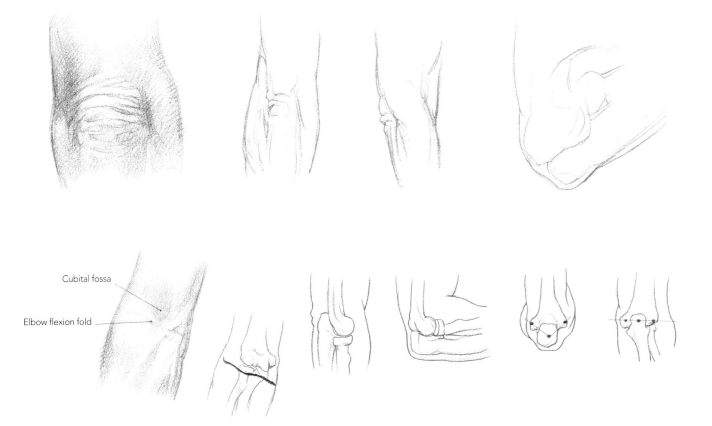

Cubital fossa

Elbow flexion fold

THE FOREARM

The forearm is the segment of the upper limb between the elbow and the wrist. Its external shape changes considerably depending on movements of pronation and supination, based on which the radius overlaps the ulna, crossing it and causing the muscles to twist and consequently change their profiles.

In the anatomical position, the forearm is a flattened cone shape antero-posteriorly (while it can be noted that the arm is flattened transversally). It is wider in the upper half, where the bellies of the region's muscles are located, but grows thinner in the lower half, where almost only the tendons of single muscles travel over the ulna and radius. The anterior surface of the forearm is flat with the upper portion of this formed by two muscle elevations separated by a shallow median hollow arranged longitudinally. The large, voluminous lateral elevation comprises the brachioradialis and extensor carpi radialis longus and brevis muscles.

The smaller, medial elevation comprises the muscles in the anterior cavity, which originate from the humeral epitrochlea, that is, the flexor muscles overlapped by the pronator teres muscle in the upper portion. The lower half of the anterior surface is flat and narrow and has thin, longitudinal elevations from the flexor tendons close to the wrist.

The thin, hairless skin of the ventral surface of the forearm shows the path, sometimes elevated, of the superficial venous reticulum (see page 68), which can be subject to individual variations. The posterior (or dorsal) surface of the forearm is flat or only slightly convex, and is separated into two parts by the posterior border of the ulna, which crosses it obliquely subcutaneously, determining a slight groove between the medial muscle group (flexor profundus digitorum covered by the flexor carpi ulnaris) and the lateral group (extensor muscles in the posterior cavity). The extensor carpi ulnaris and the extensor digitorum communis are particularly visible when the fingers are fully extended (see pages 187–188).

The medial border of the forearm has a uniformly rounded surface which outlines a slightly convex profile: it joins the anterior surface with the posterior surface without revealing separate muscle elevations and has the basilic vein travelling through a section of it.

The lateral border surface is also rounded, but less evenly as some muscles determine three external convexities along its edge: at the top there is the extensor carpi radialis longus jutting out, then that of the extensor carpi radialis brevis, and in the lower part of the forearm, that of the abductor longus and extensor pollicis brevis muscles. The cephalic vein runs obliquely through this section.

The skin of the back of the forearm and the lateral border is covered by long, thin hairs, especially in males, which extend as downy hair to the medial border too; the anterior surface has none, as has already been mentioned.

The female forearm has the same morphological characteristics as the male forearm, although the muscles are less evident, the surface is more rounded and the shape is more of a regular conoid. Also, the longitudinal axis of the forearm forms – together with that of the arm, in the anatomical position – an obtuse angle that opens externally; this is more marked in women (physiological valgus elbow). The extension of the forearm towards the arm reaches a wider extension in women than in men (hyper extension), due to a normal distancing of the elbow joint ligaments.

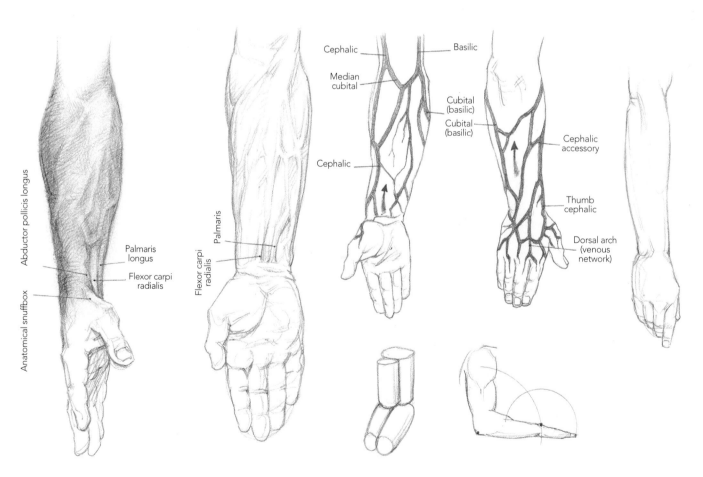

THE WRIST

The wrist is the region positioned between the forearm and the hand, comprising the lower extremities of the ulna and the radius, the first series of carpal bones and the tissues covering them. It therefore corresponds to the radiocarpal joint, and as it continues into the forearm, has the same flattened cylinder shape in an antero-posterior direction.

The dorsal surface is flat, and medially the styloid process of the ulna juts out. The extensor digitorum tendons run on the surface but are not visible as they are covered and adhered securely to the lower extremity of the radius by the dorsal carpal ligament. At maximum flexion of the hand, the dorsal surface of the wrist is slightly convex due to the jutting out of the radius, the scaphoid and the semilunaris.

The medial border is rounded, but sometimes has a slight depression between the flexor carpi ulnaris tendon, anteriorly, and the extensor carpi ulnaris tendon, positioned dorsally.

The lateral border is crossed obliquely by the side-by-side tendons of the abductor longus and the extensor pollicis brevis, in an anterior position, and by the extensor pollicis longus tendon in a more dorsal position: there is a hollow in the space known as the anatomical snuffbox, in which the radial styloid process can be seen under the skin.

The anterior surface of the wrist contains longitudinally the tendons with flexor action on the hand: the direction of these tendons does not exactly follow the forearm axis but is slightly oblique towards the medial border. The tendons are more evident when the hand is slightly flexed: that of the palmaris longus, positioned on the wrist's median line, is the thinnest and most obvious, being the only one that runs subcutaneously, not covered by the transverse carpal ligament. The flexor carpi radialis tendon can be found towards the lateral border; the flexor digitorum superficialis and the flexor carpi ulnaris tendons come in succession towards the medial border.

In addition to subcutaneous veins, the anterior surface of the wrist also has some cutaneous flexion creases: these are arranged transversally, almost horizontal, with slight upward concavity. Two creases are close together, placed in correspondence to the joint and therefore close to the border between the wrist and hand. A third, thinner, crease is located about 1cm (⅜in) higher. Like the tendons, the creases are clearer to the eye when the hand is slightly flexed. If, on the other hand, the hand is highly extended, the scaphoid juts out in the area between the visible end section of the flexor carpi radialis tendon and the thenar eminence of the hand.

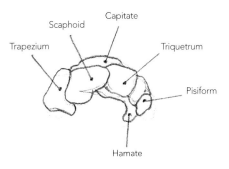

Arrangement of the carpal bones.

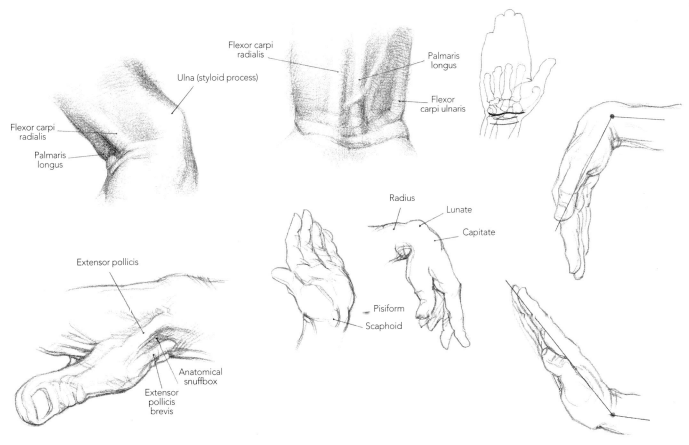

THE HAND

The hand is the end section of the upper limb, after the wrist, and its external morphology, above all that regarding the dorsal surface, is widely influenced by the skeletal structure.[5] There are two sections: the hand itself and the fingers.

The anterior surface of the hand, the palm, is slightly concave at the centre while it is elevated along the borders, due to muscle or adipose formations.

The lateral, oblique elevation, located at the base of the thumb, is oval in shape and more voluminous, comprising the muscles of the thenar eminence (flexor brevis, abductor brevis, adductor and opponens pollicis).

The medial elevation is more elongated, close to the lateral elevation near the wrist, but extended onto the border of the hand at the little finger, and comprises the muscles of the hypothenar eminence (abductor, flexor brevis and opponens digiti minimi).

The distal transverse elevation comes from the jutting heads of the metacarpals covered by and adjacent to ovoid adipose pads.

Surrounded by these elevations, there is a hollow at the centre of the hand, a permanent depression which is accentuated by flexing the fingers: determined by the adherence of the palmar aponeurosis skin which completely covers the flexor muscle tendons in the fingers.

The skin of the palm, which is not very mobile, is hairless and has visible superficial veins, has some characteristic creases caused by the flexion movements of the fingers and the adduction movements of the thumb.

The appearance of the creases vary, and subject to the movements of the individual. However, there are most frequently four palm creases, schematically arranged like the letter W: the thumb crease, which outlines the thenar eminence; the fingers crease, located between the hollow and the transverse elevation; the longitudinal crease and the oblique crease, arranged diagonally on the hollow of the hand. Numerous other variable grooves form temporarily following finger movements.

The medial border of the hand is rounded due to the presence of the hypothenar eminence muscles, more often in the section next to the wrist, which is thinner towards the root of the little finger. The lateral border is occupied at the top by the base of the thumb, while the lower portion corresponds to the metacarpophalangeal joint of the index finger: the large skin crease inside which the adductor pollicis is partly contained is stretched between the two parts of the border.

The dorsal surface of the hand, the back, is convex shaped on the bone structure and therefore the elevations of the metacarpal heads are noted on which the extensor tendons travel (see extensor digitorum communis muscle, page 188). These are particularly prominent during maximum extension of the fingers. It must be observed that there are two tendons side by side travelling to the index fingers: laterally the extensor communis tendon, and medially the extensor tendon.

The skin on the back of the hand glides easily over the underlaying planes and is more mobile than the skin on the palm. It is almost without adipose tissue, and has a few hairs (mostly in males) and a clear superficial venous network, which can vary greatly (see page 68).

The five fingers have an approximately cylindrical shape and originate from the distal transverse border of the hand. While the

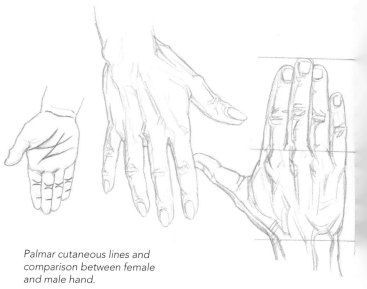

Palmar cutaneous lines and comparison between female and male hand.

first finger (thumb) has only two free segments, each of the other fingers comprises three segments articulated with each other and corresponding to the phalanges.

The dorsal surface of the fingers follows the conformation of the phalanges and is therefore rounded and slightly convex. It is interrupted by transverse creases of abundant skin corresponding to the joints and has some sparse hairs on the first and second phalanges, particularly in males. On the back of the third phalanx there is normally a nail, a cutaneous laminar annex, with horn-like consistency and a square or oval shape, while slightly convex transversally. It occupies the distal half of the phalanx with its free part, surrounded on three sides by a cutaneous elevation, whose characteristics are easily seen *in vivo*. The thumbnail is always larger than the others, which are proportionate to the size of the finger they belong to. Anonychia, that is, the absence of nails, which can sometimes be noted in sculptures or paintings and which may represent the artist's stylistic character, is actually a symptom of a congenital or acquired disease. With the exception of the thumb, which has its own characteristics as it is formed by only two phalanges, the length of the fingers differs due to the size of each of them and the different level of origin, as the heads of the metacarpals form a curved line with downward convexity.

The third (middle) finger is usually the longest, followed by the fourth (ring), the second (index) and the fifth (little) finger. Overall, these four fingers appear to be longer on the dorsal face than on the palmar, where the distal transverse elevation reaches the middle of the first phalanges, forming interdigital joining folds.

The volar face of the fingers is therefore divided into three convex sections, made of adipose pads, separated in each finger by three transverse creases: the distal (mostly single) and the intermediate (double) correspond exactly to the relative joints, while the proximal one (superior), which is also often double, forms about half the length of the first phalanx. The elevation of the last phalanx, known as the fingertip, is oval and the skin has grooves formed by individually characteristic epidermal ridges (digital dermatoglyphs or fingerprints).

5 The anatomical position is providing that the palms of the hands are turned forwards and the fingers are extended. In fact, if the hand is in a natural relaxed position (or subject to cadaveric rigidity) the fingers are partly flexed. This slightly alters the spatial relationships between the normally described anatomical structures.

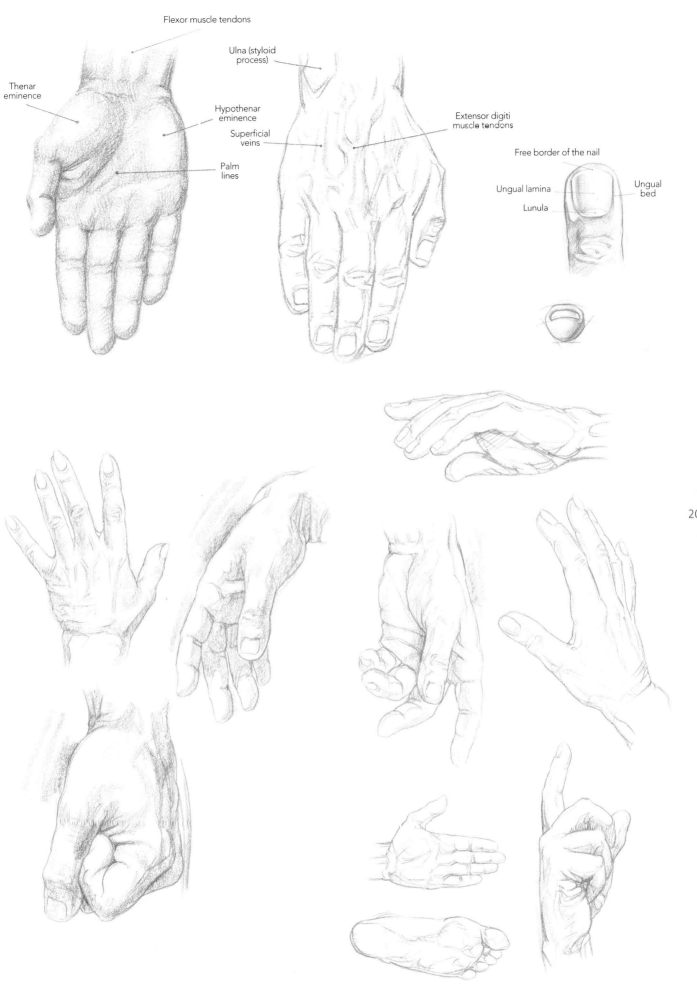

Flexor muscle tendons

Thenar eminence

Ulna (styloid process)

Hypothenar eminence

Superficial veins

Palm lines

Extensor digiti muscle tendons

Free border of the nail

Ungual lamina

Lunula

Ungual bed

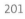

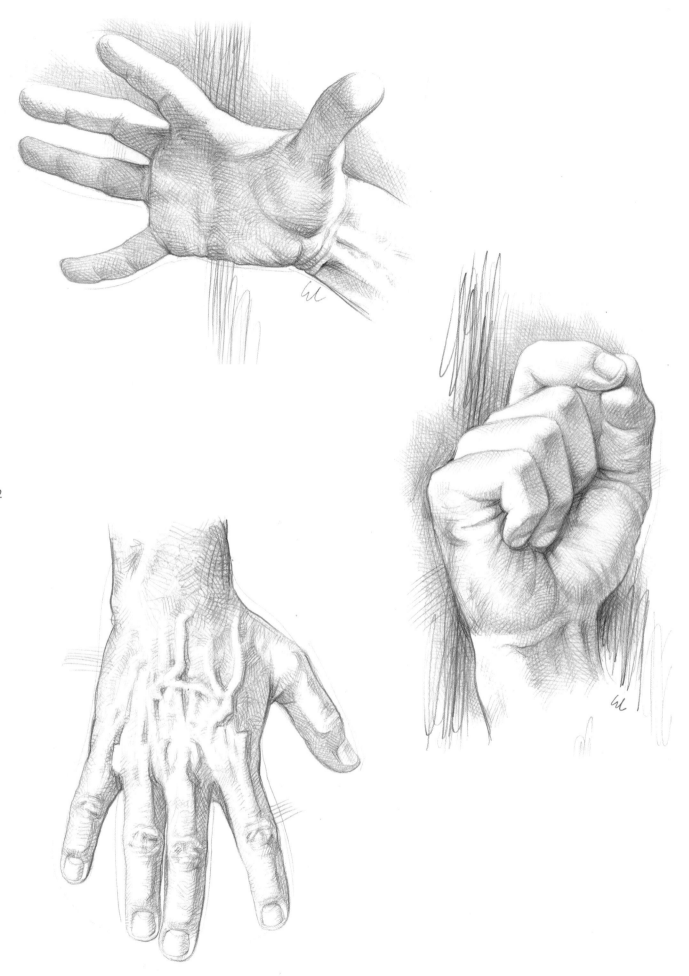

THE LOWER LIMB

NOTES ON EXTERNAL MORPHOLOGY

The lower limbs are paired, symmetrical and attached to the lower part of the trunk. Each of them comprises a free part (separated into: thigh, leg and foot) articulated with the pelvic girdle, the pelvis, at the level of the hip and the gluteal region, already morphologically described when speaking about the trunk.

The general construction is similar to that of the upper limb. There are, therefore, some large muscles, especially the gluteal muscles, which head towards the first segment of the free part, the thigh, and contribute to the shape of the buttock.

The thigh is shaped like a slightly flattened truncated cone on the lateral surface. It connects at the front directly with the trunk, forming the inguinal fold. The muscles are arranged around a single bone, the femur, separated into three groups: anterior, posterior and medial.

The leg joins the thigh via the knee joint and is conoid in shape, with the narrow part towards the foot. The muscles are arranged around two parallel bones, the tibia and the fibula, divided into an anterolateral group and a posterior group.

The foot is the terminal part of the lower limb and rests on the ground. Unlike the hand, the foot does not prolong the longitudinal axis of the limb but connects to it at a right angle at the ankle. The foot is arched, convex on the dorsal surface and concave on the medial border of the sole: this section corresponds to the tarsal and metatarsal bones. The distal section of the foot, comprising the phalanges of the toes, is rather wide and flat.

Borders of the main regions of the lower limb

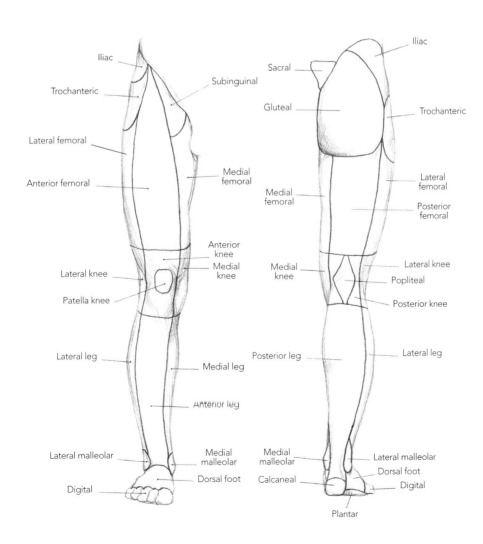

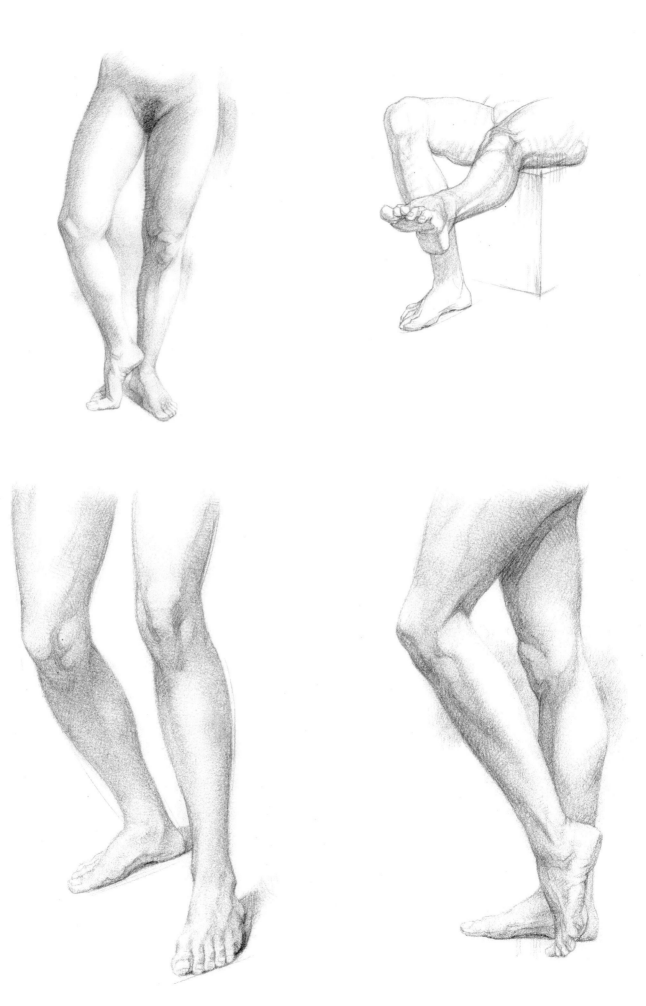

OSTEOLOGY

The skeleton of the lower limb (or pelvic, abdominal limb) recapitulates the layout of the upper limb; in fact, it is formed by an attachment girdle to the axial skeleton (the pelvis), which we have already described, and by bones making up the free part: the femur, the bone corresponding to the thigh and to which the patella is connected; the tibia and the fibula, corresponding to the leg; the tarsus, the metatarsus and the phalanges corresponding to the foot. The bony elements are arranged one over the other, vertically, with the axes of the first two segments at slight angles with each other. The foot has the greater axis positioned almost orthogonally to that of the leg, and is differentiated from the construction of the upper limb given its primary function of supporting the body and walking.

In short, the skeleton of the lower limb includes the attachment girdle, that is, the pelvic girdle, already described, and the bones of the free part: femur and patella, tibia and fibula, tarsus and metatarsus and phalanges; these correspond to the thigh, leg and foot regions respectively.

The femur is the strongest, longest and largest bone in the human body. The diaphysis is curved antero-posteriorly; it has three surfaces: the curved anterior, the flatter lateral surfaces, converging posteriorly into a longitudinal crest (linea aspera). The lower epiphysis is very large, with two lateral protuberances (medial condyle and epicondyle, lateral condyle and epicondyle) separated by a deep intercondylar fossa. The proximal extremity comprises the femoral head (hemispherical in

shape), the femoral neck (which forms an obtuse angle, usually between 120 degrees and 130 degrees with the axis of the femoral diaphysis) and two uneven prominences: the larger greater trochanter, directed laterally; and the lesser trochanter, facing medially and posteriorly.

The patella is a short bone, generally considered to be a sesamoid bone of the quadriceps. It has an irregular disc shape and varies in thickness, with a rough external surface for tendon insertions and an internal articular surface which is very smooth because it is covered by cartilage.

The tibia is located medially in the leg: it is a long, column-shaped bone, with a large upper epiphysis and a smaller lower epiphysis. The diaphysis is formed by three surfaces joined by rather clear borders: the anteromedial surface is superficial, subcutaneous, and smooth, as it is not covered by muscles. The upper epiphysis is the largest part of the tibia, with a significant expansion on the sides and posteriorly and an evident tuberosity on the anterior surface; the upper surface, which articulates with the femur, has two condyloid articular surfaces, separated by an intercondylar crest. The lower epiphysis is conoid in shape, with a process positioned medially (the tibial or medial malleolus) on the surface. The articular surface with the astragolus is extremely concave and widened transversally; laterally there is a resting notch for the fibula.

The fibula is a long, very thin, tubular bone: the diaphysis has slightly flat, twisted surfaces, the upper epiphysis (head) is ovoid with an articular surface for the tibia and the lower epiphysis (fibular or lateral malleolus) is slightly thicker than the body, and elongated, with a pointed apex.

Right femur

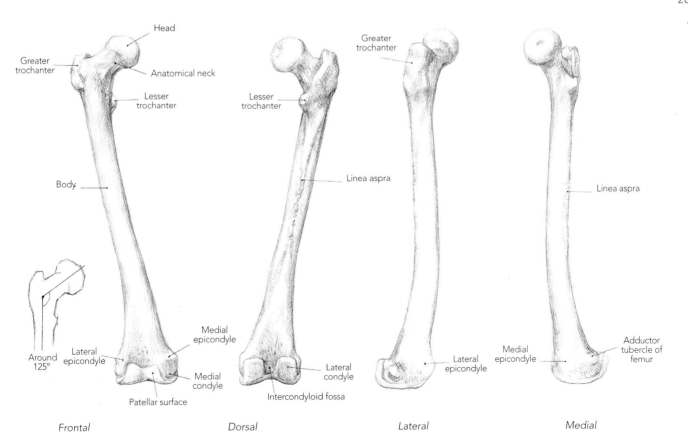

Frontal *Dorsal* *Lateral* *Medial*

The tarsus is a set of seven bones, two of which are very large and therefore decisive in in the external morphology of the foot: the talus, which articulates with the tibia, and the calcaneus, a cuboid shape that juts out posteriorly. The remaining five bones are the scaphoid, the cuboid and the three cuneiform bones.

The metatarsus (metatarsal bones) is a set of five long bones forming a slightly arched body of decreasing length, proceeding from the first, which is very large, to the fifth; a proximal epiphysis (base) joining with the cuneiform bones; and a distal epiphysis (head) which joins with the phalanges.

The phalanges have structural and morphological characteristics similar to those of the hand: there are only two for the first toe and three for the remaining four toes, and they can be distinguished as the proximal, middle and distal phalanges. Two sesamoid bones can frequently be found at the point of the plantar border of the head of the first metatarsal, close to the joint with the phalanx.

Right tibia

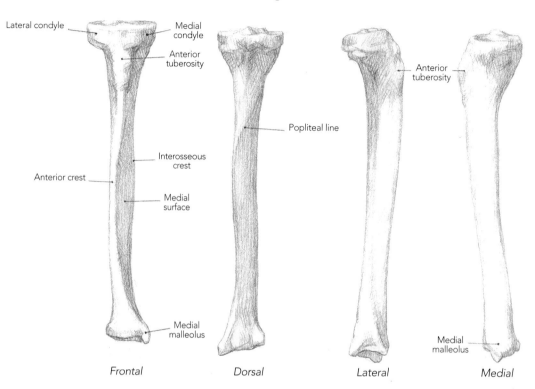

Frontal *Dorsal* *Lateral* *Medial*

Right fibula (peroneal bone)

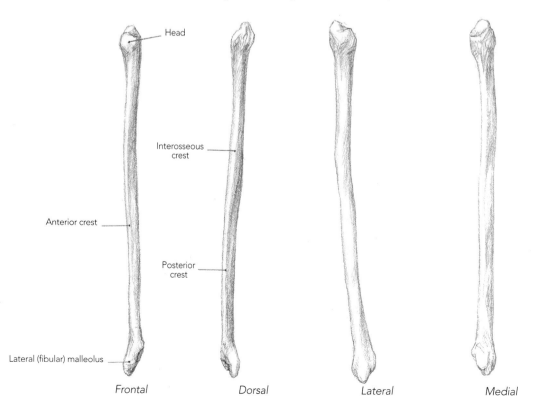

Frontal *Dorsal* *Lateral* *Medial*

Bones of the right foot

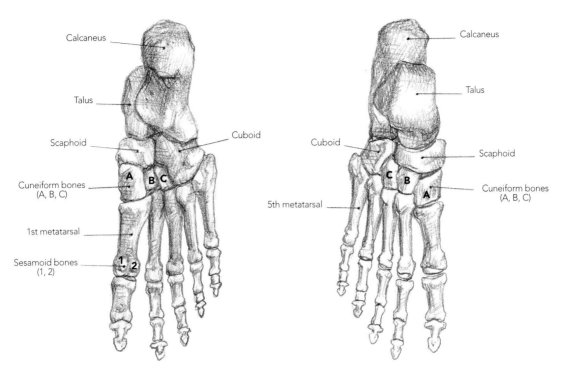

Calcaneus

Talus

Scaphoid

Cuboid

Cuneiform bones
(A, B, C)

1st metatarsal

Sesamoid bones
(1, 2)

A B C

1 2

Plantar surface

Calcaneus

Talus

Cuboid

Scaphoid

5th metatarsal

Cuneiform bones
(A, B, C)

C B A

Dorsal surface

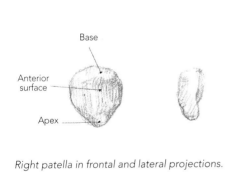

Base

Anterior
surface

Apex

Right patella in frontal and lateral projections.

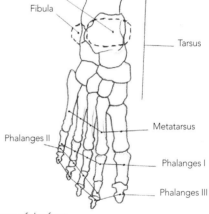

Tibia

Fibula

Tarsus

Metatarsus

Phalanges II

Phalanges I

Phalanges III

The bone groups of the foot.

*Normal and reciprocal anatomical relations of the right leg bones
(tibia and fibula) in frontal projection and lateral projections.*

Lateral projection

Medial projection

ARTHROLOGY

Like the bones, the joints of the lower limb have some important similarities with those of the upper limb. There are, in fact, three articular groups: the pelvic girdle joints, basically the ones in the pelvis itself (sacroiliac and pubic symphysis) which have already been described in the section on the pelvis; the free part joints: the coxofemoral joint, the knee joint, the tibiotarsal and the tibiofibular joints; the joints in the foot.

The hip (or coxofemoral) joint is a large enarthrosis, the largest in the human body, via which the femoral head comes into contact with the concave surface of the acetabulum (or cotyloid cavity) which has a fibrous ring (the acetabular rim) arranged around its perimeter. Both articular surfaces are mostly covered by cartilage and held together by a capsule, the borders of which surround the acetabulum, inserting onto the femoral neck. The capsule is very strong, and is also reinforced by some fibrous ligaments: the iliofemoral ligament (stretched from the anterior inferior iliac spine to the femur, at the intertrochanteric line), the pubocapsular ligament (which originates at the pubis and the anteroinferior border of the ischium acetabulum to the posterior surface of the femoral neck); and the round teres ligament (which is a short intracapsular fibrous lamina which connects the fovea capitis with the acetabular notch. Lastly, we must note that the joint is restricted by some muscle tendons (piriformis, internal obturator and gemellus) layered on the capsule. The lower limb's movements on the pelvis depend on the coxofemoral joint: flexion, extension, abduction, adduction, rotation and circumduction. These movements, or a combination of them, can be considerably wide-ranging, especially if combined with those of the lumbar vertebral column and the pelvis, allowing the complex dynamic mechanisms of the entire body in walking, running or even standing erect with balance shifted to only one limb.

The knee joint is between the femur and the tibia and is complex due to the morphological characteristics of the articular heads which come into contact with each other. The bone parts contributing to forming the joint are: the femoral condyles, the upper extremity of the tibia and the deep surface of the patella. The femoral condyles, with their oval surface, rest in the tibial head's glenoid cavities, lending the condyloid nature to the joint. As the articular surfaces can differ greatly in shape, the glenoid cavities are adapted and made deeper by the presence of two cartilaginous crescent-shaped menisci, which are thicker at the outer edge, while in the centre there is a hole through which the cartilage of the glenoid cavity can be seen. The three bones in the joint are wrapped by the capsule, with rather irregular insertions on which several ligaments are layered: the patella ligament, positioned anteriorly, close to the surface and robust, which runs from the lower border of the patella to the tibial tuberosity as an extension of the rectus femoris tendon; the collateral ligaments, stretched from the epicondyles at the head of the tibia, one on the lateral section (fibular ligament) and one on the medial section (tibial ligament); the posterior (or popliteal ligament), formed by some crossed-over bundles stretched between the femur and the tibia at the bottom of the popliteal fossa; and the cruciate ligaments, two fibrous cords, anterior and posterior, located inside the articular capsule and very important for blocking the extension of the joint. This set of ligaments is further reinforced by the stratification of some aponeutoric expansions on the articular capsule, which originate from the muscle tendons in the thigh and leg, as well as the covering fascia (in particular the fascia lata). The possible movements of the knee joint between leg and thigh are rather limited due to the shape of the articular heads, which only allow flexion and extension of the leg on the thigh (the latter action intended as a return of the segment to the anatomical position). In flexion, a few rotary movements of the leg on the thigh are also possible.

The tibiotarsal joint connects the leg with the foot. It is an angular ginglymus where the surface of the lower end of the tibia, the talar trochlea and the fibula malleolus come into contact. A rather loose capsule covers it and some ligaments reinforce it: the deltoid, collateral and fibulocalcaneal ligaments. The joint only allows flexion and extension movements (called dorsal flexion and plantar flexion).

There are two tibiofibular joints: an upper (or proximal) one, independent of the knee joint, between the fibula head and the corresponding tibial surface; and a lower (or distal) one, between the lower end of the fibula and the corresponding articular surface

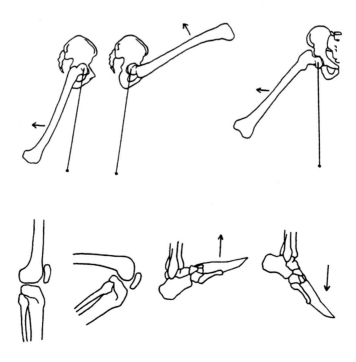

Diagram of movements of the main lower limb joints.

of the tibia. Movements are minimal, only slight gliding ones. It is to be noted that in the leg, unlike in the forearm, there is no pronation and supination movement and that the two bones are also joined by an interosseous membrane, much stronger than that of the forearm, which separates the group of flexor muscles from the extensor muscles. In comparison to the hand joints, the foot joints are less important from a functional point of view, given the fewer actions of the organ, which is mainly used to support body weight and maintain balance. The joints are: the talocalcaneal joint, the calcaneocuboid joint, the tarso-metatarsal and intermetatarsal articular groups, the metatarso-phalangeal joints and the interphalangeal joints. More so than in the hand, there is an extended network of ligaments in the foot, with the function of stabilizing the bones and reinforcing the traction lines that they carry out on the plantar arch. All these joints allow the foot to make some limited movements: dorsal and plantar flexion, adduction and abduction.

• Functional characteristics of the lower limb

In the erect position in humans, the lower limb mostly carries out two functions: supporting and discharging body weight onto the resting area and creating body movements by walking. The lower limb differs from the upper limb due to these characteristics of stability and robustness. The upper limb is also more mobile and shorter. The opposing actions of the flexor and extensor muscles, together with the mechanisms of the large joints (hip and knee) and fasciae, make the sections of the free part solid and stable in their relations with the pelvis, mainly during dynamic activities such as running, jumping and walking. The overall arched structure of the foot bones also helps to cushion gravity stress, while the limb's muscles collaborate with other body sections (pelvis, vertebral column and head) and with oscillating, rhythmical alternation with the upper limb in order to maintain balance.

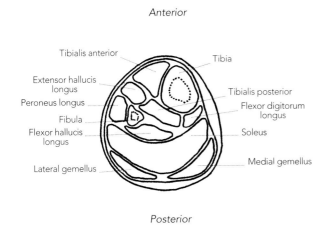

Hypothetical transverse section of the left leg in the middle third.

MYOLOGY

In the lower limb, the large muscles are constructed in a similar way to those of the upper limb, so we can distinguish: the spinoappendicular muscles and the buttock (or gluteal region) muscles, already described in the section on the trunk (see page 124); the thigh muscles; the leg muscles and the foot muscles.

The thigh muscles are long and robust, arranged around the femur in three groups: anterior, for a mainly extension action on the leg (quadriceps etc.); posterior, with a flexion action on the leg (biceps femoris, semitendinosus, semimembranosus); medial, with abduction of the thigh (pectineus, adductors longus and brevis, adductor major and minor, gracilis, external obturator etc.).

The leg muscles are divided into a posterior group (triceps surae, plantar, popliteus, flexor digitorum longus, tibialis posterior and flexor hallucis longus), with a flexion action of the foot and toes; an anterior group (tibialis anterior, extensor digitorum longus, extensor hallucis longus and peroneus anterior), mainly with an extension action of the foot and toes; and a lateral group (peroneus) with an abduction action of the foot.

The short muscles of the foot are arranged both dorsally (extensor digitorum brevis), and in the plantar region, and these are divided into three groups: medial (abductor hallucis, flexor hallucis brevis and adductor hallucis); lateral (abductor digiti minimi, flexor brevis and opponens); and central (flexor digitorum brevis, quadratus plantae, lumbricales and interossei).

• Auxiliary organs to lower limb muscles

These are laminar formations which cover the muscles and aid the tendons' function: covering fasciae, intermuscular septa, containing ligament expansions, tendinous sheaths and mucosa bursae. The fasciae of the lower limb are large fibrous laminae that cover the surface of muscles and from which they descend to the bone surfaces of the separation septa in the separate cavities. The following can be seen: the hip (or gluteal) fascia (see page 125); the thigh (or femoral) fascia, of which there are several particular formations, and above all the lateral thickened area, known as the fascia lata; the popliteal fascia; the leg fascia and the foot fascia, with thickening of the plantar aponeurosis.

The tendon-containing system is made up of fibrous laminae, arranged transversally. They are located at the level of the neck of the foot and toes. The tendinous sheaths are channel-like devices which facilitate the gliding of the tendons directed at the toes.

The mucosa bursae are globular formations containing synovial fluid, located in sites which are particularly subject to friction or mechanical stress: they are located in the gluteal and trochanteric regions, between the rectus femoris muscle and the acetabulum, at the patella, at the end of the sartorius, under and to the rear of the calcaneus and at the insertion point of the Achilles tendon.

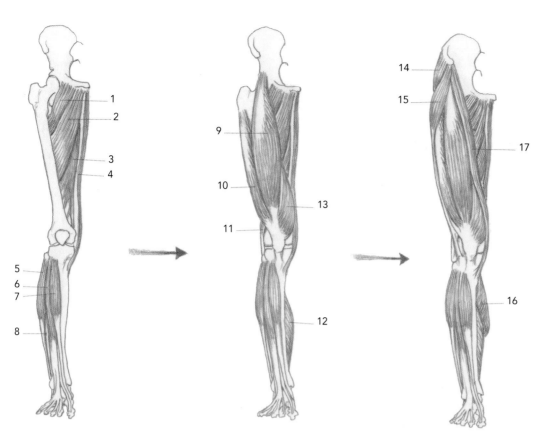

Topographical diagram of some muscles of the lower limb (frontal projection) from deep layers to superficial layer:

1 - Pectineus
2 - Adductor longus
3 - Adductor magnus
4 - Gracilis
5 - Peroneus longus
6 - Extensor digitorum longus
7 - Tibialis anterior
8 - Peroneus brevis
9 - Quadriceps, rectus femoris
10 - Quadriceps, vastus lateralis
11 - Biceps femoris
12 - Soleus
13 - Quadriceps, vastus medialis
14 - Gluteus medius
15 - Tensor fasciae latae
16 - Gastrocnemius, medial head
17 - Sartorius

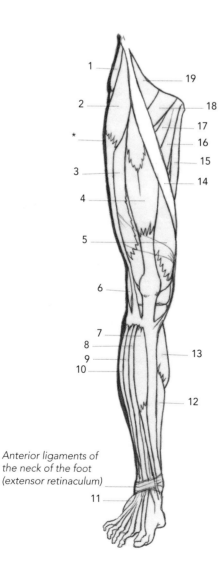

Anterior ligaments of the neck of the foot (extensor retinaculum)

Diagram of the muscles of the right lower limb (frontal projection):

* - Thickness of skin and subcutaneous layer
1 - Gluteus medius
2 - Tensor fasciae latae
3 - Quadriceps: vastus lateralis
4 - Quadriceps: rectus femoris
5 - Quadriceps: vastus medialis
6 - Biceps femoris
7 - Tibialis anterior
8 - Extensor digitorum longus
9 - Peroneus longus
10 - Soleus
11 - Extensor digitorum brevis
12 - Soleus
13 - Gastrocnemius: medial head
14 - Sartorius
15 - Gracilis
16 - Adductor longus
17 - Adductor brevis
18 - Pectineus
19 - Iliopsoas

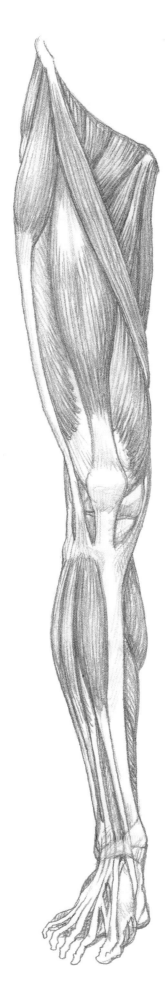

Superficial muscles of the right lower limb: frontal projection.

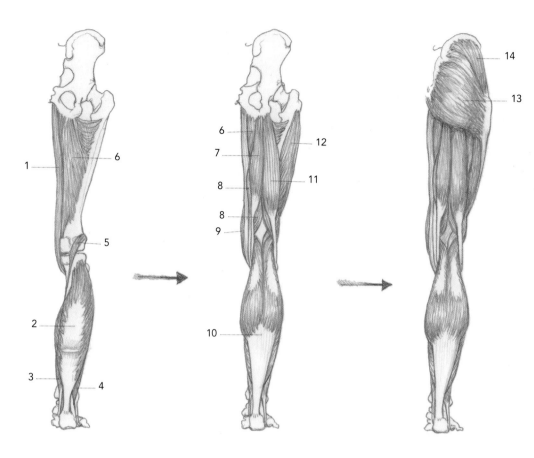

Topographical diagrams of some muscles of the lower limb (dorsal projection) from deep layers to superficial layer:
1 - Gracilis
2 - Soleus
3 - Flexor digitorum longus
4 - Peroneus brevis
5 - Plantar
6 - Adductor magnus
7 - Semitendinosus
8 - Semimembranosus
9 - Sartorius
10 - Gastrocnemius
11 - Biceps femoris
12 - Vastus lateralis
13 - Gluteus maximus
14 - Gluteus medius

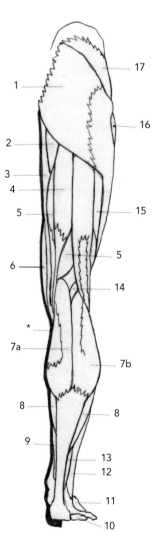

Diagram of the muscles of the right lower limb (dorsal projection):
* - Thickness of skin and subcutaneous layer
1 - Gluteus maximus
2 - Adductor magnus
3 - Gracilis
4 - Semitendinosus
5 - Semimembranosus
6 - Sartorius
7 - Gastrocnemius: (a) medial head; (b) lateral head
8 - Soleus
9 - Flexor digitorum longus
10 - Abductor digiti minimi
11 - Extensor digitorum brevis
12 - Peroneus longus
13 - Peroneus brevis
14 - Plantaris
15 - Quadriceps: vastus lateralis
16 - Tensor fasciae latae
17 - Gluteus medius

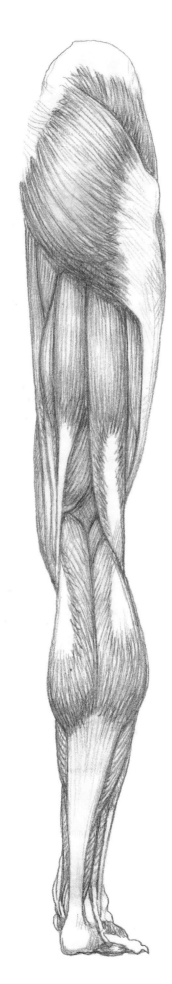

Superficial muscles of the right lower limb: dorsal projection.

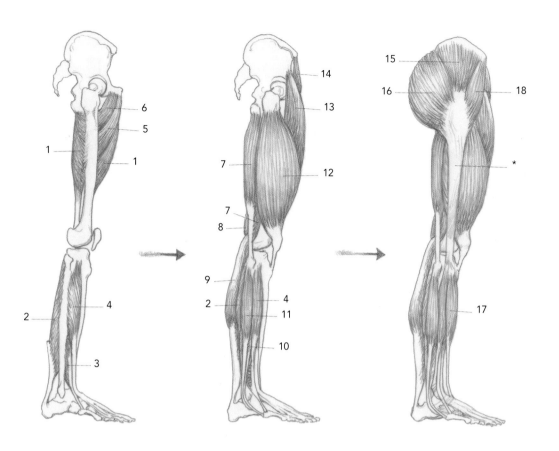

Topographical diagram of some muscles of the lower limb (lateral projection) from deep layers to superficial layer:

* - Fascia latae
1 - Adductor magnus
2 - Soleus
3 - Peroneus tertius
4 - Extensor digitorum longus
5 - Adductor longus
6 - Pectineus
7 - Biceps femoris
8 - Semitendinosus
9 - Gastrocnemius
10 - Peroneus brevis
11 - Peroneus longus
12 - Vastus lateralis
13 - Rectus femoris
14 - Sartorius
15 - Gluteus medius
16 - Gluteus maximus
17 - Tibialis anterior
18 - Tensor fasciae latae

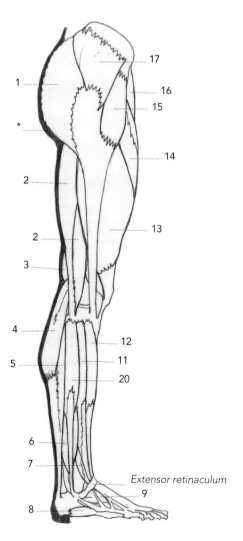

Extensor retinaculum

Diagram of the muscles of the right lower limb (lateral projection):

* - Thickness of skin and subcutaneous layer
1 - Gluteus maximus
2 - Biceps femoris
3 - Semimembranosus
4 - Gastrocnemius
5 - Gastrocnemius soleus
6 - Peroneus brevis
7 - Peroneus tertius (plantar)
8 - Abductor digiti minimi
9 - Extensor digitorum brevis
10 - Peroneus longus
11 - Extensor digitorum longus
12 - Tibialis anterior
13 - Quadriceps: vastus lateralis
14 - Quadriceps: rectus femoris
15 - Tensor fasciae latae
16 - Sartorius
17 - Gluteus medius

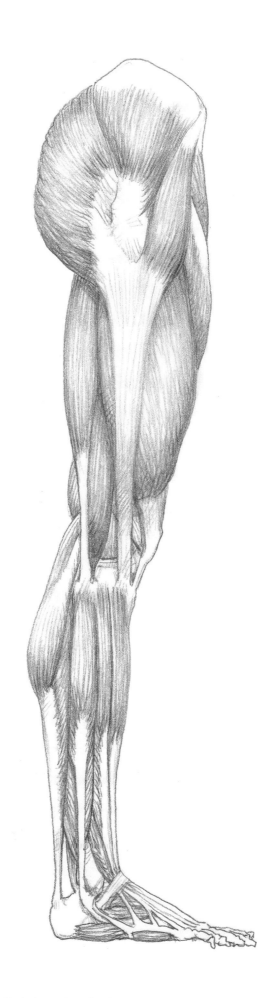

Superficial muscles of the right lower limb: lateral projection.

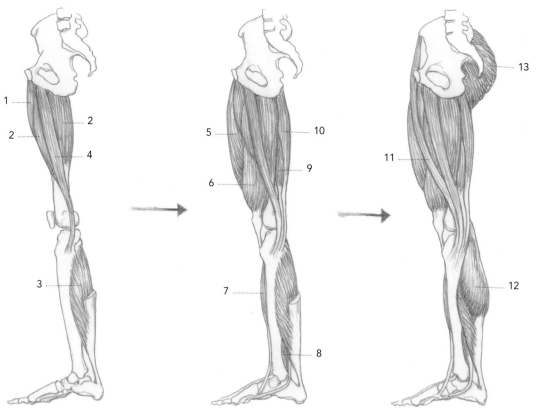

Topographical diagram of some muscles of the lower limb (medial projection) from deep layers to superficial layer:
1 - Adductor longus
2 - Adductor magnus
3 - Soleus
4 - Gracilis
5 - Rectus femoris
6 - Vastus medialis
7 - Tibialis anterior
8 - Flexor digitorum longus
9 - Semimembranosus
10 - Semitendinosus
11 - Sartorius
12 - Gastrocnemius
13 - Gluteus maximus

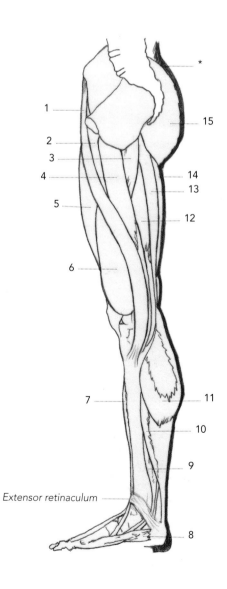

Extensor retinaculum

Diagram of the muscles of the right lower limb (medial projection):
* - Skin and subcutaneous thickness
1 - Sartorius
2 - Pectineus
3 - Adductor magnus
4 - Gracilis
5 - Quadriceps: rectus femoris
6 - Quadriceps: vastus medialis
7 - Tibialis anterior
8 - Abductor hallucis
9 - Flexor digitorum longus
10 - Soleus
11 - Gastrocnemius (medial head)
12 - Semimembranosus
13 - Semitendinosus
14 - Biceps femoris
15 - Gluteus maximus

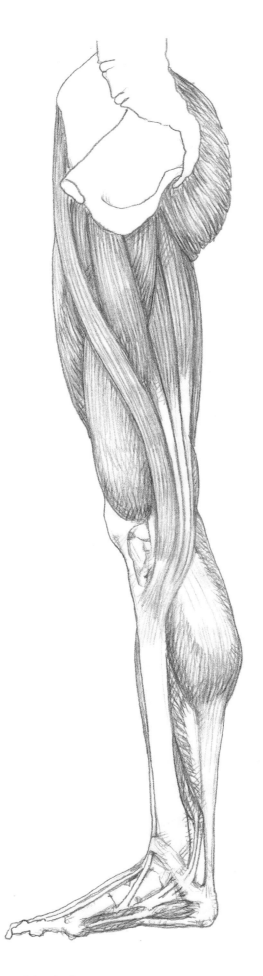

Superficial muscles of the right lower limb: medial projection.

TENSOR FASCIAE LATAE MUSCLE (Tensor fasciae latae)

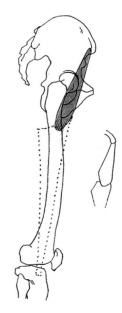

Form, structure, relations. The tensor fasciae latae muscle is thick, flat, long and almost triangular, located superficially on the anterolateral border of the pelvis. The contracting fibres originate with a tendon arranged on a narrow area of the ilium and head downwards, vertically, widening into a broad insertion section on the fascia lata. The muscle (which may be missing, connected with the gluteus maximus or divided into two separate bundles) is covered by the femoral fascia and the skin. It partly covers the gluteus minimus and the rectus femoris; and it is in relation medially with the sartorius and lateroposteriorly with the gluteus medius.

Origin. Anterior section of the outer rim of the iliac crest; lateral surface of the anterior superior iliac spine.

Insertion. Iliotibial tract of the fascia lata, below the greater trochanter. (The iliotibial tract is a ribbon-like thickening of femoral aponeurotic fascia, or fascia lata: it is located on the lateral surface of the thigh, arranged vertically, extended from the pelvis at the iliac crest (where it begins to widen due to the converging of bundles which cover the gluteal muscles) up to the lateral condyle of the femur and the lateral margin of the tibial head.

Action. Tension of the fascia lata, with extension of the leg and slight abduction of the thigh; stabilization of the entire limb in the erect position.

Surface anatomy. The tensor fasciae latae muscle is subcutaneous and its contractible mass in the erect position and with the thigh abducted, appears as an elongated vertical elevation between the anterior portion of the iliac crest and the area in front of and underneath the greater trochanter. The muscle runs between the gluteus medius, located posteriorly, and the sartorius, in a more medial position. When the thigh is highly flexed, a deep cutaneous fold forms which passes transversally over the muscle belly of the tensor. The iliotibial tract of the fascia flattens the lateral surface of the thigh, which is especially visible in the erect position and the contrapposto position on one limb only, while the insertion point on the tibia appears as a lightly flattened, rope-like elevation, arranged vertically immediately above the lateral condyle of the femur.

218

SARTORIUS MUSCLE (Sartorius)

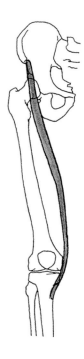

Form, structure, relations. The sartorius muscle is very long (about 50cm/19¾in); thin, flat and narrow (approx. 4cm/1½in); ribbon-like; and is located superficially on the anterior and medial surfaces of the thigh, where it runs almost as a spiral. It is, in fact, arranged obliquely from top to bottom and from lateral to medial, from its origin on the pelvis to its insertion on the tibia. The sartorius muscle, which has no insertions on the femur but which acts on two joints (the hip and the knee), is covered by the femoral fascia and the skin; it covers the rectus femoris, the iliopsoas, the vastus medialis and the adductors longus and brevis muscles, crossing them diagonally; the gracilis runs alongside it posteriorly.

Origin. Anterior superior iliac spine and upper border of the underlying notch.

Insertion. Medial border of the tibial tuberosity. The insertion tendon of the sartorius muscle extends onto a tendinous expansion, known as the goose foot, or pes anserinus, to which the tendons of other muscles travel: the sartorius tendon is positioned anteriorly, followed by that of the gracilis and then that of the semitendinosus. The expansion fans out on to the medial surface of the tibial tuberosity, part of the diaphysis, and on to the aponeurotic of the leg.

Action. Flexion of the thigh on the pelvis, with slight abduction or lateral rotation; flexion of the leg onto the thigh, with adduction.

Surface anatomy. The sartorius muscle is subcutaneous. In the erect position, with thigh muscles relaxed or slightly contracted, the sartorius travels in a depression between the quadriceps, laterally, and the adductors and the gracilis, medially. It is therefore hardly visible. When strongly contracted, with the thigh and the leg flexed and abducted, the sartorius appears as an elevated strip and is extremely prominent, especially in the initial section below the iliac spine, which travels diagonally onto the thigh's medial surface. In addition, when the thigh flexes on the pelvis, a hollow can be seen just below the iliac spine, between the sartorius and the tensor fasciae latae, located more laterally. The tendon of origin of the rectus femoris runs along the bottom of the hollow.

QUADRICEPS FEMORIS MUSCLE (Ouadriceps femoris)

Form, structure, relations. The femoral quadriceps is located in the anterior part of the thigh. It acts as an extensor and is a muscle group with four heads (rectus femoris, vastus lateralis, vastus medialis and vastus intermedius) with different origins, both on the pelvis and on the femur, but with a common insertion point on the tibia. Of the four heads, the rectus femoris is bi-articular, that is it involves two joints in its action, the coxofemoral joint and the knee joint, while the others act only on the knee joint.

The rectus femoris is the median and most superficial portion of the quadriceps. It is a long, slightly flat, fusiform muscle directed downwards almost vertically, following the femoral axis. It originates from the pelvis with a strong tendon which continues inside the muscle belly up to past half its length and which can be seen on the surface as a slight longitudinal cutaneous hollow. From the tendon, the muscle fibres run both medially and laterally and give the muscle its pennate appearance. Insertion is on the tibia via a long, flat tendon which starts at the point of the lower third of the femur. The muscle is superficial, covered by the femoral fascia and the skin (only the point of origin is covered by the iliopsoas and the sartorius); it covers the vastus intermedius and laterally has relations with the tensor fasciae latae and the vastus lateralis, medially with the vastus medialis.

The vastus lateralis is the largest part of the quadriceps and occupies the entire lateral part of the thigh. It is a wide, flat muscle, thin at the top and thicker at the bottom. The muscle fibres head downwards, medially and anteriorly, from a large area of origin on the femur to the common tendon insertion area of the quadriceps. The muscle has the lower superficial portion covered by the femoral fascia and the skin, while the upper portion is covered laterally by the iliotibial section of the fascia lata and its tensor. Medially it has relations with the vastus intermedius, the vastus medialis and the rectus femoris.

The vastus medialis is the part of the quadriceps which occupies the medial and inferior part of the thigh. It is a flat, tapered, thin muscle at the top and thicker at the bottom. The muscle fibres travel downwards, anteriorly and laterally, from their origin on the femur to insertion on the common quadriceps tendon. The muscle adheres to the anterior surface of the femur and is covered by the rectus femoris, the vastus medialis and the vastus lateralis. Some muscle bundles, partly separated from the vastus intermedius and which form the articular knee muscle, originate from the ventral surface of the femur's lower extremity and insert on to the knee's articular capsule.

Origin. Rectus femoris: anterior surface of the anterior inferior iliac spine, with tendon expansion on to the upper border of the acetabulum.

Vastus lateralis: anterior and inferior borders of the femoral greater trochanter; upper half of the lateral rim of the linea aspera.

Vastus medialis: lower part intertrochanteric line and medial rim of the linea aspera. Vastus intermedius: upper two thirds of the anterior and lateral surfaces of the femoral diaphysis.

Insertion. Tibial tuberosity (via a common tendon to which the tendons from the four muscle bellies converge, overlapping, and which covers the patella).

Action. Extension of the leg on the thigh; collaboration with flexion of the thigh on the pelvis and vice versa (the quadriceps muscle as a whole stabilizes the limb in the erect position).

Surface anatomy. The quadriceps femoris occupies the entire anterior lateral part of the thigh and is subcutaneous, except for its intermediate part, which still takes part in determining the overall volume of the muscle. The rectus femoris travels the anterior surface of the thigh on the median line: in the upper part, it appears under the anterior inferior iliac spine, between the lateral elevation of the tensor fasciae latae and the medial elevation of the sartorius. In the erect position, this part is prominent, but when the thigh is flexed onto the pelvis, it appears as a hollow with the large protuberance of the two stated muscles alongside it. The vastus medialis is visible medially at the rectus femoris, but only in the lower half of the thigh, where it appears as an elevation which almost reaches the patella. The vastus lateralis is visible on the anterolateral part of the thigh, laterally to the rectus femoris and anteriorly to the iliotibial tract of the fascia lata. Compared with that of the vastus medialis, the muscle belly arrives further away from the patella and the femoral condyle. The anterior surface of the lower third of the thigh, just above the patella, is crossed diagonally by a thickened aponeurotic fascia which depends on the femoral fascia and produces a slight transverse groove on the surface when the quadriceps is relaxed.

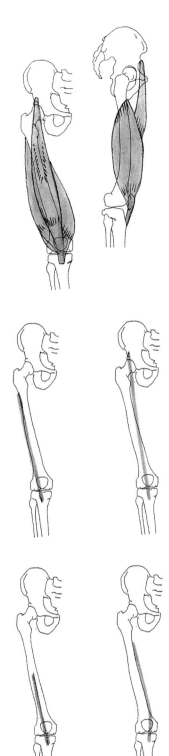

GRACILIS MUSCLE (Gracilis)

Form, structure, relations. The gracilis (or rectus internus) muscle, located on the medial surface of the thigh, is the most medial and superficial of the adductor muscles. The belly is directed vertically downwards and is thin, long, flat and wide at the point of origin on the pelvis, then narrow and conoid in the subsequent section. The insertion tendon is very long, thin and cylinder-shaped, and runs posteriorly to the femoral medial condyle, then immediately afterwards flattens by expanding into the goose foot. The muscle is covered by the femoral fascia and skin; it partly covers the adductor longus and adductor magnus; anteriorly, the sartorius runs alongside it, and posteriorly, the semimembranosus, while the semitendinosus is next to it in the tendinous portion.

Origin. Inferior ramus of the pubis (along the medial border, in the section between the pubic symphysis and the ascending ramus of the ischium).

Insertion. Medial surface of the tibia, below the tuberosity. (The tendon contributes to the formation of the goose foot, placing itself between the sartorius tendon positioned anteriorly and the semitendinosus tendon positioned posteriorly.)

Action. Adduction of the thigh; flexion of the leg on the thigh, with slight medial rotation (in synergy with the sartorius for flexion or adduction, but in antagonism for rotation).

Surface anatomy. The gracilis muscle is subcutaneous along its entire extension on the medial surface of the thigh. When this is in abduction, it juts out clearly, in particular the upper portion, as a thin elevation originating at the ischial tuberosity and travelling between the adductor longus anteriorly, and the adductor magnus and the semimembranosus posteriorly. The insertion tendon is not visible on the surface if the limb is extended, but can easily be seen, together with the semitendinosus tendon along the medial border of the popliteal fossa of the knee, when the leg is partly flexed on the thigh.

ADDUCTOR LONGUS MUSCLE (Adductor longus)

Form, structure, relations. The adductor longus is the most anterior of the adductor muscles and is triangular in shape. Its fibres are directed obliquely downwards, backwards and laterally from the pelvis to their insertion on the femur. The section close to the origin is narrow, flat, and thick, while the subsequent section widens and becomes almost laminar, expanding into the insertion of the aponeurosis. The muscle is superficial at the start, covered by the femoral fascia and skin, but in the lower section, it remains deep and has relations with the vastus medialis and the sartorius, by which it is partly covered. Medially, it has relations with the gracilis and laterally, with the pectineus; it covers the adductors brevis and magnus.

Origin. Anterior surface of the pubic bone (in the section between the crest and the symphysis, at the angle formed by the superior ramus and the inferior ramus).

Insertion. Medial border of the middle third of the femur's linea aspera.

Action. Adduction of the thigh, with slight flexion and lateral rotation (in synergy with the other adductors).

Surface anatomy. The upper section of the adductor longus muscle is subcutaneous, but cannot be distinguished from the other adductors on the anterior-medial surface of the thigh, as they tend to appear as a single mass. When heavily contracted, it can be observed as a moderate vertical elevation at the root of the thigh, narrow below the inguinal ligament and then widening towards the sartorius.

PECTINEUS MUSCLE (Pectineus)

Form, structure, relations. The muscle is flat, rather thick and quadrangular in shape, located at the root of the thigh, heading obliquely downwards, laterally and backwards from its origin on the pelvis to its insertion on the femur. The muscle, which can also be split into two separate, overlapping laminae, is superficial at the start, covered by femoral veins, the femoral fascia and the skin; it covers the coxofemoral joint and medially, the adductor brevis and the external obturator; the lateral border is in relation with the psoas major and the medial border is in relation with the adductor longus. Together with the iliopsoas, the pectineus muscle forms the deep part of the femoral fossa, which is a pyramidal space bordered laterally by the sartorius, medially by the adductor longus and superiorly by the inguinal ligament, stretched between the anterior superior iliac spine and the pubic tubercle. The artery, vein and femoral nerve run along the femoral fossa.

Origin. Pectineal crest of the horizontal ramus of pubic bone; pubic tubercle.

Insertion. Pectineal line, located between the lesser trochanter and the linea aspera on the femur.

Action. Adduction of the thigh, with slight flexion and lateral rotation.

Surface anatomy. The pectineus muscle is superficial, but as it is partly covered by the femoral veins and adipose tissue, it is not visible externally and blends with the emergence of the adductor longus, located more medially, below the ischiopubic ramus.

ADDUCTOR MAGNUS MUSCLE (Adductor magnus)

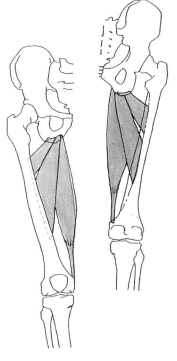

Form, structure, relations. The adductor magnus is a wide, robust, very large laminar muscle, located in the medial portion of the thigh. It is triangular, almost cone-shaped; its fibres travel inferiorly and laterally, but with different angles, as the upper ones are almost horizontal, the middle ones are oblique and the lower ones are almost vertical. The muscle originates from the pelvis and can be divided into two portions depending on the mode of insertion: the more prominent, constituted by the middle fibres, insert onto the femoral diaphysis with a wide arched tendon, while the slimmer one inserts onto the medial condyle with a separate, thin, cylinder-shaped tendon. The upper fibres are frequently separated from the remaining part of the muscle and are therefore recognized as the adductor minimus muscle. The muscle is only subcutaneous in the short upper origin section, covered by the femoral fascia and skin; anteriorly, it has relations with the pectineus and the adductors brevis and longus; posteriorly, it has relations with the gluteus maximus, the biceps femoris, the semitendinosus and the semimembranosus; medially, it has relations with the gracilis and the sartorius.

Origin. Anterior border of the inferior ramus of the pubic bone; inferior ramus of the ischium; ischial tuberosity.

Insertion. Gluteal tuberosity of the femur; medial border of the linea aspera; tubercle of the adductor magnus on the femoral medial condyle. (The tendinous insertion aponeurosis medially separates the posterior flexor group of muscles in the thigh from that of the extensor muscles, positioned anteriorly.)

Action. Adduction of the thigh, with flexion and lateral rotation (the latter opposed by the bundles that insert on the condyle, which tend to rotate the femur medially). We can note that the adductor muscles are not active during adduction of the abducted thigh in the erect position, as in this case the force of gravity is sufficient to realise the movement. They act energetically on all the other positions, especially to cross over the lower limbs.

Surface anatomy. The adductor magnus muscle is mostly located deeply, but the short upper subcutaneous section is sometimes visible when highly contracted; it appears on the surface on the medial surface of the thigh as a triangular prominence next to the ischial tuberosity and the gluteus maximus, posteriorly to the gracilis and anteriorly to the semitendinosus.

BICEPS FEMORIS MUSCLE (Biceps femoris)

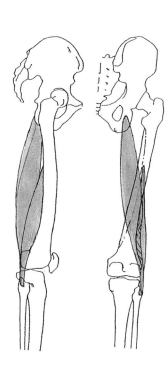

Form, structure, relations. The biceps femoris muscle comprises two heads, long and short, located vertically in the posterior section of the thigh. They originate from the pelvis and the femur and at the lower third of the thigh, merge into a single insertion tendon on the fibula. The long head is fusiform and elongated, superficial, travelling slightly backwards, downwards and laterally, slightly obliquely from the origin on the ischium to the common insertion. The short head is short and flat, covered mostly by the long head, and heads vertically downwards from its origin on the femur to insertion. The long portion of the biceps femoris muscle, which may be missing its short head or have anomalous insertions, is subcutaneous, covered by the femoral fascia and by skin; it partly covers and runs alongside the semimembranosus medially; and it has relations laterally with the vastus lateralis and the adductor magnus.

Origin. Long head: inferomedial surface of the upper surface of the ischial tuberosity; lower part of the sacrotuberous ligament.
Short head: middle third of the lateral rim of the femur's linea aspera.

Insertion. Head of the fibula, with expansions on to the leg fascia and the lateral surface of the tibial tuberosity.

Action. Extension of the thigh (in synergy with the semimembranosus and semitendinosus muscles); flexion of the leg on the thigh with weak lateral rotation; collaboration in walking movements.

Surface anatomy. The biceps femoris is subcutaneous, especially its long portion. In the anatomical erect position, it appears as an elongated elevation which runs vertically along the entire lateral half of the thigh's posterior surface, not entirely separated from the semimembranosus, which is medial to it, but more clearly separated from the vastus lateralis. In this position the insertion tendon, which forms the posterolateral border of the knee, forms

one wall of the popliteal fossa, and is not usually visible on the surface. The tendon, on the other hand, appears clearly when the leg is highly extended and especially when it is in flexion on the thigh: in this position, a short section of the short head can also be seen laterally, close to the tendon.

SEMITENDINOSUS MUSCLE (Semitendinosus)

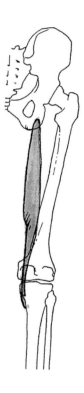

Form, structure, relations. The semitendinosus muscle is so called due to the sizeable length of the insertion tendon which forms about half of its overall extension. The contractible part is tapered, approx. 5cm (2in) wide and 3cm (1¼in) thick, and about halfway down the thigh it extends into a thin, cylindrical insertion tendon. The muscle is positioned vertically in the posteromedial portion of the thigh, directed downwards and slightly posteriorly from the origin on the pelvis to insertion on the tibia.
It is superficial, covered by the femoral fascia, the skin and also, for a short proximal section, by the gluteus maximus; the long head of the biceps femoris is positioned alongside it laterally and the semimembranosus is positioned medially, which it partly covers.
Origin. Inferomedial surface of the upper portion of the ischial tuberosity (with a common tendon with that of the biceps femoris long head).
Insertion. Medial border of the tibial tuberosity. (The tendon travels posteriorly to the femoral medial condyle and expands into the goose foot, placing itself posteriorly to the gracilis tendon.)
Action. Extension of the thigh on the pelvis; flexion of the leg on the thigh (in synergy with the biceps femoris); weak medial rotation of the leg (in antagonism with the biceps femoris).
Surface anatomy. The semitendinosus muscle is subcutaneous along almost its entire extension, excluding a short section close to the point of origin which is covered by the gluteus maximus. It is located in the upper portion of the medial half of the thigh's posterior surface and appears as an elongated vertical elevation between the biceps' long head laterally, and the semimembranosus medially. If the leg is in the anatomical position, the tendon is not elevated and creates a vertical groove at the edge of the popliteal region medially, while it clearly emerges as a rope-like elevation when the leg is flexed on the thigh.

SEMIMEMBRANOSUS MUSCLE (Semimembranosus)

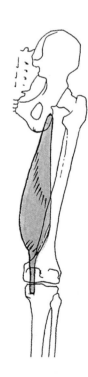

Form, structure, relations. The semimembranosus is a large, flat muscle located in the posteromedial portion of the thigh. It runs downwards and slightly backwards from its origin on the pelvis to its insertion on the tibia. It owes its name to the fact that the origin tendon expands into a wide lamina which penetrates the muscle belly to about halfway down the thigh, and from where the contractible bundles converge towards another tendinous expansion prior to the insertion tendon. The lower portion of the muscle is superficial, covered by the femoral fascia and the skin; at the top it is covered by the gluteus maximus and the semitendinosus; it covers the adductor magnus and the quadratus femoris; medially, the gracilis is positioned next to it.
Origin. Superolateral surface of the ischial tuberosity.
Insertion. Posterior surface of the tibia's medial condyle. (Close to the femoral condyle, the insertion tendon splits into three branches: direct, to the medial tuberosity of the tibia; recurrent, to the posterior border of the femoral medial condyle with extension to the leg's fascia; and reflexed to the anterior part of the tibial medial tuberosity. Overall, the tendinous expansion is located under the goose foot, but has no insertion relations with it.)
Action. Flexion of the leg on the thigh, with slight medial rotation; collaboration in extending the thigh on the pelvis.
Surface anatomy. The semimembranosus muscle has its belly covered medially, mostly by the adductor magnus and the long head of the biceps. It also has the semitendinosus positioned laterally to it, which partly covers it for its entire length: except for its inferior portion, it is not therefore visible directly on the surface, but contributes to determining the external morphology of the thigh's medioposterior border. The insertion tendon runs along the medial border of the popliteal region, crossing the femoral medial condyle vertically on its posterior surface, and is located underneath and laterally to the gracilis and semitendinosus tendons. If the limb is in the anatomical position, it is not visible on the surface, while it appears when the leg is partly flexed on the thigh, together with other surrounding tendons.

POPLITEUS MUSCLE (Popliteus)

Form, structure, relations. The popliteus muscle is short, flat and triangular. It is located on the posterior surface of the knee joint at the bottom of the popliteal fossa. The muscle fibres head obliquely downwards and medially. They originate from the lateral condyle of the femur and widen towards their insertion on the tibia. The muscle covers the knee joint and is covered by the plantaris and the two heads of the gastrocnemius; it has relations with the soleus at the bottom.

Origin. Posterior and lateral surfaces of the femur's lateral condyle; articular capsule of the knee.

Insertion. Upper third of the tibia's posterior surface (popliteal triangular area).

Action. Flexion of the leg on the femur; medial rotation of the leg.

Surface anatomy. The popliteus muscle is located deeply and has no influence on external morphology.

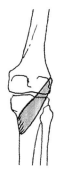

ADDUCTOR BREVIS MUSCLE (Adductor brevis)

Form, structure, relations. The adductor brevis muscle is flat, laminar and triangular. Its fibres originate from a rather narrow area on the pelvis and head slightly obliquely downwards, laterally and slightly backwards, widening towards the insertion aponeurosis on the femur. The muscle, which can be divided into two or three separate parts or fused with the adductor magnus, is covered by the pectineus and the adductor longus; its superior lateral border is in relation with the external obturator and the psoas major tendon; the lower border is in relation to the gracilis and also with the adductor magnus, which it partly covers.

Origin. Lateral surface of the pubic bone's inferior ramus.

Insertion. Upper third of the medial rim of the linea aspera of the femur.

Action. Adduction of the thigh, with slight flexion and lateral rotation (in synergy with the adductor longus).

Surface anatomy. The adductor brevis muscle is located deeply in the upper part of the thigh's medial surface and therefore does not directly influence the external morphology.

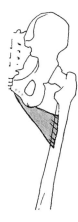

TIBIALIS ANTERIOR MUSCLE (Tibialis anterior)

Form, structure, relations. The tibialis anterior muscle runs superficially for the entire length of the anterior surface of the leg, laterally to the tibia. The muscle belly is large and thin. About halfway down the leg, it thins out and continues in a long, robust insertion tendon. From its origin on the tibial condyle, the muscle runs vertically in accordance with the leg's axis, but the tendinous section heads medially and crosses the distal third of the tibia slightly diagonally, inserting onto the tarsus. The tibialis anterior is subcutaneous along its entire extension, covered by the superficial fascia of the leg and by skin. At the instep, the tendon is wrapped in a synovial sheath and by a thickened fascia, known as the transverse ligament of the foot. The muscle adheres to the tibia and to the interosseous membrane and medially has relations with the extensor digitorum longus and the extensor hallucis longus.

Origin. Lateral condyle of the tibia; upper half of the anterolateral surface of the tibial diaphysis; anterior surface of the interosseous membrane.

Insertion. Medial and inferior surface of the first (or medial) cuneiform; medial surface of the base of the first metacarpal.

Action. Dorsal flexion of the foot on the leg, with slight adduction and supination (that is, lifting the medial border of the foot); collaboration in walking movements.

Surface anatomy. The tibialis anterior muscle is subcutaneous along its entire extension; the belly forms an elongated elevation in the upper half of the leg, laterally to the anterior border of the tibia, which it does not cover but slightly overlaps. The tendon diagonally crosses the instep and is positioned medially to it, being the most medial of the tendons. In the erect position it is not evident and forms the concave profile of the front of the ankle, but it becomes rope-like and much more evident when the foot is flexed dorsally.

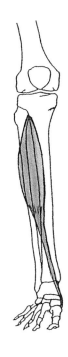

EXTENSOR HALLUCIS LONGUS MUSCLE (Extensor hallucis longus)

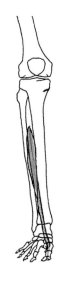

Form, structure, relations. The extensor hallucis longus is a thin, elongated muscle positioned between the tibia and the fibula in the middle third of the front of the leg. The belly travels downwards vertically and continues into a flat tendon that inserts onto the phalanges of the hallux (big toe). In the section close to the point of origin, it is located deeply, covered by the extensor digitorum longus and medially by the tibialis anterior, but it becomes superficial in the section after the muscle belly and for the tendon's entire path.
Origin. Middle portion of the anterior surface of the fibula and the interosseous membrane.
Insertion. Dorsal surface of the base of the second phalanx of the big toe.
Action. Extension of the hallux; dorsal flexion of the foot (in synergy with the tibialis anterior).
Surface anatomy. The extensor hallucis longus muscle is located deeply and only the tendon is visible on the surface, as it runs diagonally on the back of the foot. It appears as a rope-like elevation, particularly evident along the first metatarsal when the big toe is extended.

EXTENSOR DIGITORUM LONGUS MUSCLE (Extensor digitorum longus)

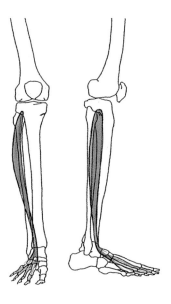

Form, structure, relations. The extensor digitorum longus (or communis) is a long, flat, almost wedge-shaped muscle which is partly located superficially on the anterolateral surface of the leg, from its origin on the tibia to insertion on the phalanges. The muscle belly is positioned vertically and continues into a strong insertion tendon halfway down the leg, which sinks into the fibres, lending the pennate form to the muscle. For a certain section, the tendon is single (or divided into two strands wrapped in the same sheath) but at the tibiotarsal joint, after being covered by the transverse and cruciate ligaments, it splits into four tendons headed to the last four toes (excluding the big toe). The muscle, which may have independent origin bundles or be connected to nearby muscles, is flanked laterally by the peroneus muscles and medially by the tibialis anterior and by the end section of the extensor hallucis, which it partly covers.
Origin. Lateral condyle of the tibia; lateral tuberosity of the tibia, upper half of the medial surface of the fibula and adjacent surface of the interosseus membrane.
Insertion. Dorsal surface of the phalanges of the last four toes.
Action. Extension of the four lateral toes; dorsal flexion of the foot (in synergy with the tibialis anterior and with the extensor hallucis longus); slight lateral torsion and abduction of the foot.
Surface anatomy. The extensor digitorum longus muscle is located on the leg's lateral surface, between the tibialis anterior medially and the peroneus longus laterally. It is therefore only subcutaneous on the lateral border and may appear as a thin vertical elevation between the two named muscles. The single tendon runs along the anterolateral border of the instep and the four termination sections into which it splits appear as rope-like elevations on the back of the foot (especially when the toes are extended), arranged laterally to the extensor hallucis longus tendon. They run to the dorsal surface of the middle phalanges of the last four toes, where they are not much elevated as they widen into expanses of insertion tendon.

PERONEUS BREVIS MUSCLE (Peroneus brevis)

Form, structure, relations. The peroneus brevis muscle is robust and flat. It is partly covered by the peroneus longus and partly superficial in the lower half of the lateral part of the leg. The muscle fibres originate from the fibula and travel downwards, converging into a flat tendon which goes deeper into them at the beginning (lending the pennate form to the muscle). It then continues as a thin, cylindrical shape, to insertion on the fifth metatarsal, running posteriorly to the lateral malleolus and behind the peroneus longus. The muscle is located underneath the peroneus longus and has relations with the soleus posteriorly, and with the extensor digitorum longus and peroneus tertius anteriorly.
Origin. Lateral surface of the lower half of the fibula.
Insertion. Lateral surface of the tuberosity at the base of the fifth metatarsal.
Action. Abduction of the foot and slight plantar flexion (in synergy with the peroneus longus); weak pronation of the foot (that is, raising the lateral border).
Surface anatomy. The lower portion of the peroneus brevis muscle is subcutaneous at its lower portion, and during contraction it appears as a slight elevation above the external malleolus, at the sides of the peroneus longus. The tendon appears as a rope behind the malleolus and runs posteriorly to that of the peroneus longus on the lateral surface of the foot.

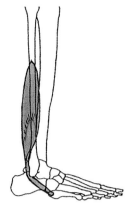

PERONEUS TERTIUS MUSCLE (Peroneus tertius, fibularis tertius)

Form, structure, relations. The peroneus tertius (or anterior, or fibular) muscle is considered to be a distal dependant of the extensor digitorum communis, with which it is often partly fused. When it is completely separated from it, it is a small, superficial, thin, conoid-shaped muscle with its belly travelling downwards and slightly forwards. It originates from the fibula and at the tibiotarsal joint, it continues into the long, flat insertion tendon on to the fifth metatarsal, running alongside the extensor digitorum longus tendon group laterally. The muscle is located on the lateral surface of the leg, in the distal third and close to the ankle. It is adherent to the fibula and covers the extensor digitorum brevis muscle. It has relations with the extensor digitorum longus medially and the peroneus brevis laterally, and only with the portion close to the origin site.
Origin. Lower third of the medial surface of the fibula and adjacent area of the interosseous membrane.
Insertion. Dorsal surface of the base of the fifth metatarsal, with a small expansion at the fourth.
Action. Dorsal flexion of the foot (in synergy with the tibialis anterior and the extensor digitorum longus), slight abduction of the foot.
Surface anatomy. The peroneus tertius muscle is subcutaneous, but its belly cannot easily be distinguished from that of the peroneus brevis, while during dorsal flexion of the foot, the tendon appears as a thin rope elevation that runs in front of the lateral malleolus and laterally to the tendon for the extensor digiti minimi longus.

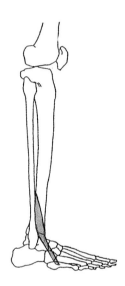

PERONEUS LONGUS MUSCLE (Peroneus longus)

Form, structure, relations. The peroneus longus is a long, flat, superficial muscle which covers most of the fibula and is located along the leg's external side. The muscle fibres head vertically downwards and converge into a long, flat tendon which sinks into the muscle belly, lending it the pennate appearance. The tendon is also thin along the lower half of the leg, runs posteriorly to the lateral malleolus, crosses the calcaneus and the cuboid and finally crosses the sole of the foot obliquely forwards and medially and inserts onto the first metatarsal bone. The muscle is superficial, covered by the fascia of the leg and by skin; it partly covers the peroneus brevis. At the front it is flanked by the extensor longus and the peroneus tertius, posteriorly by the soleus and deeply by the flexor hallucis longus. There are often an excess number of insertions, fusion with the peroneus brevis and the presence of one or two sesamoid bones, covered by the tendon at the point of the lateral malleolus and the cuboid groove.
Origin. Lateral surface of the head and the upper two thirds of the fibula; tibial lateral condyle.
Insertion. Lateral surface of the base of the first metatarsal and the lateral cuneiform.
Action. Extension (plantar flexion) of the foot; abduction of the foot; collaboration in some walking movements. Works in synergy with the peroneus brevis.

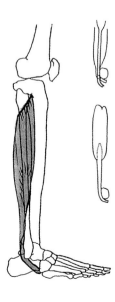

Surface anatomy. The peroneus longus muscle is entirely subcutaneous, located on the leg's lateral surface, where it appears as a slight elongated prominence directed behind the external malleolus and positioned between the soleus posteriorly, and the extensor digitorum longus and the tibialis anterior anteriorly. During contraction, the muscle belly emerges clearly and the pennate structure of the muscle causes a flattened hollow in the surface, halfway up the leg, corresponding with the tendon portion which sinks between the fibres. In the subsequent section, the tendon becomes a rope-like prominence, heading downwards behind the lateral malleolus and flanked by the belly borders of the deeper peroneus brevis. The tendon of this latter muscle runs together with that of the peroneus longus in the section behind the malleolus, but immediately afterwards it positions itself anteriorly and is more evident on the lateral surface of the foot.

PLANTAR MUSCLE (Plantaris)

Form, structure, relations. The plantaris (or plantaris gracilis) is a muscle located at the back of the knee joint. It comprises a small, very short, fusiform belly approximately 8–10cm (3¼–4in) long and a very long, thin tendon that runs obliquely downwards and medially between the gastrocnemius and the soleus until it inserts alongside the Achilles tendon, after travelling alongside its medial border. The muscle, which may be missing or doubled, is covered almost entirely by the gastrocnemius, especially by the lateral head, and covers the popliteus and the soleus.
Origin. Posterior surface of the lateral epicondyle of the femur; articular capsule of the knee.
Insertion. Calcaneal tubercle (medially to the Achilles tendon).
Action. Plantar flexion of the foot and flexion of the leg on the knee (in synergy with the gastrocnemius and the soleus).
Surface anatomy. The plantaris muscle is located deep in the popliteal fossa (of which it forms part of the inferolateral border), mostly covered by the lateral head of the gastrocnemius. The small portion of the subcutaneous belly is not visible on the surface, as it is covered by the adipose tissue that fills the popliteal cavity. The tendon runs along the Achilles tendon's medial border and is too thin to be visible on the surface.

GASTROCNEMIUS MUSCLE (Gastrocnemius)

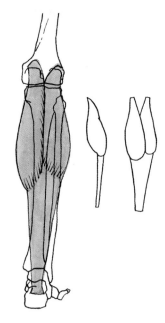

Form, structure, relations. The gastrocnemius muscle is a part of a muscle group called the triceps surae, which occupies the rear portion of the leg, forming the calf. The other component, located deeper, is the soleus muscle. Both merge into a single insertion tendon on the calcaneus (calcaneal or Achilles tendon). The gastrocnemius comprises two (or twin) heads, lateral and medial, which are separate, superficial and alongside each other. Their muscle fibres head vertically downwards from their origin on the femoral condyles to their insertion, about halfway down the leg, on the common tendon, via a wide aponeurosis which is located on the deep surface of the muscle. Each head has a strong, flat origin tendon which then expands on the superficial surface of the corresponding belly. Two wide tendinous laminae are thus formed, which determine the two local flattened areas which can also be seen in an external morphological examination. The belly of the medial head is rather large and long and reaches further down than the lateral head. It occupies the posterior medial border of the leg to about half its height and ends with a thick, rounded border before extending into the tendon. The belly of the lateral head is thinner than the medial one. It inserts onto the tendon higher up and with a flatter border. The gastrocnemius muscle (which may be missing or have two separate heads until close to the insertion point on the calcaneus) is superficial, covered by the leg fascia and the skin, and covers the popliteus, the plantaris and the soleus. The points of origin of the two muscle bellies form the lower borders of the popliteal fossa.
Origin. Medial head: posterosuperior surface of the femoral medial condyle (behind the tubercle for the adductor magnus), with expansions on to the femoral popliteus.
Lateral head: lateral and posterior surface of the femoral lateral condyle.
Insertion. Upper surface of the calcaneal tubercle. The insertion tendon is common to the gastrocnemius and the soleus. It is very strong and thick, oval in section and slightly elastic due to a particular arrangement of the bundles contained therein. It is about 15cm (6in) long as it originates halfway down the leg, in a widened, laminar shape, then converges into a cylindrical rope and expands and flattens close to the calcaneus. There is a mucosa bursa between the calcaneal bone and the tendon.

Action. Plantar flexion (extension) of the foot, in synergy with the soleus; weak flexion of the leg on the thigh; collaboration in walking; slight abduction of the foot (as the tendon's line of traction is medial to the foot's rotation axis).

Surface anatomy. The gastrocnemius muscle is entirely subcutaneous and forms the fleshy mass of the calf. The longitudinal separation line between the two muscle bellies is not visible on the surface, while (in the anatomical position, and even more so during contraction), the long, wide elevation of the medial head clearly outlined at the bottom can be seen. The lateral head is less marked, however, and is short and narrow. The flat, wide Achilles tendon in the bottom half of the leg covers the soleus (which overflows slightly at the sides) and becomes almost cylindrical in the last section near the insertion. It has two shallow surface depressions alongside it here, the lateral and medial retromalleolar grooves, which highlight the rope-like elevation.

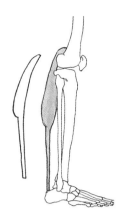

SOLEUS MUSCLE (Soleus)

Form, structure, relations. The soleus is the deep part of the triceps surae (see above) and is mostly covered by the gastrocnemius. It is a very wide, flat muscle, the fibres of which are directed downwards at different angles and lengths, as they are arranged on the sides of a tendinous lamina which sinks into the muscle belly and lends it the pennate appearance. The muscle is covered by the plantaris and gastrocnemius; it is superficial with its lateral and medial borders; and it covers the flexor digitorum longus, the flexor hallucis longus and the tibialis posterior.

Origin. Posterior surface of the head and upper section of the fibular diaphysis: middle third of the tibia's medial border; the fibrous arch between the two bone areas of origin.

Insertion. Upper surface of the calcaneal tubercle (via the common tendon with the gastrocnemius).

Action. Plantar flexion of the foot (in synergy with the gastrocnemius). The soleus does not take part in the leg's flexion on the thigh as its insertions are mono-articular.

Surface anatomy. The soleus muscle, covered by the gastrocnemius, juts out laterally and medially from this muscle with its subcutaneous borders. They appear as longitudinal elevations which run almost the entire length of the leg vertically and are especially evident when in strong dorsal flexion and plantar flexion. The lateral border of the soleus is included between the lateral gemellus located posteriorly, and the peroneus longus located anteriorly. It is very narrow and is visible on the surface from the point of origin on the fibula to the common tendon. The medial border, on the other hand, is wider and more prominent, flanking the anteromedial surface of the tibia, but does not travel the whole length of the leg, as in the upper half, as it is covered by the medial gemellus.

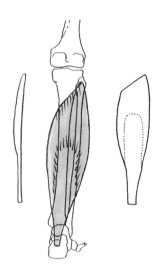

TIBIALIS POSTERIOR MUSCLE (Tibialis posterior)

Form, structure, relations. The tibialis posterior is a long, flat muscle located deeply in the posterior section of the leg, slightly obliquely towards the medial side. The muscle fibres are directed downwards and insert onto the tendon which sinks between them (lending the pennate appearance to the muscle) and runs behind the lateral malleolus to the insertion point on the tarsus. The muscle adheres to part of the interosseous membrane of the tibia and fibula; it is covered by the soleus and the flexor hallucis longus; medially it has relations with the flexor digitorum longus.

Origin. Upper two thirds of the posterior face of the interosseous membrane and adjacent tracts on the tibia and fibula.

Insertion. Tuberosity of the navicular bone and plantar surface of the medial cuneiform bone (with branches to other cuneiform bones and the cuboid).

Action. Adduction and medial rotation of the foot (in synergy with the tibialis anterior); plantar flexion of the foot (in antagonism with the tibialis anterior); collaboration in some walking movements.

Surface anatomy. The tibialis posterior muscle is located deeply and has no direct influence on external morphology. Only its tendon appears on the surface, as a short rope-like section located posteriorly and inferiorly to the medial malleolus.

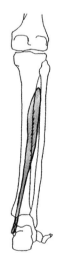

FLEXOR DIGITORUM LONGUS MUSCLE (Flexor digitorum longus)

Form, structure, relations. The flexor digitorum longus (or tibial) muscle is flat, thin, elongated and located deeply in the lower half of the posteromedial section of the leg. The muscle belly is quite pointed at the origin on the tibia and widens transversally just above the medial malleolus, close to where it changes into the insertion tendon. The tendon enters the muscle belly and gives it its semipennate appearance, then passes posteriorly to the medial malleolus and medially to the calcaneus, then finally runs along the sole of the foot, branching out into four tendons which insert onto the phalanges of the last four toes. The muscle partly covers the tibia and the tibialis posterior and is covered by the soleus. At the malleolus, the tendon is located posteriorly to that of the tibialis posterior, while it has relations on the sole of the foot with the flexor hallucis longus, the abductor hallucis, the adductor hallucis, the lumbricales muscles and the quadratus plantaris.
Origin. Middle section of the tibia's posterior surface; cover fascia of the tibialis posterior.
Insertion. Plantar surface of the base of the phalanges of the four lateral toes from the second to the fifth.
Action. Flexion of the last four toes; weak plantar flexion of the foot; collaboration in walking movements.
Surface anatomy. The flexor digitorum longus muscle is mostly located deeply. Only the lower portion of its medial border is subcutaneous and forms a slight longitudinal prominence above the internal malleolus, between the soleus and the tibia. Although subcutaneous in the section running along the foot's medial surface, the tendon is not visible as it is slightly covered by that of the tibialis posterior, which juts out further.

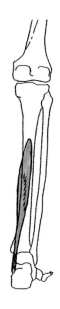

FLEXOR HALLUCIS LONGUS MUSCLE (Flexor hallucis longus)

Form, structure, relations. The flexor hallucis longus (or fibular) muscle is flat and elongated, located deeply in the posterolateral section of the leg. Its fibres are directed almost vertically downwards, with slight medial obliquity, from the origin on the fibula to insertion on the hallux phalanges. The tendon travels medially to the calcaneus and continues on the plantar surface of the first metatarsus and the hallux phalanges. The muscle covers the fibula and, more medially, the tibialis posterior; it is covered by the soleus and the calcaneal tendon; it is laterally in relation with the peroneus muscles.
Origin. Middle third of the fibula's posterior surface and adjacent section of the interosseous membrane.
Insertion. Plantar surface of the base of the distal phalanx of the first digit.
Action. Plantar flexion of the hallux; moderate flexion of the other toes and collaboration in plantar flexion of the foot (in synergy with the flexor digitorum longus).
Surface anatomy. The flexor hallucis longus muscle is located deeply and is not visible on the surface. However, it contributes to determining the external morphology of the medial retromalleolar area.

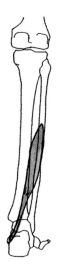

EXTENSOR DIGITORUM BREVIS MUSCLE (Extensor digitorum brevis)

Form, structure, relations. The extensor digitorum brevis (or EDB) muscle is superficial, located laterally on the upper surface of the foot. It is triangular and rather flat around the origin, becoming thicker in the central part and then splitting into four thin, flat bellies travelling to the central toes and the big toe. The muscle fibres head anteriorly and slightly obliquely towards the foot's median line. The most medial bundle is sometimes identified as the extensor hallucis brevis muscle and its tendon is directed towards this toe. The muscle is covered by the extensor digitorum communis longus tendons and the peroneus tertius, by the fascia of the foot and the skin; it covers the tarsus and metatarsus bones and at the origin, the peroneus brevis flanks it laterally.
Origin. Lateral and superior surfaces of the anterior part of the calcaneus.
Insertion. Insertion is with three tendons: on the dorsal aponeurosis of the second, third and fourth toe (excluding the little toe); on the lateral surface of the corresponding sections of the extensor digitorum longus; and on the dorsal surface of the base of the first phalanx of the big toe.
Action. Extension (dorsal flexion) of the three central toes and the big toe (in synergy with the extensor digitorum longus and the extensor hallucis longus); slight lateral inclination of the toes.

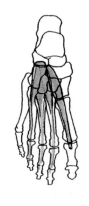

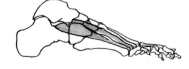

Surface anatomy. The extensor digitorum brevis muscle is subcutaneous and when contracted, it appears as an ovoid prominence on the upper lateral surface of the back of the foot, anteriorly to the malleolus. The tendons travelling to the four toes run under the tendons belonging to the extensor longus muscles and can sometimes be seen on the surface in the gaps between the latter.

ADDUCTOR HALLUCIS MUSCLE (Adductor hallucis)

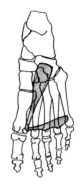

Form, structure, relations. The adductor hallucis muscle is located deeply and comprises two heads, oblique and transverse, which have different origins and directions, but the same insertion. The oblique head is rather large and is directed obliquely forwards and medially, from the origin on the tarsus and the metatarsus to insertion on the hallux. The transverse head is thin, directed medially from the origin on the metatarsal bones to insertion on the hallux. The muscle rests on the plantar surface of the metatarsals and on the interossei muscles: it is covered by the lumbricales, the flexor digitorum longus tendons and the plantar aponeurosis; medially it is flanked by the flexor hallucis brevis.

Origin. Oblique head: bases of the second, third and fourth metatarsals; plantar surface of the lateral cuneiform and the cuboid; long plantar ligament.

Transverse head: capsules and ligaments of the metatarsophalangeal joints of the third, fourth and fifth toes.

Insertion. Lateral sesamoid bone and base of the first phalanx of the hallux.

Action. Adduction of the hallux, with slight flexion.

Surface anatomy. The adductor hallucis muscle is located deeply and therefore has no influence on external morphology.

FLEXOR DIGITI MINIMI BREVIS MUSCLE (Flexor digiti minimi brevis)

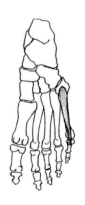

Form, structure, relations. The flexor digiti minimi brevis is a thin muscle, located deeply along the lateral border of the foot, directed forwards from its origin on the fifth metatarsal to its insertion on the little toe via a flattened tendon. The abductor digiti minimi runs alongside the muscle laterally.

Origin. Plantar-medial surface of the base of the fifth metatarsal; long plantar ligament; peroneus longus tendon sheath.

Insertion. Lateral part of the base of the first phalanx of the fifth toe.

Action. Weak plantar flexion of the little toe.

Surface anatomy. The flexor digiti minimi brevis muscle is covered by the plantar aponeurosis and skin, and therefore it does not directly influence external morphology.

ABDUCTOR HALLUCIS MUSCLE (Abductor hallucis)

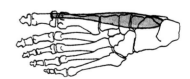

Form, structure, relations. The abductor hallucis brevis is a large, tapered muscle, positioned superficially along the medial border of the foot. The muscle bundles originate from the calcaneus and head anteriorly along the axis of the foot, converging on the sides of the insertion tendon. The muscle is partly covered by the plantar aponeurosis and then by the skin; it covers the flexor hallucis brevis; it medially has relations with the flexor digitorum brevis and the flexor hallucis longus tendon.

Origin. Medial process of the calcaneal tubercle; plantar aponeurosis.

Insertion. Medial surface of the basis of the first phalanx of the hallux; medial sesamoid bone of the first metatarsus.

Action. Abduction of the hallux (that is, distancing the first toe from the second); weak plantar flexion of the hallux.

Surface anatomy. The abductor hallucis muscle is subcutaneous and is visible as an elongated prominence which limits the medial border of the foot, covering the longitudinal plantar arch.

FLEXOR HALLUCIS BREVIS MUSCLE (Flexor hallucis brevis)

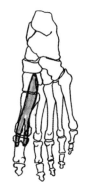

Form, structure, relations. The flexor hallucis brevis muscle is located along the medial border of the foot, mostly covered by the abductor hallucis. After its origin on the cuboid, it splits into two bellies side by side, one medial and one lateral, the tendons of which insert onto the sides of the first phalanx of the hallux and with the flexor hallucis longus tendon running between them. The muscle covers the first metatarsal and the peroneus longus tendon.
Origin. Medial part of the lower surface of the cuboid and third cuneiform bone.
Insertion. Medial and lateral surfaces of the base of the first phalanx of the big toe.
Action. Plantar flexion of the first phalanx of the big toe; fixing of the sesamoid bones belonging to the head of the first metatarsal.
Surface anatomy. The flexor hallucis brevis muscle is also covered by the thick plantar aponeurosis and therefore has no direct influence on the external morphology.

ABDUCTOR DIGITI MINIMI MUSCLE (Abductor digiti minimi)

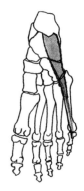

Form, structure, relations. The abductor digiti minimi muscle is large, elongated, located superficially on the foot's lateral border. The muscle belly originates on the calcaneus and heads anteriorly changing into a long insertion tendon of the fifth toe. It is covered by the plantar aponeurosis and the skin; it covers a part of the peroneus longus tendon and the flexor digiti minimi muscle.
Origin. Lateral process, inferior surface and medial process of the calcaneal tuberosity; plantar aponeurosis.
Insertion. Lateral surface of the base of the first phalanx of the fifth toe.
Action. Abduction (distancing) of the small toe from the fourth toe, with slight flexion.
Surface anatomy. The abductor digiti minimi muscle is subcutaneous but, being covered by the expansion of the plantar aponeurosis and by adipose tissue, it has a modest influence on the external morphology.

230

FLEXOR DIGITORUM BREVIS MUSCLE (Flexor digitorum brevis)

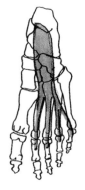

Form, structure, relations. The flexor digitorum brevis is a large muscle located superficially in the central part of the sole of the foot, covered by the plantar aponeurosis and the skin. It originates from the calcaneus and heads forwards wider and flatter, dividing into four thin bellies, the tendons of which insert onto the last four toes. The muscle is flanked by the abductor hallucis and abductor digiti minimi muscles and it covers the flexor digitorum longus, the quadratus plantae and the lumbricales.
Origin. Medial process and inferior surface of the calcaneal tubercle; plantar aponeurosis.
Insertion. Medial and lateral surface of the second phalanges of the last four toes.
Action. Plantar flexion of the four lateral toes; helps to maintain the plantar arch curvature.
Surface anatomy. The flexor digitorum brevis muscle is covered by the thick plantar aponeurosis and is therefore not visible under the skin.

OPPONENS DIGITI MINIMI MUSCLE (Opponens digiti minimi, adductor digiti minimi)

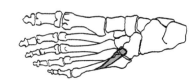

Form, structure, relations. The opponens (or adductor) digiti minimi is a small muscle, not always present, positioned laterally to the flexor digiti minimi brevis, with which it is often fused.
Origin. Long plantar ligament.
Insertion. Lateral border of the fifth metatarsal.
Action. Slight adduction (that is, movement towards the foot's axis) of the fifth metatarsal.
Surface anatomy. The opponens digiti minimi muscle is covered by the plantar aponeurosis and has no influence on the external morphology.

QUADRATUS PLANTAE MUSCLE (Quadratus plantae)

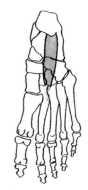

Form, structure, relations. The quadratus plantae muscle (or auxiliary to the flexor digitorum longus) is located deeply in the middle portion of the sole of the foot, covered by the flexor digitorum brevis. It originates with two heads, medial and lateral, directed forwards and converging into a single flat, fleshy mass which inserts on to the flexor digitorum longus tendon (in the section which immediately precedes its split into four secondary tendons).
Origin. Medial and inferior surfaces of the calcaneus.
Insertion. Lateral border of the flexor digitorum longus tendon.
Action. Plantar flexion of the last four toes (in synergy with the flexor digitorum longus); maintaining the curvature of the plantar arch.
Surface anatomy. The quadratus muscle is located deeply and is therefore not visible externally. However, together with the surrounding muscles it contributes to determining the morphology of the plantar region of the foot.

LUMBRICALES PEDIS MUSCLES (Lumbricales pedis)

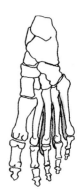

Form, structure, relations. There are four lumbrical muscles in the foot arranged medially to the flexor longus tendons, corresponding to the last four toes. The muscles, which can be totally or partly missing, are covered by the flexor digiti brevis muscle and cover the abductor hallucis muscle and the interossei muscles.
Origin. They originate with two heads on the adjacent borders of the flexor digitorum longus tendons, with the exception of the first lumbricalis, which originates with a single head on the medial border of the first tendon (the one for the second toe).
Insertion. Base of the proximal phalanges of the four lateral toes.
Action. Weak flexion and adduction of the four lateral toes.
Surface anatomy. The lumbricales muscles are located deeply and are not visible on the surface.

INTEROSSEI PEDIS MUSCLES (Interossei pedis)

Form, structure, relations. The interossei pedis muscles are located in the spaces between the metatarsals and are split into two groups: the three plantar interossei, which have a semipennate form, and the four dorsal interossei, which have a pennate structure. Dorsally, they have relations with the extensor digitorum brevis, extensor hallucis brevis and extensor digitorum longus tendons; inferiorly, with the flexor digitorum longus and flexor hallucis brevis tendons.
Origin. Plantar interossei: bases and medial surfaces of the third, fourth and fifth metatarsals. Dorsal interossei: adjacent sides of the metatarsals.
Insertion. Plantar interossei: medial side of the first phalanges of the third, fourth and fifth toes. Dorsal interossei: bases of the first phalanges of the second, third, fourth and fifth toes.
Action. Adduction of the toes with slight flexion (plantar interossei); abduction of the toes with slight extension (dorsal interossei).
Surface anatomy. The interossei muscles have no direct influence on the external morphology.

THE THIGH

The thigh is the part of the lower limb between the pelvis and the knee. It is cone-shaped, and is wider at the top due to the presence of large muscle masses and narrower and thin towards at the bottom, where the volume of the muscles decreases.

The longitudinal axis of the thigh reproduces that of the femur, and therefore slopes from lateral to medial and, to a lesser degree, antero-posteriorly: in women, the slope is more accentuated due to the greater width of the pelvis. The external morphology is rounded, as the surfaces are curved and blend into each other, with no clear limits. When highly contracted, on the other hand, especially in athletic individuals, the muscle prominences are clear and accentuated.

The anterolateral region of the thigh is occupied by the quadriceps muscle. The lateral surface, which extends from the subcutaneous portion of the greater trochanter to the knee, comprises the vastus lateralis. The posterior border of this muscle outlines the shallow longitudinal depression of the external lateral groove, and is rather flat on the surface due to the presence of the iliotibial tract of the fascia lata (see femoral quadriceps muscle, page 219). The vertically elongated elevation of the tensor fasciae latae muscle appears at the root of the thigh on the front of the greater trochanter.

The anterior surface of the thigh is largely made up of the rectus femoris and the vastus medialis, bordered medially by the sartorius. Just below the anterior superior iliac spine, the two muscles originating there (sartorius and tensor fasciae latae) surround the femoral depression, a small triangular hollow, elongated towards the bottom, which disappears in the area corresponding to the rectus femoris tendon.

The belly of this muscle, which may appear double up at the top due to the long tendon and the pennate structure (see quadriceps muscle, page 219), is located on the middle portion of the anterior surface of the thigh, and follows the anterior curve of the femur, outlining the thigh's convex profile and blending on the lateral surfaces.

The inferior-medial portion of the anterior surface is occupied by the vastus medialis. Its oval elevation borders with the rectus femoris and the sartorius at the top and extends to the patella at the bottom. Here we can note that the vastus lateralis, on the other hand, flattens at the bottom and ends a few centimetres above the knee.

The sartorius is a very long, ribbon-like muscle which, when moderately contracted, causes a shallow depression to form which crosses the thigh's anterior surface diagonally; descending from the anterosuperior iliac spine, it travels medially at the lower third of the thigh and outlines the vastus medialis posteriorly.

The upper portion of the thigh's antero-medial surface comprises the elevation of the adductor muscles, which jut out towards the median line and come into contact with the contralateral group. On the surface, the adductor muscles cannot be identified individually, but form a compact mass which gradually continues onto the thigh's posterior surface. This mass, bordered at the top by the gluteal fold, extends from the medial surface to the lateral groove and is rounded at the sides and also slightly flat on the median axis.

It mainly comprises two bellies of the biceps femoris, which decrease in volume until it ends at the borders of the knee's posterior surface with two slightly divergent elevations which border the popliteal surface. The lateral elevation comprises the terminal section of the biceps; the medial elevation from the tendons of the gracilis, semimembranosus and semitendinosus muscles.

The subcutaneous adipose tissue makes the thigh evenly rounded, especially in women, where the characteristic deposits are localized, laterally in the superior section, just below the greater trochanter and medially in the inferior portion. In males, the thigh is frequently covered by varying degrees of hair.

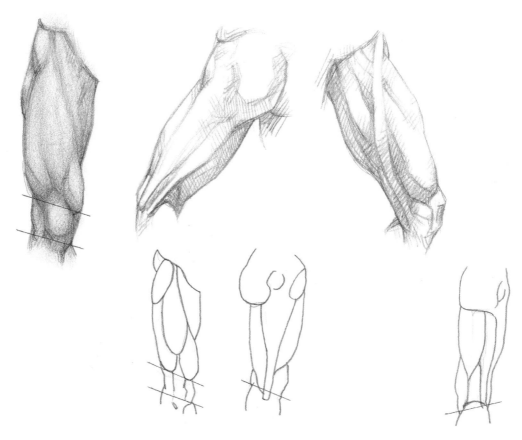

Notes on external morphology and the structure of the thigh.

THE KNEE

The knee is the section of the lower limb which joins the thigh to the leg, and corresponds to the joint of the same name between the femur and the tibia. Its approximately cubic shape is determined by the underlying bone structure (the femoral condyles and the heads of the tibia, fibula and patella) with soft tissue comprising tendons and muscle portions, aponeurotic formations and subcutaneous adipose tissue layered over it. The knee's external morphology undergoes considerable modifications depending on the flexion movements and has a very different appearance anteriorly (patellar region) and posteriorly (popliteal region).

In the anatomical position of the limb, the anterior surface of the knee has the patella as a protuberance in the centre, bordered at the sides by two hollows which continue downwards to run alongside the large patellar tendon. This is the quadriceps tendon insertion on the tibial tuberosity and it is visible when the muscle contracts when the leg is moderately flexed. In a resting state, it is flanked by two small protuberances, due to the small adipose masses which rise as far as the patella, and which may have an oblique or transverse fold of extra skin. Above the patella there is a flat area corresponding to the quadriceps tendon, bordered laterally by the vastus lateralis and the iliotibial section of the fascia lata, and medially by the vastus medialis. The different volumes and levels that these two bellies of the quadriceps reach determine the asymmetric profile of the knee: the lateral border is slightly convex, comprising the thin lower portion of the vastus lateralis and its tendon; while the medial border is more convex, comprising the vastus medialis which extends almost to the patella with its fleshy mass.

The external surface which corresponds to the vastus medialis is crossed by a shallow oblique hollow when the muscles are relaxed, which is caused by the subcutaneous presence of the lacertus fibrosus, which originates from the aponeurotic fascia covering the thigh.

Flexing the leg causes noticeable changes to the external morphology of the knee's anterior surface, mainly due to the patella moving between the femoral condyles and their gradual protuberance.

When in the erect position, the posterior area of the knee is slightly convex with a small longitudinal prominence. This corresponds to the popliteal fossa, a rhomboid area bordered at the top by the biceps and semimembranosus muscle bellies, at the sides by the respective tendons and at the bottom by the proximal portions of the gastrocnemius and the plantaris. Neurovascular bundles run through this space and the interstitial spaces are filled by adipose tissue, which determines the external protuberance of the area. The elevation is flanked by two shallow longitudinal grooves: the lateral one is the clearest – it follows the biceps tendon and reaches the lateral thigh groove; the medial one is more blended and continues with the sartorius depression, tracing a concave line anteriorly.

A cutaneous flexion fold, corresponding to the articular interline, crosses the popliteal prominence slightly obliquely downwards and towards the medial border. When the leg is flexed, the popliteus surface transforms in a cavity of various depths, bordered by the protuberance of the thigh muscle tendons which move away from the femur: laterally, the biceps tendon and medially the gracilis, semimembranosus and semitendinosus tendons.

The lateral surface of the knee, bordered at the top by the lower portions of the vastus lateralis and the biceps, is modelled on the knee's bone structure. The protuberances of the femoral lateral condyle and the head of the fibula can be seen, on which the rope-like elevation of the iliotibial tract of the fascia lata and, more posteriorly, the biceps tendon run, separated by the lower section of the lateral thigh groove.

The medial surface of the knee is rather rounded and convex, formed by the lower portion of the vastus medialis, the shallow depression of the sartorius, the hollow which medially borders the patella, and the tendons belonging to the goose foot (gracilis, semimembranosus and semitendinosus). It continues to blend in lower down on the tibial surface.

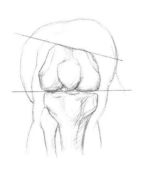
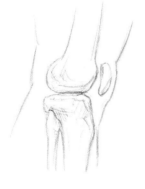
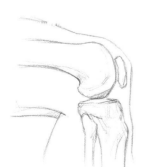

Some influencing aspects of the bone components of the knee on the external shapes, in extension and in flexion.

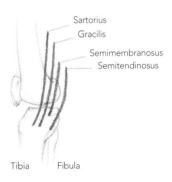

Sartorius
Gracilis
Semimembranosus
Semitendinosus

Tibia Fibula

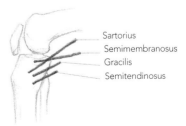

Sartorius
Semimembranosus
Gracilis
Semitendinosus

Arrangement of the pesanserinus tendons in extension and flexion.

THE LEG

The leg, the part of the lower limb between the knee and the ankle, is conoid or almost pyramidal in shape, wide at the top, where the muscle bellies are located and narrow at the bottom, where the tendons are mostly located. The skeleton that supports it, comprising the tibia and the fibula, is covered by muscles on only three sides as the tibia's medial surface is subcutaneous and its shape causes a longitudinal depression which makes the anteromedial surface of the leg quite flat.

The anterolateral surface begins on the anterior border of the tibia, heading laterally. It is rounded and decidedly convex, with the overall elevation provided by the group of anterior cavity muscles. The tibialis anterior is at the front, with its tapered belly protruding a little out from the tibia's anterior border, especially in the upper two thirds of the leg, while its tendon runs slightly medially on the lower third. Then there are the extensor muscles of the hallux and other toes (see page 224), and lastly, the peroneus muscles, the tendons of which surround the fibula malleolus and cause variable elevations or depressions around it, particularly during contraction.

There is a line which joins the head to the fibula malleolus, bordering the lateral border of the soleus, and indicates the posterior limit of the lateral surface, which arcs across it towards the posterior region. This is entirely constituted by the triceps surae, that is, the two heads of the gastrocnemius which overlap the soleus (forming the calf) and continue into the common Achilles (or calcaneal) tendon (see page 226).

The posterior surface of the leg is convex and begins, at the top, with a slight flattening of the lower part of the popliteal fossa, bordered by the medial margins of the two gemellus muscles. This is followed by the strong elevation of the calf: the medial gemellus is the largest and descends further than the lateral one and, in the resting state, their two

lower extremities are ideally attached by an oblique line headed laterally and upwards. Also, a different profile emerges of the sides of the leg: the lateral one is evenly curved and rather convex; the medial one is convex in the upper half, while it becomes straighter, almost a little concave, in the lower half. Many individuals, mostly those of African ancestry, have an inverse ratio of the two gemellus muscles: they are extremely tapered and the lateral one is longer than the medial one.

When the muscle contracts, the borders of soleus overflow from the gastrocnemius and appear at the sides of the leg, while the lower borders which insert onto the end of the two gemellus muscles trace two concave arched lines upwards, which start joined and then head obliquely, one laterally and one medially.

The triangular area of the calcaneal tendon, which is narrow at the bottom and slightly convex, extends below the elevation of the two heads.

At the top, it is flanked by the muscle insertions of the soleus which, depending on individual variations, can end some distance from the malleolus, highlighting the retromalleolar grooves and the rope-like elevation of the tendon, or descend further, reducing the size of the hollows and making the tendon jut out less.

The medial surface of the leg comprises the medial gemellus and the medial border of the soleus, which are both rather prominent and which border with the tibia and the anteromedial surface via an anterior convex line.

The skin on the leg is quite densely covered with hairs, especially in males, and two superficial veins run along it: the great saphenous vein runs on the medial surface and the small saphenous vein, which is shorter, runs from the lateral malleolus towards the posterior surface, inserting into the soleus muscle between the two gemellus muscles (see page 68).

They are connected by collateral rami that are sometimes extremely prominent in the lower half of the leg.

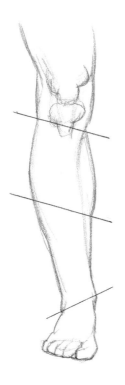
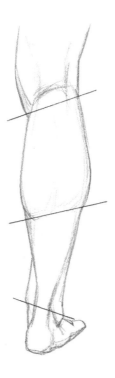
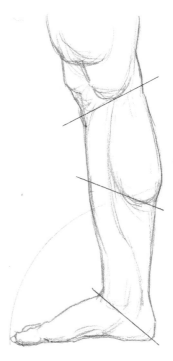

Some lines of analogy or contrast in the shapes and volumes found on the external appearance of the leg.

THE ANKLE

The ankle, or neck of the foot, is the part of the lower limb which joins the leg to the foot. It has an irregular, cylindrical shape, flattened at the sides, and corresponds to the tibiotarsal joint. Its external morphology is basically determined by the bone structure (the lower extremities of the tibia and fibula, and the talus) and the tendons which run along it. It comprises a curved front section, with the prominent extensor tendons. There are two sections, medial and lateral, comprising the malleolus bones and relative hollows; and a posterior section, comprising the calcaneal tendon.

The anterior surface of the ankle has a convex, anteriorly rounded surface. The extensor muscle tendons travel subcutaneously, but are partly visible as rope-like prominences (especially that of the tibialis anterior), but only during muscle contraction as they are covered and held on the surface of the bone by the leg's ligaments and fasciae (see page 209). The posterior region comprises the Achilles tendon, which

inserts onto the calcaneus and appears as a strong rope-like elevation with an elliptical section, slightly flattened antero-posteriorly and slightly widened close to the insertion point.

Its profile traces a slightly concave posterior line. The cutaneous surface of the posterior region has transverse creases, some permanent, others temporary, caused by the plantar flexion of the foot. The lateral surface is dominated by the protuberance of the lateral (or peroneal) malleolus, bordered posteriorly by the peroneus longus and brevis tendons (see page 225) and anteriorly by the peroneus tertius tendon. Likewise, the medial surface shows the elevation of the medial (or tibial) malleolus. The posterior section of both surfaces contains the retromalleolar grooves, which can be more or less accentuated depending on individual conformation. These continue upwards in two separation recesses between the malleolus and the calcaneal tendon.

The two malleolus muscles have different positional and shape characteristics: the lateral malleolus is prominent and pointed, and is located in the centre of the region and descends further; the medial malleolus juts out less, is more rounded, and is moved a little higher and forwards.

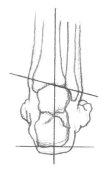

The medial malleolus is a convex prominence on the inner side of the ankle, and is positioned a little higher than the lateral malleolus, a slightly concave prominence of the outer side of the ankle.

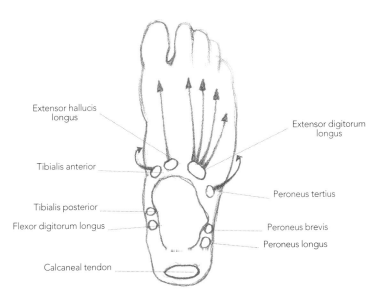

Extensor hallucis longus

Extensor digitorum longus

Tibialis anterior

Peroneus tertius

Tibialis posterior

Flexor digitorum longus

Peroneus brevis

Peroneus longus

Calcaneal tendon

Arrangement of muscular tendons at ankle level. In this position (and similarly to the structures of the wrist), the tendons are kept adhered to the surface of the ankle bone via some robust fibrous fasciae (retinaculae of the flexor muscles, peroneus muscles, etc.).

THE FOOT

The foot is the free extremity of the lower limb and joins the leg, forming a right angle. It is separated into two parts: the actual foot (or the surface of the foot) and the toes. The external morphology of the foot reproduces the skeletal structure and has dorsal, medial and plantar surfaces.

The dorsal surface is convex and curved, and is at its maximum height medially (corresponding to the talus) and then decreases, sloping anteriorly and laterally. The extensor muscles travel through it, diverging from the ankle towards the toes: the tibialis anterior tendon is positioned medially, while the peroneus anterior is positioned laterally. The thin skin of the dorsal surface shows the elevations of the superficial venous network, which forms a characteristic arch originating from the great saphenous vein. The medial surface has a triangular shape: it begins from the calcaneus, has its maximum extension at the point of the tibial malleolus and thins out as it heads anteriorly.

The lower border is slightly hollowed as it follows the shape of the plantar arch (or vault) and forms the sloping border as it moves to the sole of the foot.

The plantar surface only partly reproduces the bone shape, as it is modified by the presence of abundant adipose pads, the plantar aponeurosis and thick skin. The external shape is flattened posteriorly, at the point of the calcaneus, in the anterior area close to the toes, and on the lateral border; while it is concave on the joining border with the medial surface.

At the metatarsal heads, the transverse border has an elevated adipose pad; a deep crease borders it at the front of the plantar surface of the toes, which are separated from each other by single interdigital spaces: this makes the toes seem shorter on the plantar side than on the dorsal side.

Toes do not have specific names, except for the first one, the hallux. This is the largest toe, separated from the others by a deep interdigital groove; it has a large nail and has a slightly laterally deviated axis.

The length of the toes decreases regularly from the hallux to the fifth toe: sometimes the longest toe is the second one, but usually the anterior border of the foot traces a regularly arched line.

The ovoid shape of the toe tips, the plantar extremities of the toes, is due to the presence of fat pads which join in contact (when the toes are not extended) with the transverse anterior border of the foot; the tip of the big toe is flattened, widened and separated from the foot via a clear cutaneous crease.

The back of the toes, on the other hand, shows the enlarged joints of the phalanges, some transverse skin creases (above all the big toe) and the ungual laminae, which are all rather small, except for that of the big toe. On average, the length of a normal adult foot corresponds to about 15 per cent of their height, while the maximum width corresponds to about 6 per cent.

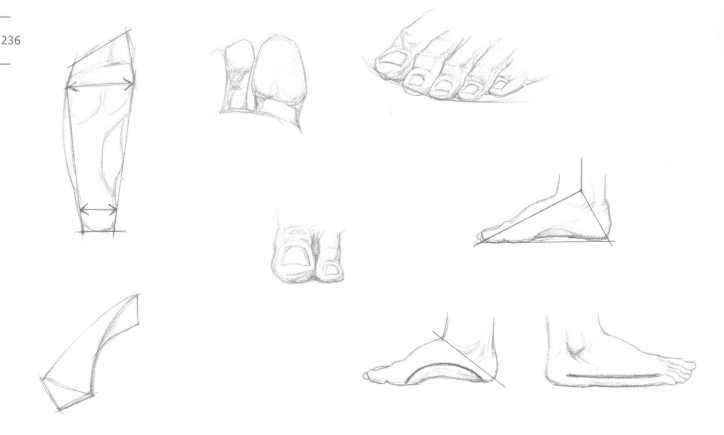

Structural diagrams of the foot and the curvature and biomechanics of the plantar surface.

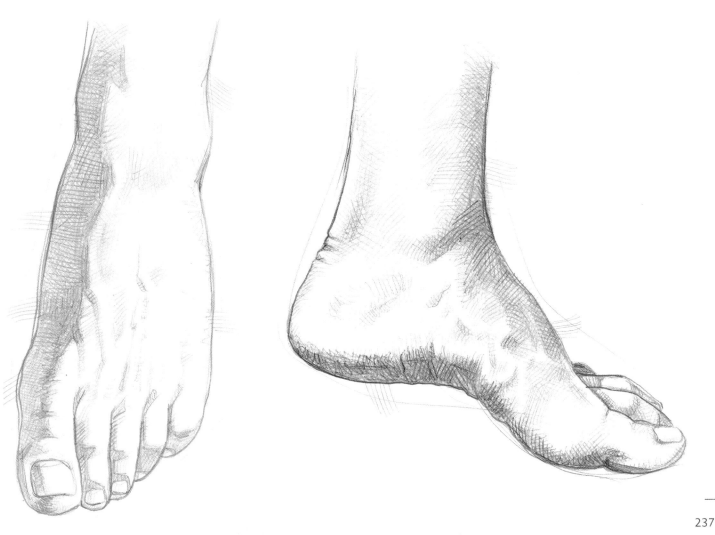

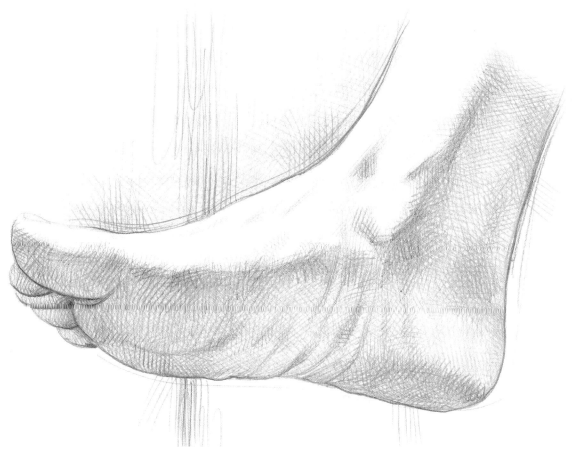

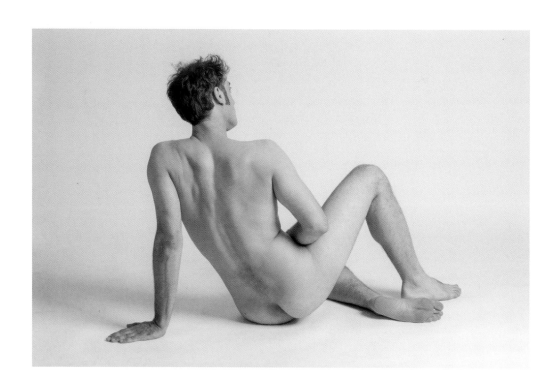

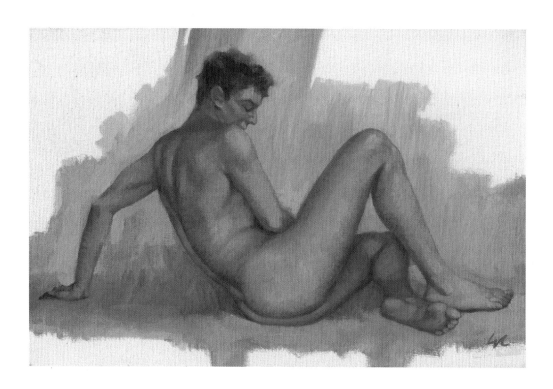

APPENDIX

ANATOMY AND DRAWING: FROM STRUCTURE TO SHAPE

Anatomical knowledge is indispensable if, after carrying out a quick, direct study of the living model, one intends to proceed with a more elaborate, realistic drawing, but without resorting to further consultation of the model or a photograph of him/her.

The method of studying the human figure is based on observing the model. If we intend to portray the human body in its actual appearance, welcoming its natural forms and working according to standard drawing, painting or sculpture practices (and these days, electronic and digital varieties), the study of anatomy (morphology) becomes a foundation of knowledge and an important tool for interpreting or evaluating biological plausibility. It therefore encourages us to recognize the structure of the human body – identifying its typical forms and the key features of its construction, so that we can achieve a meaningful synthesis of artistic expression. A drawing taken from a living model does not necessarily imply a scientific 'anatomical' rendering; it usually follows two other stages. The first is investigative: the recognition and objective evaluation of the structures that make up the body (bones, muscle, skin, proportions, etc.), which become tangible in the graphic shapes drawn as sketches and studies. The second stage follows on from this and is of a more subjective, emotional nature: the meditated, aesthetic and expressive elaboration in both the overall summary and the analysis of significant details. This is what is captured most in the drawing.

For further information and reflections about on this theme, I refer the reader to some of my previous books: *Drawing the Female Nude* (2017), *Drawing the Male Nude* (2017), and *Figure Drawing: A Complete Guide* (2016), all available from Search Press, and to other works by authors cited in the Bibliography (see page 250).

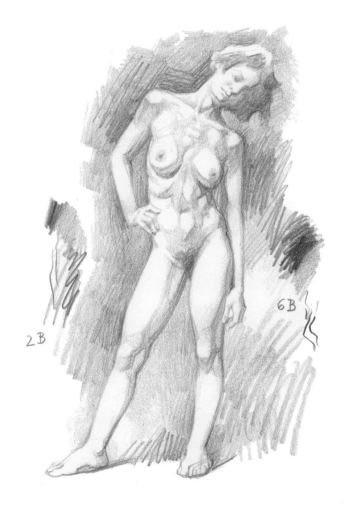

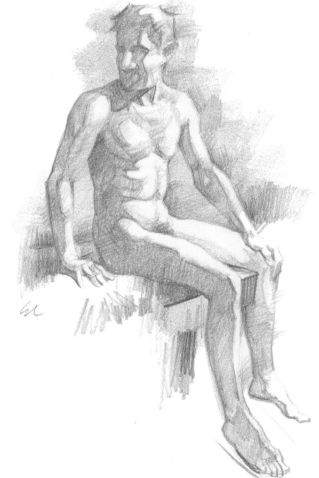

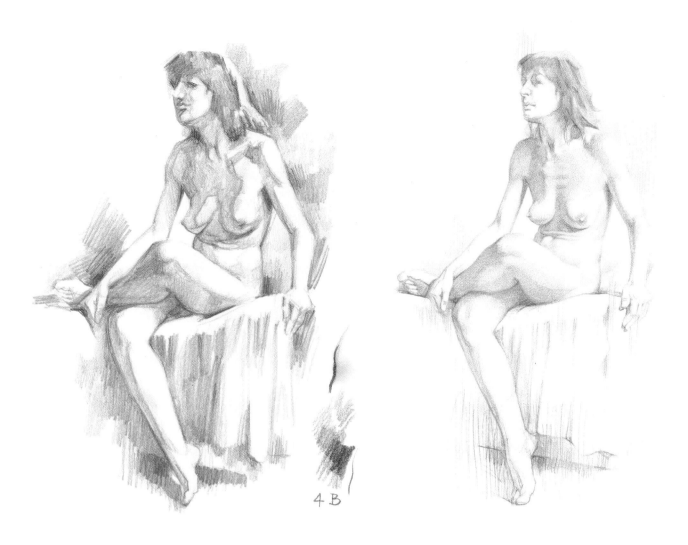

4 B

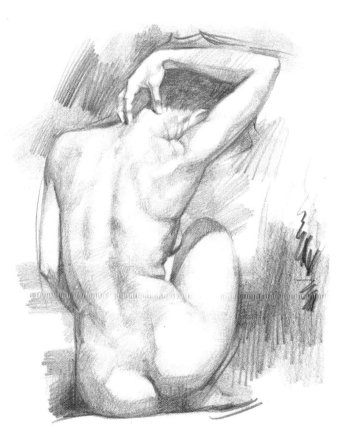

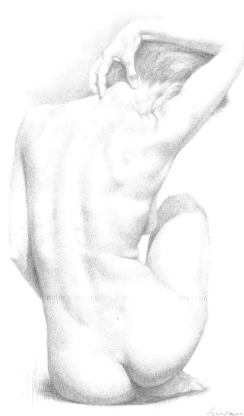

NOTES ON STATIC AND DYNAMIC DIMENSIONS OF THE HUMAN BODY

Movement is the most important function of skeletal muscles: action is mainly achieved by the movement of bone segments, which is caused by the contraction (and therefore usually by the shortening) of muscle tissue. This activity, carried out by the locomotor apparatus, also brings some aesthetic effects as it almost always causes modifications, sometimes significant ones, of the external shapes of the body. Locally, for example, it is easy to note the formation of elevations or depressions caused by tendons or muscles in action, accompanied by skin tensions, folds or creases, or even more generally, the adaptation of the entire body caused by a gesture made by a part of it.

The various movements have the main function of moving the body or some of its segments in space, or of carrying out an expressive gesture or coordinated activity. In all cases, the movements require energy in the muscle tissue to conquer the various forces (gravity, inertia, friction etc.) which oppose a postural stance or the execution of body movements.

The study of these subjects therefore takes on two different, but closely connected, directions. One is 'statics': the search for the body's centre of gravity and the analysis of balance mechanisms in the erect, seated or lying down positions, etc.. The other is 'dynamics': the analysis of movement when walking, running, jumping, swimming, etc.. The mechanical structure of the human body comprises a passive component: the skeletal system; a connecting component: the joints, organized differently in relation to the various functional needs; and an active component: the muscles, which when contracting, act on the whole system of bone-joint levers. It therefore seems useful to briefly recall some characteristics of each component.

• The bones

The skeleton, the structure which acts as a support and in passive movement, comprises two portions: axial, comprising the skull, the vertebral column with ribs and the sternum; and appendicular, formed by the bones in the limbs. The bones of the upper limb are: the scapula, clavicle, humerus, ulna, radius, carpus, metacarpus and phalanges. The bones of the lower limb are: the pelvis, femur, tibia, fibula, tarsus, metatarsus and phalanges.

The pelvis and vertebral column (see page 114) take on a fundamental importance for the human body's spatial situation, both in static and dynamic positions. The bones vary in shape: short, flat, irregular or long. There are two extremities in the latter (the epiphyses, which also form the articular heads) joined by an elongated portion, the diaphysis. For long bones, it is important to consider the mechanical axis (sometimes different from the anatomical axis) which is formed by the straight line which joins the centres of the joints placed at the ends of the bone.

The internal architecture of bones allows them to reach the maximum degree of solidity together with maximum lightness. In fact, the long bones of the limbs, the body segments which are functionally most relevant for locomotion, have a hollow cylindrical shape, while the trabeculae of the expanded extremities are arranged to mechanically reinforce the articular surfaces, so that they can withstand maximum pressure.

• The joints

Based on the different shapes of the articular heads and the presence of an articular cavity, the joints are classified as fixed joints (or synarthroses) and mobile joints (or diarthroses). In some cases (for example, in the knee or in the shoulder) they are joined into articular groups.

- **Synarthroses** are joints by continuity, as the articular join in them is created by the interposition of connective tissue and cartilage. There are three types:
 - *Syndesmoses*, where the articular heads are joined by fibrous connective tissue. In sutures, the bone segments are joined by the borders (for example, the bones of the skull). In gomphoses, the bone segments slot into bone cavities (for example, teeth)
 - *Synchondroses*, where the articular segments are joined by hyaline cartilage (for example, ribs)
 - *Symphyses*, where the articular segments are joined by hyaline cartilage and fibrous tissue (for example, the pubis).

- The **diarthroses** are joints by proximity, as the articular heads, covered by hyaline cartilage, are joined by the interposition of an articular cavity, sometimes with the attachment of a fibrocartilaginous disc. The joint is surrounded by a capsule and by ligaments. There are four types:
 - *Arthrodia*, where the articular heads have flat surfaces (for example, the carpus)
 - *Enarthrosis*, where the articular heads have matching spherical shapes, one concave and one convex (for example, the hip)
 - *Condylarthrosis*, where the articular heads have an elliptical, curved shape, one concave and once convex (for example, temporomandibular)
 - *Ginglymus*, where the articular heads are shaped like a cylindrical segment, one concave and the other convex. There are two variants: the angular ginglymus (or trochlea), which are hinge-like, for example, in the elbow joint, and the lateral ginglymus and the lateral ginglymus (or trochoid), which form a pivot, such as, for example, the proximal radioulnar and the atlanto-odontoid joints.

The main function of the joints is to allow bones to move and thus carry out articular mobility. However, to carry this out correctly, it must be limited in some way, thus avoiding instability and the loss of normal relations between the articular surfaces.

The limitation factors of articular mobility (or stability) are connected to the shape of the bone heads, the capsule system and relative internal pressure, and the ligament system and traction of adjacent muscles. The fundamental movements are carried out according to three spatial planes conventionally adopted in anatomical descriptions:

- Movements on the **sagittal (antero-posterior) plane** are flexion (directed towards the anterior plane, with a reduction of the articular angle) and extension (directed towards the posterior plane, or a simple return from flexion). Wider degrees of mobility can be achieved using the limbs, which are defined as hyperflexion and hyperextension.

- Movements on the **frontal plane** are abduction (directed laterally, moving away from the median plane), adduction (directed

medially, moving closer to the median plane) and lateral flexion, for movement of the head and trunk.

- Movements on the **horizontal plane** are lateral and medial rotation and, for the forearm, pronation and supination. These main movements are added to, especially in relation to the limbs, by the ones on an oblique plane and intermediate ones between the frontal and lateral plane, and those of circumduction, which is an ordered sequence of movements carried out on different planes.

• The muscles

The skeletal muscles (striated and voluntary) are the most active components in bodily movements. *In vivo*, the muscle always preserves a slight degree of physiological contraction, known as muscle tone, but effective movement is usually carried out via an ordered sequence: the nervous (voluntary) impulse causes the muscle tissue it is destined for to contract (the muscle belly), which, acting via the tendons, causes the bone lever to move.

It may be useful for our purposes to recall a few other functional aspects of skeletal muscles.

The active movements of our body or segments of it (unlike passive movements, which do not require any effort as they are carried out by others on the subject's body) are almost always carried out with the intervention of several other muscles in addition to the ones specifically responsible for the movement in question. There is a muscular coordination in which the muscles collaborate to regulate a body's movement in space, breadth or intensity, by contrasting or facilitating the movement.

Each time, therefore, the same muscles can take on functions with different purposes. We can therefore recognize support muscles, that is, stabilizers (which bring the articular heads closer together, with traction along the bone axis) and movement muscles, which imprint a movement on the mobile bone. This is done differently depending on whether their fibres are mainly red (rich in haemoglobin), favouring slow, protracted contraction, or mainly white (low haemoglobin), favouring rapid, energetic contraction. The motor (or agonist) muscle is the one directly responsible for a movement. Immobilizer, stabilizer and support muscles are the muscles whose static contraction balances or supports a part of the body, balancing the action of motor muscles or gravitational force. The neutralizer muscle is the one that opposes undesired secondary actions caused by the agonist. The antagonist muscle is the one which causes the opposite movement to the one carried out by the agonist muscle.

Muscle contraction can be shortening (or concentric, isotonic) when it causes the shortening of the muscle belly and therefore determines movement of the bone lever on which the muscle is applied; lengthening (eccentric) which corresponds to the gradual release of the muscle with a return to the length at resting state; or static (isometric) when, due to the effect of the balance of the forces of two muscles in antagonist action or while bearing a weight, the muscle is completely or partly contracted but without changing its length.

• The mechanism of partial articular movements

The static position and overall movements of the human body are better understood if we consider the individual partial movements that are possible in the joints in the more mobile body regions. It therefore seems useful to briefly summarize the mechanical characteristics of some joints and list the main muscles acting or intervening in their various movements. Given the importance of the vertebral column both for physiology and anatomy, and for artistic representation, the references to it have been developed separately (see page 115, 'Functional characteristics and movements of the vertebral column').

• The upper limb

1. The shoulder

The shoulder joint allows movements of the arm on the trunk. The scapulohumeral joint and the shoulder girdle joints collaborate with them.

The scapulohumeral joint is an enarthrosis formed by the humeral head and the glenoid cavity of the scapula. The low correspondence between the two articular surfaces (one convex, almost spherical, and the other concave but only shallow) allows a broad possibility of movement, but also requires strong containing apparatus. Other essential articular components are therefore: the capsule and mucosa bursae (at the deltoid and above the acromion), the ligaments (coracohumeral, glenohumeral and scapulohumeral) and muscle reinforcements provided by the local muscle tendons (supraspinatus, biceps long head, infraspinatus etc.). The possible movements and main muscles which act to carry them out are:

- Flexion, or anteropulsion (latissimus dorsi, teres major, posterior portion of deltoid)
- Abduction: in the first stage, up to 90 degree (medial portion of deltoid, supraspinatus), in the second stage, beyond 90° and with the intervention of other joints in the shoulder girdle (serratus anterior, trapezius, rhomboid)
- Adduction (pectoralis major, latissimus dorsi, teres major, infraspinatus, subscapular). Gravitational force is sufficient when the limb is free
- Lateral rotation of the humerus (infraspinatus, teres minor, trapezius, rhomboid)
- Medial rotation of the humerus (clavicular portion of the pectoralis major, latissimus dorsi, subscapularis, pectoralis minor, serratus anterior).

Some complex movements, such as horizontal flexion, horizontal extension and circumduction, involve many of the shoulder's motor muscles to various extents and in subsequent moments.

There are two shoulder girdle joints:

- **Acromioclavicular joint,** which is an arthrodia, between the acromion of the scapula and the clavicle, reinforced by a capsule and ligaments (acromioclavicular and coracoclavicular). Shoulder girdle movements are closely connected to those of the arm and mostly comprise movements of the scapula via some specific movements:
 - the elevation or raising of the scapula, that is, the distancing of the scapula from the rib surface (ascending portion of the trapezius)
 - The abduction or distancing of the scapula from the vertebral column, preserving parallelism between this and the medial scapular border (serratus minor)
 - The adduction or bringing closer of the medial border to the vertebral column (rhomboid minor, rhomboid major, transverse portion of the trapezius)
 - Upwards rotation (ascending and descending portions of the trapezius).
- **Sternoclavicular joint,** which is an enarthrosis, is reinforced by the capsule and ligaments and allows for some limited movements.

2. The elbow

The elbow joint is trochlear, comprising three articular heads (humerus, ulna and radius) contained in a single articular capsule, reinforced by ligaments (collateral ulnar, collateral radial, annular radialis). It

comprises three separate joints (radiohumeral, ulnohumeral and proximal radioulnar) which overall allow two types of movements: flexion and extension (which involve all three articular bones), and pronation and supination (which involve only the bones of the forearm, ulna and radius and their distal joint).

Therefore, the articular movements are:
- extension (triceps brachii, anconeus)
- flexion (biceps brachii, brachial, brachioradialis)
- pronation (pronator quadratus, pronator teres)
- supination (supinator, biceps brachii).

3. The wrist (and forearm)

There are several wrist joints, due to the number of bones involved. In addition to the distal radioulnar joint, which allows for pronosupination of the forearm (and therefore also of the hand), there are also the radiocarpal and intercarpal joints.

- The most functionally important joint is the **radiocarpal joint**, between the articular surface of the radius and the carpal bones of the proximal row (scaphoid, semilunaris and pyramidalis, but not pisiform). The capsule is reinforced by several ligaments (volar and dorsal radiocarpal, ulnar collateral, radial collateral, etc.). The possible movements, of a different range, depending on whether the hand is prone or supine, are:
 - *flexion*, up to 90 per cent (flexor carpi radialis, flexor carpi ulnaris, palmaris longus, abductor pollicis longus)
 - *extension*, up to 70 per cent (extensor carpi radialis brevis, extensor carpi radialis longus, extensor carpi ulnaris)
 - *abduction* or *radial inclination* (abductor pollicis longus, extensor pollicis brevis, flexor carpi radialis, extensor carpi radialis, extensor pollicis brevis)
 - *adduction* or ulnar inclination (extensor carpi ulnaris, flexor carpi ulnaris)
 - *circumduction*, which is the complex and ordered succession of various simple movements after which the hand as a whole draws a cone in the air.
- The **intercarpal joints** are created between the carpal bones in the proximal row and those of the distal row (trapezium, trapezoid, capitate, hamate) and only allow small sliding movements between the bones on the same row. The mediocarpal joint, which is created between the two rows of carpal bones, allows a wide range of movement.

4. The hand

The specific joints of the hand act between the carpal, metacarpal and phalanges bones, with a few differences in mobility between the thumb (first digit) and the remaining four fingers.

- The carpometacarpal joint of the thumb is a saddle joint and unlike the carpometacarpal joints of the other four fingers, it allows rather broad movement, as far as circumduction:
 - *abduction* (abductor pollicis longus, extensor pollicis brevis, abductor pollicis brevis, opponens pollicis)
 - *adduction* (adductor pollicis, flexor pollicis brevis, extensor pollicis longus)
 - *flexion* (flexor pollicis brevis, adductor pollicis)
 - *extension* (abductor pollicis longus, extensor digitorum longus and extensor digitorum brevis)
 - *opposition*, which is the movement with which the thumb manages to touch the tip of each of the other four fingers (opponens pollicis, flexor pollicis brevis).

- The interphalangeal joints occur between the phalanges of each finger. These are trochlear joints wrapped in a capsule and reinforced by anterior and lateral ligaments. They only allow flexion and extension movements through the same muscles that act on the first and distal phalanges. Limited hyperextension is also possible, but to a different degree depending on the finger involved.

The lower limb

1. The hip

The hip (or coxofemoral) joint allows the movements of the lower limb on the trunk. It is an enarthrosis joint between the head of the femur, which is spherical, and the acetabular cavity (formed by three pelvic bones: the ilium, the ischium and the pubis). If compared with the scapulohumeral joint, however, it can easily be seen that it is more robust. Due to the depth of the acetabulum and the complex restraining system, the freedom of movement is reduced but, on the other hand, it provides the greater stability required for the lower limb to support the weight of the trunk in the erect position and during locomotion. Stability factors therefore derive from the articular surfaces, the capsule, the ligaments (teres, iliofemoral, pubofemoral, ischiofemoral and transverse acetabular), the muscle reinforcements and the almost vertical orientation of the femur's mechanical axis.

Femur movements at the hip and the main muscles allowing them are:
- **flexion** (tensor fasciae latae, pectineus, iliopsoas, sartorius, rectus femoris or quadriceps femoris, upper portion of the adductor magnus, gracilis)
- **extension** (semitendinosus, semimembranosus, biceps femoris, gluteus maximus)
- **abduction** (gluteus minimus, gluteus medius, tensor fasciae latae, upper portion of the gluteus maximus)
- **adduction** (adductor magnus, adductors longus and brevis, gracilis, pectineus)
- **external rotation** or **extra-rotation** (obturators, piriformis, gluteus maximus, gluteus minimus and gluteus medius, iliopsoas)
- **internal rotation** or **intra-rotation** (anterior portions of the gluteus minimus and gluteus medius, gracilis)
- **circumduction**, created by the ordered sequence of movements on the three axes, similar to the shoulder joint but with a more limited range.

2. The knee

The knee joint is complex and similar to an angular ginglymus with a particular shape which, in addition to flexion and extension, also allows a slight rotation if the leg is flexed. The surfaces of the articular heads have different shapes as the two femoral condyles are of different sizes and are ovoid and highly convex while the tibial condyles are only slightly concave. Joint stability is ensured by a robust capsule with attached mucosa bursae, menisci, a complex system of ligaments (patellar, tibial collateral, peroneal collateral, popliteal and cruciates) and muscle tendons, especially the patellar tendon, which surrounds the patella and the iliotibial tract of the fasciae latae.

The main movements of the leg and muscles involved are:
- **flexion** (biceps femoris, semimembranosus, semitendinosus, sartorius, gracilis, gastrocnemius)
- **extension** (quadriceps femoris, that is: rectus femoris, vastus medius, vastus lateralis, vastus intermedius).

As already mentioned, if the knee is flexed, a limited external rotation of the tibia (biceps femoris) becomes possible, as does an internal rotation (semimembranosus, semitendinosus, gracilis, sartorius, and popliteus).

3. The ankle and foot

The ankle joint, that is, the tibiotarsal or talocrural joint, is a trochlea formed by the talus and the distal extremities of the tibia and fibula. It is wrapped in the capsule and reinforced by strong ligaments (deltoid, posterior talofibular, anterior talofibular, calcaneofibular etc.). It allows only flexion (dorsal flexion) and extension (plantar flexion) movements.

There are several foot joints but overall and compared with those of the hand, they allow rather limited movements. We can recognize: the talocalcaneal joint, the tarsometatarsal joints, the intermetatarsal joints, the metacarpophalangeal joints and the interphalangeal joints. These are all reinforced by strong ligaments which give the foot the solidity and elasticity it needs.

The possible movements are similar in the various sections of the foot. In particular: the ankle joint allows dorsal flexion (tibialis anterior, peroneus anterior, extensor digitorum longus, extensor hallucis longus) and plantar flexion or extension (gastrocnemius, soleus, peroneus longus, tibialis posterior, peroneus brevis, flexor digitorum longus, flexor hallucis longus).

The tarsus joints permit the following movements:

- **dorsal flexion** (tibialis anterior, peroneus anterior, extensor digitorum longus, extensor hallucis longus)
- **plantar flexion** (tibialis posterior, flexor digitorum longus, flexor hallucis longus, peroneus longus, peroneus brevis)
- **medial rotation** or **adduction** (tibialis anterior, tibialis posterior, flexor digitorum longus, flexor hallucis longus)
- **lateral rotation** or **abduction** (peroneus longus, peroneus brevis, peroneus anterior, extensor digitorum longus).

Toe joints allow:
- **flexion** (flexor digitorum longus, flexor hallucis longus, flexor digitorum brevis, flexor hallucis brevis, flexor digiti minimi brevis)
- **extension** (extensor digitorum longus, extensor hallucis longus, extensor digitorum brevis).

BALANCE AND STATIC POSITIONS

• Balance

Balance is the set of muscular and cerebral functions of adaptation which sustain the (human) body during active and passive movements during a change in position in space. The body is continually subjected to mechanical forces (gravity, transfer, friction, etc.) even when no movement is carried out. So, in this condition, the acting forces reciprocally cancel themselves out, that is, they are in equilibrium. This can be: 'static', when identified with the body's posture, that is, with the function which maintains the body in the 'normal' position (especially the erect position) compared with the surrounding space, retaining the line of gravity within the area of body support. Or it can be 'dynamic', related to the correct execution of movements, especially movements which involve the entire body, for example walking, running, jumping, climbing and swimming. Mechanical balance is closely connected with the position of the centre of gravity, or the barycentre. This can be defined as the point in which the parts of the body and the forces which act on it are balanced on each side. In the erect position in man, this is located in the pelvis, at the point of or just in front of the vertebral section going from L5 to S2 vertebrae.

The centre of gravity which the line of gravity passes through (that is, the perpendicular line which joins it to the ground) does not change position, or it undergoes only slight oscillations so that the shape of the body and the arrangement of the body's parts in space do not change. Instead, the position of the centre of gravity in human beings in the erect position changes slightly depending on the morphological type, age and gender.

As mentioned, the human body maintains its balance (with continuous adaptations) if the line of gravity falls within the resting base which, in the erect position, is provided by the plantar surface of both feet and the area between them, which can differ in size depending on the distance or proximity of the feet. In other static positions, for example sitting or lying down, the resting base corresponds to the surfaces of those body parts which are touching the support and it is larger, thus allowing a more stable balance. The mechanical factors for maintaining balance in man are governed by a complex cerebral coordination of reflexes which originates in the peripheral sensory system, in the inner ear, and in visual, psychological or physiological stimulation. There are two types: passive (resistance of the bone, elasticity of the ligaments and capsules), joint structure, the overlapping of the various body segments etc.) and active (contraction of muscles in antigravitational action such as, for example, the extensor muscles of the head, trunk, lower limbs or abdominal wall muscles.

• The erect position

The erect (or normal, anatomical, bipodalic) position, with the support of body weight balance on both feet close together, is the static position of humans.

By observing the body in this position frontally, it can be seen that the median plane, in an antero-posterior direction, passes through the line of gravity and divides the body into two symmetrical halves. Observing the body laterally, it can be seen that the frontal plane corresponding to the line of gravity crosses the various body segments asymmetrically, according to the vertical line passing in front of the external auditory foramen and the lateral malleolus.

In fact, the various body sections (head, trunk, lower limbs, etc.) each has its own centre of gravity and its own axis: as they overlap, they trace a dotted line with segments at various angles in an antero-posterior direction.

The muscles, but above all the ligaments, act to maintain the sections in equilibrium with each other and through continuous adaptations, to transmit weight at the support base according to the body's overall line of gravity.

In the normal erect position, for example, the nuchal ligaments and extensor muscles prevent the head from falling forwards; the paravertebral extensor muscles of the column (iliocostalis, longissimus, transverse, etc.) prevent the thoracic segment from falling forwards, the abdominal muscles prevent the trunk from falling backwards; the iliopsoas and tensor fasciae latae muscles and the iliofemoral ligament prevent the knee from flexing; the gemellus and soleus muscles prevent anterior flexion of the tibia.

The human body's external morphology in a normal erect position, is characterized by contraction of the nuchal muscles (splenius, rectus, etc.); and a slight tension of the abdominal muscles; and by contraction of the superficial back muscles (lumbar tract) which are not very evident; the tensor fasciae latae; the posterior leg muscles (gastrocnemius and soleus) and also the tibialis anterior.

In the forced erect position (or the gymnastic 'attention' position), on the other hand, contraction of the quadriceps femoris (and consequent fixing of the patella), gluteus maximus and back muscles can be noted.

• Variations on the normal erect position

The erect position can also be maintained in different stances from the one defined as normal.

In these cases, the centre of gravity can be altered (with consequent modification of the size of the resting area) in relation to deviating the body set-up from the gravitational line. Balance conditions vary in accordance with the stance assumed and are maintained by continuous articular adaptation and action of the muscles specifically involved.

There are several stances deriving from the normal position, but which can be traced back to types which require standing on both feet (bipodalic) or on only one of them (monopodalic) and which, however, are almost always characterized by a condition of unstable or even precarious balance.

- **The erect two-footed stance with legs divaricated** allows for a wider resting base transversally. This allows for a wider variation of the line of gravity on the frontal plane and therefore greater possibility of balance on this plane. The relation between spine and pelvis stays more or less the same, although it is possible that there is a slight reduction of lumbar lordosis and femurs which are in abduction at the hips. In this position, the trunk and lower limb muscles used are the same ones involved in maintaining the normal erect position.

- **The erect two-footed stance with one limb in front** has similar characteristics to the one where limbs are divaricated. The resting area, in fact, is larger, but in an antero-posterior direction, providing greater stability for the body on the sagittal plane. This is a factor which is also useful in walking. The limb at the rear shows the femur in hyperextension compared with the hip, the knee is extended and the angle formed by the foot's axis with the leg's axis is slightly less than 90 degrees. The limb at the front, on the other hand, shows a moderately flexed femur on the hip, the knee is slightly flexed and the foot/leg angle is just over 90 degrees. In maintaining this position, the gluteus maximus, quadriceps, triceps surae and tibialis anterior are decidedly more involved.

- **The stance with metatarsophalangeal support**, that is, resting on tiptoed, is quite frequent but considerably reduces stability on the sagittal plane and this lends a rather precarious overall balance to the body. Lumbar lordosis, extension of the femur on the hip and extension of the knee are all accentuated. While maintaining this position, some muscles of the lower limbs act more intensely: the adductors, quadriceps, gastrocnemius and soleus, tibialis posterior and peroneus longus, but not the gluteus muscles.

- The stance whereby balance is on the heels, **the calcaneal stance,** is extremely unstable, therefore it is rarely adopted voluntarily and only for very short periods. On the other hand, it may be found in some phases of walking, with some analogies. Lumbar lordosis decreases, the femurs are slightly flexed on the hip and the knees are extended. In addition to the quadriceps (and in particular the rectus femoris) some muscles of the foot and leg act intensely (tibialis anterior, peroneus longus, etc.).

- **The asymmetrical erect** (or lateralized, 'station hanchée', contrapposto or counterposed) **stance** asymmetrically divides the vertical body axis and therefore, as shown in a particular era of Greek statues, offers great interest for artistic representation. Body weight in this position is completely borne on one limb (the supporting limb), left or right, while the other is mostly used to maintain balance. The position can also be compliant or opposing (in relation to the direction of the shoulder and pelvis axes). It is a resting position as it allows alternative side movements acting on robust hip ligaments (in particular the iliofemoral ligament) and on the fascia lata.

The supporting limb is hyperextended and laterally sloping, distancing itself from the line of gravity. The leg is maintained in position by contraction of the gemellus, soleus and other flexor muscles (biceps, semimembranosus, peroneus longus, etc.). The muscles in the other limb, the flexed limb, are almost all loose.

The trunk's skeletal structure undergoes lateral inclination movements, as the side of the pelvis that corresponds to the flexed limb is lower than the other side. Also, a slight rotation movement allows the 'bearing' hip to be slightly more forward than the other. Consequently, to compensate for the slope of the pelvis and to maintain the body's equilibrium, the thorax must flex at the lumbar column point, on the opposite side. The head also adapts to the new equilibrium, flexing laterally on the higher shoulder.

By observing the figure in an asymmetric erect position frontally or dorsally, it is easy to see the counterposed inclination of the transverse axes at the shoulders and pelvis. In fact, the shoulder on the side of the supporting limb is lower and closer to the pelvis. Consequently, the costal margin on this side is only a short distance from the iliac crest, while the opposite happens on the other side. The pelvis slopes in the opposite direction to the shoulders, higher in correspondence with the supporting limb and lower on the side on which the limb is flexed.

To judge the angle of the two axes, it is useful to refer to the specific subcutaneous bone points in the two regions, that is, the acromia and the anterior superior iliac spines. While the overall external shape of the flexed limb is rounded, not showing particular muscle prominences, the shape of the supporting limb shows the flattening of the thigh's lateral surface (due to the stabilizing tension of the fascia lata), the contraction of the leg's posterior muscles and contraction of the vastus medialis and vastus lateralis. The buttocks assume different shapes as the one corresponding to the supporting limb is narrower and more elevated than the other, due to contraction of the gluteus medius muscle and sometimes also of the gluteus maximus. This forms a clear gluteal fold which on the other side appears less defined.

On the back, the transverse lumbar groove is more evident on the side of the supporting limb and the sacrolumbar muscles are slightly contracted on the side of the flexed limb, to contrast the lateral curvature of the vertebral column. Here, the vertebral groove is deep and convex on the side of the flexed limb.

- **The single-foot erect stance**, that is, balancing on one foot, can easily be assumed starting from the asymmetrical position, which has already moved the body weight to one limb only. As the surface resting on the ground is greatly reduced in this position, the body's balance is highly unstable. Usually the position is free, but it can also be assisted by a stand or by some form of support.

Depending on the point where the line of gravity passes, the stance is maintained passively for a short time or via fleeting and alternate contraction of the gluteus muscles, the adductors and the tensor fasciae latae in the supporting limb. It is clear that the raised limb can be oriented to various degrees of flexion and in various directions, for example: laterally, forwards or backwards.

- Lastly, it should be remembered that if **carrying a heavy item**, the human being is forced to assume stances to adapt the limbs or trunk in compliance with the degree of movement that its centre of gravity undergoes and in proportion to the moving of the body axis compared with the line of gravity. The angle of the body or its segments can be anterior, posterior or lateral in relation to the size and weight of the burden transported, and clearly the muscle effort required to maintain the balance of the body and the weight carried correlates to the extent of movement.

Other static positions

In addition to the erect position in its several variations, there are other customary stances, generally more static and resting, that the body can take on, such as sitting and lying down.

To cover the matter thoroughly, the main and most frequently assumed positions can be listed, as they contain some interest from an anatomical-artistic point of view.

- In the **sitting position**, the lower limbs lose their function of supporting the trunk as it sits directly on the support, which may be the ground or another support at any height.

 The resting base, corresponding to the part of the gluteal region and the posterior surface of the thighs, is large and therefore the balance of the body is quite stable, allowing the trunk to move widely: backwards, to the side, but above all forwards. This may cause some movements of the upper or lower limbs or the hands and feet, to aid the assumption of a new balance.

 The sitting position, free or with the back resting, allows the vertebral column to reduce its physiological curvatures, especially the lumbar curve, which can also be cancelled out when the trunk is flexed forwards resting on the elbows. When maintaining balance in a sitting position, the paravertebral muscles are the main ones acting, in particular the nuchal muscles, which keep the trunk and the head erect or contrast the gravitational fall forwards.

 The external forms of the body are influenced by the sitting position and usually they are characterized by the protuberance of the abdomen, caused by the relaxation of the ventral muscles, the accentuation of the abdominal folds, the curvature or straightness of the dorsal surface, and the inferior flattening and posterior/lateral protuberance of the gluteus adipose tissue.

- The **crouching position** involves resting only on the feet, but unlike the erect position, causes the simultaneous flexion of all the lower limb joints and also a considerable lowering of the centre of gravity. This, however, does not provide much stability, especially if the foot support is reduced to the tips. There are, in fact, several variations of this position, for example: with both heels lifted, with the soles of the feet fully on the ground, with one foot in front and more lateral than the other, etc., but the resting base remains quite small in all cases. Greater stability is achieved by discharging the body's weight onto the upper limbs too, stretched in front to touch the ground. Each of these stances brings about different and complex adaptations in the skeleton and muscle efforts, which would be too many and perhaps superfluous to describe anatomically as they can easily be discovered by carefully observing the model's external morphology.

- In the **kneeling position**, the resting base comes from the anterior surfaces of the knees and legs and from the dorsal surface of the extended feet. One variation of this position sees only the knees and toes resting on the ground; another sees one limb on the surface in one of the two positions mentioned, while the other is flexed to form a right angle or slightly acute or obtuse angle between thigh and leg. Lastly, the body (that is, the head, trunk, thighs and upper limbs) can be kept erect on the knees, vertically or with a certain posterior inclination, or can rest with the thighs on the heels and the posterior surface of the legs.

- **Lying down** or **reclined positions** bring with them favourable conditions for stable equilibrium as the resting base is usually very extended. For simplification of description, we can identify three basic positions which deserve some morphological consideration, as in their several variations they have been and are frequently chosen for artistic representation.

- The *lying down supine position* is also said to be anatomical as it corresponds to that of the cadaver on the autopsy table. The body rests on the base with its occipital region, the surface of the upper section of the back, the sacral region and the posterior surface of the thighs, legs and heels. The feet are therefore in slight plantar flexion and the vertebral column, while maintaining its physiological curvature (only slightly less so in the cervical and thoracic sections), has an accentuation of the lumbar lordosis.

 The body's centre of gravity is very low, about the point of the sacral vertebra, and falls in the centre of the resting base, making it much more stable.

 The external forms undergo some changes due to gravitational force and the compression of the resting surface. It is known that other positions can derive from this one, for example: with one or both lower limbs flexed, with the sole of the foot resting on the floor; with abduction or extension of one or both arms folded behind the neck; etc.

- The *prone position* is assumed more rarely as, if held for a long time, it becomes uncomfortable, especially for breathing, which requires the head to be laterally rotated in order to be easy. The body rests on the chin (or cheek), almost all the anterior surface of the trunk and thighs, and the tops of the feet.

- The *lateral lying down position* provides low stability transversally, as the body rests on its lateral surface, which is rather limited in extension. The centre of gravity is elevated and this creates a tendency for the trunk to fall anteriorly and dorsally to find more stable resting conditions, which can be effectively contrasted by the part flexion of the lower limbs and movement of the upper limbs.

 The pelvis may be rotated slightly anteriorly or posteriorly and the vertebral column may maintain or decrease its physiological curves, but on a frontal plane it always shows downward convexity in the lumbar region and upward convexity in the thoracic region.

 In this position too, the gravitational shape influences adipose tissue and relaxed muscle mass, causing the characteristic variations to the external shapes of some body areas (abdominal, gluteal, pectoral, etc.).

247

DYNAMIC POSITIONS

As in the erect position, the position and movement of the entire body's centre of gravity and line of gravity are highly important in locomotion (that is, in moving around the environment using muscular force).

Human locomotion is bipedal (that is, carried out on two feet), plantigrade (that is, with the soles of both feet on the ground) and orthograde (that is, carried out in the erect position).

Coordinated, rhythmical movements of the lower limbs and other body segments move the centre of the body and its support base. Natural human locomotor actions are walking and running, which depend on two sets of factors, one intrinsic to every individual (gender, age, state of health, constitutional type, etc.) and the other connected with the environment (sloping or uneven ground, etc.).

Each individual walks and runs in their own style, influenced to varying degrees by the stated factors, but nevertheless, it is possible to identify the fundamental mechanisms characteristic of the two locomotor actions.

Naturally, the human body can carry out an unlimited number of other movements and actions (just think of gymnastics, dancing, social relations, work, etc.) which it would be superfluous to mention but which are relevant to kinesiological analysis.

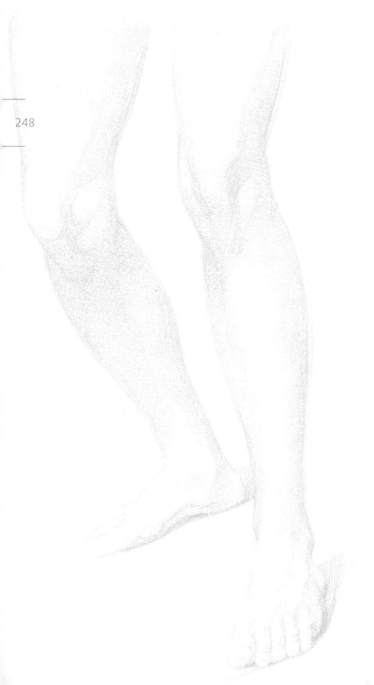

• Walking

Walking (or marching) is the particular type of land locomotion characteristic for humans, by which the body is moving in space through successive moments.

While walking, the body never leaves the ground: the lower limbs, moving alternately one in front of the other, carry the trunk, the head and the upper limbs while carrying out a step. This refers to the space between one foot and the other, therefore walking comprises a succession of steps: a cycle is completed after two steps when each lower limb is back in its initial position. In the full walking cycle, some typical stages for each human being in a normal state of health have been identified. In reference to a single lower limb, a resting stage and an oscillation stage; in reference to both lower limbs (and therefore the whole body), two stages of dual resting and two stages of one-sided resting.

In a simplified manner, the sequence of movements can be summarized by considering the basic aspects:

- Walking on flat ground begins from the erect position with bilateral rest

- Flexion of one lower limb, which enters the oscillating stage with flexion at the hip (iliopsoas), at the knee (biceps femoris, sartorius, etc.), at the ankle (the foot's flexor muscles, especially the triceps surae), causes monolateral resting of the body weight on the other side, the supporting side. This opposes the force tending to flex it by contracting the tensor fasciae latae, the rectus femoris and gluteus medius and minimus

- The oscillating limb extends the leg to reach the ground, contracting the quadriceps and the iliopsoas

- The resting limb extends the foot, moving itself and the trunk forwards, allowing the oscillating foot to reach the ground by gravitational fall

- The dual resting stage is carried out when the limb that moved forwards becomes the supporting limb, while the other begins its flexion to become the oscillating one.

These stages then follow on from each other:

- The **dual resting stage**, that is, the moment when both feet are touching the ground

- The **one-sided resting stage** – that is, the subsequent moment when the limb located posteriorly is brought forwards, therefore supporting the body weight on the other foot, which is resting on the ground, first with the heel and then with the toes

- The **dual resting stage**, in which the calcaneus of the foot brought forwards is on the ground and so is the tip of the other foot

- The **one-sided resting stage**, now referring to the foot that was brought forwards.

During walking, the trunk twists slightly and undergoes continuous antero-posterior and lateral oscillations so that, as the centre of gravity moves, the line of gravity falls within a continually varying resting area.

The upper limbs swing, normally and spontaneously, with an opposite movement to that of the lower limbs, therefore the arm on one side is pushed forwards while the leg on the same side is moved backwards. The movement causes alternating twisting of the trunk, especially evident at the shoulders. Lastly, we can state that how we walk differs depending on the features of the terrain we walk on

(sloping upwards or downwards, rough or smooth etc.) or on particular conditions, such as climbing or descending stairs, dragging, pushing or supporting a weight, etc..

During the various phases of walking, we can note some modifications to the external body shapes. Some of them can easily be seen by directly observing the model, for example:

- The gluteal region of the supporting limb is contracted and elevated, while the one on the other side is flatter

- The prominences of the quadriceps in the supporting limb are clear and well defined due to contraction, but only in the first part of the resting stage, as immediately afterwards the muscles relax and the prominences soften

- In the oscillating limb, during the first part of the stage, the thigh's flexor muscles (sartorius, tensor fasciae latae, etc.) and the leg's flexor muscles (biceps femoris, semimembranosus, semitendinosus, etc.) are contracted and elevated

- In the leg section of the supporting limb, the soleus, gastrocnemius and peroneus muscles are contracted and therefore elevated, while the same muscles are at rest when the leg enters the oscillating stage

- In addition to the nuchal muscles, the spinal muscles of the lumbar section on the side of the oscillating limb in the trunk are contracted.

• Running

Like walking, running is also a mode of locomotion often adopted by man, as it allows rapid movement. However, it lacks the dual resting stage of the lower limbs as the one-sided resting period is followed by that of the entire body suspended in the air. The body, in fact, is projected forwards by the action of the foot resting on the ground, by the strong contraction of the triceps surae, which lifts the heel.

It is not enough to observe the model directly to study running, given the rapidity of movement, and it is therefore essential to enlist the aid of technology (photographs, films, etc.). We can, however, list some observations that are useful for artistic representation.

- The trunk is slightly twisted, but its inclination (forwards at the start of the resting stage and backwards when slowing down) is more accentuated than in normal walking, and this is due to the speed of running

- The foot touches the ground, placing itself parallel to it with the entire sole, but immediately afterwards the mechanism that also belongs to walking occurs, that is, the initial raising of the heel, and then gradually of the foot to the toes, which are the last to leave the ground

- In all the stages of running, the lower limbs are not extended, but are in a more or less marked state of flexion

- The upper limbs move in a similar way to walking, but carry out a wider excursion and maintain a certain degree of flexion

- Balance while running is quite unstable as in almost all the stages, the centre of gravity falls outside the resting base (which is formed in particular by the tip of the foot) and the whole body undergoes inertia, as well as the force of gravity

- The muscle groups which act during the stages of running are the leg flexors, the quadriceps, the triceps surae, the gluteus muscles and the foot's dorsal flexors.

More specifically:

- During the one-sided resting phase, when the foot touches the floor, the quadriceps muscle and all the leg muscles are highly contracted to prevent the knee and tibiotarsal joints from collapsing; when the foot begins to leave the ground, the gemellus and soleus muscles seem to be more contracted to carry out propulsion. The leg's flexor muscles on the thigh (biceps femoris, semitendinosus, semimembranosus) then enter into action.

- During the suspension stage, during oscillation of the limb, the thigh's flexor muscles on the trunk (sartorius, rectus femoris, tensor fasciae latae) enter into action, as well as the leg's flexor muscles. The gluteus muscles, which play a modest role in walking, act intensely and alternately during running, especially in the suspension stage, during which there is a high contraction and clear elevation of the gluteus maximus corresponding to the limb pushed backwards, while that of the other limb is relaxed and flat.

• Jumping

Jumping is a mode of movement in space which is rarely used by man as locomotion. It consists of a rapid, powerful extension of the lower limbs, previously flexed to various degrees, and due to which the body is pushed forwards and upwards.

Jumping can be executed in several ways (vertically, longways, with a run-up, etc.) but it is not useful or appropriate to mention the morphological variations of each type here as these body gestures are rarely represented in art and they can only be fully appreciated by observing photos or films. It is therefore sufficient to consider the fact that all types of jumping comprise three stages:

- The **preparation stage**, during which the body and lower limbs flex, bend or carry out the leap;

- The **suspension stage**, both ascending and descending, during which the body is detached from the ground, also aided by the position of the upper limbs;

- The **final stage**, during which the feet touch the floor and the lower limbs flex to absorb the recoil.

Artistic representation of locomotion movements come close to aspects found in scientific analysis, which is a sign that the careful observation of nature has led to a basically correct, but also a very expressive interpretation of the sequence of movements and essential dynamics. For example, walking has almost always been portrayed during the dual resting stage, in the position where the back foot is partly raised from the ground. The trunk slopes forwards and is supported by the supporting limb, which is slightly flexed at the knee. Running is almost always portrayed during the one-sided resting stage, with the supporting limb slightly flexed and the other pushed backwards. The trunk and the head slope heavily forwards.

This does not correspond much to the scientific outline (where the trunk is almost erect, to allow the line of gravity to fall within the resting area), but it is much more dynamically expressive of muscle tension and instability in balance.

BIBLIOGRAPHY

BOOKS

ARISTIDES, Juliette, Lessons in Classical Drawing, Watson-Guptill Pub. Random House, New York, 2011

BACKHOUSE, Kenneth M. & HUTCHINGS, Ralph T., *A Colour Atlas of Surface Anatomy, Clinical and Applied*, Wolfe Medical Pub. Ltd, London, 1986

BARRINGTON, John S., *Anthropometry and Anatomy*, Encyclopaedic Press Ltd., London, 1953

BERGMAN, Ronald A. et al., *Atlas of Microscopic Anatomy*, W.B. Saunders Co., Philadelphia, 1974

BERGMAN, Ronald A. et al., *Catalog of Human Variation*, Urban-Schwarzenberg, Baltimore-Munich, 1984

BERRY, William, *Drawing the Human Form*, Van Nostrand-Reinhold, New York, 1977

BEVERLY HALE, Robert, *Master Class in Figure Drawing*, Watson Guptill Pub., New York, 1985

BEVERLY HALE, Robert & COYLE, Terence, *Anatomy Lessons from the Great Masters*, Watson-Guptill Pub., New York, 1977

BLOOM, William & FAWCETT, Don, *A Textbook of Histology, Chapman and Hall* (Twelfth ed.), New York, London, 1994

BRADBURY, Charles Earl, *Anatomy and Construction of the Human Figure*, McGraw Hill, New York, 1949

BRIDGMAN, George B., *Constructive Anatomy*, Dover, New York, 1973

CAVALLI SFORZA, Luigi Luca & MENOZZI Paolo, *The History and Geography of Human Genes*, Princeton University Press, Princeton, 1994

CAZORT, Mimi (ed.), *The Ingenious Machine of Nature: Four Centuries of Art and Anatomy*, National Gallery of Canada, Ottawa, 1996

CHUMBLEY, C.C. & HUTCHINGS, Ralph T., *A Colour Atlas of Human Dissection*, Wolfe Medical Pub. Ltd., London, 1988

CIVARDI, Giovanni, *Drawing Hands & Feet*, Search Press, Tunbridge Wells, 2005

CIVARDI, Giovanni, *Drawing Human Anatomy*, Search Press, Tunbridge Wells, 2018

CIVARDI, Giovanni, *Drawing Portraits: Faces & Figures*, Search Press, Tunbridge Wells, 2002

CIVARDI, Giovanni, *Drawing the Female Nude*, Search Press, Tunbridge Wells, 2017

CIVARDI, Giovanni, *Drawing the Male Nude*, Search Press, Tunbridge Wells, 2017

CIVARDI, Giovanni, *Figure Drawing: A Complete Guide*, Search Press, Tunbridge Wells, 2016

CIVARDI, Giovanni, *Portraits of Babies & Children*, Search Press, Tunbridge Wells, 2017

CIVARDI, Giovanni, *Understanding Human Form & Structure*, Search Press, Tunbridge Wells, 2015

CLARK, Kenneth, *The Nude – A Study in Ideal Form*, John Murray, London, 1956

CLARKSON, H.M. & GILEWICH, G.B., *Musculoskeletal Assessment*, Williams & Wilkins, Baltimore, 1989

CODY, John, *Visualizing Muscles*, The University Press of Kansas, Lawrence, 1990

COLE, J.H. et al., *Muscles in Action: An Approach to Manual Muscle Testing*, Churchill-Livingstone, London-New York, 1988

CUNNINGHAM, D.J., *Manual of Pratical Anatomy*, Oxford University Press, London, 1893

EWING, William A., *The Body – Photoworks of the Human Form*, Thames & Hudson Ltd., London, 1994

FARRIS, Edmond J., *Art Student's Anatomy*, Dover, New York, 1961

FAU, Julien, *Anatomy of the External Forms of Man*, Baillière, London, 1849

FAWCETT, Robert, *On the Art of Drawing*, Watson-Guptill Pub., New York, 1958

FAWCETT, Robert & MUNCE, Howard, *Drawing the Nude*, Watson-Guptill Pub., New York, 1980

FRIPP, Alfred & THOMPSON, Ralph, *Human Anatomy for Art Students*, Sealey, Service and Co. Ltd., London, 1911 (recent ed. Dover, New York, 2006)

GOLDFINGER, Eliot, *Human Anatomy for Artists*, Oxford University Press, New York, 1991

GORDON, Louise, *The Figure in Action: Anatomy for the Artist*, Batsford Ltd., London, 1989

GOSLING, J.A. et al., *Atlas of Human Anatomy*, Churchill-Livingstone, Edinburgh-London-New York, 1985

GUYTON, Arthur G., *Texbook of Medical Physiology* (Fourth Ed.), W.B. Saunders Co., Philadelphia, 1971

VON HAGENS, Gunther (ed.), *Body Worlds: The Anatomical Exhibition of Real Human Bodies*, Institut für Plastination, Heidelberg, 2002

HARARI, Yuval Noah, *Sapiens: A Brief History of Mankind*, Harville Secker & Random House Inc., London, 2014

HATTON, Richard G., *Figure Drawing*, Chapman and Hall Ltd., London, 1904

KEMP, Martin & WALLACE, Marina, *Spectacular Bodies: The Art and Science of the Human Body from Leonardo to Now*, University of California Press, London, 2000

KRAMER, Jack N., *Human Anatomy and Figure Drawing* (Second Ed.), Van Nostrand-Reinhold Co., New York, 1984

LANTERI, Edouard, *Modelling and Sculpture*, Vol. I, Chapman and Hall, New York, 1902

LARSEN, Claus, *Anatomia Artistica*, Zanichelli, Bologna, 2007

LOCKHART, R.D.et. al., *Living Anatomy*, Faber & Faber, London, 1963

LOOMIS, Andrew W., *Figure Drawing For All It's Worth*, Viking Press, New York, 1946

LUCCHESI, Bruno, *Modeling the Figure in Clay: A Sculptor's Guide to Anatomy*, Watson-Guptill Pub., New York, 1980

LUMLEY, John S., *Surface Anatomy: The Anatomical Basis of Clinical Examination*, Churchill-Livingstone, London, 1990

MARSHALL, John, *Anatomy for Artists*, Smith, Elder and Co., London, 1890

McHELHINNEY, James L. (ed.), *Classical Life Drawing Studio*, Sterling Pub. Inc., New York, 2010

250

MCMINN, R.M.H. & HUTCHINGS, R.T., *A Colour Atlas of Human Anatomy*, Wolfe Medical Pub. Ltd., London, 1988

MORRIS, Desmond, *Bodywatching: A Field Guide to the Human Species*, Compilation Ltd., London, 1985

MUYBRIDGE, Eadweard, *The Human Figure in Motion*, Dover, New York, 1955

PECK, Stephen R., *Atlas of Human Anatomy for the Artist*, Oxford University Press, New York, 1951

PERARD, Victor, *Anatomy and Drawing*, Dover, New York, 2004

PETHERBRIDGE, Deanna (ed.), *The Quick and the Dead: Artists and Anatomy*, Hayward Gallery Catalogue, London, 1997

POLLIER-GREEN, Pascale et. al. (ed.), *Confronting Mortality with Art and Science*, Brussels University Press, Brussels, 2007

QUIGLEY, Christine, *The Corpse: A History*, McFarland and Co. Inc., Jefferson, 1996

RAYNES, John, *Anatomy for the Artist*, Crescent, New York, 1979

RAYNES, John, *Complete Anatomy and Figure Drawing*, Batsford, London, 2007

REED, Walt, *The Figure: An Approach to Drawing and Construction*, North Light Pub., Westport, 1976

RIFKIN, Benjamin A. et al., *Human Anatomy – Depicting the Body from the Renaissance to Today*, Thames & Hudson, London, 2006

ROBERTS, K.B. & TOMLINSON, J.D.W., *The Fabric of the Body*, Clarendon Press-Oxford University Press, Oxford, 1992

RÖHRL, Boris, *History and Bibliography of Artistic Anatomy*, Georg Olms Verlag, Hildesheim, 2000

RUBINS, David, *The Human Figure: An Anatomy for Artists*, The Studio Pub. Inc., New York, 1953

RUBY, Erik A., *The Human Figure: A Photographic Reference for Artists*, John Wiley & Sons Inc., New York, 1974

RYDER, Anthony, *The Artist's Complete Guide to Figure Drawing*, Watson-Guptill Pub., New York, 2001

SAUERLAND, Eberhhardt K., *Grant's Dissector*, Williams & Wilkins, Baltimore, 1991 (1940)

SAUNDERS, Gill, *The Nude: A New Perspective*, Harper & Row Pub. Inc., New York, 1989

SEELEY, Rod et. al., *Anatomy and Physiology* (Second Ed.), Mosby Inc., St. Louis, 1992

SIMBLET, Sarah, *Anatomy for the Artist*, Dorling Kindersley, London, 2001

SHEPPARD, Joseph, *Anatomy: A Complete Guide for Artists*, Watson Guptill Pub., New York, 1975

SHEPPARD, Joseph, *Drawing the Living Figure*, Watson-Guptill Pub., New York, 1984

SPARKES, John C. L., *A Manual of Artistic Anatomy for the Use of Students of Art, Baillière* (Third Ed.), Tindall and Cox, London, 1922 (recent ed. Dover, Mineola, 2010)

TATTERSALL, Ian, *Becoming Human: Evolution and Human Uniqueness*, Harcourt Brace, New York, 1998

THOMSON, Arthur, *A Handbook of Anatomy for Art Students*, Oxford University Press, London, 1896

TOMPSETT, D.H., *Anatomical Techniques*, Livingstone Ltd., Edinburgh-London, 1956

VIDIC, Branislav & SUAREZ, F., *Photographic Atlas of the Human Body*, Mosby Co., St Louis, 1984

WELLS, Katherine & LUTTGENS, K., *Kinesiology: Scientific Basis of Human Motion*, W.B. Saunders Co., Philadelphia, 1982

WINSLOW, Valerie L., *Classic Human Anatomy: The Artist's Guide to Form, Function and Movement*, Watson-Guptill Pub.- Random House Inc., New York, 2009

WOLFF, Eugene, *Anatomy for Artists, Lewis and Co.* (Fourth Ed.), London, 1958 (recent ed. Dover Mineola, 2005)

ZUCKERMAN, Solly, *A New System of Anatomy*, Oxford University Press, London, 1961

WEBSITES

- Artnatomy/Artnatomia
 <www.artnatomia.net/uk/index.html>
- Fine Art: Anatomy References for Artists
- 3D.SK – Human photo references for 3D artists and game developers
 <www.3d.sk>
- Human Anatomy Table of Contents
 <act.downstate.edu/courseware/haonline/toc.htm>
- Human Anatomy for the Artist
 <www.artistanatomy.com/index.html>
- PoseSpace – models for the artist
 <www.posespace.com>
- A.D.A.M. Education
- AnatomyTools.com

ANATOMICAL INDEX

A

Abdomen 17, 21, 24, 25, 29, 30, 33, 68, 73, 109, 111, 122, 123–167, 247

Abdominal external oblique 126, 128, 130, 150

Abduction 31, 52, 146, 148, 149, 150, 156, 157, 158, 162, 169, 173, 185, 187, 188, 189, 190, 192, 193, 195, 208, 209, 218, 220, 224, 225, 227, 229, 230, 231, 242, 243, 244, 245, 246, 247
- Abductor digiti minimi 193, 194, 209, 212, 214, 229, 230
- Abductor hallucis 209, 216, 228, 229, 230, 231
- Abductor pollicis brevis 192, 244
- Abductor pollicis longus 57, 60, 177, 179, 181, 187, 188, 189, 190, 191, 192, 198, 244

Acetabulum 43, 123, 125, 208, 209, 219, 244

Achilles (calcaneal) tendon 209, 226, 227, 235

Acromion 62, 65, 66, 119, 120, 122, 148, 149, 161, 164, 243

Adduction 31, 52, 145, 146, 147, 149, 150, 156, 157, 158, 173, 182, 183, 185, 187, 189, 190, 191, 193, 195, 200, 208, 209, 218, 220, 221, 223, 227, 229, 230, 231, 242, 243, 244, 245
- Adductor brevis 190, 210, 220, 223
- Adductor hallucis 209, 228, 229
- Adductor longus 58, 126, 210, 214, 216, 220, 221, 223
- Adductor magnus 60, 210, 212, 214, 216, 220, 221, 222, 223, 226, 244
- Adductor pollicis 174, 179, 190, 193, 195, 200, 244
- Adductors 63, 64, 209, 218, 220, 221, 244, 246

Age, ageing 23, 35, 39, 42, 44, 66, 68, 73, 74, 77, 84, 101, 102, 114, 115, 116, 117, 119, 120, 124, 159, 160, 163, 165, 245, 248

Anal sphincter 155

Anatomical position 17, 18, 19, 20, 28, 30, 31

Anatomy (definition) 11

Anatomy (history) 11–14, 37–41

Anconeus 57, 60, 174, 177, 179, 182, 184, 187, 197, 244

Ankle 21, 33, 34, 38, 52, 54, 203, 223, 225, 234, 235, 236, 245, 248

Antihelix 104

Antitragus 104

Aponeurotic 139, 141, 143, 146, 147, 149, 151, 152, 153, 156, 181, 182, 185, 186, 193, 194, 195, 218, 219, 233

Apophysis 111, 112, 114, 141, 172

Apparatuses 13, 16, 25, 28, 30, 33, 54, 55 , 72, 89, 100, 112, 123, 124, 163, 165, 169, 242, 243

Areola 67, 163, 164

Arm 17, 21, 28, 33, 34, 41, 52, 56, 68, 73, 145, 146, 147, 148, 149, 150, 161, 162, 164, 168, 169, 173, 174, 181, 182, 183, 191, 196, 197, 198, 243, 248

Arthrodia 51, 52, 114, 116, 242, 243

Arthrology 11, 51–53, 88–89, 114–117, 118, 120–122, 123–124, 172–174, 208–209

Articular capsule 51, 116, 173, 208, 219

Articular complexes (complex joint/s) 51, 52

Articular structure 51, 52

Artistic anatomy 7, 9, 10, 11–14, 17, 22, 25, 30, 37–41, 72

Auricles 75, 84, 91, 104, 132

Axilla 34, 143, 145, 147, 149, 161, 162, 163, 164, 168, 181, 183

Axioappendicular 116, 124, 174

B

Balance 23, 116, 138, 141, 174, 208, 209, 242, 243, 245–247, 249

Basilic (vein) 68, 185, 196, 197, 198

Biceps brachii 55, 58, 62, 64, 175, 179, 181, 244

Biceps femoris 57, 60, 128, 130, 209, 210, 212, 214, 216, 221, 222, 232, 244, 245, 248, 249

Bilateral symmetry 42

Body's centre of gravity 22, 31, 114, 115, 117, 242, 247

Bones 42, 43, 44, 44, 45, 46, 47, 48, 49, 50, 65, 77, 78, 79, 80, 81, 82, 83, 84, 85, 86, 87, 88, 111, 112, 113, 114, 115, 116, 117,118, 119, 120, 121, 122, 123, 124, 125, 169, 170, 171, 172, 173, 174, 196, 197, 198, 199, 200, 201, 205, 206, 207, 208, 232, 233, 234, 235, 236, 242–249

Bone marrow 42, 44

Brachialis 58, 161, 168, 174, 175, 179, 181, 182, 183, 184, 196, 197

Brachioradialis 57, 60, 175, 177, 179, 181, 182, 183, 184, 186, 188, 190, 196, 197, 198, 244

Brachycephalic 85, 86

Breast 24, 66, 68, 73, 163, 164
- Male breast 164

Buccal fat pad 70, 89, 103

Buccinator 58, 89, 90, 93, 94, 96, 97, 103

Bulbospongiosus 155

Buttock 21, 33, 35, 66, 73, 109, 124, 125, 158, 166, 167, 203, 246

C

Caninus (muscle) 89, 90, 92, 93, 94, 95, 96, 108

Canon 7, 12, 34, 35, 37, 38, 39, 40, 41

Carpal ligament 177, 179, 185, 186, 187, 188, 189, 190, 191, 192, 193, 194, 199

Carpometacarpal 52, 173, 244

Carpus 169, 171, 173, 174, 185, 188, 190, 192, 193, 194, 242

Cartilage 28, 32, 35, 42, 44, 51, 52, 81, 83, 91, 93, 94, 96, 102, 104, 118, 119, 120, 121, 122, 134, 136, 144, 145, 151, 153, 159, 160, 169, 172, 205, 208, 242
- Articular cartilage 35, 42, 44, 52
- Costal cartilage 119, 120, 121, 122, 136, 144, 145, 151
- Nasal cartilage 94

Cell 11, 22, 32, 44, 54, 66, 67, 72

Cephalic (vein) 68, 148, 181, 196, 197, 198

Cervical fascia see fascia(e)

Cheek 75, 83, 86, 89, 94, 95, 96, 101, 102, 103, 106, 108, 247

Circumduction 31, 52, 117, 122, 173, 208, 243, 244

Clavicle 43, 45, 46, 48, 52, 65, 109, 111, 117, 119, 120, 122, 132, 133, 134, 136, 145, 148, 149, 151, 160, 161, 169, 242, 243

Clitoris 155, 166

Condylarthrosis 242

Condyle 44, 81, 82, 88, 98, 99, 114, 138, 169, 188, 197, 205, 206, 208, 218, 219, 220, 221, 222, 223, 224, 225, 226, 233, 244

Constitution 15, 16, 22, 24, 25, 62, 67, 114, 120, 248

Coracobrachialis 145, 148, 162, 174, 175, 179, 181, 183

Cornea 100

Corrugator supercilii 91, 96, 97, 108

Cortical (of bone) 44

Costal arch 29, 65, 68, 117, 119, 120, 121, 151

Costovertebral 120, 122

Counterposed (position) 246

Coxofemoral 52, 123, 156, 157, 208, 219, 220, 244

Cranial sutures see Suture(s)

Craniometric points 85, 86

Cranium 28, 42, 43, 75, 77, 78, 79, 80, 81, 83, 84, 85, 86, 88, 99, 104, 106
- Development, shape 77, 78, 79, 80, 81, 82, 83, 84, 85
- Gender differences 28, 86

Crest (bone) 42, 63, 65, 66, 80, 81, 117, 123, 125, 139, 147, 148, 152, 153, 156, 157, 158, 166, 169, 170, 183, 205, 206, 218, 220, 246

Cytology 32

D

Deltoid 54, 58, 60, 62, 63, 64, 68, 109, 124, 125, 126, 128, 130, 132, 145,146, 147, 148, 150, 161, 162, 168, 170, 175, 177, 179, 181, 182, 183, 196, 208, 243, 245

Depressor anguli oris 58, 89, 90, 92, 94, 108

Depressor septi 94

Dermis 32, 33, 67, 68, 72

Diaphragm 33, 122, 124, 143, 154

Diaphysis 43, 44, 169, 183, 205, 218, 219, 221, 223, 227, 242

Diarthrosis 51, 52, 115, 122

Digastric 55, 108, 126, 132, 134, 135, 140, 160

Dimorphism 22, 25

Dissection 9, 10, 11, 12, 16, 32, 40, 56

Distal 30, 31, 44, 67, 169, 171, 172, 173, 181, 184, 185, 186, 187, 188, 189, 190, 191, 194, 195, 200, 203, 206, 208, 223, 225, 228, 244, 245

Dolichocephalic 85, 86

Dorsal digital of foot (veins) 68

Dorsal digital of hand (veins) 68

Dorsal plane 17

E

Ear 42, 104, 105

Elbow 21, 33, 34, 51, 52, 54, 67, 68, 168, 172, 173, 174, 182, 183, 184, 187, 197, 247

Electromyography 56, 106

Enarthrosis 51, 52, 173, 208, 242, 243, 244

Endoskeleton 23

Epicondyle 44, 65, 170, 173, 182, 183, 184, 185, 186, 187, 188, 189, 190, 197, 205, 208, 226

Epicranius (muscle) 91

Epidermis 32, 66, 67, 72

Epiphysis 44, 169, 205, 206

Epitrochlea 44, 169, 170, 173, 184, 197, 198

Erect position 17, 22, 23, 30, 33, 37, 38, 41, 43, 73, 115, 117, 120, 123, 132, 141, 151, 152, 154, 158, 165, 166, 174, 208, 209, 218, 219, 221, 223, 233, 242, 244, 245, 246, 247, 248, 249

Ethmoid 79, 80, 81

Exoskeleton 23

Extension 31, 42, 52, 55, 56, 66, 114, 115, 116, 117, 118, 122, 132, 137, 138, 139, 140, 141, 142, 145, 146, 147, 148, 149, 157, 158, 159, 166, 173, 174, 182, 184, 187, 188, 189, 190, 191, 192, 194, 195, 198, 200, 208, 209, 218, 219, 220, 221, 222, 224, 225, 227, 228, 231, 233, 242, 243, 244, 245, 246, 247, 249

Extensor carpi radialis brevis 57, 175, 177, 179, 187, 188, 198, 244

Extensor carpi radialis longus 57, 58, 60, 175, 177, 179, 182, 183, 188, 191, 196, 197, 198, 244

Extensor carpi ulnaris 55, 60, 177, 179, 183, 184, 187, 188, 189, 191, 198, 199, 244

Extensor digiti minimi 177, 179, 188, 189, 191, 193

Extensor digitorum brevis 57, 209, 210, 212, 214, 225, 228, 229, 231, 244, 245

Extensor digitorum communis 60, 64, 177, 179, 187, 188, 189, 190, 191, 198, 200, 225, 228

Extensor digitorum longus 57, 209, 210, 214, 223, 224, 225, 226, 228, 231, 235, 244, 245

Extensor hallucis longus 209, 223, 224, 228, 235, 245

Extensor indicis 191

Extensor pollicis brevis 60, 177, 179, 181, 187, 188, 189, 190, 191, 192, 198, 199, 244

Extensor pollicis longus 189, 190, 199, 244

External genital organs 21, 24, 28, 67, 109, 165–166

Eye 16, 22, 23, 24, 28, 32, 33, 38, 66, 72, 75, 78, 83, 89, 95, 96, 97, 100–101, 106, 108
 - Eyebrow 75, 78, 83, 91, 95, 96, 97, 101, 102, 104, 106, 108

F

Facial profile 84, 85
 - Camper's 85

Facial block 22, 33, 74, 77–90, 98, 102, 106

Fascia(e) 32, 51, 54, 66, 72
 - Cervical fasciae 54, 125, 132, 134, 135, 136, 137, 151
 - Fascia lata 57, 58, 60, 63, 208, 209, 214, 218, 219, 232, 233, 235, 244, 246

- Fascia of the arm 174
- Fasciae of the head 83, 84, 89, 91, 92, 94, 95, 96, 98, 99
- Fascia of the lower limb 208, 209, 223, 225, 226, 228,
- Fasciae of the trunk 111, 117, 123, 124, 132, 134, 135, 136, 137, 139, 141, 143, 145, 146, 147, 148, 149, 151, 152, 153, 154, 155, 156, 158, 162, 163,
- Fasciae of the upper limb 174, 181, 182, 184, 185, 186, 187, 188, 192, 193, 194, 195, 196,
 - Femoral fascia (sheath) 158, 209, 218, 219, 220, 221, 222,
 - Gluteal fascia 125, 158, 166, 209, 218
 - Popliteal fascia 209
 - Tensor fasciae latae 55, 57, 58, 62, 63, 64, 124, 126, 128, 130, 158, 210, 212, 214, 218, 219, 232, 244, 245, 246, 248, 249

Femur 23, 43, 45, 46, 48, 117, 123, 124, 156, 157, 158, 203, 205, 208, 209, 218, 219, 220, 221, 223, 226, 232, 233, 242, 244, 246

Fingers 22, 23, 34, 67, 171–174, 185, 186, 187, 188, 189, 191, 192, 193, 194, 195, 200–201, 244

Fissure(s) 44, 95, 100, 101, 162

Fibula 43, 45, 46, 48, 65, 203, 205, 206, 207, 208, 209, 221, 224, 225, 227, 228, 233, 234, 235, 242, 245

Fibular 31

Flexion 23, 31, 33, 51, 52, 56, 66, 67, 114, 115, 116, 132, 137, 138, 139, 141, 142, 148, 149, 151, 152, 153, 156, 158, 159, 164, 166, 173, 174, 181, 183, 184, 185, 186, 190, 191, 192, 193, 194, 195, 197, 199, 200, 208, 209, 218, 219, 220, 221, 222, 223, 224, 225, 226, 227, 228, 229, 230, 231, 233, 235, 242, 243, 244, 245, 246, 247, 248, 249

Flexor carpi radialis 57, 58, 64, 175, 181, 185, 186, 188, 198, 199, 244

Flexor carpi ulnaris 58, 64, 175, 177, 184, 185, 186, 187, 191, 193, 197, 198, 199, 244

Flexor digiti minimi brevis 193, 194, 229, 230, 245

Flexor digitorum brevis 209, 229, 230, 231, 245

Flexor digitorum longus 58, 209, 212, 216, 227, 228, 229, 230, 231, 235, 245

Flexor hallucis brevis 209, 229, 230, 245

Flexor hallucis longus 209, 225, 227, 228, 229, 230, 245

Flexor pollicis brevis 190, 192, 244

Flexor pollicis longus 175, 186, 190, 191

Flexor digitorum profundus 175, 177, 186, 187, 191

Foot 21, 22, 23, 31, 33–34, 38, 39, 40, 41, 68, 77, 203–207, 208, 209, 223, 224, 225, 226, 227, 228, 229, 230, 231, 235, 236–237, 244–249

Forearm 17, 21, 28, 33–34, 38, 41, 66, 67, 68, 168–171, 173, 174, 175, 181, 182, 183, 184, 185, 186, 187, 188, 189, 191, 192, 196, 197, 198, 199, 209, 243, 244

Forehead 24, 28, 33, 38, 67, 68, 75, 83–4, 86, 91, 96, 101, 102, 106, 107, 108

Fossa(e) 44, 67, 68, 80, 81, 83, 94, 98, 104, 119, 167, 168, 170, 205
 - Canine fossa 22, 81, 95
 - Cubital fossa 197
 - Intramuscular fossa 83
 - Jugular fossa 75
 - Popliteal fossa 67, 68, 197, 208, 220, 222, 223, 226, 233, 234
 - Temporal fossa 83, 88, 89, 99

Fossae lumbales laterales 28

Frankfurt plane 78, 79, 85

Frontal plane 17, 22, 31, 104, 117, 242, 245, 246, 247

Functional anatomy 11

G

Galea capitis 91

Gastrocnemius 57, 58, 62, 63, 68, 210, 212, 214, 216, 223, 226, 227, 233, 234, 244, 245, 246, 249

Gemellus superior and inferior 157

Geniohyoid 134, 135

Genotype 24

Ginglymus 242
 - Angular ginglymus 208, 242, 244
 - Lateral ginglymus 173, 242

Glabella 80, 83, 85, 91, 96, 97, 101

Gluteal fold 41, 125, 158, 166, 167, 232, 246

Gluteus maximus 60, 62, 64, 125, 128, 130, 156, 157, 158, 166, 167, 212, 214, 216, 218, 221, 222, 244, 245, 246, 249

Gluteus medius 57, 58, 60, 126, 128, 130, 157, 158, 210, 212, 214, 218, 244, 246, 248

Gluteus minimus 124, 157, 158, 218, 244

Goose foot 218, 220, 222, 233

Gracilis 58, 60, 63, 126, 128, 186, 197, 209, 210, 212, 216, 218, 220, 221, 222, 223, 226, 232, 233, 244, 245

Great saphenous (vein) 68, 69, 234, 236

Growth 32, 35, 37, 41, 72, 73–74, 77, 84, 85, 104

H

Hair 24, 28, 32, 33, 34, 37–38, 66, 67, 73, 74, 75, 83, 91, 99, 101, 103, 104, 159, 163, 165, 166, 198, 200, 232, 234

Hallux (big toe) 34, 224, 228, 229, 230, 234, 236

Hand 17, 21, 22, 23, 33, 34, 37, 38, 40, 41, 66, 67, 68, 77, 168, 169, 171, 172, 173, 174, 175, 185, 186, 187, 188, 189, 191, 192, 193, 194, 195, 199, 200–201, 203, 206, 209, 244, 245

Head 17, 21, 22, 23, 24, 28, 30, 33, 34, 35, 37, 38, 39, 40, 41, 42, 43, 50, 55, 68, 73, 74, 75–108, 109, 111, 112, 114, 115, 116, 117, 118, 124, 132, 134, 135, 136, 137, 138, 139, 140, 142, 150, 159, 160, 243, 245, 246, 247, 248, 249

Hereditary 16, 24, 67, 104

Hip 17, 21, 33, 34, 41, 51, 52, 109, 123, 124, 125, 148, 156, 166, 203, 208, 209, 218, 242, 244, 246, 248

Helix 91, 104

Humerus 43, 44, 45, 46, 48, 56, 65, 145, 146, 147, 148, 149, 161, 162, 168, 169, 170, 172, 173, 174, 181, 182, 183, 184, 185, 186, 187, 188, 189, 190, 196, 197, 242, 243
 - Humeral head 43, 120, 146, 148, 162, 169, 170, 172, 184, 185, 243

Hypothenar eminence 34, 174, 175, 193, 194, 200, 201

I

Ilium 45, 46, 48, 123, 125, 153, 156, 157, 158, 218, 244

Iliocostalis 117, 128, 139, 152, 245

Iliolumbar (ligament) 124, 152

Iliopsoas 117, 124, 126, 152, 153, 156, 210, 218, 219, 220, 244, 245, 248

Incisivus labii inferioris 92

Incisivus labii superioris 93

Infraspinatus 57, 60, 64, 119, 124, 128, 130, 146, 147, 148, 149, 161, 173, 177, 243

Inguinal (ligament) 109, 125, 130, 152, 153, 154, 156, 220

Intercostal muscles 124, 133, 143, 144, 153

Integumentary (system) 25, 30, 66–67, 72, 125, 163

Internal pterygoid 96

J

Joints 22, 43, 51, 52, 54, 56, 72, 88, 91, 242, 243, 244, 245
 - Acromioclavicular joint 120, 122, 161, 172, 243
 - Calcaneocuboid joint 52, 209
 - Carpal joints 43, 45, 46, 48, 52, 63, 168, 171, 173, 174, 199, 244
 - Coracoacromial joint 51
 - Coxofemoral (hip) joint 33, 51, 52, 123, 156, 157, 208, 218, 219, 220, 244
 - Elbow joint 33, 168, 172, 173, 182, 183, 184, 187, 197, 198, 242, 243

- Humeroulnar joint 52, 186
- Interphalangeal joints 173, 206, 209, 244, 245
- Intermetacarpal joints 173
- Knee joint 51, 52, 203, 208, 218, 219, 220, 223, 226, 233, 244
- Metacarpophalangeal joints 171, 173, 188, 189, 190, 191, 195, 200, 245
- Nasofrontal joint 85, 102
- Pubic symphysis joint 35, 41, 65, 123, 124, 125, 220, 166, 208
- Radiocarpal joint 52, 172, 173, 188, 199, 244
- Radioulnar joints 51, 52, 172, 173, 242, 244
- Sacroiliac joint 123, 124, 208
- Saddle joints 52, 122, 173, 244
- Scapulohumeral (shoulder) joint 23, 33, 52, 120, 143, 145, 146, 147, 148, 161, 169, 172, 173, 181, 182, 183, 243, 244
- Sternocostal joints 120, 122
- Sternoclavicular joint 120, 122, 151, 172, 243
- Temporomandibular joint 51, 52, 82, 88, 89, 98, 104, 106, 242
- Tibiotarsal (ankle) joint 52, 208, 224, 225, 245, 249
- Vertebral column joints 114–117, 122, 235, 138, 242
Jump(ing) 209, 242, 245, 248–249

254

K
Knee 21, 34, 37, 38, 40, 203, 218, 219, 220, 221, 232, 233, 245, 246, 247, 248, 249
Kyphosis 111, 114, 116, 151

L
Labial commissure 92, 94, 95, 96, 103, 108
Labia majora 166
Labia minora 166
Lacrimal caruncle 100
Landmark(s) 17, 62, 65, 66, 101, 104, 119
Lateral (fibular) malleolus 33, 34, 62, 63, 65, 66, 68, 205, 206, 208, 225, 226, 227, 234, 235, 245
Lateral plane 17, 30, 31, 243
Lateral pterygoid muscle 98
Latissimus dorsi 55, 57, 58, 60, 62, 64, 124, 125, 126, 128, 130, 143, 145, 146, 147, 148, 149, 150, 152, 153, 161, 162, 174, 183, 243
Leg 17, 21, 28, 31, 33, 34, 40, 41, 68, 73, 203, 205, 207, 208, 209, 218, 219, 220, 221, 222, 223, 224, 225, 226, 227, 228, 233, 234, 235, 244, 245, 246, 247, 248, 249, 254
Lens 32, 100
Leptorrhine 102
Levator ani 154
Levator costarum 144

Levator scapulae 57, 124, 126, 128, 130, 132, 133, 138, 143, 150, 160
Levers 43, 52, 55, 56, 242, 243
Linea alba 29, 63, 125, 134, 151, 152, 153, 165
Line of gravity 22, 31, 114, 115, 117, 242, 245, 246, 247, 248, 249
Locomotor system 13, 16, 25, 28, 30, 33, 42–70, 72, 89, 106, 242
Longissimus 117, 128, 132, 133, 137, 139, 140, 141, 245
Long-limbed (longilineal) 24, 25, 73, 120
Lordosis 111, 114, 116, 151, 246, 247
Lower limb(s) 17, 22, 23, 24, 30, 31, 33, 34, 68, 203
- Lower limb (morphology) 33, 203, 210, 211, 212, 213, 214, 215, 216, 217
- Lower limb (movements) 33, 208, 244
Longus capitis 133, 135, 137, 138
Longus colli 133, 137
Lumbricales 174, 175, 194, 195, 209, 228, 229, 230, 231

M
Macroscopic structure 11, 30
Mandible 33, 45, 46, 48, 65, 68, 79, 74, 77, 81, 82, 83, 84, 88, 89, 92, 93, 97, 98, 99, 103, 104, 106, 108, 118, 132, 134, 135, 159
Maxilla 22, 45, 46, 79, 81, 82, 83, 84, 93, 94, 95, 96, 97, 102, 103
Masseter 57, 58, 62, 75, 89, 90, 92, 94, 95, 98, 108, 132
Masticatory (muscles) 77, 82, 89–90, 98, 106
Medial (tibial) malleolus 62, 63, 65, 205, 206, 208, 227, 228, 234, 235, 236
Median (vein) 68
Median elbow (vein) 68
Median plane 31, 83, 88, 102, 103, 117, 120, 145, 161, 165, 166, 242, 243, 245
Melanin 66, 67, 74
Mentalis 58, 89, 90, 92, 97, 103, 108
Mesocephalic 85, 86
Mesorrhine 102
Metacarpus 169, 171, 174, 187, 192, 193, 194, 195, 242
Metatarsus 65, 68, 205, 206, 207, 228, 229, 242
Metazoa 72
Microscopic structure(s) 32, 44, 54
Mimicry (expressions) 13, 14, 67, 72, 77, 89, 91, 92, 93, 94, 95, 96, 97, 98, 101, 102, 106–108, 132
Mouth 23, 83, 88, 92, 93, 94, 95, 96, 98, 99, 103, 106, 108, 13, 134
Mucosa bursae 174, 209, 243, 244
Muscle belly 54, 55, 132, 181, 182, 185, 187, 188, 189, 190, 191, 192,

218, 219, 222, 223, 224, 225, 226, 227, 228, 230, 243
Muscle fascia 54–65, 84, 125, 148, 154, 155, 164
Muscle structure 54–56, 116–117
Myological sculptures, models 13, 42–43, 52, 56, 66

N
Nail 22, 32, 34, 66, 171, 200, 201, 236
Nape 21, 33, 37, 116, 124, 149, 159
Nasalis (bone) 79
Nasalis (muscle) 89, 90, 94, 96, 108
Nasal lobule (tip of the nose) 102
Navel 28, 29, 28, 40, 41, 68, 151, 152, 164, 165, 166
Neck 17, 21, 30, 33, 35, 37, 38, 40, 68, 77, 82, 83, 89, 106, 108, 109, 111, 114, 115, 117, 118, 119, 122, 124, 125, 132, 133, 134, 136, 137, 138, 139, 140, 141, 142, 144, 149, 150, 159–160, 162, 247
Neurocranium (braincase) 22, 25, 35, 77, 78, 80, 82, 83, 84, 85, 88, 89,
Nipple 41, 62, 67, 68, 145, 163, 164
Norma (skull) 78, 79, 82, 83, 85
Normal-limbed (normotype) 24–25, 26–27
Nose 23, 33, 38, 41, 42, 67, 75, 78, 81, 83, 89, 90, 91, 92–93, 94, 96, 100, 102, 103, 104, 106, 108

O
Obliquus capitis superior 142
Occipital bone 22, 43, 45, 48, 57, 60, 78, 79, 80, 81, 82, 83, 84, 85, 88, 91, 108, 114, 115, 116, 117, 137, 138, 140, 142, 149, 159, 247
- Foramen magnum 22, 80, 81, 83, 85, 142
Old World anthropoids 22, 23
Olecranon 62, 63, 169, 170, 171, 173, 182, 184, 185, 197
Omohyoid 58, 125, 126, 130, 132, 133, 134, 135, 136, 160
Opponens digiti minimi 174, 193, 194, 200, 230
Opponens pollicis 190, 192, 200, 244
Opposability of the thumb 22, 23, 34, 173, 174, 192, 193, 194, 244
Orbicularis oris 57, 58, 89, 90, 92, 93, 94, 95, 97, 99, 106, 108
Orbicularis oculi 55, 57, 58, 89, 90, 94, 95, 97, 101, 108
Orbital cavity (eye socket) 75, 77, 81, 82, 83, 95–96, 100, 102
Organs 11, 12, 14, 15, 16, 17, 22, 23, 24, 30, 31, 32, 33, 42, 43, 44, 54 72
Organisms 11, 22, 32, 66, 72
Osteocytes 44

P
Patella 43, 45, 46, 63, 65, 203, 205, 207, 208, 209, 219, 232, 233, 244, 245
Pathological anatomy 11, 15, 16, 24, 72, 85
Pectoralis major 57, 58, 62, 63, 124, 126, 130, 132, 143, 145, 147, 148, 150, 151, 153, 161, 162, 163, 164, 174, 175, 179, 181, 183, 196, 243
Pectoralis minor 143, 145, 148, 150, 151, 243
Pelvic girdle 42, 111, 123, 124, 203, 205, 208
Pelvis 22, 23, 25, 28, 29, 31, 33, 34, 42, 52, 73, 111, 115, 117, 123, 124, 125, 151, 152, 153, 154, 156, 157, 158, 166, 203, 205, 208, 209, 218, 219, 220, 221, 222, 223, 232, 242, 245, 246, 247
Phalanges (of the hand) 34, 43, 168, 169, 171, 173, 186, 188, 189, 190,191, 194, 195, 200, 242, 244
Phalanges (of the foot) 203, 205, 206, 207, 224, 228, 230, 231, 242
Phenotype 24
Physical anthropology 11, 13, 38, 86
Pigment see Melanin
Piriformis 157, 158, 208, 244
Plantar muscle (plantaris) 60, 212, 223, 226, 227, 228, 233
Platyrrhine 102
Platysma 92, 95, 98, 106, 108, 117, 124, 126, 132, 134, 135, 136, 145, 148, 160
Popliteus 209, 223, 226, 233, 245
Primates 22, 23
Process (terminology) 44
Pronator quadratus 184, 185, 190, 244
Pronator teres 175, 181, 183, 184, 185, 186, 197, 198, 244
Proportions 12, 13, 24, 28, 29, 34–41, 42, 62, 73, 74, 77, 78, 84, 86, 100, 120, 200, 240
Protozoa 72
Proximal plane 30, 31, 55
Psoas minor 124, 155
Pubis (pubic bone) 38, 40, 45, 46, 48, 123, 125, 151, 152, 153, 154, 155, 156, 165, 208, 220, 242, 244
Pyramidalis 89, 90, 152, 153, 244

R
Recess (terminology) 44
Rectus capitis lateralis 138
Rectus capitis posterior major 142
Rectus capitis posterior minor 142
Rhomboid muscles 124, 125, 128, 138, 139, 143, 146, 149, 150, 161, 233, 243,
Rib cage 23, 24, 29, 33, 42, 55, 109, 111, 117, 119, 120–122, 124, 143, 144, 145, 146, 151, 152, 153, 159, 161, 163, 164

Ribs 33, 42, 43, 68, 109, 112, 115, 117, 119, 120, 121, 122, 133, 139, 143, 144, 145, 147, 150, 152, 153, 162, 242

Rima oris (oral rim) 97, 103

Risorius 89, 90, 92, 94, 95, 96, 103, 108

Rotation 31, 43, 52, 114, 115, 116, 117, 132, 133, 137, 138, 139, 140, 141, 142, 143, 145, 146, 147, 148, 149, 150, 152, 153, 156, 157, 158, 159, 162, 173, 181, 183, 184, 189, 190, 192, 194, 208, 218, 220, 221, 222, 223, 227, 243, 244, 245, 246

Rotatores (muscles) 140, 141

Running 174, 208, 209, 242, 245, 248, 249

S

Sacrococcygeal muscles 139

Sacrospinalis 139, 140, 141, 148

Sagittal plane 17, 31, 33, 109, 114, 117, 246

Sartorius 55, 57, 58, 60, 62, 63, 126, 130, 156, 209, 210, 212, 214, 216, 18, 219, 220, 221, 232, 233, 244, 245, 248, 249

Scapula 43, 45, 46, 48, 52, 65, 109, 111, 116, 117, 119, 120, 136, 143, 145, 146, 147, 148, 149, 150, 161, 169, 172, 181, 182, 183, 242, 243

Scrotum 165

Semimembranosus 55, 60, 209, 212, 214, 216, 220, 221, 222, 232, 233, 234, 244, 245, 246, 249

Semispinalis 139, 140, 141, 142

Semitendinosus 55, 60, 128, 209, 214, 216, 218, 220, 221, 222, 232, 233, 244, 245, 249

Serratus anterior 57, 62, 63, 64, 124, 126, 128, 130, 143, 145, 147, 148, 150, 153, 162, 163, 243

Serratus posterior inferior 124, 139, 143, 146, 147, 150

Serratus posterior superior 143, 145, 146, 150

Sexual differences (dimorphism) 17, 25–29, 33, 35, 36, 66, 83, 86, 104, 114, 118, 120, 123, 125, 159, 163–164, 165, 166, 167, 198

Short-limbed (brevilineal) 25, 26–27 120

Shoulder girdle 42, 111, 119, 120, 124, 134, 145, 148, 149, 159, 161, 168, 169, 172, 174, 243

Skeletal muscles (striated) 32, 54, 243

Skeleton 17, 42, 242
 - Appendicular skeleton 17, 30, 42, 109, 111, 169
 - Axial 11, 17, 30, 33, 41, 42, 55, 66, 72, 109, 111, 114, 115, 120, 124, 169, 172, 174, 205, 242
 - Cephalic skeleton 82, 84, 85, 86

Skin 9, 24, 32, 33, 44, 50, 54, 55, 56, 62, 66–67, 68, 72, 74, 75, 89, 91, 92, 93, 94, 95, 96, 97, 101, 102, 103, 104, 106, 108, 126, 128, 130, 132, 134, 136, 143, 145, 146, 147, 148, 149, 151, 153, 155, 158, 160, 161, 162, 163, 164, 165, 166, 175, 177, 179, 181, 182, 184, 185, 186, 188, 190, 192, 193, 195, 197, 199, 200, 210, 218, 219, 220, 221, 222, 223, 225, 226, 228, 229, 230, 233, 236, 240, 242

Skull 17, 22, 23, 28, 33, 38, 75, 77, 78, 79, 80, 82, 83, 84, 85, 86, 87, 88, 104, 242

Small saphenous veins 68, 69, 234

Smooth muscles 32, 54

Sphenoid 79, 80, 83, 96, 97, 98, 99

Spinous process 111, 112, 114, 116, 117, 137, 138, 140, 141, 142, 143, 146, 147, 149, 159

Squama 44, 80, 81, 83, 88, 99, 142

Static 11, 22, 31, 37, 44, 54, 56, 77–78, 115, 116, 117, 174, 242–247

Sternocleidomastoid 55, 57, 58, 60, 62, 68, 75, 91, 117, 124, 126, 128, 130, 132, 133, 134, 135, 136, 138, 149, 150, 159, 160

Sternothyroid 126, 132, 134, 136

Sternum 29, 33, 42, 43, 46, 65, 117, 119, 120, 121, 122, 132, 134, 136, 144, 145, 159, 160, 163, 242

Striated muscle 32, 54

Styloid process(es) 62, 63, 65, 80, 81, 135, 169, 170, 171, 181, 187, 188, 199, 201,

Suboccipital muscles 124, 142

Subclavius muscle 124, 151

Sudoriferous (sweat) glands 67, 162

Superficial veins 67, 68, 132, 165, 196, 197, 198, 200, 234, 236
 - Superficial epigastric vein 68

Superior plane 30, 112

Suture(s) 42, 51, 77, 80, 82, 84, 88, 94, 242

T

Tarsus 96, 101, 205, 206, 207, 223, 227, 228, 229, 242, 245

Teeth 22, 23, 33, 74, 81, 82, 83, 84, 98, 242

Temporal bone 22, 43, 45, 75, 79, 80, 81, 82, 83, 88, 91, 99, 132, 135, 138

Temporal fascia 84, 89, 91, 95, 99

Temporal process 82, 83, 94, 117, 139

Temporal veins 69

Temporal (temporalis) muscle 57, 58, 80, 83, 89, 90, 91, 98, 99, 108

Tendon 9, 42, 43, 44, 52, 54, 55, 199, 208, 209, 233, 234, 235, 242, 243, 244
 - Tendon sheaths 54, 174, 185,

186, 188, 189, 209, 223, 224, 229

Teres major 57, 60, 64, 124, 128, 130, 146, 147, 149, 161, 162, 177, 179, 182, 183

Teres minor 60, 128, 146, 147, 148, 149, 173, 177, 182, 243

Terms of motion, movement 31

Terms of position 17, 30–31

Territories (sections of the body) 17, 21, 30, 33–34

Thenar eminence 34, 58, 174, 175, 186, 190, 192, 193, 199, 200, 201

Thigh 17, 21, 33, 34, 40, 41, 73, 156, 157, 158, 203, 205, 208, 209, 218, 219, 220, 221, 222, 223, 227, 232, 233, 246, 247, 249

Throat 159, 160

Tissue(s) 32, 44, 50, 72, 77
 - Epithelial tissues, 32, 72
 - Connective tissue 28, 32, 33, 42, 51, 54, 66, 68–69, 72, 77, 88, 89, 94, 95, 103, 145, 146, 148, 158, 159, 162, 163, 164, 165, 166, 174, 193, 200, 221, 226, 230, 232, 233, 242, 247
 - Muscle tissue 32, 54, 72, 242, 243
 - Nervous tissue 32, 72

Topographical anatomy 10, 11, 17, 30, 56, 111, 119, 126, 128, 130, 175, 177, 179, 183, 210, 212, 214, 216

Trabecular (cancellous) bone 44

Transverse process 112, 114, 116, 122, 133, 137, 138, 139, 142

Triceps brachii 60, 182, 244,

Trochlea(e) 44, 52, 169, 170, 173, 182, 208, 242, 243, 244, 245

Trunk 17, 22, 24, 25, 28, 29, 30, 31, 33, 35, 38, 40, 42, 50, 52, 55, 66, 68, 73, 74, 77, 88, 109, 110, 111, 115, 116, 117, 123, 124, 125, 126, 127, 128, 129, 130, 131, 132–158, 159, 161, 168, 174, 203, 243, 244, 245, 246, 247, 248, 249

Tubercle 44
 - Superficial tubercle(s) 103, 104,
 - Tubercle(s) on bones 44, 81, 85, 92, 112, 120, 122, 133, 137, 138, 139, 142, 146, 147, 151, 152, 154, 169, 170, 172, 181, 187, 190, 192, 205, 220, 221, 226, 227, 229, 230

Tuberosity 44, 63, 65, 97, 170, 125, 145, 148, 181, 182, 183, 205, 206, 208, 218, 219, 220, 224, 225, 227, 230, 233,
 - Ischial (gluteal) tuberosity 123, 124, 125, 154, 155, 157, 158, 166, 220, 221, 222

U

Ulna, ulnar 31, 43, 168, 169, 171, 173, 182, 183, 184, 185, 186, 187, 189, 191, 192, 196, 197, 198, 199, 242, 243, 244

Upper limb(s) 17, 30, 31, 68, 161, 168, 169, 174, 196, 197, 198, 200
 - Upper limb (morphology) 168, 172, 174, 175, 176, 177, 178, 179, 180 , 242
 - Upper limb (movements) 28, 120, 172, 174, 243

V

Variation 15–16, 43, 52, 62, 112, 116, 197, 246, 247

Venus dimples see Fossae lumbales laterales

Vertebrae 43, 111, 112, 114, 116, 117, 118, 119, 120, 141, 144
 - Cervical vertebrae 62, 112–117, 118, 128, 133, 137, 138, 139, 140, 141, 142, 144, 146, 149, 150, 159
 - Coccygeal vertebrae 112, 115
 - Lumbar vertebrae 112, 115, 116, 117, 124, 139, 140, 141, 143, 147, 152, 156, 165, 245
 - Sacral vertebrae 112, 115, 245
 - Thoracic vertebrae 112, 116, 117, 119, 122, 137, 138, 139, 140, 141, 142, 144, 146, 147, 149

Vertebral arch (movement) 112, 114, 115, 116, 117

Vertebral column 112, 115, 116

Vertebral curves 111, 114

Volar 31, 67, 171, 172, 174, 195, 200, 244

Voluntary muscles 43, 54, 158, 243

Vomer 44, 79, 81

Vulva 166

W

Walking 22, 23, 33, 123, 156, 158, 166,174, 205, 208, 209, 221, 223, 225, 227, 228, 242, 245, 246, 248, 249

Wrist 21, 33, 34, 54, 67, 68, 168, 169, 173, 174, 184, 185, 186, 187, 188, 189, 190, 191, 192, 198, 199, 200, 235, 244

X

Xiphoid process 119, 120, 121, 122, 144, 151, 163, 165

Z

Zygomatic arch (cheek bone) 65, 82, 83, 84, 85, 86, 89, 95, 98, 99

Zygomatic bone 22, 45, 46, 65, 75, 79, 81, 82, 83, 84, 93, 94, 99, 108

Zygomaticus muscle 93, 94

Zygomatic process 80, 81, 82, 83, 98